DATE DUE

MAY 0 1 1990

10-23-02 11:

W9-AYS-401

3 1611 00174 0163

FEB 8 1982

The Artist and Political Vision

The Artist and Political Vision

edited by

Benjamin R. Barber
Michael J. Gargas McGrath

UNIVERSITY LIBRARY

GOVERNORS STATE UNIVERSITY

PARK FOREST SOUTH, ILL.

Transaction Books
New Brunswick (U.S.A.) and London (U.K.)

Copyright © 1982 by Transaction, Inc.
New Brunswick, New Jersey 08903

All rights reserved under International and Pan-American Copyright
Conventions. No part of this book may be reproduced or transmitted in
any form or by any means, electronic or mechanical, including photocopy,
recording, or any information storage and retrieval system, without prior
permission in writing from the publisher. All inquiries should be addressed
to Transaction Books, Rutgers — The State University, New Brunswick,
New Jersey 08903

Library of Congress Catalog Number: 80-80317
ISBN: 0-87855-380-0
Printed in the United States of America

Library of Congress Cataloging in Publication Data
Main entry under title:

The Artist and political vision.

 Includes index.
 1. Politics in literature—Addresses, essays,
lectures. I. Barber, Benjamin R., 1939-
II. McGrath, Michael J. Gargas, 1942-
PN51.A74 809′.93358 80-80317
ISBN 0-87855-380-0

PN
51
A74
c.1

For John Duffy and Martin Best
Collaborators in Politics and the Arts

BRB

For Natasha, Demitri and Anastasia
beautiful dreams, yet unborn

MJGM

UNIVERSITY LIBRARY

GOVERNORS STATE UNIVERSITY

PARK FOREST SOUTH, ILL.

Contents

Introduction

Like old lovers, politics and the arts have shared an extended intimacy characterized by unfulfilled promises and lingering regrets, by frequent quarrels and occasional wars, by mutual fascination and common distrust. The artist has a public and thus political vision of the world interpretated by his art — by her art — no less than the statesman and the legislator have a creative vision of the world they wish to make. Art and politics are often regarded as denizens of different realms, but few artists have been comfortable with the notion of a purely aesthetic definition of art.

Dr. Johnson's insistence that "it is always the writer's duty to make the world better" is illustrative. Shelley identified poetry with "the center and circumference of knowledge" and called poets "the unacknowledged legislators of the world." If Plato preferred to see them as "image-makers whose phantoms are far removed from reality," he was nonetheless at one with Johnson and Shelley in viewing art as morally engaged — corrupting rather than edifying, but certainly not neutral.

Ortega y Gassett's portrait of art as a "weapon" that "turns against natural things and murders them" is no more melodramatic than Solzhenitsyn's description of the artist as "a foreign government in the heart of a nation." Sartre first believed that it was possible to "treat the pen as a sword," but came ultimately to believe "culture saves nothing and nobody." In both cases, the uses of art are debated in the language of political action and social redemption. Robert Brustein recently called a group of social dramatists "metaphysical rebels," conflating the language of the abstract and the concrete in a most provocative fashion.

Thus, whether they treat one another as comrades or adversaries, it seems apparent that the artist and the statesman, the poet and the legislator, occupy some of the same ground and pursue many of the same objectives: a clear view of human reality in its private and public dimensions; a vision of alternate human futures; and a full picture of complex human reality, particularly as it impinges on how women and men choose to live their lives. Whether art "stands above reality to gaze on the current situation from the heights" (as Gorki believed), or engages actively in shaping that reality, it is concerned with vision. As Conrad wrote, it "makes men see."

Art is thus necessarily and ineluctably political. It challenges or complements political vision, reenforces or spurns public mores, enjoins social integration or promotes social alienation. Art celebrates or defies, rejoices or despairs. It is neither detached, nor impartial, nor isolated, nor pure.

By the same token, there is an intrinsically artistic aspect to politics. Since the fifteenth century at least, many influential political thinkers have viewed the state itself as a work of art — a tribute to the powers of human artifice in the face of natural disorder and anarchy. Machiavelli's *Prince,* Hobbes' *Leviathan,* Rousseau's *Social Contract,* as well as the great founding document of the American republic, were quite literally works of art — not simply because they reflected the artistic sensibility of their creators, but because they represented creative visions of the human condition. Rousseau and Robespierre address the same reality; Madison and Melville treat with the same condition; Lenin and Brecht wrestle with the same dilemmas.

The sixteen original essays in this volume bear eloquent witness to this interpenetration of art and politics. Each confronts the intersection of the aesthetic and the social; each is concerned with the interface of poetic vision and political vision, of reflection and action. They take art in the broadest sense, ranging over poets, dramatists, novelists, essayists and filmmakers. They examine the continental tradition (Part I, including essays on Rousseau and Brecht; Baudelaire; Dostoevsky and Unamuno; Camus; Trotsky and Malraux; and Hesse) and the Anglo-American tradition (Part II, including essays on Shakespeare; Joyce; Cooper; Melville; Twain; Orwell; Faulkner, Naipaul, and Zola; Capra; and Kesey and Vonnegut).

It would be misleading to regard the essays as mere biographical portraits of particular artists, however. Their focus is on the political dilemma of art, not simply on the artist. They consider the issues raised for politics and culture by alienation, violence, modernization, technology, democracy, progress, and revolution. They debate the capacity of art to stimulate social change and incite revolution, the temptations of social control of culture and of political censorship, and the uncertain relationship between art and history. The essays discuss the impact of economic structure on artistic creation and of economic class on artistic product, and detail the common ground between art and legislation and between creativity and control.

The contributors to the volume are as varied in their interests and backgrounds as their essays. While all share an interest in the politics of culture, some are teachers and scholars of political philosophy while others are historians, biographers, or social critics. Some have worked in the genres they subject to analysis; others are sympathetic critics. None come

to the arts as mere social scientists looking for the "political message" of culture. Together, they constitute as experienced and reflective a group of commentators as is likely to be found in a single volume.

We trust that a collection such as this will find a hospitable reception among students and teachers of courses in politics and literature, modern political philosophy, intellectual history, and the sociology of culture; but it is also intended as an appropriate introduction to the general reader of vital current themes in the political criticism of culture and the cultural criticism of politics. We hope it will open the controversial, interdisciplinary study of politics and art to a very wide public indeed; for these essays are an integral part of the continuing dialogue about art, politics, and human nature that is at the heart of the Western tradition.

<div style="text-align: right">

Benjamin R. Barber
Michael J.G. McGrath

</div>

Part I

The Artist in the Continental Tradition

Chapter One

Rousseau and Brecht: Political Virtue and the Tragic Imagination

Benjamin R. Barber

In a civilization accustomed to thinking "all the world's a stage and all the men and women merely players," the history of theater and the history of politics are bound to unfold as interlocking narratives. They share much more than metaphors, for both politics and theater are forms of public activity born of an interaction between actors and an active audience (a participating constituency). Both occupy the public arena and take for granted our natural sociability. Both generate conventions of communication aimed at revealing, perhaps even creating, our common nature and our common aspirations. Most importantly, both are forms of *public seeing*. Each rests on the paradoxical claim that the real can be unmasked and revealed only through the donning of masks, that public perception depends on the surrender of private roles, that to see truly is first to be blinded — deprived of the mundane faculties of private sense experience. The right ordering of human affairs as art or as justice demands a special, disinterested vision. In *Oedipus Rex,* it is the blind Teiresias who alone is able to see, whereas Oedipus himself discovers the truth only when he has lost his sight.

To some degree, then, both theater and politics treat private men as denizens of Plato's cave — chained in a shadowed abyss of illusions by partial interests, personal chimeras and private prejudices. The art of politics and the art of drama look perforce beyond the cave for realities embedded in but not revealed by the mundane. The natural order, in aesthetics as well as in morals, is secreted by the natural, and must be cajoled, ferreted, even conjured out by art. Or, to dispense with Platonic imagery, both theater and politics are necessarily normative in their vision, even when prescription is camouflaged by the descriptive categories of

1

nature and naturalism. (There are naturalists in drama just as there are naturalists in political theory, and the two are more closely related than one might think.)

Given their common history as normative forms of public seeing, it is no surprise that the theater and the polity have so often been in conflict, or that the role of political vision in drama and of dramatic vision in politics has occasioned such controversy among theorists. For the conflict between theater and the polity over their competing visions of the right ordering of human affairs embodies a competition fundamental to Western society: the competition between art (the realm of the aesthetic) and politics (the realm of law, convention and right) for justice (the realm of morals). Although liberal culture dreams of a harmonious balance of the three, and integral societies (mostly traditional) have sometimes achieved a momentary equilibrium, conflict has been the rule. Societies or theories of society with claims to civic virtue or natural order have generally regarded the arts in general and theater in particular as potential corrupters; at the same time, dramatic traditions that successfully embody some vision of the pure and the right have regarded the societies in which they evolve as censorious tyrannies, in potential if not in practice. Thus theater may appear as a corrupting influence in virtuous polities, or as a pristine or even revolutionary influence in corrupt polities. Plato and Rousseau share the first perspective, Ibsen, Lukács, and Brecht the second. There is also a third alternative, offered by those who, like Nietzsche, perceive in the aesthetic a transcendent realm indifferent to the political and the moral alike; that, however, is a different story.

The generally adversary relationship between politics and theater becomes, in the setting of political theory, the particular problem of virtue and corruption — in republics of virtue as well as regimes of power. The relevant question is whether theater can make good polities bad, or bad polities good. Within this setting, Jean Jacques Rousseau's rather extravagant experiences in and opinions about the theater of his time acquire a rationality and a clarity that illuminate the intrinsic dilemmas of dramatic art, as well as elucidating and extending the dualities of his own moral and political theory.

I propose to subject Rousseau's views about theater to a critical examination that will show (1) that they are wholly consonant with and extend significantly his general critique of corruption and tyranny in urban civilization — his critique, that is to say, of the ravages committed by the human imagination; (2) that they are shaded with the same prudent sociological relativism found in the political works and are thus less rigid and more subtle than most critiques have allowed; (3) that they are deeply prophetic of political and aesthetic dilemmas intrinsic to the the-

ater and, in this sense, of the most excruciating paradoxes of the aesthetic-revolutionary sensibility. In other words, I believe that Rousseau's opinions about theater can be assimilated into his political and moral theory without having to dismiss them as telling dramatic theory. His assault on the theater grew out of intimate knowledge of its working forms, and his conclusions about it — as unfashionable now as then — were anything but perverse. His criticism offered an analysis which two centuries of theater has had to confront; it raised dilemmas that neither Brecht nor Lukács nor the dramatic pioneers of our own time have been able fully to resolve. Finally, he understood the art he assailed far better than those, like Voltaire and Diderot, who practiced it with greater success; and he probably appreciated it as much as, loved it more than, those, like D'Alembert, who sprang mindlessly to its defense. Whatever judgments we finally make of them, Rousseau's writings on the theater surely do more to exhibit than to confound his genius.

I.

Rousseau's critique of the theater can almost be reduced to an epigram: in virtuous republics, real or imagined, theater corrupts; in actual societies, corrupt and corrupting, it makes little difference. It may sometimes mitigate the degree of mischief done by fallen states but it can never make them virtuous again.

The first part of this critique is elucidated in the *Letter to D'Alembert on Theater*,[1] the second largely in the preface to the published version of *Narcisse* — the most successful of Rousseau's seven plays.[2] Both parts reflect the dualism that can be found in Rousseau's work between social reality (history) as the corrupter of natural innocence and social possibility (theory) as the remedy to this inevitable corruption. In this section of the essay our attention will be focused on the *Letter to D'Alembert;* in the next we will turn to *Narcisse* and the problems raised by its sociological relativism.

The *Letter to D'Alembert,* like all of Rousseau's work, is rooted in traumatic contingencies that it nevertheless almost immediately transcends. It was written (1758) during a period when Rousseau was in flight from Paris—from his French patrons and erstwhile colleagues among the *philosophes* and from romantic entanglements that were better treated in the pages of *Julie* than in person. He stood on the verge of a complete break with Voltaire,[3] with whom he had never enjoyed friendly relations, and who had now prompted D'Alembert to include a quite gratuitous call for a theater in Geneva in the *Encyclopedia* article on Geneva published in 1757; he faced an inevitable but deeply painful break with Diderot, once his

closest companion and friend, but now part of a suspected "plot" against him; and he was beginning to look seriously to Geneva, his birthplace, as a sanctuary for his troubled soul, if not for his uremia-wracked body. The preface to the *Letter* thus announces the break with Diderot in the most histrionic terms,[4] while its substance completes the philosophical rupture, initiated in the two *Discourses*, with the standard Enlightenment position. The heated atmosphere in which the *Letter* was conceived itself constituted high drama: Voltaire poised at Délices on the very outskirts of Geneva, ready to stain its republican virtue with his entertainingly corrosive satires;[5] all of Europe watching to see if the unbending pastors of Geneva would succumb to what Voltaire liked to call good sense but Rousseau condemned as vanity; and Rousseau himself filled with "righteous indignation at all these intrigues to corrupt my country."[6]

Yet the resulting document, despite the urgency of its rhetoric, does possess, as Rousseau accurately notes in the *Confessions*, a "singular tone" reflecting the dearness with which he holds Geneva, the "tenderness" and vulnerability of his new isolation, and the ambivalence of his attitudes towards an art form to which he had recently devoted ten years of his life.[7] The *Letter* is thus much more than a contingent outburst of rhetoric: it both illustrates and extends the general critique of man's fall from natural innocence that was initiated less concretely in the *Discourses*. The focus, in the *First Discourse*, on the arts and sciences as the chief villains of the drama of civilization involved a good deal more than felicitous metaphors. For if it was psychological dependence *(amour propre)* and economic dependence (property) that had placed the human race in chains, then the arts and sciences had done much more than, in the familiar phrase, fling garlands of flowers over them; arts and letters no less than natural science stood as tributes to the powers of human imagination, and it was in imagination that every kind of dependence (and thus corruption) was rooted. And if the arts in general stood as an archetype for imagination, theater in particular illustrated most convincingly its insidious powers when put in the service of the passions. *The Letter to D'Alembert* is thus first of all a case study of the corruption of republics by passion and imagination. The corroborating evidence it provides is intended to confirm the serious charges Rousseau had leveled at the society in which he lived.

His charges had both a sociological and a psychological thrust. As sociology, the *Letter* treated theater as a representative institution of, and standing symbol for, the city — for urban life in all its unnatural tendencies. Rousseau had spent the years from 1742 to 1752 primarily in Paris, a city which in 1750 had achieved a population of nearly half a million. His portrait of city life in the *Letter* initiates a disenchantment that grows more vehement in each work he publishes. *The Letter to D'Alembert* charges that depravity defines life

in a big city, full of scheming, idle people without religion or principle, whose imagination, depraved by sloth, inactivity, the love of pleasure, and great needs, engenders only monsters and inspires only crimes . . . in a big city, where manners [moeurs] and honor are nothing because each, easily hiding his conduct from the public eye, shows himself only by his reputation and is esteemed only for his riches.[8]

His charges had become still more inflamed and sweeping in the "Project for a Constitution of Corsica" where, in 1765, he wrote: "But if cities are harmful, capital cities are still more so; a capital is an abyss in which virtually the whole nation loses its morals, its laws, its courage and its freedom . . . the capital breathes forth a constant pestilence which finally saps and destroys the nation."[9]

Rousseau suggests that certain defining characteristics of cosmopolitan life account for its corruptive potential: its playfulness, which inspires frivolity, weak-spiritedness, and finally moral collapse; its leisure, which leads to idleness, ennui, and an insatiable desire for passive, vicarious living (entertainment);[10] and its preoccupation with fashion and reputation, which begins as mere vanity and ends as the triumph of *amour propre* — envy, small-mindedness and a shallow but total dependence on opinion for well-being (indeed, for being itself). What is striking about these traits is that they aptly define the theater as well as the city. The drama rests precisely on conventionalized play, organized leisure, and the vicarious titillation of the comparative imagination; it panders to opinion and corrodes autonomy; it is thus, unlike the city, not merely a symptom but a (potential) cause of the corruption of virtuous republics. Despite Molière's passing allusions to the moral duty theater has to "correct men's errors in the course of amusing them,"[11] his petition to the king of France (1669) illustrates Rousseau's complaint perfectly: "May your bounty deign to accord me protection, Sire," Molière begs, "and so enable me, when you return from your triumphant campaign, to afford Your Majesty diversion after the fatigues of your conquests, provide you with innocent pleasures after your noble exertions, and bring a smile to the countenance of the Monarch before whom Europe trembles."[12] If Molière's satires fawn to kings and aspire to provide guilty tyrants with innocent pleasures, what then can be expected from Beaumarchais who chases after the favor of the new property owners of eighteenth-century Paris (or indeed of Neil Simon who plies the sycophant's trade in modern New York)? "What!" exclaims Rousseau: "Plato banished Homer from his Republic and we will tolerate Molière in ours?"[13]

Rousseau will tolerate neither ancient nor modern dramatists in his Republic (Geneva), for reasons which differ little from Plato's at the level of the psychology of passions. Underlying the sociological dilemmas of urbanity and leisure are insidious psychological processes that undermine

the autonomy, the independence, and finally the citizenship of civilized men.[14] These processes reflect the evolution of *amour de soi* into *amour propre,* of natural self-consciousness into artificial other-consciousness, and depend on the exacerbation (via the imagination) of unquenchable passions and unfulfillable desires, and on the deadening of reason.

In Plato's psychic imagery:

> As a country may be given over into the power of its worst citizens while the better sort are ruined, so we shall say, the dramatic poet sets up a vicious form of government in the individual soul: he gratifies that senseless part which cannot distinguish great and small, but regards the same things as now one, now the other; and he is an image-maker whose images are phantoms far removed from reality.[15]

In Rousseau's:

> In encouraging all our penchants [theater] gives a new ascendency to those which dominate us. The continual emotion which is felt in the theater excites us, enervates us, enfeebles us, and makes us less able to resist our passions. And the sterile interest taken in virtue serves only to satisfy our vanity without obliging us to practice it.[16]

Here then are the elements of theater's assault on virtue and the psychic conditions necessary to virtue: (1) the exacerbation and titillation of passions, including (2) those passions which in themselves may seem benign; (3) a sapping of power, which is the inevitable outcome of the excitation of unnatural and thus unfulfillable desires; (4) the silencing of reason (which, to begin with, speaks only in the most hesitant of whispers); (5) the ensuing subordination of public truth to private opinion; (6) the substitution of vicarious and thus inauthentic sentimentality for true feeling and active obligation, and a consequent decline into passivity; and (7) the enhancing of privatism and isolation from public consciousness.

Each of these elements plays on the fundamental dependency of theater on affective rather than cognitive response, on passion rather than reason, on simulation and deception rather than authenticity.

1. By exacerbating our passions, theater undermines both the simplicity and the harmony of our natural sentiments. In their natural form, our passions are limited, our desires fulfillable, and our spiritual condition tranquil. In a theater, our passions are fanned by professional titillators, our desires are multiplied by comparison and envy, and our tranquillity is destroyed by the roar of prejudice and opinion. The drama claims, with Aristotle, to play on our passions only to purge them. But, Rousseau asks, "Is it possible that in order to become temperate and prudent we must begin by being intemperate and mad?" When "all the passions are sisters . . . and

one alone suffices for arousing a thousand,"[17] can we ever safely toy with even one? Can we, above all, when we know that reason, an inefficient moderator of passion at best, is not permitted on the stage at all?

2. Nor can it be said that an audience is in any less jeopardy because the passions on which a drama plays may be benign or even beneficent. Raw passion's potential for doing harm lies in its irrational compulsiveness, not in the worthiness of its objectives. It might be thought, Rousseau notes in the *Letter,* that passions conducive to patriotism, which reenforced the sense of "national character," could be exercised without danger in a drama, but "it would remain to be seen if the passions did not degenerate into vices from being too much excited."[18] The general principle adumbrated here emerges in the *Émile* with great clarity:

> It is a mistake to classify the passions as lawful and unlawful, so as to yield to the one and to refuse the other. All alike are good if we are their masters: all alike are bad if we abandon ourselves to them[19]

But if stage passions do not master us in the theater, the drama fails. Only to the degree that an audience is lost in tears, beside itself with emotion, utterly carried away, can a play be said to succeed. The very abandon, that signals the abdication of autonomy and the failure of will in morals, signals the triumph of stagecraft in drama.

3. There is, in Rousseau's moral vision, a direct relationship between the exacerbation of desires that cannot be realized and the erosion of our sense of control over our destinies. The more we want, the less potent we feel. "True happiness," in the teaching of the *Émile,* "consists in decreasing the differences between our desires and our power, in establishing a perfect equilibrium between the power and the will."[20] "Is it not very strange," Rousseau asks, that it is precisely man's superfluity of power that "makes him miserable?"[21] Because our liberty increases with our power, we can be free only to the extent that unnatural desires remain dormant and that we are able to accomplish the modest goals set by nature. Theater, like the cities which nourish it, contracts our freedom by multiplying our desires and increases our frustration by titillating our lusts.

4. Reason has the capacity to speak a kind of truth to passion, but in Rousseau as in Plato its voice is weak and its motivational power negligible. Again, the lesson is fully articulated only in the *Émile,* where Rousseau reminds us that "mere reason is not active; occasionally she restrains, more rarely she stimulates, but she never does any great thing."[22] Where reason is, on occasion, employed in the theater it "has no effect";[23] it is only by law, by pleasure and by opinion that manners and mores *(moeurs)* are influenced and the moral climate of social life affected.

5. The absence of reason in the theater, and consequently, the absence of law (which is reason embodied in convention), leaves manners and mores entirely to the untender mercies of opinion. Rousseau concluded early that opinion was the most potent and the least resistable molder of character for civilized men. In his essay on the government of Poland he warns:

> Whoever concerns himself with the problem of creating institutions for a people ought to know how to dissect opinion, and thus to govern the passions of men.[24]

The theater does not dissect public opinion, it apes it; it does not govern the passions, it unleashes them. Moreover, it does so necessarily. For its success depends on its capacity to please, and to please it must always follow and never lead popular opinion. "A good play never fails," Rousseau writes in the *Letter,* quite without irony, "because a good play never shocks the morals *[moeurs]* of its time."[25] Dramas can only be effectively performed in Plato's cave, where lighting effects can be staged, familiar shadows manipulated, and the chains (prejudices) of a captive audience polished. Poets of the cave are, as Plato suggested, men who "produce images at the third remove from reality,"[26] copiers of copies. To Rousseau they are producers of fictions about fictions, traitors to truth who use their perceptive understanding of prejudice to ensnare an audience in its own private cave of bias and opinion. The lawgiver studies men to insulate them better from their weaknesses; the dramatist studies men to weaken them still more. "Fair is foul and foul is fair" stands as a motto to the moral confusions on which effective theater depends.

6. The simulation and manipulation of public opinion and prejudice by the dramatist effectively paralyze public will and thus public action. In playing to simulated sentiments and discharging fictitious obligations, the theater becomes a surrogate for action — an arena of vicarious experience that saps resolution as it erodes the will. "In giving our tears to these [dramatic] fictions," Rousseau cautions, "we have satisfied all the rights of humanity without having to give anything more of ourselves."[27] Diderot thinks it a compliment to the actor's talent for simulation that weeping maidens can seem moving and even beautiful on the stage, though in real life they are both ugly and ridiculous.[28] To Rousseau, this is but further proof of the denatured hypocrisy intrinsic to acting, and of the inauthenticity that seems to define effective drama. In fact, the "fleeting and vain emotion" evoked by stage characters, the "sterile pity" aroused by stage distress, have "never produced the slightest act of humanity."[29] Although there is no evidence of personal animus in his view, Rousseau was deeply suspicious of actors and of the talents they employed; the profession seemed to make an art of dissembling:

What is the talent of the actor? It is the art of counterfeiting himself, of putting on another character than his own, of appearing different than he is, of becoming passionate in cold blood, of saying what he does not think, and finally of forgetting his own place by taking another's.[30]

The theater, in Rousseau's portrait of it, nourishes a silent conspiracy in self-deception between the audience, the actor, and the dramatist. A titillating fiction is created jointly by an audience and an actor, both of whom know better; their common illusion allows them to live out sterile fantasies without substance, to feel passions without consequence, to take risks with nothing at stake, to enjoy emotion without suffering, and to revel in sentiment without commitment or obligation. The counterfeit existence they manufacture impairs their autonomy, corrodes their will, and relieves them of all real public responsibility for their biases. Rousseau would have found nothing surprising in Broadway audiences who, after applauding the sentiments of black plays like Lorraine Hansberry's *Raisin in the Sun,* or Richard Wesley's *Mighty Gents,* rush anxiously from the theater into waiting taxis, buses and limousines that will protect them from and take them out of an inner city peopled with real-life equivalents of the struggling characters they have just finished cheering. Experiencing "black culture" in the theater becomes a means to avoiding it in reality. The ultimate result of all this titillation is not Dionysian frenzy but numbness. In Schiller's portrait of traditional theater, "[she] takes to her broad bosom the dull-witted teacher and the tired businessman and lulls the spirit into a magnetic sleep by warming up the numbed senses and giving the imagination a dull rocking."[31]

7. If inauthenticity impairs our capacity for autonomy, and vicarious passivity impairs the capacity for action, the two in combination immobilize the spectator as citizen. An audience has much in common with a constituency that allows itself to be represented: "The moment a people allows itself to be represented," Rousseau warns in the *Social Contract,* "it is no longer free."[32] How free then can the spectator be who permits his being — his experience — to be *re*-presented on stage, who allows real feelings to be simulated, real obligations to be vicariously discharged, real tears to be falsely shed, real sentiments to be skillfully counterfeited?

There was, of course, potentially a communitarian element in the theater — one which Rousseau himself appealed to in encouraging outdoor festivals celebrating public commitments and social ties in dramatic ways.[33] Applause, laughter, tears and other collective responses issue from an audience, not from individuals; they are public conventions, not private exclamations, as anyone who has laughed at the wrong moment, or sat alone in a theater to watch a performance, can testify. Yet the main action is

represented for an audience by actors; the audience's role as participant is limited.

Even the subject matter of the drama was, in Rousseau's time, becoming increasingly privatistic. The court-oriented drama of the earlier period (typified by Molière's and, to some degree, by Rousseau's own efforts) had been a theater of manners dealing with the foibles of the gentle classes in comedy and the conflicts and sorrows of their rulers in tragedy. But the new drama being forged by Diderot, Beaumarchais, and others turned to bourgeois life for its themes. It was an urban theater concerned with the material aspirations and familial complications of the new middle classes. Clerks, shopkeepers, and tradesmen now related their small woes where kings had once gone grandly beserk and earls had once been royally cuckolded. Stillbirths, business failures, unwed mothers, and bankrupt fathers — all of the stock situations that have energized creaky plots from then to now — became as riveting as the fall of kingdoms and the death of kings once had been. Diderot's *Père de Famille,* though not a very great success, became a model for the more commercial bourgeois dramas like Beaumarchais's *Eugénie.*

Because Rousseau was more suspicious of *how* an audience was touched in the theater than *what* it was touched by, he gave little attention to content other than to assail certain distortions of character traits, as in his careful analysis Molière's Alceste (in *The Misanthrope*).[34] However, the shifting of drama's focus — from the grand to the petty, from spiritual to material fate, from public to private destinies — which began in the eighteenth century, which dominated the nineteenth century (Naturalism), and which continues to define much commercial theater today would surely have enhanced his conviction that theater could only be a leech on the public soul, turning citizens into cadavers as it drank away their life blood.

Each of the seven elements sorted out here implicates, in one way or the other, the human imagination in human corruption. Indeed, although the *Letter to D'Alembert* may seem in its praise of rustic republics to be suffused with a sense of hope, its focus on the imagination can only strengthen the belief that Rousseau's pessimism about human history outweighed his hypothetical hopes for human salvation — hopes lodged either in the preservation of rustic simplicity or in the wisdom of some providential Lawgiver. To the extent that the Fall portrayed in the *Discourses* arises out of contingent or avoidable features of social organization (as parts of the *Discourse on Arts and Sciences* and a smaller portion of the *Discourse on the Origin of Inequality* suggest), there is presumably hope for the future to be found in natural instincts, prudent laws, and our capacity for change. The damaging acquisitions of civiliza-

tion need not be fatal: we can still try to go backward (the romantic impulse) or go forward (the impulse to progress and perfectibility), to retrieve or achieve the virtue once promised by our innocence. But if the Fall is caused by inborn rather than acquired characteristics — if we are miserable not because we are civilized but because we are men — then our suffering is inevitable and our fate irredeemable. Happiness then is not for those born of human wombs.

The role of imagination in the corruption purveyed by theater, as portrayed in the *Letter to D'Alembert,* is thus a serious obstacle to an optimistic interpretation of Rousseau's moral philosophy. Imagination is indicted in a number of places in Rousseau's corpus. Thus, in the *Émile:* "It is the errors of the imagination which transmute into vices the passions of finite beings, of angels even, if indeed they have passions."[35] Natural desires refracted by the imagination become artificial passions and, by destroying our natural self-love *(amour de soi),* prepare the ground for vanity, greed, and envy *(amour propre)* — the evils from which all social and political injustices follow. *The New Heloise (Julie)* attributes suffering directly to imagination:

> The real world has boundaries, the world of the imagination is infinite. Since we cannot enlarge the real one, we must restrict the imaginative one, since all the suffering that makes us really miserable arises from the disparity between them.[36]

The *Letter to D'Alembert* confirms each of these complaints against the imagination — in the last pages most explicitly:

> The immediate power of the senses is weak and limited; it is through the intermediary of the imagination that they make their greatest ravages; it is the business of the imagination to irritate the desires in lending to their objects even more attractions than nature gave them; it is the imagination which scandalizes the eye in revealing to it what it sees not only as naked but as something that ought to be clothed.[37]

If imagination is at the root of our misery and its containment (Rousseau's ascetic strategy) is our only recourse, then we must apparently purchase our tranquility by selling our humanity. The innocence of animals can perhaps be ours, but virtue is beyond us. We are miserable because we are human and real happiness, as Sophocles put it, lies only beyond the grave.

This is, of course, an extreme interpretation, and there are a sufficient number of alternative emphases in Rousseau to warrant a host of contradictory interpretations.[38] But there can be no question that imagina-

tion is the chief villain of the *Letter,* and that — ironically — the attack on tragedy that it launches is itself propelled by a tragic vision of human destiny.[39] And if imagination is a crucial crossroads in man's journey from innocence to vice and a fatal detour on the road to republican virtue, then the theater must remain as one of the most dangerous catalyzers of corruption. For it is designed to provoke the imagination and force it into the service of the passions — perhaps more quintessentially than any of the other arts or sciences. And if the men Rousseau would save from the imaginative corruptions of theater are in fact beyond salvation (inasmuch as they are defined by the imagination, which theater only exploits), what can Rousseau do but flail the drama still more vehemently for using so well the fatal curse that has ruined the species?

This is where an initial reading of the *Letter,* in the context of Rousseau's general critique of social corruption and the human imagination, may seem to leave us.

II.

A basic problem persists unresolved, however. The *Letter* is written specifically to defend Geneva, as a part of Rousseau's more general belief that republics, rare and fragile as they are, ought simply to be left alone.[40] But most states were not republics. Generally, the drama developed as part of an urban culture and thus (from Rousseau's perspective) was in historical terms more a symptom than a cause of urban decadence. The problem, then, was this: if theaters were to be banned from virtuous republics, how were they to be treated in fallen capital cities or corrupt, inegalitarian societies? What sense would it make to prohibit corrupting influences in a city of thoroughly corrupted sinners? Even if redemption is possible, the prodigal son must surely have to be wooed back home by devices other than those employed to keep the faithful from departing.

Rousseau does respond to these difficulties, although not primarily in the *Letter.* His response provides access to another part of his thought while revealing subtleties in his understanding of theater not immediately evident in the *Letter.*

Anyone who has read Rousseau's political writings carefully knows that Rousseau, no less than Montesquieu, acknowledged the profound effect of differing conditions on the general propositions advanced by theory. Early in the *Letter to D'Alembert* he offers a powerful relativistic caution:

> Man is one; I admit it. But man modified by religions, government, laws, customs, prejudices and climates becomes so different from himself that one ought not to seek among us what is good for men in general, but only what is good for them in this time or that country.[41]

In the particular Republic of Geneva in his particular time, traditional sumptuary laws prohibiting theater were under assault from external enemies, and Rousseau's defense could be bold. But elsewhere in Europe, in corrupt tyrannies and decadent cities, extant theaters had long since done their worst. What, from the point of view of prudent relativism, could be said of them? Was drama really the principal vice of Paris?

Rousseau appreciated these questions, and even entertained the possibility (in the *Letter*) "that when the people is corrupted, the theater is good for it" just as when a people is good, theater is bad for it. Yet his position here is far more complicated and thus more puzzling than in his unambiguous defense of republics. It is not just that "the drama will not harm us if nothing at all can harm us any more,"[42] for Rousseau wants to distinguish degrees of corruption and to explore possible noncorrupting uses of the theater. His arguments here seem closely tied to the attempt to justify his own seemingly hypocritical involvement in, and love of, theater; they thus are most effectively articulated in the preface which he appended to the published version of *Narcisse,* a play performed successfully at the end of his residence in Paris at the Comédie-Francaise in 1752, but written much earlier.[43] In the *Preface,* the ameliorative potential of theater is explored as part of the general principle suggesting that "the same causes which have corrupted nations may sometimes serve to deter a still greater corruption."[44] He vigorously resists what he claims are extreme readings of the *First Discourse* and, far from extending the *Discourse's* vilification of the arts and sciences, urges those interested in virtue to

> leave in existence, indeed, even to nourish with concern, the academies, colleges, universities, libraries, entertainments and all the other amusements which are capable of diverting men from their wickedness and preventing them from occupying their idleness with still more dangerous things. For in a country where there can no longer be any question of honest people, of either morals or manners [*moeurs*], it may well be better to live with knaves than with brigands.[45]

What serves as pernicious distraction from duty in a republic may become useful diversion from evildoing in corrupt cities. If leisure is the enemy and idleness the instrument by which the devil seduces our weaknesses, then theater can at least occupy in relatively innocent frivolity the time we might otherwise use up in inventing new crimes and more extravagant follies. "It is not a matter of moving people to do good," Rousseau cautions in the *Preface,* "it is only necessary to distract them from doing evil — necessary to occupy them with trifles in order to deter them from malicious actions. If they cannot be preached to they must be amused."[46] Even the *Letter* is cautious about prohibiting the theater when

the corruptions of a city have surpassed the potential for corruption of the drama. If we ban actors then we will be forced "to recall them soon or to do worse." For although we will have undoubtedly "done wrong in establishing the drama [in the first place] . . . we will do wrong in destroying it; after the first fault, we will have the choice only of our ills."[47] The Fall, in Rousseau's secular theology no less than in Christianity, leaves us only with the choice between wrong and lesser wrong. The ravages done by the imagination can be mitigated but not wholly reversed: we may choose our vices with temperance, moderate the extent of our wrongdoing, and limit the damage done by the arts and sciences. But, in the words of the *Social Contract,* "liberty may be gained, but can never be recovered."[48]

Innocence, like liberty, can be lost only once: if it is not lost to virtue it is lost to vice, and it is doubtful that either innocence or virtue can ever be recovered. The tutor, the Lawgiver and the seer may offer some comfort, but it is not clear that the dramatist can offer anything other than diversion, a kind of early death which, by robbing us of our freedom (our time and leisure), protects us from our nature.

Two questions emerge from this discussion: by permitting theater to play a remedial (if not a reformist) role in corrupt societies, does not Rousseau undermine the charges he levels in the *Letter?* And by denying that it can play a more decisive role in the remaking of society, does he not undermine the hope for moral redemption that issues from both the educational and the political works? In other words, does not Rousseau's *Preface* give the drama both too much credit (by the standards of *Émile* or the *Social Contract*) and too little?

The answer to both questions is complicated by Rousseau's own love for the theater, and his ambivalent responses to a decade spent chasing success in it. The argument of the *Letter* seems fairly definitive: theater has only bad effects. Even in less-than-virtuous societies, it is designed to render us more impassioned, impotent, irrational, conformist, heteronomous, inauthentic, privatistic and inactive than we may already be. If this is so, Rousseau may seem to excuse himself — even flatter himself — too often in the *Preface,* where he writes:

> I would esteem myself more than happy to have a play hissed every day, if I were able, at this price, to contain for even two hours the malicious designs of a single spectator, and thereby save the honor of the daughter or the wife of his friend, the secret of his confidant, or the fortune of his creditor.[49]

Surely he did not rush impatiently to the theater every time he came to Paris, and work for years trying to have his plays and operettas staged, exclusively from a disinterested love for republican virtue. On the contrary, the *Letter to D'Alembert* makes quite clear that his "passionate love" of drama arises out of "personal" prejudices which he is at pains to resist in his

serious public writings.[50] In fact, his attachment to theater left him deeply troubled, vulnerable to charges of hypocrisy and insincerity. Voltaire had written to him, "You are like Achilles who rose up against glory, and like Malebranche whose brilliant imagination caused him to write against imagination."[51] Having written seven plays and several ballet-operettas, he was implicated in the scourge he assailed. If he felt constrained to belittle the success of *Narcisse* at the *Comédie-Francaise,* imagine how troubling the still greater success of *Le Devin du Village* must have been; for it played before the royal family a number of times and became a charming rustic fixture in the Paris Opera where it was performed regularly until 1778.[52] Although he had written in a letter of 1753: "It is time to renounce, once and for all, my verses and music, and to devote the leisure that remains to more useful and satisfying occupations, if not for the sake of the public for my own sake,"[53] he nonetheless insisted on including his works for the theater in an edition of his collected works projected in 1758. Moreover, he continued to attend theater and opera performances into his old age, assiduously following performances of Savigny, Gluck, and others on his return to Paris in 1770.[54]

At times, he seemed embarrassed by his passion, and excused his plays as indiscretions of a youthful rustic overwhelmed by the charms of the cosmopolis.[55] At other times, he went on the offensive, charging his critics to show him a man who is not a hypocrite.[56]

But always he remained troubled, for the problem of his putative hypocrisy was not merely a matter of his being tainted by the times in which he lived, but of the consistency of his argument and the relevance of his critique of theater to the real afflictions of his society. Was there any role for the drama that would redeem Rousseau's love of theater? If innocence is lost to vice rather than virtue, and if history (hypothetical history, as conceived in the *Discourses*) shows the loss to result from man's own imaginative nature, can there by any hope for salvation, or even for amelioration, in a medium that rests on imagination? If salvation is a dubious objective for the Lawgiver and the seer, who deploy reason to contain passion, and law to impose a disinterested order on imagination's anarchic desires, what chance has the dramatist?

Yet imagination is more than just the villain of human history, and if the Lawgiver is capable of making men better by manipulating the social conditions of their lives, cannot theater use the constructive side of imagination to restore their virtue? In the *Émile,* Rousseau notes that in ruining us, imagination also provides us with the psychology of affection and social community:

> Our common sufferings draw our hearts to our fellow-creatures . . . every affection is a sign of insufficiency . . . so our frail happiness has roots in our weakness . . . if our common needs create a bond of interest, our common

sufferings create a bond of affection . . . imagination puts us in place of the other.[57]

This then is the dilemma: to the degree that our corruption is intrinsic to our imaginative nature, the world is tragic, the Fall irremediable, our suffering inconsolable and our destiny beyond redemption by civil institutions. Every effort to turn desolation into progress worsens our condition; for, as Rousseau puts it in the *Confessions,* our "pretended perfection [is] the true source of [our] misery."[58] But to the degree that our imaginative nature is intrinsic to our corruption, it holds out the promise of reconstructing what is destroyed. This is the promise of the *Social Contract:*

> He who dares to undertake the making of a people's institutions ought to feel himself capable, so to speak, of changing human nature, of transforming each individual, who is by himself a complete and solitary whole, into part of a greater whole . . . of altering man's constitution for the purpose of strengthening it; and of substituting a partial and moral existence for the physical and independent existence nature has conferred on us all.[59]

Thus does the Lawgiver transform weakness into strength, dependency into moral autonomy and imagination into disinterest. Is there then an analogous role for the dramatist to play? He may want to shelve his onionskins in a rustic village, or turn his pen to public spectacles in a small republic, but what is his place to be in the real world of corrupted cities and cosmopolitan men? There is in Rousseau's hypothetical history an "unseizable moment" between innocence and civilization, a utopian moment of rustic domesticity where men have somehow cultivated the rudimentary imagination without being ruined by its envious comparisons, a moment which Judith Shklar has called the Age of Gold, when men have progressed beyond innocence but do not yet require republican Law-givers.[60] Neither the Lawgiver nor the dramatist knows these conditions, however; they come after the Fall and, with the road back to rusticity blocked by history, can only plunge forward. Is the theater really fated at its very best to be no more than a mischievous diversion from greater malice?

After all, in the century in which Rousseau lived, many regarded the theater as a potential source of powerful education and reform. Even Molière had claimed to reveal hypocrisy and expose vice in his satires, and Schiller, Lessing and others were developing a theater tradition devoted entirely to edifying moral instruction. By the end of the century Rousseau's own work in *Émile* and in *The New Heloise (Julie)* had helped to create a German tradition of *Bildungsromane* that, as nourished by Goethe, turned the literary imagination into a pedagogical tool of the highest order. And what Rousseau had done in his literary works he at least contemplated

attempting in dramatic form. Following *Narcisse,* he had begun a dramatic work about the Death of Lucretia that he hoped might be an instructive moral tragedy of quite a different order than the whimsical comedies he had written earlier.[61] Moreover, he spends almost 14 pages in the *Letter to D'Alembert* suggesting rewrites that might make Molière's *Misanthrope* a more "instructive" drama, and Alceste a more noble (less ridiculous) character.[62]

All of this suggests that the theater may yet make good its aspirations to be a teacher of virtue as well as an entertainer of men — that, even in Rousseau, the dramatist might do with and for our imagination what the prudent Lawgiver does with and for our chains: legitimate it, ennoble it, find in its potential for corruption the possibility of our redemption.

This is a conclusion Rousseau will not and cannot draw for reasons that go to the heart of the relationship between theater and society and point to fundamental moral limits of the drama.

III.

Finally, whatever concessions he made in the *Preface to Narcisse,* and whatever compromises he made in his own life as a playwright, Rousseau stood by the convictions expressed in the *Letter to D'Alembert.* A judicious relativism might focus attention on the changing social conditions that confront the theater in different times and places, but the moral limits of the drama were intrinsic to it and thus unaffected by time or place. The structure of dramatic affect, the structure of imaginative response, and the structure of corruption were interconnected in the theater to a degree that rendered it constitutionally unsuited to moral instruction and unfit for the revival of civic virtue in corrupt polities.

The consequences of this view for theater as a social institution and as a potential force for reform, reconstruction and revolution are obviously very grave: they suggest that however radical the moral aspirations of drama may be, the forms in which it necessarily manifests itself remain deeply conformist—biased, impassioned, and conservative. It is thus incapable of challenging either corruption, opinion, or power, and although it can undermine virtuous societies, it can never rescue corrupt ones — even when its ideological content and thrust are reformist or revolutionary.

This part of Rousseau's critique applies specifically and exclusively to theater, and thus moves beyond the general assault on the arts and sciences represented in the *Discourses.*[63] It reflects Rousseau's unique sensitivity to theater as an independent art form and, if taken seriously, creates dilemmas for the theater that remain absolutely crucial today.

At the core of Rousseau's skepticism about theater, and implicit in all of

the features of his argument explored above, is a fundamental paradox he believes theater cannot, by its very nature, overcome. The paradox is simply this: to be effective, theater must be entertaining; it is, by definition, an amusement. To be entertaining, it must follow rather than challenge public taste and coddle rather than confront public prejudice. Yet to be a force for moral reconstruction, it must be instructive, rationally suasive, even disturbing and discomfiting, and when it becomes discomfiting it clearly ceases to be either amusing or entertaining. It cannot both discomfort and please at the same moment and, because its success and its survival rest on pleasure, instruction is necessarily sacrificed. And so, Rousseau concludes:

> Let no one then attribute to the theater the power to change sentiments or morals, which it can only follow and embellish. An author who would brave the general taste would soon write for himself alone.[64]

To challenge an audience is to condemn the play to failure, whereas by the same token a successful play can "never fail . . . because [it] never shocks the morals of its time."[65] Some may feel impelled "by the best of intentions" to write plays that will do more than merely amuse:

> But what happens then? They are no longer really comic and produce no effect. They are very instructive, if you please; but they are even more boring. One might as well go to a sermon.[66]

That this paradox is no mere conceit on Rousseau's part can perhaps best be shown by looking at the way it has become the central question in the theater of Bertolt Brecht — a dramatist whose name is not generally brought into the discussion of Rousseau's theater writings (primarily because they have so rarely been taken seriously as *theater* writings).[67] Brecht states the paradox in terms that can only be called Rousseauian:

> The problem holds for all art, and it is a vast one . . . How can the theater be both instructive and entertaining? How can it be divorced from spiritual dope traffic and turned from a home of illusions to a home of experiences?[68]

For Brecht as for Rousseau, the problem was created not merely by the ideological caste of given dramatic traditions but by the very structure of theater and the conditions required for its success. And for Brecht as for Rousseau, the general paradox precipitates three lesser paradoxes.

For the sake of shorthand, these three constituent paradoxes may be identified as Diderot's paradox, Molière's paradox and Sophocles' paradox — though they are general to the theater and not peculiar to the

playwrights associated with them. Each is concerned with the structure and effectiveness of theater as a working company of actors enacting a dramatist's vision before a live audience, rather than with questions of ideological content. Each thus raises questions that are universal to the Western theater tradition and that remain as irksome today to Peter Brook, Richard Schechner, Joseph Chaikin, Julian Beck, André Gregory, Jean-Paul Sartre, Jery Grotowski, and Fernando Arrabal as they once were to Racine, Molière, Rousseau, Voltaire, Beaumarchais, and Brecht.

Diderot's paradox sets the basic terms for a debate about the nature of acting that preceded the publication of his *Paradoxe sur la Comédien* and persists into the present time. The question is whether an actor assumes the role of — actually becomes — the character he plays, playing it from the heart, or whether he retains some distance and thus detachment, crafting a role that is played from the head. Is the actor best understood as a craftsman, who creates a character external to him, or as a magician, an ingenious chameleon of the emotions who *is* the character he plays? That the paradox still exists can be seen from the differences in acting method among various schools of theater. The English (e.g., the Royal Academy of Dramatic Art) favor detachment and craftsmanship, while the Actor's Studio — steeped in the teaching method of Stanislavski — opts for emotional alchemy. Diderot championed detached craftsmanship: the actor, he writes in *Paradoxe sur la Comédien,* is a "cold and tranquil spectator to his own art."[69] His talent does not, as we too readily suppose, "consist in feeling . . . but in rendering so scrupulously the exterior signs of feeling that [we] are deceived."[70] There is thus a fundamental inequality between audience and actor — the former feels, the latter calculates; the spectators end up emoting while the actors become spectators to their own art, the better to execute their dramatic objectives. All the powerful effects that are so touching to an audience,

> this tremolo of the voice, these suspended words, these hesitating or muffled sounds, this shivering of the limbs, vacillation of the knees, these faintings and fits — pure imitation, a lesson recorded in advance . . .[71]

The actor may shed fulsome and passionate tears, but they "fall from his brain, not his heart."[72]

Diderot's paradox is part of Rousseau's paradox because it raises the question of authenticity for actor and audience alike. Rousseau implicitly accepts Diderot's account of crafted acting, but execrates the consequences. If Diderot's actor is a "cold and tranquil spectator," Rousseau's actor affects to be "passionate in cold blood," thus "counterfeiting" himself in defiance of his own nature.[73] The very distance maintained by an actor

V–effect.

from the character he portrays is a measure of the distance he has traveled from his own soul to the rubber heart of a fiction — a measure of how much he has succeeded in deceiving the audience into joyless laughter or sorrowless tears. Even a revolutionary orator, when in a play, is but an actor simulating an orator; thus, unlike the speaker who uses rhetoric only to underscore what he truly feels, he is defined by an inauthenticity that discredits the virtue his part is meant to promote.

The very meaning and use of the word "play" is at stake in Diderot's paradox. To Diderot acting is playing ("players" do, after all, "play" their parts), and playing in turn is a vital aspect of civilized man's capacity for self-consciousness, detachment, and humor (which also requires a self-conscious separation of self and role). Roles, masks, and pretenses define us as civilized creatures capable of escaping out of the unselfconsciousness of mere animal existence. Authenticity, however, rejects all roles as insincere and treats masks as fragmenting enemies of the integral self. The integral self, in turn, is alone capable of citizenship and virtue. This makes play a twin to imagination — equally dangerous to autonomy and natural selfhood.[74]

This is not to say that Rousseau would be any more friendly to Stanislavski's possessed method actors than he is to Diderot's prepossessed craftsmen, for theirs is another and perhaps still more deceitful mode of pretense. To assume the identity of a shadow and thus transmute the self into a fiction, with a passion so intense that it seems authentic, is to extend audience deception to self-deception. Who then is worse: the actor who misleads only the audience and is thus an inauthentic deceiver, or the actor who misleads both the audience and himself and is thus an authentic deceiver and a fool? From Rousseau's perspective, neither type is capable of moral instruction, because what is inherently artful (inauthentic) can never better our condition or our mores.

Rousseau's view is no mere artifact of his intolerance or his Calvinist austerity. Brecht, no less than Rousseau, was perturbed by the deceptions by which traditional theater measured its success. Much of his directorial method was concerned with stripping away the fictitious "fourth wall" that made it possible for the actors to pretend their actions were unseen and their feelings correspondingly real. What Brecht hoped to do was to create a theater in which both the actor and the audience *know* they are in some basic sense pretending, know that they are playing or watching others play; this knowledge, he believed, would dispel the conspiracy of illusions typical of proscenium theater and, by acknowledging its inauthenticity, overcome it.[75] All of the "alienation effects" (*Verfremdungseffekte*) of the Brechtian theater — the narrative use of the third person by actors playing parts in the first person, the use of exposed white stage lights, the avoidance of sentimentality, the abrupt interruption of plot by characters and events

external to the play (the Messenger in *The Threepenny Opera*, for example) — have as their objective the smashing of pretense. A theater based on play could never portray reality, much less enlighten or change its audience. Authenticity began with an explicit acknowledgement by actor and spectator of who they were, where they were, and why they were there. In this sense, Brecht's theater was a response to the difficulties raised by Rousseau. The paradox of acting as represented by Diderot was in turn a part of these difficulties.

Molière's paradox raises a different set of problems. It is also Voltaire's paradox, Shaw's paradox, and Max Frisch's paradox: namely, how can satire, revealing of hypocrisy and corruption though it is, possibly be socially constructive or morally instructive when its techniques depend on cynicism and ridicule? Molière had claimed that "the duty of comedy . . . [is] to correct men's errors in the course of amusing them, attack the vices of the age by depicting them in ridiculous guise;"[76] Rousseau, who admired Molière's talent as much as he regretted the uses to which it was put, acknowledged that he had succeeded in puncturing the hypocrisies of his age. Yet Molière remained one of those men "who at the most sometimes make fun of vices without ever making virtue loved — men who, as the ancients say, know how to snuff out the lamp but who never put any oil in it."[77] His satires were, Rousseau perceived, better suited to the caricaturing of virtue than to the condemnation of vice; the malicious are generally without pretense, whereas the righteous are borne aloft by inflated aspirations and soaring ideals. How much better targets the latter make. Molière notes that

> People put up with rebukes but they cannot bear being laughed at; they are prepared to be wicked but dislike appearing ridiculous.[78]

Unfortunately it is the virtuous who are most easily ridiculed, and thus it is virtue that suffers when a people shrink from exposing themselves to ridicule. In the *Misanthrope,* in Machiavelli's *Mandragola,* in Aristophanes' *Clouds,* and even in Barbara Garson's *MacBird* it is the chaste and not the promiscuous, the cerebral and not the bawdy, the righteous and not the corrupt who are most often cooked in the satirist's simmering juices. Rousseau sees in Molière's *Misanthrope* a good character made ridiculous; for Molière's target is not the vain sycophants of Parisian society who surround Alceste, but Alceste himself. Yet Alceste — Rousseau cannot fail to notice — is "a good man who detests the mores of his age and the viciousness of his contemporaries; who precisely because he loves his fellow creatures, hates in them the evils they do to one another and the vices of which these evils are the product."[79]

Finally, satire leaves behind a residue of cynicism that, in showing virtue

to be folly and vice to be inevitable, denies the possibility of morality. The satirist is a literary Thrasymachus who sees behind every moral disclaimer an interest, behind every ideal a lust, and behind the rhetoric of virtue a language no less dirty than the base motives it assays to conceal. Even Brecht, who hoped that the distance and self-reflection on which satire technically depends might reenforce the distance he wanted to put between the audience and the play they watched, employed the satirical method at very real costs to his political-moral vision. His critics have been quick to notice that his plays are far more devastating to bourgeois society than they are nourishing to the socialist aspirations he harbored.[80] The early plays like *Baal, Drums in the Night,* and *In the Jungle of Cities* are pervaded by despair. In *Baal:* "I see the world in a mellow light — it is God's excrement" and "the meanest thing alive, and the weakest, is man." And even later, in the plays explicitly informed by Brecht's Marxism, darkness seems to overwhelm light. In the *Good Woman of Setzuan:* "The world is uninhabitable, you must admit that . . . "; in *Mahagonny:* "We cannot help ourselves — or you, or any man." Rousseau would not have wondered that Brecht was treated so gingerly by the authorities whose cause he putatively served. The cynicism and irony with which he dispatched their enemies could too easily spill over and corrode their own wavering visions. Nor could they find much hope (of the kind socialist realism so readily provided) for their own successes in Brecht's portrait of human failure prior to the coming of Marxist consciousness.

Molière's paradox, too, feeds Rousseau's paradox. Satire can perhaps distance an audience sufficiently to instruct it, but the distance it buys with cynicism permits it to teach only despair; and real despair, no less than vicarious hope, leaves men passive and resigned in the face of corruption. "Nothing is less funny or laughable than virtue's indignation," writes Rousseau, and the ridicule that entertains is "the favorite arm of vice."[81] In ridiculing virtue, satire encourages corruption; in exposing corruption, it encourages despair. Laughter is the final redoubt of inconsolable sorrow and can never be a stronghold of virtue. In this, it shares a great deal with tragedy. Molière's paradox is, in fact, not so different from Sophocles' paradox.

Sophocles' paradox suggests that tragedy shares satire's fatal flaw: resignation. Tragedy weeps where satire grins, but to the same effect: acquiescence in the face of evil and pain. Sympathy and empathy — emotions tragedy is designed to evoke — do not cultivate justice or virtue. In explaining our sorrows, they exonerate our guilt. In gaining comfort from the knowledge tragedy imparts — that our suffering is ineluctable — we lose responsibility for our lives and hope for change in the world. Indeed tragedy, like satire, is intended to puncture our vain hopes and lay bare the

futility of our virtuous aspirations — the standards we pretend to meet, the freedom we pretend to enjoy.

Tragedy thus seems to excuse our sins with sympathy while it negates our virtues and our hopes with fatalism. Of sympathy, Rousseau writes (in the *Letter*):

> It is not even true that murder and parricide are always hateful in the theater. With the help of some easy supposition, they are rendered permissible or pardonable. It is hard not to excuse Phaedra, who is incestuous and spills innocent blood. Syphax poisoning his wife, the young Horatius stabbing his sister, Agamemnon sacrificing his daughter, Orestes cutting his mother's throat, do not fail to be figures who arouse sympathy.[82]

Of fatalism:

> What do we learn from Phèdre and Oedipus other than that man is not free and that heaven punishes for crimes that it makes him commit?[83]

Tragedy thus robs men of the belief in the possibility of change — a sin the Greeks called hubris. Although Rousseau himself had written a hypothetical history of man that to some degree seemed to render human misery ineluctable and corruption inevitable, and although the psychology of the imagination implicit in his very assault on theater seemed directed primarily at hubris, all of his social theory required a belief in man's changeability. Yet it was just this that tragedy denied. It taught men how to accommodate themselves to resignation rather than to hope.

Again, Brecht can be found to share Rousseau's dissatisfaction. Like Rousseau, he too had to combat his own bleak vision of a world beyond redemption and, like Rousseau, saw the possibility of change as indispensable to political and social reform. "Can the world of today be represented on the stage," he asks? "Yes," he answers, fortified by Marx's *Theses on Feuerbach,* "but only if the world is regarded as transformable."[84] Only if men are, like Galy Gay in *Man is Man,* responsive to changing social conditions, malleable in the hands of Lawgivers, Poets and Seers.

Brecht and Rousseau both wept at the victimization of man by forces seemingly beyond his control; yet both knew that weeping could be an invitation to passivity no less than laughing, and that tragedy, for all of its powerful poignancy, was thus incapable of making either the world or its inhabitants better.

These then are the paradoxes that participate in the larger paradox posed by Rousseau. Actors cannot act without betraying either the audience or both the audience and themselves; satire cannot be effective without placing virtue in greater jeopardy than vice and without promoting

and enervating cynicism in its audience; and tragedy cannot be moving without engendering an amoral sympathy that forgives all, and an irresponsible fatalism that makes all human activity futile and all human hope hubristic—*tout comprende c'est tout pardonner*.

To touch us theater must be inauthentic or divest us of our aspirations (satire) or our hopes (tragedy). It plays to our prejudices while excusing our weaknesses, and it thus disqualifies itself for moral instruction by the very merits that make it entertaining. One might try, as Brecht says, to make the theater a "place for philosophers" but this is more likely to "drive the audience out of the theater" than to instill in it philosophical virtues.[85] Nonetheless, all of Brecht's theater life was devoted to the attempt to overcome the "sharp distinction between learning and amusing oneself," which — his epic theater insisted — "is not laid down by divine rule."[86] It is perhaps the most powerful tribute to Rousseau's fears that Brecht failed. Not only did his own work seem always to succeed *despite* the lessons it wished to teach,[87] but he himself had by the end of his life lost confidence in the didactic proposition offered in the 1930s which insisted "there is such a thing as pleasurable learning, cheerful and militant learning."[88] In 1948 he was ready, in the *Short Organum,* to back off from the didacticism that characterized the militantly Marxist *Lehrstucke* of the 1930s (e.g., *The Measures Taken* and *The Exception and the Rule*). He entertained the idea that an instructive drama might be beyond the capacities of "good" theater; indeed, he as much as suggested that this was fitting. Just as the moralist in Rousseau finally conquered the playwright, the playwright in Brecht seemed to have vanquished the moralist. His 1948 voice spoke with a strange timbre:

> From the first it has been the theater's business to entertain people . . . it is this business which always gives it its particular dignity; it needs no other passport than fun (*Spass*), but this it has got to have. We should not by any means be giving it a higher status if we were to turn it into a purveyor of morality.[89]

Brecht's ambivalence underscores Rousseau's certainty. Rousseau's paradox had been recognized by a genius of the theater, and this genius had failed to overcome it. His amusements instructed far too little (they played to capacity audiences in the bourgeois capitals of the world without ever creating a political ripple), and his instructions, when they became too didactic, amused far too little. Ultimately, he could only say "the theater must in fact remain something entirely superfluous, though this means that it is the superfluous for which we live. Nothing needs less justification than pleasure."[90] Rousseau's paradox had finally driven Brecht from the arms

of Marx into the arms of Nietzsche: the aesthetic in him was stronger than the moral.

Rousseau, however, remained a moralist. But we see that his critique of theater turns out to be much more than a parading of the prejudices of a censorious and intolerant Calvinist. He has posed a dilemma that not only calls into question the future of virtue, but which captures the central paradox of theater itself; its structural incapacity to make good the challenge it offers when it claims to be a repository of morals and tries to bring its powerful influence to bear on the construction or reconstruction of the polity. Rousseau wrote, in the very last sentence of *Narcisse:*

> It is true that one day it may be said: "this declared enemy of the arts and sciences nevertheless wrote and published works for the theater"; and this declaration will, I avow, be a bitter and ironic comment not on me, but on my century.[91]

In fact, Rousseau's paradoxical involvement in and critique of the theater are a profound comment on modernity itself, on the inability of modern men, liberated finally from the chains of their history, to remake themselves either through politics or art. The contest between theater and politics today is thus a stalemate, virtue gone its own way, oblivious alike to art and justice — and dramatists and lawgivers, living out the bleakest parts of Rousseau's prophecy, equally unable to arrest the ongoing decline.

Notes

1. I have used Allan Bloom's translation, *Politics and the Arts: Letter to M. D'Alembert on the Theater* (Ithaca: Cornell University Press, Cornell Paperbacks, 1968).

2. *Narcisse ou L'Amant de Lui-Même;* I have used the text given in the Pléiade edition of the *Oeuvres Complètes*, Vol. II, Jacques Scherer, ed. (Paris: Editions Gallimard,1964). The translations are my own, based on the translation I did with Janice Forman: *Preface to Narcisse,* in *Political Theory,* vol. 6 no. 4, (Nov. 1978), pp. 543-554.

 I have discussed the larger paradoxes raised by Rousseau's *Letter to D'Alembert* and his *Preface to Narcisse* in my "Rousseau and the Paradoxes of the Dramatic Imagination," *Daedalus,* Rousseau issue, vol. 107, no. 3 (summer 1978), pp. 79-92.

3. Rousseau gives this account in the *Confessions:* "One thing which greatly contributed to confirm my resolution, was the fact that Voltaire had settled in the neighborhood of Geneva. I knew that this man would cause a revolution there; that I should find again in my own country, the tone, the airs, and the manners which drove me from Paris; that I should have to maintain a perpetual struggle; and that no other choice would be left to me, except to behave either as an insufferable pedant, or as a coward and a bad citizen." *Confessions* (New York: Modern Library, n.d.), p. 409.

4. The passage reads: "I had an Aristarchus, severe and judicious. I have him no

more; I want him no more; but I will regret him unceasingly, and my heart misses him even more than my writings." Rousseau, *Letter to D'Alembert*, p.7.

5. If Voltaire won the skirmish, Rousseau won the battle; within two years Voltaire had abandoned Délices and moved well up the lake to Ferney, giving up his designs on Geneva. In the long run, of course, Voltaire was to win the war — all of history being on his side.

6. Rousseau, *Confessions,* p. 512.

7. Ibid., pp. 512–13.

8. Rousseau, *Letter to D'Alembert*, pp. 58–59.

9. *"Project for a Constitution of Corsica,"* in F. M. Watkins, ed. and trans. *Rousseau: Political Writings* (Nelson, 1953), p. 292. Rousseau's rustic prudence is much in evidence in his reply to Voltaire's *Lettre sur le Providence*, in which Voltaire draws deeply pessimistic conclusions from the disastrous Lisbon earthquake of 1752. Rousseau urges Voltaire to "consider, for example, that nature surely never would have gathered together twenty thousand six or seven story buildings; had the inhabitants of this great town been dispersed . . . the damage would have been much less — perhaps negligible." In Voltaire, *Oeuvres Choisies,* ed. Louis Flandrin, (Paris: Libraire A. Hatier, 1928), p. 692, my translation.

10. "The habit of work renders inactivity intolerable and . . . a good conscience extinguishes the taste for frivolous pleasures. But it is discontent with one's self, the burden of idleness, the neglect of simple and natural tastes, that makes foreign amusement so necessary." Rousseau, *Letter to D'Alembert*, p. 16.

11. *Preface to Tartuffe* in Molière, *The Misanthrope and Other Plays,* trans. John Wood (New York: Penguin, 1959), p. 104.

12. Ibid., p. 108.

13. Rousseau, *Letter to D'Alembert,* p. 116.

14. "In a well-constituted state, each citizen has his duties to fulfill; and these important concerns are too dear to him to leave him with leisure." Rousseau, *Preface to Narcisse,* p. 965, my translation. The relationship between work, leisure and citizenship is spelled out in its relationship to theater in the *Letter to D'Alembert,* pp. 62-63.

15. Plato, *The Republic,* trans. F. M. Cornford (Cambridge: Cambridge University Press, n.d.), p. 329.

16. Rousseau, *Letter to D'Alembert,* p. 57.

17. Ibid., p. 21.

18. Ibid., p. 20.

19. Rousseau, *Émile,* trans. Barbara Foxley (London: Dent, Everyman's Library, 1911), p. 409. A new and much superior translation has recently become available: Allan Bloom, ed. and transl., *Rousseau's Émile* (New York: Basic Books, 1979).

20. Ibid., p. 44.

21. Ibid., p. 45.

22. Ibid., p. 286.

23. Rousseau, *Letter to D'Alembert,* p. 21.

24. *"Considerations on the Government of Poland"* in Watkins, *Rousseau: Political Writings,* p. 175.

25. Rousseau, *Letter to D'Alembert,* pp. 18–19.

26. Plato, *The Republic,* p. 322.

27. Rousseau, *Letter to D'Alembert,* p. 25. The passage concludes: "Whereas

unfortunate people in person would require attention from us, relief, consolation, and work, which would involve us in their pains and would require at least the sacrifice of our indolence, from which we are quite content to be exempt."

28. Diderot, *Paradoxe sur la Comédien,* in *Oeuvres,* Pléiade edition, ed. Andre Billy (Paris: Editions Gallimard, 1951), p. 1014.

29. Rousseau, *Letter to D'Alembert,* p. 24.

30. Ibid., p. 79. Actors have, of course, traditionally been burdened with the reputation of servants (at court) or courtesans, and to some degree have played that role in life as well as in their profession. For centuries acting was one of the few professions in which women could exercise an independent role, and it is hardly surprising that this should often make actresses appear to the public as prostitutes of one kind or another. The role played by women on the stage was especially disturbing to Rousseau because it so flagrantly contradicted his notion of woman's special role in the idyllic home. In the contrasting attitudes of Rousseau and Voltaire to actresses can be seen all of the issues that made them enemies.

31. *The Encyclopedia of World Drama,* eds., J. Gassner and E. Quinn (New York: T. W. Crowell, 1969), p. 84.

32. Rousseau, *The Social Contract, and Discourse,* ed. G. D. H. Cole (London: Dent, Everyman Edition, 1913), p. 80.

33. Although the revolutionary spectacles mounted by Robespierre and others during the French Revolution are often seen as expressions of the Rousseauian spirit, Rousseau in fact has in mind the outdoor festivals often held in conjunction with assemblies, public debates and other political events in rural Switzerland. See Rousseau, *Letter to D'Alembert,* p. 125. Also see the important study by Francois Jost, *Jean-Jacques Rousseau — Suisse: Étude sur sa Personnalité et sa pensée,* 2 vols. (Freibourg: Editions Universitaries, 1969).

34. Cf. Rousseau, *Letter to D'Alembert,* pp. 36–37.

35. Rousseau, *Émile,* p. 180.

36. Rousseau, *Julie or the New Heloise,* trans. J. H. McDowell (College Station, Pa.: Pennsylvania State University Press, 1968), p. 45.

37. Rousseau, *Letter to D'Alembert,* p. 134.

38. However, it gives a conviction to readings like those of J. N. Shklar — in her *Men and Citizens: A Study of Rousseau's Social Theory* (Cambridge: Cambridge University Press, 1969) — that take seriously Rousseau's pessimism, and it makes both the romantic and the totalitarian readings that were once so fashionable look quite foolish.

39. Rousseau, as becomes apparent below, singles out tragedy for criticism in the *Letter* — seemingly unaware of how closely his own vision of imagination as hubris and progress as futility resembled the tragic view world view of the late Greeks (and the early Christians).

40. " . . . in a state as small as the republic of Geneva, all innovations are dangerous and . . . they ought never to be made without urgent and grave motives." Rousseau, *Letter to D'Alembert,* p. 123.

41. Ibid., p. 17.

42. Ibid., p. 65.

43. In the *Confessions,* Rousseau makes out the performances of December 10 and 12 at the Comédie-Francaise to be failures, but in fact *Narcisse* seems to have had a mild success and might have played again had not Rousseau withdrawn it. His modesty may reflect the self-flagellatory inclinations some commenta-

tors attribute to him — his "need to be hissed" as a contemporary of his put it — but it also seems likely that he was embarrassed by the success of a rather frothy little example of civilized frivolity so closely on the heels of his *First Discourse.* However, it is Rousseau's *Preface to Narcisse* rather than the play itself that is of interest here, and his comment on it in the *Confessions* is thus of some importance: it is, he writes, "one of my best productions . . . [in it] I began to express my principles a little more freely than I had hitherto done." *Confessions,* p. 400.

44. Rousseau, *Preface to Narcisse,* p. 972.
45. Ibid.
46. Ibid.
47. Rousseau, *Letter to D'Alembert,* p. 125.
48. Rousseau, *The Social Contract,* p. 36.
49. Rousseau, *Preface to Narcisse,* p. 973.
50. "Never did personal views soil the desire to be useful to others . . . I have almost always written against my own interest . . . beware of my errors and not my bad faith." Rousseau, *Letter to D'Alembert,* pp. 131–32, footnote.
51. Cited by Matthew Josephson, *Jean-Jacques Rousseau* (New York: Harcourt, Brace & Co., 1931), p. 179.
52. It was performed in 1759, 1765, 1767, 1771, 1777 and 1778.
53. Josephson, *Rousseau,* p. 179.
54. See F. Jost, *Jean-Jacques Rousseau — Suisse,* p. 245.
55. He speaks in the *Preface to Narcisse* of his plays as "those amusements of my youth," and likens them to "illegitimate children that one caresses once more with pleasure, blushing still at being their father, and then, saying one's final farewells, sends off in search of their fortune without worrying too much about what they become." *Preface to Narcisse,* p. 963.
56. "If it were permitted to extract from the actions of men, the proof of their sentiments, one would have to say that love and justice are banned from every heart and that there is no longer a single Christian on earth." *Preface to Narcisse,* p. 962.
57. Rousseau, *Émile,* p. 182.
58. Rousseau, *Confessions,* p. 400.
59. Rousseau, *Social Contract,* p. 32. The *Letter to D'Alembert* also rejects romantic primitivism: "The argument drawn from the example of the beasts proves nothing and is not true. Man is not a dog or a wolf. It is only necessary in his species to establish the first relations of society to give his sentiments a morality unknown to beasts. The animals have a heart and passions; but the holy image of the decent and the fair enters only the heart of man." *Letter,* pp. 86–87.
60. J. G. A. Pocock's masterful study of the theory of republics and their corruption uses the imagery of the "unseizable moment": cf. *The Machiavellian Moment* (Princeton: Princeton University Press, 1975). Judith Shklar also treats this ideal as an ungraspable utopia in her *Men and Citizens.* The moment itself is alluringly depicted in the *Discourse on the Origins of Inequality* as follows: " . . . this period of expansion of the human faculties, keeping a just mean between the indolence of the primitive state and the petulant activity of our egoism, must have been the happiest and most stable of epochs." Rousseau, *The Social Contract and Discourses,* p. 198.
61. Fragments of the projected drama are reproduced in Volume II of the Pléiade Edition of Rousseau as *La Mort de Lucréce,* pp. 1019–46.

62. Rousseau, *Letter to D'Alembert*, pp. 34–47.

63. As Lionel Trilling points out, both rhetoric and the novel are treated as acceptable forms of art by Rousseau; cf. Lionel Trilling, *Sincerity and Authenticity* (Cambridge, Mass.: Harvard University Press, 1971), pp. 58–67.

64. Rousseau, *Letter to D'Alembert*, p. 19.

65. Ibid.

66. Ibid., pp. 46–47. Rousseau's skepticism about the possibilities of instructive theater extend to his own efforts; he footnotes the suggestions he makes for edifying rewrites of Molière's *Misanthrope* as follows: "I do not doubt that, on the basis of the idea that I have just proposed, a man of genius could compose a new *Misanthrope*, not less true nor less natural than the Athenian one, equal in merit to that of Molière and incomparably more instructive. I see only one difficulty for this new play, which is that it could not succeed. For, whatever one may say, in things that dishonor, no one laughs with good grace at his own expense." Ibid., p. 42, footnote.

67. Unlike Diderot, Voltaire and other philosophers who wrote for the theater, Rousseau is usually omitted from theater encyclopedias and reference works, and is ignored in most theater courses at the university. One can presume that Brecht had no direct knowledge of his theater writings.

68. John Willet, ed., *Brecht on Theater: the Development of an Aesthetic* (New ← York: Hill and Wang, 1964), p. 135.

69. Diderot, *Paradoxe sur la Comédien*, p. 1006.

70. Ibid., p. 1009.

71. Ibid., p. 1010.

72. Ibid., p. 1011.

73. Rousseau, *Letter to D'Alembert*, p. 79.

74. I am in debt to Richard Sennett for his provocative discussion of play in his *The Fall of Public Man* (New York: Alfred A. Knopf, 1976).

← 75. See, for example, Willet, *Brecht on Theater*, pp. 81, 91 et passim.

76. Molière, *The Misanthrope*, p. 104.

77. Rousseau, *Letter to D'Alembert*, p. 35.

78. Molière, *The Misanthrope*, p. 101.

79. Rousseau, *Letter to D'Alembert*, p. 37.

80. See, for example, Martin Esslin, *Brecht: The Man and His Work* (New York: Doubleday & Co., 1959).

81. Rousseau, *Letter to D'Alembert*, p. 26.

82. Ibid., p. 33.

83. Ibid., p. 32.

84. Willet, *Brecht on Theater*, p. 72.

85. Ibid.

86. Ibid., p. 72.

87. The austere principles of Brecht's epic theater were more often breached than ← realized in his stage productions. The theory can be examined in his stunning "model books" which he developed during his productions (e.g., cf. *Theater-arbeit* [Berlin: Suhrkamp, 1961]), but the practice was another matter. For example, his best known play, *Mother Courage*, usually succeeds in terms Brecht would associate with failure — that is, by arousing our sympathy and exciting our admiration. But Brecht's intention is to make us pity and even despise Mother Courage for her ignorance and blame her for her own unwitting (and thus witless) role in serving as a link between capitalism and war. He wants her suffering to move us to action not to tears, as his *Modellbuch* for the

original production of the play at the Theater am Schiffbauerdam in East Berlin makes clear. Unless this happens, the effect of *Mother Courage* is that of tragedy, and it can no longer hope to be instructive. Yet it is precisely and perhaps only as tragedy that *Mother Courage* succeeds.

88. Willet, *Brecht on Theater,* p. 73. Brecht concludes "if there were no such amusement to be had from learning, the theater's whole structure would be unfit for teaching." That is, of course, precisely the question.
89. Ibid., pp. 180–81.
90. Ibid., p. 181.
91. Rousseau, *Preface to Narcisse,* p. 974.

Chapter Two

Baudelaire: Modernism in the Streets

Marshall Berman

But now imagine a city like Paris, . . . imagine this metropolis of the world, . . . where history confronts us on every streetcorner.
Goethe to Eckermann, 3 May 1827

It is not merely in his use of imagery of common life, not merely in the imagery of the sordid life of a great metropolis, but in the elevation of such imagery to first intensity — presenting it as it is, and yet making it represent something beyond itself — that Baudelaire has created a mode of release and expression for other men.
T.S. Eliot, "Baudelaire," 1930

In the past three decades, an immense amount of energy has been expended, all over the world, in exploring and unraveling the meanings of modernity. Much of this energy, in the West at least, has fragmented itself in perverse and self-defeating ways. Our vision of modern life has divided itself into material and spiritual planes: one group of people devotes itself to "modernism," a species of pure spirit, evolving in accord with its autonomous, artistic and intellectual imperatives; a wholly separate group of people investigates "modernization," a complex of material structures and processes — political, economic, social — which, once it has got underway, runs on its own momentum with little or no input from human minds or souls. This intellectual dualism, pervasive in contemporary Western culture, cuts scholars and thinkers off from one of the pervasive facts of modern life: the interfusion of its material and spiritual forces, the intimate unity of the modern self and the modern environment. But the first great wave of writers and thinkers about modernity — Goethe, Hegel and Marx, Stendhal and Baudelaire, Carlyle and Dickens, Herzen and

31

Dostoevski — had an instinctive feeling for this unity; it gave their visions a richness and depth that contemporary writing about modernity sadly lacks.

This essay is built around Baudelaire, who did more than anyone in the nineteenth century to make the men and women of his century aware of themselves as moderns. Modernity, modern life, modern art: these terms recur incessantly in Baudelaire's work, and two of his great essays, the short "Heroism of Modern Life" and the longer "Painter of Modern Life" (1859-90, published in 1863), have set agendas for a whole century of art and thought. In 1865, when Baudelaire was living in poverty, illness, and obscurity, the youthful Paul Verlaine tried to revive interest in him by stressing his modernity as a primary source of his greatness: "Baudelaire's originality is to portray, powerfully and originally, modern man . . . as the refinements of an excessive civilization have made him, modern man with his acute and vibrant senses, his painfully subtle spirit, his brain saturated with tobacco, his blood burning with alcohol . . . Baudelaire portrays this sensitive individual as a type, a *hero*."[1] The poet Theodore de Banville developed this theme two years later in a moving tribute at Baudelaire's grave:

> He accepted modern man in his entirety, with his weaknesses, his aspirations and his despair. He had thus been able to give beauty to sights that did not possess beauty in themselves, not by making them romantically picturesque, but by bringing to light the portion of the human soul hidden in them: he had thus revealed the sad and often tragic heart of the modern city. That was why he haunted, and would always haunt, the minds of modern men, and move them when other artists left them cold.[2]

Baudelaire's reputation, in the century since his death, has developed along the lines de Banville suggests: the more seriously Western culture is concerned with the issue of modernity, the more we appreciate Baudelaire's originality and courage as a prophet and pioneer. If we had to nominate a first modernist, Baudelaire would surely be the man.

And yet, one salient quality of Baudelaire's many writings on modern life and art is that the meaning of the modern is surprisingly elusive and hard to pin down. Take, for instance, one of his most famous dicta, from "The Painter of Modern Life": "By 'modernity' I mean the ephemeral, the contingent, the half of art whose other half is eternal and immutable." The painter (or novelist or philosopher) of modern life is one who concentrates his vision and energy on "its fashions, its morals, its emotions," on "the passing moment and all the suggestions of eternity that it contains." This concept of modernity is meant to cut against the antiquarian classical fixations that dominate French culture. "We are struck by a general

tendency among artists to dress all their subjects in the garments of the past." The sterile faith that archaic costumes and gestures will produce eternal verities leaves French art stuck in "an abyss of abstract and indeterminate beauty," and deprives it of "originality," which can only come from "the seal that Time imprints on all our generations." We can see what Baudelaire is driving at here; but this purely formal criterion for modernity — whatever is unique about any period — in fact takes him directly away from where he wants to go. By this criterion, as Baudelaire says, "Every old master has his own modernity," insofar as he captures the look and feeling of his own era. But this empties the idea of modernity of all its specific weight, its concrete historical content. It makes any and all times "modern times"; ironically, by spreading modernity through all history, it leads us away from the special qualities of our own modern history.[3]

The first categorical imperative of Baudelaire's modernism is to orient ourselves toward the primary forces of modern life; but Baudelaire does not make it immediately clear what these forces are, or what our stance toward them is supposed to be. Nevertheless, if we go through Baudelaire's work, we will find that it contains several distinctive visions of modernity. These visions often seem to be violently opposed to one another, and Baudelaire does not always seem to be aware of the tensions between them. Still, he presents all of these visions with verve and brilliance, and often develops them with great originality and depth. Moreover, all of Baudelaire's modern visions, and all his contradictory critical attitudes toward modernity, have taken on lives of their own, long past his death and into our own time. This essay will start from Baudelaire's most simplistic and uncritical interpretations of modernity: his lyrical celebrations of modern life that created distinctively modern modes of pastoral; his vehement denunciations of modernity, which generated modern forms of counter-pastoral. Baudelaire's pastoral visions of modernity would be elaborated in our century under the name of "modernolatry"; his counterpastorals would turn into what the twentieth century would call "cultural despair."[4] From these limited visions, we will move on for most of the essay to a Baudelaiean perspective that is far deeper and more interesting — though probably less well known and less influential — a perspective that resists all final resolutions, aesthetic or political, that wrestles boldly with its own inner contradictions, and that can illuminate not only Baudelaire's modernity but our own.

I. Pastoral and Counterpastoral Modernism

Let us start with Baudelaire's modern pastorals. The earliest version occurs in the preface to Baudelaire's "Salon of 1846," his critical review of

the year's showing of new art. This preface is entitled "To the Bourgeois."[5] Contemporary readers who are accustomed to think of Baudelaire as a lifelong sworn energy of the bourgeois and all its works are in for a shock.[6] Here Baudelaire not only celebrates the bourgeoisie, but even flatters them, for their intelligence, willpower, and creativity in industry, trade, and finance. It is not entirely clear of whom this class is meant to consist: "You are the majority — in number and intelligence; therefore you are the power — which is justice." If the bourgeoisie constitute a majority of the population, what has become of the working class, let alone the peasantry? However, we must remind ourselves, we are in a pastoral world. In this world, when the bourgeoisie undertake immense enterprises — "you have combined together, you have formed companies, you have raised loans" — not, as some might think, to make lots of money, but for a far loftier purpose: "to realize the idea of the future in all its diverse forms — political, industrial, artistic." The bourgeoisie's fundamental motive here is the desire for infinite human progress, not just in the economy, but universally, in the spheres of politics and culture as well. Baudelaire is appealing to what he sees as the bourgeois' innate creativity and universality of vision: because they are animated by the drive for progress in industry and politics, it would be unworthy of their dignity to stand still and accept stagnation in art. Baudelaire also appeals, as Mill will appeal a generation later (and as even Marx did in the *Communist Manifesto*), to the bourgeois belief in free trade, and demands that this ideal be extended to the sphere of culture: just as chartered monopolies are (presumably) a drag on economic life and energy, so "the aristocrats of thought, the monopolists of things of the mind," will suffocate the life of the spirit, and deprive the bourgeoisie of the rich resources of modern art and thought. Baudelaire's faith in the bourgeoisie neglects all the darker potentialities of their economic and political drives — that is why I call it a pastoral vision. Nevertheless, the naïveté of "To the Bourgeois" springs from a fine openness and generosity of spirit. It will not — it could not — survive June, 1848, or December, 1851; but, in a spirit as bitter as Baudelaire's, it is lovely while it lasts. In any case, this pastoral vision proclaims a natural affinity between material and spiritual modernization; it holds that the groups that are most dynamic and innovative in economic and political life will be most open to intellectual and artistic creativity — "to realize the idea of the future in all its diverse forms"; it sees both economic and cultural change as unproblematically progressive for mankind.[7]

Baudelaire's 1859–60 essay, "The Painter of Modern Life," presents a very different mode of pastoral: here modern life appears as a great fashion show, a system of dazzling appearances, brilliant facades, glittering triumphs of decoration and design. The heroes of this pageant are the

painter and illustrator Constantin Guys and Baudelaire's archetypal figure of The Dandy. In the world Guys portrays, the spectator "marvels at the . . . amazing harmony of life in capital cities, a harmony so providentially maintained amid the turmoil of human freedom." Readers familiar with Baudelaire will be startled to hear him sound like Dr. Pangloss; we wonder what's the joke, until we conclude ruefully that there isn't any. "The kind of subject preferred by our artist . . . is the pageantry of life *(la pompe de la rie)* as it is to be seen in the captials of the civilized world; the pageantry of military life, of fashion, and of love *(la vie militaire, la vie elegante, la vie galante)."* If we turn to Guys' slick renderings of the "beautiful people"and their world, we will see only an array of dashing costumes, filled by lifeless mannequins with empty faces. However, it isn't Guys' fault that his art resembles nothing so much as Bonwit's or Bloomingdale's ads. What is really sad is that Baudelaire has written pages of prose that go only too well with them:

> He [the painter of modern life] delights in fine carriages and proud horses, the dazzling smartness of the grooms, the expertness of the footmen, the sinuous gait of the women, the beauty of the children, happy to be alive and well dressed — in a word, he delights in universal life. If a fashion or the cut of a garment has been slightly modified, if bows and curls have been supplanted by cockades, if bavolets have been enlarged and chignons have dropped a fraction toward the nape of the neck, if waists have been raised and skirts have become fuller, be very sure that his eagle eye will have spotted it.[8]

If this is, as Baudelaire says, "universal life," what is universal death? Those who love Baudelaire will think it a pity that, as long as he was writing advertising copy, he couldn't arrange to get paid for it. (He could have used the money — though of course he would never have done it for money.) But this mode of pastoral plays an important role, not merely in Baudelaire's own career, but in the century of modern culture between his time and our own. There is an important body of modern writing, often by the most serious writers, that sounds a great deal like advertising copy. This writing sees the whole spiritual adventure of modernity incarnated in the latest fashion, the latest machine, or — and here it gets sinister — the latest model regime:

> A regiment passes, on its way, as it may be, to the ends of the earth, tossing into the air of the boulevards its trumpet-calls as winged and stirring as hope; and in an instant Monsieur G. will already have seen, examined and analyzed the bearing of the external aspect of that company. Glittering equipment, music, bold, determined in a few moments the resulting "poem" will be virtually composed. See how his soul lives with the soul of that regiment, marching like a single animal, a proud image of joy and obedience.[9]

These are the soldiers who killed 25,000 Parisians in June, 1848, and who opened the way for Napoleon III in December, 1851. On both those occasions Baudelaire went into the streets to fight against — and could easily have been killed by — the men whose animal-like "joy in obedience" so thrills him now. The passage above should alert us to a fact of modern life that students of poetry and art could easily forget: the tremendous importance of military display — psychological as well as political importance — and its power to captivate even the freest spirits. Armies on parade, from Baudelaire's time to our own, play a central role in the pastoral vision of modernity: glittering hardware, gaudy colors, flowing lines, fast and graceful movements, modernity without tears.

Perhaps the strangest thing about Baudelaire's pastoral vision — it typifies his perverse sense of irony, but also his peculiar integrity — is that the vision leaves him out. All the social and spiritual dissonances of Parisian life have been cleaned off these streets. Baudelaire's own turbulent inwardness, anguish and yearning — and his whole creative achievement in representing what Banville called "modern man in his entirety, with his weakness, his aspirations and his despair" — are completely out of this world. We should be able to see now that, when Baudelaire chooses Constantin Guys, rather than Courbet or Daumier or Manet (all of whom he knew and loved), as the archetypal "painter of modern life," it is not merely a lapse in taste, but a profound rejection and abasement of himself. His encounter with Guys, pathetic as it is, does convey something true and important about modernity: its power to generate forms of "outward show," brilliant designs, glamorous spectacles so dazzling that they can blind even the most incisive self to the radiance of its own darker life within.

Baudelaire's most vivid counterpastoral images of modernity belong to the late 1850s, the same period as "The Painter of Modern Life": if there is a contradiction between the two visions, Baudelaire is wholly unaware of it. The counterpastoral theme first emerges in an 1855 essay "On the Modern Idea of Progress as Applied to the Fine Arts."[10] Here Baudelaire uses familiar reactionary rhetoric to pour scorn, not merely on the modern idea of progress, but on modern thought and life as a whole:

> There is yet another, and very fashionable error which I am anxious to avoid like the very devil. I refer to the idea of "progress." This obscure beacon, invention of present-day philosophizing, licensed without guarantee of Nature or God — this modern lantern throws a stream of chaos on all objects of knowledge; liberty melts away, punishment [chatiment] disappears. Anyone who wants to see history clearly must first of all put out this treacherous light. This grotesque idea, which has flowered on the soil of modern fatuity, has discharged each man from his duty, has delivered the soul from responsibility, has released the will from all the bonds imposed on it by the love of beauty. . . . Such an infatuation is a symptom of an already too visible decadence.

Here beauty appears as something static, unchanging, wholly external to the self, demanding rigid obedience and imposing punishments on its recalcitrant modern subjects, extinguishing all forms of enlightenment, functioning as a kind of spiritual police in the service of a counterrevolutionary church and state.

Baudelaire resorts to this reactionary bombast because he is worried about an increasing "confusion of material order with spiritual order" that the modern romance of progress spreads. Thus,

> take any good Frenchman who reads *his* newspaper in *his* café, and ask him what he understands by progress, and he will answer that it is steam, electricity and gaslight, miracles unknown to the Romans, whose discovery bears full witness to our superiority over the ancients. Such is the darkness that has gathered in that unhappy brain! . . .

Baudelaire is perfectly reasonable in fighting the confusion of material progress with spiritual progress — a confusion that persists in our century, and becomes especially rampant in periods of economic boom. But he is as silly as the straw man in the café when he leaps to the opposite pole, and defines art in a way that seems to have no connection with the material world at all:

> The poor man has become so Americanized by zoöcratic and industrial philosophies that he has lost all notion of the difference between the phenomena of the physical world and those of the moral world, between the natural and the supernatural.[11]

This dualism bears some resemblance to the Kantian dissociation of the noumenal and phenomenal realms, but it goes a lot further than Kant, for whom noumenal experiences and activities — art, religion, ethics — still operate in a material world of time and space. It is not at all clear where, or on what, this Baudelairean artist can work. Baudelaire goes further: he disconnects his artist not only from the material world of steam, electricity and gas, but even from the whole past and future history of art. Thus, he says, it is wrong even to think about an artist's forerunners or the influences on him. "Every efflorescence [in art] is spontaneous, individual. . . . The artist stems only from himself. . . . He stands security only for himself. He dies childless. He has been his own king, his own priest, his own God."[12] Baudelaire leaps into a transcendence that leaves Kant far behind: this artist becomes a walking *Ding-an-sich*. Thus, in Baudelaire's mercurial and paradoxical sensibility, the counterpastoral image of the modern world generates a remarkably pastoral vision of the modern artist who floats, untouched, freely above it.

The dualism first sketched here — counterpastoral vision of the modern

world, pastoral vision of the modern artist and his art — is extended and deepened in Baudelaire's famous 1859 essay, "The Modern Public and Photography."[13] Baudelaire begins by complaining that "the exclusive taste for the True (so noble a thing when limited to its proper applications) oppresses the taste for the Beautiful." This is the rhetoric of balance, resisting exclusive emphases: truth is essential, only it shouldn't stifle the desire for beauty. But the sense of balance doesn't last long: "Where one should see nothing but Beauty (I mean in a beautiful painting) our public looks only for Truth." Because photography has the capacity to reproduce reality more precisely than ever before — to show the "Truth" — this new medium is "art's mortal enemy"; and insofar as the development of photography is a product of technological progress, "Poetry and progress are like two ambitious men who hate each other. When they meet on the same road, one or the other must give way." But why this mortal enmity? Why should the presence of reality, of "truth" in a work of art, undermine or destroy its beauty? The apparent answer, which Baudelaire believes so vehemently (at least at this moment) that he doesn't even think of saying it clearly, is that modern reality is utterly loathsome, empty not only of beauty but of even the potential for beauty. A categorical, nearly hysterical contempt for modern men and their life animates statements like these: "The idolatrous mob demanded an ideal appropriate to itself and worthy of its nature." From the moment that photography was developed, "our squalid society, Narcissus to a man, rushed to gaze at its trivial image on a scrap of metal." Baudelaire's serious critical discussion of the representation of reality in modern art is crippled by his uncritical loathing for the real modern people around him. This leads him once more to a pastoral conception of art: it is "useless and tedious to represent what exists, because nothing that exists satisfies me. . . . I prefer the monsters of my fantasy to what is positively trivial." Even worse that the photographers, Baudelaire says, are the modern painters who are influenced by photography: more and more, the modern painter "is given to painting not what he dreams, but what he sees." What makes this pastoral, and uncritical, is the radical dualism and the utter lack of awareness that there can be rich and complex relations, mutual influences and interfusions, between what an artist (or anyone else) dreams and what he sees.

Baudelaire's polemic against photography was extremely influential in defining a distinctive mode of aesthetic modernism, pervasive in our century — e.g., in Pound, Wyndham Lewis, and their many epigones — in which modern people and life are endlessly abused, while modern artists and their works are exalted to the skies, without any suspicion that these artists may be more human, and more deeply implicated in *la vie moderne,* than they would like to think. Other twentieth-century artists like

Kandinsky and Mondrian have created marvelous works out of the dream of a dematerialized, unconditioned, "pure" art. (Kandinsky's 1912 manifesto, "Concerning the Spiritual in Art," is full of echoes of Baudelaire.) But one artist whom this vision wholly leaves out, alas, is Baudelaire himself. For his poetic genius and achievement, as much as any poet before or after him, are bound up with a particular material reality: the everyday life — and night life — of the streets, cafes, cellars and garrets of Paris. Even his visions of transcendence are rooted in a concrete time and place. One thing that marks Baudelaire off radically from his Romantic precursors, and from his Symbolist and twentieth-century successors, is the way in which what he dreams is inspired by what he sees.

Baudelaire must have known this, at least unconsciously; whenever he is in the midst of sealing off modern art from modern life, he keeps reaching out to trip himself up and bring the two together again. Thus he stops in the midst of the 1855 "Progress" essay to tell a story, which he says is "an excellent lesson in criticism":

> The story is told of M. Balzac (and who would not listen with respect to any anecdote, no matter how trivial, concerning that great genius?) that one day he found himself in front of a beautiful picture — a melancholy winter scene, heavy with hoarfrost and thinly sprinkled with cottages and mean-looking peasants; and that after gazing at a little house from which a thin wisp of smoke was rising, "How beautiful it is!" he cried, "But what are they doing in that cottage? What are their thoughts? What are their sorrows? Has it been a good harvest? *No doubt they have bills to pay?*" [Baudelaire's emphasis].

The lesson for Baudelaire, which we will unfold in the following sections of this essay, is that modern life has a distinctive and authentic beauty, which, however, is inseparable from its innate misery and anxiety, from the bills that modern man has to pay. A couple of pages later, in the midst of fulminating complacently against the modern idiots who think themselves capable of spiritual progress, he becomes suddenly serious, and cuts sharply from a patronizing certainty that the modern idea of progress is illusory into an intense anxiety over the possibility that this progress is real. There follows a brief and brilliant meditation on the real terror that progress creates:

> I leave aside the question of whether, by continually refining humanity in proportion to the new enjoyments it offers, indefinite progress might not be its most cruel and ingenious torture; whether, proceeding as it does by a negation of itself, it would not turn out to be a perpetually renewed form of suicide, and whether, shut up in the fiery circle of divine logic, it would not be like the scorpion that stings itself with its own tail — progress, that eternal desideratum that is its own eternal despair![14]

Here Baudelaire is intensely personal, yet close to universal. He wrestles with paradoxes that engage and enrage all modern men, and envelop their politics, their economic activities, their most intimate desires, and whatever art they create. This sentence has a kinetic tension and excitement that reenact the modern condition it describes; the reader who arrives at the end of this sentence feels he has really been somewhere. This is what Baudelaire's best writing on modern life, far less well-known than his pastorals, is like. We are now ready for more of it.

II. The Heroism of Modern Life

At the very end of his review of the Salon of 1845, Baudelaire complains that the painters of the day are too inattentive to the present: "And yet the heroism of modern life surrounds and presses in on us. . . . " He goes on:

> There is no lack of subjects, or of colors, to make epics. The true painter we're looking for will be one who can snatch from the life of today our cravats and our patent-leather boots. Next year let's hope that the true seekers may grant us the extraordinary delight of celebrating the advent of the new![15]

These thoughts are not very well developed, but two things are worth noting here. First, Baudelaire's irony in the "cravats" passage: some people might think that the juxtaposition of heroism with cravats is a joke; it is, but the joke is precisely that modern men really are heroic, despite their lack of the paraphernalia of heroism; indeed, they are all the more heroic without paraphernalia to puff up their bodies and souls. Second, the tendency of modernity to make all things new: next year's modern life will look and feel different from this year's; still, both will be part of the same modern age; but the fact that you can't step into the same modernity twice will make modern life especially elusive and hard to grasp.

Baudelaire goes deeper into modern heroism a year later in his short essay of that name.[16] Here he gets more concrete: "The spectacle of fashionable life *(la vie elegante)* and the thousands of floating existences — criminals and kept women — that drift about in the underworlds *(souterrains)* of a great city; the *Gazette des Tribunaux* and the *Moniteur* all prove to us that we need only open our eyes to recognize our heroism." The fashionable world is here, just as it will be in the essay on Guys; only here it appears in a decidedly nonpastoral form, linked with the underworld, with dark desires and deeds, with crime and punishment; it has a human depth far more arresting than the pallid fashion plates of "The Painter of Modern Life." The crucial point about modern heroism, as Baudelaire sees it here, is that it emerges in *conflict*, in situations of conflict

that pervade everyday life in the modern world. Baudelaire gives examples from bourgeois life as well as from the fashionable high- and lowlife: the heroic politician, the government minister in the Assembly, beating back the opposition with a searing and stirring speech, vindicating his policies and himself; the heroic businessman, like Balzac's perfumer Birotteau, fighting the specter of bankruptcy, striving to rehabilitate not only his credit but his life, his whole personal identity; respectable rascals like Rastignac, capable of anything — of the meanest as well as the noblest actions — as he fights his way to the top; Vautrin, who inhabits the heights of the government as well as the depths of the underworld, and who shows the essential intimacy of these two *métiers*. "All these exude a new and special beauty, which is neither that of Achilles nor yet that of Agamemnon." Indeed, Baudelaire says — in rhetoric guaranteed to outrage the neoclassical sensibility of most of his French readers — "the heroes of the Iliad are as pygmies compared to you, Vautrin, Rastignac, Birotteau, . . . and you, Honoré de Balzac, you, the most heroic, the most extraordinary, most romantic and most poetic of all the characters you have produced from your womb." In general, contemporary Parisian life "is rich in poetic and marvelous subjects. The marvelous envelopes and soaks us like an atmosphere, but we don't see it."

There are several important things to notice here. First, the wide range of Baudelaire's sympathy and generosity, so different from the standard image of an *avant-garde* snob who exudes nothing but scorn for ordinary people and their travails. We should note, in this context, that the one artist in Baudelaire's gallery of modern heroes is not one who strives to distance himself from ordinary people, but rather the one who has plunged deeper into their life than any artist has ever done before, and who has come up with a vision of that life's hidden heroism. Finally, it is crucial to note Baudelaire's use of fluidity ("floating existences") and gaseousness ("envelopes and soaks us like an atmosphere") as symbols for the distinctive quality of modern life. Fluidity and vaporousness will become primary qualities in the self-consciously modernist painting, architecture and design, music and literature that will emerge at the end of the nineteenth century. We will encounter them, too, in the thought of the deepest moral and social thinkers of Baudelaire's generation and after — Marx, Kierkegaard, Stirner, Dostoevski, Nietzsche — for whom the basic fact of modern life is that, as the *Communist Manifesto* says, "all that is solid melts into air. . . ."

Baudelaire's "Painter of Modern Life" is undermined by its pastoral romance with the vapidities of the *vie elegante*. Nevertheless, it offers some brilliant and arresting images, poles away from pastoral, of what modern art should seek to capture in modern life. First of all, Baudelaire says, the

modern artist should "set up his house in the heart of the multitude, amid the ebb and flow of motion, in the midst of the fugitive and the infinite," in the midst of the metropolitan crowd. "His passion and his profession are *to become one flesh with the crowd*" — "*épouser la foule*" — Baudelaire gives special emphasis to this strange, haunting image. This "lover of universal life" must "enter into the crowd as though it were an immense reservoir of electrical energy . . . Or we might compare him to a kaleidoscope gifted with consciousness." He must "express at once the attitude and the gesture of living beings, whether solemn or grotesque, and their luminous *explosion* in space."[17] Electrical energy, the kaleidoscope, explosion: modern art must recreate for itself the immense transformations of matter and energy that modern science and technology — physics, optics, chemistry, engineering — have brought about. The point is not that the artist should utilize these innovations (though, in his essay on photography, Baudelaire says he approves this — so long as the new techniques are kept in their subordinate place). The real point for the modern artist is to reenact these processes, to put his own soul and sensibility through these transformations; the artist must bring these explosive forces to life in his work. But how? I don't think Baudelaire or anyone else in the nineteenth century had a clear grasp of how to do this. Not until the early twentieth century will these images begin to realize themselves — in cubist painting, collage and montage, the cinema, the stream of consciousness in the novel, the free verse of Eliot, Pound, Apollinaire, Futurism, Vorticism, Constructivism, Dada, poems that accelerate like cars, paintings that explode like bombs. And yet, Baudelaire knows something that his twentieth-century modernist successors tend to forget. It is suggested in the extraordinary emphasis he gives to the verb *épouser,* as a primary symbol for the relationship between the artist and the people around him. Whether this word is used in its literal sense, to marry, or in a figurative sense, to embrace sexually, it is one of the most ordinary of human experiences, and one of the most universal: it is, as the songs say, what makes the world go round. One of the fundamental problems of twentieth-century modernism is the way this art tends to lose touch with everyday people's lives. This is not, of course, universally true — Joyce's *Ulysses* may be the noblest exception — but it is true enough to be noticed by everyone who cares about modern life and art. For Baudelaire, however, an art that is not *épousé* with the lives of the men and women in the crowd is not properly modern art at all.

Baudelaire's richest and deepest thought about modernity begins just after "The Painter of Modern Life," in the early 1860s, and continues through the decade until the point, not long before his death in 1867, when he became too ill to write. This work is contained in a series of prose poems that he planned to bring out under the title of *Paris Spleen.* Baudelaire did

not live to finish the series or publish it as a unity, but he did complete fifty of these poems, plus a preface and an epilogue, and they appeared as a unity in 1868, just after his death. Walter Benjamin, in his series of remarkable essays on Baudelaire and Paris, was the first to grasp the great depth and richness of these prose poems.[18] Benjamin's Parisian writings, along with their many intellectual virtues, constitute a remarkable dramatic performance, surprisingly similar to Greta Garbo's in *Ninotchka*. His heart and his sensibility draw him irresistibly toward the city's bright lights, beautiful women, fashion, luxury, its play of dazzling surfaces and radiant scenes; meanwhile his Marxist conscience wrenches him insistently away from these temptations, instructs him (and presses him to instruct us) that this whole glittering world is empty, decadent, hollow, vicious, oppressive to the proletariat, condemned by history. Benjamin makes many ideological resolutions to forsake temptation — and to stop leading his readers into new temptation — but he cannot resist one last sweet look down the boulevard or under the arcade; he wants to be saved, but not yet. These inner contradictions, acted out on nearly every page, give Benjamin's Parisian work a luminous energy and poignant charm. (Ernst Lubitsch, *Ninotchka*'s scenarist and director, came out of the same Berlin Jewish bourgeois world as Benjamin, and also sympathized with the left; he would have appreciated the drama and the charm, but would doubtlessly have rewarded it with a happier denouement than Benjamin's own.) My own work in the vein that Benjamin opened up is less compelling as drama, but perhaps more coherent as history, whereas Benjamin lurches between total merger of the modern self (Baudelaire's, his own) with more constant currents of metabolic and dialectical flow. All my work is in the vein Benjamin opened up, though I have found different elements and compounds from the ones he brought out.

In the following two sections, I want to read, in detail and in depth, two of Baudelaire's late prose poems: "The Eyes of the Poor" (1864) and "The Loss of a Halo" (1865).[19] We will see at once from these poems why Baudelaire is acclaimed universally as one of the great urban writers. In *Paris Spleen,* perhaps more vividly than in any of his other writing, the city of Paris plays a principal role in the spiritual drama. Here Baudelaire belongs to a grand tradition of Parisian writing that reaches back to Villon, runs through Montesquieu and Diderot, Restif de la Bretonne and Sebastien Mercier, and into the nineteenth century with Balzac and Hugo and Eugène Sue. But Baudelaire also expresses a radical break in this tradition. His best Parisian writing belongs to the precise historical moment when, under the authority of Napoleon III and the direction of Haussmann, the city was being systematically torn apart and rebuilt. Even as Baudelaire worked in Paris, the work of its modernization was going on

alongside him and over his head and under his feet. He saw himself not only as a spectator, but as a participant and a protagonist in this ongoing work; his own Parisian work expresses its drama and trauma. Baudelaire shows us something that no other writer sees so well: how the modernization of the city at once inspires and enforces the modernization of its citizen's souls.

It is important to note the form in which the prose poems of *Paris Spleen* first appeared: as *feuilletons* that Baudelaire composed for the daily or weekly mass-circulation Paris press. The *feuilleton* was roughly equivalent to an Op-Ed piece in the newspapers of today. It normally appeared on the paper's first or center page, just below or opposite the editorial, and it was meant to be one of the very first things the reader would read. It was generally written by an outsider, in an evocative or reflective tone, intended as a contrast to the editorial's combativeness — though the piece might well be chosen to reinforce (often subliminally) the editor's polemical point. By Baudelaire's time the *feuilleton* was an extremely popular urban genre featured in hundreds of European and American newspapers. Many of the greatest nineteenth-century writers used this form to present themselves to a mass public: Balzac, Gogol and Poe in the generation before Baudelaire; Marx and Engels, Dickens, Whitman, and Dostoevski in his own generation. It is crucial to remember that the poems in *Paris Spleen* do not present themselves as verse, an established art form, but as prose, in the format of news.[20]

In the Preface to *Paris Spleen,* Baudelaire proclaims that *la vie moderne* requires a new language: "a poetic prose, musical without rhythm and without rhyme, supple enough and rugged enough to adapt itself to the soul's lyrical impulses, the undulations of reverie, the leaps and jolts of consciousness *(soubresauts de conscience)*." He emphasizes that "It was above all from the exploration of enormous cities and from the convergence of their innumerable connections *(du croisement de leurs innombrables rapports)* that this obsessive ideal was born." What Baudelaire communicates in this language, above all, is what I will call primal modern scenes: experiences that arise from the concrete everyday life of Bonaparte's and Haussmann's Paris, but carry a mythic resonance and depth that propel them beyond their place and time and transform them into archetypes of modern life.

III. The Family of Eyes

Our first primal scene emerges in "The Eyes of the Poor" *(Paris Spleen* #26). This poem takes the form of a lover's complaint: the narrator is explaining to the woman he loves why he feels distant and bitter toward

her. He reminds her of an experience they recently shared. It was the evening of a long and lovely day that they had spent alone together. They sat down on the terrace "in front of a new café that formed the corner of a new boulevard." The boulevard was "still littered with rubble," but the café "already displayed proudly its unfinished splendors." Its most splendid quality was a flood of new light: "The café was dazzling. Even the gas burned with the ardor of a debut; with all its power it lit the blinding whiteness of the walls, the expanse of mirrors, the gold cornices and moldings." Less dazzling was the decorated interior that the gaslight lit up: a ridiculous profusion of Hebes and Ganymedes, hounds and falcons; "nymphs and goddesses bearing piles of fruits, pâtés and game on their heads," a melange of "all history and all mythology pandering to gluttony." In other circumstances the narrator might recoil from this commercialized grossness; in love, however, he can laugh affectionately, and enjoy its vulgar appeal — our age would call it camp.

As the lovers sit gazing happily into each other's eyes, suddenly they are confronted with other people's eyes. A poor family, dressed in rags — a greybearded father, a young son, and a baby — come to a stop directly in front of them, and gaze raptly at the bright new world that is just inside. "The three faces were extraordinarily serious, and those six eyes contemplated the new café fixedly with an equal admiration, differing only according to age." No words are spoken, but the narrator tries to read their eyes. The father's eyes seem to say, "How beautiful it is! All the gold of the poor world must have found its way onto these walls." The son's eyes seem to say, "How beautiful it is! But it is a house where only people who are not like us can go." The baby's eyes "were too fascinated to express anything but joy, stupid and profound." Their fascination carries no hostile undertones; their vision of the gulf between the two worlds is sorrowful, not militant, not resentful but resigned. In spite of this, or maybe because of it, the narrator begins to feel uneasy, "a little ashamed of our glasses and decanters, too big for our thirst." He is "touched by this family of eyes," and feels some sort of kinship with them. But when, a moment later, "I turned my eyes to look into yours, dear love, to read *my* thoughts there" (Baudelaire's italics), she says: "Those people with their great saucer eyes are unbearable! Can't you go tell the manager to get them away from here?"

This is why he hates her today, he says. He adds that the incident has made him sad as well as angry: he sees now "how hard it is for people to understand each other, how incommunicable thought is" — so the poem ends — "even between people in love."

What makes this encounter distinctively modern? What marks it off from a multitude of earlier Parisian scenes of love and class tension? The difference lies in the urban space where our scene takes place: "Toward

evening you wanted to sit down in front of a new café that formed the corner of a new boulevard, still piled with rubble but already displaying its unfinished splendors." The difference, in one word, is the *boulevard:* the new Parisian boulevard was the most spectacular urban innovation of the nineteenth century, and the decisive breakthrough in the modernization of the traditional city.

In the late 1850s and through the 1860s, while Baudelaire was working on *Paris Spleen,* Georges-Eugène Haussmann, the Prefect of Paris and its environs, armed with the imperial mandate of Napoleon III, was blasting a vast network of boulevards through the heart of the old medieval city. Napoleon and Haussmann envisioned the new roads as arteries in an urban circulatory system — these images, commonplace today, were revolutionary in the context of nineteenth-century urban life. The new boulevards would enable traffic to flow through the center of the city, and to move straight ahead from end to end — a quixotic and virtually unimaginable enterprise till then. In addition, they would clear slums, and open up "breathing space" in the midst of layers of darkness and choked congestion. They would stimulate a tremendous expansion of local business at every level, and thus help to defray the immense municipal demolition, compensation, and construction costs. They would pacify the masses by employing tens of thousands of them — at times as much as a quarter of the city's labor force — on long-term public works, which in turn would generate thousands more jobs in the private sector. Finally, they would create long and broad corridors in which troops and artillery could move effectively against future barricades and popular insurrections.

The boulevards were only one part of a comprehensive system of urban planning that included central markets, bridges, sewers, water supply, the Opera and other cultural palaces, a great network of parks. "Let it be said to Baron Haussmann's eternal credit" — so wrote Robert Moses, his most illustrious and notorious successor, in 1942 — "that he grasped the problem of step-by-step large-scale city modernization." The new construction wrecked hundreds of buildings, displaced uncounted thousands of people, destroyed whole neighborhoods that had lived for centuries. But it opened up the whole of the city, for the first time in its history, to all its inhabitants. Now, at last, it was possible to move not only within neighborhoods, but through them. Now, after centuries of life as a cluster of isolated cells, Paris was becoming a unified physical and human space.[21]

The Napoleon-Haussmann boulevards created new bases, economic, social, aesthetic, for bringing enormous numbers of people together. At the street level they were lined with small businesses and shops of all kinds, with every corner zoned for restaurants and terraced sidewalk cafés. These cafés, like the one where Baudelaire's lovers and his family in rags come to

look, soon came to be seen all over the world as symbols of *la vie parisienne*. Haussmann's sidewalks, like the boulevards themselves, were extravagantly wide, lined with benches, lush with trees.[22] Pedestrian islands were installed to make crossing easier, to separate local from through traffic, and to open up alternate routes for promenades. Great, sweeping vistas were designed, with monuments at the boulevard's ends, so that each walk led toward a dramatic climax. All these qualities helped to make the new Paris a uniquely enticing spectacle, a visual and sensual feast. Five generations of modern painters, writers and photographers (and, a little later, filmmakers), starting with the Impressionists in the 1860s, would nourish themselves on the life and energy that flowed along the boulevards. By the 1880s, the Haussmann pattern was generally acclaimed as the very model of modern urbanism. As such, it was soon stamped on emerging and expanding cities in every corner of the world, from Santiago to Saigon.

What did the boulevards do to the people who came to fill them? Baudelaire shows us some of the most striking things. For lovers, like the ones in "The Eyes of the Poor," the boulevards created a new primal scene: a space where they could be private in public, intimately together without being physically alone. Moving along the boulevard, caught up in its immense and endless flux, they could feel their love more vividly than ever as the still point of a turning world. They could display their love before the boulevard's endless parade of strangers — indeed, within a generation Paris would be world-famous for this sort of amorous display — and draw different forms of joy from them all. They could weave veils of fantasy around the multitude of passersby: who were these people, where did they come from and where were they going, what did they want, whom did they love? The more they saw of others, and showed themselves to others — the more they participated in the extended "family of eyes" — the richer became their vision of themselves.

In this environment, urban realities could easily become dreamy and magical. The bright lights of street and café only heightened the joy; in the next generations, the coming of electricity and neon would heighten it still more. Even the most blatant vulgarities, like those café nymphs with fruits and pâtés on their heads, turned lovely in this romantic glow. Anyone who has ever been in love in a great city knows the feeling, and it is celebrated in a hundred sentimental songs: "The great big city's a wondrous toy/ Made for a girl and boy. We'll turn Manhattan into an isle of joy." In fact, these private joys spring directly from the modernization of public urban space. Baudelaire shows us a new private and public world at the very moment when it is coming into being. From this moment on, the boulevard will be as vital as the boudoir in the making of modern love.

But primal scenes, for Baudelaire as later on for Freud, cannot be idyllic. They may contain idyllic material, but at the climax of the scene a repressed reality breaks through, a revelation or discovery takes place. "A new boulevard, still littered with rubble, . . . displayed its unfinished splendors." Alongside the glitter, the rubble: the ruins of a dozen inner-city neighborhoods — the city's oldest, darkest, densest, most wretched and most frightening neighborhoods, home to tens of thousands of Parisians — razed to the ground. Where would all these people go? Those in charge of demolition and reconstruction did not particularly concern themselves. They were opening up vast new tracts for development on the northern and eastern fringes of the city; in the meantime, the poor would make do, somehow, as they always did. Baudelaire's family in rags step out from behind the rubble and place themselves in the center of the scene. The trouble is not that they are angry or demanding. The trouble is simply that they will not go away. They, too, want a place in the light.

This primal scene reveals some of the deepest ironies and contradictions in modern city life. The setting that makes all urban humanity a great extended "family of eyes" also brings forth the discarded stepchildren of that family. The physical and social transformations that drove the poor out of sight now bring them back directly into everyone's line of vision. Haussmann, in tearing down the old medieval slums, inadvertently broke down the self-enclosed and hermetically sealed world of traditional urban poverty. The boulevards, blasting great holes through the poorest neighborhoods, enable the poor to walk through these holes and out of their ravaged neighborhoods, to discover for the first time what the rest of their city and the rest of life is like. And as they see, they are seen: the vision, the epiphany, flows both ways. In the midst of the great spaces, under the bright lights, there is no way to look away. The glitter lights up the rubble, and illuminates the dark lives of the people at whose expense the bright lights shine.[23] Balzac had compared those old neighborhoods to the darkest jungles of Africa; for Eugène Sue they epitomized *The Mysteries of Paris*. Haussmann's boulevards transform the exotic into the immediate; the misery that was once a mystery is now a fact.

The manifestation of class divisions in the modern city opens up new divisions within the modern self. How should the lovers regard the ragged people who are suddenly in their midst? At this point, modern love loses its innocence. The presence of the poor casts an inexorable shadow over the city's luminosity. The setting that magically inspired romance now works a contrary magic, and pulls the lovers out of their romantic enclosure, into wider and less idyllic networks. In this new light, their personal happiness appears as class privilege. The boulevard forces them to react politically. The man's response vibrates in the direction of the liberal left: he feels guilty

about his happiness, akin to those who can see but cannot share it; he wishes, sentimentally, to make them part of his family. The woman's affinities — in this instant, at least — are with the Right, the Party of Order: call somebody with the power to get rid of them. Thus the distance between the lovers is not merely a gap in communication, but a radical opposition in ideology and politics. Should the barricades go up on the boulevard — as in fact they will in 1871, seven years after the poem's appearance, four years after Baudelaire's death — the lovers could well find themselves on opposite sides.

That a loving couple should find itself split by politics is reason enough to be sad. But there may be other reasons: maybe, when he looked deeply into her eyes, he really did, as he hoped to do, "read *my* thoughts there." Maybe, even as he nobly affirms his kinship in the universal family of eyes, he shares her nasty desire to deny the poor relations, to put them out of sight and out of mind. Maybe he hates the woman he loves because her eyes have shown him a part of himself that he hates to face. Maybe the deepest split is not between the narrator and his love, but within the man himself. If this is so, it shows us how the contradictions that animate the modern city street resonate in the inner life of the man on the street.

Baudelaire knows that the man's and the woman's responses, liberal sentimentality and reactionary ruthlessness, are equally futile: on one hand, there is no way to assimilate the poor into any family of the comfortable; on the other hand, there is no form of repression that can get rid of them for long — they'll always be back. Only the most radical reconstruction of modern society could even begin to heal the wounds — personal as much as social wounds — that the boulevards bring to light. And yet, too often, the radical solution seems to be dissolution: tear the boulevards down, turn off the bright lights, expel and resettle the people, kill the sources of beauty and joy that the modern city has brought into being. We can hope, as Baudelaire sometimes hoped, for a future in which the joy and beauty, like the city lights, will be shared by all. But our hope is bound to be suffused by the ironic sadness that permeates Baudelaire's city air.

IV. The Mire of the Macadam

Our next archetypal modern scene is found in the prose poem "Loss of a Halo" (*Paris Spleen* #46), written in 1865 but rejected by the press and not published until after Baudelaire's death. Like "The Eyes of the Poor," this poem is set on the boulevard; it presents a confrontation that the setting forces on the subject; and it ends (as its title suggests) in a loss of innocence. Here, however, the encounter is not between one person and another, or

between people of different social classes, but rather between an isolated individual and social forces that are abstract yet concretely dangerous. Here the ambience, imagery, and emotional tone are puzzling and elusive; the poet seems intent on keeping his readers off balance, and he may be off balance himself.

"Loss of a Halo" develops as a dialogue between a poet and an "ordinary man" who bump into each other in *un mauvais lieu,* a disreputable or sinister place, probably a brothel, to the embarrassment of both. The ordinary man, who has always cherished an exalted idea of the artist, is aghast to find one here:

> What! you here, my friend? you in a place like this? you, the eater of ambrosia, the drinker of quintessences! I'm amazed!

The poet then proceeds to explain himself:

> My friend, you know how terrified I am of horses and vehicles? Well, just now as I was crossing the boulevard in a great hurry, splashing through the mud, in the midst of a moving chaos, with death galloping at me from every side, I made a sudden move (*un mouvement brusque*), and my halo slipped off my head, and fell into the mire of the macadam. I was much too scared to pick it up. I thought it was less unpleasant to lose my insignia than to get my bones broken. Besides, I said to myself, every cloud has a silver lining. Now I can walk around incognito, do low things, throw myself into every kind of filth (*me livrer a la crapule*), just like ordinary mortals (*simples mortels*). So here I am, just as you see me, just like yourself!

The straight man plays along, a little uneasily:

> But aren't you going to advertise for your halo? or notify the police?

No: the poet is triumphant in what we recognize as a new self-definition:

> God forbid! I like it here. You're the only one who's recognized me. Besides, dignity bores me. What's more, it's fun to think of some bad poet picking it up and brazenly putting it on: What a pleasure to make somebody happy! especially somebody you can laugh at. Think of X! Think of Z! Don't you see how funny it will be?

It is a strange poem, and we are apt to feel like the straight man, knowing something's happening here but not knowing what it is.

One of the first mysteries here is that halo itself: what's it doing on a modern poet's head in the first place? It is there to satirize and to criticize one of Baudelaire's own most fervent beliefs: belief in the holiness of art. We can find a quasi-religious devotion to art throughout his poetry and

prose. Thus, in 1855: "The artist stems only from himself. . . . He stands security only for himself. . . . He dies childless. He has been his own king, his own priest, his own God."[24] "Loss of a Halo" is about how Baudelaire's own God fails. But we must understand that this God is worshipped not only by artists, but equally by many "ordinary people" who believe that art and artists exist on a plane far above them. "Loss of a Halo" takes place at the point at which the world of art and the ordinary world converge. This is not only a spiritual point, but a physical one, a point in the landscape of the modern city. It is the point where the history of modernization and the history of modernism fuse into one.

Walter Benjamin seems to have been the first to suggest the deep affinities between Baudelaire and Marx. Although Benjamin does not make this particular connection, readers familiar with Marx will notice the striking similarity of Baudelaire's central image here to one of the primary images of the *Communist Manifesto:* "The bourgeoisie has stripped of its halo every activity hitherto honored and looked up to with reverent awe. It has transformed the doctor, the lawyer, the priest, the poet, the man of science, into its paid wage-laborers." For both men, one of the crucial experiences endemic to modern life, and one of the central themes for modern art and thought, is *desanctification*. Marx's theory locates this experience in a world-historical context; Baudelaire's poetry shows how it feels from inside. But the two men respond to this experience with rather different emotions. In the *Manifesto,* the drama of desanctification is terrible and tragic: Marx looks back to, and his vision embraces, heroic figures like Oedipus at Colonus, Lear on the heath, contending against the elements, stripped and scorned but not subdued, creating a new dignity out of desolation. "Eyes of the Poor" contains its own drama of desanctification, but there the scale is intimate rather than monumental, the emotions are melancholy and romantic rather than tragic and heroic. Still, "Eyes of the Poor" and the *Manifesto* belong to the same spiritual world. "Loss of a Halo" confronts us with a very different spirit: here the drama is essentially comic, the mode of expression is ironic, and the comic irony is so successful that it masks the seriousness of the unmasking that is going on. Baudelaire's denouement, in which the hero's halo slips off his head and rolls through the mud — rather than being torn off with a violent *grand geste,* as it was in Marx (and Burke and Blake and Shakespeare) — evokes vaudeville, slapstick, the metaphysical pratfalls of Chaplin and Keaton. It points forward to a century whose heroes will come dressed as antiheroes, and whose most solemn moments of truth will be not only described but actually experienced as clown shows, music-hall or nightclub routines, *shticks.* The setting plays the same sort of decisive role in Baudelaire's black comedy that it will play in Chaplin's and Keaton's later on.

"Loss of a Halo" is set on the same new boulevard as "Eyes of the Poor."

But although the two poems are separated physically by only a few feet, spiritually they spring from different worlds. The gulf that separates them is the step from the sidewalk into the gutter. On the sidewalk, people of all kinds and all classes know themselves by comparing themselves to each other as they sit or walk. In the gutter, people are forced to forget what they are as they run for their lives. The new force that the boulevards have brought into being, the force that sweeps the hero's halo away and drives him into a new state of mind, is modern *traffic*.

When Haussmann's work on the boulevards began, virtually no one understood why he wanted them so wide: from a hundred feet to a hundred yards across. It was only when the job was done that people began to see that these roads, immensely wide, straight as arrows, running on for miles, would be ideal speedways for heavy traffic. Macadam, the surface with which the boulevards were paved, was remarkably smooth, and provided perfect traction for horses' hooves. For the first time, riders and drivers in the heart of the city could whip their horses up to full speed. Improved road conditions not only speeded up previously existing traffic, but — as twentieth-century highways would do on a larger scale — helped to generate a volume of new traffic far greater than anyone, apart from Haussmann and his engineers, had anticipated. Between 1850 and 1870, while the central city population (excluding newly incorporated suburbs) grew by about 25 percent, from about 1.3 million to 1.65 million, inner city traffic seems to have tripled or quadrupled. This growth exposed a contradiction at the heart of Napoleon's and Haussmann's urbanism. As David Pinkney says in his authoritative study, *Napoleon III and the Rebuilding of Paris,* the arterial boulevards "were from the start burdened with a dual function: to carry the main streams of traffic across the city and to serve as major shopping and business streets; and as the volume of traffic increased, the two proved to be ill-compatible." The situation was especially trying and terrifying to the vast majority of Parisians who walked. The macadam pavements, a source of special pride to the Emperor — who never walked — were dusty in the dry months of summer, and muddy in the rain and snow. Haussmann, who clashed with Napoleon over macadam (one of the few things they ever fought about), and who administratively sabotaged imperial plans to cover the whole city with it, said that this surface required Parisians "either to keep a carriage or to walk on stilts."[25] Thus the life of the boulevards, more radiant and exciting than urban life had ever been, was also more risky and frightening for the multitudes of men and women who moved on foot.

This, then, is the setting for Baudelaire's primal modern scene: "I was crossing the boulevard, in a great hurry, in the midst of a moving chaos, with death galloping at me from every side." The archetypal modern man, as we see him here, is a pedestrian thrown into the maelstrom of modern

city traffic, a man alone contending against an agglomeration of mass and energy that is heavy, fast, and lethal. The burgeoning street and boulevard traffic knows no spatial or temporal bounds, spills over into every urban space, imposes its tempo on everybody's time, transforms the whole modern environment into a "moving chaos." The chaos here lies not in the movers themselves — the individual walkers or drivers, each of whom may be pursuing the most efficient route for himself — but in their interaction, in the totality of their movements in a common space. This makes the boulevard a perfect symbol of capitalism's inner contradictions: rationality in each individual capitalist unit, leads to anarchic irrationality in the social system that brings all these units together. Street traffic was not, of course, the only mode of organized motion known to the nineteenth century. The railroad had been around on a large scale since the 1830s, and a vital presence in European literature since Dickens *Dombey and Son* (1846–48). But the railroad ran on a fixed schedule along a prescribed route, and so, for all its demonic potentialities, became a nineteenth-century paradigm of order.

We should note that Baudelaire's experience of "moving chaos" antedates the traffic light, an innovation developed in America around 1905, and a wonderful symbol of early state attempts to regulate and rationalize the chaos of capitalism.

The man in the modern street thrown into this maelstrom, is driven back on his own resources — often on resources he never knew he had — and forced to stretch them desperately in order to survive. In order to cross the moving chaos, he must attune and adapt himself to its moves, must learn to not merely keep up with it but to stay at least a step ahead. He must become adept at *soubresauts* and *mouvements brusques,* at sudden, abrupt, jagged twists and shifts — and not only with his legs and his body, but with his mind and his sensibility as well.

Baudelaire shows how modern city life forces these new moves on everyone; but he shows, too, how in doing this it also paradoxically enforces new modes of freedom. A man who knows how to move in and around and through the traffic can go anywhere, down any of the endless urban corridors where traffic itself is free to go. This mobility opens up a great wealth of new experiences and activities for the urban masses. Moralists and people of culture will condemn these popular urban pursuits as low, vulgar, sordid, empty of social or spiritual value. But when Baudelaire's poet lets his halo go, and keeps moving, he makes a great discovery. He finds, to his amazement, that the aura of artistic purity and sanctity is only incidental, not essential, to art, and that poetry can thrive just as well, and maybe even better, on the other side of the boulevard, in those low, "unpoetic" places like *un mauvais lieu* where this poem itself is born. One of the paradoxes of modernity, as Baudelaire sees it here, is that

its poets will become more deeply and authentically poetic by becoming more like ordinary men. If the poet throws himself into the moving chaos of everyday life in the modern world — a life of which the new traffic is a primary symbol — he can appropriate this life for art. The "bad poet" in this world is the poet who hopes to keep his purity intact by keeping off the streets, free from the risks of traffic. Baudelaire wants works of art that will be born in the midst of the traffic, that will spring from its anarchic energy, from the incessant danger and terror of being there, from the precarious pride and exhilaration of the man who has survived so far. Thus "Loss of a Halo" turns out to be a declaration of something gained, a rededication of the poet's powers to a new kind of art. His *mouvements brusques,* those sudden leaps and swerves so crucial for everyday survival in the city streets, turn out to be sources of creative power as well. In the century to come, these moves will become paradigmatic gestures of modernist art and thought. Forty years later, with the coming (or rather the naming) of the Brooklyn Dodgers, popular culture will produce its own ironic version of this modernist faith. The name expresses the way in which urban survival skills — specifically, skill at dodging traffic (they were at first called the *Trolley* Dodgers) — can transcend utility and take on new modes of meaning and value, in sport as in art. Baudelaire would have loved this symbolism, as many of his twentieth-century successors (W.C. Williams, E.E. Cummings, Marianne Moore) did.

Ironies proliferate from this primal modern scene. They unfold in Baudelaire's nuances of language. Consider a phrase like *la fange du macadam,* "the mire of the macadam." *La fange* in French is not only a literal word for mud; it is also a figurative world for mire, filth, vileness, corruption, degradation, all that is foul and loathsome. In classical oratorical and poetic diction, it is a "high" way of describing something "low". As such, it entails a whole cosmic hierarchy, a structure of norms and values not only aesthetic but metaphysical, ethical, political. *La fange* might be the nadir of the moral universe whose summit is signified by *l'auréole.* The irony here is that, so long as the poet's halo falls into *"la fange,"* it can never be wholly lost, because so long as such an image still has meaning and power — as it clearly has for Baudelaire — the old hierarchical cosmos is still present on some plane of the modern world. But it is present precariously. The meaning of macadam is as radically destructive to *la fange* as to *l'auréole:* it paves over high and low alike.

We can go deeper into the macadam: we will notice that the word isn't French. In fact, the word is derived from James MacAdam of Glasgow, the eighteenth-century inventor of modern paving surface. It may be the first word in that language that twentieth-century Frenchmen have satirically named *Franglais:* it paves the way for *le parking, le shopping, le weekend,* and far more. This language is so vital and compelling because it is the

international language of modernization. Its new words are powerful vehicles of new modes of life and motion. The words may sound dissonant and jarring, but it is as futile to resist them as to resist the momentum of modernization itself. It is true that many nations and ruling classes feel — and have reason to feel — threatened by the flow of new words and things from other shores.[26] There is a wonderful paranoid Soviet word that expresses this fear: *infiltrazya*. We should notice, however, that what nations have normally done from Baudelaire's time to our own is, after a wave (or at least a show) of resistance, not only to accept the new thing, but to create their own word for it, in the hope of blotting out embarrassing memories of underdevelopment. (Thus the Academie Francaise, after refusing all through the 1960s to admit *le parking-meter* to the French language, coined and quickly canonized *le parcmètre* in the 1970s.)

Baudelaire knew how to write in the purest and most elegant classical French. Here, however, with the "Loss of a Halo," he projects himself into the new, emerging language, to make art out of the dissonances and incongruities that pervade — and, paradoxically, unite — the whole modern world. "In place of the old national seclusion and self-sufficiency," the *Communist Manifesto* says, modern bourgeois society brings us "intercourse in every direction, universal interdependence of nations. And, as in material, so in intellectual production, the spiritual creations of nations become" — note this image, paradoxical in a bourgeois world — "common property." Marx goes on: "National one-sidedness and narrow-mindedness become more and more impossible, and from the numerous local and national literatures, there arises a world literature." The mire of the macadam will turn out to be one of the foundations from which this new world literature of the twentieth century will arise.[27]

There are further ironies that arise from this primal scene. The halo that falls into the mire of the macadam is endangered, but not destroyed; instead, it is carried along and incorporated into the general flow of traffic. One salient feature of the commodity economy, as Marx explains, is the endless metamorphosis of its market values. In this economy anything goes if it pays, and no human possibility is ever wiped off the books; culture becomes an enormous warehouse in which everything is kept in stock on the chance that someday, somewhere, it might sell. Thus the halo that the modern poet lets go (or throws off) as obsolete may, by virtue of its very obsolescence, metamorphose into an icon an object of nostalgic veneration for those who, like the "bad poets" X and Z, are trying to escape from modernity. But alas, the antimodern artist — or thinker or politician — finds himself on the same streets, in the same mire, as the modernist one. This modern environment serves as both a physical and a spiritual lifeline — a primary source of material and energy — for both. The differences between them at all: both alike are hindrances and hazards to the horses

and vehicles whose paths they cross, whose free movement they impede. Then, too, no matter how closely the antimodernist may cling to his aura of spiritual purity, he is bound to lose it, more likely sooner than later, for the same reason that the modernist lost it: he will be forced to discard balance and measure and decorum, and to learn the grace of brusque moves, in order to survive. Once again, however opposed the modernist and the antimodernist may think they are, in the mire of the macadam, from the viewpoint of the endlessly moving traffic, the two are one.

Ironies beget more ironies. Baudelaire's poet hurls himself into a confrontation with the "moving chaos" of the traffic, and strives not only to survive but to assert his dignity in its midst. But his mode of action seems self-defeating, because it adds yet another unpredictable variable to an already unstable totality. The horses and their riders, the vehicles and their drivers, are trying at once to outpace each other and to avoid crashing into each other. If, in the midst of all this, they are also forced to dodge pedestrians who may at any instant dart out into the road, their movements will become even more uncertain, and hence more dangerous than ever. Thus, by contending against the moving chaos, the individual only aggravates the chaos.

But this very formulation suggests a way that might lead beyond Baudelaire's irony and out of the moving chaos itself. What if the multitudes of men and women who are terrorized by modern traffic could learn to confront it *together?* This will happen just six years after "Loss of a Halo" (and three years after Baudelaire's death), in the days of the Commune — in Paris in 1871 — and again in Saint Petersburg in 1905 and 1917, in Berlin in 1918, in Barcelona in 1936, in Budapest in 1956, in Paris again in 1968, and in dozens of cities all over the world, from Baudelaire's time to our own — the boulevard will be abruptly transformed into the stage for a new primal modern scene. This will not be the sort of scene that Napoleon or Haussmann would like to see, but nonetheless one that their mode of urbanism will have helped to make. As we reread the old histories, memoirs and novels, or regard the old photos or newsreels, or stir our own fugitive memories of 1968, we will see whole classes and masses move into the street together. We will be able to discern two phases in their activity. At first the people stop and overturn the vehicles in their path, and set the horses free: here they are avenging themselves on the traffic by decomposing it into its inert original elements. Next, they incorporate the wreckage they have created into their rising barricades: they are recombining the isolated, inanimate elements into vital new artistic and political forms. For one luminous moment, the multitude of solitudes that make up the modern city come together in a new kind of encounter, to make a *people.* "The streets belong to the people": they seize control of the city's elemental

matter and make it their own. For a little while, the chaotic modernism of solitary brusque moves gives way to an ordered modernism of mass movement. The "heroism of modern life" that Baudelaire longed to see will be born from his primal scene in the street. Baudelaire does not expect this (or any other) new life to last.

But it will be born again and again out of the street's inner contradictions. It may burst into life at any moment, often when it is least expected. This possibility is a vital flash of hope in the mind of the man in the mire of the macadam, in the moving chaos, on the run.

V. The Twentieth Century: The Halo and the Highway

In many ways, the modernism of Baudelaire's primal modern scenes is remarkably fresh and contemporary. In other ways, his street and his spirit seem almost exotically archaic. This is not because our epoch has resolved the conflicts that give *Paris Spleen* its life and energy — class and ideological conflicts, emotional conflicts between intimates, conflicts between the individual and social forces, spiritual conflicts within the self — but rather because our epoch has found new ways to mask and mystify conflict. One of the great differences between the nineteenth and twentieth centuries is that our century has created a network of new haloes to replace the ones that Baudelaire's and Marx's century stripped away.

Nowhere is this development clearer than in the realm of urban space. If we picture the newest urban spatial complexes we can think of — all those that have been developed, say, since the end of the Second World War, including all our newer urban neighborhoods and new towns — we should find it hard to imagine Baudelaire's primal encounters happening here. This is no accident: in fact, for most of our century, urban spaces have been systematically designed and organized to ensure that collisions and confrontations will not take place in them. The distinctive sign of nineteenth-century urbanism was the boulevard, a medium for bringing explosive material and human forces together; the hallmark of twentieth-century urbanism has been the highway, a means for putting them asunder. We see a strange dialectic here, in which one mode of modernism both energizes and exhausts itself trying to annihilate another, all in modernism's name.

What makes twentieth-century modernist architecture especially intriguing to us here is the very Baudelairean point from which it starts out — a point that it soon does its best to blot out. Here is Le Corbusier, possibly the greatest twentieth-century architect and certainly the most influential, in *L'Urbanisme* (translated as *The City of Tomorrow*), his great modernist manifesto of 1924. His preface evokes a concrete experience from which, so

he tells us, his great vision arose.[28] We shouldn't take him literally, but rather understand his narrative as a modernist parable, formally similar to Baudelaire's. It began on a boulevard — specifically, on the Champs Élysées — on an Indian summer evening in 1924. He had gone for a peaceful walk in the evening twilight, only to find himself driven off the street by traffic. This is half a century after Baudelaire, and the automobile has arrived on the boulevards full force: "it was as if the world had suddenly gone mad." From moment to moment, he felt, "the fury of the traffic grew. Every day increased its agitation." (Here the time frame and the dramatic intensity are somewhat broken.) Le Corbusier felt himself threatened and vulnerable in the most direct way: "To leave our house meant that, once we had crossed our threshold, we were in danger of being killed by the passing cars." Shocked and disoriented, he contrasts the street (and the city) of his middle age with that of his youth before the Great War: "I think back twenty years, to my youth as a student: *the road belonged to us then*; we sang in it, we argued in it, while the horse-bus flowed softly by." (Emphasis mine.) He is expressing a plaintive sadness and bitterness as old as culture itself, and one of poetry's perennial themes: *Où sont les neiges d'antan?* Whither hath fled the visionary gleam? But his feeling for the textures of urban space and historical time make his nostalgic vision fresh and new. "The road belonged to us then. . . ." The young students' relation to the street was their relation to the world: it was — at least it seemed to be — open to them, theirs to move through, at a pace that could accommodate both argument and song; men, animals and vehicles could coexist peaceably, in a kind of urban Eden; Haussmann's enormous vistas spread out before them all, leading to the Arc de Triomphe. But now the idyll is over, the streets belong to the traffic, and the vision must flee for its life.

How can the spirit survive this change? Baudelaire showed us one way: transform the *mouvements brusques* and *soubresauts* of modern city life into the paradigmatic gestures of a new art that can bring modern men together. At the ragged edge of Baudelaire's imagination we glimpsed another potential modernism: revolutionary protest that transforms a multitude of urban solitudes into a people, and reclaims the city street for human life. Le Corbusier will present a third strategy that will lead to a third, extremely powerful mode of modernism. After fighting his way through the traffic, and just barely surviving, he makes a sudden daring leap: he identifies himself totally with the forces that have been bearing down on him:

> On that 1st of October, 1924, I was assisting in the titanic rebirth [*renaissance*] of a new phenomenon . . . traffic. Cars, cars, fast, fast! One is seized, filled with enthusiasm, with joy . . . the joy of power. The simple and naive pleasure of being in the midst of power, of strength. One participates in it. One takes part in this society that is just dawning. One has confidence in

this new society: it will find a magnificent expression of its power. One
believes in it.

This Orwellian leap of faith is so fast and so dazzling (just like that traffic)
that Le Corbusier hardly seems to notice that he has made it. One moment
he is the familiar Baudelairean man in the street, dodging and fighting the
traffic; a moment later his point of view has shifted radically, so that now he
lives and moves and speaks from *inside* the traffic. One moment he is
speaking about himself about his own life and experience — "I think back
twenty years . . . the road belonged to us then"; the next moment the
personal voice utterly disappears, dissolved in a flood of world-historical
processes; the new subject is the abstract and impersonal *on,* "one," who is
filled with life by the new world power. Now, instead of being menaced by
it, he can be in the midst of it, a believer in it, a part of it. Instead of the
mouvements brusques and *soubresauts* that Baudelaire saw as the essence
of everyday modern life, Le Corbusier's modern man will make one big
move that will make further moves unnecessary, one great leap that will be
the last. The man in the street will incorporate himself into the new power
by becoming the man in the car.

The perspective of the new man in the car will generate the paradigms of
twentieth-century modernist urban planning and design. The new man,
Le Corbusier says, needs "a new type of street" that will be "a machine for
traffic," or, to vary the basic metaphor, "a factory for producing traffic." A
truly modern street must be "as well-equipped as a factory."[29] In this street,
as in the modern factory, the best-equipped model is the most thoroughly
automated: no people, except for people operating machines; no unar-
mored and unmechanized pedestrians to slow the flow. "Cafes and places
of recreation will no longer be the fungus that eats up the pavements of
Paris."[30] In the city of the future, the macadam will belong to the traffic
alone.

From Le Corbusier's magic moment on the Champs Élysées, a vision of a
new world is born: a fully integrated world of high-rise towers, surrounded
by vast expanses of grass and open space "the tower in the Park" —
linked by aerial superhighways, serviced by subterranean garages and
shopping arcades. This vision had a clear political point, stated in the last
words of *Towards a New Architecture*:

> *Architecture or Revolution.*
> *Revolution can be avoided.*

The political connections were not fully grasped at the time — it is not clear
whether Le Corbusier entirely grasped them himself — but we should be
able to understand them now. *Thesis,* a thesis asserted by urban people

starting in 1789, all through the nineteenth century, and in the great revolutionary uprisings at the end of World War I: the streets belong to the people. *Antithesis,* and here is Le Corbusier's great contribution: no streets, no People. In the post-Haussmann city street, the fundamental social and psychic contradictions of modern life converged and perpetually threatened to erupt. But if this street could only be wiped off the map — Le Corbusier said it very clearly in 1929: "We must kill the street!"[31] — then maybe these contradictions need never come to a head. Thus modernist architecture and planning created a modernized version of pastoral: a spatially and socially segmented world — people here, traffic there; work here, homes there; rich here, poor there; barriers of grass and concrete in between — where haloes could begin to grow around people's heads once again.[32]

This form of modernism has left deep marks on all our lives. The city development of the last forty years, in capitalist and socialist countries alike, has systematically attacked, and often successfully obliterated, the "moving chaos" of nineteenth-century urban life. In the new urban environment — from Lefrak City to Century City, from Atlanta's Peachtree Plaza to Detroit's Renaissance Center — the old modern street, with its volatile mixture of people and traffic, businesses and homes, rich and poor, is sorted out and split up into separate compartments, with entrances and exits strictly monitored and controlled, loading and unloading behind the scenes, parking lots and underground garages the only mediation. All these spaces, and all the people who fill them, are far more ordered and protected than any place or anybody in Baudelaire's city could be. The anarchic, explosive forces that urban modernization once brought together, a new wave of modernization, backed by an ideology of developing modernism, has pulled apart. New York is now one of the very few American cities in which Baudelaire's primal scenes can still take place. And these old cities, or segments of cities, are under pressures far more threatening than the ones that gripped them in Baudelaire's day. They are economically and politically condemned as obsolete, beset by chronic blight, sapped by disinvestment and cut off from opportunities for growth, constantly losing ground in competition with areas that are considered more "modern." The tragic irony of modernist urbanism is that its triumph has helped to destroy the very urban life it hoped to set free.[33]

The twentieth century has also produced a dismal flattening out of social thought, corresponding in a most curious way to this flattening out of the urban landscape. Serious thinking about modern life has polarized itself into two sterile antitheses, which may be called, as I suggested earlier, Modernolatry and Cultural Despair. For modernolators, from Marinetti and Mayakovski and Le Corbusier to Buckminster Fuller and the later

Marshall McLuhan and Herman Kahn, all the personal and social dissonances of modern life can be resolved by technological and administrative means; the means are all at hand, and the only thing needful is leaders with the will to use them. For the visionaries of cultural despair, from T. E. Hulme and Ezra Pound and Eliot and Ortega, onward to Ellul and Foucault, Arendt and Marcuse, all of modern life seems uniformly hollow, sterile, flat, "one-dimensional," empty of human possibilities: anything that looks or feels like freedom or beauty is really only a screen for more profound enslavement and horror. We should note, first of all, that both these modes of thought cut across the political divisions of left and right; second, that many people have clung to both these poles at different points in their lives, and some have even tried to cling to both at once. We can find both polarities in Baudelaire, who indeed (as I suggested in Section II) might lay claim to having invented both. But we can also find in Baudelaire something that is missing in most of his successors: a will to wrestle, to the end of his energy, with modern life's complexities and contradictions, to find and create himself in the midst of the anguish and beauty of its moving chaos.

It is ironic that, both in theory and in practice, the mystification of modern life and the destruction of some of its most exciting possibilities have gone on in the name of progressive modernism itself. And yet, in spite of everything, that old moving chaos has kept — or perhaps has renewed — its hold on a great many of us. The urbanism of the past two decades has conceptualized and consolidated this hold. Jane Jacobs wrote the prophetic book of this new urbanism: *The Death and Life of Great American Cities,* published in 1961. Jacobs argued brilliantly, first, that the urban spaces created by modernism were physically clean and orderly, but socially and spiritually dead; second, that it was only the vestiges of nineteenth-century congestion, noise and general dissonance that kept contemporary urban life alive; third, that the old urban "moving chaos" was in fact a marvelously rich and complex human order, unnoticed by modernism only because its paradigms of order were mechanical, reductive and shallow; and finally, that what still passed for modernism in 1960 might turn out to be evanescent and already obsolete.[34] In the last two decades, this perspective has gathered widespread and enthusiastic assent, and masses of Americans have worked steadfastly to save their neighborhoods and cities from the ravages of motorized modernization. Every movement to stop the construction of a highway is a movement to give the moving chaos a new lease on life. Despite sporadic local successes, no one has had the power to break the accumulated power of the halo and the highway. But there have been enough people with enough passion and dedication to create a strong undertow, to give modern city life a new

tension and excitement while it lasts. And there are recent signs that it may last longer than anyone — even those who loved it most — would have thought. Amid gas lines, truckers' strikes, pressures from OPEC, intense (and legitimate) fear and anxiety about energy sources of the future, the motorized pastoral appears at last to be breaking down. As it cracks, the moving chaos of our nineteenth-century cities looks more orderly — and more up-to-date — every day. Thus Baudelaire's modernism, as I have portrayed it here, may turn out to be even more relevant in our time than it was in his own; the urban men and women of today may be the ones to whom he was most truly, in his image, *épousé*.

All this suggests that modernism contains its own inner contradictions and dialectics; that forms of modernist thought and feeling may congeal into dogmatic orthodoxies and become archaic; that other modes of modernism may be submerged for generations without ever being super-seded; and that the deepest social and psychic wounds of modernity may be repeatedly sealed, without ever being really healed. The contemporary desire for a city that is openly troubled but intensely alive is a desire to open up old but distinctively modern wounds once more. It is a desire to live openly with the split and unreconciled character of our lives, and to draw energy from our inner struggles, wherever they may lead us in the end. If we learned through one modernism to construct haloes around our spaces and ourselves, we can learn from another modernism — one of the oldest, but also, we can see now, one of the newest — to lose our haloes and find ourselves anew.

Notes

1. Quoted by Marcel Ruff, ed., *Baudelaire: Oeuvres Complètes* (Paris: Editions du Seuil, 1968), pp. 36–37, from an article by Verlaine in the magazine *L'Art*. All French texts cited here are from Ruff's edition.
2. Quoted by Enid Starkie, *Baudelaire* (New Directions, 1958), pp. 530–31, from a paraphrase in the Paris newspaper *L'Étendard,* 4 September 1867.
3. Baudelaire, *The Painter of Modern Life, and Other Essays,* trans. and ed. by Jonathan Mayne, with extensive illustrations (London & New York: Phaidon, 1965), pp. 1–5, 12–14. Marx, in the same decade, was complaining, in terms surprisingly similar to Baudelaire's, about classical and antique fixations in the politics of the left: "The tradition of all the dead generations weighs like a nightmare on the brain of the living. And just when men seem engaged in revolutionizing themselves and things, in creating something entirely new, . . . they anxiously conjure up the spirits of the past and borrow from them names, battle slogans and costumes in order to present the new scene of world history in this time-honored disguise and this borrowed language." *The Eighteenth Brumaire of Louis Bonaparte, 1851–52.* Cf. Robert Tucker, ed., *The Marx-Engels Reader* (New York: Norton, 1978), p. 595.
4. Pontus Hulten, *Modernolatry* (Stockholm: Moderna Museet, 1966); Fritz

Stern, *The Politics of Cultural Despair: A Study in the Rise of the Germanic Ideology* (Berkeley: University of California, 1961).

5. "To the Bourgeois," pp. 41–43. Baudelaire's *Salons* critiques are all in *Art in Paris, 1845–62,* the companion volume to *The Painter of Modern Life,* also translated and edited by Jonathan Mayne, and published by Phaidon, 1965. Note: I have occasionally altered Mayne's translations generally in the direction of greater precision; where the alterations are important, the French is given.

6. This sterotype is presented exhaustively, and uncritically, in Cesar Graña, *Bohemian versus Bourgeois: Society and the French Man of Letters in the Nineteenth Century* (New York: Basic Books, 1964), pp. 90–124. (Note: the paperback edition, 1967, is entitled *Modernity and its Discontents*). A more complex account of Baudelaire, the bourgeois, and modern life is given by Peter Gay, *Art and Act: On Causes in History — Manet, Gropius, Mondrian* (New York: Harper and Row, 1976), esp. pp. 88–92.

7. Baudelaire's faith in bourgeois receptivity to modern art may derive from the Saint-Simonians. Saint-Simon, who seems to have invented the modern idea of the *avant-garde* in the 1820s, saw the arts as the most effective medium for speading new ideas of modern science, industry, and social organization. Cf. Donald Drew Egbert, "The Idea of *Avant-Garde* in Art and Politics," *American Historical Review,* 73, no. 2 (December, 1967).

8. Baudelaire, *The Painter of Modern Life,* p. 11.

9. Ibid., p. 24.

10. Baudelaire, *Art in Paris,* pp. 121–29. This essay appears as Part I of a lengthy critical discussion of the 1855 Paris Exposition Universelle.

11. Ibid., pp. 125–26.

12. Ibid., p. 127.

13. "Salon of 1859," Part II, in Ibid., pp. 149–55.

14. Ibid., pp. 125, 127.

15. Ibid., pp. 31–32. Cf. Baudelaire's comments, in the "Heroism" essay, on the grey or black suit that was becoming the standard modern man's outfit: it expresses "not only political beauty, which is an expression of universal equality, but also poetic beauty, an expression of the public soul." The emerging standard outfit is "the necessary garb of our suffering age, which wears the symbol of perpetual mourning on its thin black shoulders." *Art in Paris,* p. 118.

16. "The Heroism of Modern Life," in Ibid., pp. 116–20.

17. Baudelaire, *Painter of Modern Life,* p. 18.

18. These essays have been brought together under the title of *Charles Baudelaire: Lyric Poet in the Era of High Capitalism,* trans. Harry Zohn, published in England (New Left Books, 1973), but scandalously unavailable in the United States as of 1980.

19. *Paris Spleen,* trans. Louise Varese (New Directions, 1947, 1970). In the poems below, however, translations are my own.

20. On the *feuilleton,* and its connections with some of the greatest of nineteenth-century literature, cf. Walter Benjamin, *Baudelaire,* pp. 27 ff., and Donald Fanger, *Dostoevsky and Romantic Realism* (Chicago, Ill: University of Chicago Press, 1965), throughout.

21. My picture of the Napoleon III-Haussmann transformation of Paris has been put together from several sources: Siegfried Giedion, *Space, Time and Architecture* (4th edition, Cambridge, Mass.: Harvard University Press, 1966),

64 The Artist and Political Vision

pp. 744–75; Robert Moses, "Haussmann," in *Architectual Forum,* 77.1 (July, 1942), pp. 57–66; David Pinkney, *Napoleon III and the Rebuilding of Paris* (Princeton, New Jersey: Princeton University Press, 1972); Leonardo Benevolo, *A History of Modern Architecture,* trans. H. J. Landry (Cambridge, Mass.: The MIT Press, 1971), I, pp. 61–95; Francoise Choay, *The Modern City: Planning in the Nineteenth Century* (New York: George Braziller, 1969), especially pp. 15–26; Howard Saalman, *Haussmann: Paris Transformed* (New York: George Braziller, 1971). Cf. also Louis Chevalier, *Laboring Classes and Dangerous Classes: Paris in the First Half of the Nineteenth Century,* trans. Frank Jellinek (New York: H. Fertig, 1973), for a horrific, excruciatingly detailed account of the ravages to which the old central neighborhoods were subjected in the pre-Haussmann decades: demographic bombardment, which doubled the population while the housing stock was sharply reduced; periodic mass unemployment, which in a prewelfare era led directly to starvation; dreadful epidemics of typhus and cholera which took their greatest tolls in the old *quartiers.* All this suggests why the Parisian poor, who fought so bravely for much else in the nineteenth century, put up no resistance to the destruction of their neighborhoods; they may well have been willing to go, as Baudelaire said in another context, anywhere out of their world.

 The little-known essay by Robert Moses is a special treat for all those interested in the ironies of urban history and culture. In the course of giving a lucid and balanced overview of Haussmann's accomplishments, Moses crowns himself as Haussmann's successor, and implicitly bids for still more Haussmann-type authority to carry out even more gigantic public works after the war. The piece ends with an admirably incisive and trenchant critique that anticipates, with amazing precision and deadly accuracy, the criticism that would be directed a generation later against Moses himself, and that would finally help to drive Haussmann's greatest disciple from public life.

22. Haussmann's engineers invented a tree-lifting machine that enabled them to transplant thirty-year-old trees in full leaf, and thus to create shady avenues, seemingly *ex nihilo,* virtually overnight. Giedion, pp. 757–59.

23. Cf. Engels, in his pamphlet *The Housing Question* (1872), on "the method called 'Haussmann'. . . . I mean the practice, which has now become general, of making breaches in working-class quarters of our big cities, especially in those that are centrally situated. . . . The result is everywhere the same: the most scandalous alleys and lanes disappear, to the accompaniment of lavish self-glorification by the bourgeoisie on account of this tremendous success — but they appear at once somewhere else, and often in the immediate neighborhood." Karl Marx and Friedrich Engels, *Selected Works* (Moscow: Foreign Languages Publishing House, 1955), Vol. I, pp. 559, 606–9.

24. Baudelaire, *Art in Paris,* p. 127.

25. Cf. Pinkney, *Napoleon III,* census figures, pp. 151–54; traffic counts and estimates, and conflict between Napoleon and Haussmann over macadam, pp 70–72; dual function of boulevards, pp. 214–15.

26. In the nineteenth century the main transmitter of modernization was England, in the twentieth century it has been the United States. Power maps have changed, but the primacy of the English language — the least pure, the most elastic and adaptable of modern languages — is greater than ever. It might well survive the decline of the American empire.

27. On the distinctively international quality of twentieth-century modernist

language and literature, see Delmore Schwartz, "T. S. Eliot as International Hero" (1945), in Irving Howe, ed., *Literary Modernism* (New York: Fawcett, 1967), 277–85.

28. Le Corbusier, *The City of Tomorrow,* trans. Frederick Etchells (Cambridge: MIT Press, 1971), pp. 3–4. I have sometimes used my own translations, based on the French text of *L'Urbanisme* (10th ed., G. Cres, 1941).

29. Ibid., pp. 123, 131.

30. Le Corbusier, *Towards a New Architecture* (1923), trans. Frederick Etchells (1927; New York: Praeger, 1959), pp. 56–59.

31. Quoted by Sybil Moholy-Nagy, *Matrix of Man: An Illustrated History of Urban Environment* (New York: Praeger, 1968), pp. 274–75.

32. This ideal might be reformulated in a more specifically American way, in terms of the symbology elaborated so beautifully by Leo Marx, *The Machine in the Garden: Technology and the Pastoral Ideal in America* (New York: Oxford University Press, 1964). The new motorized pastoral could allay nineteenth-century fears that the idyllic peace of "the garden" would be crushed forever by the triumph of "the machine": a twentieth-century promise of Eden, Jay Gatsby's vision of "the fresh, green breast of the new world," would be reincarnated in the aura of the green light. Many fascinating books could be written around this theme; it is surprising that they haven't been written yet.

33. This needs to be qualified. Le Corbusier dreamt of an ultramodernity that could heal the modern city's wounds. More typical of the modernist movement in architecture was an intense and unqualified hatred for the city, and a fervent hope that modern design and planning could wipe it out. One of the primary modernist cliches was the comparison of the metropolis to the stagecoach or (after World War I) to the horse and buggy. A typical modernist orientation toward the city can be found in *Space, Time and Architecture,* a monumental work by Le Corbusier's most articulate disciple, and the book that, more than any other, was used for two generations to define the modernist canon. The book's original edition, composed in 1938–39, concludes with a celebration of Robert Moses' new network of urban highways, which Giedion sees as ideal models for the planning and construction of the future. The highway demonstrates that "there is no longer any place for the city street with heavy traffic running between rows of houses; it cannot possibly be permitted to persist" (p. 832). This idea comes directly out of *The City of Tomorrow;* what is different, and disturbing, is the tone. Le Corbusier's lyrical, visionary enthusiasm has been replaced by the truculent and threatening impatience of the commissar. "Cannot possibly be permitted to persist": can the police be far behind? Even more ominous is what comes next. The urban highway complex "looks forward to the time when, after the necessary surgery has been performed, the artificial city will be reduced to its natural size." This passage, which has the chilling effect of a marginal note by Mr. Kurtz, suggests how, for two generations of planners, the campaign against the street was only one phase of a wider war against the modern city itself.

The antagonism between modern architecture and the city is explored sensitively and subtly by Robert Fishman, *Urban Utopias in the Twentieth Century* (New York: Basic Books, 1977).

34. "It is disturbing to think that men who are young today, men who are being trained now for their careers, should accept, *on the grounds that they should be modern in their thinking,* conceptions about cities and traffic which are not

only unworkable, but also to which nothing new of any significance has been added since their fathers were children." *The Death and Life of Great American Cities* (New York: Vintage, 1961), p. 371; Jacobs's emphases. The Jacobs perspective is developed interestingly in Richard Sennett, *The Uses of Disorder: Personal Identity and City Life* (New York: Alfred A. Knopf, 1970), and in Robert Caro, *The Power Broker: Robert Moses and the Fall of New York* (New York: Alfred A. Knopf, 1974).

It should be added that the Jacobs vision may contain pastoral distortions of its own. Jacobs concludes a beautiful analysis of her block in Greenwich Village with an assertion (in 1960) that crime cannot possibly occur on this block because of its vitality, diversity, and wonderful human mix. Jacobean urban history tends to pastoralize the nineteenth-century metropolis, to leave out the misery, desperation, starvation in the doorways and blood on the streets — to leave out, in effect, everything that Baudelaire saw so well.

Chapter Three
Dostoevsky and Unamuno: The Anti-Modern Personality

Michael A. Weinstein

The use of imaginative literary works to clarify the questions of political philosophy is a risky intellectual enterprise. Within the Western tradition, at least, literature and political philosophy have neither the same form nor the same finality. Despite widely varying definitions of political philosophy, its practitioners have generally interpreted their endeavor as a form of rational inquiry into the principles that do (and/or should) guide common life. Literary artists, on the contrary, have not been constrained by the canons of rational argument. Although political themes, situations, and even arguments frequently appear in works of literature, one cannot assume that they should be judged at face value. The political content of a literary work may perform the function of a symbol; it may provide a context for the action; it may be a means of illuminating a character; or it may be introduced as part of an aesthetic whole. Political philosophy is supposed to aim at rational truth and to present it as intelligibly as possible. There is a question as to whether literature does or should approach rational truth about human existence straightforwardly.

Employing literature for the purposes of political philosophy itself betrays the doubt that inquiry into politics can be exhausted by rational inquiry. Were such doubt absent, there would be no apparent reason for political philosophers to undertake the double movement of interpretation that literary criticism demands. Literary critics not only must provide an exposition of a work, but they must determine whether or not that work has a hidden or symbolic meaning. For example, the works of Franz Kafka appear to have a political meaning concerned with the agonies of bureaucratic life, but they may also have a less obvious religious meaning for which the political content is merely a symbol.[1] Certainly the

interpretation and criticism of works of political philosophy often demands that the analyst penetrate beneath the surface and unmask ideologies and concealed motives, but in such works the overt content is not usually taken to symbolize a covert content (as politics symbolizes religion in Kafka). Hence it is a serious mistake to assume that literary artists and political philosophers are merely doing the same thing in different ways — the philosopher presenting systematic and logical arguments to clarify the public situation, and the artist providing examples of principles. Some literature may be a revolt against the limitations of reason that opens up dimensions of human existence which are inaccessible to philosophers.

Literary works are often far more closely linked to the agonies of their creators than are works of political philosophy, though political thinkers who are also imaginative writers, such as Camus and Marcel, are exceptions to this rule. The characters in a novel may be fragments of an author's personality, enacting an inner conflict. Commentators on political philosophy may have to determine the historical circumstances to which a thinker responded, but they are less concerned with the particular conflicts reflected in the thinker's biography. Although the distinction is relative, political philosophy is usually judged by universal criteria, whereas literary works are normally interpreted as expressions of a person. Literature overlaps political philosophy when the particular agonies of the artist appear to represent more general tensions in culture and civilization.

The multiple dialectic between literature and political philosophy is compounded in the study of many works of recent literature. The irrationalist movement in Western thought that began in the nineteenth century influenced literary artists far more than it affected political philosophers. The aftershocks of existentialism, for example, have been far more intense in the novel and the short story than in technical philosophy. It may not be exaggerated to claim that in many cases literature has offered an alternative to philosophy rather than an exemplification of it.[2] Particularly on the margins of the West, where cultures lack a modern rationalist tradition and are subject to more-or-less imposed modernization, literature rather than philosophy has served as a vehicle for articulating the structure of a changing public situation marked by seemingly irreconcilable conflicts and tragedies. In nineteenth-century Russia, for example, there was no tradition of rational philosophy and the struggle between Slavophils and Westernizers was expressed intellectually more through imaginative literature than through systematic and rational discourse. Similarly, in the Hispanic world, where the *pensador* who combined imagination with intellect was the central intellectual type, philosophy was, in the main, self-consciously antisystematic and frequently expressed in literary forms.

Insofar as literature has been an alternative to philosophy, it has been a means of opposing wisdom to theoretical knowledge. The impulse to wisdom is illustrated by the reflections of Tikhon, a character in *Peter and Alexis,* a work of the Russian symbolist Dmitri Merejkowski.[3] Tikhon, the "eternal pilgrim," is set loose in the Russia of Peter the Great, which is undergoing enforced modernization from above. He has been exposed to Western rationalism and the Orthodox Christianity of the Old Believers, who are being suppressed forcibly to make way for a new Orthodoxy on more Protestant lines. Tikhon suffers the agony of modernization, being torn between reason and faith. One night, while poring over Spinoza's works, he realizes that he must choose between reason without God or God without reason. He ruthlessly criticizes philosophers such as Leibniz who optimistically hope for a harmony of efficient cause and final cause, and prophesies that attempts to compromise with scientific rationalism will fail. Tikhon's reflections do not end with a rational critique of Spinoza and the institution of a new philosophy, but with a decision to continue his wandering and to affirm his agonized faith. Tikhon's conclusion was not rational knowledge, but a decision based on an examination of his torn experience. He had read the modern rationalists not as sources of theoretical truth but as possible providers of wisdom, as guides to living. Although he had found no wisdom in their works, he gained his own wisdom that modernization is tragic.

The impulse to wisdom presupposes doubt that knowledge is virtue. The mainstream of Western political philosophy has assumed that the truth about human existence is consistent with the requirements for maintaining social life. Even thinkers such as Freud, who have highlighted the irrational dimensions of human existence, have believed that knowledge of the unconscious is better than ignorance of it. Repressed memories carry the penalty of self-destructive neuroses; those who do not live in truth are punished on earth if not in heaven. Those writers who have been agonized by modernization are not as quick to assume the equivalence of theoretical knowledge and virtue. They interpret modernization primarily as a process of secularization in which the traditional religious supports to society are knocked away, and nothing is erected to replace them but the quest for advantage and the exercise of brute power. The traditional cultures that they represent were buttressed by myth, revelation and mysticism — not by the Western belief in a natural law that can be apprehended by reason. Hence they do not understand the constructive functions of speculative reason, but only the corrosive effects of critical reason.

Political philosophy, understood as a rational inquiry, is only made possible by belief in a rational good and in the possibility of a rational will to achieve that good. Western civilization has differed from all others in being based upon the idea of a rational good. Insofar as this idea is

undermined by reason itself, in its critical form, the principle that knowledge is virtue is also destroyed. The relations between knowledge and virtue became an obsessive concern for some of the greatest literary figures of the past century. Dostoevsky in Russia and Unamuno in Spain made this problem the focus of their literary work and reached the conclusion that critical reason and the political good are antithetical. Lev Shestov, a Russian philosopher and follower of Dostoevsky, summarized Dostoevsky's revolution against philosophy:

> There can be no doubt: hope had not been supported by doctrine, but vice versa, doctrine, by hope. With this acknowledgement, there ends for man the thousand-year reign of "reason" and "conscience"; a new era begins — that of "psychology," which Dostoevsky was the first in Russia to discover.[4]

The scission of hope from reason forms the basis of political reflection in Dostoevsky's and Unamuno's works. Each of them created a literary persona who experienced the split between knowledge and virtue in the public situation. Dostoevsky's Grand Inquisitor and Unamuno's San Manuel are, in the phrase of Merejkowski, "spiritual politicians" who encounter the agonies of leadership in a secularizing society.

I. The Grand Inquisitor and San Manuel

The Grand Inquisitor and San Manuel the Good, Martyr, are among the most remarkable figures in modern literature. They are perhaps the closest approximations to mythical characters in modern thought, synthesizing the agonies of secular society and providing wisdom about leadership. The Grand Inquisitor and San Manuel are both priests, but they are also politicians and educators, ministering to the totality of their followers' needs. Among many other possible interpretations, they are literary reflections of the totalitarian leader who provides comprehensive solutions for the problems of life; but neither of them is actuated by the desire for wealth, power, approval, or rectitude. They are exceptional people, modern philosopher-kings, who rule against their will. However, unlike the Platonic philosopher-king, they rule and lead in contradiction to the truth that agonizes them. The figures of the Grand Inquisitor and San Manuel bear witness to the principle that politics, religion, and education cannot be permanently separated from one another. Even in a differentiated society, the leader must confront the interconnections of human activities although the followers may be assigned partial and specialized roles. The Grand Inquisitor and San Manuel take on responsibility for the public situation and, through that act, transcend mass secular life.

The Grand Inquisitor and San Manuel are alternatives to the lonely existential hero who searches for personal authenticity against the mass. The existential hero lives, in Merejkowski's phrase, by the principle "love thy neighbor and flee thy neighbor." He acknowledges some truth that he believes most others cannot live by or that might even destroy them, so he loves the others by leaving them alone and following his own way in solitude or secrecy. The spiritual politician cannot flee from others, but must somehow square a judgment about the truth of human existence with the needs and demands of the mass. For both Dostoevsky and Unamuno the primary human need and demand is for meaning. The Grand Inquisitor states that "without a stable conception of the object of life, man would not consent to go on living, and would rather destroy himself than remain on earth, though he had bread in abundance."[5] San Manuel remarks that people live in as much contentment as they can "in the illusion that everything has a finality."[6] The secret of both the Grand Inquisitor and San Manuel is that they doubt that life has any meaning, and this very doubt is what enables them to rule and lead. Their public project is to provide others with a meaning that they themselves cannot affirm.

The legend of the Grand Inquisitor appears as an interlude in *The Brothers Karamazov*. It is a poem or fantasy told by Ivan Karamazov, a rebel against God, to his brother Alyosha, who affirms a mystical Christian faith. The legend describes the return of Christ to Spain during the Holy Inquisition and his subsequent confrontation with the cardinal directing the Inquisition (the Grand Inquisitor). Ivan's fantasy is a detailed indictment against Christian freedom and charity in which the Grand Inquisitor defends the political empire of the Church. The short novel *San Manuel the Good, Martyr* takes place in a small Spanish village during the period of modernization. It tells the story of a parish priest, San Manuel, who is able to insulate the village from politics and modernity by infusing his parishioners with Christian belief through his saintly example. San Manuel creates a spiritual empire over the village although he does not believe in immortality or resurrection of the flesh.

Although the Grand Inquisitor and San Manuel exemplify almost diametrically opposed responses to the agony of modernization, in both cases critical reason is pitted against the hope that Dostoevsky and Unamuno believe is necessary to sustain social life. Although both figures keep their deepest truth, their agony, from their followers, the Grand Inquisitor creates a political religion whereas San Manuel creates a religious anarchy. In both cases the tension between church and state, a hallmark of the Western tradition that depended upon the independence of natural reason, is broken. For Dostoevsky and Unamuno modernization means that either the state must absorb the church, or the church must

absorb the state (as in *"The Grand Inquisitor"*), or make the state unnecessary (as in *San Manuel*).

The grounds for the alternative interpretations of modern wisdom offered by Dostoevsky and Unamuno are found in their differing views of the nature of the mass personality and of the exceptional individual. Though the Grand Inquisitor and San Manuel apparently share the same agony, secret, and political problem, their responses are contradictory because they view themselves and the others to whom they are related in different manners. Their opposing projects show that doubts about the equivalence of knowledge and virtue do not result in the same attitudes or commitments. Perhaps the most obvious and striking difference between the two figures is that one is an inquisitor and the other a martyr. The Grand Inquisitor's leadership is based on his exceptional strength "to endure the freedom" that the mass of human beings "have found so dreadful." From his viewpoint only those who know enough to lie and who have the strength to suffer by being "forced to lie" can rule over those who wish to remain weak, obedient, and illusioned. The Grand Inquisitor accuses Christ of speaking only to the strong who can tolerate freedom, while he, by providing dogmatic solutions and enforcing them, ministers to the weak. The martyr, in contrast, founds his leadership on weakness. San Manuel privately admits that had he not continually kindled the faith of his parishioners he would have committed suicide. His martyrdom consists in having to bolster the faith of others while hiding from them his own doubts. Yet, unlike the Grand Inquisitor who lives in loneliness and suffering, San Manuel saves himself from existential nausea and isolation by losing himself in others. The Grand Inquisitor's relation to the mass is unidirectional: he is an agonized and tortured savior. San Manuel's relation to his parishioners is reciprocal: he provides them with faith and hope in order that their faith and hope may sustain his life. The Grand Inquisitor believes that the people need him, whereas San Manuel is acutely aware that he needs the people. The one has only indirect or secondary relations mediated by rules; the other is absorbed in face-to-face or primary relations in which his personality is projected without any mediating supports.

The ways of the inquisitor and the martyr, the two antithetical types of spiritual politician, are not based only upon opposing interpretations of the public situation, but also upon differing reactions to God, traditional religious belief, and the agony of modernization. Behind the Grand Inquisitor's bitter and sorrowful assumption of public responsibility is resentment that has been suppressed and projected consciously as *ressentiment*.[7] Like Ivan Karamazov, who relates the legend, the Grand Inquisitor is one who feels cheated by God and religion. Obviously the

cardinal has taken Christianity seriously, perhaps too seriously, because he has discovered that it places responsibility completely on the free individual, whose only guidance is the absolute law of love. Yet he finds that the mass of human beings seek to escape from freedom and responsibility, and clamor both for bread and for fixed meaning for life and death. The Grand Inquisitor claims to have once "prized the freedom" that Christ gave to human beings, but later "awakened and would not serve madness." He became a "corrector" of Christ's work by surrendering what he calls his pride and going back "to the humble, for the happiness of the humble."

The Grand Inquisitor's correction of Christianity is to substitute miracle, mystery, and authority for personal freedom. Had he never "been in the wilderness," "lived on roots and locusts," and striven to stand among the elect, his revolt and his indictment would simply have been that of the unreflective mass. However, the Grand Inquisitor's attraction lies in the fact that he tasted freedom and found that it was madness, an idiocy that isolated him from other human beings. Ivan Karamazov interprets the Grand Inquisitor as having reached the "clear conviction" that "nothing but the advice of the great dread spirit could build up any tolerable sort of life for the feeble, unruly, 'incomplete, empirical creatures created in jest.'"[8] Yet it is questionable whether or not the cardinal's wisdom is actually the result of a "clear conviction." He "prized" freedom and does not dispute that to live in freedom is to live in truth. He does not even dispute that freedom is a higher good than happiness founded on the falsehoods of miracle, mystery, and authority. Christ's way is "madness," not because it is false, but because it is difficult and perhaps impossible for most human beings.

There would be no problem if the Grand Inquisitor did not feel the need to justify himself before Christ, if he had merely ordered Christ to be executed. The issue that Dostoevsky does not address explicitly is why the Grand Inquisitor chose not to be mad, why he decided to lower himself to the level of the mass rather than, against all odds, to try to raise the mass to his level. It is not sufficient to say that "ought implies can." The Grand Inquisitor's "clear conviction" is not derived from universal reason, but is a judgment of his neighbor and a fleeing from his neighbor. The Grand Inquisitor decided to be a spiritual politician. His choice was not merely the result of disillusionment. He does not claim that when he prized freedom he believed that his imitation of Christ would provide happiness for the mass. Rather, his turn toward the mass came after his judgment that only a terrible God could create a world in which only the elect could be saved. Hence, his correction of Christianity resulted from an inversion of values, not from a new reflection on the implications of the same value premises.

He substituted solidarity with the common run of humanity for an exceptional life. His purpose was not to realize the value of solidarity, which his exceptional character prohibited, but to affirm his conception of justice against absurd freedom.

The irony of the Grand Inquisitor is that his rebellion does not give him happiness, although it is intended to provide happiness for others: "For only we, we who guard the mystery, shall be unhappy."[9] The Grand Inquisitor suffers regardless of whether he imitates or rebels against Christ. The tortured dialectic of his project shows a fundamentally ambiguous relation to the mass. On the one hand, he surrenders his highest value preference, to live in truth, in order to serve the preferences of the unreflective mass. Yet in humbling himself, he actually raises himself above the mass by taking on the burden of guarding the mystery within the privacy of his own torn being. The solidarity that he gains with the mass is superficial, because the mass never accepts him as he is, but only in the role of public protector. The Grand Inquisitor's rebellion, then, far from being grounded in humanitarian impulses, is based on the refusal to resign himself to a world in which all people cannot live in truth. His deepest reasoning is that if God has been unjust, he will usurp God's place and institute an earthly empire by using God as a means to anti-Christian ends. The Grand Inquisitor is a figure of the Antichrist.

The Grand Inquisitor's *ressentiment* is evidenced by the one thing that he will not resign himself to: the objective structure of values that he himself acknowledges. He simultaneously affirms the supremacy of freedom and rejects a world in which freedom is difficult or, perhaps, impossible. Yet he is unable or unwilling to maintain a tension between his hierarchy of values and the limitations of the world. Thus, he carries over his resentment against the world and the God who created it to an inversion of the hierarchy of values itself. Not only does he struggle against the world, but he also affirms the values of the world publicly against the values of the spirit, which he denominates "madness." He does not, like the pragmatist, adapt himself to the possible because it is all that he can appreciate. Rather, he glorifies the possible in a spirit of bitterness. He does not so much reject or refute universal freedom as rebel against it.[10] The Grand Inquisitor can never make a complete return to the herd morality of mass life, because he cannot erase the memory of the years he spend in the desert striving to stand among the elect. His simultaneous self-abasement and self-aggrandizement constitute the wisdom of *ressentiment*.

While the inquisitor's project is ultimately grounded in *ressentiment,* the martyr's is rooted in resignation. The Grand Inquisitor is a cardinal who has attained to the commanding heights of power in the earthly empire of the church. San Manuel the Good is a parish priest who "had distinguished

himself by his mental acuteness and talent" in the seminary, but "had rejected offers of a brilliant ecclesiastical career." He lives by being a peacemaker, reconciling husbands to wives and parents to children, and "above all consoling the bitter and depressed, and helping all to die well." Through his imitation of Christ, San Manuel creates a "spiritual empire" in which politics is rendered unnecessary: "His actions among the people were such that nobody would dare to lie before him and everyone, without having to go to confession, would confess to him."[11] Yet San Manuel is a martyr because he cannot carry out his own saintly project without keeping his own doubts about salvation, immortality, and resurrection of the flesh a secret from his parishioners. His secret is only revealed to Angela Carbellino, who narrates the story, and her brother Lazaro, whom San Manuel converts from positivism to his atheistic Christianity. San Manuel's confession is thus not the same as the Grand Inquisitor's accusation and justification before his Lord, but is done out of agony and humility before those whom he is supposed to guide. He even begs Angela for absolution. San Manuel is not a rebel but a seeker after salvation. When he is alone and walks along the shore of the lake that lies next to his village, he is tortured by his doubts and contemplates plunging himself in the water and losing himself in its eternal depths. He can resist the temptation of suicide only by submerging himself in the "spiritual lake" of his people, whose naive faith he fortifies so that it will be strong enough to protect him. Rather than the bitterness of the Grand Inquisitor, San Manuel displays an "imperturbable happiness" that conceals his desperate struggles to gain faith. The guiding motive in his life is what Unamuno called "the hunger for immortality"; his central problem is his agonized doubt that this hunger will, or even could, be satisfied. When Angela accuses him of hyprocrisy he answers: "I feign belief? No! This isn't feigning! Take holy water, someone said, and you will end by believing."[12] While the Grand Inquisitor believes in the base intentions of the mass which desires bread and meaning, San Manuel is incapable of believing that anyone has evil intentions. He finds that he is at fault for his lack of belief, not that the world and God are at fault for their injustice. San Manuel does not seek to "correct" Christianity by basing it on miracle, mystery, and authority, but to insulate the people of his village from modernization by maintaining them in their traditional "dream." He would like that dream to continue uninterrupted from birth through death.

The key to San Manuel's deepest motivations is provided by Angela's reflections on his death. She concludes that he died "believing that he did not believe in what most concerns us, but without believing that he believed it, believing it in an active and resigned desolation."[13] This complicated account of San Manuel's agony demonstrates the differences between the

grounds of his projects and those of the Grand Inquisitor. Despite the apparent disparity between the Grand Inquisitor's problem of justice and San Manuel's problem of immortality, both of them suffer the same basic agony of being unable to believe in an ultimate meaning for life and death. The inquisitor interprets this problem and his suffering as a sign that God is evil, while the martyr interprets them as a sign of his inadequacy. Hence, the inquisitor is consumed by resentment which shifts imperceptibly to *ressentiment,* or an inversion of the table of values that he implicitly acknowledges and affirms. The martyr, on the contrary, must resign himself to his inability to achieve his highest value, faith. Yet this resignation cannot be passive and quiescent; it must be active; ceaselessly fortifying the faith of others in the hope that their faith may somehow make a change in him.

Max Scheler has argued that the only alternative to *ressentiment* is resignation. If one cannot realize a value the supremacy of which one acknowledges, then the choice is between inverting the hierarchy of values in bad faith (making a virtue out of necessity), or resigning oneself to one's incapacity while continuing to acknowledge and affirm the original table of values. San Manuel's wisdom, then, is that of resignation. Had he chosen *ressentiment* he would have become a nihilist, working to undermine faith and glorifying individual freedom and desire. Instead, he continued to prize faith and actively resigned himself to serving it, although he could not live in it for himself.

While the inquisitor and the martyr represent two alternative responses to the loss of ultimate meaning and the insight that knowledge is not virtue, these responses are based on heterogeneous interpretations of the negation of meaning; that is, they are not merely different forms of practice, but are rooted in radically different experiences. For the inquisitor, the absence of a meaning for life and death is interpreted as absolute freedom of moral choice, which he takes to be the essence of Christianity. Here the function of meaning is primarily ethical because it provides a standard of good and evil which is incompatible with absolute freedom. In the Grand Inquisitor's eyes, either God commands and human beings obey or some human beings must take on the responsibilities of God. Hence, the Grand Inquisitor's rebellion is made inevitable by the intuition of absolute freedom joined to the judgment that human beings need a fixed standard of good and evil in order to live in a community. For the martyr, the lack of ultimate meaning signifies a lack of faith. Here the function of meaning is primarily religious, because it offers a guide to salvation and a promise of immortality. In the martyr's eyes, God is revealed and human beings either accept the revelation or find themselves unable or unwilling to do so. Those who do not have faith should not take on God's responsibility, but should cement community by acting "as if" they were believers.

The inquisitor and the martyr, then, are distinguished from one another by different tables of values. For the inquisitor the highest value is absolute freedom, whereas for the martyr it is faith. The inquisitor as Antichrist is originally a rebel against faith and only later a rebel against freedom. The martyr has discovered freedom but refuses to rebel against faith, choosing instead to resign himself actively to his defect. Placing the inquisitor and the martyr into a political context, one might say that the first has lived the agony of modernization as a modern, but the second has lived it as a traditionalist: Salvation is a dead issue for the inquisitor (his empire is of the secular world); it is still a live option for the martyr. Neither of these "spiritual politicians" explore the possibility of making their agonies public, i.e., of publicizing freedom or the death of meaning and of God.

The agonized Antichrist and the agonized imitator of Christ have distinctive political styles, which depend upon the character of the mass to which they refer. The inquisitor's mass is that defined by twentieth-century thinkers such as Scheler, Ortega, Heidegger, and Jaspers: that aggregation of people identified with modernization and characterized by the desire for comfort, the desire to have one's cake and eat it too, the desire for bread and goodness, and the drive to evade responsibility for maintaining a community. The martyr's mass is the traditional "people," subject to sin, but unified by an all-encompassing faith that must be continually renewed. In neither case is the possibility broached of a responsible public of free human beings, taking active responsibility for their own rule and voluntarily submitting to authorities that are accountable to them. This possibility is grounded in the Western tradition of a rational good presupposing the exercise of rational will, a tradition that is at least partly alien to those outside of or on the margins of the Occident. Seen from this perspective, the Grand Inquisitor is the "spiritual politician" of the present and future, while San Manuel is a nostalgic remembrance of things past.

The Grand Inquisitor presides over a material empire legitimated by spiritual symbols. He intends to provide bread and meaning to the mass in order to relieve the three human needs of someone to worship, someone to serve as a conscience, and "some means of uniting all in one unanimous and harmonious ant heap." The Grand Inquisitor claims that "craving for universal unity is the third and last anguish of man," the first two being the craving for bread and for the knowledge of good and evil. The capstone of his politics will be a universal state, because, although there have been "many great nations with great histories," "the more highly they were developed the more unhappy they were, for they felt more acutely than other people the craving for worldwide union."[14] Hence, for the Grand Inquisitor, the quest for salvation has been transferred to history; the absence of the possibility for a spiritual empire makes inevitable the drive for a material empire. His genius, the wisdom of *ressentiment,* is shown by

his insight that only a state masquerading as a church can achieve secular and temporal human unity, and by his admission that the solidarity achieved will be the unity of the "ant heap."

Vasily Rozanov, a Russian philosopher and follower of Dostoevsky, argued that the Grand Inquisitor's political strategy provided a "powerful way out of the contradictions of history" by "lowering the psychical level in man":

> By extinguishing in [man] all that is vague, disquieting, and tormenting, and by simplifying his nature to the point where it will know only the serenity of short-lived desires, by making him know in moderation, feel in moderation and desire in moderation — this is the way to satisfy him finally and to set his mind at rest.[15]

Such has been the wisdom of what Pitirim Sorokin called the "decentralized totalitarianism" of the West and the "centralized capitalism" of the East. Once the system is in operation it does not need agonized Grand Inquisitors to lead it, but merely functionaries who have been effectively "socialized" or "conditioned" to a low "psychical level." The Grand Inquisitor's political secret is not his atheism or his insight into absolute freedom, but his knowledge that human beings can be made to be less than they might be or than they are.

San Manuel presides over a spiritual empire that he keeps free from modern politics. Much of Unamuno's story concerns the encounter between the parish priest and Lazaro Carbellino, who returns to the village from the New World, where he has absorbed positivistic philosophy and developed a penchant for scientific reform and modernization. For the Grand Inquisitor the "social question" is all-embracing and supreme; for San Manuel it is at best a diversion that leads one to forget momentarily the hunger for immortality, and at worst a destroyer of the traditional dream. Even after Lazaro has been converted to San Manuel's way (resurrected as a New Lazarus), he proposes to the parish priest that they organize a Catholic agricultural union. San Manuel responds:

> Social question? Pass this by; this does not concern us. So they will bring in a new society in which there are neither rich nor poor, in which riches are justly divided, in which all belongs to all — then what? You do not believe that the most intense boredom will result from general well-being?[16]

San Manuel concludes: "Let them play with their union if this makes them happy." For him there is but one principle of political action: "Resignation and charity in all and for all."[17] San Manuel's avoidance of politics goes so far that when a judge in a neighboring town asks him for an opinion about

testimony in a case, he states that "human justice does not concern me."[18]

San Manuel's refusal to participate in institutional reform and his repudiation of law and human justice stand in stark contrast to the Grand Inquisitor's program of a universal state. The Grand Inquisitor is eager to grasp Caesar's sword, whereas San Manuel's standard is to render unto Caesar the things that are Caesar's. Yet the wisdom of San Manuel's resignation is utopian; his project would be impossible were he not in a village still insulated from modernization. His type of "spiritual politics" is inconsistent with modernization and cannot be applied once secularization has proceeded to the point at which the mass is characterized by the simultaneous desire for bread and meaning. Were he in the situation of the Grand Inquisitor or of Lenin, Mao, or even Roosevelt, he would have to choose between being an inquisitor and loving his neighbor while fleeing his neighbor.

II. Modern Wisdom

The legends of the Grand Inquisitor and San Manuel find their most immediate political application in the task of understanding leadership within regimes that are marginal to the Western democracies. Western democratic ideas have been supported by a civilization based on Greco-Roman conceptions of universal reason capable of determining at least the temporal ends of human life. Where such conceptions have not taken root, leaders must rule in the name of wisdom, which is inaccessible to the mass, or in the name of some special revelation or dogma, the details of which the mass does not understand. Universal reason allows for public judgment of leaders according to such standards as natural law, natural rights, historical finality, or rational will. Lacking such standards, human beings are thrown back upon either authority or their own intuitions of value. When traditional authority collapses and the idea of a rational good does not take its place, new authority will be instituted based on personal wisdom. Hence, the appearance of charismatic figures ruling in terms of political religions throughout the non-Western world is probably not a transitional phenomenon, but rather a paradigm for the future. The new leaders, such as Mao and Castro, do not follow the way of San Manuel but at best that of the Grand Inquisitor. The "cult of personality" is built into political leadership that must act in cultures to which the idea of rational good is alien. Even when the rhetoric of non-Western regimes is phrased in terms of historical reason (Marxism, for example), there is no guarantee that this rhetoric is understood in the same way that it is in the West. The word "reason" can be understood mystically, particularly when it is the property of an elite or vanguard. The idea of a rational good supports a

community of debate and discussion in which claims are judged by criteria of factual accuracy, logical consistency, and coherence with substantive values and norms. There are no such public checks upon wisdom, which is a function of privileged insight achieved through personal suffering.

It would be a mistake to believe, however, that the stories of San Manuel and the Grand Inquisitor are useful only for understanding politics in the non-Western world. Beginning with Kierkegaard's irrationalist critique of Hegel's absolute idealism, there has been a persistent revolt against speculative reason in the West. With regard to political theory, this revolt was perhaps best expressed in Max Weber's idea that modernization has meant the triumph of instrumental rationality that is divorced from ends. Along with the perfection of rational means has gone the appearance of "charismatic" societies. It is worth considering the hypothesis that fascism, which combines advanced technology with political myth and the cult of personality, was not a deviation from progress, but a precursor of things to come. It is possible that the future of the world lies in alternations between fascist eruptions and bureaucratically-imposed stability. Such prophecy, which is out of fashion in contemporary political philosophy (perhaps because it is too unsettling), is not the result of random intuition, but of reflection upon the cultural consequences of the erosion of the idea of a rational good.

The underlying political assumption of the Grand Inquisitor and San Manuel is that the bulk of humanity seeks neither the rational good nor wisdom. They both believe that the mass most desires a meaning and a justification for life and death, whether it be in the form of an enforced dogma (the Grand Inquisitor) or a dream (San Manuel). Most contemporary political philosophy still challenges this assumption, holding to the possibility of some type of moral education, even in the attenuated form of conditioning people to act reasonably by methods of behavior modification. Whether political philosophy as an endeavor of moral education is any longer rational depends upon one's view of whether or not reason is capable of determining ends. The question of the limits of practical reason has preoccupied several generations of twentieth-century political philosophers, and no conclusion commanding a consensus has been reached. Rather, a multitude of doctrines has appeared, each one of which has been subject to appropriation as ideology by some group seeking power over others.

Few contemporary political philosophers have dared to raise the question of whether they should any longer continue the project of moral education. Yet this is the great question implied in the tales of the Grand Inquisitor and San Manuel. If knowledge is not virtue, or even if virtue cannot be taught by rational argument and definition of a rational good,

then who does the political philosopher address except those whom already seek wisdom? Lev Shestov grasped the implications of the legend of the Grand Inquisitor and concluded that political philosophers will eventually be forced to give up moral education:

> And if it is no longer possible to remain silent, if the time has finally come to tell the world the secret of the Grand Inquisitor, then people must seek their priests not from among teachers as in the olden days, but from among disciples, who always perform all sorts of solemn duties willingly and in good faith. The teachers have been deprived of their last consolation: they are no longer acknowledged as the people's benefactors and healers. They have been told and they will be told: physician, heal thyself.[19]

Shestov's major point, that philosophy cannot exist as philosophy in bad faith, implies that there is but one rational alternative to instrumental reason left: critical reason that begins with self-criticism and then overflows into social criticism. Perhaps in an era of emerging totalitarianism the choice that political philosophers will face will be between being spiritual politicians and being critics who show that politics and the public situation do not, and should not, exhaust the possibilities and actualities of human existence. Or perhaps the choice is not so romantic and is really between intransigent criticism and becoming a "policy scientist" *cum* ideologist: the paid lackey of a would-be Grand Inquisitor.

The either/or choice between apology and criticism has been grasped most fully by those philosophers who are usually called existentialists. The "precursors" of existentialism such as Kierkegaard, Nietzsche, Dostoevsky, and Unamuno were primarily involved with the encounter between Christian consciousness and secularizing society, whether or not they affirmed absurd (Kierkegaard) or mystical (Dostoevsky) faith. However, it would be a mistake to believe that existentialism is merely a transitional ideology, defining the agony of modernization as culture changes from sacred paradigms to a new secular humanism (roughly Jean-Paul Sartre's position). As Karl Jaspers notes, although Kierkegaard and Nietzsche are unthinkable outside of Christian civilization, their resistance to bureaucratic life and the "herd morality" that defines its social relations opens up dimensions of experience that overflow the Christian problematic. According to Jaspers, Kierkegaard discovered *"Existenz,"* or "a sense through which we look into infinite depths at what defies all determinate knowledge."[20] In other words, insight into the disproportion between rational knowledge and virtue does not eliminate virtue, as positivists seem to claim, but removes virtue to the arena of wisdom based upon reflection on the totality of experience. The interpretation of the "depths" of experience need not be Christian or even religious in any traditional sense,

although it may treat of contents with which religions have been traditionally concerned. The difference between the many varieties of existentialism and competing twentieth-century philosophies such as logical positivism, logical realism, and transcendental phenomenology is that the former are critical of any attempts to reduce contrarational or irrational experiences to the measure of reason and the latter either ignore or despise such experiences and thereby give implicit support to the Grand Inquisitor's conglomerate empire.

Examples of *"Existenz"* are apparent in the reflections of Dostoevsky and Unamuno. The notions of the burden of absolute freedom in the Grand Inquisitor's indictment and of the hunger for immortality in San Manuel's confession are "existentials," to use Heidegger's term, that have no rational resolution but that may form the center of a human life. No secular and rational good can relieve a person from the responsibility of determining how to act; no social arrangement can satisfy the hunger for individual immortality. The only responses that secular ideologies have to the "existentials" are to deprecate them as emotive "ejaculations," to deny them by reducing them either to "false consciousness" based on group interest or to neurosis, or to ignore them altogether by removing them from the realm of public concern to the sphere of private problems. From the existential viewpoint, secular rationalism is a massive denial of and sometimes even a conspiracy against the very deepest experiences.

The existentialist rejoinder to secular rationalism has not been to proclaim a new doctrine of moral education, but to institute the healing process of which Shestov spoke. Neither Kierkegaard, Nietzsche, Dostoevsky, nor Unamuno founded a school. In fact, they specifically warned against schools of thought and presented their work as personal encounters with their existence, urging others to do their own reflecting. That it is possible today to speak of "existentialism" and to moralize the existentials by proclaiming attention to them as "authentic existence" merely shows how firmly the project of moral education is embedded in Western philosophy. There is no doubt that the very act of criticizing rationalism presupposes accepting the rationalist's ground rules. Hence, any attempts to vindicate the existentials by showing that they are complex attitudes combining cognition, will, and emotion, that they are partially independent of any reductionist ground because they can be interpreted according to multiple and contradictory reductive schemes, or that they have public consequences (i.e., the "spiritual politics" of the Grand Inquisitor and San Manuel) presuppose an irrationalist philosophy that can itself be criticized on rationalist grounds. Rationalists, then, cannot be engaged in dialogue on the terms of wisdom, but only on the terms of rational argument. The existentialist's temptation is to attempt to construct a *counterphilosophy*

of *"Existenz"* and then to defend it on rationalist grounds, rather than to describe *"Existenz"* while only alluding to the presuppositions that make that description possible. Literature is a fruitful field for describing *"Existenz,"* as are literary criticism, the imaginative essay, and aphoristic writing. Many existentialists, and most notably the precursors of existentialism, have found the systematic treatise and even the thematic essay inappropriate vehicles for the exposition of the "existentials" and have turned to more fluid and imaginative forms to express their thought.

Efforts to carry the existential approach from a descriptive project that may issue in wisdom to a fundamental ontology or critique of "pure experience" that uncovers the principles that make description possible are not only an attempt at once again linking knowledge to virtue, but a self-contradictory failure. If the existentials are indeed nonrationalizable, and the process of self-reflection is itself an existential, any attempt to ground them will invariably result in a statement in the form of a negation. Radical skepticism is the epistemology implied by the description of *"Existenz,"* but paradoxically the wisdom of description is not nihilistic, but affirmative, because it rehabilitates all of the experiences that constitute the bulk of conscious life (guilt, anxiety, regret, *ressentiment,* myth, among others). There is no ground, however, for this rehabilitation. There is only a commitment to the process of self-reflection, which has no "rational" rules and can only be characterized by such oxymorons as "active receptivity." To call self-reflection "authentic" and the failure to reflect "inauthentic" only adds a gratuitous moral distinction to the activity.

Ironically, the Grand Inquisitor and San Manuel are more honest than the partisans of existential heroism. Both of them are preoccupied primarily with their own salvation, although they attempt to heal themselves by making others comfortable. Those who claim that agonized self-reflection is "authentic" and, therefore, more worthy than a peaceful and equilibrated (Socrates' unreflective) life are still making the demand that everyone live according to their truth. This demand need not be in any sense chauvinistic but may proceed instead from the most intimate agonies, some of which may not even have been disclosed consciously. Most significantly, the demand for universality may be rooted in the desperate attempt to relate oneself to others, to escape from the loneliness of an exceptional life. San Manuel and the Grand Inquisitor are exceptional beings. However, they live in a civilization that does not honor exceptions, only "everydayness" — and sometimes rationality, particularly in the service of material functions. Hence, they must disguise their alien and exceptional insights; they know that if these insights were made public they would be misinterpreted as permission to hedonistic gratification, the exercise of domination, and sadism — all of which have penetrated

contemporary "everyday" life. Yet even the Grand Inquisitor and San Manuel find that they have to confess to someone. How much more this impulse to confession must work in those who have less strength than the two great spiritual politicians! And how much less this confession is apt to be honest, masking itself instead in the wrappings of a gift. And, finally, how much more it is likely to be an expression of *ressentiment,* in which the philosophers get back at the mass by proclaiming their superiority and their "authentic" existence. The dialectics of *ressentiment* reach, perhaps, their fever pitch when philosophy becomes an appendage of university life, a "department" of knowledge. Then philosophers must decide what it is that they have to "offer" to students, very few of whom wish to make the sacrifices necessary for an exceptional life of self-reflection.

The basic question of both ruling and teaching in the contemporary world is the same one that the Grand Inquisitor and San Manuel confronted: How is one to relate to people who either will not or cannot undertake a self-critical existence? Dostoevsky and Unamuno concluded that it is problematic to tell them the truth. If for some reason they do not seem to want the truth, and if, more importantly, one is doubtful that truth is consistent with the requirements of social life, philosophy becomes a tragic rather than a progressive enterprise. Of course, it is not possible to claim that truth and society will always be contradictory. How much particular historical institutions are responsible for the tragedy of philosophy is an open question that cannot be resolved philosophically. Yet because the gap between knowledge and virtue, in this case the elitism of wisdom, cannot be grounded in a theory of being, one cannot conclude that an effort should be made to encourage self-criticism. The rebuttal to those who, like the Grand Inquisitor and San Manuel, preach "vital lies" (Ibsen's term for beliefs that sustain everyday life) is the accusation that the philosopher is filled with pride: "You prefer to live in truth. Why do you keep others from it?!" This accusation misses the point that the philosophers may not have chosen to live in truth, may be caught up in agony, and may even seek (as San Manuel did) to be saved by others who have no care for the truth at all. Even if one is dedicated to affirming the truth, as Nietzsche seemed to be, no guarantee of universality and goodness accompanies the affirmation.

Although spiritual politics based on "vital lies" remains a "live option" for both leaders and political philosophers, Dostoevsky's Grand Inquisitor and Unamuno's San Manuel demonstrate the limits of this project and ultimately, as Shestov and Rozanov argued, its end, because the "secret" has been made public for those who are prepared to receive it. Without the fig leaf of a rational good, political philosophers either become technicians, or they speak from their own reflected experience and to those who can and

who are willing to listen. In speaking from their own reflected experience, political philosophers disclose the "existentials" — those dimensions of experience that cannot be rationalized and, therefore, have no immediate relation except opposition to an increasingly rationalized political order. It is fitting for them to express themselves in literary rather than scientific forms, because imaginative literature is not only permissive enough to support the description of life's complexities, tensions, contradictions, and agonies, but is also the last refuge of the nonrational experiences in contemporary intellectual life. The quest for the philosopher's stone in the twentieth century has been the search for a way to make sure that everyone will listen to the philosopher, or for a proof that they will inevitably listen. Realizing that the only method is rigorous self-criticism, Dostoevsky and Unamuno gave up the "search for a method," but they were tempted to make one last venture into spiritual politics. Their ventures, however, are failures and result in one last prescription: Leave moral education to the disciples who can be trusted to transmute the base metal of any criticism into the gold of ideology.

Notes

1. See particularly Franz Kafka, *The Trial,* Willa and Edwin Muir, tr. (New York: Knopf, 1956).
2. Imaginative literature has often been interpreted as deriving from previous philosophical works. For example, H. Stuart Hughes, in *Consciousness and Society* (New York: Vintage Books, 1958), argues that twentieth-century novelists and dramatists "completed what the social theorists had either combated or left unsaid." (p. 365) The present essay is an attempt to show that not only did some literary figures anticipate philosophical tendencies, but that they expressed what philosophers *could not* say.
3. See Dmitri Merejkowski, *Peter and Alexis,* Bernard Guerney, tr. (New York: Modern Library, 1931). Merejkowski was born in 1865 and became an adherent of positivism in his youth. He later turned against rationalistic philosophies and became a novelist whose works are united by the quest for archetypal symbols transcending particular historical periods. *Peter and Alexis,* the third volume of his trilogy *Christ and Anti-Christ,* is a study of Russia under Peter the Great. The two earlier volumes treat Julian the Apostate and Leonardo da Vinci respectively. Each volume of the trilogy investigates a period of cultural change in which the old gods are dying and new ones rising to take their place.
4. Lev Shestov, *Dostoevsky, Tolstoy, and Nietzsche,* Bernard Martin, tr. (Athens, Ohio: Ohio University Press, 1969), p. 174.
5. Fyodor Dostoevsky, *The Brothers Karamazov,* Constance Garnett, tr. (New York: New American Library, 1957), p. 235.
6. Miguel de Unamuno, *San Manuel Bueno, Martir y Tres Historias Más* (Madrid: Espasa-Calpe, 1963), p. 49. All quotations from Unamuno in this article have been translated from the original Spanish by the author.

7. *Ressentiment* refers to repressed resentment, stemming from inferiority feelings, that is projected consciously as the disposition to detract from others and to depreciate their accomplishments. The fullest discussion of *ressentiment* and its application to modern mass movements and mass politics is found in Max Scheler's *Ressentiment,* William W. Holdheim, tr. (New York: Free Press of Glencoe, 1961).
8. Dostoevsky, *The Brothers Karamozov,* p. 241.
9. Ibid., p. 239.
10. One might claim that, far from being afflicted with *ressentiment,* the Grand Inquisitor is a partisan of human conceptions of justice and reason against an unjust God who has made unreasonable demands upon human beings. Under this interpretation, the Grand Inquisitor would not have inverted his hierarchy of values, but would have self-consciously affirmed a new hierarchy in which rebellion against the absurdity of the world is the highest value. This interpretation seems to be the one favored by Ivan Karamazov, who tells the Grand Inquisitor's story. Support for the *ressentiment* interpretation is found mainly in the continued acknowledgement of freedom as the supreme value by the Grand Inquisitor and also by the ruin of Ivan Karamazov at the end of the novel.
11. Unamuno, *San Manuel,* p. 29.
12. Ibid., p. 42.
13. Ibid., p. 57.
14. Dostoevsky, *The Brothers Karamozov,* p. 238.
15. Vasily Rozanov, *Dostoevsky and the Legend of the Grand Inquisitor,* Spencer E. Roberts, tr. (Ithaca: Cornell University Press, 1972), pp. 146–47.
16. Unamuno, *San Manuel,* p. 49.
17. Ibid.
18. Ibid., p. 30.
19. Shestov, *Dostoevsky,* p. 233.
20. Karl Jaspers, *Reason and Existenz,* William Earle, tr. (New York: The Noonday Press, 1955), p. 49.

Chapter Four
Camus: The Absurdity of Politics*

Lyman Tower Sargent

Albert Camus, though recognized as one of the most important novelists of the twentieth century, has not received the recognition he deserves as a political thinker. There have, of course, been studies of his social and political thought,[1] but none have come to grips with his significance in the history of modern political thought. In this essay I will analyze Camus's works from the perspective of political thought, note the development of his political thought, and suggest his significance in the history of modern political thought. Obviously in an essay of this length much of the analysis must be suggestive rather than definitive, and few of the subtleties can be discussed, but it is still possible to do more with Camus as a political thinker than has generally been done.

Any such analysis of a literary figure faces one central problem. Camus was primarily an artist;[2] he was only secondarily a social theorist; he never developed a systematic political theory. Therefore, it is necessary to search out his political thought in his fiction as well as in his essays. Students of political thought often make grievous errors in analyzing fiction; the most common temptation is to assume that a particular character speaks for the author. I have tried to avoid this common error, and fortunately Camus gives us many clues to interpreting his fiction in his essays.

Camus's social thought centers around a set of closely interrelated concepts, of which the absurd, rebellion, and exile are the most important. These concepts and their interrelationships are developed by Camus in a variety of ways, and they are often most clearly expressed in his less known works. In order to see how these ideas developed, I shall trace Camus's thought chronologically, and although it will not be possible to discuss all his works to the extent they deserve, almost all will be touched upon. This approach allows us to come to grips with Camus the thinker much more clearly and comprehensively than the usual approach that refers only to

L'Étranger (1942), *Le Mythe de Sisyphe* (1942), *La Peste* (1947), and *L'Homme révolté* (1951).

I. The Absurd

The first and most important concept in Camus's thought is the absurd, which represents the basic epistemological and metaphysical assumptions that undergird all this thought. Best characterized as "the confrontation between man's questing mind and the silent universe," the concept of the absurd posits that man can know virtually nothing with any certainty. Camus specifically questions the existence of God and notes that life has no built-in meaning. The lonely, purposeless man described by the absurd is often overcome, at least temporarily, by fear or despair. Deserted by God and overwhelmed by his own limitations, he despairs. This despair can lead to an exile of man from other men which only serves to deepen the original fear. This exile, often symbolized by silence, can only be broken by revolt. In his early writings, through *Le Mythe de Sisyphe,* this is as far as Camus gets. He leads us through a pattern of the absurd and its recognition, despair, exile, and revolt. The latter two points are only suggested, not developed.

But the absurd has more of a social and political content than it is usually given. The absurd appeared as early as January, 1936,[3] and plays a role in all Camus's early works, including *La Mort Heureuse* (first published in 1971), *L'Envers et l'endroit* (1937), *Noces* (1939), *Révolte dans les Asturies,* (1936), and, most centrally, in *Caligula* (published in 1944 but first written in 1937–38).[4]

Camus's first published work, *Révolte dans les Asturies,* does not fit any pattern very well; it does have some minor antireligious sentiment, and it does mention the absurd, but it does not illuminate Camus very much, particularly since it was written in collaboration with others. In general this play must be classified as a part of proletarian literature: it shows the forces of good (the miners) pitted against the forces of evil (the bourgeoisie and their supporters, the soldiers). Only the staging of the play, the absurd, and one character show the hand of Camus. The absurd is mentioned once, in the introduction written by Camus. Here he speaks of the play's theme as death, which he connects to a "form of grandeur peculiar to man: absurdity."[5] This statement shows some of the content that the absurd takes on in the later works. If the connection of death and the absurd is the theme of the play for Camus, it is necessary to discard the simple proletarian trappings and look at the characters in the play more carefully.

Most of the characters are stereotyped representatives of social classes, but there is one man, Pepe, who is more. After the miners' revolt against the

rightist government, he joins the cause and fights fiercely with the miners. Just as all is lost, he charges the barricades and is killed. As a result of this act Pepe can be seen as an exemplary suicide or as symbolizing that "form of grandeur peculiar to man." Because each answer is discussed by Camus in his later writings, it will be best to leave them as possible interpretations, for there is not sufficient evidence within the play on which to base a sound conclusion.

Finally, there is one other important characteristic of the play, the staging. In this respect *Révolte dans les Asturies* is extremely experimental and much ahead of its time. The set is constructed in such a way that the spectator is in the town. Each individual in the audience is at the center of the tragedy. On the stage itself is the town square and a cafe while two city streets run the length of the theater. In the center of the theater, with the audience surrounding it on all sides, is a platform where the governmental officials are located, and during the fighting the troops run throughout the theater. With all these devices Camus is attempting to involve the audience in the play. They become part of the set and must participate in the action. The point of all this is fairly simple and obvious: Camus is trying to force the audience to be more than passive spectators. He is making them part of the drama that is taking place all around them, and he is producing an individual drama for each member of the audience because the action will appear differently from different parts of the theater; ideally it will be different from each seat.

The first work of real significance was a collection of essays entitled *L'Envers et l'endroit* in which he developed the theme of the contrast between the world of poverty and the world of beauty. In a preface to the 1958 edition Camus comments that he rejects none of what he said in these essays and that "there is more genuine love in these clumsy pages than in all the others that have followed them."[6] Although he viewed *L'Envers et l'endroit* as flawed with poor writing, he also saw it as expressive of the source of all his art. As he put it, "each artist thus keeps in his heart a single source which, as long as he lives, feeds what he is and what he says. For me, I know that my source is in *L'Envers et l'endroit*, in this world of poverty and sunlight where I have lived so long."[7] And elsewhere he says, "It is in the life of poverty, among these humble or vain people, where I have most surely touched what appears to me the true meaning of life."[8]

This world of poverty and sunlight represents two countervailing forces in Camus' thought which remain throughout most of his writings. *L'Envers et l'endroit* stresses the world of poverty. Most of the stories portray life and death in poverty with an emphasis on the problem of indifference. Poverty breeds an indifference to life and an indifference to death, and this problem, this tendency to give up is one that Camus fought against all his

life. Camus always stressed honesty and facing life squarely. As he put it, "Don't let them tell us stories. Don't let them say of the man sentenced to death: 'He is going to pay his debt to society,' but: 'They are going to cut off his head.' It looks like nothing. But it does make a little difference. And then, there are people who prefer to look their fate in the eye."9

One story, "Entre oui et non," portrays the death of an old and poor woman. She is cut off from her relatives; even though her son visits her, the possibility of communication had been lost years before. She waits for death, and he struggles against a feeling of indifference. We are never told whether he succeeds, but it is obvious at the end that Camus is saying that indifference must be overcome. It is particularly important because it expresses a central motif of Camus's. In a sense it is the same as the relationship between sunlight and poverty, but even more, it is his basic approach to the absurd and most of life. He says both yes and no; we must maintain the balance between affirmation and negation; we must reject both absolutes. Camus's position between yes and no is a balancing act or a walk on a tightrope. An individual must not see the world in black and white; he must see it in the shades of grey in between, because the world is not composed of blacks and whites but of greys. This may be a reflection of the classical Greek notion of the Golden Mean, and hence helps to demonstrate the influence of classical Greek thought on Camus.

In the notion of the absurd Camus is searching for a way of avoiding absolutes. Therefore, one of the best ways of summing up his thought is with the phrase "between yes and no." If we see only the Algerian sun and miss the poverty, we have a warped view of life; if we do the reverse and see merely the poverty and not the sunlight, we also have a warped picture. Therefore, we must see both. The phrase "entre oui et non" will appear many times in the following pages, and it is essential to recognize that Camus is not merely suggesting a sterile intellectual exercise. His entire argument against suicide in *Le Mythe de Sisyphe* is based on the maintainance of the absurd "entre oui et non," as is his argument for moderation in *L'Homme révolté.*

The most important early work is *Caligula,* and it is the first extended and explicitly absurdist work. In a preface to the book written for the American edition, Camus described the play as he viewed it. On the death of Drusilla, his sister and mistress, Caligula, who had been a fairly well liked and happy prince, realized that all is not right with the world. He becomes "obsessed with the impossible" and begins a reign of terror that separates him from all his subjects. "He takes those about him at their word and forces them to be logical." He destroys everything about him.

But if his truth is to rebel against fate, his error is denying mankind. One cannot destroy everything without destroying oneself. This is why Caligula

depopulates the world around him and, faithful to his logic, does what is necessary to arm those who will eventually kill him.[10] After this statement Camus contends he finds no philosophy in the play.[11] He says that, if there is any, "it stands on the level of this assertion by the hero: 'Men die; and they are not happy.'"[12]

The "modest ideology," as Camus calls it, that is presented in the statement "men die; and they are not happy," is a reiteration of the theme found in *L'Envers et l'endroit.* Caligula discovers this truth during a period of emotional turmoil. As Caligula describes it, he "suddenly felt a need for the impossible."[13] The desire for the impossible stems most immediately from his confrontation with death. The confrontation with death, the realization of man's mortality, heightens awareness, particularly the awareness of life, of vitality, of the sun.

He decides that the means to the impossible "is to remain logical until the end."[14] Caligula, being ruler, decides that everyone should be logical; he says, "I have resolved to be logical, and since I have the power, you will see what logic is going to cost you. I shall exterminate contradictors and contradictions."[15]

Before this Caligula seemingly had been a kind and gentle ruler, insofar as Scipio, a young poet, mentions that Caligula had told him, "life wasn't easy, but it has in it religion, art, and the love one inspires in others. He often repeated that to cause suffering was the only mistake one makes."[16] The notion that one should not cause suffering to another is basic to the development of Camus' thought and is a central theme in *L'Homme révolté.* Here it is merely an expression of the degree to which Caligula changes as an individual and as a ruler. He had been a kind, thoughtful man; he became cruel and heartless; and, as ruler, he forced his people to accept his vision.

Perhaps the message of *Caligula* is summed up in a statement justifying a plot against Caligula's life. Cherea, one of the plotters, says, "But to see the sense of this life drained away, our reason for existing disappear, that is insupportable. A man cannot live without a reason."[17] By relentlessly forcing people to be logical, Caligula has drained all meaning from their lives. Caligula's life has meaning, but it is a meaning found in denying meaning to others. In act 2, Caligula exclaims that "One is always free at the expense of another. It is absurd, but it is normal."[18] A passage read from a book on execution written by Caligula confirms the proposition that complete freedom is achieved at everyone else's expense. In it he says, "Execution relieves and liberates. It is universal, tonic, and just in its applications as in its intentions. A man dies because he is guilty. A man is guilty because he is one of Caligula's subjects. But all mankind is subject to Caligula. Therefore, all mankind is guilty."[19] Caligula has completely lost

the balance between affirmation and negation that he seemed to be capable of earlier in his life. He is no longer "entre oui et non" but in flight after *non*. He is wholly negative; and his negativity leads him to lose the balance of moderation, and he uses the absolute power he has as emperor to bring about the absolute in negation, death.

The early history of the absurd is further developed in "L'Été à Alger" where Camus says, "In the summer of Algiers, I learn that only one thing is more tragic than suffering, and that is the life of a happy man."[20] For Camus, "Everything that exalts life at the same time increases its absurdity"[21] because the more fully one enjoys life, the more meaningless is its ending in death. One need only recall the idea expressed in the introduction to *Révolte dans les Asturies* to the effect that death produces "a certain form of grandeur that is peculiar to man: absurdity" to recognize that simply ignoring death or hoping for a hereafter lessens life. "If there is a sin against life, it is perhaps not so much in despairing of it than hoping for another life, and evading the implacable grandeur of this one."[22] Death is a part of life and must be recognized and accepted as such. One who denies death denies life. And here is the key to the later development of the absurd. Death cannot be denied, but neither can life — both are essential.

"Le Desert" develops this theme. In it Camus begins to speak of a revolt against death which is both a denial and an affirmation. "I realized that at the heart of my revolt slept a consent."[23] Man must maintain a balance between affirmation and negation; he cannot merely accept the absurd or merely revolt against it; he must do both.

This balance between yes and no remains an underlying motif in all Camus writes, but part of his attention is directed to the conditions of the world around him. As a journalist he witnessed the evil treatment of men by other men and sought to correct it. In a sense this was part of his revolt. As he put it in "Les Amandiers," written in 1940, "Our task as men is to find those few principles that will calm the infinite anguish of free souls. We must stitch up what has been torn apart, render justice imaginable in a world so obviously unjust, make happiness meaningful for nations poisoned by the misery of this century."[24]

The short novel *L'Étranger* was the first major piece that Camus published, and it began to make his reputation. *L'Étranger* reminds one somewhat of *Caligula* — it is even more obviously concerned with the absurd, and the major character is killed in the end. The plot of *L'Étranger* is extremely simple. The main character, Meursault, wanders through life with no definite attachment to others. His mother dies, and he shows little feeling. Through a series of accidents he shoots a man while blinded by the sun and after a short pause fires four more bullets into the body. He is arrested and tried. He refuses to defend himself. His indifference to his

mother's death is held against him. He is convicted and sentenced to be guillotined.

His life, all life, is meaningless, and death is its end. Still there is an affirmative here that is lacking in *Caligula.* Meursault hopes for a cheering, jeering crowd at his execution, and the crowd is significant. The only certainty in Meursault's life is that he is to be executed; he wants his execution to be a grand affair with an angry crowd, as executions should be. This is his life, so he wants it to be as full as possible.

Above all else *L'Étranger* is meant to evoke the feeling of the absurd. If one follows the life and thought of Meursault, one gradually becomes emotionally, not intellectually, aware of the meaning of the absurd. Although it seems plausible to view Meursault as a man who unconsciously recognizes the absurd until the very end when he becomes consciously aware of it, there is one other possible interpretation that follows similar lines. Until the end Meursault is totally indifferent to his surroundings. He seems to blend into the indifference of the world. Only when he is directly faced with the immediacy of his own death does he awake to the fact that he had been right all along. These interpretations are not in fact fundamentally different. Meursault's indifference, so like the indifference of the world, is one part of the absurd as Camus develops it in *Le Mythe de Sisyphe,* and his growing lucidity at the end is also a primary characteristic of the absurd man. The absurd is created by the confrontation of a searching mind and an indifferent universe, but the absurd can only be recognized by a lucid man, and only he can consciously assent to and revolt against the absurd.

Finally, the nature of Meursault as a condemned man is an important aspect of *L'Étranger.* In a note entitled "Sur L'Absurde?" in *Carnets,* Camus says that in the case of such a man,

> the absurd is perfectly clear. It is the opposite of irrationality. It has all the signs of truth. What is and would be irrational is the passing and dying hope that it is going to stop and that death can be avoided. But [this is] not the absurd. The truth is that they are going to chop off his head while he is lucid — even while his lucidity is concentrated on the fact that his head is going to be chopped off.[25]

In *Le Mythe de Sisyphe* Camus comes the closest he will ever come to defining the absurd. "What is absurd is the confrontation of this irrational (the world) and the wild longing for clarity whose call echoes in the heart of man."[26] In this, the most thorough definition as contrasted with a mere enumeration, the absurd is born of the confrontation, contradiction, or opposition between man's seeking mind and the silence of the universe.

Absurdity is not just of man or just of the world; it depends on both. This point is best made in "L'Exil d' Hélène" (1950) where Camus reflects on Greek thought in such a way that one is immediately struck by the comparability of the Greek notions of *hubris* and *nemesis* to the absurd. He says,

> We have exiled beauty; the Greeks took up arms for her. First difference, but one that is long-standing. Greek thought always took its stand on the idea of limit. It never carried anything to extremes, neither the sacred nor reason, because it denied nothing, neither the sacred nor reason. It gave everything its share, balancing light with shadow. Our Europe, on the other hand, eager for the conquest of totality, is the daughter of excess. She denies beauty, as she denies all she does not exalt.[27]

The necessity of maintaining the parts of the absurd can be directly compared to the Greek notion of limits. If man fails to balance the parts of the absurd, he loses both himself and the world. Again, we note the existence of the notion of the Golden Mean, the idea of maintaining the balance between yes and no that is so important for Camus. The Greek idea of limits is an important parallel here. Man in his pride would often violate the limits, and many Greek myths are based upon the problem of redressing the balance — this often resulted in the destruction of the individual who had violated the limits. The parallel to Camus' idea of the necessity of maintaining the parts of the absurd is clear. If an individual loses his balance in this sense, he loses both himself and the world.

A final play of the early period, *Le Malentendu* (1943), has often posed problems for interpreters, but it is of fairly easy access if we look at the play as a modern tragedy, as Camus suggests.[28] Through pride *(hubris)* a man established a situation in which the absurd must be faced. He demands recognition from his mother and sister after many years' absence, without identifying himself. They murder him for his money. They cannot maintain the balance required by the absurd. They upset the balance even more and kill themselves. Although not a perfect parallel to the classical form of tragedy, it is close enough to see what Camus meant and to give us another insight into the play. In destroying the parts necessary for the maintenance of the absurd by committing murder and suicide, the sister and her mother also play the traditional roles in the tragedy. Through their pride they upset the balance, and they die.

In addition, it is necessary to consider the basis for Camus' argument "that the play's morality is not altogether negative."[29] First, the nature of the tragic drama virtually dictates a positive morality. Whether or not the actions of the characters in the tragedy are determined by outside forces, the drama implies that if someone had acted differently — such as the man

by saying "I am your son" — the whole chain of events would have been different. Also, the act of murder was not inevitable, and thus a choice was made, a choice that led to suicide. Hence, looking back at the chain of choices that were made, it becomes clear that other choices were preferable.

In addition, it is necessary to turn to a second argument, which points to another aspect of the absurd man that has been neglected so far. We find this in the character of the sister and her desire for life. As she says,

> I've no more patience in reserve for this dreary Europe, where autumn has the face of spring and the spring smells of poverty. But I imagine with pleasure those other lands over which summer overwhelms everything, where the winter rains flood the cities, and where . . . things are what they are.[30]

This passage reminds one of "La Mort dans l'âme,"[31] where the protagonist feels closed in and longs for the bright sunlit seashore. Prague, where he was unknown, unrecognized, where he searched desperately for a smile that would acknowledge his existence, is like the "dreary Europe" of the sister.

Life is a fluctuation between despair and joy. Both are omnipresent, we live between yes and no. The absurd man experiences both. He recognizes the despair, the death, with which he always lives, but he can also feel the joy, the love, which is always there too. Sometimes joy is below the surface of recognition, but then it bursts forth and despair is momentarily hidden.

There is an emerging concern with a joy for life in *Le Malentendu* even though the tenor of the play is predominantly one of gloom. But the joy seems to flourish only with others. In Prague the man's lightheartedness began to return when his friends arrived. In *Le Malentendu,* the man says that "no one can be happy in exile or estrangement,"[32] and his sister feels that she desperately needs her mother. Thus, happiness is not as readily found in solitude as it is in society. Man lives in both, and both are necessary, but happiness is more readily found with others.

The suggestion that happiness can be found primarily among others is seen throughout Camus' writings, but it predominates in the works of the immediate postwar period. World War II turned Camus' attention more to social questions. Originally illustrated in some of his newspaper articles, this concern dominates *Lettres à un ami allemand* (1948), *La Peste* (1947), *L'État de Siège* (1948), "Ni victimes ni bourreaux" (1946), and *L'Homme révolté* (1951).

Lettres à un ami allemand, which was written in 1943 and 1944, shows the immediate effect of World War II. In this short work Camus addresses four letters to an "imaginary" friend with whom he had had discussions before the war. The discussions had centered on the love that each felt for his country. The German had contended that country must be put above all

else. In these letters Camus is answering that position, and in doing so he illuminates a number of important themes. As might be expected, the letters show considerable bitterness; they are written dispassionately, but they reveal deep feelings. In a preface written for the first foreign edition, an Italian one, he says, "They are topical writings and hence they may have an air of injustice,"[33] but at the same time he refuses to reject a single word because the book is "a document of the struggle against violence."[34]

The first letter[35] establishes the basis of the conflict between the two friends and suggests a few answers by Camus. The German had argued that "the Greatness of my country has no price. Anything is good that contributes to it. And in a world where nothing has meaning, those who, like us young Germans, are lucky enough to find one in the destiny of our nation must sacrifice everything else."[36] Camus is bothered by all three parts of the statement even though he does not immediately separate them. His answer and the German's retort are equally important. Camus said,

> No, I say to you, I cannot believe that everything must be subordinated to a single end. There are means that cannot be excused. And I should like to be able to love my country and still love justice. I don't want just any greatness for it, particularly one of blood and falsehood. I want to keep it alive by keeping justice alive.

The German answers, "Well, you don't love your country."[37]

In *Lettres* Camus accepts violence in a good cause, but he doesn't say until the second letter how he has been able to create a "good cause" from meaninglessness.[38] There he argues that all values are created by man and depend upon man's relations with other men for their existence. Each value is a social value. The implication is obvious: Man can overcome meaninglessness and create values only if the values depend on other men. As he noted in *Carnets,* "Posing the question of the absurd world is to demand: 'Are we going to accept despair, without doing anything.' I suppose no honest person can answer yes."[39] Here the contrast between Camus and his German friend is quite pointed. The German is allowing the absurd to drive him to despair. This is precisely the point that Camus had argued against in *Le Mythe* — despair must be overcome; it must not be allowed to overwhelm one. Thus, in a different context, the German represents the suicide that Camus had rejected. But this particular suicide, this acceptance of despair, led to the death of millions.

The war forced Camus into a position where he had to deal with broader issues of social and political thought. He had to come to grips with the problem of killing on a social as well as an individual level. He had already noted an opposition to capital punishment,[40] an opposition that was to grow stronger and culminate in "Réflexions sur la guillotine" (1957).

Between 1944 and 1946 Camus wrote many articles, most of which were

published in *Combat,* and they reflect the gradual change in emphasis in this thought. At the end of the war, a few articles reflected the optimism implied in *Lettres à un ami allemand.* For example, in "Le Sang de la liberté" he says, "The Paris that is fighting tonight intends to command tomorrow. Not for power, but for justice, not for politics, but for ethics, not for the domination of France, but for her grandeur."[41] Less than a month later he argues that it is difficult yet possible to reconcile justice and liberty in a "superior balance."[42]

In a series of articles collectively entitled "Morale et Politique" and written between 1944 and 1945, Camus makes a number of points that are worth noting. He says that what is necessary as a first step is "to introduce the language of ethics into the exercise of politics."[43] He argues for a return to the ability to say yes and no that he had posited in his earlier essays and says that it must be said "with the same seriousness and the same objectivity."[44]

Camus' first major piece in this new period was "Ni victimes ni bourreaux" (originally published in *Combat* in 1946). It begins in much the same way as *Lettres à un ami allemand,* but these essays are much more pessimistic than the *Lettres.* He characterizes the twentieth century as the century of fear and says that "We have seen men lie, degrade, kill, deport, torture, and each time it was not possible to persuade them not to do these things because they were sure of themselves and because one cannot appeal to an abstraction, i.e., the representative of an ideology."[45]

Finally, he suggests, as he did in *Lettres à un ami allemand* and in some of his prewar essays, that man must find some sort of solidarity with others in order to live a full life. But this is impossible at present; real communication is impossible. Fear rules men, and its rule keeps men from changing the world. But the world must be changed. Thus, fear must be faced.

"To come to terms, one must understand what fear means: what it implies and what it rejects. It implies and rejects the same fact: a world where murder is legitimate, and where human life is trifling."[46] Camus says, "I will never again be one of those, whoever they be, who compromise with murder."[47] This may seem utopian; Camus accepts the label, and it is here that he changes from his position in *Lettres à un ami allemand:*

> People like myself want not a world in which murder no longer exists (we are not so crazy as that!) but rather one in which murder is no longer legitimate. Here indeed we are utopian and contradictory. For we do live, it is true, in a world where murder is legitimate, and we ought to change it if we do not like it. But it appears that we cannot change it without risking murder.[48]

Camus has modified his position on murder. He has moved from his earlier position, which accepted murder, at least during war, in a good cause. But

he has not solved his fundamental problem. He still is looking for a way of changing the world, of bringing about a revolution, preferably a nonviolent revolution. War failed, and another way must be found. He is not sure that justice can be established, but he hopes that "a future remains possible."[49]

Further, he also rejects national considerations as irrelevant, saying, "There no longer exists any policy . . . which can operate exclusively within a national framework,"[50] and "within any given nation there exist now only administrative problems, to be solved provisionally after a fashion, until a solution is worked out which will be more effective because more general."[51]

We still live in a world where murder is legitimate. This must be changed. "An order for everybody which will somewhat allay each one's misery and fear is today our logical objective."[52] Camus says that to reject murder forces a man to reconsider his actions; he must act, but first he must "reconsider everything from the beginning so as to shape a living society inside a dying society."[53] As individuals, men must destroy the frontiers that separate them and draw up "a new social contract which will unite them according to more reasonable principles."[54] And to achieve all this he suggests a peace movement that would be based on work communities inside nations and intellectual communities internationally. "The former, organized cooperatively, would help as many individuals as possible to solve their material problems, while the latter would try to define the values by which this international community would live, and would also plead its cause on every occasion."[55]

One goal of this movement would be the establishment of international democracy. Camus does not expect this goal to be reached easily or soon, but he does hope for the establishment of the rule of law. According to Camus, international democracy would require the formation of a world parliament, elected by all peoples, which could pass legislation that would be binding on all national governments. Until this is achieved, the peace movement outlined above is the only hope.[56]

This series of articles concludes by returning to the problem of sociability or solidarity. Again Camus notes that fear causes silence and isolation, that men must communicate, that all must be staked on "a formidable gamble: that words are more powerful than munitions."[57] Camus's words are designed to take the bet, as they always have been. He has constantly bet that a balance can be maintained between affirmation and negation, and he is still grappling with the problem of the absurd, still trying to clarify his views on murder and on man. Yet he does begin to introduce a topic that will become more and more important in the years to come. The question of rebellion as a response to the absurd is certainly not a new topic per se, but it begins to assume a central role in Camus' thought.[58]

II. Rebellion

La Peste and *L'État de Siège,* a novel and a play, have much in common. Both show the effects of a plague on man. Both show the struggle of man with the plague. Both have major characters who conquer the plague but die of it. Undoubtedly, the plague represents the absurd. Camus says as much in *L'Homme révolté* when he calls the absurd a mass plague.[59] But such an interpretation is too simple. The absurd is only a starting point; it is unimportant by itself, man's reaction to it is important.[60]

In *La Peste* Camus deals with the problem of an entire society's reaction to the absurd, rather than the individual's reaction as he did in *Caligula* and *L'Étranger.* He presents his analysis through the characters of seven men and a town, all of whom must meet a visitation of plague. The town is Oran[61] in Algeria. The men are Rieux, a doctor; Tarrou, a rebel; Rambert, a journalist; Grand, a municipal clerk; Cottard, a criminal; Paneloux, a Jesuit; and Othon, a magistrate. The town and each of these men come to grips with the plague in different ways.

La Peste is presented in much the same manner as Defoe's *A Journal of the Plague Year.* It is a straightforward narration of events and of reactions to the events by an observer. The narrator removes himself from the chronicle; it is only at the end that we discover Rieux's identity. There is little that could be called a plot. The chronicle simply follows the progression of the plague from the first appearance of rats dying in the streets, through the first cases of plague among men, through the rapid increase of deaths, the shift from bubonic to pneumonic plague, to the disappearance of the plague. The plague came from nowhere for no known cause. It was never defeated, but merely went away for no known reason.

If there is a major character in *La Peste,* next to the plague itself, it must be the townspeople of Oran. The first sign of the plague was the thousands of dead rats in the streets. No one knew the meaning of these deaths, but they bothered people. "It was as if the earth on which our houses stood was being purged of its burden of humors, thrusting up to the surface the boils and pus that, until now, had been working inside it."[62] The people were shocked, confused, frightened. Then the people began to die; fear grew; the town was closed and all contact with the outside world, with the single exception of the radio, was denied. The closing of the town introduces one of the dominant themes of the book, exile — "that sensation of a void which never left us, that precise emotion, the irrational longing to hark back to the past or else to speed up the march of time, and those burning shafts of memory."[63] This exile was more than the separation of the town from the world around it. It was the imprisonment of each man in his individual cell. Exile produced silence and solitude.

The theme of exile is extremely important for understanding both Camus and *La Peste* because Camus once noted that the philosophy that he was trying to develop, "inexistential philosophy" as he called it, was to be a "philosophy of exile,"[64] and because he often said that exile was the major theme of *La Peste*.[65] One of the effects of the absurd is solitude, each man cut off from every other man, and as he said of *La Peste,* "there are only solitary men in the novel."[66] Exile, silence, solitude are among the major effects of the absurd and human solidarity is the only way to combat them.

Gradually the plague destroyed all individuality and reduced the people to a single mass; it did not create solidarity among most of the population, but it showed that everyone was equal before the plague:

> Now, at least, the position was clear; this calamity concerned everybody. What with the gunshots echoing at the gates, the punctual thuds of rubber stamps marking our lives or our deaths, the files and fires, the panics and formalities, all alike were pledged to an ugly but recorded death; and, amidst noxious fumes, and the muted clang of ambulances, all of us ate the same sour bread of exile, unconsciously waiting for the same reunion, the same miracle of peace regained.[67]

A climax of sorts is reached for Rieux and the others with the death of a small boy, the son of the magistrate Othon. Othon is a cold, impersonal man whom Tarrou characterized as "enemy number one" after Othon had said, "It's not the law that counts, it's the sentence."[68] The plague tortures and kills the small boy, and Rieux exclaims to Paneloux, "Until my dying day I shall refuse to love a scheme of things in which children are put to torture."[69] This death illustrates all the horrors of the world. That a small boy shall be racked with pain and slowly, inch by inch, lose in the fight for life rocks Paneloux's faith and seems to prove that Tarrou and Rieux are right. Othon is shattered by the death of his son, whom he had never treated very well in life. The death changes him. He becomes gentle and compassionate and dies helping to fight the plague.

Rieux lived to see the plague disappear as mysteriously as it appeared and to see everything and everyone return to normal. He saw the return of love, of communication, and the defeat of silence, of solitude. But he knew that the plague was not defeated, that it would return again, and that his narrative "could only be the record of what had had to be done, and what assuredly would have to be done again in the never-ending fight against terror and its relentless onslaughts, despite their personal afflictions, by all who, unable to be saints but refusing to bow down to pestilences, strive their utmost to be healers."[70] Again, Camus gives the call of "Ni victimes ni bourreaux." Man must undertake the absurd quest for relative utopia, for sainthood, and the perfect phrase. He will undoubtedly fail, but without this revolt he has more truly failed.

On one level, *La Peste* is concerned with the absurd; on a slightly different level it is a social commentary, but, as Camus says, each level means the same thing.[71] Camus is arguing that the reaction to the absurd that was developed on an individual level in *Caligula, L'Étranger,* and *Le Mythe de Sisyphe* must now be seen in a social context. Man should revolt against the plague since his only hope, albeit an absurd one, is found in revolt, and this revolt is always among men; it must also be for men because the key to happiness, the key to liberty and justice, can only be found in human solidarity.

Perhaps the clearest illustration of this point is found in the play *L'État de Siège* in which the plague returns and the same problem is presented much more blatantly. *L'État de Siège* reads like *Nineteen Eighty-Four* and belongs to the genre of the dystopia. The play opens in Cadiz, Spain, a rather poorly ruled city intended to typify all modern governments, but totalitarian governments in particular. Into this city comes The Plague and his secretary, Death. They are in love with order, statistics, and forms, and they set about to establish a completely logical, ordered, and consistent government, one in which death is planned. The major rules of the government are announced by five town criers as follows:

1. All infected houses are to marked on their front doors with a black star with rays a foot long, and headed by this inscription: "We are all brothers." The star is to remain in place until the house is reopened, under the pain of law.
2. All essential foodstuffs must be placed at the disposal of the community, that is to say, they will be doled out in equal and exiguous shares to all who can prove their adhesion to the new social order.
3. All lights must be extinguished at nine P.M. and no one is permitted to remain in any public place after that hour, or to leave his home without an official permit in due form, which will be accorded only in very special cases and at our pleasure.
4. It is strictly forbidden to give help to any person stricken with the disease, except by reporting the case to the authorities, who then will take the necessary steps. A favorable view is taken of reports made between members of the same family, and such reports will entitle their makers to the double food ration, known as the Good Citizen Ration.
5. So as to avoid contagion through the air you breathe and since words are carriers of infection, each of you is ordered to keep permanently in his mouth a pad soaked with vinegar. This will not only protect you from the disease but teach you discretion and silence.[72]

In addition, the men and women are separated. The purpose behind all these regulations is to break down sociability by destroying love and human contact, and by encouraging silence and human conflict. All of which instills fear in men.

Fear is the great ally of the plague because when men conquer their fear the plague is defeated. This occurs in the third act when one of the main

characters, Diego, overcomes his fear and is cured. He finally dies by trading his life for the life of Victoria, his fiancée. The plague leaves, the old government returns congratulating themselves on escaping the plague. The Plague had said that it was customary for the rulers to be allowed to escape. The city returns to normal, but it is not quite the same; there is some thought of limits and rebellion.

In *L'État de Siège* Camus includes all the themes that we have previously discussed and hints at some new ones; a pattern emerges:

1. The Absurd
2. Despair — Fear
3. Silence Created by Fear
4. Overcoming of Fear — Recognition of Limits — Rebellion — Creation of Meaning
5. Sociability — Solidarity — Happiness

Putting these themes in order obviously suggests a pattern, and such a pattern, or part of it, definitely does exist in *L'État de Siège.* If, as seems quite clear, the plague and the absurd can be identified, the first effect is fear or despair. Giving in to this fear or despair produces silence, the world of the Nazis or of The Plague in *L'État de Siège.* Man can no longer communicate; love withers and dies or is forcibly suppressed; logic and efficiency rule. But it is possible to overcome this fear. This is done by recognizing that there are limits and rebelling against the absurd in yourself and the world around you. As the Chorus says at the end of the play, "No, there is no justice — but there are limits. And those who stand for no rules at all, no less than those who want to impose a rule for everything, overstep the limit."[73] Here it is important to note that Camus has rejected both extremes on the political spectrum — both totalitarianism and anarchism. Although Camus does at times seem to come very close to holding an anarchist position, here he clearly repudiates it. When he says that "And those who stand for no rules at all . . . overstep the limit," he is clearly rejecting the notion of complete anarchism. Then rebellion is necessary. Here *L'État de Siège* ends. Sociability, solidarity, and happiness do not result in the play, but they remain a possibility if the rebellion continues.

In addition to helping to clarify the pattern, the play illustrates some of the content of the various themes. The result of the absurd is the same as it was in *Lettres à un ami allemand*; despair, and the government of The Plague, and typical of any totalitarian government such as that attacked in *Lettres.* The Plague abolished sentiment, happiness, love, beauty, and irony.[74] He kills for "the delight of being logical,"[75] and death is administered through the maintenance of lists. The Plague concludes that he brings "order, silence, absolute Justice."[76] But the previous government was not that different. The Governor had ordered that "Good governments

are governments under which nothing happens. Thus it is the Governor's will that nothing shall happen under his government, so that it may remain benevolent as it always has been."[77] Perhaps we are to conclude that although governments differ in degree they do not differ in kind. This of course is similar to the notion hinted at in *Lettres à un ami allemand*: that governments are not to be trusted. Certainly this is true in *L'État de Siège* where the Governor turned over his office to The Plague in return for the health of the members of his government. This argument is strengthened by two occurrences under the government of The Plague. First, the Secretary points out that all government regulations should have a touch of obscurity because people behave better the less they understand.[78] Second, The Plague comments on the necessity of "great useless public works."[79] Although both these points, and innumerable others on bureaucracy, are applied to the government of The Plague, they are obviously intended to be ironical comments on all government.

But the most important point of the play is man's ability to overcome his fear. An interchange between Diego and Victoria makes the point perfectly. "What else should I struggle against in this world of ours if not the injustice that is done us?" "The anguish that you have within yourself. And all the rest will follow."[80] Man must rebel against fear if justice is to be at all possible. The same point as was made in "Ni victimes ni bourreaux." Diego also makes another argument from that work in talking to The Plague:

> No, I know those stale old arguments. To do away with murder we must kill, and to prevent injustice we must do violence. That's been dinned into our ears till we took it for granted. For centuries fine gentlemen of your kind have been infecting the world's wounds on the pretense of healing them, and none the less continuing to boast of their treatment; because no one had the courage to laugh them out of court![81]

These things must all be recognized for fear to be overcome. Rebellion, the overcoming of fear, is an effort of the will produced by "nonsensical ideas, or righteous indignation, or . . . any of those little gusts of petulance which lead to big revolts."[82] But so far Camus seems not to have come completely to grips with rebellion. It is a vague shadow on the horizon of his thought, informed by the memory of the absurd but not yet fully recognized.

L'État de Siège ends on a cry for balance. A chorus of women deplore Diego's choice and plead for love, passion and sentiment rather than ideas or abstractions. But Camus' point seems to be that both Diego and the women are wrong.[83]

This concern is clearly seen in one of Camus' best short essays, "L'Exil d' Hélène," in which he reflects on Greek thought. He notes that the Greeks assumed the existence of limits and that Europe is today being torn apart

by its constant striving for absolutes, particularly absolute justice.[84] But, as he points out, the Greeks also believed that the limits could be violated, and that whoever did so would be destroyed. "Nothing in the history of today can contradict them."[85] The only hope for man is to rejoin the Greeks, to recognize that limits are essential and that unless they are respected, mankind will be destroyed. It cannot be stressed too often that this notion of limits is an essential part of Camus' thought. He either specifically discusses the notion of limits, or he argues against positions that reject limits.[86]

Camus explores the problem of establishing limits and meaning in two books, *Les Justes* (English title: *The Just Assassins*) (1950)[87] and *L'Homme révolté* (1951), and a variety of articles. In both books he is concerned with revolution and rebellion as means of establishing limits. The first, a play, characterizes five revolutionists as they plan to assassinate the Grand Duke in Moscow. In *L'Homme révolté* Camus provides his own interpretation of *Les Justes* in a discussion of the Russian terrorists on which the play was based. *Les Justes* was based on the actual killing of the Grand Duke Sergei by Kaliayev, and many of the incidents and characters are drawn from the actual assassination. Camus argues that the terrorists of 1905 were a peculiar chapter in the history of rebellion because they found murder both necessary and inexcusable.[88] But before this odd chapter in the history of rebellion can be understood, the spirit of rebellion must be understood, and *L'Homme révolté* is an extended essay on the spirit of rebellion. It is as close to a treatise in political philosophy as Camus ever comes.

With *L'Homme révolté* Camus consciously returns to the absurd, but again only as a starting point. He restates the arguments made in *Le Mythe de Sisyphe* for rejecting suicide and says:

> But it is clear that absurdism admits life as the only necessary good since it permits precisely this encounter without which the absurdist wager would have no basis. To say that life is absurd, the conscience must be alive. How is it possible, without making remarkable concessions to one's desire for comfort, to preserve exclusively for oneself the benefits of such a process of reasoning? From the moment that life is recognized as good, it becomes good for all men. One cannot give coherence to murder if it is refused to suicide.[89] A mind imbued with the idea of the absurd will undoubtedly accept fatalistic murder but it would not accept calculated murder. In terms of the encounter murder and suicide are the same thing, and must be accepted or rejected together.[90]

This passage explains the basic steps of Camus' movement from *Le Mythe* to *L'Homme révolté*.

Rebellion is almost as complex as the absurd and must be analyzed as carefully and as thoroughly.

It protests, it demands, it insists that the outrage be brought to an end, and that what has up to now been built upon shifting sands should henceforth be founded on rock. Its preoccupation is to transform. But to transform is to act, and to act will be, tomorrow, to kill, and it still does not know whether murder is legitimate. Rebellion engenders exactly the actions it is asked to legitimate.[91]

This fundamental complexity in the idea of rebellion leads Camus to search throughout all of *L'Homme révolté* for a way to justify rebellion and to use rebellion in order to transform, but to transform in a way that will not kill, that will not justify murder, and that will accept the overwhelming responsibility for the transformation.

The most important characteristic of rebellion is that it is not merely a negative act but one which includes an affirmation. The rebel, from the moment of his rebellion, says yes and no. Rebellion, in a word, produces awareness. "No matter how confused it may be, awareness is born of the act of revolt: the awareness, sudden, dazzling, that there is in man something with which he can identify himself, even if only for a moment."[92] The rebel has suddenly become aware of something of value in man, something that must not be destroyed, something that must be preserved. And in this realization is found the basis for both the value and excesses of rebellion. That something of value that is found in man is the basis of the rest of Camus' analysis of rebellion.

Camus' first conclusion is that rebellion "questions the very idea of the individual."[93] He argues that the rebel acts in the name of something that he feels is common to all men. Rebellion seems to assert that there is something akin to human nature. At least the rebel acts as if such a thing exists, and thus rebellion is a "passionate affirmation" of a natural community among all men. "The community of victims is the same as that which united victim and executioner. But the executioner does not know this."[94] "The individual is not, in himself alone, this value he wished to defend. When he rebels, a man goes beyond himself."[95] Here Camus is solidly linking rebellion and the sociability he discussed earlier. The last part of the pattern is becoming clearer.

Rebellion is an attempt to find "a rule of conduct outside the realm of religion and its absolute values,"[96] and human solidarity is the key. "Man's solidarity is founded upon rebellion, and it, in its turn, can find its justification only in this complicity. We have, then, the right to say that any rebellion which claims the right to deny or destroy this solidarity loses simultaneously its right to be called rebellion and becomes in reality an acquiescence in murder."[97] Rebellion has limits built into itself as does the absurd. The absurd must not lead one to suicide, or the absurd is destroyed. Rebellion must not lead one to murder, or rebellion is destroyed. Murder is

not legitimate. But of course these limits can be, and are, regularly violated.

Camus had been traveling the road to *L'Homme révolté* from the very beginning, but from "Ni victimes ni bourreaux" onward the direction became sure and accurate. "I rebel, therefore we exist,"[98] is the resounding cry of the rebel, but very few have followed its logic.

Les Justes is an illustration of a particular type of historical rebellion, and Camus in *L'Homme révolté* treats the actual event that served as the basis of the play under the heading "The Fastidious Assassins." Camus argues that these terrorists recognized that murder was wrong, while at the same time they believed it was necessary. According to Camus, this is why they felt that they had to offer themselves as a sacrifice. "They lived on the plane of their idea. They justify it, finally, by incarnating it to the point of death."[99]

The five terrorists in *Les Justes* are Dora Dulebov, who builds the bombs; Boris (Boria) Annenkov, the leader of the group; Alexis Voinov, a bomb-thrower who is overcome with fear; Stepan Fedorov, the most violent of the group; and Ivan Kaliayev, known as Yanek, a poet who throws the bomb that kills the Grand Duke. Each experiences his own personal hell in the period of waiting for the assassination, planned for a night when the Grand Duke is attending the theater. Each character is an important part of the point that Camus is making; but no single character represents Camus's point of view. As a matter of fact, the positions presented in *Les Justes* are positions that Camus opposes. It must always be kept in mind that characters in Camus's novels and plays do not necessarily represent Camus's point of view. This is particularly true in *Les Justes,* where he is specifically presenting a series of characters with whom he disagrees. It is difficult to find anyone in *Les Justes* with whom Camus could agree.

There seem to be two points in *Les Justes*. First, that the act was innocent because the killing was symbolic — killing something far worse than a mere man. Such murder is innocent because it is justified by a higher justice. Second, Yanek must give his life in atonement for this innocent murder. Dora argues passionately that Yanek's death justifies them all.[100] But this seems to be an odd contradiction — the killing is innocent but the killer must die to atone for it. This complicated point regarding the necessity of atonement for a supposedly innocent killing is another part of the reason Camus entitled his analysis of *Les Justes* in *L'Homme révolté* "The Fastidious Assassins." These assassins are fastidious in the sense that they know that the murder they commit is wrong even though they justify it through the means-ends argument. Thus, the killing of the Grand Duke, even though justified and in that sense innocent, was murder, and the assassin hopes to further justify himself and the cause of justice by accepting his execution. Also, the fact of Yanek's execution removed the

taint of injustice from their cause of justice. Because they recognize that the murder was wrong though innocent, it sullied the cause at least slightly with injustice. Therefore, the giving of a life for a life was supposed to remove this bad mark. Finally, it seems that the assassins, particularly Yanek and Dora, almost look forward to execution as a means of removing themselves from their internal struggle over the rightness or wrongness of their actions. They seem to feel that giving their lives for their cause will prove to themselves and others that the cause is right. In this way also they are "fastidious assassins." They never seem quite convinced of the justice of what they are doing, but they are certain that giving their lives for it will prove them right.

Camus argues that rebellion must be viewed as a philosophy of limits or moderation, and "should be embodied in an active consent to the relative."[101] Much of the absurd is found here again. The absurd puts man into a position of attempting to maintain a balance, of negating neither himself nor the world around him, and his is a balance that must constantly be reasserted. But most importantly, the absurd is a philosophy that exalts life. Rebellion exalts life even more than the absurd and the tension and balance it requires are, if anything, even more difficult to maintain. It is almost impossible not to kill indirectly, and the temptations to revolution rather than to rebellion are great. The rebel must strive for moderation; he must be able to stop at the limit he has asserted. The absurd and rebellion are intimately connected in Camus's thought. "To conquer existence, we must start from the small amount of existence we find in ourselves and not deny it from the very beginning."[102] In order to do this the rebel must reject absolutes; he must search for the balance between justice and freedom. He must, above all, protest against those who would deny life, and he must struggle to keep from denying life himself.

The problem of a balance between justice and freedom referred to above is undoubtedly the most purely political problem that Camus discusses, but he does so in a most characteristic way. In an interview with Ignazio Silone and Nicola Chiaromonte he puts it this way:

> I believe . . . that the indispensible condition for intellectual creation and for historical justice is liberty and the free opposition of differences of opinion. Without liberty, there is no art. Art lives only by the limits which it sets for itself. It dies for all others. And without liberties, there is no Socialism either, except that of the gallows.[103]

And in his *Carnets* he makes a similar point.

> Finally, I choose liberty. For even if justice is not realized, liberty preserves the power of protest against injustice and maintains communication. Justice in a silent world, justice of the mutes, destroys complicity, negates revolt, and

restores acquiescence, but in the lowest possible form. It is here that one sees the priority gradually accept the value of liberty. But the difficulty is never to lose sight of the fact that it must *at the same time* insist upon justice, as has been said. Once this has been established, there is justice also, although quite different, at the foundation on the only constant value in the history of men, who have never really died except for liberty.

Liberty is the ability to defend what I do not think even in a regime or a world that I approve. It is the ability to admit that the adversary is right.[104]

Liberty and justice find their limits in each other. Neither can exist as absolutes without destroying the other.[105]

III. Exile

The novel *La Chute* is a complicated work; the central character, Clamence, is a complicated character, and it is necessary to sort out the purpose of Camus's use of Clamence before it will be possible to understand the novel. At the outset Camus tells us what Clamence represents by quoting Lermontov. "Some were dreadfully insulted, and quite seriously, to have held up as a model such an immoral character as *A Hero of Our Times*; others shrewdly noticed that the author had portrayed himself and his acquaintances. . . . *A Hero of Our Times,* gentlemen, is in fact a portrait, but not of an individual. It is an aggregate of the vices of our generation in their fullest expression."[106] Therefore, if we take Camus at his word, Clamence represents an aggregate of contemporary man. He is not a good man; in fact, he is immoral, but he is contemporary man. Clamence's definition of modern man as one who "fornicated and read the papers,"[107] is an apt description of his early life. Later he stopped reading the papers.

After leading a totally unexamined life for years, Clamence was alerted, he met death, undoubtedly representing the absurd, and the result was fear and despair. Fear brought on his stage of silence, the period of debauchery, but he did not rebel. For Clamence the key was to avoid judgment:

> A ridiculous fear pursued me, in effect: one could not die without having confessed all one's lies. Not to God or to one of his representatives; I was above that, as you will imagine. No, it was a matter of confessing to men, to a friend, to a beloved woman, for example. Otherwise, were there but one lie hidden in a life, death made it definitive.[108]

Clamence could not find innocence; he had to admit that he was guilty, but he also realized that he was not alone in his guilt, that "we can state with certainty the guilt of all."[109]

Thus, he became a judge-penitent. He took his pleasure in confessing his guilt with the purpose of forcing others to recognize their guilt so that mutual forgiveness could result. At the same time, Clamence wanted to

forgive so that he could be forgiven. "My great idea is that one must forgive the pope. To begin with, he needs it more than any one else. Secondly, that's the only way to set oneself above him."[110] Obviously, Clamence has not lost his vanity, and by setting himself above others he could still cherish the illusion that he was free of guilt even though he knew that this was not true.

Being a judge-penitent entails condemning oneself; Clamence makes two statements regarding this that seem to contradict each other. First, he says "it is essential to begin by extending the condemnation to all without distinction, in order to thin it out at the start."[111] A few pages later he says, and one should note the parallels to Caligula,

> Inasmuch as one couldn't condemn others without immediately judging oneself, one had to overwhelm oneself to have the right to judge others. Inasmuch as every judge someday ends up as a penitent, one had to travel the road in the opposite direction and practice the profession of penitent to be able to end up as a judge.[112]

Both positions are intended to avoid the judgment of others, but they are presented in reverse order, and this is what is confusing. One must first become a penitent by condemning oneself. Then, and only then, is it possible to spread out the condemnation to all men in an attempt to ease the burden. The purpose is "to get everyone involved in order to have the right to sit calmly on the outside myself."[113]

But Clamence ends by saying that "the essential thing is being able to permit oneself everything, even if, from time to time, one has to profess vociferously one's own infamy."[114] And here is the key to Clamence as modern man. He refuses limits, he rejects human solidarity. He wished to free himself, but no one else. He is the modern *Hero of Our Times* because all men wish this escape. Camus has portrayed a cowardly, weak man who cannot muster the courage to rebel. As Clamence says, "my solution to be sure, is not the ideal."[115]

Camus's last published works are all essays. The first, "Reflexions sur la guillotine" (1957), is an example of the type of protest that the rebel must undertake. In it Camus makes a number of arguments against capital punishment that need not be recounted here. His major point is that capital punishment is merely unjustified revenge, and a revenge that society is ashamed of since it hides the actual execution from the people. He points out that if capital punishment were actually capable of deterring someone from committing a crime, the execution should be carried out in public, to bring home the full horror of death to the potential criminal. Because this is not done, he concludes that even the executioners must not be convinced of its efficacy.

Appropriately, the last published work of Camus is his *Discours de*

Suède (1958), the speeches on the role of the artist in the mid-twentieth century that he gave at the time of his acceptance of the Nobel Prize for Literature in 1957. Art "is a means of exciting the greatest number of men by offering them a privileged image of suffering and universal happiness."[116] The artist must "find again the feeling of a living community that will justify him."[117] He must accept the service of truth and liberty[118]— particularly liberty, because it has lost favor today and is constantly misrepresented.[119] Beauty "cannot serve any party; it can only serve, in the long or short run, the suffering or the liberty of men."[120] Liberty is the key to art and justice; neither can exist without it. "Liberty alone draws me from isolation, slavery hovers only on a crowd of solitudes. And art, by virtue of its free essence . . . reunites whereas tyranny separates."[121]

Camus sees art in the same way that he sees rebellion; art simultaneously accepts and rejects reality.[122] Art, rebellion, and the absurd are all viewed from similar perspectives, except that the absurd is a different kind of force in the world. Art and rebellion are creative activities, a remolding of reality. The absurd is a confrontation that is not necessarily creative. The artist should be a rebel. The end of both is solidarity; "The sea, rains, need, desire, the struggle against death, these are the things that reunite us all."[123] This reunion, though, cannot be achieved without involvement, without active rebellion. The artist cannot sit by the sidelines any more than the rebel. "One may desire without doubt, and I also desire it, a gentler flame, a respite, a propitious pause for reverie. But perhaps there is no other peace for the artist than that which he finds in the heat of combat."[124]

Here Camus has provided a comment on Clamence in *La Chute*. Man must not merely sit on the sidelines; modern man must break from his self-imposed exile and seek those things that reunite men. He must give up the false excuses that he has used so long, particularly the excuse, phrased here as "you can't make an omelet without breaking eggs,"[125] that he attacks in *L'Homme révolté*. The means do not justify the end.

Finally, Camus ends on an optimistic note, "I believe rather that it [hope] is created, revived, maintained by millions of solitary individuals whose deeds and works each day negate the frontiers and the crudest appearances of history. . . . "[126] Each and every individual, particularly the artist, must rebel against all those things that kill men, that deaden creativity. Man must constantly struggle against all those forces that wish to make him something less than man, all those absolutes that kill freedom and justice in the name of their truth.

Camus's philosophy is a philosophy of limits, a philosophy of moderation. He is not a conservative; he is not a liberal. He is most sympathetic with radicalism, but with a radicalism that respects limits, that respects beauty, and that upholds man.

Notes

* Except as noted, all translations are by the author.

1. Works commenting extensively on Camus's social and political thought include Germain Paul Gelinas, *La Liberté dans la pensée d'Albert Camus* (Freibourg: Editions Universitaires Fribourg suisse, 1965); Joseph Majault, *Camus, Révolte et liberté* (Paris: Editions du Centurion, 1965); Emmett Parker, *Albert Camus, The Artist in the Arena* (Madison: University of Wisconsin Press, 1965); Gerhard Stuby, *Recht und Solidaritat im Denken von Albert Camus* (Frankfurt am Main: Vittorio Klosterman, 1965); Eric Werner, *De la violence au totalitarisme; essai sur la pensée de Camus et Sartre* (Paris: Calmann-Lévy, 1972); and Fred H. Willhoite, Jr. *Beyond Nihilism; Albert Camus's Contribution to Political Thought* (Baton Rouge: Louisiana State University Press, 1968).

2. See his comments on this question in an interview given at the time he received the Nobel Prize. Albert Camus, "Conférence du 14 decembre 1957," *Discours de Suède* (Paris: Gallimard, 1958), p. 161.

3. Camus, *Carnets mai 1936 - février 1942* (Paris: Gallimard, 1962), p. 23.

4. There was also a *diplôme d'études supérieures* in 1936 on Neoplatonism and Christian thought. See note by Roger Quilliot in Camus, *Essais* (Paris: Gallimard, 1965), p. 1228. The thesis can be found in the same volume, pp. 1224–1313.

5. Camus, "Introduction," to *Révolte dans les Asturies; Essai de creation collective,* in *Théâtre Récits Nouvelles* (Paris: Bibliotheque de la Pleiade, 1962), p. 399. For evidence regarding the parts written by Camus see Roger Quilliot, "Révolte dans les Asturies — Présentation," in Camus, *Théâtre,* pp. 1844–45.

 Révolte was the only published work he wrote while he was a member of the Communist Party, and both his membership and the play point out his serious concern with social and political problems at the beginning of his career. Camus joined the Algerian Communist Party in 1934, and he twice said that he left the party in May, 1935; others have said that he remained in the party until 1937 when he was expelled. [See Parker, *Albert Camus*, pp. 6, 219n3.] In either case he left the party because he believed that the Communists were concerned with exploiting the poverty of Algeria for purely political motives. He remained as part of the Maison de la Culture, which was sponsored by the Communist Party, until 1937, and did not directly condemn the Communist Party of the USSR until 1951 when he published *L'Homme révolté*. In the meantime he viewed the experiment in the Soviet Union with some hope, believing that it might be possible for it to bring about the type of humanitarian, democratic socialism he believed was desirable.

6. Camus, "Préface," *L'Envers et l'endroit* (Paris: Gallimard, 1958), p. 13.

7. Ibid. Variant: "au long de sa vie," at end of first sentence, Camus, *Essais,* p. 1181.

8. Camus, *Carnets mai 1935–février 1942,* p. 16. On this theme, see also Camus, *La Mort Heureuse,* vol. 1 of *Cahiers Albert Camus* (Paris: Gallimard, 1971).

9. "Entre oui et non," *L'Envers et l'endroit,* pp. 76–77.

10. Camus, "Préface à l'édition Américaine du théâtre," *Théâtre Récits Nouvelles,* pp. 1727–28.

11. Ibid., p. 1728.

12. Ibid.
13. Camus, "Caligula pièce en quatre actes," in *Le Malentendu pièce en trois actes suive de Caligula pièce en quatre actes* (Paris: Gallimard, 1947), p. 11.
14. Ibid.
15. Ibid., p. 118. It is important to realize what Camus means when he uses the words "logic" or "logical," because they do not refer to any specific philosophical position on logic. For Camus, logic means consistency. This can be seen in part in the foregoing quotation where Camus sets logic against contradiction. Contradiction, as used by Camus, could equally mean inconsistency. Therefore, it seems that Camus is saying that logic is consistency, consistency with one's premises. In other words, for Camus, to be logical one starts from one's premises, whatever they may be, and argues consistently from them without contradicting oneself.
16. Ibid., p. 114.
17. Ibid., pp. 130–31.
18. Ibid., p. 142. All later editions replace "absurd" with "annoying."
19. Ibid., p. 143.
20. "L'Été à Alger," *Noces* (Paris: Gallimard, 1950), p. 68.
21. Ibid.
22. Ibid., p. 69.
23. *Noces*, "Le Desert" p. 100.
24. "Les Amandiers," *L'Été* (Paris: Gallimard, 1954), pp. 69–70.
25. *Carnets mai 1935 — février 1942*, p. 141.
26. Camus, *Le Mythe de Sisyphe: Essai sur l'absurde* (Paris: Gallimard, 1942), p. 37.
27. "L'Exil d'Hélène," *L'Été*, pp. 106-107.
28. Camus, "Préface à l'édition Americaine du théâtre," in *Théâtre Récits Nouvelles*, p. 1729.
29. Ibid.
30. *Le Malentendu*, in *Théâtre Récits Nouvelles*, p. 15.
31. "La Mort dans l'ame," *L'Envers et l'endroit*, pp. 79-102. This story was based on a section of *La Mort heureuse*.
32. Camus, *Le Malentendu*, p. 127.
33. "Préface à l'edition italienne," *Lettres à un ami allemand* (Paris: Gallimard, 1948), p. 14.
34. Ibid., p. 15.
35. Originally published in 1943 in *Revue Libre* no. 2.
36. *Lettres*, p. 19.
37. Ibid., pp. 19-20.
38. In *Carnets* Camus wrote "Value judgments cannot be suppressed *absolutely*. That negates the absurd." *Carnets janvier 1942 — mars 1951* (Paris: Gallimard, 1964), p. 88.
39. *Carnets janvier 1942 — mars 1941*, p. 116.
40. *Carnets mai 1935 — février 1942*, p. 24.
41. "Le Sang de la liberté," in "La libération de Paris," in *Actuelles: chroniques 1944-1948* (Paris: Gallimard, 1950), p. 21. Originally published in *Combat*, August 24, 1944.
42. "Morale et politique" from *Combat*, September 8, 1944, in *Actuelles*, p. 46. In this short essay Camus makes one other point that reflects a continuing theme in his thought. He says that "Christianity in its essence (and this is its paradoxical grandeur) is a doctrine of injustice."

43. "Morale et Politique," October 7, 1944, p. 51.
44. Ibid.
45. "Le Siècle de la peur," in "Ni victimes ni bourreaux," *Actuelles: Chroniques 1944-1948*, pp. 142-43.
46. Ibid., p. 145.
47. *Actuelles,* "Vers le dialogue," p. 176.
48. *Actuelles,* "Sauver les Corps," p. 147.
49. Ibid., p. 149.
50. *Actuelles,* "Le Révolution travestie," p. 147.
51. *Actuelles,* "Un nouveau contrat social," p. 170.
52. Ibid., pp. 171-72.
53. Ibid., p. 172.
54. Ibid.
55. Ibid., pp. 172-73.
56. Ibid., p. 164.
57. *Actuelles,* "Vers le dialogue," p. 179.
58. This process is clearly seen in "Promethée aux enfers" (1946) in his discussion of the first rebel. He argues that were Prometheus to return he would again be attacked by the voices of Force and Violence. But the myth of Prometheus, the hope of rebellion, must be kept alive. In particular it must be kept alive in the twentieth century, because men have chosen absolutes and have failed to recognize the necessity of saying no at the same time as they say yes. They have accepted murder, torture, and hate, and they have refused beauty and happiness. "Promethée aux enfers," in *L'Été,* p. 81.
59. Camus, *L'Homme révolté* (Paris: Gallimard, 1951), p. 36.
60. Camus gives two warnings regarding his writings, one directly related to the disappearance of the absurd. First, he says, "No man can say what he is. But sometimes he can say what he is not. People want one who is still searching to have reached a conclusion. A thousand voices are already telling him what he has found, and yet he knows that is not it." Later he says, "What is the good of repeating that in the experience that interested me and on which I happened to write, the absurd can be considered only as a point of departure, even if its memory and emotion accompany subsequent steps." See "L'Énigme," in *L'Été,* pp. 122, 131. I have tried to take Camus's suggestions.
61. In 1939 Camus had written an unflattering description of Oran. "Le Minotaure ou la halte d'Oran," *L'Été,* pp. 11-64. See variant title: "Oran ou le Minotaure," Camus, *Essais,* p. 1819.
62. *La Peste,* in *Théâtre Récits Nouvelles,* p. 1227.
63. Ibid., p. 1274.
64. *Carnets janvier 1942 — mars 1951,* p. 106.
65. Ibid., pp. 70, 73, 80.
66. Ibid., p. 80.
67. "La Peste," p. 1367. Variant after "the files and fires" "Warnings and censures." Also, see *Carnets janvier 1942—mars 1951,* p. 36.
68. Ibid., p. 1336. Variant following "sentence": "Men are bad and they need to be sentenced."
69. Ibid., p. 1395.
70. Ibid., p. 1472. Variant after "saints": "nor executioners, but only healers."
71. *Carnets janvier 1942 — mai 1951,* p. 50.
72. "L'État de Siège" in *Théâtre Récits Nouvelles,* pp. 222-227.

73. Ibid., pp. 299–300.
74. Ibid., p. 228.
75. Ibid., p. 229.
76. Ibid., pp. 229–230.
77. Ibid., p. 194.
78. Ibid., p. 222.
79. Ibid., p. 240.
80. Ibid., p. 263.
81. Ibid., p. 290.
82. Ibid., p. 229.
83. For an additional comment on *L'État de Siège*, see "Pourquoi l'espagne?," *Actuelles chroniques 1944–1948*, pp. 241–250.
84. L'Exil d'Hélène," *L'Été*, p. 107.
85. Ibid., p. 113.
86. Similar points rejecting absolutes are found in "Deux résponses à Emmanuel d'Astier de la Vigerie," in *Actuelles: chroniques 1944–1948*, pp. 183–207; "L'Incroyant et les chrétiens," in *Actuelles: chroniques 1944–1948*, pp. 211–212; "Le Temoin de la liberté," in *Actuelles: chroniques 1944–1948*, pp. 253-267; and "Les Pharisiens de la justice," in "Justice et haine," *Actuelles II: Chroniques 1948–1953*. (Paris: Gallimard, 1953), pp. 20–24.
87. First performed in 1949.
88. Camus, *L'Homme révolté*, p. 211.
89. Variant: Insert "Sade en bonne logique justifie les deaux." Camus, *Essais*, p. 1635.
90. Camus, *L'Homme révolté*, p. 17.
91. Ibid., pp. 21–22.
92. Ibid., p. 26.
93. Ibid., p. 28.
94. Ibid., p. 28n.
95. Ibid., p. 29.
96. Ibid., p. 35. As he puts it elsewhere: "Can man alone create his own values? That is the whole problem." *Carnets janvier 1942 — mars 1951*, p. 123.
97. Ibid.
98. Ibid., p. 36.
99. Ibid., p. 212.
100. *Les Justes, Pièce en cinq actes* in *Théâtre Récits Nouvelles*, p. 392.
101. Camus, *L'Homme révolté*, p. 358.
102. Ibid., p. 359.
103. "Parties and Truth." *Encounter*, 8 (April, 1957), p. 5. Originally published in *Tempo Presente*.
104. *Carnets janvier 1942 — mars 1951*, pp. 136–137.
105. Camus continues to explore the related problems of limits, justice, and absolutes in two series of essays published between 1951 and 1953: "Lettres sur la révolte" and "Creation et liberte." See *Actuelles II. Chroniques 1948–1953*, pp. 39–182. He also dealt specifically with the Algerian crisis at this time. See "Lettre à un militant algérien," "L'Algérie déchirée," "Appel pour une trêve civile," "L'Affaire Maisonseul," and "Algérie 1958." All in *Actuelles III. Chroniques algériennes 1939–1958*.
106. This epigraph, according to Roger Quilliot, only appears in the fourth version of *La Chute* and he only cites the last sentence of the quotation that appears in the American edition. See "La Chute," in *Théâtre Récits Nouvelles*, p. 2007.

107. Ibid., p. 1477.

108. Ibid., p. 1519.

109. Ibid., p. 1530.

110. Ibid., p. 1539.

111. Ibid., p. 1541.

112. Ibid., p. 1544.

113. Ibid.

114. Ibid., p. 1546. For variant see Ibid., p. 2026.

115. Ibid., p. 1548. In a sense the lack of an ideal solution is the theme of *L'Exil et le royaume*. More precisely this collection of short stories presents six different views of exile. The word "Kingdom" in the title refers to "a certain free open life in which we have to find ourselves in order to be revived." (Albert Camus, "Prière d'insérer (1957)," *L'Exil et le royaume*, in *Théâtre Récits Nouvelles*, p. 2031.) Each of the six stories portrays someone who is in exile, who has been cut off from the free and open life. They picture the contrast between the exile experienced by all men and the kingdom that is sometimes possible. *La Chute* had shown a man given over to exile without a kingdom. *L'Exil et le royaume* shows man cut off from himself and from others, but it also demonstrates the possibility and potentiality of rebellion resulting in a new life, a life of solidarity with others, a life that is free and open.

116. "Discours du 10 decembre 1956," *Discours du Suède* (Paris: Gallimard, 1958), p. 13.

117. Ibid., p. 15.

118. Ibid.

119. "Conférence du 14 décembre 1957," under the title, "L'Artiste et son temps," *Discours du Suède*, p. 34.

120. Ibid., p. 60.

121. Ibid., p. 63.

122. Ibid., pp. 53–55.

123. Ibid., p. 42.

124. Ibid., p. 69.

125. Ibid., p. 50.

126. Ibid., p. 70.

Chapter Five
Trotsky and Malraux: The Political Imagination

Marc Scheinman

I. Malraux's Legacy as a Political Novelist

Although André Malraux was neither a social scientist nor a political philosopher, his novels about revolution are extremely important and should receive more attention from students of politics than they have. Before Jean-Paul Sartre popularized the notion of a literature of commitment that addresses itself to major social and political issues, Malraux's work, especially during the late 1920s and 1930s, epitomized the committed writer. Malraux's leftist sympathies were quite consistent with the larger cultural milieu, as this period excited the political imaginations and artistic visions of left-wing intellectuals such as Arthur Koestler, Ignazio Silone, George Orwell, Andre Gide, and Stephen Spender. In terms of achievement, however, Malraux's political novels provide a more substantial and impressive body of literature than those of any of his contemporaries on the left.

In the early 1930s the Soviet Union still represented the possibility of a radiant future, in which the excesses and unpredictability of capitalism could be overcome and replaced by a new order that would meet the needs and hopes of all its citizens rather than protecting the privileges of the haute bourgeoisie. The Soviet Union embodied the Marxist dream of replacing the nightmare of the great capitalist depression with socialism. This period predates the great purge trials of the late 1930s and the Nazi-Soviet Pact of 1939 when Soviet communism began to harden into a highly bureaucratic and oppressive state. Understandably, "Marxist" or "fellow-traveler" at this time were not just epithets; such a political commitment indicated an optimism about the future. Also, it was certainly *avant-garde* to be militant against capitalist abuses.

In spite of the fact that Malraux rejected orthodox Marxist theory and

117

never joined the Communist Party, his novels — *The Conquerors, Man's Fate* and *Man's Hope* — represent an increasingly positive conception of political revolution. The first two novels examine the early development of the Chinese Revolution during the Canton and Shanghai periods and the last depicts the first year of the Republican's struggle against fascism in the Spanish Civil War. Clearly Malraux's analysis of these events is dramatized and deepened by his own ideological convictions. He fought in the Spanish Civil War on the side of the Republicans who strove to defeat Franco; he also tirelessly spoke at meetings of revolutionary writers and artists in defense of the Soviet Union and the revolution that it symbolized. He did not play a role in the Chinese Revolution, but his novels about China benefit from his years in Indochina and from the first-hand accounts of the developments in China that he received from a friend. Malraux was not only fascinated by Trotsky and Trotskyism, but he also debated Trotsky about specific strategies to be undertaken in both the Chinese Revolution and the Spanish Civil War. No wonder, then, that Malraux treated Trotskyist positions sympathetically in *Man's Fate.*

The major themes encountered in Malraux's novels focus on the philosophical and metaphysical meanings of revolution, the tension between individual aspirations and collective requirements in revolutionary theory, and the relationship between means and ends in revolutionary strategies. Malraux's novels raise profound questions about the price of not supporting a revolution, as well as the costs of engaging in revolution. His answers are never simple or dogmatic: Malraux believes that no important political goals are achieved without sacrificing "pure" values. He thus insists that the study of revolutionary politics must focus on the problems of "dirty hands."

The examination of revolutions is especially suited to the novel because this genre can dramatize the fate of specific individuals involved in collective actions, while allowing for a philosophical analysis of the political issues, which have universal import. We are able to understand why revolutionary problems are not easily resolved by abstract calculations about costs and benefits, but require instead concrete, often agonizing, decisions that lead to profound and sometimes irreversible consequences for distinct individuals and cultures. The novel also reflects man's primordial struggle to achieve the conditions necessary for a good life and a just society.

Ironically, Malraux abandoned his leftist sympathies after World War II, and became a Gaullist minister and art historian. He never again wrote a political novel. However, posterity will remember him more for his brilliant depictions of revolutions than for his government service or his writing about art.

Malraux scholars emphasize the unity of his writing, the constancy of his

preoccupations from the early novels to the most recent work on the philosophy of art and the *Anti-Memoirs*.[1] Although there is no unanimity about precisely what constitutes the essence of Malraux's literary contribution or even which of his novels is best, there is widespread agreement about what Malraux's works are *not:* they are not historical chronicles, nor is politics of primary importance in Malraux's vision.[2] These critics argue that the political events depicted in Malraux's novels are important only as dramatic settings which allow Malraux to examine his more fundamental preoccupation: metaphysical and ethical revolt against Destiny, against human limitations.[3] From this vantage point, Malraux's work represents an attempt to discover what is universal in Man; such a quest is defined in ahistorical and apolitical terms.

Also, most of the recent studies view his work retrospectively: the postwar writing on philosophy of art serves as the mature criterion by which to evaluate the earlier work. Likewise, when the novels are isolated from the writing about art, it is Malraux's last, but fragmentary, novel, *The Walnut Trees of Altenburg,* that is often cited as his highest artistic achievement.[4]

The major consequence, if not the explicit intention, of this type of criticism is to depoliticize and therefore to sanitize the political content of Malraux's novels by insisting that their value must be judged solely in literary or artistic terms. Thus contemporary critics argue that Malraux is a "dominated writer" but not a "committed writer" of the left, a latter day Romantic, an existential thinker who deeply influenced the development of Camus' and Sartre's concept of the Absurd,[5] a writer of tragedies,[6] a critic of culture, and an educator.[7]

The problem with these approaches is that they underestimate the influence of politics on Malraux's writing, especially during the 1930s, when his work reflects an intense interest in Marxist ideas, communism, and Leon Trotsky. Moreover, by emphasizing the wholeness and continuity of Malraux's writing these critics are forced to overlook the argument that Malraux did some of his best writing during the period from 1928-37, a period that is significantly different from all others in Malraux's career. *The Conquerors* (1928), *Man's Fate* (1933), and *Man's Hope* (1937) are all deeply political. It is these novels (not his philosophy of art or the fragmentary *Altenburg*) that will guarantee Malraux's literary posterity.

It may be argued that the literary critics have underplayed the importance of politics in Malraux's work because it rekindles their own intense ideological commitments of the past, particularly those associated with the Spanish Civil War and the subsequent Stalinization of communism; the dominant political themes in *The Conquerors* and *Man's Hope* are similar to the ones espoused by the Stalin-directed Comintern (International Communist Movement). After the defeat of the Republi-

cans by Franco and the communists' opposition to the anarchists, the defeat of the Chinese communists by Chiang Kai-shek in 1927 and Stalin's extreme repression through the purges which abruptly ended the Soviet Revolution, even leftist critics such as F. W. Dupee,[8] Nicola Chiaromonte,[9] and Irving Howe[10] are bitter about what they perceive as Malraux's opportunism and demonic pursuit of action.

The inadequacies in the literary critics' analyses of the political import of Malraux's work requires a reexamination of Malraux's three best political novels with specific emphasis on their relationship to Marxist ideas, communism, and Leon Trotsky. An understanding of the political characteristics and sources of Malraux's inspiration will clarify why his politics changed so dramatically after World War II. It will also explain the oscillation in Malraux's work between Classicism and Romanticism: between an emphasis on universal laws, abstractions, and order and the contrary emphasis on the concrete, spontaneous, and historical revolt against this order.

Malraux came to view revolution and communism in increasingly positive terms. His changing attitudes are reflected in his novels.[11] *The Conquerors* is Malraux's first political novel and marks a distinct, if somewhat ambiguous, departure from his earlier writing.[12] In *The Temptation of the West* (1926) Malraux established themes characterizing the sense of anomie that pervaded the European intellectuals of the post-World War I generation. In a series of philosophical letters exchanged between a young European intellectual and his Chinese counterpart, this volume asserts a Spenglerian and Nietzschean despair over the decline of western civilization, the decadence of excessive individualism, and the subsequent discovery of the Absurd in the absence of believable and coherent social norms. In spite of social and cultural dissolution, or perhaps because of these very factors, A. D., the young European, is conscious of Western man's activism. He is "committed to the test of the *act,* hence pledged to the bloodiest fate."[13] In *The Conquerors* Malraux not only examines these problems in abstract metaphysical terms, but also locates them within a specific historical and collective context. Moreover, this new concentration on the political provides at least a glimpse of how Malraux will resolve the problem of western individualism in his later novels: through a commitment to revolutionary action that integrates individual and ethical needs with collective ones.

II. *The Conquerors:* Malraux's First Novel on the Chinese Revolution

The Conquerors is simultaneously a novel about the Canton period of the Chinese Revolution (1925) and a psychological analysis of the novel's

hero, Pierre Garine. The political setting reflects the actual historical setting, in which the nationalist Kuomintang party, the party of Sun Yat-sen, was assisted in its struggle against the warlords and British imperialism by agents of the Comintern and Soviet military advisers. Pierre Garine is a fictional character. He is Swiss and has left bureaucratic Europe in order to become the Kuomintang's Director of Propaganda. He works directly with Borodin, the Comintern's agent (who has the same name as the historical Russian agent), to prepare a blockade of Hong Kong and Canton which is designed to cripple British shipping interests and to instill the revolutionary forces with a feeling of their growing power. This policy of collaboration between the Bolsheviks (Comintern), Chinese communists, and the bourgeoisie within the Kuomintang is the same one that was supported by the historical Stalin and Borodin and opposed by Trotsky.

Politically, the blockade is a success and the novel ends with an implied victory of the revolutionary forces over the British, over the Chinese terrorists led by Hong who refuse to collaborate with the bourgeoisie in the Kuomintang, and over the moral idealists and pacifists represented by Cheng-Dai. Although Garine led the struggle to achieve these results, the novel's conclusion is ambiguous because Garine's actions bring about his own death and also because the revolution becomes bureaucratized.

Psychologically, Garine is a complex character whose motives and actions are contradictory. He is a revolutionary adventurer who fights with the Bolsheviks, but does not believe in Marxist doctrine. For him the revolutionary spirit derives from a "revolution in being." He is convinced that the only concept of right that makes any sense is "the efficient use of force." Garine also believes that his individual life is futile and lacks any transcendental meaning, and therefore decides that he will devote himself entirely to "a great action." However, when his great action is finally to be realized, he still feels an acute solitude that separates him from his comrades. He feels defeated by overwhelming forces that are outside of his control: death and the Absurd. Ironically, Garine, the penultimate individualist who nevertheless devotes his life to collective action, is not comforted by the political victory that he more than any other character is responsible for achieving.

This incongruity between the political, metaphysical and psychological aspects of the novel has elicited three different kinds of responses from the literary critics:

1. that the novel is primarily a tragedy and that politics is only tangential; also that the novel is a critique of the European bourgeois mind and culture;
2. that Garine's frenetic activism is irrational and perhaps fascistic and is the harbinger of Malraux's subsequent "shabby defense" of Stalinism in the Spanish Civil War; and

3. that the novel is a historical "chronicle" of the early stages of the Chinese Revolution which is corrupted by the author's individualism.

The first response is an aesthetic and cultural one and is characteristic of W. M. Frohock,[14] Cecil Jenkins,[15] and Denis Boak.[16] For them *The Conquerors* is essentially a continuation of the themes outlined earlier in *The Temptation of the West* and in "D'une jeunesse europeene" (1927). Thus they argue that Garine's individual fate overshadows that of the revolution, and that the depiction of his tragedy is representative of the dilemma of the post-Nietzschean European intellectuals of the 1920s, who had lost faith in the rationality and transcendental value of their culture. In support of this position, Frohock asserts that political action is of secondary value because Garine remains ambivalent toward the revolution, and because its results are ambiguous. Although he devoted his life to it, the success of the revolutionary action does not eliminate his personal *angst:* collective action, therefore, is not to be construed as the solution to personal despair.[17] And Jenkins suggests that the very structuring of the plot as representing a choice between British imperialism or collaboration with Soviet power is symptomatic of the deeply European bias that pervades the novel at the expense of the Chinese nationalist movement, which was suspicious of European interference.[18]

There are several important problems that this first type of response raises; primarily, it is too one-sided. For a bourgeois like Garine who values individuality and collective action in their extreme forms, there is no definitive resolution between these two conflicting values. In addition, as Malraux will later suggest in *Man's Hope,* collective action must be directed at the amelioration of political and social problems, not individual ones; it is on this basis of political consequences that the action should be judged. Therefore, to insist that the revolution is unsatisfactory because it fails to satisfy Garine's personal needs is not sufficient reason to condemn the revolution. Paradoxically, Jenkins himself points out that Garine's excessive individualism is primarily the result of European intellectual despair; from this vantage point it is clear that Garine's individualism is a form of European disease.[19]

Also, even if it is granted that the results of the revolution are ambiguous, neither Frohock nor Jenkins stresses the fact that Garine prefers to leave "decadent" Europe behind, thereby rejecting the purely tragic or contemplative existence of the European intellectuals in favor of one based on revolutionary action. Frohock and Jenkins, like Malraux's contemporaries Drieu la Rochelle and Emanuel Berl, envision Garine as a type of "New Man" in European culture, but Malraux also notes that Garine's revolt is deeply political.[20] In writing about Garine Malraux emphasizes the

revolutionary nature of his personality and his fraternal ties with his comrades, in a passage quoted by Jean Lacouture[21] and alluded to by David Wilkinson[22] (it is important to note that neither Lacouture nor Wilkinson is a literary critic; the former is a political journalist and the latter a political theorist):

> He does not know how the Revolution will turn out, but he knows where he will go when he has taken a particular decision. He couldn't care less about the earthly paradise. I cannot lay too much stress on what I have called the mythology of ends. He does not have to define the Revolution: he makes it.

> When Saint Just set out on his course of action, he was not yet a republican; and Lenin did not expect the Revolution to produce the NEP. *The revolutionary is not a man with a ready-made ideal; he is a man who wants to demand and get the most for his people, for those I called just now his brothers-in-arms.*[23]

Even though this fraternity did not entirely mollify Garine, it is significant because it does somewhat compensate for his angst and is an indication, however qualified, that Malraux envisions revolution in a positive way. In addition, it establishes the direction of his future novels, which strongly intimate that excessive individualism — the compulsion to be different and to view oneself as an outsider — is the most important form of alienation in the West and can only be overcome by a type of society in which the individual can identify positively with his culture.

Another problem with insisting on the secondary importance of politics in the novel is that it ignores Malraux's intense and detailed interest in and knowledge of politics in general and of the Chinese Revolution in particular. This may be substantiated by referring to Malraux's biography. As both Jean Lacouture and Walter Langlois[24] amply document, Malraux coedited two anticolonial newspapers in Southeast Asia in the early and mid-1920s. By today's standards the policies espoused — the legal protection of the Annamese against French judicial fiat and economic exploitation — would hardly qualify as revolutionary. From this perspective, then, Jenkins is certainly correct when he claims that Malraux was "uncommitted" in the 1920s. However, only uncommitted in comparison with his later support of revolutions. Compared with his earlier extreme aestheticism and that of his contemporaries, the very act of publishing newspapers that openly criticized the French colonial administration was radical. Equally important, these adventures from 1924–26 allowed Malraux to establish contact with the nationalist political leaders in Saigon and also made it possible for him to receive virtually daily reports about political developments in Canton and Hong Kong.[25] Malraux's explicit political views may not have been as revolutionary as the fictional Garine's

with whom he identified, but it cannot be denied that Malraux attempted to convince his audience that he actually held the same Directorship of Propaganda as the fictional Garine.[26] While Frohock, Lacouture, Jenkins and Langlois all severely question the truth of this revolutionary myth that Malraux created about his own activities in Asia, the fact that he identifies so strongly with his fictional creation strongly implies that the Chinese Revolution fascinated Malraux not simply as an example of tragedy, but as a great political act.

Malraux's political identity at the time of his writing *The Conquerors* is ambiguous, but it is less important to decipher what Malraux felt personally than to emphasize what the novel actually conveys: a specific historical moment and the reaction of distinct characters to it. Malraux indicates exactly this in response to an essay by Trotsky which will be discussed later. "It is not my judgments that are found in *The Conquerors,* but the judgments of independent individuals . . . at particular moments."[27]

Malraux's intense interest in the Canton period of the Chinese Revolution is further illustrated by an exchange of essays between himself and Leon Trotsky which appeared in *The New French Review*[28] in April 1931 over the meaning of *The Conquerors.* Frohock and Lacouture both refer to this controversy, but for different reasons. Frohock insists that its significance lay in the fact that Malraux defended the novel on artistic grounds against Trotsky's accusation that it is a fictionalized "chronicle." Where Trotsky sees the revolution as the hero of the novel and Garine as a defective revolutionary, Frohock argues that Garine is a tragic hero who only coincidentally happens to be involved in a revolution — he fears the coming Brave New World of the revolution.[29] Frohock's defense of Malraux's artistic vision overlooks the entire section of Malraux's response which focuses on the "essential": the quality of his characters as social symbols and the best political strategy to espouse in the given circumstances.[30] Briefly, Malraux defends Garine's and the historical Borodin's policy of collaboration with the nationalist bourgeoisie because he believes that the Chinese proletariat and peasantry are not sufficiently powerful in 1925 to launch a purely communist insurrection. As Lacouture observes, this policy corresponds with the Comintern's "Possibilist Thesis" and was opposed by Trotsky's support of an independent communist revolt in spite of the immediate consequences. Thus, Lacouture emphasizes the strategic import of Malraux's position.

Lastly, Jenkins underestimates the crucial importance of European intellectuals in the Chinese Revolution and in the Third World countries in general. He also ignores the leading role that bourgeois intellectuals play in these revolutions: they are especially critical in the early phases because of their ability to mobilize large masses of discontented people through

propaganda and a highly elaborate speech code that depicts the revolutionary struggle in terms of universal liberation.[31] Not all bourgeois intellectuals are revolutionaries, only a certain segment that is déclassé and therefore unable to achieve positions of power and status in the society's traditional framework. In spite of this self-interest of the déclassé intellectuals in the revolution, they lend these movements a fundamental idealism: they publicly espouse a more egalitarian and rational society and risk their lives in the pursuit of these goals. From this vantage point it is very important that Lenin, Trotsky, Mao, Fidel, and Ho are all members of this segment of the bourgeoisie, déclassé intellectuals, even though the revolution that they make is ostensibly in the name of and for the benefit of the proletariat or peasantry, which are alien to them.

As Alvin Gouldner has recently argued, revolutionary history would be remarkably different without the participation of this disaffected elite.[32] Garine, like the above revolutionaries, is a disaffected bourgeois who is alienated from contemporary culture, politics, and the intellectuals' refusal to act decisively. Therefore, he may be compared fruitfully with those revolutionary intellectuals; for Garine as for them, the most basic social and political inequalities could be overcome only through revolutionary action.

Jenkins correctly observes that the historical Gallen and Borodin, as agents of the Comintern, were responsible for establishing the Whampoa Military Academy, which trained Chiang Kai-shek, and supported the republican movement of Sun Yat-sen when the West refused such aid. However, he does not draw the logical conclusion from this that the aid and leadership provided by the Soviet Union and its *déclassé* intellectuals should be considered as critical as Malraux suggests. Jenkins' failure to acknowledge this is due to his conviction that the nationalist Chinese movement was the most important one, and that it hated the interference of the Russians as much as it despised the British. With hindsight it can now be argued that the nationalist movement proved to be stronger than the communist one in the 1920s. But given the chaotic nature of Chinese politics at the time, and the failure of the West to support, at least initially, Sun Yat-sen, the role of the Soviet Union was crucial, particularly when Malraux wrote his novel. Paradoxically, it was the Soviet aid that greatly helped the nationalist movement of Chiang and the eventual defeat of the communists in Shanghai, much to Malraux's and Trotsky's chagrin.

The second kind of response to *The Conquerors* is political, and more complex because the arguments are both implicit and explicit. Explicitly, Boak and Jenkins argue that Garine is a fascist because of his obsession with power, violence, and superior individuals. Boak and Jenkins recoil from these obsessions because they consider them highly undemocratic

and, therefore, elitist (implicitly they support a democratic form of politics). In support of their argument they cite Garine's contemptuous attitude toward democracy: he considered democratic slogans "gibberish." However, this citation is taken out of context and ignores Malraux's explanation of its use in his response to Trotsky.

In this response Malraux makes it clear that he unequivocally supports the "democratic" goals of the Chinese Revolution. What he and Garine are opposed to is the mechanical way in which democratic slogans were recited[33] — so that they bore little relationship to the actual historical circumstances. Garine opposed the pacifist Cheng-Dai because his democratic ideals were rendered meaningless in the face of political opposition. Moreover, this pacifism was used by the warlords to support their antidemocratic government, and thereby undermine the hope for change. Thus ideals are mere phantoms unless they can be realized in action; or, conversely, good intentions (Cheng-Dai) can produce extremely bad consequences in politics.

Further, Malraux distinguishes between Garine's and Borodin's propaganda within the novel. Whereas Borodin emphasized that the oppressed proletariat, with the aid of the peasantry, would conquer power because it was their historically determined mission as outlined in Marxist theory, Garine conducted a form of propaganda that insisted that no dogma could guarantee the victory of the oppressed. On the contrary, Garine argued that unless the smoldering hatred of the Chinese masses could be transformed into superior organization and courageous action, they would remain "the conquered." Thus Garine collaborates with the Bolsheviks not because he is a Marxist, which he is not, but because he believes that the democratic goals of the revolution can best be realized through efficient organization, not "idealistic chatter."

Garine's obsession with power may be unpalatable, as is his proclivity for violence, but in the chaotic situation depicted in the novel (i.e., omnipresent violence, extreme political repression, and uncertainty) it appears unlikely that any democratic goals could be realized without violence. Contemporary political scientists in the West characteristically argue that democratic methods and a sense of efficacy offer powerful foundations for a democratic political system;[34] but in the absence of this type of system democratic methods may render the achievement of democratic reforms impossible, as is evidenced in the behavior of Cheng-Dai. Boak and Jenkins share the contemporary theorists' distaste for violent behavior, and also their unstated assumption that democratic goals can be achieved only through the democratic process. In the abstract this is certainly defensible, but it should not be forgotten that even in the West some of our most significant democratic gains have been achieved through violence, for

example, the French and American Revolutions.[35] Some of Garine's violence may be gratuitous, but this aspect of his personality should not be used to condemn categorically the use of political violence.

Irving Howe and Nicola Chiaromonte further develop Boak's and Jenkins's critique of Garine's activism.[36] Implicit in their argument is not only the claim that political violence is bad, but that Garine's is especially insidious because it is equated with irrationality and Stalinism. Thus Garine's support, despite severe reservations, of the Borodin-Comintern line is viewed as "dubious adventurism," in which the mind yields uncritically to an instinctual activism, which by definition has no logical foundation: it is "senseless."[37] This argument is tantamount to insisting that once an action is rendered questionable or ambiguous to our rational faculty, it is preferable not to act.

Howe envisions the similarity between Malraux and Trotsky primarily in terms of activism. Where Trotsky emphasizes the revolutionary party, Howe argues that Malraux emphasizes the revolutionary individual. This analogy is superficial because it ignores Trotsky's roles in the two Russian Revolutions and also Malraux's response to Trotsky's criticism of *The Conquerors,* in which he defends the fictional Garine's policy because Garine believed that it was the one most likely to strengthen the communist party in the long run. Howe overlooks the profoundly ambiguous nature of Trotsky's politics and the ways in which his ideas changed throughout his exceptional life. Although Trotsky finally (1917) accepted Lenin's position on the significance of the revolutionary party as a vanguard organization that would direct the masses, Trotsky's ideas before then should not be ignored, nor should his role in the leadership of the Petrograd Soviet in 1905. Trotsky's leadership of the Soviet was romantic because he envisioned himself as the representative of the masses. He was clearly no Leninist then and did not believe that a revolutionary theory of the party, such as Lenin's, was necessary for a successful revolution. Nicholas Krasso has recently argued that it is precisely because of this lack of an organization that could mediate the needs of the masses and defeat their opponents that the Petrograd Soviet and the revolution of 1905 failed.[38] From this perspective it appears that Trotsky's role was as undogmatic and romantic as Garine's: both were propagandists, reflective, highly individualistic, and convinced that they reflected the needs of the masses. Paradoxically, Garine is more efficiency-minded than the young Trotsky. He is also more pragmatic and willing to accept an incremental victory rather than insisting on a pure communist revolt as Trotsky did in his criticism of Garine and Borodin.

Howe distinguishes between Malraux's emphasis on the revolutionary individual and Trotsky's emphasis on the revolutionary party in order to

argue that Trotsky's — and, by implication, a Marxist's — understanding of history is deeper than Malraux-Garine's, because the latter do not accept the limitations of the historical moment whereas the former does. This distinction is questionable because it is based on a dogmatic interpretation of Marxism which insists that there is little place for revolutionary (political) initiative in history. On the contrary, it emphasizes the primacy of historical or economic determinism. However, Trotsky, Lenin, and Garine were not "orthodox" Marxists or revolutionaries; they saw in Marxism a revolutionary will (voluntarism) in addition to a determinism, and they emphasized the former aspect of Marxism, not its determinism. Even after Trotsky supported Lenin, it is crucial to observe that Lenin accepted Trotsky's theory of telescoping the bourgeois and socialist revolutions. This was antithetical to orthodox Marxism, which maintains that the two revolutions must be historically distinct. Thus Trotsky and Lenin shared Garine's romantic refusal to accept the "limitations" of history as prefigured. They were less the executors of history's inevitable laws than its makers. Howe's interpretation does not account for the fact that there are different Marxisms — a Romantic and a Classical one — nor does it demonstrate that Malraux's understanding of history is inferior to Trotsky's with specific reference to the Chinese Revolution depicted in the novel.

Both Chiaromonte and Howe insist that Garine's irritation with Borodin is a form of Trotskyism, which they define almost exclusively in terms of an opposition to Stalinism without discussing Trotsky's analysis of the novel or the Chinese Revolution. Though they refuse to offer a better "solution," they condemn Garine for silencing his doubts about the bureaucratization of the revolution, thereby implying that Garine's distaste for this type of mechanical organization is identical with doubting the substantive policy recommended by Borodin, i.e. class collaboration. This is misleading. Garine does not like the fact that victory demands a kind of organization that negates his individuality, but he agrees with Borodin over the choice of political strategy in Canton and Hong Kong.

To Chiaromonte, Garine's doubts about Borodin are sufficient justification for abandoning the revolution, because the likely consequences of the revolution will not correspond perfectly with either Garine's or its own ideal intentions. Consequently, he considers Garine's devotion to victory a mere fetish. In retrospect, the actual policy that Garine supported later proved to be catastrophic for the Chinese communists, because their former bourgeois allies in the Kuomintang annihilated them. In the uncertain circumstances depicted in the novel, as well as in the actual historical circumstances, it was impossible to know this. However, Chiaromonte insists that Malraux should have recognized that Borodin's

mechanical strategy contradicted the logic of reality itself;[39] this was something which Garine's Trotskyist ideas apprehended, but he silenced them in the name of pure action. Thus Chiaromonte and Howe categorically refuse to acknowledge that Garine's, and therefore Borodin's and Stalin's, policy of class collaboration appeared far more sensible in the political circumstances.

Underlying Chiaromonte's and Howe's extreme criticism of Garine's activism is the specter of Stalinism. Both identify Garine's actions with Malraux's subsequent "shabby defense" of Stalinism in the Spanish Civil War:

> His acts already announce the crazed Stalinist commissars who, in Spain, will make of the slaughter of their ideological adversaries a dogma to which practical reason itself must yield.[40]

This attack does not sufficiently take account of the ambiguity with which Malraux describes the Spanish Civil War in *Man's Hope* and is itself an ideological criticism rather than a well-defended argument. A more detailed response will be given to this criticism in the section on *Man's Hope*.

The third response to *The Conquerors* is Trotsky's. To him the novel is really a fictionalized chronicle, in which certain important political lessons emerge "unbeknownst to their author" because of his individualism and "aesthetic caprice":[41] — the very qualities that led Frohock to conclude mistakenly that Garine is essentially a tragic hero for whom the revolution is unimportant. Although Trotsky greatly admires Garine's revolutionary temperament, he is critical of him because he believes that Garine's rejection of revolutionary theory as "dogmatic rubbish" makes it impossible for him to understand correctly the events that Malraux so brilliantly depicted in the novel. Specifically, Trotsky argues that "a good inoculation of Marxism" might have prevented Malraux-Garine from making such disastrous political mistakes as supporting the Borodin-Comintern policy. Trotsky concluded rightly in 1931, six years after the implementation of that policy, that it had strangled the Chinese Revolution. He insisted that:

> The bureaucracy of the Komintern tried to "control" the class struggle in China, just as the international banking system controls the economic life of underdeveloped countries. A revolution, however, cannot be commanded. One can only give political expression to its interior forces. One must know to which of these forces one will link one's destiny.[42]

Thus Trotsky maintains that a correct theory can apprehend what those interior forces are, but, as Jenkins himself has argued, Trotsky did not

clearly favor the above position until 1927, when it was already too late; the failure of the Chinese insurrection can be attributed to the immense struggle between Trotsky and Stalin for control of the Comintern as well as the Soviet Union.[43] Nevertheless, Trotsky's criticism of Malraux-Garine is entirely political. Trotsky, the great symbol of the Bolshevik Revolution, now in exile since 1931, is really attacking the policy of his ideological and political enemy, Stalin, because his policy of collaboration sacrificed the interests of the Chinese masses from 1924–27; Trotsky believed that the novel attested to this political disaster. Yet this does not prove that Trotsky's policy of an independent communist insurrection would have produced better political results.

As in the 1905 revolution, Trotsky again emphasized that the revolution must be made from below, from its interior forces, and not imposed by a vanguard party if it is to be legitimate. From this vantage point he considers Hong the real hero of the novel because he represents the Chinese masses' undiluted revolutionary fervor that refused collaboration with the class enemy, even if only for strategic purposes.

Ironically, as Jean Lacouture has already pointed out, it is the novelist, Malraux, who answered the great revolutionary leader, Trotsky, in strategic political terms, not in idealistic ones.[44] Malraux argued that Hong represented only an "ethical" revolt that is anarchistic, and that this position, when combined with his terrorism and demands for immediate retribution, could not be achieved in political action. Malraux's perception is acute; apocalyptic visions are incompatible with revolutionary politics. Malraux shared Trotsky's sympathy for the oppressed but believed that in 1925 following Hong would result in immediate defeat, whereas collaboration at least held out the possibility for a future communist victory. Lastly, it must be emphasized that Trotsky's interpretation of Marxism was not necessarily the correct one; it certainly was not the only one, as Malraux reminded him — for example, Stalin and Borodin remained dedicated revolutionaries even if they disagreed with Trotsky's policies. While Garine had certain Trotskyist tendencies (his hatred of bureaucratizing the revolution), he refused to support Trotsky's thesis on the Chinese Revolution. In this instance, Trotsky was far more romantic and idealistic than either Malraux or Garine.

I have dwelt on *The Conquerors* because it is the work that announces most decisively Malraux's increasing dissatisfaction with the western cult of individualism and simultaneously, his own political radicalization. In spite of Garine's personal despair over the inevitability of his own death — personal defeat — and the ultimate power of Destiny, his revolutionary actions contain certain important fragments of hope for a better future, which are clearly perceived by David Wilkinson:

His own propaganda has convinced thousands who had no aspirations that their lives, their individual identities, were important: in them he has created a dream of victory, a hope for a future when they will live in dignity — and "it is hope that makes men live and die." They are defended by the hope, the myth, that he has created. He himself is briefly defended by the consciousness that he has created souls: "This is my work." And Garine finds to his surprise that in the struggle and desire for common victory he is bound more strongly to certain of his comrades than he would have believed; indeed, it is the death of one such man that precipitates his final decline into despair. Garine is barely conscious of the immense possibilities, the potential victories, which the sentiments of the believer, the creator, the fellow fighter contain.[45]

Although Malraux's relationship to Trotskyism, communism, and Marxism is ambiguous, in his two subsequent great political novels he will emphasize the quest for fraternity, community, and a type of dignity that could only be achieved through revolutionary action — tendencies undeveloped in *The Conquerors*. He thereby abandons the idea of the highly individualistic and alienated hero for the revolutionary hero.

From 1928–33, the years that separated the publication of *The Conquerors* and *Man's Fate,* Europe was rent by two tumultuous political events, namely the advent of Hitler and the threat of war. During this period Malraux became a leading spokesman of the left: he denounced fascism and French imperialism, "the accomplice of Hitler,"[46] and joined the Association of Revolutionary Writers and Artists in 1933. This was dominated by Vaillant-Couturier, a leading French communist, and by Maurice Thorez, who later became the Secretary of the French Communist Party. Clearly, the period was characterized by acute tension among European intellectuals. Malraux's writing as well as his actions were now based on a more positive conception of revolution and a hopeful future that communist society in general, and Soviet society in particular, despite its "painful abuses," represented, as opposed to western European civilization based on individualism.

III. *Man's Fate:* Malraux Reconsiders the Chinese Revolution

Man's Fate also focuses on the Chinese Revolution. In this novel Malraux examines the communist insurrection at Shanghai in 1927. The political themes are similar to the ones first developed in *The Conquerors*: should the communists collaborate with the Comintern and the bourgeois-dominated Kuomintang, or should they revolt independently and attempt to establish immediately a system based on soviets and radical agrarian reform — the redistribution of land and the abolition of rents (Trotskyism)? The major political policy articulated in this work is Trotskyist and anti-Comintern, and therefore represents a significant change from the political

rationale of the previous novel. The main political action in *Man's Fate* concludes with the destruction of the Chinese communists and their Trotskyist leader, the novel's hero, Kyo Gisors, by their former allies in the Kuomintang. However, Kyo is not driven to despair by personal failure or a sense of metaphysical defeat, as was Garine. On the contrary, Kyo is reconciled to his fate by the fervent conviction that he had devoted his life to the achievement of human dignity, which he identified with communism. Also, Kyo found a fraternity among his revolutionary comrades that overcame the kind of extreme solitude and individualism that tormented Garine.

> His life had a meaning, and he knew what it was: to give to each of these men whom famine, at this very moment, was killing off like a slow plague, the sense of his own dignity.[47]

> He had fought for what in his time was charged with the deepest meaning and the greatest hope; he was dying among those with whom he would have wanted to live; he was dying, like each of these men, because he had given a meaning to his life.[48]

Politically, the novel ends ambiguously. Although the Comintern's policy is discredited and the communists are defeated, hope for a future communist victory is implied by the journey of May, Kyo's wife, and Kyo's remaining comrades to Moscow. They will work in the Soviet Union, plan to return to China, and preserve the same revolutionary ideals that motivated Kyo; thus they remained to inspire the training of new revolutionary cadres who would not be overcome with a sense of defeat. May emphasizes this hope in a conversation with Kyo's father.

> The Revolution had just passed through a terrible malady, but it was not dead. And it was Kyo and his men, living or not, vanquished or not, who had brought it into the world.

> "I am going to return to China as an agitator. . . . Nothing is finished over there."[49]

Man's Fate is more complex than the earlier novel; there are more characters of importance. In addition to politics, it is characterized by an intense metaphysical perspective that views the human condition primarily in terms of its limitations: the failure of Man to live together harmoniously in society and his inability to reconcile himself with personal anguish and obsessions. This perspective is fundamentally pessimistic and is developed in its clearest form by Old Gisors, Kyo's father, who has given up training revolutionary cadres and has become an opium addict. He is purely contemplative; he understands and is fascinated by the frailty of the human

condition and the uniqueness of each individual. He believes that everyone requires a form of intoxication in order to escape the frustrations that are inherent in man's fate:

> Men are perhaps indifferent to power. . . . What fascinates them in this idea, you see, is not real power, it's the illusion of being able to do exactly as they please. The king's power is the power to govern, isn't it? But man has no urge to govern: he has an urge to compel. . . . To be more than a man in a world of men. *To escape man's fate.* . . . Not powerful: all-powerful. The visionary disease, of which the will to power is only the intellectual justification, is the will to god-head: every man dreams of being god.[50]

With the exception of Kyo and to a lesser extent his comrade, Katov, all of the characters enact this visionary disease of escape: Ferral through sex, Clappique by gambling and mythomania, Ch'en by murder, and Old Gisors through opium.

In spite of the apparent conflict between the novel's metaphysical pessimism and the optimism represented by Kyo's revolutionary ideals, the critics of the 1930s associated *Man's Fate* with Malraux's growing commitment to revolution.[51] Edmund Wilson argued that the novel was a clear statement of the fact that Malraux now respected only those characters motivated by the Marxist revolutionary will. [52] He identified Malraux's political ideals with those of the fictional Kyo and the historical Trotsky, but suggested that Malraux maintained a certain independence from Trotsky, although he never stipulated precisely how Malraux's ideas differed from Trotsky's.

What is most acute in Wilson's brief analysis of the novel is his emphasis on Malraux's definition of Marxism as primarily a will rather than a doctrine of inevitability or a type of fatality, an emphasis which Kyo himself makes in the novel when he refuses to obey the Comintern's orders to collaborate with Chiang. From this vantage point Kyo's commitment to revolution combines political action with the moral imperative to create the social conditions that will provide the basis for a political order in which dignity, the absence of class inequality and oppression and subsequent humiliation, will be possible for all. In 1927 Shanghai, Kyo insists that this can best be accomplished by opposing both Chiang and the Comintern. Thus Wilson's analysis makes it clear that Malraux's emphasis on the revolutionary will provides the novel with more than an examination of the apolitical and "mere theme of escape from the human situation."[53] To Wilson, therefore, the change in character from Garine to Kyo and the change in the concept of revolution from *The Conquerors* to *Man's Fate* demonstrated that, in line with Trotsky's advice, Malraux had made substantial progress in Marxism.[54]

Similarly, Ilya Ehrenburg, the Soviet writer and critic, responded to the novel by insisting that even though Malraux's characters are dominated by a sense of fatality that is irrelevant to politics, Malraux himself would not emulate Old Gisors; he would not be overcome with despair, focus only on the personal, and withdraw from political activism.[55] On the contrary, as Malraux's future activities would prove, he found it impossible to avoid proclaiming publicly the moral necessity for revolution in France, opposition to the Nazis, and the defense of Spain against Franco and the fascists. And once again Trotsky argued that Malraux's new book was a crushing indictment of the Comintern's policy in China. Trotsky still believed that Malraux did not understand political relations and their consequences but considered Malraux's novels as confirmation of everything that he and the left opposition in the Soviet Union had explained in theses and formulas.[56]

Contemporary critics, however, have divorced Malraux's interest in metaphysics and ethics from his revolutionary commitments and from the political significance of *Man's Fate*. Instead, they emphasize the universal aspects of the novel. To them, *Man's Fate* is essentially neither a form of historical reportage nor a political statement. Joseph Frank,[57] Howe, Frohock, Boak, and Jenkins argue that the novel is ambiguous politically and that Malraux's intense preoccupation with metaphysics, ethics (primarily Kyo's desire for human dignity for all), and myth (a form of utopia which is a negation of present evils) make it clear that the Chinese Revolution in particular, and revolutionary politics in general, serve Malraux only as a backdrop to examine these more fundamental themes, which constitute the real achievement of Malraux's art.

To Frank, Malraux's novel demonstrates that he is never interested simply in a particular social or economic injustice, but rather in man's immemorial longing for communion in the face of death.[58] From this perspective Malraux's heroes are viewed through the eyes of Old Gisors — they are struggling against the limitations of life itself.[59] To Howe and Frohock, Kyo's commitment to dignity supersedes his commitment to politics and to a particular party. Moreover, they underscore the contention that dignity is an ethical and not a political value.[60] Denis Boak argues that Kyo dies for a personal and not for a collective idea: his revolutionary action springs from altruism, not from his social position, because he is a bourgeois, not a member of an oppressed social class.[61] And Wilkinson maintains that Kyo's and Malraux's ideals represent a utopian myth of a harmonious future social order which he divorces from the political context of Malraux's biography and novel.[62]

The problem with these perspectives is that Malraux never divorces the political from the metaphysical, ethical, and utopian aspects of thought

and action. Some of Malraux's characters are unaware of or uninterested in politics, but his major characters, particularly Kyo and Katov, act politically. Kyo is certainly aware that his actions are ambiguous: disobedience of the Comintern will not produce immediate victory, but it will or could provide an alternative basis for a future revolution. Thus when Kyo learns about the inevitability of defeat by the Kuomintang he decides to resist:

> They might as well bequeath this cadaver to the next insurrectional wave, instead of letting it dissolve in crafty schemes. No doubt they were all condemned: the essential was that it should not be in vain.[63]

To abandon his communist comrades after the preparation of the insurrection, merely on the orders of the Comintern, would be tantamount to treason. Also, it is crucial to understand that Kyo had become a communist because he believed that the social order must be radically transformed in order for dignity to be possible for all. Without this commitment to revolutionary action his ideal would have been a harmless idea. However, his commitment to his comrades and the revolution indicates that for him politics and ethics are inseparable. Hence the profound ambiguity of the novel's politics does not mean that politics is of subordinate value to the metaphysical, ethical, and utopian. Kyo's revolutionary ideals and myth provided the rationale for Malraux's growing revolutionary commitment, as well as the model for future generations which would enact a revolution that was fundamentally different from the Soviet experiment.

Lastly, the fact that Kyo is a bourgeois does not nullify the revolutionary significance of his actions. One need not be a proletarian or peasant to be a revolutionary. What is important about Kyo's commitment is his identification with the oppressed rather than with his own social class. His value or ideal is not personal, but deeply political.

Where Frank, Howe, Frohock, and Boak underemphasize the role of revolutionary politics in the novel, Cecil Jenkins argues that Malraux's Pascalian metaphysical vantage point transforms it into a profoundly antirevolutionary work.[64] This criticism is the most radical and deserves a fuller treatment than the others because it most forcefully argues against reading the novel in political terms:

> No man can endure his own solitude. Whether by means of love, fantasy, gambling, power, revolt, heroism, comradeship, opium, contemplation or eroticism, it is this fundamental *angst,* consciously or not, that the characters of this novel — Communists, Fascists, terrorists, financiers, adventurers, police chiefs, opium addicts, artists and the women with whom they are

involved — are defending themselves, engaged as they are to the point of torture and suicide in the Chinese Revolution, upon which for some years depended the destiny of the Asiatic world and perhaps that of the West.[65]

This quote is taken from the novel's first advertisement, which Jenkins believes that Malraux personally wrote. From it he concludes that all of the actions catalogued above are of equal value to Malraux. In addition, he maintains that the final line is "something of a flourish." The significance of this interpretation is that Jenkins identifies the actions with the Pascalian idea of *"divertisement"*: the mode of life which man adopts as a "pathetic" attempt to conceal from himself the wretchedness of his condition.[66] All forms of action are equally self-deceptive and illusory.

For Jenkins the failure of Kyo to inspire his father with his revolutionary mission and Malraux's emphasis on the sad ends to which his characters come indicate that the idea of destiny not only obscures the value of revolution, but completely undermines it: *divertisements* do not overcome man's condition. Jenkins makes this resounding point by citing the capture of Kyo by the Kuomintang police because Clappique is unable to tear himself away from the roulette wheel to warn him of his imminent doom.

What can be the political force of a view of Marxism as will rather than "fatality" in a fictional world where Kyo's own life is suspended, and lost, on the most ironically trivial of "fatalities," the obsession of the marginally Dostoevskyean clown Clappique, lingering fatefully at the roulette table, with a perversely spinning ball?

Politics implies acceptance of the reality of the world. The pessimism of Malraux's Pascalian perspective and the whole tone and structure of the novel tend to deny that reality. The Chinese revolution and the historical possiblity in general are everywhere subordinated to the monolithic and, in the event, very European idea of Destiny.[67]

There are three major problems with Jenkins's interpretation. First, he insists that Kyo be identified with the historical Chou En-lai; if Malraux wanted to be historically accurate, he would have had Kyo escape from Shanghai as Chou had. Second, he fails to see that Malraux's characters and their *divertisements* are not of equal value. Third, his conception of politics is too simplistic.

Earlier, Frohock had identified Kyo with Chou En-lai and drawn a similar conclusion. However, Kyo need not be identified with Chou in order to represent the type of communist who rebelled against Moscow's orders and who was subsequently captured by Chiang's police. For the purposes of fiction, the import of Kyo's death is dramatized by his willingness to sacrifice his life for the collective struggle. This is precisely

how Kyo envisioned his death: "What would have been the value of a life for which he would not have been willing to die?"[68] Thus the fact that Kyo is captured because of Clappique's trivial fatality can be used to illustrate the radical difference between the blindness and relative emptiness of Clappique's life and Kyo's profound commitments, which are based on lucidity and free choice — a contrast Frohock has already pointed out.[69] Here fatality does not contradict the political import of the novel; it enhances it.

The values of the characters are not equal. Kyo and Katov are superior to Clappique, Ferral, Old Gisors and the others precisely because their lives are based on collective values that surpass their own individuality. Frohock, Howe and Wilkinson also indicate this, but insist that this superiority, particularly Kyo's, is due to ethics, which they divorce from political commitments. Kyo's and Katov's commitment to collective values protects them, unlike the other characters, from despair. Moreover, the fact that Old Gisors does not emulate his son does not mean he denies the values for which Kyo died. On the contrary, it testifies to his intellectual paralysis. Though he personally refused Kyo's ideals, May and Kyo's former comrades did not. They too saw in Marxism a revolutionary will. It should not be forgotten that Old Gisors was representative of an older generation and that it was he who remained faithful to traditional mandarin values.

Lastly, Jenkins's conception of politics as an acceptance of reality is very conventional and narrow. Surely, parliamentary and democratic politics implies an acceptance of "the rules of the game," but revolutionary politics declares that the rules are not just and democratic — if they were, then there would be no need for revolutionary change — and must be transformed. The espousal of revolutionary politics indicates that the traditional distinctions between ethics, metaphysics, and politics are considered illegitimate and inseparable. Whereas traditional politics is restricted to known limits, revolutionary politics obscures or transcends these limitations on acceptable actions and thereby redefines politics. This challenge to previously accepted limits is what accounts for the apocalyptic nature that often characterizes revolutionary thought.

Moreover, Malraux's intense interest in the Chinese Revolution and his fascination with revolutionary ideals indicates that Jenkins's dismissal of the import that Malraux attached to the Chinese Revolution is a serious misreading. Malraux's concept of revolution may be romantic because it implies a Trotskyist position which was defeated, but this does not negate the political content of his thought. Also, Malraux's metaphysical perspective is pessimistic because it asserts that no form of society — even one based on the communist ideals embodied by Kyo — can entirely

eliminate personal suffering. However, in *Man's Fate* it is clear that the personal aspect of suffering is infinitely less important than the struggle of the communists to eliminate the most acute form of fatality — a social order and repressive political system that humiliated the lower classes. Thus the novel is a very political statement in which Malraux abandons the extreme individualism and alienation of a Garine for the social idealism represented by Kyo's refusal to accept the political system as "given" and therefore legitimate. Kyo is a romantic revolutionary who insists that social and political systems are entirely human creations, and must be made to respond to our highest ethical values: such values can only be achieved through revolt.

IV. *Man's Hope:* Malraux Defends the Spanish Republic and Is Sympathetic to the Communists

If there could be any doubt about this dramatic change in *Man's Fate,* then Malraux's writing and activities from 1933–37 should provide sufficient evidence of his new political ethic. As Jean Lacouture has indicated, during 1933 and 1934 Malraux envisioned himself as a sympathizer of Trotsky's if not actually a Trotskyist.[70] In July 1933 he met Trotsky in France and, before the Association of Revolutionary Artists and Writers, defended Trotsky's revolutionary heroism and ideals against certain communists who accused him of being a counterrevolutionary and a fascist.[71] To Malraux, Trotsky was a romantic figure, a great revolutionary leader whose actions had transformed history. However, with Hitler's growing power and the rise of Franco, Malraux abandoned his Trotskyist sympathies because he identified fascism as the major enemy.[72] While Trotsky argued that Stalinism was to be relentlessly combated and continued calling for revolution in the Soviet Union, Malraux sided with Stalin and the Comintern's decision to aid Spain because he believed that the communists were the only force capable of defeating Franco.[73] Trotsky denounced Malraux's defense of Comintern policy in Spain because he believed that it obscured the fact that Stalin was annihilating former Russian revolutionaries. He also equated this policy with Stalin's earlier catastrophe in China. Trotsky was correct in arguing that Stalin was destroying his opponents in the Soviet Union, but Malraux believed that these abuses should not be allowed to enervate the antifascist struggle or besmirch the dignity of communism. In an interview in *The Nation* Malraux answered Trotsky's charges by declaring that "just as the Inquisition did not affect the fundamental dignity of Christianity, so the Moscow trials have not diminished the fundamental dignity of communism."[74] By 1937 Malraux and Trotsky were bitter political enemies. In additon to debating Trotsky in magazines and newspapers, Malraux

embarked on a speaking tour of the United States in order to raise money for the Republicans and formed an air squadron of his own to fight in their defense.

By the writing of *Man's Hope* it was clear that Malraux was a committed antifascist. He had travelled to Moscow to attend a writers' conference and had described himself as a revolutionary writer who was prepared to take up arms in defense of the Soviet Union if war broke out.[75] He proclaimed that communist society could supplant the exaltation of individualism in the West with the concept of Man. Instead of an emphasis on what separates each individual, there could be a culture founded on what unites all; this would provide the basis for a new humanism.

Man's Hope differs from *The Conquerors* and *Man's Fate* because there is less character development and no single character dominates. On the contrary, what dominates is a series of intense political discussions about the nature of the Spanish Civil War by numerous combatants — communists, anarchists, and Christians. Also, there is emphasis on the ultimate aims and immediate strategy of the war, plus discussions of the relative value of politics. The novel actually examines the first year of the war and concludes that the Republicans can and will defeat the fascists if they adopt the discipline of the communists. This type of discipline is represented in the novel primarily by Garcia and Manuel. It is crucial to emphasize, however, that both are intellectuals (as are the other leading characters) who understand the fundamental ambiguity of revolutionary politics and the immense price that one must pay in individual terms if one submits to communist discipline. Garcia and Manuel accept the discipline only with great reluctance in order to avert the greater evil of fascism. They are contrasted with the anarchists, who refuse to compromise the purity of their values in the name of political efficacy. In spite of Malraux's preference for the position of the communists, he portrays the anarchists and the other opponents of the communists with sympathy. This is epitomized in Garcia's discussion of the revolution with Hernandez, an officer with anarchistic values.

> The communists, you see, want to get things done. Whereas you and the anarchists, for different reasons, want to be something. That's the tragedy of a revolution like this one. Our respective ideals are so different; pacifism and the need to fight in self-defense; organization and Christian sentiment; efficiency and justice — nothing but contradictions. We've got to straighten them out, transform our apocalyptic vision into an army — or be exterminated. That's all.[76]

Man's Hope is not entirely about the Republican resistance to Franco; it also has an apolitical or metaphysical dimension represented by Old Alvear. Alvear resembles Old Gisors and Cheng-Dai of the earlier novels.

In the midst of the brutal fighting Alvear, an art historian, refuses to become politically committed because he is not convinced that the extreme violence and discipline necessary for a communist victory will be better than fascism; he remains committed only to his art. Thus, if the novel concludes with the hopeful implication that the Republicans can defeat the fascists, then this conclusion is severely qualified by the pervasive sense of suffering and violence that must accompany such a victory.

All of the critics agree that this novel is fundamentally political and that Malraux's sympathies greatly influenced its construction. Although a few argued that Malraux's personal experience in the Civil War deepened the meaning of the novel and made it one of his most profound, the majority were very disturbed by what they perceived as communist propaganda or the shabby defense of Stalinism. In varying degrees Frohock, Howe, Chiaromonte, and Dupee have argued that the book is pure communist propaganda, or that it slanders the anarchists. This criticism is an overreaction; it also overlooks the complexity with which Malraux portrayed the competing values of the different factions in the Republican army. The rationale of Garcia and Manuel is that of Garine and Borodin, and their differences with the anarchists are the same as Garine's with Hong. In retrospect Malraux's policy and that of Garcia and Manuel failed in Spain, but this does not mean, as Chiaromonte suggests, that the value of efficacy represented by the communists in the novel is diminished.[77] Nor does it mean that Malraux countenanced the annihilation of the anarchists in the novel (according to Lacouture's account it is not exactly clear to what extent Malraux supported communist surveillance of the anarchists in his own squadron). The novel illustrates how deeply Malraux understood that it is easier to talk about than achieve a society based on humanitarian values and that, at a minimum, it was necessary to defeat fascism for these values to exist. He was honest enough to show that in a civil war violence is unavoidable and may be used to achieve desirable as well as undesirable consequences.

V. Conclusion

From *The Conquerors* (1928) to *Man's Hope* (1937) Malraux became radicalized along with a particular segment of European and American intellectuals. He became a leading "committed writer" rather than a "dominated one," although a metaphysical perspective is important in his political novels. French imperialism, fascism, and nazism and the alienation produced by an excessively individualistic culture, as well as an empathy for the oppressed, led Malraux to conceive of communism and the Soviet Union in positive terms in the 1930s. However, Malraux never

adhered to orthodox Marxist theory. If he may be called a Marxist, then it is necessary to see him from the vantage point of the young Marx, who, combining the ethical imperative of Kant with Rousseau's creative Legislator and Hegel's sense of history, argued that all those conditions which debased man must and will be eliminated.[78] Yet even during his most revolutionary period Malraux never totally abandoned a perspective that dramatized the suffering of distinct individuals.

Although Malraux greatly admired Trotsky, he disagreed with him over specific political tactics. Garine and Kyo share Trotsky's immense energy, activism, and heroism. In actual controversy Malraux supported political efficacy in the Chinese Revolution and Spanish Civil War, while Trotsky espoused more apocalyptic and romantic goals. Only *Man's Fate* is dominated by a Trotskyist rationale which emphasizes the betrayal of the Comintern. Why Malraux changed is still open to conjecture. Dupee claims that Malraux became critical of the Comintern's quiescence in the early thirties[79], and Wilson suggests that it marked an advance in Marxism for Malraux. Dupee's position seems more nearly accurate, although it could also be argued that Malraux had had sufficient time to recognize that the Comintern's policy had resulted in disaster — something he could not understand in the midst of writing *The Conquerors*. Thus Malraux admired Trotsky's heroism and ideals, but rejected his policies.

After *Man's Hope* Malraux's politics changed dramatically when he became a Gaullist minister and anticommunist. If he had supported communism and the Soviet Union in the 1930s because they were weak and because they represented a romantic form of revolt, then he rejected them in the postwar years because the Soviet Union had become an immensely powerful state that was extremely repressive and that thereby betrayed its earlier hope of founding a new humanism. Instead, Malraux viewed the Soviet Union as a severe threat to Western democratic values and culture.

Malraux began to write philosophy of art and art history, but his literary talents will not be recognized because of these works. On the contrary, it is ironic that his reputation as a great writer will be preserved by his political novels, in which he identified with those communist revolutionaries and ideals that he had long since abandoned.

Notes

1. This is stated most forcefully in the excellent collection of essays edited by R.W.B. Lewis, *Malraux* (Englewood Cliffs, N.J.: Prentice-Hall, 1964). Lewis in particular underscores the unity of Malraux's work in the introduction. W.M. Frohock makes essentially the same argument in *Andre Malraux and the Tragic Imagination,* (Stanford: Stanford University Press, 1952), but this outstanding work does not take into account Malraux's post-World War II

writing, his nonfiction, or his political activities. Interestingly, Jean Lacouture's recent biography, *Andre Malraux,* trans. Alan Sheridan (New York: Pantheon, 1975) also insists that Malraux's vision has remained constant. In addition, see the special Malraux issue of the 1957 *Yale French Studies;* David Wilkinson, *Malraux: An Essay in Political Criticism* (Cambridge: Harvard University Press, 1967); Cecil Jenkins, *Andre Malraux* (New York: Twayne Publishers, 1972); and Irving Howe's analysis of Malraux in *Politics and the Novel* (Cleveland: World Publishing Co., 1957).

2. Virtually all of Malraux's recent critics share this view. This is particularly ironical for writers like Lacouture, Wilkinson and Howe since they acknowledge Malraux's fascination with politics and power. Nevertheless, they are hesitant to emphasize the pervasive influence of politics on Malraux's vision and activities. Instead, they concentrate on the role of myth and metaphysics. However, the argument maintained here is that, though these aspects certainly should not be ignored or underemphasized, it is a serious mistake to underestimate the political aspects of Malraux's work, i.e., it is unnecessary to elevate the metaphysical and mythical significance at the *expense of* politics. On the contrary, Malraux's great novels demand our attention precisely because they integrate and blur the standard distinctions between the political, metaphysical and mythical. It should also be pointed out that those critics who "detect" a "political line" in Malraux's work are quick to maintain that this interest is disastrous to his creativity as a writer. See particularly the analysis of Frohock and Howe of *Man's Hope* and Nicola Chiaromonte's general assessment of Malraux, "Malraux and the Demons of Action," in Lewis, pp. 96–116. It is clear that the literary critics feel much more comfortable with aesthetic problems or with the depiction of political events that appear remote, i.e., those like the Shanghai and Canton uprisings that Malraux describes in *Man's Fate* and *The Conquerors,* which do not arouse the political passions of the critics in the same way that the Spanish Civil War, analyzed in *Man's Hope,* does.

3. See especially Lewis's introduction and Joseph Frank, "Andre Malraux: The Image of Man," pp. 71–85, in Lewis.

4. Lewis, *Malraux,* Introduction.

5. Frohock, *Andre Malraux and the Tragic Imagination,* p. vii.

6. Frohock, *Andre Malraux and the Tragic Imagination,* p. xii.

7. Wilkinson, *Malraux: An Essay,* pp. ix–xi.

8. F.W. Dupee, "Andre Malraux," *Partisan Review,* 5, 4 (March 1938), pp. 24–35.

9. Chiaromonte, " Malraux and the Demons," pp. 106–110.

10. Howe, *Politics and the Novel,* p. 213.

11. Lacouture, *Andre Malraux,* p. 167.

12. This aspect of the novel is considered only by Wilkinson and Lacouture.

13. This quotation is from Malraux's *The Temptation of the West,* cited in Irving Howe, *Politics and the Novel,* p. 207.

14. Frohock, *Andre Malraux and the Tragic Imagination,* p. 44.

15. Jenkins, *Andre Malraux.*

16. *Denis Boak, Andre Malraux* (Oxford: Oxford University Press, 1968).

17. Frohock, *Andre Malraux and the Tragic Imagination,* pp. 43–44.

18. Jenkins, *Andre Malraux,* pp. 66–69.

19 Ibid.

20. Cited in Lacouture, *Andre Malraux,* p. 134.

21. Ibid.
22. Wilkinson, *Malraux: An Essay,* p. 41.
23. Cited in Lacouture, *Andre Malraux,* p.134.
24. Walter Langlois, *Andre Malraux: The Indochina Adventure* (New York: Praeger, 1966).
25. Lacouture, *Andre Malraux,* p. 131.
26. See particularly Malraux's response to Edmund Wilson's review of his work in Lewis, *Malraux,* p. 30.
27. Cited in Lewis, *Malraux,* p. 20.
28. Reprinted in Lewis, "Reply to Trotsky," pp. 20–24.
29. Frohock, *Andre Malraux and the Tragic Imagination,* p. 44.
30. Frank, *Andre Malraux: The Image,* p. 72.
31. Alvin Gouldner, "Prologue to a Theory of Revolutionary Intellectuals," *Telos,* 26 (Winter 1975–76) pp. 9, 12.
32. Ibid., p. 12.
33. This is somewhat ambiguous in the novel, but in his "Reply to Trotsky," p. 20, Malraux makes the point unequivocally.
34. Gabriel Almond and Sidney Verba, *The Civic Culture* (Princeton: Princeton University Press, 1963).
35. See especially Barrington Moore, Jr., *Social Origins of Dictatorship and Democracy* (Boston: Beacon Press, 1966).
36. See Howe and Chiaromonte. Their analyses focus on Garine and on the communist characters in *Man's Hope,* whom both Howe and Chiaromonte agree are dreadful Stalinists.
37. Chiaromonte, "Malraux and the Demons," pp. 106–110.
38. Nicholas Krasso, "Trotsky's Marxism," *New Left Review* 44 (July–August, 1967), pp. 64–85.
39. Chiaromonte, "Malraux and the Demons," pp. 106–110.
40. Ibid., p. 104.
41. Leon Trotsky, "The Strangled Revolution," in Lewis, p. 13.
42. Ibid.
43. Jenkins, *Andre Malraux,* pp. 67–68.
44. Lacouture, *Andre Malraux,* p. 221.
45. Wilkinson, *Malraux: An Essay,* p. 41.
46. Lacouture, *Andre Malraux,* p. 166.
47. Andre Malraux, *Man's Fate,* trans. Haakon Chevalier (New York: Modern Library, 1934), p. 70.
48. Ibid., p. 223.
49. Ibid., p. 353.
50. Ibid., p. 242.
51. Lacouture, *Andre Malraux,* p. 167.
52. Edmund Wilson, "Andre Malraux," in Lewis, *Malraux,* p. 29.
53. Ibid., pp. 27–29.
54. Ibid., p. 29.
55. Cited in Lacouture, *Andre Malraux,* p. 163.
56. Ibid., p. 227.
57. Frank, *"Andre Malraux: The Image,"* p. 72.
58. Ibid.
59. Ibid.
60. This is a general problem in the literature that obviously raises the difficult

political problem of Malraux's changing ideologies — from fellow-traveler to Gaullist minister.

61. Boak, *Andre Malraux,* p. 71.
62. Wilkinson, *Malraux: An Essay,* especially chapter 3, "The Bolshevik Hero." It is probably more accurate to argue that Wilkinson distinguishes too clearly and emphatically between Kyo's "ethics" and his political commitment. Although Kyo certainly rebels against the "mechanistic" determinism of the Comintern, embodied in Vologin's orders for the communists to surrender their arms to Chiang, it is also clear that Kyo remains a dedicated "Communist," albeit one who is motivated by the Marxist "will" as his father, Old Gisors, had taught him.
63. Malraux, *Man's Fate,* p. 156.
64. Jenkins, *Andre Malraux,* pp. 63–65, 69.
65. Cited in Ibid., p. 63. This quote comes from the original "blurb" that accompanied the first announcement or advertisement of *Man's Fate* in the June, 1933 issue of *The New French Review (La Nouvelle Revue Francaise).* Jenkins insists that it was probably penned by Malraux or that at the very least that Malraux approved of it.
66. Ibid., p. 64.
67. Ibid., p. 69.
68. Malraux, *Man's Fate,* p. 323.
69. Frohock, *Andre Malraux and the Tragic Imagination,* p. 89.
70. Lacouture, *Andre Malraux,* p. 227.
71. Ibid., p. 226.
72. Ibid., p. 228.
73. Ibid., pp. 228, 233.
74. Ibid., p. 230.
75. Ibid., p. 174. Malraux actually made this statement on June 16, 1934 in *Literaturnaia Gazeta* in response to Paul Nizan's charge four days earlier that he was not a revolutionary writer.
76. Andre Malraux, *Man's Hope,* trans. Stuart Gilbert and Alastair Macdonald (New York: Random House, 1938), p. 174.
77. Chiaromonte, "Malraux and the Demons," p. 106.
78. Karl Marx, "Contribution to a Critique of Hegel's Philosophy of Right," in *The Marx-Engels Reader,* ed. Robert Tucker (New York: W. W. Norton, 1972), p. 18.
79. F.W. Dupee, "Andre Malraux," pp. 24–35.

Chapter Six
Hermann Hesse: Passion and Politics

Samuel H. Hines, Jr.

I. Introduction

For many the works of Hermann Hesse, the Nobel-prizewinning German author, may be known only as a part of the "counterculture" literature so popular in this country in the late 1960s. Hesse is one of many authors whose works, viewed simplistically, concern individuals seeking to find themselves in a "world gone mad." Escapism, flirtations with the mysteries of the East, antiestablishmentarianism, Bohemianism, and themes of alienation — these and much more can be found if one pursues Hesse's works with only a modicum of sensitivity and awareness. The popularity of *Demian, Steppenwolf, Siddartha,* and *Journey to the East,* works now readily available in paperback, rivaled that of American authors including Joseph Heller, Saul Bellow, and Kurt Vonnegut.

Unfortunately the popular and oversimplified view of Hesse's work ignores the more subtle and, from the political theorist's point of view, more significant themes of Hesse's novels, essays, and poems. The development of Hesse's novels represents a complex and detailed, though often repetitive, examination of the human condition and includes numerous themes not adequately identified by many of Hesse's readers and critics. One of the most important of these themes is the problem of "self" in relation to community. This, in fact, is the theme which will serve as the focal point of this essay.

The secondary literature on Hesse, most notably the studies of Theodore Ziolkowski, attests to the seriousness of Hesse's literary works, though most would agree that a distinction must be made between the early and the later works of the artist.[1]

Despite this relative abundance of secondary literature and the availability in English translation of nearly all, if not all, of Hesse's works, there has been very little discussion (outside of biographical information) of Hesse's political views and of the political significance of Hesse's writings. Robert Galbreath's important, but all-too-brief study, "Herman Hesse and the Politics of Detachment,"[2] represents one of the few explicitly political studies in English. I must concur with Galbreath that one of the important factors contributing to the neglect of Hesse is the seemingly unpolitical image of Hesse's work — an image that I shall argue is altogether inaccurate. The problem is not that Hesse fails or chooses not to deal with political phenomena; rather the problem relates to the all-too-narrow "orthodox" view of what constitutes "political phenomena." Quite clearly, Hesse and his work will be of little interest to the empirically oriented political scientist. But Hesse's concern with the "self," with the nature of man, the purposes of human existence, and the nature of "community" qualify him as a writer whose subject matter is of vital interest to the normative theorist and the statesman, at least if the latter is genuinely concerned with the perennial problems of legitimate rule and statecraft. Hesse's attempt to understand man's relation to his fellow man and his "obligations" to himself and others puts him squarely in the midst of a venerable tradition of political philosophers beginning with Plato and ranging up to our contemporary, Hannah Arendt.[3]

Hesse is not easily classified, either in political terms or as a literary figure, which makes characterization of his work more difficult. The "psychological" dimension of his novels, for example, is troublesome and merits our further consideration below.[4] In addition, Hesse's commitment to individualism, pacifism and internationalism — apparent in his work and his life — are important political positions we shall be concerned with.

In the remainder of this essay I shall treat the following issues. First, I shall clarify what I perceive to be the central political question or issue in Hesse's life and writings and a fundamental dilemma of our age. That is, what is the social responsibility or obligation of the individual — in this case an *intellectual* — and what course of *action* is required to allow for self-development in the context of a human community? To accomplish this I shall contrast Hesse's position with traditional answers to this question as proposed by other German intellectuals — an alternative which I define (following Galbreath) as the politics of withdrawal. Then, in the main section of the essay, I shall consider the views of Hesse in detail, outlining what I identify as his "politics of self" which is an affirmation of communal existence and historical commitment that in some important respects resembles the political philosophy of Hannah Arendt. In the course of elaborating Hesse's views I shall consider the impact of Jung on Hesse's writings, as it relates to Hesse's political views.

II. Individualism, Freedom and Order in the Modern World:
Hesse and the Role of the Intellectual in Society

Because Hesse is so often stereotyped as an advocate of dropping out and doing one's own thing, it is important to begin by describing the dominant political context in which any study of literary figures and intellectuals must occur today. At the risk of oversimplifying the situation, but at the same time reinforced by the persistent development of this line of argument by such political and social theorists as Hannah Arendt, Sheldon Wolin, Carl Friedrich, and Robert Nisbet, I would suggest that the essential dilemma of modern times is the tension between the ever-increasing demand for personal freedom and the perennial requirements for social order.

The contemporary period in Western history (and perhaps world history) has been characterized by the breakdown of community and the assertion of self, particularly as the politics of self is represented in the extreme individualism that dominates American society and politics today. This individualism is designated by some theorists (notably Lowi and Kariel) as interest-group liberalism, and the resultant society is said to be "pluralist" in nature. It is perhaps accurate to say that apathy, alienation, and rebellion are all indicators of the successive loss of community in the form of church, family and polity. The new freedom that results is a form of freedom that is based on a positive valuation of the privatization of the individual. Concern over the rejection of tradition and subsequent loss of authority and community has been evidenced primarily, though not exclusively, by conservative thinkers. Some of the radical literature (e.g., the works of Herbert Marcuse) bears witness to the eclipse of community and of public action in the face of privatization. It must be said, however, that the recommendations of Marcuse and others would suggest that retreat from action, especially in the American context, may be a legitimate option.

To suggest that the modern age is an "Age of Anxiety" brought on by the isolation of man from his fellow man does indeed imply a reduction or "loss" of politics, as the available "political space" is reserved for fewer and fewer political actors. In turn, this implies a movement toward statism (centralization and bureaucratization). We witness, regardless of ideological preference, governments being transformed into corporations, with the isolated individual becoming objectified for purposes of design and control with the latter euphemistically described as "planning."

Hesse's concern with this modern problem as it manifested itself in Germany would alone seem to justify our interest in his life and work. As a German writer he would seem an obvious choice as an example of an intellectual who had to face the dilemma of choosing between political

commitment or political withdrawal in the face of political and social events that for him represented a breakdown in civilization. Let us consider, for a moment, these two options as they have been viewed by German intellectuals.

III. Political Withdrawal and the German Intelligentsia

Edward Shils, eminent sociologist and student of intellectuals and their relationship to society, has been particularly concerned with the obligation of intellectuals to the "center" of society — the responsibility of intellectuals to transmit from one generation to the next the central values and traditions of the society. Intellectuals, by virtue of their avowed pursuit of knowledge, are prone to find themselves faced with contradictory pressures, often emanating from sources of power within the society. According to Shils,

> The tension between the intellectuals and the powers — their urge to submit to authority as the bearer of the highest good, whether it be order or progress or some other value, and to resist or condemn authority as a betrayer of the highest values — comes ultimately from the constitutive orientation of the intellectuals toward the sacred.[5]

As critic, the intellectual performs what Shils terms the "rejection function." This is the important function of "molding and guiding the alternative tendencies which exist in any society." Withdrawal, given this understanding of intellectual roles, amounts to the abandonment of the rejection function and, consequently, the loss of ability to deny, when appropriate, the legitimacy of the "powers."

This fundamentally ambivalent relationship with "the powers" has resulted in the emergence of several intellectual traditions, according to Shils. The first of these is scientism, which rejects tradition outright. Romanticism, a second, tends to be in opposition to scientism and "starts with the appreciation of the spontaneous manifestations of the essence of concrete individuality."[6] The apocalyptic or millenerian intellectual tradition is exceedingly complex and encompasses aspects of scientism and romanticism, depending upon which examples of the tradition one considers (e.g., Marxism as opposed to heretical Christian sects). The populist intellectual tradition represents a fourth, characterized by "a belief in the creativity and in the superior moral worth of the ordinary people, of the uneducated and unintellectual."[7] The last, in Shils's typology, is the anti-intellectual tradition of order which he claims is best represented in "the West in the form of French positivism (Saint-Simon and Comte)" and "has its roots in antiquity and in the belief that excessive intellectual analysis and discussion can erode the foundations of order."[8]

Among German intellectuals, particularly during the nineteenth century, the romantic and populist traditions have been predominant.

> German historical and philological scholarship in the nineteenth century — imbued with the romantic hatred of the rational, the economic, the analytic spirit, which it castigated as the source and product of the whole revolutionary, rationalistic trend of Western European culture — discovered in the nameless masses, the folk, the fountain of linguistic and cultural creativity.[9]

Questions concerning participation by German intellectuals in political life are more difficult to answer. There is a tradition running from Goethe to Thomas Mann which eschews political involvement.[10] At the same time, however, there is evidence of considerable participation by intellectuals in German politics, although these are professional intellectual types, largely the professoriate.[11] The proper placement of Hesse in relation to these alternative views of the German intelligentsia requires a closer look at the former tradition of withdrawal.

From the standpoint of the individual artist the decision to commit oneself to a life that encompasses political activism or to withdraw from politics is a matter of personal choice. In both instances the "political" is of great significance, the difference being that, in the latter case, the decision stems from a perception of politics as a destructive rather than a creative force. Levi feels that the apolitical characteristic of many humanist intellectuals is "an enduring German cultural characteristic."[12]

> There has always been a persistent German conception that politics and culture are antithetical, and that humanity of the writer and the artist should express itself in extrapolitical territory. It is typical of the German intelligentsia of the nineteenth and twentieth centuries (figures like Schopenhauer and George, Hofmannsthal and Rilke) that it should have withdrawn from the political arena out of a contempt for its debasement of values, and isolated itself from political conflict in order to maintain the aesthetic purity of literature and the arts.[13]

We shall not consider the interesting and important question of why these figures may have withdrawn. To do so would take us beyond our immediate concern with Hesse specifically. We must, however, note Levi's contention that Goethe set the tone for this particular style and observe that Levi sees Thomas Mann as exemplifying this posture among more modern German intellectuals.

> The fact that a figure of the commanding stature of Goethe should make the great refusal of politics, should establish with force and authority the stereotype of the productive and self-sufficient artist withdrawn from the political arena as from a plague, was to dominate the cultural life of Germany

for one hundred and fifty years, and to foreshadow in ways yet unforeseen the tragedy of the Third Reich. . . . He confessed that he preferred injustice to disorder, but the order which he sought was of the personal rather than of the political kind. His reverence for creative achievement, and for the perfection of one's own talents, his aversion to politics and to the various revolutionary strategies for social reform, have come down unbroken, carried by the German intelligentsia of the nineteenth century, into the possession of Thomas Mann.[14]

The foreshadowing of later events suggested by Goethe's withdrawal is brought to fruition in Mann's conviction that "democracy, even politics itself, is strange and unnatural to the German spirit."[15] Although it could not be construed as an explanation of the difference between Hesse and those German writers who are included in this tradition of refusal, Levi's omission of any reference to Hesse in his treatment of German intellectual withdrawal is significant and not inconsistent with other studies of German intellectuals, particularly literary figures during the Weimar period and under Nazi rule.[16]

How then does Hesse differ from this tradition, if indeed he does? If he is not to be included among those who "refused," what is the basis for excluding him? The answers to these questions require that we first take a brief look at the content of his essays and novels.

IV. Hesse's Politics of Self

According to Galbreath, Hesse attracted very little attention during this period, his only significant political writings being *Zarathustras Wiederkehr* (1919) and numerous "scattered pieces" on politics, some of which were published anonymously or carried the pseudonym of Emil Sinclair. Though this is correct, Hesse was, in addition, by his own account actively involved with liberal oppositionist publications *(Marz* and *Simplicissimus)* and was the cofounder of one such publication *(Marz).*[17] Though his political essays were not published as a collection until 1946, taken individually the essays portrayed consistently and vigorously his anti-war feelings and his anxieties regarding the final results of German xenophobia.[18]

Again, Galbreath is admittedly correct in stating that a "breakdown of original publication dates" indicates that the political essay was not Hesse's regular fare, but Galbreath fails to note that the concentration of essays is heaviest during the war years; and, after all, one need not infer that a literary figure is apolitical simply because he ceases to deal frequently or explicitly with politics when the larger environment becomes less hazardously politicized. The issue of withdrawal is important in the context of a

highly politicized environment and, in this case at least, Hesse responded rather vigorously. Hesse himself addresses this matter in the foreword to the 1946 edition of his essays, *If the War Goes On . . .* :

> A glance at the table of contents will show that I wrote "political" or timely articles only in certain years. But from this it should not be inferred that I relapsed into sleep in between, and turned my back on current affairs. To my own great regret, this has been impossible for me since my first cruel awakening in the First World War. Anyone who looks into my life work as a whole will soon notice that even in the years when I wrote nothing on current affairs the thought of the hell smoldering beneath our feet, the sense of impending catastrophe and war never left me. From *Steppenwolf,* which was in part a cry of anguished warning against the approaching war and which was attacked and ridiculed as such, down to *The Glass Bead Game* with its world of images seemingly so far removed from current realities, the reader will encounter this feeling time and time again, and the same tone may be heard repeatedly in the poems.[19]

It must also be mentioned, not as justification but explanation, that from 1916 through the interwar period, Hesse experienced a period of personal crisis; his previously high level of productivity was reduced, and more of his time was devoted to the writing of poetry — a medium far less amenable to public consumption — than to the publication of essays and novels.[20] This, however, was a rich period for Hesse and had a major impact on the course of his life and career as a writer, an impact ignored by some who have too readily dismissed Hesse as an unpolitical or apolitical writer.

Galbreath has seen fit to characterize Hesse's political philosophy as one of "detachment." This posture he defines as follows:

> "Detachment" is used here rather to suggest a distancing effect which is intensely personal, a withdrawal from the frantic pursuit of chimerical external solutions so that a calming of the self may ensue through which brotherhood and peace may be experienced directly as living knowledge.[21]

In elaborating on the concept he likens the practice of the politics of detachment to "nonviolent protest, writing, teaching by personal example. Its advocates share a rejection of violence and traditional politics, a strongly moral outlook which focuses especially on the relationship of ends and means, and an insistence upon inner transformation."[22]

While I do not necessarily disagree with the description, I believe the expression "detachment" is not really descriptive of the man and his work viewed holistically. Hesse is clearly an individualist. But the most significant development in his life and literary works, in my opinion, is his transition (represented in his writings by the difference between the earlier

Peter Camenizind and the later *The Glass Bead Game*) from radical individualism to a more "communal" and socially conscious posture. Ultimate self-development finally involves, for Hesse, the adequate location of self in community. The transition from his earlier tendency toward egoism and escapism *(Peter Camenzind)* to the more socially conscious posture he assumes in his later works *(Journey to the East* and *The Glass Bead Game)* is marked by a rather crucial development in the novel *Demian,*[23] but before examining this crucial shift of emphasis we must explore the events and influences on Hesse from the period immediately preceding World War I up to the publication of *The Glass Bead Game* in 1949.

World War I was a crucible for Hesse. Even his early involvement with the journal *Marz* was based upon his total opposition to the "saber rattling and the cultural hypocrisy of the Wilhelmine minions."[24] The brutalities of war forced him to reflect still further on his commitment to the pacifist alternative. During the war he was actively involved in Swiss relief organizations, and he edited a biweekly Sunday journal as well as a series of literary editions for German prisoners of war.[25]

All this activity occurred while Hesse was attempting to overcome a personal crisis stemming from a series of events: his father's death, a serious illness to his youngest son, and his wife's mental breakdown. At this point, Hesse, on the verge of a serious nervous breakdown himself, placed himself under the care of Dr. Josef B. Lang, a disciple of Carl Gustav Jung, at the Sonnmatt sanatorium located near Lucerne.

It is difficult, at best, to discern the effect of exposure to Jungian psychoanalysis on Hesse. The specific relationship of Hesse's novel *Demian* to Jung's views has been discussed in a number of studies, but there has been no real attempt to relate this influence to Hesse's political views.[26] This neglect stems in part from a similar neglect of the political and social implications of Jung's psychological approach.[27] Jung claims to have decisively influenced Hesse, whereas Hesse has said that Jung was but one of a number of influences on him and, moreover, that his artistic goals went beyond the scientific purposes of Jung's psychology.[28]

The influence of Jung — in particular Jung's studies of mythical and religious symbolization and his theory of the collective unconscious — merges with Hesse's lifelong interest in religion. Hesse was deeply influenced by Christianity and by oriental philosophy and religion. Hesse's father, Johannes, it must be recalled, was a Christian missionary, but a missionary who was unusually sensitive to the value of non-Western religions. Johannes was highly critical of provincial and dogmatic views of Christianity and was in fact a mystic and a Pietist. In this context, Hesse came to see man's salvation as a highly personal affair. As Ernst Rose

notes: "There were no dogmatically fixed rules for Christianity. Everything must be held in flux so that the right spirit could enter into all decisions."[29] Throughout his life and his novels Hesse struggles with and in this "flux" seeking to establish the "right spirit" for his personal fulfillment. According to Rose, Hesse was initially drawn to Jung's psychology because it seemed to provide the right orientation for an *individualistic* approach to sanity, but he later came to realize that retreat or "withdrawal" (Galbreath's term) was not the solution.[30]

This quest for spiritual contentment, and Hesse's gradual realization that there must be a social as well as a personal solution to the problem, is the single most important difference between Hesse and other modern writers who have dealt with alienated man. Kafka, for example, quite unlike Hesse, sees no real solution — no redemption, least of all, realizable through action.[31] Hesse, by contrast, is optimistic concerning man's capacity through his own acts to develop a sense of self.

We must trace this development in Hesse's works more closely by comparing several of his novels. The novels to be discussed are: *Peter Camenzind, Demian,* and *The Glass Bead Game.*[32]

Peter Camenzind is one of Hesse's earlier novels, first appearing in 1903. This novel is a typical German *Bildungsroman* and its central focus is on the "inner growth of the youth toward an affirmation of life."[33] In the novel Hesse offers, as the solution to the problem of alienation, a retreat into nature. This affirmation of the natural life is symbolized by his praise of Saint Francis of Assisi in the novel.[34] Even here, while advocating a highly individualistic, in fact almost antisocial, withdrawal, Hesse amends his isolationist posture by having the hero, Peter Camenzind, befriend a cripple (Boppi), thereby indicating the inadequacy of an existence apart from his fellow man, and indicating, as well, a sense of altruism. Moreover, after the death of Boppi, when Camenzind returns to his father's home, depressed and overcome with grief, he occupies himself, with apparent satisfaction, by serving on a disaster relief committee, representing his village before the cantonal government, and writing newspaper articles arousing the country to support his village in this time of crisis. In the end, however, Hesse, through the character Peter Camenzind, seems to value the writing of memoirs above serving as a village councilor.[35] In this novel Hesse deals with the relationship of self to others on a far more superficial level than in his later novels. Nonetheless, the concern over withdrawal versus commitment is present, albeit tacitly.

Hesse's deep concern with self-fulfillment is often dealt with in his novels by representing various aspects of the individual personality or psyche in the form of different characters. Perhaps the most pronounced of these "schizophrenic" personalities are the main characters in Hesse's *Narcissus*

and Goldmund,[36] a novel that foreshadows, in my opinion, *The Glass Bead Game.* Hesse's criticism of formal education (which began with his novel *Beneath the Wheel*)[37] is reflected in the "split personality" characters of Narcissus and Goldmund, which contrast the sensual life of the artist (Goldmund) with the orderly and sacrificial life of the intellectual and educator (the monk Narcissus). The question of whether service and self-sacrifice are more important than sensual fulfillment is raised and answered, as so often in Hesse, by resolving the apparent opposites into a lived synthesis: both are necessary.

Hesse's recognition of fundamental "contradictions" in life is one of the most significant dimensions of his novels. The political significance lies in Hesse's insistence, increasingly, that neither isolation (total retreat into self or a merger of self with nature) nor total commitment to service (i.e., public action) is by itself the solution to the human dilemma. What is necessary is the simultaneous engagement of the individual in a process of self-examination leading to spiritual fulfillment ("know thyself") and in a process of presenting the self to others in a responsible way.

In *Demian,* one of Hesse's most popular and profound novels, the spiritual quest of the individual serves as the starting point for a much broader interpretation of the "crisis of Western Civilization." The crisis of Western civilization, as presented in the novel, is a spiritual crisis, the breadth and depth of which cannot be adequately explored here. From Hesse's point of view, the root of the problem lies in our inability to live with our passions, with the demonic side of our personality, if you will. Jung's theory of the collective unconscious and other psychological theories (e.g. Freud's) become critical to Hesse's thought here. The need for self-analysis, which Hesse advocates as a prerequisite to change in the social world, is presented through the experiences of the character of Emil Sinclair in the novel *Demian.* Jung's concern with the role of symbols as a psychological mechanism for transforming surplus psychic energy into cultural manifestations is much in evidence in the symbolism of *Demian.* The point here is that Hesse, like Jung, sees the alternative to spiritual fulfillment through self-analysis as irrational manifestations of the demonic — that is to say, violence, war, virulent nationalism, "totalitarian" rule. The implication of both Hesse's and Jung's views of human culture is, as Odajnyk notes, "that the community begins to reflect and live out its symbols in practice, and that symbols, therefore, are the formative agents of communities and supply both the psychic and the organizational foundations of social life."[38] Personal and collective consciousness evolve simultaneously, in theory, but there are many possibilities for the aberrant development of either or both, as one may dominate the other, forcing the latter into *un*consciousness. Social and political conflicts, from this

viewpoint, are manifestations of deep-rooted psychological conflicts that have not been allowed to resolve themselves consciously. Jung's term for these aberrant developments is "psychic inflation."[39] The most pronounced of these developments in Western civilization is the result of man's lack of awareness that our personal and our collective unconscious have been repressed, but their force (psychic energy) has not diminished.

Because the personal dimension has been most neglected, the collective unconscious more readily "breaks through," resulting in "mass psychoses, which, because of the postenlightenment secular orientation of society, appear as political movements."[40] If, as Odajnyk concludes, Jung sees the most significant problem facing modern man as the struggle to maintain one's individuality in the face of an increasingly mass-oriented society dominated by a centralized bureaucracy, then it can be argued that the same problem is central to Hesse's works as well, though Hesse does not use the historical context of the modern state as the setting for his inquiries.[41] Instead he uses the hierarchical mode of the Catholic Church or a rigidly structured intellectual community (Castalia). Again, though his subject matter is not explicitly political, his point of view has an important bearing on the fundamentally political issue of the appropriate relationship of man and the state to one another.

Demian contains elements of all the themes typically presented in Hesse's works. The study is intensely subjective, and, like many other works, the very title suggests the centrality of the hero and his personal struggles. But there is, in addition to the spiritualism, mysticism, internationalism, and pacifism, evidence of a growing awareness of the necessity to act in history, an awareness that finally culminates in *The Glass Bead Game.* In *Demian,* a crucial decision to which I've alluded earlier is made by the two main characters, Demian and Sinclair. Upon hearing that war has broken out, the two men decide to become soldiers. Ernst Rose sees this as an important shift in Hesse's perspective.

> In the period when he was writing *Peter Camenzind,* Hesse still hoped to reach salvation by withdrawing from a hostile "world" into a Franciscan communion with nature. Now he was actively fighting for self-realization within as well as without himself. This meaning was conveyed not too clearly by the taking up of arms by Sinclair and Demian. Although this looks like an affirmation of war, it has only symbolical meaning for a convinced pacifist like Hesse.[42]

Ziolokowski notes that in *Journey to the East* and *The Glass Bead Game* "the individual is subordinated to the whole and portrayed in his relationship to such human institutions as the League and the Pedagogic Province to Castalia."[43] Perhaps even more significant is the ultimate

decision of the Magister Ludi, Joseph Knecht, in *The Glass Bead Game* to forsake Castalia, a rarefied, utopian, intellectual community, for the "real world". By having Knecht choose to step into history rather than remain detached and "outside" of history, Hesse offers his final judgment with respect to the proper stance or role of the intellectual in society. The proper role, it should be stated, is not political radicalism. Rather, it is "an intermediate position of responsible action controlled by dispassionate reflection."[44] This shift on Hesse's part was, in the view of Ziolkowski, the result of two factors.

> First, the sheer reality of contemporary events — the disintegration of the Weimar Republic, the rise of Hitler, the horrors of Nazism — opened Hesse's eyes to the failure of the intellectuals and convinced him of the futility of any spiritual realm divorced wholly from contemporary social reality.[45]

This development in Hesse does not, it seems to me, reflect a "detached" posture, not in the final analysis at any rate. Moreover, it would appear that Hesse is committed to performing the "rejection function" in protesting (particularly in *If the War Goes On . . .*) the dominant view in Germany — virulent nationalism — and attempting to develop an alternative tendency, namely, internationalism.

To be sure, the focus is on the individual's personal development. But the point is that the personal development must, of necessity, involve participation in and not withdrawal from society. Hesse, I would argue, is urging the reader to join together the pursuit of the spiritual ideal with a socially responsible participation in the life of the larger historical community. The reader may perhaps make his final judgment of Hesse's position by reflecting on Joseph Knecht's comments in *The Glass Bead Game* upon deciding to leave Castalia.

> My consciousness of a world outside our little Province I owe not to my studies, in which this world occurred only as the remote past, but primarily to my fellow student Designori, who was a guest from outside, and later to my stay among the Benedictines, and to Father Jacobus. What I have seen of the world with my own eyes is very little, but Father Jacobus gave me an inkling of what is called history. And it may be that in acquiring that I was laying the groundwork for the isolation in which I stumbled after my return. I returned from the monastery into a land where history virtually didn't exist, into a Province of scholars and Glass Bead Game players, a highly refined and extremely pleasant society, but one in which I seemed to stand entirely alone with my smattering of the world, my curiosity about that world, and my sympathy for it. To be sure, there was enough to compensate me here. There are several men I revered, so that I felt all at once abashed, delighted, and honored to work with them as their colleague, and there were a large number of well-bred and highly cultivated people. There was also work aplenty and a

great many talented and lovable students. The trouble was that during my apprenticeship under Father Jacobus I had made the discovery that I was not only a Castalian, but also a man; that the world, the whole world, concerned me and exerted certain claims upon me. Needs, wishes, demands, and obligations arose out of this discovery, but I was in no position to meet any of them. Life in the world, as the Castalian sees it, is something backward and inferior, a life of disorder and crudity, of passions and distractions, devoid of all that is beautiful or desirable. But the world and its life was in fact infinitely vaster and richer than the notions a Castalian has of it; it was full of change, history, struggles, and eternally new beginnings. It might be chaotic, but it was the home and native soil of all destinies, all exaltations, all arts, all humanity; it had produced languages, peoples, governments, cultures; it has also produced us and our Castalia and would see all these things perish again, and yet survive. My teacher Jacobus had kindled in me a love for this world which was forever growing and seeking nourishment. But in Castalia there was nothing to nourish it. Here we were outside of the world; we ourselves were a small, perfect world, but one no longer changing, no longer growing.[46]

One final note, which underscores the extent to which the evolution of Hesse's position had been misunderstood, bears mentioning. Ziolkowski, in the foreword to the new English translation of *The Glass Bead Game*, takes care to point out that the earlier English version was published as *Magister Ludi*, thus erroneously emphasizing the *individual*. The new translation by Richard and Clara Winston carries Hesse's original title — *The Glass Bead Game* (*Das Glasperlenspiel*) and is a more accurate reflection of Hesse's shifting focus from the individual to the community of players of the glass bead game.

V. Conclusion

The problem of the relationship of self-development to the development of community remains, for me, the central problem of the modern age. Hesse's "solution" is not an easy one. I do not believe it is withdrawal, refusal, or "detachment" in any sense except that his activism is tempered by an unusual sensitivity to the spiritual needs of man. Be that as it may, the sensitive reader cannot but feel challenged on a personal level by the intensity with which Hesse tried to resolve the problem for himself. The record of that struggle is to be found in his works, as he makes the transition from popular novelist and writer of typically German *Bildungsromane* to the author of such complex works as *The Glass Bead Game*.

Because Hesse is not widely known by political theorists, at least as indicated by the lack of attention they have given to him, it is useful to review the implications of Hesse's largely tacit political philosophy by comparing Hesse's views to those of a well-known contemporary theorist, Hannah Arendt. The comparison is all the more interesting since Hesse is a

German who responds vigorously to the horrors of xenophobic national-ism and totalitarianism, those curses of mass politics and the modern age which have occupied a central position in Arendt's works also. Arendt, like Hesse, is deeply concerned about man in the modern age. Like Hesse, she sees the modern crisis as having an all-important spiritual dimension, and she and Hesse both emphasize human action as the essential solution to the problems of modern man.[47] Both have been characterized as "existential-ists" because of their emphasis on action or *praxis,* not only as essential to self-fulfillment and as the highest form of human activity, but also as a process by which one obtains knowledge and "understanding."[48] Hesse, however, is interested in the common man's position in the scheme of things to a far greater degree than Arendt. This is apparent in the choice of characters in his works. Hesse has no explicit interest in kings, capitalists, and other elites. He is concerned with man in the generic sense. Whereas Arendt addresses the prospect of the "few" leading the *vita activa* in the public space of the *polis,* Hesse is more deeply concerned with what happens to the individual in his quest for personal fulfillment.[49] Arendt's position is closer to the classical view that man is a social animal — moreover, a political animal — and that his humanity is defined by criteria outside himself, i.e., social criteria. Hesse, though recognizing (as I have tried to point out) the ultimate necessity for historical commitment, could not agree with Arendt insofar as his view, more akin to that of Rousseau, Nietzsche, and modern psychological theory, reflects an appreciation of self that calls for inward as well as outward criteria of humanity. The authentic human existence combines a spirituality that is inward with a social responsibility that is outward. Hesse, like Jung, understood the necessity of *complementarity* — the recognition of a fundamental tension between the demands of selfhood and citizenship. And he recognizes the cost to man of failing to meet the inward, spiritual criteria. Perhaps Zetterbaum captures the feeling of Hesse more accurately when he points out that

> between man and man, between man and nature, between man and his God there is a void, a nothingness. Where necessity compels man to insert himself in this void — as it surely does — and so constitute a network of social and political relations, it does so at some frightful cost to his genuine self.[50]

If, as I suggested at the outset, the individual quest for authority in a modern world that has seen the traditional sources of authority under-mined is indeed a central dilemma, we must consider the alternative explored by Hesse — a combination of spiritual renewal, psychic ordering, and historical commitment. In addition we must guarantee our intellec-

tuals the opportunity to perform the "rejection function" of "molding and guiding the alternative tendencies which exist in any society."[51] Otherwise the cultural transformation projected by Hesse in *Demian, Steppenwolf,* and *The Glass Bead Game* will not be a possibility. If Hesse is a cultural determinist, he is at least in keeping with contemporary efforts to reassert the powerful force of human symbolization in the shaping of our collective political future.[52]

Notes

1. See especially Theodore Ziolkowski, *The Novels of Hermann Hesse: A Study in Theme and Structure* (Princeton: Princeton University Press, 1965); Ziolkowski, ed., *Hesse: A Collection of Critical Essays* (Englewood Cliffs: Prentice-Hall, 1973). Other secondary literature (in English) includes George Field, *Hermann Hesse* (New York: Twayne, 1970); Ernst Rose, *Faith From the Abyss: Hermann Hesse's Way From Romanticism to Modernity* (New York: New York University Press, 1965); Franz Baumer, *Hermann Hesse,* trans. John Conway (New York: Frederick Ungar, 1969); Ralph Freedman, *The Lyrical Novel: Studies in Hermann Hesse, André Gide, and Virginia Woolf* (Princeton: Princeton University Press, 1963); Hans Mayer, *Steppenwolf and Everyman,* trans. Jack Zipes (New York: Crowell, 1971); Bernard Zeller, *Portrait of Hesse: An Illustrated Biography,* trans. Mark Hollebone (New York: Herder and Herder, 1971); Joseph Mileck, *Hermann Hesse and His Critics* (Chapel Hill: University of North Carolina Press, 1958); and Wayne Andrews, *Sigfried's Curse: The German Journey from Nietzsche to Hesse* (New York: Atheneum, 1972).
2. Robert Galbreath, "Herman Hesse and the Politics of Detachment," *Political Theory* 2 (February 1974), 62–76.
3. For a recent attempt to assess the political philosophy of Hannah Arendt, see George Kateb, "Freedom and Worldliness in the Thought of Hannah Arendt," paper presented at the 1976 annual meeting of the American Political Science Association, Chicago, Illinois, September 2–5, 1976.
4. Hesse was influenced, to some degree, by his own experience with Jungian therapy. In 1916, the year of his father's death, Hesse put himself under the care of I. B. Lang, a disciple of Jung. According to Baumer, Hesse had about 70 sessions with Lang, lasting until November 1917. Field, *Hermann Hesse,* p. 52. This experience with psychoanalysis is most fully expressed in *Demian,* and clearly the time spent with Lang had an effect on Hesse's later writings. We shall examine this influence on Hesse more fully below.
5. Edward Shils, "The Intellectuals and the Powers," in *The Intellectuals and the Powers and Other Essays* (Chicago: University of Chicago Press, 1972), pp. 7 and 17.
6. Ibid., p. 18.
7. Ibid., p. 20.
8. Ibid., p. 21.
9. Ibid., p. 20.
10. This tradition is described in detail by Albert Levi in his "The Great Refusal: The German Withdrawal from Goethe to Thomas Mann," in Levi, *Humanism*

and Politics: Studies in the Relationship of Power and Value in the Western Tradition (Bloomington: Indiana University Press, 1969), pp. 96–133.

11. Shils, "Intellectuals and the Center of Society," *The Intellectuals and the Powers,* p. 158. For a further discussion of the range of activities by German intellectuals at various times during the first half of this century, see Galbreath, *passim.*

12. Levi, "The Great Refusal," p. 97.

13. Ibid., pp. 97–98.

14. Ibid., pp. 113–114.

15. Ibid., p. 117. Mann is reported to have said: "I confess to being deeply convinced that the German people will never be able to love political democracy, for the simple reason that it will never be able to love politics as such."

16. Cf. Galbreath, "Hermann Hesse and the Politics of Detachment," p. 64.

17. Theodore Ziolkowski, "Introduction," in Hermann Hesse, *Autobiographical Writings,* ed. Ziolkowski, trans. Denver Lindley (New York: Farrar, Straus and Giroux, 1972), p. xxi; Baumer, *Hermann Hesse,* p. 49; Field, *Hermann Hesse,* pp. 33, 41–2; Rose, *Faith From the Abyss,* pp. 26–7.

18. Hesse, *If the War Goes On . . . : Reflections on War and Politics,* trans. Ralph Manheim (New York: Farrar, Straus and Giroux, 1971), p. 5.

19. Hesse, *If the War Goes On,* p. 5.

20. Baumer, *Hermann Hesse,* pp. 58–60.

21. Galbreath, "Hesse and the Politics of Detachment," p. 66.

22. Ibid.

23. For a discussion of the significance of this development, see Ziolkowski, "Introduction," Hesse, *Autobiographical Writings,* pp. xvi–xvii; Ziolkowski, *The Novels of Hermann Hesse,* pp. 253–338; Rose, *Faith from the Abyss,* pp. 54–55, 122–144, 156.

24. Rose, *Faith from the Abyss,* pp. 26–27, 46–47.

25. Ziolkowski, "Introduction," Hesse, *Autobiographical Writings,* p. xxii. During the 1930s and early 1940s, according to Ziolkowski, Hesse maintained his involvement in the "real world" by engaging in correspondence with friends protesting National Socialism in Germany, and by assisting in the flight of friends and colleagues from the Nazis.

26. For one of the better discussions of Jung and Hesse see George Wallis Field, *Hermann Hesse* (New York: Twayne, 1970), pp. 46–56. For a personal account of Jung and Hesse's relationship see Miguel Serrano, *C. G. Jung and Hermann Hesse: A Record of Two Friendships,* trans. Frank MacShane (New York: Schocken, 1966). Galbreath makes no mention of this decisive experience at all.

27. This *lacuna* has been partially filled with the recent publication of Volodymys Walter Odajnyk's *Jung and Politics: The Political and Social Ideas of C. G. Jung* (New York: Harper and Row, 1976). See also James M. Glass, "Marx, Kafka, and Jung: The Appearances of Species-Being," *Politics and Society,* 2 (Winter 1972), pp. 255–71.

28. See Ziolkowski, *The Novels of Hermann Hesse,* pp. 10–12. Ziolkowski notes that Hesse studied, in addition to Jung's works, the writings of Freud, Stekel, and other prominent psychologists.

29. Rose, *Faith from the Abyss,* p. 48.

30. Ibid., p. 49.

31. James Glass, though he does not discuss Hesse, deals effectively with this issue

in his comparison of Marx and Kafka, using Jungian psychology as a tool of analysis. Glass, "Marx, Kafka, and Jung," p. 255.

32. These are not the only novels that depict this shift in Hesse's perception of the *vita activa*. Other examples would include *Knulp, Iris, Steppenwolf,* and *Journey to the East.*

33. Ziolkowski, *The Novels of Hermann Hesse,* p. 90.

34. Ibid., pp. 278–79; Rose, *Faith From the Abyss,* pp. 20–21; Field, *Hermann Hesse,* pp. 23–24.

35. *Peter Camenzind,* trans. Michael Roloff (New York: Farrar, Straus and Giroux, 1969), pp. 192–201.

36. Hesse, *Narcissus and Goldmund,* trans. Ursule Molinaro (New York: Farrar, Straus and Giroux, 1968).

37. Hesse, *Beneath the Wheel,* trans. Michael Roloff (New York: Farrar, Straus and Giroux, 1968).

38. Odajnyk, *Jung and Politics,* p. 6.

39. Ibid.

40. Ibid., p. 32.

41. A better example of a writer who does use these settings effectively to criticize bureaucraticized society is Heinrich Böll. See Don Schoonmaker, "The Politics of Heinrich Böll: Sketches of a Counter Culture," paper presented at the 1977 annual meeting of the South Carolina Political Science Association, Charleston, South Carolina.

42. Rose, *Faith from the Abyss,* p. 55.

43. "Introduction," Hesse, *Autobiographical Writings,* p. xvi–xvii.

44. Ziolkowski, "Foreword," Hermann Hesse, *The Glass Bead Game,* trans. Richard and Clara Winston (New York: Holt, Rinehart & Winston, 1969), pp. xvi–xvii.

45. Ziolkowski, "Foreword," Hesse, *The Glass Bead Game,* p. xvi.

46. Hesse, *The Glass Bead Game,* pp. 399–400.

47. Arendt's political theory is most clearly developed in *The Human Condition* (Chicago: University of Chicago Press, 1958); *Between Past and Future,* 2d ed. (New York: Viking, 1968); *The Origins of Totalitarianism,* rev. ed. (Cleveland: Meridian Books, 1958); and *Crises and the Republic* (New York: Harcourt Brace Jovanovich, 1972). For commentary on her political philosophy see Noel O'Sullivan, "Hannah Arendt: Hellenic Nostaligia and Industrial Society," in Anthony de Crespigny and Kenneth Minogue, eds., *Contemporary Political Philosophers* (New York: Dodd, Mead and Co., 1975), pp. 228–52; and George Kateb, "Freedom and Worldliness in the Thought of Hannah Arendt."

48. O'Sullivan, "Hannah Arendt," pp. 230–31; Walter Kaufmann, "The Inevitability of Alienation," in Richard Schacht, *Alienation* (New York: Doubleday, 1971), pp. xxxi–xxxii.

49. See especially Arendt's *The Human Condition,* passim.

50. Marvin Zetterbaum, "The Self and the Problem of Political Knowledge," paper presented at the 1976 annual meeting of the American Political Science Association, Chicago, Illinois, September 2–5, 1976, p. 4. See also his "Self and Political Order," *Interpretation* 2 (Winter 1970), pp. 233–46.

51. See the discussion of this function in subhead III above.

52. For further discussion of the significance of the "symbolic" dimension of politics and of social existence generally, and of selfhood in relation to politics, see Robert Jay Lifton, *The Life of the Self* (New York: Simon and Schuster,

1976); Kenneth Hoover, *A Politics of Identity: Liberation and the National Community* (Urbana: University of Illinois Press, 1975); and the already-classic study by Murray Edelman, *The Symbolic Uses of Politics* (Urbana: University of Illinois Press, 1964).

Part II

The Artist in the
English-Speaking World

Chapter Seven
Shakespeare: Poetic Understanding and Comic Action (A Weaver's Dream)

Richard H. Cox

. . . what hinders one to be merry and tell the truth? as good-natured teachers at first give cakes to their boys, that they may be willing to learn at first the rudiments.

Horace[1]

. . . imitation is a kind of play, and not serious . . .

Socrates[2]

I.

Political life generally is understood to be a serious matter. And in particular, founders of cities and regimes generally are understood to be serious men undertaking a supremely serious task: Lycurgus, Theseus, and Romulus, in the ancient world, and Washington, Lenin, and Hitler, in the modern world, are so regarded. How, then, are we to understand Shakespeare's playfulness in treating Theseus, legendary founder of Athens, one of the most extraordinary polities that ever existed, in a "comedy"?

This question is the starting point for my musings on *A Midsummer Night's Dream*. The musings are rooted in wonder and perplexity concerning the purpose of this dazzling display of Shakespeare's poetic art and buttressed by certain views I hold concerning how one should go about the study of a play by Shakespeare. Because those views underlie and inform the substance of the musings, it is necessary to say a few words about them at the outset.

It is easy to call Shakespeare a poet, and everyone does. It is a good deal more difficult, as the heap of critical works attests, to specify what Shakespeare himself conceived the poetic art to be: its nature; its purpose;

165

its relationship to other human activities, including the making arts (e.g., carpentry), the doing arts (e.g., ruling), and not least, philosophy, in its original sense of the desire to become wise about the nature of things. It is instructive, on this point, to compare the problem as it pertains to Shakespeare and to Sir Philip Sidney, his distinguished contemporary.

Shakespeare, for whatever reason, left nothing but his poetic works: a series of intelligible yet partially enigmatic compounds of action and speech, much like Plato's dialogues. Sidney, on the other hand, wrote not just poetic works, such as the *New Arcadia,* but also a prose analysis of the poetic art, *An Apology for Poetry* (1595). Sidney argues that the true poet practices the noblest form of the art of imitation: he seeks, by his deeds and words, to teach men to be virtuous. He does so, first, by delighting men with his imitations of virtuous actions and repelling them with his imitations of vicious actions. Having thus enticed men's souls with his "speaking picture,"[3] he then teaches them to seek virtue and flee vice. He does so at the lowest level by artfully drawing upon the soul's general moral tendency to imitate what is good and shun what is bad; and at the highest level, by stimulating the tendency of the reasoning part of the soul to seek the good, in and for itself. The poet, so understood, is the "right popular philosopher." His mode of teaching is intrinsically superior not only to the historian, who necessarily deals in specific cases, but even to the moral philosopher, who seeks to give compelling precepts. Sidney recognizes that the moral philosopher — such as Aristotle, in his treatment of justice in Book V of the *Nichomachean Ethics* — seeks, and may even discover, conclusive definitions of virtue and of vice. But even though the moral philosopher may thus, in principle, furnish men with "infallible grounds of wisdom," these must "lie dark before the imaginative and judging power if they be not illuminated or figured forth by the speaking picture of poesy."[4]

As for "comedy" in particular, it is, according to Sidney, that kind of poetic imitation that fuses actions and speeches that teach us by both "delighting" us, and by moving us to the "scornful tickling" called laughter. In Sidney's own words: "all the end of the comical part of comedy [is] not upon such scornful matters as stirreth laughter only, but mixed with it, that delightful teaching which is the end of poesy."[5]

The task of musing on *A Midsummer Night's Dream* might be easier if we had a comparable argument by Shakespeare to turn to, but we do not. On the other hand, inasmuch as, as one scholar recently has shown,[6] Shakespeare evidently knew and even at times drew upon Sidney's *Apology,* it seems reasonable to consider the possibility that the two poets' understanding of the nature and purpose of poetry is similar if not identical. And yet, however suggestive such a procedure may be, it clearly is inconclusive, and we are thus compelled to recognize that Shakespeare's

poetic works directly confront us, time and again, in all their puzzling and beguiling concreteness. If there is a "delightful teaching" imbedded in them, it seems that we must seek it in the interstices of the action and speech that make up the whole of a given work.

How, then, to proceed? I confess that I am not altogether sure, and that what follows on *A Midsummer Night's Dream* is, essentially, a playfully serious set of conjectures. The procedural premises that underlie its substance are these: First, Shakespeare's poetic works present themselves to us as "deeds" — something *done* by him, that is, but presented to us with no explicit explanation as to what the given work, as deed, seeks to do. Second, we thus seem always to have to work our way from the surface of the work toward an attempt to grasp the meaning of its parts, and then toward an understanding of the whole that makes up the context for the parts. Third, Shakespeare's general "deed" in constructing a given work includes specific "deeds": the title, the setting, the names of the characters, the overall movement of the action, the placement as well as the content of the speeches, the interaction of speeches and actions, and the problems posed "in speech" that may be imitated by the "action."[7]

II.

A Midsummer Night's Dream is the only play in which Shakespeare treats one of the founders of antiquity.[8] By that deed he singles out Theseus and Athens above all other ancient founders and cities. Furthermore, within the play, Shakespeare makes Hermia, whose name evokes that of the god Hermes, compare Athens to "paradise" (I, i, 205).[9] Nowhere else in the corpus does Shakespeare make a character compare a city to "paradise."

However one eventually construes Hermia's remark, the singling out of Theseus and of Athens is at once compelling and perplexing. It is compelling because it seems fitting: is not Athens *the* glory of the ancient world, indeed, *the* glory of Western civilization? Is it not *the* city renowned in its own time, and ever since, for its architecture, poetry, political greatness, military valor, and not least, for its being *the* city of antiquity famous for "philosophy"?

It is perplexing, however, because of these features of the play — features that constitute specific "deeds" by Shakespeare:

1. The title itself shrouds Theseus and Athens. Stated somewhat differently, Shakespeare's deed in titling this play, in contrast to *Julius Caesar, Timon of Athens,* and *Coriolanus,* wholly obscures the political setting. Furthermore, the title points away from the political world altogether: it suggests darkness, sleeping, and dreaming, rather than the light, wakefulness, and vivid conscious-

ness ordinarily associated with the works of the mind and the body so gloriously displayed by Athens in her greatness.

2. "Midsummer" is connected with the notion "height of madness," as is the lunar month in which "midsummer day," or the summer solstice, occurs. And the word "wood," in addition to its ordinary meaning, in Shakespeare's time, also had the meaning of "madness."[10] Given the fact that the central, longest, and most complex sequence of actions in the play occurs in the "wood" outside the walls of Athens, it seems that a triple madness is pointed to by the season, the moon, and the physical setting of the central action of the play.

3. The greatest part of the action concerns not Theseus and the display of the ruling art, but the adventures of lovers (whether humans or fairies); and even more puzzling, the antics of "rude mechanicals" (III, ii, 9), who have leapt out of their station to engage in a dramatic form of the poetic art.

4. The title, taken literally and in abstraction from the body of the work, evokes the notion of a particular dream that occurs on the eve of the summer solstice. Yet within the body of the play, not only is there no specific reference to that astronomical event — just as, in *Twelfth Night, or What You Will,* there is no specific reference to the Epiphany — but, in fact, Theseus' speech at the moment of discovering the young lovers in the woods seems to change the seasonal locus to that of May Day (IV, i, 133).

5. The title, taken in relation to the epilogue spoken by Puck, suggests that the entire body of the play may be "thought" of as but a "dream." But given Puck's notorious penchant for mischief at the expense of humans, it surely is a problem whether to take him seriously or no. And even if we do, we are left to wonder how to interpret the play's words and deeds in terms of the involuntary activity of dreaming.

Stated in the language Bottom uses at one point, the question is: how to go about "expounding" the meaning of a poetic drama disguised as a "dream"? Or is it a dream disguised as a poetic drama? And whatever it is, how to expound its meaning? Indeed, should one even make the attempt to do so? Should one be warned of the folly one may thereby fall into, warned, that is, by Nick Bottom's wondering speech that he makes when he awakes from *his* "dream": "Man is but an ass, if he go about [t'] expound this dream"? (IV, i, 206–7). But perhaps this is to take seriously what Shakespeare only means to be laughable. Perhaps a man *is* an ass who would apply to the poet's "dream" what the poet makes a weaver turned tragic actor for a day utter in his perplexity. And yet, could it be that a serious warning against "expounding" is meant to be conveyed by the playfulness of Shakespeare's treatment of Nick Bottom? Or is it, possibly, a playful warning against taking poetry seriously? But if the latter, what, then, should one take seriously? Political life? Philosophy? The revealed truth of the Bible? More questions than answers thus bubble up when one permits oneself the luxury of dwelling on titles and on the risible speech of a lowly weaver.

At the risk, then, of imitating Bottom, when one tries to expound on

Shakespeare's "dream" one begins to wonder how to reconcile the discord between the sense of the play as a *single dream* and these two qualities of the action: (a) The play includes waking as well as dreaming activity. (b) The dreaming activity, which takes place only in the woods outside the city walls, is multiple: (1) Hermia's dream which occurs when she and Lysander first fall asleep in the woods (II, ii, 144–156); (2) the four lovers' dream-vision of what happened to them in the woods (IV, i, 187–199); (3) Bottom's dream-vision of what happened to *him* in the woods (IV, i, 200–219). If the title is meant to focus on one of these "dreams," it certainly is not obvious which one. A case might be made that the lovers' dream is most crucial; and yet, to make that case requires that one consider it on its merits in relation to the dream that precedes and the one that follows.

These features of *A Midsummer Night's Dream* suggest that there is a "discord" among its elements. That discord reverberates in the poet's playing on the antinomies of dreaming/waking, madness/sanity, woods/city, fairies/humans, artisans/nobles, and the like. In attempting to discover whether there is an underlying concord in the discord, and whether such a concord might itself convey the kind of "delightful teaching" so praised by Sidney, I have been struck by the pains Shakespeare took to make the artisans play an *integral* part in the action of the whole. On the supposition that such a deed may be rooted in something more than a mere desire to reduce us to the "scornful tickling" Sidney refers to, I will scrutinize Shakespeare's treatment of the denizens of Athens's stalls.

I will begin again, by looking briefly at two classical treatments of Theseus: Plutarch's in his *Lives of the Noble Grecians and Romans,* and Socrates' in Plato's *Republic.* I will do so to throw into sharper relief the strangeness of Shakespeare's comic treatment, a prime element of which is the prominence and the hilarity of the deeds and speeches of the artisans. I will then analyze certain features of the treatment of the artisans; most importantly, their place in the structure, and the nature of the problems that emerge from what they are made to do and say. Next, I will look closely at the most singular of the artisans, Nick Bottom the weaver. And I will conclude with a few observations on why I think that the treatment of the artisans has an underlying, serious purpose that makes the poetic art, strangely, become the ruling art.

III.

Plutarch's Theseus — manifestly known to Shakespeare from his partial drawing on Sir Thomas North's translation of the *Lives* — is a fusion of hero and lawgiver. As hero, Theseus, whose descent from the gods is

emphatically conveyed by Plutarch, had many adventures, amorous and military. Among the latter was his audacious slaying of the Minotaur, the monster that annually devoured seven each of the cream of Athenian youths and maidens. As lawgiver, Theseus — in North's words — "dyd gather a people together of all nations." Further, he at length resigned his "regall power" to constitute a "common weale or popular estate." The commonwealth had three "orders": noblemen, husbandmen, and artificers. To the noblemen Theseus assigned the judging of "matters of religion," the bearing of civil office, the determination of the laws, and the telling of "all holy and divine things." And thus the noblemen "dyd passe the other [two orders] in honour: even so the artificers exceeded them in number, and the husbandmen in profit."[11] In sum, although Plutarch's account of Theseus emphasizes his giving a place in the civil order to the common people, its focus is simply on Theseus, and its treatment of the common people is not only minimal but utterly sober, as contrasted to Shakespeare's treatment.

Socrates' Theseus — possibly known to Shakespeare — is also a hero and lawgiver, descended of the gods. However, Socrates, in speaking to young Adeimantus about the poetic education of the young in his "city in speech," blames the poets' accounts that portray Theseus, son of Poseidon, and Perithous, son of Zeus, as "eagerly" undertaking "terrible rapes," or as engaging in other "terrible and impious deeds." Socrates then says to Adeimantus: " . . . we should compel the poets to deny either that such deeds are theirs, or that they are children of gods . . . "[12] Thus Socrates' brief account, though it says nothing directly about Theseus in relation to the common people, draws on the civic sense that Adeimantus has of that aspect of the lawgiving activity of Theseus at Athens, and portrays Theseus even more soberly than does Plutarch.

Shakespeare's comic framework for the portrayal of Theseus thus stands out the more sharply when one considers that classical treatments of the ancient lawgiver place him in a strictly sober, heroic context, and that those classical treatments were the very images that educated persons of Shakespeare's time would have brought to the play.[13] It is true, of course, that Shakespeare seems to retain the sense of the heroic, and even the sense of the kinship to the gods (by Theseus' reference to Hercules as his "kinsman"). (V, i, 43ff). Even so, on balance, there is a great tension with the persistent sobriety of the classical treatments.

The tension between the sobriety of lawgiving and the comedy of mad adventures of lovers, fairies, and artisans in the woods is greatest precisely at the point where Theseus is made by Shakespeare to take his greatest political action: Theseus suddenly overrules the ancient marriage laws of Athens. Let us see how and why that is so.[14]

At the beginning of the action, when the play seems to have all the

makings of a tragedy — in the mode of *Romeo and Juliet,* for example — Hermia appeals to Duke[15] Theseus to override the ancient law of Athens which requires her either to marry the man her father chooses (Demetrius) instead of the man she loves (Lysander), or else suffer one of two other fates: to be killed, or to live out her life as a cloistered virgin. But Theseus at once replies that not even he has the power to "extenuate" its application (I, i, 120). What is the status of this law that makes it exempt from the power of a god-related heroic duke? It seems that it must be one of those awe-inspiring *nomoi* which exist from the most remote past of the city: a law derived from the gods, or at least having the aura of such divinity. And yet, in the aftermath of the lovers' and the artisans' often hilarious adventures in the woods, and as a prelude to the hilarity of the performance of the artisans' comic-tragedy in the Duke's palace, Theseus peremptorily overrules that ancient law. But then, taken in abstraction from Shakespeare's deliberate framing of Theseus' singular political action, that action must appear as an act of great impiety. Yet precisely by the way in which Shakespeare does frame it — above all by making the last phase of Bottom's adventures with Titania and his wondering and comical speech about those adventures constitute the immediate dramatic frame for Theseus' action — the impious act is greatly muted.[16]

That Shakespeare's comic framing of this singularly political episode is intended to have that moral effect is reinforced, I believe, by the framing that he also gives to what is, strictly speaking, Hermia's impious act in fleeing the reach of the city's laws. Following this act Hermia has a remarkable dream — the only dream that occurs in the woods as a *natural* dream, rather than as a retrospective, magic-induced dream-vision of waking events that actually occur there.

Hermia flees to the "wood" — the place of madness, in the punning sense of that word — in the company of Lysander. They manifestly intend to defy the city's law that forbids them to marry in opposition to Egeus' will. The lovers lose their way in the woods and at last fall asleep. When Hermia awakes, she is nearly mad with fear. Her fear, at first, is occasioned by starting into bewildered consciousness from a nightmare: a serpent has entered her breast and is eating her heart away; meanwhile, Lysander sits by and only smiles at that cruel act. But Hermia's fear becomes terror when she suddenly realizes that Lysander, who had been asleep nearby, has vanished. Hermia calls to him in great anguish. He does not respond. Hermia then races madly off to find him, determined to meet death if necessary.

Now as I have just summarized this episode, I have deliberately falsified it. I have, that is, torn it out of its framework in the whole play, and in so doing, I have made it appear much more an episode of fear and near-

madness than it is when we react to it in that framework. For then we, the auditors/witnesses, are aware of two crucial circumstances: first, that nearly all of what is happening in the woods is somehow under the control of the fairies, and especially Oberon, who has already indicated his benevolence toward the young lovers. Second, that given the hilarity of the earlier deportment of Peter Quince and company, and given the expectation we have of soon seeing them cavort in these same woods, at the rehearsal of their ludicrous play, we have every reason to suppose that no harm can come to Hermia. But our assurance of that is, ultimately, the effect of the poet's deed — his practicing his poetic art on our souls. In particular, he makes us know what Hermia cannot know; and that knowledge *works* in us by causing the painful passions of fear and pity to be replaced, or overridden, by wonder, amusement, and perhaps even laughter.[17]

To restate the preceding point in relation to the problem of impiety: The natural moral consequence of willfully breaking man-made laws is that the offender deserves to be punished by human punishment. But the natural moral consequence of willfully breaking sacred laws is that the offender deserves to be punished by divine punishment. And we know from ancient tragedies that one form of punishment for breaking sacred laws is madness. Hermia, one may say, is portrayed as coming close to madness as an immediate aftermath of her fleeing the sacred law of marriage of the city, yet as being saved from it, in the action within the play, by the poet's deed in causing Oberon to reunite the lovers, and bless them. As for us, Shakespeare's so framing the episode saves us from the sense of dread that ordinarily derives from contemplating just punishment inflicted on one who has broken a sacred law.

To sum up: Shakespeare's comic framing of both Hermia's dream and of Theseus' bold action in overriding the sacred law of marriage gently assuages the awe that the *nomoi* naturally inspire in us. It seems that the poetic art, as practiced by Shakespeare, seeks to *teach* statesmen by indicating to them the reason and the means to assuage that awe.

IV.

Now the most hilarious element in the comic framing of Theseus' action is what happens to Nick Bottom, weaver turned tragedian, metamorphosed into an ass/man, and beloved of Titania. In order to see more exactly how that element is integrated into the action and speech of the entire play, we need to look closely at the precision and care with which Shakespeare treats the "rude mechanicals."

Dramatically speaking, the artisans' drollery first bursts upon us as a

charming, comical discord in what seems to be an impending tragedy: Peter Quince calls the artisans to order to rehearse their play immediately following Helena's anguished soliloquy, which concludes with her fateful decision to betray Lysander and Hermia by revealing to Demetrius their plan to flee Athens. Historically speaking, the artisans' appearance is even more of a charming, comical discord: we suddenly hear Anglo-Saxon, presumably Christian, artisans who have somehow miraculously been transposed to the ancient pagan Athens of Theseus. Thus they are given, with one exception, Christian names: Peter, Nick (Nicholas), Francis, Tom (Thomas), and Robin (Robert). And each of their English surnames is either a technical word that refers to the art practiced, or alludes to it: Quince comes from *quoins* or *quines,* wedge-shaped blocks of wood used by carpenters; Bottom comes from the *bottom* or core of the skein on which the weaver winds the yarn; Flute comes from the *flute stop* of an organ, which a bellows mender would repair; Snug refers to the compact joining that a joiner would do; Snout refers to a spout of a kettle, a common object mended by tinkers; Starveling alludes to the proverbial leanness of tailors: according to an old phrase, "Nine tailors make a man."[18]

I will comment later on the significance of this specification of the arts practiced by each artisan. For now, it suffices to remark that it is an integral element of the sudden, comic appearance of the artisans; and that the comic turning curiously and unexpectedly produces a shift in the political focus of the action: Up to this point, the focus is wholly on ruler and nobles; now, of a sudden, it is on men who represent the lowest order in the city, which is to say the people, or *demos.*

The initial, sudden shift in the political focus of the action proves, on reflection, to be linked to a *series* of shifts in the locus of the play's action. The action begins inside the city walls at the palace of Duke Theseus. It then moves to Peter Quince's cottage. The next, and much the longest part of the action, takes place outside the city walls in the "wood" of Athens. It then returns to Peter Quince's cottage. And it concludes in the great hall in the Duke's palace. The placement of the action, abstracted, thus proves to be highly symmetrical: palace, to carpenter's cottage, to woods, to carpenter's cottage, to palace. The mediation, then, between the palace, the place of rule, and the woods, the place of nature where no rule as such is characteristic, proves to be the abode of an artisan — and a carpenter, at that, whose natural material is the wood of trees. His art, as carpenter, is indispensable for transforming the natural material into shelter for men. But as such, it is an art that proves, in cities, to be dependent on other arts — on what has come to be called the "division of labor." Shakespeare has seen fit, on the one hand, to make the artisans of this strange Athens practice six related arts that have to do with the provision of shelter and

clothing within the city and, on the other hand, in contrast with Plutarch, to exclude any arts that have to do with agriculture. He also has seen fit, on the one hand, to specify the arts of his handicraftsmen and, on the other hand, to give no indication whatever of whether they are truly skilled at their art. Instead, these artisans take on themselves an art — the dramatic part of the art of imitation — for which they are, as their deeds and words at once make apparent, wholly unfit. One must wonder what will happen to Athens, simply in terms of its ability to survive, if Quince and Bottom are as inept at carpentering and weaving as they are at the imitative art. But of course, such a mundane question hardly arises, at least not now. Instead, we are charmed into a blissful state of hilarity by the antics of the group, especially by Nick Bottom. The acme of mirth produced by Bottom in the woods, and at the palace, is already foreshadowed in this opening scene, and comes to a focus on his being transformed in seeking to play many parts, even as Socrates' "democratic man" *does* play many parts in *The Republic*.[19] Bottom is a thespian to keep an eye on.

In any case, the comic quality of the portrayal of the artisans depends decisively on their being made, temporarily, to forego the practice of the *productive* arts in order to engage, with stunning ineptitude, in one of the *imitative* arts — the dramatic art, the imitative art that has the greatest power to move men's souls, which is why Socrates seeks to purge it in his best city (*kallipolis*). Now the artisans' practice of the dramatic form of imitative art takes place in three phases: (1) the statement of the theme and the assignment of the parts (Quince's cottage: II,i); (2) the aborted rehearsal, during which certain problems concerning the presentation of the play are broached (the wood: III,i); (3) the actual presentation of the play (Theseus' palace: V,i). It thus happens that the central segment of the artisans' practice of the dramatic art coincides (1) with the central scene of the entire play (it is the fifth in a series of nine scenes), and; (2) with the central part of the action that takes place in the woods at night. It also thus happens that in a triple sense Shakespeare has formed his play so that the artisans of the city are at the center of the action; and so that at the center of that center, Bottom is made to enter for a time into the fairy world. The *occasion* for Bottom's temporary entry into that world is, of course, the intended rehearsal of the artisans' play. But the proximate *cause* of his entry proves to be the chance intersection of Puck's and Oberon's scheme with that of the artisans. The *effect* is that Bottom's adventures with Titania replace the rehearsal: a ludicrous, magic-induced transformation of a weaver into a man/beast, beloved of a fairy queen, replaces a ludicrous, self-induced transformation of that same weaver into an imitator of a tragic hero. What Shakespeare's purpose is in bringing about such a replacement — one that imitates and plays on the sense of "transformation" — is itself a

good question, and one to which I shall turn a bit later, in looking more directly at Bottom's part in the whole action. For now, I observe only that by that transformation of a transformation, Shakespeare causes Bottom to be the *only* human privileged to enter directly into the fairy world. That is startling, when one ponders its political implication: Bottom is made to do that which not even great Duke Theseus, nor Hippolyta, nor any of the four young noble lovers, is permitted to do.

Let us now take a closer look at the central segment of the artisans' practice of the dramatic art. As I have previously noted, it opens as the artisans treat certain problems concerning how to mount their play. Those problems, one may say, are made by Shakespeare to focus on the artisans' curious — to say the least — understanding of how the dramatic art achieves its effects on the souls of the audience. The treatment falls into two phases. In the first phase, Bottom and Snug raise the question of the presumed fearful, even terrible, effect of two episodes on the ladies in the audience: Pyramus' suicide by stabbing, and the lion's roar. Nick Bottom, peerless at his newly-acquired art, divines the solution to both problems: let a prologue be spoken by Quince, which will remove the fear from the ladies' souls by reassuring them that the actions presented are not "real," that Pyramus is really Bottom the weaver, and Lion really Snug the joiner.

In the second phase, two further problems are raised, one by one, by the poet, Peter Quince: how to bring in the needed moonlight, and how to depict the needed wall. Bottom, as eager to solve every problem as he was to play every part, now proposes, as a solution to the first problem, that the moonlight from the sky be permitted to enter the casement window of the chamber in the palace. It is a solution that depends on Quince's having first ascertained — from God help us, a printed almanac, in Thesean Athens! — that the moon "doth shine that night." (III, i, 50–55). Yet Quince does not at once accept Bottom's suggestion; instead, he suggests an alternative: let the moonlight be personified, even as the lion will be personified. The second problem raised in the second phase, that of how to depict the wall, is resolved quickly by Bottom's suggestion that it, too, be personified.

Taking them in abstraction now, Bottom makes three *kinds* of proposals: the use of a prologue, the use of the moonlight from the sky, and the use of a man to personify the wall. His central proposal is set off against Quince's proposal, but no resolution is reached in this central segment of the artisans' practice of the dramatic art. We are thus left to wonder how it will be resolved, and we do not find that out until the night of the performance. Then at last in his prologue Quince tells us, as well as the three newly-married couples, that wall, moonshine, and lion all are to be personified. It thus happens that Quince's proposed personification triumphs over Bottom's proposed reliance on moonlight at the casement.

And it thus also happens — oh blessed triumph of Quince over Bottom! — that we, as well as the lovers, are treated to a rare display of the imitative art. That is to say: If Bottom's solution had prevailed, the light of the moon from the casement would surely have been a tame business. But in the event, the triumph of the poet Quince's solution produces some of the most extended mirth in the play; for the personification of moonlight becomes the occasion, not just for the antics of Robin Starveling, the tailor, but for a comic interaction between him and four members of the audience.

I will turn to that interaction in a moment. But it first must be emphasized that Shakespeare's deed in so ordering the treatment of moonlight in the artisans' play is part of a complex *set* of deeds concerning moonlight. Perhaps the most obvious such deed is his setting the longest sequence of his play in the moonlit woods outside of Athens, and his making fairies, human lovers, and artisans alike, speak of the moonlight there on a number of occasions. A less obvious deed is forty-six uses of words referring to moonlight: moon (31), moonbeams (1), moonlight (6), and moonshine (8). This is the densest concentration of words about moonlight in any single play in Shakespeare's corpus, and by a considerable margin. Another less obvious deed is making the majority of these forty-six uses involve the artisans, and above all their comic-tragedy. I doubt that is merely accidental, in a play in which the centrality of the artisans and their play is thrice pointed to by the structure itself. Let us therefore more deliberately explore the emphasis on the moonlight in the artisans' play.

Bottom's first proposal, to use a prologue, depends on the power of speech to persuade the ladies that their fear is groundless. His last proposal, to personify the wall, depends on the power of action and speech to persuade the entire audience that a man dressed in rough garments and made to tell them that he is a massive human artifact *is* that artifact. But his central proposal, to admit moonlight at the casement, depends on the conjunction of two natural conditions being met — the moon has to be in its bright phase, and the sky has to be free of fog or clouds — with the enactment of *Pyramus and Thisby*. But the alternative solution — that of personifying moonlight — depends only on the power of words and deeds to exert a poetic charm. Shakespeare thus sets up a tension between a "natural" and a "poetic" solution, and causes that tension to come to a sharp focus on the artisans' words and deeds concerning the problem of moonlight.

When one scrutinizes the actual presentation of moonlight in the play within a play, three things stand out. First, Quince's poetic solution to the problem of bringing in moonlight contains an astronomical impossibility: On the one hand, Quince makes Moonshine three times claim to be the

crescent moon (thus echoing the natural crescent moon that Theseus and Hippolyta awaited for their nuptials); and on the other hand, he makes Pyramus speak as though the moon were *full*. (V, i, 238–239, 272–275). Quince either is ignorant of the natural difference between a crescent and a full moon, or has forgotten what he wrote in his speech for Moonshine when he wrote his speech for Pyramus. In either case, the artisan-poet's ineptitude draws our attention all the more sharply to the problem of moonlight in the play within a play. And, as I shall argue a little later, it eventually directs our attention, by reflection, to the problem of moonlight in *A Midsummer Night's Dream* as a whole.

Second, the densest, most complex jesting by the royal and noble members of the audience occurs precisely in the eleven-speech sequence in which Moonshine makes his first appearance.[20] The jests' surface target is Moonshine's perfect ineptitude in the practice of the dramatic art. The jests' deeper target, however, is the artisan's intrinsic ineptitude as a human being. There is a complex interaction between the two levels of jests. That interaction is a remarkable example of Shakespeare's integration of the poetic with the political, as I shall now argue.

The jests' surface target is, to be more precise now, the perfect if wholly unintended comedy of Moonshine's serious attempt thrice to persuade the audience that he is the man in the moon, that the lantern he holds in his hand is the moon itself, and that the moon is in its crescent phase. In reply to Moonshine's central attempt to persuade, Theseus at once mocks Moonshine. The essence of that mocking is the absurdity of the man holding the thing within which he is supposed to be; stated generally, Theseus mocks the fundamental absurdity of making "the whole" be held by or contained in "the part."

Now the sequence which provokes such mocking is, of course, itself a part of the whole enactment of *Pyramus and Thisby*. And the play within a play is, in turn, a part of *A Midsummer Night's Dream*. The Moonshine "part" surely provokes us, as well as the interior audience, to laughter. But more fundamentally, its playing with the problem of the relation of part to whole incites us to thought — if we will let it — concerning the *meaning* of the play within a play in relation to the *meaning* of the whole of which it is a part. I suggest that the perfect ineptitude of the play within a play is itself part of the perfection of *A Midsummer Night's Dream,* and that that perfect ineptitude is intended to throw light, by reflection, on the problematic character of the realization of poetic perfection.

Nor is that all. The problem of the realization of poetic perfection is intrinsically connected to that of the realization of political perfection. This is revealed by a further analysis of the deeper target of the royal and noble jesting. We must start, here, with this observation about the political

situation that is depicted: It is the artisans of Athens, the lowest "part" of the political order — indeed, the part which is only problematically even *in* the political order as such — who unwittingly incite the royal and noble parts of the city to mockery. At the core of that mockery is a punning playfulness concerning the meaning of the "crescent" moon, whether as the thin bow of the waxing moon (which is the exact astronomical sense), or the thin bow of the waning moon (which is the more ambiguous general sense). Now in either case, of course, the "crescent" moon gives very little light. The punning on "crescent," as signifying "little light," is most pointed and revealing in the two-speech dialogue that takes place between the royal couple, Theseus and Hippolyta.

The dialogue begins with the first of three speeches Hipployta makes about the moon, and the only speech she makes within the eleven-speech sequence with Moonshine. Hippolyta expresses weariness with "this moon," and a punning desire that it would "change" — i.e., that it would quickly enter its last phase and thus disappear for good. Theseus' reply to this central speech of the five-speech rejoinder to Moonshine's central speech proves to be the densest punning speech in the whole of *A Midsummer Night's Dream*. It is, in fact, a complex series of puns on "light," "discretion," "wane," "courtesy," (one of the meanings of *discretion*), "reason," and "time." I will not try to sort out all aspects of this double punning by the rulers of the city, but simply limit myself to these observations: Shakespeare makes the two most "political" characters of his play engage in a brief exchange that dwells, however playfully, on the intrinsic limitation of the artisan who plays Moonshine — on, that is, his weak "light" of "discretion." Yet Shakespeare also makes Theseus, however playfully, indicate that in all civility, yes, even "in all reason," they must accept the presence of that artisan: his "light," it seems, dim though it is, is required by the city.

Third, the playful interaction between politically lowest and politically highest parts of the city concerning the problem of moonlight reaches its climax in Pyramus-Bottom's death scene. His final speech is: "Tongue, lose thy light!/Moon, take thy flight!" Whereupon Moonshine-Starveling, ever eager to please, and blessed, as Theseus observed, with but a "small light" of "discretion," takes his leave of the action, considering himself dismissed by Pyramus-Bottom's imperative. This causes poor Thisby-Flute to try to discover her dead lover solely by the dim light of the stars, a fact gleefully commented on in Hippolyta's third and last speech on the moon, and Theseus' rejoinder to it.

This final comic collapse of Quince's poetic solution to the problem of bringing in moonlight depends, of course, on Bottom's strangely deranged speech. And the derangement, in turn, depends on the chance event that is wholly unknown to the royal couple, only confusedly known to Bottom,

but clearly known to us: Bottom's temporary sojourn in the land of the fairies. For Bottom's unwitting transposition of "moon" and "tongue" is a sign, in speech, of a confusion in the soul that first afflicted him when he awakened in the woods. He then gave the first and most complex of four speeches which reveal that confusion: "The eye of man hath not heard, the ear of man hath not seen, man's hand is not able to taste, his tongue to conceive, nor his heart to report, what my dream was" (V, i, 211–213). All three of the later speeches take place back in the city; all three occur in or with respect to the play within a play; and all three continue the initial emphasis on a confusion, above all, concerning the sense of sight, the sense that is utterly dependent for its function on the existence of external light (whether the sun, in the natural realm, or a lantern, in the artificial realm). That Bottom's sojourn in the fairies' realm has the unexpected effect, at last, of making the moon disappear should make us reflect on Bottom's derangement and on what the disappearance of the moon may signify or point to. That reflection entails a closer consideration, first, of the light that is associated with the events in the woods; and second, of the traditional symbolic sense of light, in relation to the main actions of the play.

The sense of bright moonlight bathing the woods is conveyed by speeches of several of the characters, and is maintained except for one episode: Oberon makes a black fog temporarily cut off all heavenly light around the human lovers, to prevent Lysander and Demetrius from harming each other. The surface sense of the action in the woods thus is that of bright natural moonlight interrupted, for a short time, by the black, magically-induced fog that surrounds the lovers.

Let us consider, next, the traditional symbolic sense of light. According to a common understanding widespread in Shakespeare's time, an understanding going back to antiquity and exemplified in perhaps its most famous form in the *eikon* or "image" of the cave in Plato's *Republic,*[21] the sun is symbolically connected to reason and the moon to unreason, or to reason paled by the operations of mere opinions and the force of the passions.[22]

If we now apply this traditional symbolic sense of the meaning of "moonlight" to the surface impression of moonlight bathing the adventures of the human lovers and of Bottom, it seems to make sense: those moonlit adventures result from the wholly unforeseen, fortunate intersection of the humans with the fairies. But by the same token, the happiness of the human lovers, in particular, proves to depend decisively on fortune, not on knowledge, and hence is precarious, to say the least. And when one realizes that bright moonlight is made to give way, for a time, to utter blackness — when no light whatever from the heavens reaches the human lovers — the sense of that precariousness is reinforced. As moonlight — which at least gives the human eye some possibility of engaging in its natural function —

gives way to utter darkness, the loss of function of the sense of sight naturally reaches its peak; and by analogy, the dependence of human happiness on the blindness of *fortuna* reaches its peak. It is true that in this instance the blackness is benevolent and thus not charged with the deepest sense of an utter dependence. But Shakespeare's playing, in two connected contexts, on the theme of the disappearance of the natural light of the heavens should make us consider further the implications of the disappearance of Moonshine from *Pyramus and Thisby*. To do this, we need to move from the impression of bright moonlight in the woods outside of Athens to an examination of the details of the treatment of moonlight in the play as a whole.

The play begins with Theseus and Hippolyta eagerly awaiting the appearance of the new moon, for the night when the "silver bow" of that moon appears in the heavens will be the night of their nuptials. Now the night in the woods — when Bottom, as well as the lovers, engage in their adventures by bright moonlight — is the night *before* the nuptials. But in astronomical terms, with respect to the natural phases of the moon, it is impossible for those adventures to take place by moonlight. The moon is invisible for a few nights between the last thin bow of the old and the first thin bow of the new moon. What is more, on the night when the crescent moon appears, it gives little light, and is visible only for a short time, near sunset.

What, then, does Shakespeare do? In his own way, he *does* what he makes his poetic counterpart, Peter Quince, *seek* to do. That is, Shakespeare, with consummate skill in the poetic art, calls on the charms of that art to induce in us a waking-dreaming state, such that we will "see" moonlight where, in nature, there can be none. But he also reminds us, by the artisans' bumbling efforts to bring in moonlight, by the jesting of the nobles and the rulers at those efforts, and above all, by the final foolishness of Bottom's inadvertently making the moon disappear, that there is a tension between the natural and the poetic solutions to the problem of bringing in moonlight, and that his own practice of the poetic art is the ultimate cause of making the poetic solution prevail over the natural one. The political bearing of that complex, playful, and imitative treatment of the relation of the poetic art to nature remains now to be explored, above all in its application to Bottom's adventures in the woods.

V.

The delightful effect of *A Midsummer Night's Dream* surely is in part the product of the extraordinary beauty of the poetry, the hilarity of the artisans' adventures, the mischief of Puck, and so on. But it is also in part

the product of the supposition, first of all, that war for now is at an end. Theseus has lately been at war, but that has been successfully concluded: indeed, from that war has come not just victory, but the winning of Hippolyta, and thus the prospect of the gratification of wedded erotic love. Second, the city is at peace within. The artisans, so far from being in a state of unrest or rebellion, are obedient. And so are the nobles: Lysander, far from seeking to challenge the rule of Theseus or the ancient laws, instead chooses to lead his love away from the city. Third, the city is possessed, it seems, of sufficient goods for the support of life and is sufficiently free of the ravages of disease that its denizens can indulge themselves in the revelry of feasting and entertainments. In short, the duke and the nobles, but no less the artisans can afford to enjoy the sweets of life.

It might seem that the portrayal of such a condition is easily managed by a poet: all he need do is imagine it, then figure it forth in deeds and words. But such a way of conceiving of the poetic art seems to presuppose that the poet need not be concerned with the problematic basis of such a condition — with the problem, that is, of the degree to which such a condition of civil peace, plenty, health, and leisure, is necessarily, in the real world, dependent on the arduous and often marginally successful transformation of nature by human arts. Is that Shakespeare's understanding of the poetic art? I seriously doubt it, for reasons that I will now elaborate.

A key aspect of Shakespeare's poetic art is his deed in causing Bottom's entry into the fairy world. That entry is central to the action of the play; it elevates Bottom, a mere "rude mechanical," above nobles and duke; it provides the occasion for those experiences that give rise to the first speech in which he confuses the senses; and it thus also lays the basis for his later confused speech which causes the moon to disappear. It is also a key aspect of Shakespeare's poetic art so to construct the play that we are made to be the only humans privileged (1) to *know* what was done and said in the fairy world, and (2) to *hear* Bottom's first confused speech about what happened to him in that world. Our privileged status brings us, in a curious way, closer to Bottom, yet differentiates us from him. That is, we are made to know a great deal *more* than Bottom about what went on in the fairy world, and to know it in a *way* that he is not privileged to do: we are made to know it in a conscious way, whereas Bottom's residual "knowing" is but a dream that is "past the wit of man to say what dream it was." Above all, as I shall now argue, we are thus privileged to know things that connect the fairy world's effects on nature to the ordinary world of human activity and that reveal a dependence of the latter on the former, a dependence that becomes inextricably interwoven with Bottom's adventures.

The revelry at the palace, which marks the threshold of a new generative activity by the three newly married couples, is framed by the adventures

with the fairies in the woods and the unusual entry of the fairies into the palace. The revelry presupposes, as I have noted, peace, leisure, and plenty. But such a condition presupposes, in turn, that the ordinary transformation of nature by the human arts — the arts of the city and the arts of the country — has been successful. Whether it also presupposes that such a transformation of nature depends upon forces beyond human control is a question that does not obtrude itself on the revelers. It is we, the privileged ones, who are made to see that "framing" I have referred to, and perhaps to reflect on its connection to the joyousness of the revelers.

In the first part of the fairies' framing of the revelry, we learn, at once, of the quarrel between Titania and Oberon. We also learn that the quarrel can have a devastating effect on the natural world, and therefore also on the human world, especially on the human world's dependence on the transformation of nature through the human arts. In the longest speech in the entire play, Titania articulates the fateful consequences of their lovers' quarrel. The speech begins and ends with an emphasis on the quarrel itself. In between, it is a catalogue of disasters that characteristically accompany the actual quarreling: raging winds, contagious fogs, rampaging rivers, and a profound confusion of the seasons, which destroys the natural cycle of the seasons, and worse still, thus destroys the generative cycle itself. At the center of this "progeny of evils," the effect on humans is brought into sharp and dismaying focus in one of only two passages in the play that refer to the "ploughman": the "ploughman" loses his "sweat"; the cattle and the sheep die in droves from diseases; and the corn rots before it is ripe. As for humans, they are stricken with "rheumatic diseases," a result of the angry activity of the moon, that same heavenly body about whose light Shakespeare takes such pains in every dimension of his "dream."

Titania's speech, given its setting in the woods outside of Athens and its ominous contents, evokes in us, who are the privileged ones, memories of a terrible and altogether real natural catastrophe that did in fact befall that beautiful city. In the early part of the Peloponnesian Wars, in 430 B.C., when Pericles was still the leading man of the city, a devastating plague struck the Athenians. A most remarkable description of that catastrophe, and especially its political effects on civil life — such as the reduction of men to impiety and lawlessness on a great scale — is given by Thucydides. His account, in turn, forms the basis of the stark and even terrifying description of the plague that occurs at the end of one of the great classical philosophical poems, Lucretius' *Of the Nature of Things.*

Lucretius' poem begins with an invocation of Venus, the goddess of love and generation. That invocation becomes the basis of the hymn to Venus in Book IV of Edmund Spenser's *Faerie Queene,* first published in 1596.[23] Listen, for a moment, to Lucretius as transformed by Spenser, Shakespeare's great contemporary:

Great Venus, queene of beautie and of grace, . . .
That with thy smyling looke doest pacifie
The raging seas, and makst the stormes to flie;
Thee, goddesse, thee the winds, the clouds doe feare,
And when thou Spredst thy mantle forth on hie,
The waters play, and pleasant lands appeare,
And heavens laugh, and al the world shews joyous cheare.

Then doth the daedale earth throw forth to thee
Out of her fruitful lap abundant flowres . . . [24]

The last book of Lucretius' poem begins and ends with passages on Athens, the only book in the poem to be so constructed. At the beginning, Lucretius praises Athens above all cities that have ever existed:

> It was Athens of illustrious name that first in former days spread abroad the corn-bearing crops amongst unhappy mankind; Athens bestowed on them a new life and established laws; Athens first gave the sweet consolations of life, when she brought forth a man endowed with such wisdom, who in past days poured forth all revelations from truth-telling lips.[25]

Reflection on this passage shows that, in order of ascending importance, Athens has established the arts, given laws, and brought forth philosophy. Lucretius has in mind, in particular, the philosophy of Epicurus; but that single example seems to stand for the activity of philosophy as such, as the highest human activity. Athens, then, is *the* city of philosophy. Yet the emergence of philosophy decisively presupposes the arts, above all the art of agriculture, and the political art, needed for the establishment of the city as a city. The activity of the founder, it seems, is central to the human activity of bringing forth not just the city, but what the city makes possible, the life of the mind. Theseus may not himself be philosophic, but his actions underlie the emergence of *philosophia,* or the love of being wise.

At the end of Lucretius' last book, however, we see that not even Athens is exempt from the devastation of natural calamities, which destroy the ordered life of the city. Furthermore, it is irony of the deepest kind that the very artisans whose art first gave rise to the settled life of the city should now be the proximate cause of the city's undoing: the calamity proceeds from the country into the city. Listen again to Lucretius:

> And in no small degree this affliction was brought from the country into the city, for the fainting crowd of countrymen brought it, gathering from all quarters with seeds of disease. They filled all places and buildings; so, by the stifling heat, death all the more piled them in heaps, being thus packed.[26]

Lucretius' intention in formulating a stark and startling contrast between the loveliness of Venus and of generation at the beginning and the ugliness

of plague and civil destruction at the end has been summarized by Leo Strauss in these words:

> The plague is as much the work of nature as the golden deeds of Venus, nay, as the understanding of nature. It is doubtful whether philosophy has any remedy against the helplessness and the debasement which afflicts anyone struck by such events as the plague.[27]

Now as we well know, *A Midsummer Night's Dream* ends happily — not with deaths of lovers, let alone plagues and civil destruction, but with revelry. More exactly, as a final counterpoint to the human revelry, it ends with fairies dancing in an unusual place, in the Duke's palace, and with their pronouncement of a remarkable blessing. I will come to that blessing in a few moments. But first, I must take a further look at Titania's speech in relation to the sequence of actions in the whole play. Titania's speech catalogues natural disasters that accompany the quarrel of Oberon and Titania wherever they happen to be. Fortunately for Athens, the natural catastrophes have not as yet visited that fair city, for only belatedly have Oberon and Titania come to Athens from far-off India, and they separate just before, as Titania puts it, they are inclined to "chide downright." (II,i,145). But if the quarrel is not ended very soon, what can prevent catastrophe of the kind so poignantly described in Lucretius?

And now, at this moment of potential peril for the city, lo and behold, it is Bottom to the rescue. Yes, Bottom, that weaver who has left his loom to become a master of the imitative arts. Bottom, who eagerly seeks to play any part and above all a tyrant, but who settles for the part of a tragic lover. Bottom, who will play the part of the lion so well that he will roar as "gently as any sucking dove," so as not to frighten the ladies; or so well as to cause his ruler, the Duke, to say "Let him roar again; let him roar again!" (I,ii,30–73). In any case, it is Bottom, who happens to be the means of reconciliation between Oberon and Titania, hence also the means of forefending against natural catastrophes that may erupt from their quarrels, hence a kind of savior of Athens.

Not that Bottom has any intention of doing all those things, nor, of course, any real understanding of what has happened to him in the woods: he retains only that rare vision, that dream that it is past the wit of man to expound, and which is a strange blend of being lifted up — that is, being loved by a beautiful queen, with many servants at his command — and being driven down — that is, being possessed of the head of an ass, that most foolish, stubborn, and burden-bearing of beasts, which brays and cavorts, but cannot speak, let alone sing a song. Bottom has the consolation, that is to say, of not having lost his humanity, even if he has been made temporarily to wear the revolting head of an ass; for even in his

extremity, he retains the faculty of speech, which depends decisively on the faculty of reason.

This is shown in a comic but instructive way in the first exchange between Titania and Bottom. Titania first becomes aware of Bottom's presence when she hears his braying song about the birds. She then sees him and exclaims that her ear is "enamoured" by his song, her eye "enthralled" by his shape, and her soul seized with love for his "fair virtue's force," or the power of his beauty. Bottom modestly replies that Titania has "little reason" for loving him, then indulges in a "gleek," or jest, the core of which is the problem of whether — and if so how — "reason" and "love" may be "friends." Whereupon Titania says, "Thou art as wise as thou art beautiful," and Bottom again modestly claims "Not so, neither . . ." (III,i,128–150).

This is the only place in *A Midsummer Night's Dream* where someone is called "wise" as well as "beautiful." But for it to be Bottom is ridiculous: we laugh at Titania's remark, for we know that Bottom is no more wise than he is beautiful. The immediate comic effect of this episode depends, I think, on our eyes and our reason being simultaneously exempt from, yet naturally charmed by, the imagined transformations wrought on Bottom and Titania. But the comic effect's basis comes into view only when the charm gives way to reason's natural function of thinking how the effect is rooted in certain absurdities. That is to say that "love" gives way to "reason," or that reason replaces that which is loved merely because it is charming with that which is loved because it is intelligible. But for this to happen, there has at first to be the charmed awareness of the discrepancy between what *we* see and know and what the deranged senses and perception of Titania cause *her* to see and know.

We are reminded of this episode in the perplexed speech Bottom gives on awakening from his adventures with Titania. Bottom is charmed by what he recalls; and he seeks to reason concerning what it means, as well as whether it can be expounded in speech. It happens, however, that Bottom's articulation of the problem of perceiving and expounding is confused in a way that echoes the confusion of the charmed Titania, in that it reveals a derangement of the function of the senses, above all the senses of sight and hearing. Yet Bottom's speech goes beyond Titania's, for it proves to be a parody of one of the most famous passages in the New Testament, Saint Paul's *First Letter to the Corinthians* (chapter II vs. 9): "But as it is written, The things which eye hath not sene, nether eare hathe heard, nether came into man's heart, *are,* which God hathe prepared for them that loue him."[28] In Bottom's confused state that becomes, as we have seen, "The eye of man hath not heard, the ear of man hath not seen, man's hand is not able to taste, his tongue to conceive, nor his heart to report, what my dream was."

Now it is important to observe, first, that the context within which the original biblical verse is found is one of the New Testament's most important treatments of the tension between revelation and philosophy. To be more precise, Saint Paul's first chapter sets forth a profound tension between Christian revelation and Greek philosophy. Thus Saint Paul says: " . . . the Jewes require a signe, and the Grecians seke after wisdome. But we preache Christ crucified: unto the Jewes, even a stombling blocke, & unto the Grecians, foolishnes" (I: 22–23). Second, the parody spoken by Bottom draws our attention to the confusion of the senses; but in so doing, it also draws attention *away* from that which is omitted by Bottom's speech: Saint Paul's decisive emphasis on "the things" God "has prepared for them that love him." Substituted for those "things" are the things that happened to Bottom in the woods, things that transcend the sphere of the natural understanding, but in a direction that is, by Saint Paul's lights, all but blasphemous. Third, not only has Shakespeare made Bottom's adventure cause a confusion in his soul concerning the senses, but he also has made the adventure somehow add to the senses dwelt on in the biblical original. That is, in Saint Paul's text the senses of sight and of hearing are set in contrast to the "things of God," which are "revealed" to us by "the Spirit." And later in the second chapter, Saint Paul stresses the conflict between that "revealing" and the operations of the soul of the "natural man" to whom such things are "foolishness." (II: 14). But in Bottom's wondering speech the senses of sight, hearing, taste, and touch are dwelt on, thus adding the two senses most integral to the demands of the body. Finally, added to the senses of that "natural man" so excoriated by Saint Paul is the faculty of "conceiving." One wonders whether that faculty is not the root of the "natural man's" temptation to seek after that "wisdom" which the Grecians seek. I know that one ought not to put too much stock in what a confused weaver says in his perplexity. But it is worth recalling that Bottom's parodic speech in the woods outside of Athens provides an integral part of the comic framing for Theseus' overriding the *nomoi* of the city.

I must hasten, however, from the woods to the last sequence in the palace, the sequence in which the fairies leave their natural place in the woods in order to preside — unseen — over the removal of the human lovers to their respective nuptial beds.

Theseus' last speech urges all the lovers at last to bed, and jestingly adds, "'tis almost fairy time," little suspecting that the fairies are indeed close at hand. His last speech then closes with the promise of a whole fortnight of "revels," and new "jollity," as befits ducal and noble nuptials.

Between Theseus' last speech and Oberon's last speech is a single speech by Puck. The beginning of Puck's speech is starkly in contrast to Theseus' benediction, for it evokes the ordinary harshness of the world of nature. It does this, for example, by speaking of a lion's roar, and a wolf's howl. But it

does so even more tellingly with respect to the toil of the human arts in extracting the substance of life from nature, with these laconic words: "the heavy ploughman snores,/ All with weary task fordone." (V,i,373–74) This is the second and last time in the play that we are reminded of the ploughman, he who practices the art that underlies all the other arts on which the city depends, the art that stands closest to, and has most constantly to contend with, the world of living nature. The exhaustion of the ploughman is begotten of the practice of his art in extracting from nature what nature, in the absence of human art, provides in only the most minimal and problematically available way. That exhaustion is the condition, one may say, for the prolonged amorous revelry that Theseus has promised. But it is also the condition for the leisure in which the practice of the poetic art and the turning to philosophy may take place. When we place the last reference to the ploughman alongside the first reference, we may recall Titania's evocation of the fearful dislocations in nature that may afflict the city; we are reminded, that is, that the descent from the level of mere hard toil on the meager provisions of nature, as nature, to the level of natural catastrophe has been narrowly averted for this lovely city, whose potential for realizing the highest humans are capable of is yet to unfold.

Lest we forget that the saving of Athens took place in the woods, through the fortunate conjunction of the artisans' practice of the dramatic art with the appearance of the fairies, Shakespeare now makes the fairies leave their natural place, come into the palace, the seat of political rule, and pronounce a remarkable blessing on the married couples as their generative activity is about to commence. It is not just that they all will "Ever true in loving be." More remarkable still, the promise is that all their children will be free of the "blots of nature's hand": no deformities, not even a mole, let alone a "mark prodigious," such as is "despised in nativity." (V,i,401–415). The fairies thus assume, for a moment, the role of Venus, the goddess of love and generation. Their blessing on the couples replaces the somber ending of Lucretius' poem, even as Bottom's adventure replaces the rehearsal of the artisans' comic-tragedy.

VI.

If action and speech are the warp and the woof of poetic drama, then it seems Shakespeare is a kind of weaver. I will conclude with a few remarks that indicate the way in which Shakespeare's weaving in *A Midsummer Night's Dream* seems to me to be akin to the royal art of weaving that is so praised in Plato's *Statesman*.[29]

When the artisans first enter into the action, Bottom, weaver turned actor, says to Quince, carpenter turned poet: "First, good Peter Quince, say

what the play treats on . . . " Quince says: "Marry, our play is *The Most Lamentable Comedy, and Most Cruel Death of Pyramus and Thisby.*" We are at once reduced to mirth, by Quince's seriousness, and even more by the title itself: this craftsman has unwittingly given his play a title that contains an arrant self-contradiction, a discord, a confusion of two distinct modes of dramatic poetry, tragedy and comedy. Later, in act V, Philostrate presents a list of possible entertainments to Theseus, who rejects the first three, then comes at last to Peter Quince's opus, now referred to as "A tedious brief scene of young Pyramus and his love Thisby; very tragical mirth." Whereupon Theseus laughingly exclaims:

> Merry and tragical! tedious and brief!
> That is hot ice and wondrous snow.
> How shall we find the concord of this discord? (IV,i,59–60).

Stated in terms of the conventional names for two essentially different types of poetic drama, Theseus' question means: How is it possible to reconcile the fundamental discord between the end of tragedy and the end of comedy? The first seeks to move us to a catharsis of fear and pity, felt for those who are intrinsically noble; the second seeks to move us to a catharsis of contempt for those who are base and/or foolish.

The answer to Theseus' question (and to ours) proves to be the artisans' actual performance of their "lamentable comedy": The artisans, that is, inadvertently transform the tragic into the comic, and thus also unintentionally overturn the traditional order of nobility and seriousness of the two forms of poetic drama. The effect of that overturning is to reduce the ruling and the noble parts of the city to mirth and jesting mockery; they are seized with what Sir Philip Sidney called a "scornful tickling." Yet the tickling itself attenuates the hate-filled contempt that higher natures may feel for lower natures. We are reminded of the fundamental political problem represented by such contempt in various places in Shakespeare's "dream," but nowhere more pointedly than in a single remark entrusted to Oberon. Having at first himself been reduced to mirth by the drollery of Titania's loving the ass-headed Bottom, Oberon at last says to Puck that he has begun to feel "pity" for Titania's mad "dotage," which has reduced her to "seeking sweet favours" for Bottom, this "hateful fool." (IV,i,49).

Shakespeare's poetic art causes that same "hateful fool" to be transformed, if only for a time, from a mere "rude mechanical" into an ardent yet ludicrous "hero" (and, as we alone see, into the savior of Athens). Bottom's nature, so transformed, is then briefly joined by the balm and the catharsis of laughter into a tenuous and fragile harmony with the other natures in the city. The comic as well as the fortuitous and transitory character of such a

weaving together may well appear to be an exceedingly problematic solution to the fundamental political problem of joining essentially different natures into a well-ordered whole. But even Socrates, confronted with that problem, was compelled to yearn for a poet who could persuade all three kinds of "natures," and not least those of the *demiourgoi,* whose *technai* provide the basis of civil existence, that their place in the city is itself wholly the product of nature, not of human acts, or of accidents. Indeed, Socrates was compelled to make that "noble lie" be the very cornerstone of his "city in speech," the city that is simply *kata phusin,* or according to nature.

To say, then, that Shakespeare's and Socrates' respective poetic solutions to the problem of weaving essentially different natures together in the city are foolish, not least because they are so little likely to become actual, may only be to say that the modern mind's conviction that the solution to that problem is wholly within the power of human art is itself the most comical thing of all; or rather, it would be comical if modern men, who cling with unabated zeal to that conviction bred of the revolutionary possibilities opened by Shakespeare's countryman, Francis Bacon,[30] did not take themselves and their project with such deadly seriousness. I myself wonder, in fact, whether that deadly seriousness is not itself *the* obstacle, today, to every attempt to articulate the problem in the comprehensive terms in which it appears in Shakespeare's "dream."

In any case, if the foolishness of the comic weaving together of natures in the city is foolishness of the first power, then surely it is foolishness raised to the second power to make the poetic art prevail over the natural solution to the problem of bringing in light, and foolishness raised to the third power to make a weaver who has been translated into an ass/man become the savior of the city by his accidental sojourn with a fairy queen in the woods outside of Athens. Yet who among us is so bold, then, as to tell exactly how that city *did* manage to rise from obscurity and ascend to the pinnacle of the possibilities available to human life? The rarity, and even more, the cause of such a remarkable realization have ever since reduced those who truly reflect on it to wonder and perplexity. Shakespeare's comical treatment of ancient Athens at its founding phase thus seems to me itself to be rooted in those states of the soul; and his artful weaving of action and speech seems to me to be his comically serious way of teaching us something about the possibilities, and yet the harsh and perhaps ultimately unpassable limits and dependencies, of life in the city as such.

Shakespeare knew full well that even Athens was at last subject to the ravages of political and natural destruction. He knew it well enough to write a somber work in which a cynic philosopher, Apemantus, says: "The commonwealth of Athens is become a forest of beasts."[31] That Athens thus

proved, like the love of unfortunate lovers, to be a "quick bright thing," come, at last, to "confusion" (I,i,149), redirects our attention to the problem of what is highest and what it is rooted in. Or it does so if we will let Shakespeare's "dream" take us outside the city by reducing us to laughter about the things that are inside it. But whether we can learn again to imbibe the delightful *pharmakon* of such laughter is as uncertain as whether a Bottom will come, again, to be in our midst.

Notes

1. *The Satires,* I.1. 24–27, in *The Works of Horace,* trans. C. Smart (New York: Evert Cuyckinck et al., 1821), pp. 6–7.
2. Plato, *The Republic,* trans. Allan Bloom (New York: Basic Books, 1968), 602b.
3. Sir Philip Sidney, *An Apology for Poetry,* ed. Forrest G. Robinson (Indianapolis: Bobbs-Merrill, 1970), pp. 18 and 28.
4. Ibid., p. 28.
5. Ibid., p. 79. Cf. the following statement in James Amoyt's "To the Readers," at the head of Sir Thomas North's rendering of Plutarch's *Lives of the Noble Grecians and Romans,* a statement Shakespeare very likely had read: "such books as yield pleasure and profit, and do both delight and teache, have all that a man can desire why they should be universally liked and allowed of all sortes of men, according to the common saying of the poet Horace: 'that he which matcheth profit with delight,/ Doth winne the price in every poynt aright.'" *Plutarch's Lives of the Noble Grecians and Romans Englished by Sir Thomas North anno 1579,* ed. George Wyndham (London: David Nutt, 1895), vol. 1. p. 8.
6. See Alwin Thaler, *Shakespeare and Sir Philip Sidney* (New York: Russell & Russell, 1967), especially pp. 42–48.
7. Jacob Klein's penetrating analysis of "action" and "speech" in Platonic dialogues, and in particular, his treatment of the mimetic function of action in relation to speech, seem to me to be very pertinent to the study of Shakespeare's plays. See Klein's introductory remarks to his *A Commentary of Plato's* Meno (Chapel Hill: University of North Carolina Press, 1965), pp. 3–31.
8. Theseus appears, of course, in the play *The Two Noble Kinsmen,* but given the disputed authorship of that play, I have excluded it. See Hallet Smith's introduction to the play in *The Riverside Shakespeare,* ed. G. Blakemore Evans (Boston: Houghton Mifflin Co., 1974), pp. 1639–41.
9. All citations to the text of Shakespeare's plays are from *The Riverside Shakespeare.* All statements about uses of words in the plays are based on Marvin Spevack's *The Harvard Concordance to Shakespeare* (Cambridge: Harvard University Press, Belknap Press, 1973). The Spevack *Concordance* is keyed to the Evans text. In the speech in which Hermia refers to Athens as "paradise," she is momentarily disenchanted with Athens because of its marriage law. All that is required for that enchantment to resume is for her to be permitted to marry Lysander.
10. See the various articles for these words in the *Oxford English Dictionary.*
11. See Plutarch's "Life of Theseus," pp. 53–54.
12. Plato, *The Republic,* 391c.

13. It is possible that the classical sense of Theseus underlay Samuel Pepys's reaction, in 1622, to Shakespeare's "dream"; for Pepys called it "the most ridiculous play that ever I saw in my life." See Anne Barton's introduction in *The Riverside Shakespeare,* p. 217.

14. See Howard B. White's analysis of *A Midsummer Night's Dream,* in his *Copp'd Hills Towards Heaven: Shakespeare and the Classical Polity* (The Hague: Martinus Nijoff, 1970), Chap. III. I have been much stimulated and influenced by White's general line of thought, but have sought to look more directly and intensively than he did at the specifically comic aspect of the play, and in particular at the comic aspect as it emerges in the treatment of the artisians.

15. The title "duke" seems to be used in this play — and other plays, such as *Twelfth Night, or What you Will* — in sense 1 in the *OED;* "A leader; a leader of an army, a captain or general; a chief, ruler."

16. Act IV, scene i begins with the last phase of Bottom's involvement with Titania, it moves through the key episode in which the ancient law is overriden, and ends with Bottom's soliloquy.

17. See also what I argue, later on, concerning the intended moral effect of Qunice's "prologue" that will overcome the fear of the ladies.

18. See the note to I, ii, p. 225 of *The Riverside Shakespeare;* and cf. the edition of the play edited by Sir Arthur Quiller-Couch and John Dover Wilson (Cambridge: Cambridge University Press, 1969), p. 102.

19. *Republic,* 560c-d

20. Moon. *This lanthorn doth the horned moon present —*
Dem. *He should have worn the horns on his head.*
The. *He is no crescent, and his horns are invisible within
 the circumference.*
Moon. *This lanthorn doth the horned moon present;
 Myself the man i' th' moon do seem to be.*
The. *This is the greatest error of all the rest. The man should be put into
 the lanthorn. How is it else the man i' th' moon?*
Dem. *He dares not come there for the candle; for, you see, it is already
 in snuff.*
Hip. *I am a-weary of this moon. Would he would change!*
The. *It appears, by his small light of discretion, that he is in the wane;
 but yet in courtesy, in all reason, we must stay the time.*
Lys. *Proceed, Moon.*
Moon. *All that I have to say is to tell you that the lanthorn is the moon.
 I the man i' th' moon, this thorn-bush my thorn-bush, and
 this dog my dog.*
Dem. *Why, all these should be in the lanthorn; for all these are in
 the moon.*

21. Plato, *The Republic,* 514a–517b.

22. On the title page of Robert Record's *The Castle of Knowledge* (1556), the sun is made to shine above the "sphere of destinye, whose gouenour is knowledge," while the crescent of a new moon is made to shine above the "wheele of fortune, whose ruler is ignorance." On the left side, Urania, or heavenly wisdom, with open eyes, holds a pair of compasses in her right hand, and the handle of the sphere of destiny in her left. On the right side, the goddess Fortuna, blindfolded, holds a cloth in her left hand, and pulls on the cord of the wheel of fortune with

her right. The verses at the center treat the contest between the two, and conclude: "The heavens to fortune are not thralle/These spheres surmount al fortunes chance." See plate 16 in *The Riverside Shakespeare,* p. 1134, for a reproduction of Record's title page.

23. See the account of "Lucretius and the Renaissance" in George D. Hadzsits, *Lucretius and His Influence* (New York: Longmans, Green, and Co., 1935), pp. 248–83.

24. Edmund Spenser, *The Faerie Queene,* in *The Complete Poetical Works of Edmund Spenser* (Boston: Houghton Mifflin Co., 1908), Book IV, Canto X, sections xliv–xlv.

25. Lucretius, *De Rerum Natura,* trans. W. H. D. Rouse (Cambridge: Harvard University Press, 1937), VI, ll. 1–9.

26. Ibid., VI, ll. 1259–1265.

27. Leo Strauss, "Notes on Lucretius," in *Liberalism Ancient and Modern* (New York: Basic Books, 1968), p. 83.

28. It is a problem which translation of the Bible Shakespeare used. On balance, the evidence seems to me to point to the Geneva Bible. I have quoted from the 1560 version, published in a facsimile version by the University of Wisconsin Press, 1969. See p. 20 of the introduction for a brief treatment of Shakespeare's use of the Geneva Bible.

29. See especially the last speech by the Eleatic Stranger, at 311b–c.

30. See Howard B. White, *Peace Among the Willows: The Political Philosophy of Francis Bacon* (The Hague: Martinus Nijhoff, 1968) especially chapter 1, "Political Faith and Utopian Thought."

31. *Timon of Athens,* IV,iii,348.

Chapter Eight

Shakespeare: Elizabethan Statecraft and Machiavellianism

Tracy B. Strong

I. Introduction

That God and Nature provide a key to the proper ordering of the political world is perhaps the most fundamental idea of the conventional wisdom of the Tudor world. As God to the world, so also the father to the child and the magistrate to the governed: there is for all a moral relation of authority, which corresponds to the natural position into which they have been placed. William Baldwin, the compiler of the 1559 *The Mirror for Magistrates,* phrases it like this:

> I note (wishing all others to do the same) . . . that as good governors have never been lacking their deserved renoun, so have not the bad escaped infamy, besides such plagues as are horrible to hear of. For God (the orderer of offices) although he suffer them for punishment of the people to be often occupied of such, as are rather spoilers and Judases, than toilers and justices . . . yet suffers he them not to escape unpunished, because they dishonor him. For it is Gods own office, yea his chief office which they bear and abuse.[1]

God is the "orderer of offices" and the institutions and practices of this world stand properly in an ordered world that arranges itself, or should, along the lines of God's plan. This is a world in which everyone knows his place and, more importantly, in which the natural order of things protects both ruler and ruled from unpredictable occurrences. The realm of "degree" that Ulysses celebrates in his famous speech in *Troilus and Cressida* is an ethical realm, which protects a man both in his possessions and against the overwhelming ambition of himself or of another.

When such a world is not shaken, men know their rights and responsibilities and stand in known relations one with another. Reinhard Bendix has summed up this situation well: "In the medieval world . . . the

individual enjoyed rights and performed duties by virtue of his status, which could be defined by heredity . . . or by membership in an organization possessing certain immunities or liberties. The status of a person typically encompassed *all* his rights and obligations."[2] *Who* one was and *what* one might do depends here to a great extent on *where* one is in the natural-social world.

The universality of this world is perhaps as much legend as fact. Certainly by the late Middle Ages the vision of the whole that both justifies and gives rise to it was under severe challenges, both philosophical and political. The rise of conciliarist doctrine implies a challenge to the principle of hierarchy; the development of nominalism calls the relations between social order and Nature into question. Socially, the development of major urban centers and the trade and festivities that accompanies them marks the development not only of new classes but of new social relations inside classes.[3]

This is not the place to resolve the relations between these diverse elements of the Middle Ages. I will simply assert here that they coexisted for some considerable period of time, and it is their interaction that lends a fascinating complexity to the understanding of the Middle Ages. It is, however, into this world, perhaps as the embodiment of all these new developments, that there comes the figure whom we know now as the Machiavellian. *The Prince* was written in 1506, and with it the fame of Machiavelli and his new vision of man spread rapidly throughout Europe. In England, *The Prince* was known from at least 1534 onward and was bedside reading to Thomas Cromwell. As importantly for our purposes, the figure of the Machiavellian passed rapidly into literature as a symbol of human villany and treachery. Theodore Spencer has counted 395 references to Machiavelli in Elizabethan drama, almost all favorable.[4]

The Machiavellian figure radically questions the world of order and degree in which each knows his or her place. These are men with no background, or none that matters, who through force of will and cunning of intellect climb to positions of dominance and authority. As is known, such figures play important roles in Shakespeare's dramas: Richard III, Edmund the bastard in *Lear,* Cassius, Iago, and Claudius in *Hamlet* are only a few. As befits those who do not fit well into the natural order of the world, they are almost all men of unnatural birth, men who from their very entrance into the world were somehow cut off from normal parentage and past. Their birth is an objective correlative to their role in the world: they are forces of illegitimacy, destroyers of order, men who neither have nor know a place and are forced to try to make one for themselves. Their world is a world they build, an artifact of their own creation; almost always they stand in opposition to a more regular and happy existence.[5]

Richard Gloucester refers to himself, and to others like himself as "men of chaos." Such individuals raise fundamental questions, about the viability of the world of hierarchy that the Tudor period inherited from the Middle Ages. Most often, such men are seen as purveyors of rebellion against the legitimate order and as overly ambitious men who, in their pride, contravene their rightful superiors and break with their natural peers. In *The Mirror for Magistrates,* Richard III speaks to those who might learn from his experience:

> *Desire to rule made me alas to rue*
> *My fatal flaw, I could not it forsee,*
> *Puffed up with pride, so haughty I grew*
> *That none my peer I thought could be,*
> *Disdaining such as were of high degree:*
> *Thus daily rising and pulling other down*
> *At last I showed to win the crown.*[6]

The attitude of the *Mirror* is that men such as Richard Gloucester break the natural order and that this sin leads to their downfall. Though no historian, Holinshed faithfully extends the chronical tradition that stretches from Sir Thomas More to Halle and to himself when he focuses on the claim that rebellion and its consequences of discord and civil war are the central and most important facts about English history in the period extending from Richard II onward.[7]

Now, in terms of Shakespeare and more especially of *Richard III,* these considerations seem to focus attention in the wrong direction. It is certainly true that Shakespeare is attentive to the problems which have beset England since the fourteenth century. And it is obvious that the Machiavellian posed a fascinating threat to that world of hierarchy and order, a threat which Shakespeare never tires of bringing onto the stage. However, the question of what Shakespeare actually thought of the Machiavellian remains. Here most commentaries simply ring changes on a single theme. This is exemplified in Albert Levi's chapter on "The Politics of Shakespeare's Plays," not because the essay is particularly insightful, but because it rests on a whole tradition of scholarship: "Shakespeare's politics expresses the search for order."[8] What is problematic in this line of interpretation is that it sees Shakespeare's judgement as fundamentally in tune with others of his time, such as those in the *Mirror* and Holinshed's *Chronicles.* So John Palmer writes about *Richard III* that "Richard's political expediments are those of his time and class." For Palmer, Richard is the same as those around him, only more so. He is "distinguished from his contemporaries only by his mental audacity."[9]

However, it is possible to argue, as Hobbes and Bacon were shortly to,

that the "men of chaos" were not as bad as all that. After all, the men who were stripped of the natural order of rank became the "men of the Republic," the "commonwealth men," during the course of the seventeenth century.[10] It may be safely said that Shakespeare and indeed most of the Tudor Elizabethans were not men of the Republic.[11] I wish, however, to contend here that Shakespeare at least had a somewhat different reaction to the development of Machiavellianism than did most of his chronicling near-contemporaries. It is clear that, with the potential though problematic exception of Henry V in the history plays and possibly of Portia in the comedies, there is no character of an obviously Machiavellian lineage with whom one might say that Shakespeare fully symphathizes. And even in these cases the cost is substantial: Portia is forced to resort to the worst sort of legalistic piety and to deny Shylock's claims to humanity; Henry V is obliged to vest himself with a new and artificial public identity, to "turn away his former self" and exchange life, loving and Falstaff for kingship, Kate and France.[12]

All of this asserts that Shakespeare was profoundly concerned with the Machiavellian figure. In this essay I wish to argue that, instead of rejecting this new political character for the old world of order and recoiling in moral horror at the unbridled ambition such personages must have seemed to manifest to most contemporaries, Shakespeare in fact gives us a profound and coherent analysis of a central problem in the Machiavellian perspective on the world. Specifically, I wish to argue that Shakespeare calls attention to the particular relation between human will and temporality and to the particular relation of one's past to one's present identity which characterizes Machiavellian thought and action. I will suggest that Shakespeare finds a central contradiction in Machiavelli's thought that renders it destructive both to self and others, and that Shakespeare attempts to resolve this contradiction with an understanding of human beings that differs from that developed by Hobbes and the men of the Republic, and which is not simply a reassertion of the world of order and degree that the times were leaving behind.

II. The Legacy of Machiavelli

Because readings of Machiavelli are legion, I feel the need here to set out briefly those elements of his thought that seem to me of particular importance in terms of the understanding I present of Shakespeare. These elements are at the very center of Machiavelli's doctrine, but until very recently they have not been given adequate attention.[13] Specifically, they revolve around his conception of human action and of the elements which he thinks determine such activity.

Traditionally, readers of Machiavelli have been most worried about "reason of state" and the economic use of violence. This is certainly not a wrong approach to understanding him. Such interpreters[14] have seen Machiavelli's main contribution to political thought as the radical distinction of the realm of private morality from that of state activity. They see Machiavelli as justifying, or at least arguing for, the proposition that collectivities do not admit of the same structure of moral action as does private life, and furthermore as advocating a disregard for *private* moral concerns in the public realm. These commentators have been reared in the tradition of moral men and immoral societies, which to me represents a response to a positivisitic discussion of moral discourse and of the realm of facts and values. To the extent that one believes that the world of facts and values are different, one will tend to read this distinction as a central element into Machiavelli.

Such readings are, of course, at least partially accurate: Machiavelli does speak in terms of the economic use of violence and in terms of something like "reason of state." He does make a separation, on some level at least, of the realm of the private and the public. But such an emphasis seems to me to miss the new elements in Machiavelli's revolution of statecraft. After all, using violence for calculated political ends had been a part of statecraft for some while. Certainly the experiences of Friedrich II and of Henry IV with the Holy See should leave little doubt that politicians were able to move between the lion and the fox with a good deal of success. But the novelty in Machiavelli's achievement seems to me his claims that states exist and come into being through the exercise of human will, and that without this exercise of will the continued existence of the state is also necessarily called into doubt. This relation between will and artifice is the central moment for the Machiavellian: at all times the prince must be conscious of what he is doing, for the political world may shatter around him should he relax his effort at any time.[15]

By such continued volition, two potentially fatal dependencies are avoided. First, the prince will minimize to the greatest possible extent any dependence on fortune or chance. In Chapter VI of *The Prince,* for instance, Machiavelli distinguishes between those who owe to fortune their transformation from private person to prince and those who owe it to ability. Though either of the two may help the would-be prince, "he who depends least on Fortune sustains himself the longest." And among such, the most noteworthy are those who "through their own ability and not through fortune have been transformed into princes; . . . on inspecting their actions and their lives, we see that they had from Fortune nothing more than opportunity, which gave them matter into which they could introduce whatever form they chose."[16] Secondly, volition of the prince

allows him to avoid dependencies on others. Machiavelli goes on to say, in the chapter cited above, that the more one has to depend on others the more difficult will be one's task. He turns this into a requirement that prophets be armed; as we shall see, Shakespeare pushed the concept even further.

In this understanding of Machiavelli, then, it is central that the prince figure not have the exercise of his will limited either by accident or by the whims or even expectations of others: we might refer to one who has attained such a position of complete independence as a hyper-Machiavellian. It is important to notice that the attitude towards time such self-conscious actors must hold will be quite different from that which might characterize those whom Machiavelli wishes to oppose. Before Machiavelli, the past was a source of tradition and wisdom. As we saw at the beginning of the essay, the history of the period and the chronicle tradition were used as a "looking glass" with which to reflect past experiences meaningfully on to the present. In this view there is no conceptual break between the past and present. The message here is that God will punish and that princes should, in Calvin's words, "hear and fear"[17], but not that this knowledge could be of some *use* in determining what to do. The past can stand as a moral *warning* in the pre-Machiavellian tradition, but not as something from which to learn what to do. With Machiavelli, on the other hand, the past becomes a storehouse of examples of more or less fortunate actions, to be picked and learned from in the context of *determining* present activity. In Raleigh's *History of the World,* for instance, one learns that history tends to repeat itself: but the message is prudence, and moral behavior means to accept the order of things.[18] With Machiavelli, on the other hand, one can learn from the past how to seize the present and make it conform to one's *own* will: here the world can be made new, in the shape of the willing creator. There is a central accuracy in Burckhardt's old notion of the state as a work of art,[19] even if the state so created is, contrary to a work of art, a creation always in danger of consuming itself, requiring constant exercise of will to survive and prosper.[20]

It is not that Machiavelli has a doctrine of history, at least if one means by history the notion of a process at work in the past that constitutes the driving force of the present. For the Machiavellian, all of the past is at the same distance from the present; thus Machiavelli in his writing can feel free to move from period to period, country to country, in "conversation . . . which profiteth"[21] him with any past leader, and with no particular sense that any one of them might stand in any special or more direct relationship to his time. For Machiavelli, the past has neither the eternal cyclical reality that it has for the "men of order," as we might call those who reflect the medieval understanding of nature, nor the developmental dynamism that it has for men of the nineteenth century and after. Most importantly, for

these "men of chaos" the past need not *do* anything to the present. It is a presumption of Machiavellianism that no particular political problem is, in principle, not subject to solution by the prince. The past is used to create a present artificial structure of necessities. Machiavelli writes in the *Discourses:* "But since all human affairs are in motion and cannot remain fixed, they must need rise or sink down; to many things which reason does not bring you, you are brought by necessity."[22] Fortune is like a river, writes Machiavelli in *The Prince,* which will be controlled only with a proper structure of dikes and embankments: with adequate foresight, all may be accomplished.[23] Faults, it would seem, lie only in ourselves and not in the stars.

III. The Problem of Self-Consciousness in the World of Degree

It is generally recognized that something was happening to social order in fifteenth and sixteenth century England. More specifically, almost all writers accept the contention that the old world of orders and degrees, of the danger to which Ulysses warns in his famous speech, was still a living but embattled force in the Tudor world, where the gentry were beginning to change their status.[24] As early as Richard II, the king himself was in the process of becoming "Landlord of England," in Gaunt's angry accusation *(Richard II,* II,i,113*).*

In such a world, where traditional relations are being turned around, and traditional ties undone, order was a very real and central problem: with the world of degree called into question, one literally no longer knows who one is, as Richard II, Gloucester, and many others discover. In such conditions, the search for order took several forms. E. M. W. Tillyard, always an astute and elegant commentator, has argued that the Elizabethans are both inside and outside of the old world. In *Twelfth Night,* he recognizes the pretentious elements in the hierarchical world view in the face of the new yeomanry (Malvolio, Falstaff), which is yet unable to come up with another and more viable picture.[25] Frances Yates has developed another side of this picture in her books on the development of the hermetic tradition,[26] in which she demonstrates that some Elizabethans at least were striving very hard both to understand and to organize their world along lines of hierarchy and order similar to those inherited from the Middle Ages. The difference is of course that the men she depicts, who range from the courtly Spenser to the theatrical Inigo Jones, were trying *self-consciously* to organize the world along the lines of a cosmic order (drawn from the neo-Platonic and magical traditions), whereas the older order was presupposed simply natural and required no self-conscious act on the part of persons to create it.

Shakespeare is certainly not unaware of the liminal character of

Elizabethan society and of attempts such as those of the hermetics to reconstitute an organized world. Indeed, Francis Yates certainly wants us to believe that Shakespeare belonged to their group. And Shakespeare does provide both a description and a praise of a world like the one his arcane neo-Platonic contemporaries sought to bring about. This is the world sometimes termed the Renaissance idyll, a world where ambition is nonexistent and unnecessary, the happy commonwealth that the old councilor Gonzalo sketches in *The Tempest,* the world of some of the sonnets where one would "scorn to change one's state with kings." In *As You Like It,* perhaps one of Shakespeare's most extended considerations of such a universe, the whole company sings

> *Who doth ambition shun*
> * And loves to live i' the sun,*
> *Seeking the food he eats.*
> * And pleased with what he gets,*
> *Come hither, come hither, come hither,*
> * Here he shall see no enemy*
> *But winter and rough weather.*

<div align="right">

(As You Like It, II,v,33–39)

</div>

By and large, though, such moments and such gardens are recognized by Shakespeare as temporary, and as requiring such artificial conditions that they are useless as solutions to the problems with which the world has to deal. For not only is the natural world held in abeyance (here the threat of "rough weather," and of "the rain which raineth everyday" in *Twelfth Night,* is important), but these worlds also require that men lose their knowledge of who they are. A little later in *As You Like It,* Jaques, finally exasperated with Duke Senior's repeated separation of the world of the forest from the city from which he was banished, bursts angrily into the famous description of the human condition as that of a player on a stage going though several different roles, all of them played, and together the conditions of man's mortality. To know that men are born, live, and die, and that this has no more and no less significance that if they were players on a wide and universal theatre ("this Globe, this stage fretted with golden fire") is Jaques' message. It constitutes a fundamental rebuke to those who seek a world of order in the idyllic relation of unselfconsciousness. It is as if Shakespeare is saying that knowledge of the temporality and the evanescence of the human condition makes the old world impossible. In the ordered world of the Middle Ages, both one's life and death fit into a plan of things. But now those who would maintain that plan by will, such as Lear, find finally that they do so at the expense of their sanity and only as "birds in a cage."[27]

There is no solution to the contradiction of the world of order and the

problem of self-consciousness in *As You Like It* or in *Twelfth Night*. There is not even much analysis. The resolution is gained only through a price paid: Jaques leaves, Malvolio stalks off, almost as if the others simply tried to forget them. But once someone knows who he or she is, it is impossible to forget; and the Tudor world was increasingly filled with men, both prince and commoner, royalist and roundhead, who knew who they were and what they wanted. It is in *Richard III* that Shakespeare most fully examines the nature of this new kind of person who no longer saw himself as part of a natural order.

IV. The Problem as Posed in Richard III

It is commonplace to say that Richard Gloucester has received a bad press due to the fact that most of our ideas about him have been formed by the image of the "bottled spider," and "hells' black intelligencer," presented in *Henry VI,* and in *Richard III.*[28] Writing for a Tudor court, it would clearly have been unpolitical for Shakespeare to present the last of the enemies of the Tudors as comparable in charm to, say, Henry IV. However, once one gets away from all that Richard is called, he is not noticeably different from those who are his opponents, at least in terms of skullduggery. The sequence of history plays go from *Richard II* through the various *Henrys* to *Richard III* portray a world of usurpation and killing, of a kingdom cursed with incompetent legitimate kings or competent but illegitimate ones. As Richmond recognizes at the end, England is a mess in this period: any reading of *Richard III* that ignores the fact that the main character is attempting to deal with this problem must miss half of the political problem that concerns Shakespeare.

I must note here that it will not do to speak only of "ambition" when discussing Richard's motives. This is true for a number of reasons. For one thing, all the protagonists in the play were ambitious, and if we are to cast Shakespeare as more than a Tudor propagandist we will have to find something specifically wrong with the character of Richard III.[29] Second, and much more importantly, it is not until later that the sort of political thinking which separates the man from the office becomes appropriate. In a real sense, there is no central distinction between Richard as king and some kind of order in the state.[30] The problem with England is that it has not had a legitimate king since the days of Richard II; we should look, in part at least, at Richard III's desperate attempts to gather the varied strands of legitimacy to himself as a venture to put an end to the cycle of rebellion and misrule that has plagued England for a hundred years. Richard III is not some sort of fifteenth century political robber baron, but a head that would wear a crown.

So the first step to a deep understanding of *Richard III* must be the

recognition that the protagonist is attempting something honorable in itself, the unification of the kingdom and the end of civil strife. This was no different from what others had done before him; his situation is more problematic, however, because in time past strife was between families such as the Percys and the Bolingbrokes whereas now it is almost entirely within one family. Everyone seems at least a cousin; the medieval honor which arose from the combat between families is now degraded to internecine family struggles.

V. Richard III and The Tragedy of Richard III

In the play *Richard III,* Shakespeare puts together an account of the end of the quarrel between the House of York and that of Lancaster, and of the emergence of the new Tudor dynasty. The story starts during the last years of the reign of King Edward IV. We are shown Richard, Duke of Gloucester, brother to the king, plotting to take the throne he had helped his brother to win. First he eliminates his next oldest brother, Clarence; then he manages to get himself engaged to Anne, widow of a son of Henry VI (the previous king), whom he (Richard) had killed. Upon the death of Edward IV, Richard becomes regent in the name of the twelve-year-old Edward V, whom he shortly has murdered in the Tower of London. At this point he has himself declared king. He is challenged by Henry Richmond, a descendant through the female line of John of Gaunt, the Duke of Lancaster at the time of Richard II. The forces meet in battle on Bosworth plain. Richard is defeated and killed and the Tudors, led by Henry VII (Richmond), take the throne of England.

As such, this play is part of Shakespeare's second major history tetralogy dealing with the War of the Roses. These plays, however, are not just chronicles. They comprise a point of view on English history and an argument about the nature and sources of political power *during Shakespeare's time.* Especially in *Richard III* (but already with the three *Henry VI* plays), Shakespeare changes chronology, invents incidents, rearranges sequences of events in a sort of dramatic montage to make an argument about what was happening in England. Although the plays, and this play in particular, have a strong basis in historical fact, it is important to remember that not only do they not share the morality of the chronicles but also that they are not chronicles; they are plays written with a specific strategy and intention towards an audience.[31]

In *Richard III,* Shakespeare compresses into a matter of hours or days what in fact takes 14 years of history. The *historical* order of events goes as follows: In 1471 Edward, Prince of Wales, husband to Anne Nevil, is killed. Henry VI dies the same year, possibly murdered. In 1474, Anne marries

Richard. She dies before he becomes king; he seems to have been grieved at her death. In 1478 Clarence is imprisoned and killed. In 1483 Edward IV dies a natural death, Richard succeeds to the regency, the two princes are killed (it is not clear by whom), and Richard acquires the throne. In 1485, he loses to Henry Richmond and is killed.

The *dramatic* order of events is as follows: Clarence is imprisoned; shortly thereafter Richard proposes to Anne on her way to bury her father-in-law Henry VI; Edward IV dies; the princes are killed and, Richard loses to Henry Richmond. The strategy of the *dramatic* sequence is to emphasize the ability of Richard to control events and to divorce him from any normal feelings that he might have had about any of those involved. It is precisely Shakespeare's analysis of these elements that forms the focus and true subject of the play.

Shakespeare shows us, then, a character (Richard III) who has to deal with a problematic political situation — that of obtaining political power under circumstances complicated by the mandate to order and the traditions inherited from the Middle Ages. Within the first two scenes of the play he makes at least three references to the social disorder prevalent in his time. Men are unnaturally "ruled by woman" (something which is to bother Gloucester in *Lear*); men of degree have been denied the privileges of equals and of rank (men of "any degree whatsoever" are forbidden to converse with Clarence); and finally, in what seems an explicit reference to the radical social doctrine of *Piers Plowman,* Richard prickles Queen Margaret with the claim that "since every Jack became a gentleman, there's many a gentle person made a Jack." This last reference is to the fact that Margaret has been using her favored position to advance the cause of those close to her, in a self-conscious and calculating way about which even she seems to sense a certain crassness.[32]

Even though ordered social hierarchy seems to have broken down, individuals have been able for the last several years to maintain an appearance of good society. Richard's famous opening soliloquy depicts the "glorious summer" made by access of the "son of York" (Edward IV, his brother) to the throne of England. Richard, however, not "shaped for sportive tricks," is a man unable to fit into the demands of such a world. Like Jaques in *As You Like It,* he knows that the world is a stage and that this is but a "weak piping time" that will soon pass away. Richard knows about death and deformity and that side of humanity which this idyllic world of "idle pleasures" denies. Unlike to everyone else in the play, he knows precisely what the others are doing and will thus be able to use their own intentions and their desire for order against them. To this extent, he is different from Jaques, and even from Richard II. Jaques knows the nature of man and the ultimate meaninglessness of any given activity: he must

therefore leave the forest. Richard II, upon learning precisely the same thing during his abdication, calls for a mirror and, horrified at the sight, dashes the mirror to the ground. Richard III, in what must surely have been intended as a parallel by Shakespeare, calls for a mirror immediately after his wooing of Anne but uses it to preen in.

What is important to notice about Shakespeare's presentation is precisely the fact that he does not use the Middle Ages, and the concept of magistracy that characterized them, to beat Richard over the head in the manner in which the *Mirror* did. That Richard breaks with the world of order is not what troubles Shakespeare. It is the particular manner in which he does, and it is this manner to which Shakespeare directs his attention in this play.

Of all Shakespeare's plays this is the only one which begins with a soliloquy: it is what is going on inside Richard that interests Shakespeare, not just his actions, which in their villainy are not only historically exaggerated but not all that different from the common experience of politics of the time. We are given to understand that the main difference between Richard and those around him is self-consciousness. If he appears more villainous to us, it is precisely because he knows what he is doing and informs himself and us of it both before and after his acts. During the first three scenes Shakespeare hits at this again and again. The opening soliloquy ends with "Dive thoughts down into my soul — here Clarence comes!" The self of which he is so proud must remain unknown to others, even to his own brother. There follows the sequence with "poor, simple, perjured" (he had betrayed an oath sworn on the sacrament) Clarence, and then yet another soliloquy which reveals Richard's "deep intent." After this comes the famous bier-side wooing; then, having become engaged to the fiancée of a man whose father he has just admitted killing, Richard goes back into his consciousness to admire ironically the new public self he has just created:

> Upon my life, she finds (although I cannot)
> Myself to be a marvellous proper man.
> I'll be at charges for a looking glass
> And entertain a score or two of tailors
> To study fashions to adorn my body:
> Since I am crept in favor with myself
> I will maintain it with some little cost.
>
> (I,ii,253–59)

The seduction of Anne is an important moment for Richard, for he realizes precisely how easy it is going to be to use people's lack of self-knowledge and self-awareness against them. There is more than idle boasting in his "Was ever woman in this humor wooed? Was ever woman in this humor

won?" There is a realization of the nature of his power, which is such that even if the odds be "All the world to nothing" (and they will be by the end of the play), he has no doubt of his ability to manipulate situations so that the outcome is favorable to his intent.

After taking stock of his power, he follows with a lengthy exchange with the various queens. It develops that they, like others, believe in the ritual power of incantations and curses, of inherited wisdoms. Margaret attempts to curse him, but Richard discovers that he can play with even this aspect of the Middle Ages. By making a game of the curse, he demonstrates how to diffuse royal and traditional powers. With curses unmade, he now proceeds to still another soliloquy of self-consciousness. In it, Richard adds the third and final element to his understanding of himself. Previously he had understood that he could not fit into the "glorious summer" of the rule of York: he could not "prove a lover." With Anne he could, however, *appear* as the world's greatest lover; thus, in true Machiavellian fashion, Richard makes no public distinction between being something and perfectly imitating it. In his world of artifacts and artifice, imitation is the very basis of being.[33] After the exchange with Margaret he understands that he will be able to use precisely those elements his enemies assume give them the most power against him. The strength of the Machiavellian is this realization, and *never* simply the *use of power*. It is not that Richard III has power and will not hesitate to use it. It is that he knows how to draw upon other people's activity in order to use the energy that they create to further his own ends. The odds are not all the world to *one,* but, properly, all the world to *nothing*. Richard is nothing by himself, but that is precisely the source of his strength.

Through four soliloquies (in three scenes!), Richard is thus set off from all the other characters in the play in an explicit way. He is neither "royal" like Clarence, nor "loyal" like the murderers, nor can he be bought and sold like Buckingham. He has no permanent qualities. Yet by being nothing, he can appear all things. For instance, Lord Hastings, a weak man wavering in his support for Richard, is led to note that "by his face, straight shall you know his heart" an instant before Richard orders his execution. Having so appeared to Hastings, Richard and Buckingham, his cousin and chief ally through much of the play, proceed to act upon the principle that all the world *is* a stage, and put on a little play for the populace. Richard enters in costume, in "rotten armour, marvelously ill favored," and proceeds to inform his cousin that he can "counterfeit the deep tragedian."[34] This leads to the theatricality of the scene where they seek the applause of the audience-populace gathered in the street below, in an attempt to use the old Teutonic practice of electing kings by popular acclamation rather than through descent.

Shakespeare's purpose in emphasizing Richard's self-consciousness

cannot be a simple belaboring of the king's villainy. There was no ideologically important reason for Shakespeare to have gone on so long. The normal interpretation is that this is a weakness of the play. Yet it seems to me at least a possible reading that Shakespeare is trying to impress upon his audience something quite particular about the nature of this man Richard and why his alternative was not only politically bad (after all, he wasn't a Tudor) but was in addition a dangerous and self-destructive form of statecraft. By emphasizing Richard's consciousness of self, Shakespeare is, I suggest, trying to point to a manner in which Richard is a different sort of person and leader from the others around him.

VI. Machiavellian Statecraft in Richard

These lines justify an examination in somewhat greater detail of the nature of Richard's craft. After all there has to be more than the simple statement that he lies — so did they all. Why is it that his actions met with such success for so long? Two scenes provide the basis of an answer.

In the seduction scene with Anne, the man who declared just previously that he cannot prove a lover, succeeds in one of the most impossible courtships of stage memory, so much so that the scene is often called an unplayable strain on credulity. Yet Shakespeare invented it and probably placed it out of chronological order to strike us in some way. It is true that *Richard III* is an early play, but there is no reason to ascribe this scene to Shakespeare's inexperience. *Richard III* is part of the first group of 18 plays which are generally agreed to have been written by 1598, and which include such works as *Love's Labour's Lost* and *A Midsummer Night's Dream.* Furthermore, to ascribe this scene to the work of immaturity begs the fact that in such "mature" plays as *King Lear* Shakespeare still includes scenes that, from one point of view, also seem almost unplayable (in this case again a "love test" scene, act 1, scene 1).

It seems clear that the strategy[35] of the scene must revolve around the fact that Richard has declared himself not to *be* a lover, and will now play *the part of* a lover with such finesse that no one may see him as counterfeit. Shakespeare's intention here is then to show that *even ties such as love,* which were supposed to form the basis of the summer of the reign of Edward (this was made clear in the opening soliloquy), *can be used to further political aims.* On this note, it should be noticed that the other play with a similarly difficult opening scene is *Lear,* which also involves a man who tries to use love for political ends. Anne, however, is no Cordelia. Cordelia says nothing to her father's demand for love. Anne is unable to remain silent and cannot refuse the possibility that Richard might in fact be telling something of the truth in his declaration of love: she thus affords him an audience, which Cordelia denied to Lear. The scene opens with the

procession of the corpse of her father-in-law, Henry VI, lately slain by Richard Gloucester. Anne halts the procession for a rest. Her behavior is medieval: she begins an incantation and curse to inform the corpse that vengeance will occur. The result of her ritual is a parody of the Middle Ages: a spirit appears but not an avenger; instead it is the "dreadful minister of hell," Richard himself. An exchange follows between Anne and Richard; for sixty lines or so Richard has the worst of it. She rebuffs all his protestations of innocence, and has gathered up considerable vengeful momentum when Richard finds the right tactic. Anne lands her attack with success until Richard withdraws the target.

> *Anne: Didst thou not kill this King?*
> *Richard: I grant ye.*

Here, with one line, Anne is lost. Her momentum carries her onward, but now she is no longer restricted to Richard's *acts;* forced to find an account of Richard's *intentions,* she must ask *why* he killed "this king." Now, intentions can be understood: generally we show no hesitation in arriving at important understandings about people's behavior based on comprehension of their intentions. But to understand intentions requires that two people involved acknowledge each other in a manner that constitutes an acceptance of the fact that they are, for this time at least, human beings from the same realm of discourse. In inquiring into Richard's intentions, Anne falls into the position of having to treat Richard as if he were a member of a natural community, as if moral relations prevailed between them. Yet we know from the soliloquy that Richard has no such natural emotions such as love; thus what she responds to here is the perfect counterfeit of love, an artifact Richard has constructed and which, having constructed, he feels and knows (as do all true Machiavellians) he can break at any moment. Richard's "love" owes its continuing existence to an ongoing and self-conscious exercise of will on his part. Should he move elsewhere ("I'll not keep her long"), it would disappear as if it had never existed.

Richard then claims that he loves her, a claim that he apparently does not make lightly, for he offers her a chance to kill him. By this act he forces Anne into an impossible position. Either she must admit the possibility of his love, which in turn would provide some justification for the murders Richard now admits having committed, or else she must take herself out of a natural community of discourse. Either possibility requires cold-blooded calculation, of which Anne is not capable. Richard has, in effect, placed Anne in the position of being as Machiavellian as he or of loving him. And because Anne's energy is oriented towards the latter, there is *no other possibility* for her choice. Richard has been able to use her basic decency,

and her acceptance of the reality of human relationships, to his own ends. Richard's self-consciousness allows him to pretend to be moral. Anne's morality is such that she cannot see Richard as he is. It is not until Cordelia that we find in Shakespeare a person who is both truly moral and truly self-conscious.[36]

This scene occurs on the level of interpersonal relations. As always in Shakespeare, the disorders and orders of the self have parallels in the social world.[37] Here that parallel comes in the sequence that begins with the central scene of the third act. I have previously mentioned this scene, in which Richard and Buckingham decide to put on a play for the populace the intention of which is to get them to acclaim Richard king. We have just left the scene where Hastings has, in effect, condemned himself to death; unknowingly, Hastings proclaims death as the penalty to the traitors who have worked upon the body of Richard, and then associates himself with those who have done so. Again, though it may seem contrived, the device brings out the nature of Richard's power: it is not hand in a physical sense, but that he is able to trip others into condemning themselves and doing his own work. The dynamic is the same with Anne: she finds herself engaged to Richard and in support of his legitimacy; Hastings — one can only picture him as bewildered — loses his head, and with that a faction in potential opposition to Richard disintegrates.

With the last important supporter of the two young princes who claimed the throne done away with, Richard can now present himself to the populace and claim at least as much legitimacy as anyone else. There is no longer anyone to gainsay his claim as to the bastardy of the two princes (now we understand why so much has been made of Mistress Shore since the very beginning of the play), and he, Richard, is after all the brother to a king.

Through the reluctant intercession of the Lord Mayor, Richard and Buckingham now approach the populace. They justify the execution of Hastings with "the peace of England." It must be noted here that this is a credible claim. From the time of Richard II on, and with only the respite of the foreign adventures of Henry V, England had known little peace in her kingship. Buckingham, in a preliminary attempt, then goes before the people and explains to them exactly what the rightful claims of Richard are. Again, he does not seem to be actually lying, but instead forcefully presenting generally known facts about the potential illegitimacy of the princes and about other philanderings on the part of Edward IV. Buckingham concludes with an appeal to the country:

> *I bid them that did love their country's good*
> *Cry "God save Richard," England's royal king!*

To which Richard queries "And did they do so?" only to learn that "No, so God help me, they spake not a word."

As with Anne, the attempt at argument fails. The people will not be persuaded, nor can they be forced. Richard does not have the legitimacy to tell them to support him, and the Lord Mayor merely presents the facts and fails to use his authority to sway the populace. Richard is thus led back to his previous approach. He will now go before the people, dressed for "devotion and right Christian zeal." A rehearsed exchange between Richard and Buckingham follows, the gist of which is to make clear to the populace that Richard does not appear to want the throne; that he will only take it if public appeal is so great as to compel him; that, in any case, Buckingham will not allow the young princes to succeed; and, finally, that the choice for the populace is either a succession in the house with the most legitimate claim (the Plantagenet-Bolingbroke line) or else the installation of a new line, and hence more civil war. The populace is now faced with a choice: either to accept someone they clearly do not want, or else undergo a new round of chaos and disorder. Like Anne, they cannot give up their commitment to what they have been and thus are forced to acclaim Richard in order to prevent chaos. Richard has used their natural and moral inclinations to his own advantage; he has structured their necessities.

One should note here, especially because much has been made of this and similar scenes in other Shakespearean plays,[38] that this scene is not precisely an argument for the political immaturity or conservatism of the populace in Shakespeare's, or even the Elizabethan, view. It is the representation of a situation in which moral individuals are forced into a collective choice of either nothing or an alternative for which they are clearly not enthusiastic. There is no indication that the people are *fooled;* rather, the inertia of their natural choice is used against them.

With this, Richard has the throne and the authority to dispose of his last rivals. As Clarence had been drowned in a butt of malmsey, so the two young princes are suffocated. Most of those who could bear legitimate witness against Richard's claims to the throne (not to his crimes) have been silenced. Richard's success up until this point is notable: with no real power of his own, he has been able to direct the activity of others such that the peace and stability of England is identified with him. His behavior has perhaps made him horrific to the audience, in that he has told them repeatedly of his plans and his intentions. Suppose, however, we ask ourselves what our impression of him would be without the revealing soliloquies. To some degree, I think it fair to answer here that he would appear no worse than the others around him (no worse, perhaps, than Henry IV), and indeed might even take on the appearance of a man trying to do what had to be done to save England from the chaos of a new civil

war. But from the self-consciousness of the soliloquies two things stand out. First, he is bound to no one by any sort of tie. We have seen how he uses the imitation of love with Anne. In much the same way he buys the conscience of the two murderers ("Where's thy conscience now? — In the Duke of Gloucester's purse"), and, just as he eliminates Anne, so he simply cancels the agreement which tied Buckingham to him ("I am not in the giving vein today" — IV.ii.115). Such independence from mutuality or reciprocity with those around him is the source of his strength and ability. As we saw, it is a central portion of Machiavelli's message. One should note well that neither here nor in Machiavelli is there a claim that the prince should be heartless, in the ordinary moral sense of the term. Rather it is a claim that the prince cannot afford to be bound by ties either natural (family), assumed (marriage), or artificial (money). To accept a reality for such ties would be to give oneself a past and a history which would, perhaps fatally, reduce the autonomy of one's activity. For Richard, such pasts do not exist, because their source was semblance and counterfeit, and thus could acquire no natural existence. (A marriage contracted under false pretenses is not a marriage, even though it may look like a marriage for a long while and one of the partners may think it to be one. But it takes two to make a marriage, just as it takes two to have a past. Richard, we have seen, is in principle, and perhaps by nature, alone.)

The second thing that stands out about Richard, as Shakespeare has presented him, is his self-consciousness. He is aware of himself and his motivations; all of his actions are calculated. As I noted in the discussion of the seduction scene, it is precisely this element of calculation that takes him outside of normal human communities and allows him to use the dynamics of that community as he sees fit. In *The Eighteenth Brumaire of Louis Bonaparte* Marx argued, in a moment of profound anti-Machiavellian insight, that "men make their own history, but not just as they see fit." Richard's presumption, and a central feature of Machiavelli's thought, is that men make their own history; should they fail to do this, the fault lies in themselves, as Cassius proclaimed, and not in the stars. Marx argued as he did because of his understanding that no one stood so self-consciously as to be outside all class and community. Richard, as we have again seen, takes himself outside all such relationships, apparently successfully.

At this point in the play — the middle of Act IV — there is but one possible source of legitimate claim to the throne which Richard has not firmly eliminated. This is Elizabeth, queen to the now dead Edward IV, and prior to that wife of one Sir John Grey. In the wings, with less of a legitimate claim to the throne than has Richard III, is Henry Tudor, Earl of Richmond. Richard III quite accurately perceives the potential danger. During the rejection scene with Buckingham, he is busy musing on how to

prevent Richmond's likely project of marriage to Elizabeth's daughter (also named Elizabeth), which would give Richmond as much rightful claim as he himself has.

He goes then to old Queen Margaret, to his mother the Duchess of York, and to his ex-sister-in-law Queen Elizabeth. Upon raising the question of the young Elizabeth, her mother claims the child to be illegitimate and hence no threat. This, of course, is not public knowledge (it will be denied later), and thus of no particular importance. Richard then argues quite reasonably that the presence of this unmarried daughter is a threat to the peace of the kingdom and that the most reasonable thing to do, now that Anne is dead (he claims to have killed her), is for him to marry the young Elizabeth and thus tie up all the remaining strands of legitimacy into one house.

This sequence, act 4 scene 4, had started with a long exchange between Margaret and Elizabeth in which they called the roll of their dead. The complicated litany certainly remains befuddling to a modern audience in the multitude of its references ("I had a Richard too and thou didst kill him; I had a Rutland too and thou help'st to kill him. . . ."). I suspect that it had the same effect on the Elizabethan audience and, instead of constituting a weakness of the play, is in fact intended to convey the impossibility of distinguishing one side from the other and of remembering who stood with whom during the last years of the quarrel betweeen the two great houses of England. In her central speech Margaret, a Machiavellian herself, as we have seen, asks where are now all those who have been slain. No answer is given; Margaret leaves to return to Anjou, whence she came. Richard enters, and there follows an exchange with his mother; in effect, she withdraws her maternity from him, and also leaves. Richard is left with Elizabeth. Richard then claims that he wants to advance the state of her children.

> ELIZABETH: *Tell me what state, what dignity, what honor*
> *Canst thou demise to any child of mine?*
> RICHARD: *Even all I have — ay and myself and all —*
> *Will I withal endow a child of thine,*
> *So in the Lethe of thy angry soul*
> *Thou drown the sad remembrance of those wrongs*
> *which thou supposest I have done to thee.*
> .
> *I mean that with my soul I do love your daughter*
> *And do intend to make her queen of England.*
> *(IV, iii, 60–264, 275–76)*

Elizabeth responds that this is impossible unless that Richard *could be someone other than he whom he has become.* With this note, the

unraveling of Richard's achievement begins. Until now, Richard's opposition has either departed or been eliminated. It turns out now that the central obstacle to Richard's further success is Richard himself. This seems patently unreasonable to him, and he argues quite sensibly,

> *Look what is done cannot now be amended.*
> .
> *If I did take the kingdom from your sons,*
> *To make amends I'll give it to your daughter.*
> *(IV, iii, 308, 311–12)*

Somewhat further on Richard proclaims that politics demands the giving and acceptance of such love.

> *Without her, follows to myself and thee,*
> *Herself, the land and many a Christian soul*
> *Death, desolation, ruin and decay.*
> *It cannot be avoided but by this;*
> *It will not be avoided but by this;*
> *Therefore dear mother (I must call you so),*
> *Be the attorney of my love to her:*
> *Plead what I will be, not what I have been —*
> *Not my deserts, but what I will deserve;*
> *Urge the necessity and the state of the times,*
> .
> *(IV, iii, 430–36)*

Elizabeth is not convinced and leaves to give her daughter to Richmond.

Central here, I think, is the realization that Richard's position has a core of reasonableness to it. It is true that if this marriage be not effectuated, civil war will surely strike the land. Furthermore, the expectation that with this marriage an end will be put to the killings and so forth also seems quite reasonable, if only because there is really no one else to eliminate. After all, Richard did not kill for the simple pleasure of it, but for political reasons. What goes wrong, though, is that the world he has created through the manipulation of illusion has destroyed the world in which he might now make the final settlement of his political task. The destruction of the past, which his marriage to the young Elizabeth would require, now also destroys the possibility of there being any future. Machiavellians, after all, know not of the past.

It is now All Souls' Day, the feast after the Saturnalia of Halloween and the day during which one recollects all past saints. The opposing forces are prepared for battle, Richard's side outnumbering that of Richmond. Each of the opposing commanders has a short speech before falling asleep, Richard ending his with the command that he be left alone, Richmond with

the prayer that God still defend him. With the stage now set with the two sleeping rivals, there appears a succession of the ghosts of those that Richard has slain in his path to the monarchy. By the end of the sequence, there are eleven ghosts on stage, each of them having withdrawn some quality from Richard and given it to Richmond. The ghosts include erstwhile figures of legitimacy, prophetic figures, enemies, Richard's adversaries, allies and wife: everyone who has in some way had important links to Richard is now found ranged on the side of the new pretender. In a sense, Shakespeare says, his past is still with him, even if his waking self denies it.[39]

When communities of discourse and speech break down, men are tempted into solipsism. Philosophically, this position retains a great attraction. It is the final outcome of the absoute self-consciousness that Richard's life and activity require. Self-consciousness here turns on itself — a state Hegel called absolute freedom and terror — and Richard finds himself absolutely alone, as he had asked to be. His speech depicts a man who, because he has no community with others, now also has no community with himself. The very self that made possible the extraordinary manipulations of illusion has now, as a result of such activity, itself been annihilated.

> *What do I fear? Myself? There's none else by.*
> *Richard loves Richard: that is I and I.*
> *[alt. reading. I am I]*
> *Is there a murderer here? No. Yes, I am:*
> *Then fly. What, from myself? Great reason why —*
> *Lest I revenge. What, myself upon myself?*
> *Alack, I love myself. Wherefore? For any good*
> *That I myself have done to myself?*
> *O no. Also, I rather hate myself*
> *For hateful deeds committed by myself.*
> *I am a villain. Yet I lie, I am not.*
> *Fool, of thyself speak well, Fool, do not*
> *flatter.*
> .
> *I shall despair. There is no creature that loves me;*
> *And if I die, there's no soul that shall pity me.*
> *And, wherefore should they, since that I myself*
> *Find in myself no pity to myself.*
>
> (V,iii,183–203)

This is a passage extraordinary in the profundity of its understanding of the human condition. Shakespeare is showing us that the Machiavellian — the man who lives in and for the moment, without a past, always making the world new — is a man without a self, without a central core to his being.

Furthermore, Shakespeare argues that sense of self and sense of others — community, if one will — are intrinsically linked. Without a other, man has no self. Should we be psychiatrically inclined, we would call an individual with no sense of other or of self a person in an advanced state of schizophrenic breakdown. It is seen by Shakespeare to be the natural consequence of the systematically denied community. The consequence of hyper-Machiavellianism is not the strong legislator-prince, standing like Moses outside the Promised Land that he has created and given to his followers, but the fragmentation and disintegration of all personality. Richard, having followed this logic through to its end, has not even feelings for himself, because he has not been able to have them for others during his rise to the throne. He is thus reduced to the Hobbesian state, a simple unit of force.

"Our strong arms be our conscience, swords our law," he proclaims to his troops, even though just prior to his dream he had thought that it was the *combination* of the authority of his kingship and numerical superiority which would surely prevail. And though he fights like "more than a man," searching until the very end for a horse on which to seek out Richmond, he is forced to do what he has refused to do all the way through the play, namely to surrender himself to fortune.

> . . . *I have set my life upon a cast*
> *And I will stand the hazard of the die.*

Richard loses — not as a coward, but, long since, no more a man. Richmond is crowned and announces his intention to marry young Elizabeth (Richard was right, once again) and sexual and political peace is reestablished in England.

VII. The Problem of Power

In this reading of *Richard III,* I have gone to some pains to show that Shakespeare's reaction to the question of Machiavellianism is not one of moral horror; nor is it a reactionary desire to return to the well-ordered world of unvizared degree. Shakespeare sees the breakdown of such a world as leading to the understanding that was the starting point for Hobbes and the Machiavellians of the late sixteenth and seventeenth centuries, a world where

> . . . *everything includes itself in power,*
> *Power into will, will into appetite.*
> *And appetite, an universal wolf,*
> *So doubly seconded with will and power,*

> *Must perforce an universal prey*
> *And last eat up himself.*
>
> <div align="right">*(Troilus and Cressida, I,iii,119ff)*</div>

There is in Shakespeare no backing away from the fact that the Machiavellians are here to stay, and that the polity must in some manner come to terms with the new statecraft, with the new world of self-conscious calculation and myth-mongering. *King Lear,* for instance, carries the problem of *Richard III* to an even greater extent. It starts with the destructive consequences of those who attempt a manipulation of human ties for political purposes. But here there is no representative of the forces of history to act as counter. In *Richard III,* Richmond is the vanguard, if you will, of what Jan Kott calls the "Grand Mechanism"[40]; in *Lear,* however, there is no such mechanism at work, or at least it is not manned by any person. Lear is in some sense as guilty as Regan and Goneril of acting like a Machiavellian. He, too, is trying to manipulate others for his own pleasure without real regard for his relationship to them. It is the consequences of this behavior that drive him mad, as they do every one else in the play, so that by the central scene the only characters left in the storm-swept Hobbesian wilderness of the heath have either gone mad (Lear), are playing at being mad (Kent), or are mad by profession (the fool). And at the end of the play there is no resolution. Lear and Cordelia die. The only non-Machiavellian character, Kent, either leaves or dies (I prefer the first reading) and Edgar is left with:

> *The weight of this sad time we must obey*
> *Speak what we feel, not what we ought to say.*

And yet, this cannot be an answer to anything, since as Stanley Cavell points out,[41] had Cordelia spoken what she ought to have said and not what she felt, none of this would have happened.

One is tempted then to say that the problem of power, in the manner that it is posed by the development of Machiavellianism, is never solved by Shakespeare, even if he framed it properly. Shakespeare does understand that Machiavellianism implies, for the first time, a separation in kind between elites and masses; not the separation of hierarchy that had been characteristic of the earlier world view, but a separation that implies a radical and qualitative split. If, as Machiavelli argued, most people are led by immediate constraints and have no sense or calculation beyond the present, then what is needed is someone to manipulate the structure of necessities so that people see themselves constrained in a direction that works out for the good of the prince and the state. It is not necessary that

the people understand why they do what they do; in fact it is important that at least some part of them not understand or acknowledge this sort of manipulation. On the other hand, the prince figure must be in full control and in full knowledge of events in order to be able to channel passions along constructive lines.

It was left to Hobbes and other early contractarians[42] to show us that both of these roles could be combined in the same person, that one could be one's own sovereign and one's own subject at the same time. The only person in Shakespeare who seems to me to come close to such a position is the Fool in *Lear,* who seems to advocate a sort of prudence and control over self that would have kept Lear from ever engaging in the behavior that called his relations to his daughters and himself into question (see I, iv, 112ff). Yet once the die is cast, the Fool must "stay behind" (III,iv,100), and Shakespeare seems to be saying that the Fool can never fully become a person. He appears not at all during the last two acts of the play and most especially could have no role to play in the crucial recognition scene, in which Lear gains some simple recognition of who he is in his acknowledgment of the blind Gloucester ("If thou wilt weep my fortunes, take my eyes. I know thee well enough: thy name is Gloucester" — IV,vi,172-73.)[43] The prudent contractarianism of the Fool is not a solution for Shakespeare, at least not when the question is one of community and acknowledgment of persons. (Nor, might I add, can it do all that Hobbes and Locke thought it could do.)

Shakespeare's only attempt at dealing with the problem of power seems to me to occur in plays such as *The Tempest.* This play takes place on an island governed by a magician, Prospero. Years before, he had been exiled from his kingdom (Milan), and now lives here with his daughter Miranda, ruling over Caliban, "a savage and deformed slave" to whom they have taught speech, and Ariel, an "airy spirit." A boat containing many who were associated with Prospero when he was Duke of Milan is shipwrecked; eventually Prospero is acknowledged by all as the rightful ruler of Milan, and most of the company leaves the magic island to return to the world.

In *The Tempest,* the problem of Machiavellianism is taken to an even greater length than in the other plays: it is no longer a matter of manipulating *people.* Had we thought, as we might have from the other plays, that the problem came in the recalcitrance of the human condition, here we are shown, as if in counterexample, a world where the illusions are given reality by Ariel, a supernatural being, almost the emodiment of a perfect natural technology. The world is seen to turn happily only on self-restraint, both sexual (Miranda and Ferdinand must refrain from going to bed together: "The white cold virgin snow upon my heart/ Abates the ardor of my liver") and political. In a masque Prospero calls up the Renaissance

idyll once more, as a punctuation to and comment on the idyllic world they already live in. (IV,1) He breaks this off and refuses it violently:

> *Our revels now are ended. These our actors,*
> *As I foretold you, were all spirits and*
> *Are melted into air, into thin air:*
> .
> *We are such stuff as dreams are made on . . .*
>
> *(IV,i,148–156)*

Insurrection in the shape of Trinculo, Caliban and Stephano is defeated, and with that, the key recognition arrives upon Prospero. Ariel has imprisoned the insurgents. He proclaims to the magician-prince:

> *. . . Your charm so strongly works 'em*
> *That if you now behold them, your affections*
> *Would become tender.*
> *Prospero: Dost thou think so, spirit?*
> *Ariel: Mine would, sir, were I human.*
> *Prospero: And mine shall.*
>
> *(V,1,17–20)*

Prospero now finds that his "nobler reason" calls upon him to restore them to themselves and, at the same time, as his exchange with Ariel indicates, to acknowledge his own humanity by henceforth refusing the ability to be more than human, to be the God-Prince-Legislator. He then abjures "this rough magic," breaks his staff of power,

> *And deeper than did ever plummet sound*

drowns his book of spells.

The end of the play — according to tradition, the last words that Shakespeare wrote for the stage — repeats the recognition that to be human is to be limited, even though this is a time when humans are no longer in order with each other, when the state is "disjoint and out of frame," so that men are tempted, and even able, to behave as if they were more than men.

> *Now my charms are all overthrown,*
> *And what strength I have is mine alone,*
> *Which is most faint.*

Shakespeare was not a man of the republic and would, I suspect, have found the answers to the problems of power and community that the English Machiavellians eventually developed in the contract doctrine a

near-contradiction in terms. How could the rationality and self-conscious calculation that had led to the bloody worlds of *Richard III* and *King Lear,* where

> *Humanity must perforce prey on itself*
> *Like monsters of the deep.*
>
> *(King Lear, IV,ii,49–50)*

be expected to put an end to itself? Shakespeare was, however, a man of the community, and recognized that the sharing that community involves requires an admission of the limitations of human powers, both in fact and in principle, and an overcoming of whatever necessities may tempt us to drive beyond our kind. Lear's prayer in the central scene of that play is not to authority, but to the others around him. It is as if in this moment of madness he recognizes that only when we have settled with those around us do power, authority and kingship become possible, and not, as the Machiavellians would have it, the other way around.

Notes

All line references are to *The Complete Pelican Shakespeare.*
1. Lily B. Campbell, ed., *The Mirror for Magistrates* (Cambridge: Cambridge University Press, 1938) pp. 64–65 (language modernized). See also E.W. Talbert, *The Problem of Order: Elizabethan Political Commonplaces and an Example of Shakespeare's Art* (Chapel Hill: The University of North Carolina Press, 1962), pp. 7–9, on religious aspects.
2. Reinhard Bendix, "The Lower Classes and the Democratic Revolution," *Industrial Relations,* 1, no. 1 (Oct. 1961), pp. 93–94.
3. See on this Mikhail Bakhtine, *Rabelais et la culture populaire au moyen age* (Paris: Gallimard, 1965).
4. Theodore Spencer, *Shakespeare and the Nature of Man* (New York: Macmillan, 1942), p. 44.
5. See here J.F. Danby, *Shakespeare's Doctrine of Nature* (London: 1948), Chapter I.
6. Campbell, *Mirror,* p. 362 (language modernized). See Lily B. Campbell, *Tudor Conceptions of History and Tragedy* (Berkeley and Los Angeles: University of California Press, 1936) esp. p. 23f.
7. See on this the following: A. P. Rossiter, *Angel With Horns* (London: Longmans, 1961), p. 2; M. M. Reese, *The Cease of Majesty* (London: Arnold, 1961), p. 58; Geoffrey Squires, *Narrative and Dramatic Sources of Shakespeare,* Vol. III (London: Routledge and Kegan Paul, 1960), pp. 274–310.
8. Albert William Levi, *Humanism and Politics* (Bloomington: Indiana University Press, 1971), Chapter III, p. 64.
9 John Palmer, *Political Characters in Shakespeare* (London: Macmillan, 1945), p. 95. This view is shared by, e. g., G. G. Gervinius, *Shakespeare Commentaries* (London: Smith, Elder, 1883), p. 285; Christopher Morris, "Shakespeare's Politics," *The Historical Journal,* VII, 3 (1965), p. 308; and even to some degree by the great scholar L.C. Knight "Shakespeare's Politics," *Further Explorations* (London: Chatto and Windus, 1965), p. 24ff.
10. See here Caroline Robbins, *The Eighteenthcentury Commonwealthman* (New York: Atheneum, 1968), Chapters 1 and 2.

11. See C.M.W. Tillyard, *The Elizabethan World Picture* (New York: Vintage, 1957); L.C. Knights, *Drama and Society in the Age of Jonson* (London: Chatto and Windus, 1937); George W. Keeton, *Shakespeare's Legal and Political Background* (London: Pitman, 1967), pp. 312–333; Wyndham Lewis, *The Lion and the Fox* (New York: Doubleday, n. d.).
12. See on this the incredible Machiavellianism of the end of *Henry V* which should raise at least some doubts as to Shakespeare's intentions relative to Henry V.
13. Most important here are the first three chapters of J.G.S. Pocock, *The Machiavellian Moment* (Princeton: Princeton University Press, 1975); Isaiah Berlin, "The Originality of Machiavelli," in Myron P. Gilmore, ed., *Studies on Machiavelli* (Firenze: G.C. Sansoni, 1972), esp. p. 160.
14. I have in mind here G. Sabine, *A History of Political Theory* (New York: H. Holt and Co., 1937); perhaps Sheldon Wolin, *Politics and Vision* (Boston: Little, Brown, 1961); and most especially Leo Strauss, *Thoughts on Machiavelli* (Glencoe, Ill.: Free Press, 1958).
See here Pocock, pp. vii–ix,9,156ff. The difference between this position and that advanced by Strauss can be seen in Harvey Mansfield, "Strauss' Machiavelli," *Political Theory,* III, 4 (Nov. 1975) pp. 372–384 and the exchange with Pocock which follows.
15. See here Pocock, pp. vii–ix,9,156ff. The difference between this position and that advanced by Strauss can be seen in Harvey Mansfield, "Strauss' Machiavelli," *Political Theory,* III, 4 (Nov. 1975) pp. 372–384 and the exchange with Pocock which follows.
16. Machiavelli, "The Prince," *The Chief Works and Others,* trans. and ed., Allan Gilbert (Duke University Press: Durham, 1965), Vol. I, p. 25.
17. John Calvin, *Institutes of the Christian Religion,* trans. A. E. Beveridge (Edinburgh: Clark, 1863), Vol. II, p. 674.
18. Reese, *The Cease of Majesty,* p. 16; he mistakenly attributes this to Shakespeare as well.
19. See Jacob Burckhardt, *The Civilization of the Renaissance in Italy* (New York: Harper, 1962), Chapter II, "The State as Work of Art."
20. Stanley Fish has argued brilliantly that this problem is recognized and taken advantage of especially in the literature of the late seventeenth century (Donne, Herbert, Marvell, Milton) in *Self-Consuming Artifacts* (Berkeley: University of California Press, 1972).
21. Machiavelli, Vol. II, p. 929 ("Letter to Vettori").
22. Machiavelli, *Discourses* I, 6 (Vol. I, p. 210); see also *The Prince,* chapter 17 (Vol. I, p. 63).
23. Machiavelli, *The Prince,* chapter 25 (Vol. I, p. 90).
24. The historiographical debate here is best summarized in J. H. Hexter, "Storm over the Gentry," *Reappraisals in History* (New York, 1961), pp. 117–162.
25. Tillyard, *The Elizabethan World Picture,* pp. 108–109.
26. See Francis A. Yates, *Theatre of the World* (London: Routledge and Kegan Paul, 1969) and *Giordano Bruno and the Hermetic Tradition* (London: Routledge and Kegan Paul, 1965).
27. See Stanley Cavell, *Must We Mean What We Say?* (New York: Scribners, 1969), pp. 296–298.
28. See George B. Churchill, *Richard III up to Shakespeare* (Berlin: Mayer and Müller, 1900); Clements R. Markham, *Richard III, His Life and Character* (New York: Dutton, 1906); and especially P.M. Kendall, *Richard III* (London: Allen, 1955), esp. pp. 213–223, 419–434.
29. It is interesting to speculate that this might be why we have no play from

Shakespeare on Henry VII, the first of the Tudors, who reigned long and well after defeating Richard III. Henry would never have succeeded had Richard not eliminated the opposition.

30. See on this Hanna Fenichel Pitkin's discussion on *lo stato* in her *Wittgenstein and Justice* (Berkeley and Los Angeles: University of California Press, 1972), pp. 309–312 and Bendix, pp. 94–95.

31. See Norman Rabkin, *Shakespeare and the Common Understanding* (New York: Free Press, 1967), p. 90.

32. Compare her actions in 3 Henry VI, I,iv,66ff and V,iv,1ff.

33. See the discussion of simulation in Wolfgang Clemen, *A Commentary on Shakespeare's Richard III,* trans. J. Bonheim (London: Methuen, 1968), pp. 144–45. See Anne Richter, *Shakespeare and the Idea of the Play* (New York: Penguin, 1962), pp. 87–91. See also Erich Auerbach, *Mimesis* (New York: Doubleday, 1958), Chapter I.

34. The levels of presence here are astounding. The audience has before it an actor playing an actor playing a character so well that other actors playing characters should not be able to tell that there is the extra level of illusion and are thus in turn in something like the position of the audience.

35. I owe the term "strategy" to Helene Keyssar Franke, "The Strategy of *Rosencrantz and Guildenstern Are Dead,"* *Educational Theatre Journal* 28, No. 1 (March, 1975), pp. 85–97 and the references cited therein.

36. The perfectly moral, perfectly rational being stood, for Kant, as the symbol of the humanly impossible union of epistemology and ethics. Cordelia shows us, then, the advantage literature has for life, and our gratitude to it. See the discussion of intellect and morality in *Richard III* in Samuel Taylor Coleridge, *Shakespeare Criticism,* ed., T.M. Raysor (London: Dutton, 1932), Vol. I, pp. 232–33; Vol. II. pp. 286ff.

37. See Rabkin, *Shakespeare and the Common Understanding,* passim and esp. Chapter I. See also Robert Speaight, *Nature in Shakespearean Tragedy* (London: Hollis and Carter, 1955) and Danby, pp. 43ff and 214ff.

38. Rabkin, *Shakespeare,* p. 80ff. See also Thomas Jameson, *The Hidden Shakespeare* (New York: Funk and Wagnalls, 1967) for a too strong argument that Shakespeare was a democratic anti-Tudor.

39. In 2 *Henry IV,* V,v,50ff, Hal, now crowned Henry V, proclaims to Falstaff

> *I have long dreamed of such a kind of man*
> *So surfeit swelled, so old and so profane,*
> *But, being awaked, I despise my former dream.*
>
> .
>
> *Presume not that I am the thing that I was*
> *For God knows, so shall the world perceive*
> *That I have turned away my former self.*

The price paid is that he be not only king of England, but also king of France.

40. See Jan Kott, *Shakespeare, Our Contemporary* (Garden City: Anchor, 1966), pp. 3– Kott applies this notion with a hand perhaps too heavy.

41. Cavell, p. 342.

42. Cf. Richard Tuck, "*Power* and *Authority* in Seventeenth Century England," *Historical Journal,* 17, No. 1 (1974), pp. 43–61, esp. pp. 55ff.

43. See the discussion of this scene in Helene Keyssar, "The Strategy of Recognition Scenes," *PMLA* 93, 1 (March, 1977).

Chapter Nine
Joyce: Political Development and the Aesthetic of *Dubliners*

Paul Delany

I.

"It is a mistake for you to imagine that my political opinions are those of a universal lover; but they are those of a socialistic artist."[1] So James Joyce declared to his younger brother Stanislaus in May 1905, when he was immersed in the composition of *Dubliners* and *Stephen Hero*. But this political-aesthetic credo seems not to have been taken very seriously by Joyce's critics. Modern discussions of *Dubliners,* especially since Brewster Ghiselin's influential article of 1956,[2] have been devoted mainly to the stories' intricate and interlocking patterns of symbolic meaning. These patterns certainly exist, and they provide a ready and easy way of teaching *Dubliners,* but to do justice to Joyce's achievement we must combine symbolic exegesis with an equal attentiveness to the material realities on which symbolic meaning is grounded. In "Two Gallants," for example, Lenehan's paltry supper may be explained as a debased reenactment of the Eucharist; however, this interpretation takes for granted Lenehan's debased status in the society of which he forms a part. Symbolic form must be intimately and continuously linked with material circumstances if *Dubliners* is to deserve the particular status continually claimed for it by Joyce: that of a moral work.

This status was asserted most memorably in one of Joyce's early letters to Grant Richards, the English publisher who accepted *Dubliners,* then reneged on his commitment. "My intention was to write a chapter of the moral history of my country and I chose Dublin for the scene because that city seemed to me the centre of paralysis."[3] The work, moreover, was to be more than just an inert satire, a "static" creation (in terms of Joyce's later

aesthetic); it would also be a call to action: "In composing my chapter of moral history in exactly the way I have composed it I have taken the first step towards the spiritual liberation of my country. . . . I seriously believe that you will retard the course of civilisation in Ireland by preventing the Irish people from having one good look at themselves in my nicely polished looking-glass."[4]

Such claims may appear to be inconsistent with the scrupulously detached, ironic tone of the narrative voice in *Dubliners,* or with the lack of moral sense in the stories' characters. But the moral impetus of the work derives from the social condition of the city as a whole. Joyce's indictment is addressed, ultimately, to those institutions and classes responsible for Dublin's condition: the Catholic church, the colonial ruling class, and the indigenous collaborators with that class. If we restrict our attention to individual symptoms of apathy or self-hatred in *Dubliners,* we deny the Irish collective experience of colonial oppression and therefore mistake the underlying moral plan of the work. Joyce was, of course, acutely sensitive to the Irishman's typical pathology, but he attributed these flaws of character to explicitly political origins:

> The economic and intellectual conditions that prevail in [Ireland] do not permit the development of individuality. The soul of the country is weakened by centuries of useless struggle and broken treaties, and individual initiative is paralysed by the influence and admonitions of the church, while its body is manacled by the police, the tax office, and the garrison. No one who has any self-respect stays in Ireland.[5]

Though Joyce uses a medical terms — "paralysis" — to sum up the material and spiritual effects of this situation, he clearly believed that Ireland's colonial exploitation by England was the predominant cause of the disease. He need not, therefore, be unfaithful to this idea of "socialistic" art in exposing the deadly mediocrity of the characters whose banalities are preserved in the amber of *Dubliners'* lucid prose. Nor need we be shocked by the sovereign contempt in which Joyce may seem to hold most of them. If "his political opinions [were] not those of a universal lover," there is no reason why they should have been, given his personal history and the political situation in the Dublin of his youth.

Joyce's active interest in socialism extended from 1903 to 1907, precisely the years during which *Dubliners* was composed. In the later months of 1903 he attended meetings of a social-democratic group in Dublin, and at his arrival in Trieste, in October 1904, he was a self-proclaimed socialist.[6] Working at the Berlitz School, he was soon made aware of the contradictions of his class role. "Trieste is not very cheap and the difficulties of an English teacher living with a woman on a salary fit for a navvy or a stoker

and expected to keep up a 'gentlemanly' appearance . . . are very great."[7] It seemed that only socialism could remedy the indignities of his shabby-genteel mode of life and offer some genuine prospect of independence to those who shared his plight. Meanwhile, his old enemy Gogarty had given up his heretical pose and now reveled in bourgeois luxury; news of his marriage in a Catholic church provoked Joyce to argue thus with Stanislaus:

> You have often shown opposition to my socialistic tendencies. But can you not see plainly from facts like these that a deferment of the emancipation of the proletariat, a reaction to clericalism or aristocracy or bourgeoisism would mean a revulsion to tyrannies of all kinds.[8]

Joyce's socialist consciousness reached a peak during the seven months he spent in Rome (1906–7) working as a bank clerk. This was his first experience of collective work-discipline, after the relative independence of teaching, and he found his situation both humiliating and intellectually sterile. He was paid twice as much as at the Berlitz School, but this did nothing to alleviate his unhappiness. More than ever, he chafed under the conventions of bourgeois respectability; the incongruity of his position became ludicrous when he wore holes in the seat of his trousers, which he could not afford to replace, and was therefore obliged to keep on his tail-coat in the heat of a Roman August. He scorned his fellow clerks for their poverty of imagination, their reactionary views, and their petty-bourgeois aspirations. To Stanislaus he proclaimed his "detestation of the stupid, dishonest, tyrannical and cowardly burgher class. The people [i.e., the Roman proletariat] are brutalised and cunning. But at least they are capable of some honesty in these countries; or, at least, they will move because it is their interest to do so. I am a stranger to them, and a prey for them often; but, in the sense of the word as I use it now, I am not an enemy of the people."[9]

How was the hegemony of the bourgeoisie to be overthrown, particularly in Joyce's oppressed homeland? His regular reading of the socialist newspaper *L'Avanti* helped Joyce to refine his political analysis of the Irish problem. He approved the Sinn Fein program of fighting for independence by means of extraparliamentary agitation and boycott, though he mistrusted the reactionary nationalists within the party, who were "educating the people of Ireland on the old pap of racial hatred whereas anyone can see that if the Irish question exists, it exists for the Irish proletariat chiefly."[10] Still, Sinn Fein's advocacy of Irish industrial development was at least a step in the right direction: "its success would be to substitute Irish for English capital but no-one, I suppose, denies that capitalism is a stage of progress. The Irish proletariat is yet to be created."[11] In the Italian socialist

movement Joyce admired the radical syndicalist Arturo Labriola, whose antimilitarist and anarchist tendencies he found appealing, if impracticable.

Early in 1907, however, Joyce fell into a crisis of nerve that caused him to reassess both his political convictions and his sense of private identity. Work in the bank had exhausted him mentally: he recognized that his temperament was unfitted for a business career, he was drinking heavily, and he had not written a line in months. In spite of all, he clung to the belief that he was somehow "a gentleman," even if his father had denied it;[12] and if he couldn't acquire the means to support himself as one, he could at least be a despised writer rather than a despised clerk. He stopped reading L'Avanti and told Stanislaus that "The interest I took in socialism and the rest has left me."[13] In March he returned ignominiously to Trieste, where he could at least rely on Stanislaus for moral and financial support. There he expressed, in "The Dead," the nostalgia for Dublin that the disasters of Rome had awakened in him. "The Dead," with its definite, if qualified, sympathy for Gabriel Conroy, moves beyond the pose of sardonic detachment and the "meanness" of style characteristic of the stories that preceded it. A Portrait of the Artist as a Young Man, which Joyce began in September, confirmed a basic shift of direction in his literary career. Henceforth he would be "elusive of . . . social orders": the quintessential isolated artist of modern literature, absorbed in exploring the labyrinth of his private consciousness.

II.

The presentation of political issues in Dubliners is governed by Joyce's sense of Dublin's economic backwardness, and its compromised status as an intermediary between England and the Irish peasantry. He saw that the city had yet to enter the historical stage of open class struggle, nor, by 1907, did he expect that stage to commence within his own lifetime.[14] Class tensions can certainly be perceived in the world of Dubliners; but they are oblique, impacted, and expressed personally rather than collectively.

The causes of this situation go back to the eighteenth century, when England deliberately stifled the growth of manufacturing in Ireland, fearing the potential competition to domestic industry. English protective legislation, combined with Ireland's lack of substantial coal deposits, prevented any industrial revolution in Ireland; it limped through the nineteenth century as an impoverished agricultural dependency, ruthlessly exploited by both English and native landowners. Sporadic attempts at rebellion were usually grounded on the discontent of the miserable rural population. Parnell, the great nationalist leader of the 1880s, was himself a country gentleman who saw the suffering of the peasants and made their

cause his own. Dublin, the commercial and intellectual center, functioned as an intermediary between the rural hinterland and England: its trading and administrative activities served to transmit, in one way or another, the profits of agriculture to the colonial power. It did not become an autonomous center of resistance to colonialism until the labor struggles of 1907–14, and even then its industrial workers were too few to strike a decisive blow. The Dublin insurrection at Easter 1916 was likewise unsuccessful.

The "paralysis" anatomized by Joyce reflects, therefore, Dublin's ambiguous status: a city living off agriculture yet alienated from rural ways, and relying on English goodwill to sustain its modest commercial and administrative activities. The protagonists of Joyce's stories — one can hardly call them the heroes — are the dependents and flunkies of this activity; they range in status from Maria, a kitchen-servant for an English charitable home ("Grace"), through Corley, an informer for the English police ("Two Gallants"), to Gabriel Conroy, a genteel teacher and part-time journalist for a pro-British paper ("The Dead"). None are peasants or manual workers; almost all are rootless and lack any sense of solidarity with others of their class.

The great majority of Joyce's Dubliners belong to the social class described by John Middleton Murry as "the most completely disinherited section of modern society: the urban lower middle-class, whose sole conscious aim in life [appears] to be to distinguish itself from the proletariat."[15] Farrington (of "Counterparts"), an obtuse giant who fritters away his strength in irritable gestures that lead only to self-disgust, is a symbol of their complete political impotence. The distinctive features of their consciousness — their addiction to "respectability" at the expense of initiative and spontaneity, their blocked or perverted sexuality, their preoccupation with petty cash — are the inevitable products of the material conditions under which they live and of the accumulated burden of centuries of colonialism. The "socialistic" ethic of *Dubliners* does not rest in Joyce's sympathy for this urban underclass — he had little — but in his painstaking efforts to show, in his style of "scrupulous meanness," how the fates of his characters are socially determined down to the smallest details of idiom or gesture; how each character both contributes to, and is held prisoner by, the general paralysis of the city. *Dubliners* is a study in necessity, in contrast to the ethic of freedom and self-transcendence that governs *Portrait of the Artist* — a work whose central figure is the winged artificer who flies by the nets of nationality, language, and religion.

The most obvious and continually recurring symbol of economic necessity in *Dubliners* is the coin. Its prominence is appropriate to Dublin's status as a commercial rather than an industrial city; economic life is still

atomistic, centering not on the factory but on individual encounters in the marketplace. The coin therefore regulates men's comings and goings, and even their moral condition: it is more than just a material reckoning that occurs when the English shop-girl counts the takings at the end of "Araby," or when Corley triumphantly displays his sovereign, extorted from a gullible servant girl, at the end of "Two Gallants." Such exploitation is both individual and allegorical. Because Corley is an informer for Dublin Castle (the seat of English administration), and the girl is a symbol of Ireland itself, their relation sums up the political relation between the two countries: England robs Ireland of her virtue and reputation, while making her pay for the privilege.

The exchange has also a historical dimension, which illustrates Joyce's mockery of the Irishman's obsession with his country's glorious past. Corley's name is a corruption of "Cor loyal": he is indeed a debased "gallant," a knight of courtly love who takes advantage of the rituals of courtship to rob his gullible "lady." Joyce once remarked that Ireland was "an aristocratic country without an aristocracy";[16] the knights of *Dubliners* are neither gentle nor gallant, and behind their pretentions to breeding and good manners a mercenary motive usually lurks. Gallaher, for example, the courtly journalist of "A Little Cloud," means "to marry money. She'll have a good fat account at the bank or she won't do for me."[17] Money in these stories is truly "the common whore of mankind."[18] Whenever a generous emotion or disinterested tribute to virtue is found, somewhere in the background can be heard the chink of coins — material necessity mocks at such sentiments, and eventually corrupts them into their opposite.[19] Nor is religion exempt from the power of money: the first page of *Dubliners* alludes to simony, a theme that reappears in "Ivy Day in the Committee Room" and is given full expression in the conclusion of "Grace" (originally planned to be the last story), where the Church and Dublin's business establishment are congregated to celebrate the shared profits of their association.

The cash nexus can regulate even the smallest elements of social behavior; it becomes, therefore, the most efficient agency of ruling-class domination. We can see its operation most clearly in "Counterparts" and "Ivy Day in the Committee Room."

"Counterparts" is a study in the humiliation of one of Joyce's "despised clerks," and in the displacement of the victim's rage. The protagonist, Farrington, is a degenerate Samson, confined to menial tasks by his dwarfish employer, Mr. Alleyne, who is an Ulsterman and, one may assume, a Protestant. Farrington feels "strong enough to clear out the whole office single-handed," but he hesitates to smite the Philistines, for he depends on them for bread and, even more, for drink. When given the opportunity of making a joke at Mr. Alleyne's expense, he cannot resist the

temptation; the cost of his gibe, however, is an abject apology and the need to remain completely servile in the future if he hopes to keep his job.

Farrington, lacking a union to defend him, is quite at Mr. Alleyne's mercy. The core of the story lies in the way he adjusts himself psychologically to his condition of economic impotence. His actual work certainly gives him no compensatory satisfaction, since it is entirely "alienated"; it is an externally imposed task that denies his individuality instead of affirming it.[20] Robert Scholes has noted that Farrington at work is usually identified by the narrator merely as "the man"; after work, in the company of his cronies, he becomes "Farrington" — for only when released from Alleyne's tyranny can he attempt to establish a separate, respected identity.[21]

After the humiliations of the day's work, Farrington tries to "restore himself" through the animal functions of drinking, whoring, and fighting. At the office, his defeat was the more bitter for being inflicted before the wealthy and seductive Miss Delacour. But his impaired virility revives as he fingers the "little cylinder of coins" gained by pawning his watch (which regulates his work but can be discarded when he seeks pleasure). He passes "through the crowd, looking on the spectacle generally with proud satisfaction and staring masterfully at the office-girls." The shallow comradeship of the pub further restores his dignity; but the favors of the plump cockney girl who catches his eye would cost more than his few remaining coppers, and his defeat in a trial of strength with the English acrobat completes his discomfiture. At the end of the evening he is abandoned and penniless, with no resort except to discharge his pent-up fury on his own hapless son. His cruelty is despicable; yet each successive slight that has been inflicted on him in the course of the day has combined to make such a denouement inevitable. As Joyce himself put it: "I am no friend of tyranny, as you know, but if many husbands are brutal the atmosphere in which they live (vide "Counterparts") is brutal and few wives and homes can satisfy the desire for happiness."[22] How could Joyce condemn Farrington when in his own home all attempts at creating a dignified and fulfilling family life had been vitiated by the morbid social context of Dublin? An earlier letter to Nora evokes his bitter memories of the Joyce household:

> My mother was slowly killed, I think, by my father's ill-treatment, by years of trouble, and by my cynical frankness of conduct. When I looked on her face as she lay in her coffin — a face gray and wasted with cancer — I understood that I was looking on the face of a victim and I cursed the system which had made her a victim.[23]

In "Ivy Day in the Committee Room" we see the hopelessness of looking to electoral politics for a solution to personal misfortune or to the paralysis

of the city as a whole. The supporters of the Nationalist candidate, Mr. Tierney, recognize that he will betray the Nationalist cause once he is elected; the story makes it clear in every way that elections merely serve the ends of the financial and clerical establishment, and that the ostensible issues are just window dressing. Parnell has fought and died for Irish independence, yet his sacrifice counts for nothing with the hangers'on of the committee room; for them, the determining fact is that they are all "hard up." The only Parnellite to continue the battle is Hynes, who is now a socialist and supports Colgan, Tierney's working-class opponent. Nonetheless, he still haunts the Nationalist committee room, where the dying embers of the Parnellite movement are tended by old Jack, a senile father who tries vainly to control the excesses of his wastrel son. For the real contest in this election is not between socialist and Nationalist but rather, as so often in Irish politics, between a decadent present and a retrospectively glorified past. Such a contest can have but one outcome. The story invokes the sympathetic magic of evergreen ivy, of fire (symbol of phoenix-like renewal), and of the number eleven (which begins a new series); but Henchy's logic is unassailable: "Parnell is dead." Moreover, Joyce implies, if a new Parnell arose he would meet the same fate as the old one, for everyone in the story except Hynes (who is largely a surrogate for Joyce himself) would sell his country — for thirty pieces of silver, for an English title, for fourpence, or for a bottle of stout.

"Ivy Day" ends with the "maimed rites" of a fustian elegy and a volley of popping corks. It is a funeral also for Joyce's youthful political idealism (here attributed to Hynes), slain by retrospective irony. In "The Dead" Ireland's political bondage, now complete, is epitomized by Gabriel Conroy's story of Johnny, the old mill-horse who submissively circles the statue of King William of Orange, like Samson grinding for the Philistines. We are now among the complacent bourgeoisie of Dublin, reactionary in the literal sense of the word since they are agreed that vigor and grace existed only in the past, and among the dead. For most of the story Gabriel appears the perfect representative of this class, despite his superior intelligence and cosmopolitan pretensions: after all, it is he who acts out the part of Johnny, pacing round the hall in his galoshes. Even Joyce himself seems to have hankered after the comforting security of bourgeois Dublin as a respite from the tribulations of his hand-to-mouth struggle to establish himself in Rome and Trieste.[24]

Still, the atmosphere of the Misses Morkans' rooms threatens to stifle — or, if breathed too long, to paralyze. The vital Miss Ivors takes her leave early, and Gabriel too needs to breathe a more spacious air. Within bourgeois social life he remains a critical, unfulfilled outsider. Joyce exposes the deathly rigidity of bourgeois mores, but he has already condemned, in even harsher terms, those of their social inferiors. New life

cannot be infused from the lower classes, he implies, but from deeper sources — from the primitive, the feminine, and the unconscious. Gabriel achieves his great final apotheosis at the cost of his previous fixed and limited identity; he must become one with "country-cute" Gretta, with a menial employee of the gas-works, and with all the hosts of the living and the dead. Joyce here achieves his most compelling vision of human community, yet it is no community that might actually come into being through the struggles of man, as political animal, to combine with his fellows; rather it is a community that can exist only when he lapses out into the undifferentiated, unconscious world of night. We enter here the shadow-realm of "Here Comes Everybody," *Finnegans Wake*.

Gabriel's oceanic union with all humanity was a state to which Joyce felt greatly drawn; still, an opposite mood more often possessed him, wherein he might proclaim himself "Unfellowed, friendless and alone, Indifferent as the herring-bone."[25] Unfortunately, his socialistic tendencies were largely an expression of that other, less genial side of his nature, and were therefore inherently unstable: one cannot in the long run reconcile a commitment to collective political action with the cultivation of aloofness and autarchy. Such was Joyce's condition in the period of his life here discussed; the tension was resolved by his drifting away from the left, and by his ever closer identification with another of his prepotent dead: Parnell. Parnell was in fact an active opponent of socialism, but his specific views mattered less to Joyce than his style of leadership: solitary and dictatorial, he held his followers in contemptuous mistrust, an attitude that virtually invited them to betray him when the opportunity should arise. Joyce, as many critics have noted, conducted his personal relations on similar principles. His adoption of such an egregiously paranoid style seems to have originated in the traumatic misfortunes of 1891 — the death of Parnell and Mr. Joyce's related dismissal from his job in the tax office — which pushed the family down into the seedy lower middle class. Mr. Joyce, glossing over his drunkenness and incompetence, attributed his fall in status to the machinations of his enemies; and James, only nine at the time, could hardly view it otherwise. It made James into an enemy of the established order, but it also instilled in him a deep emotional conviction of the hopelessness of the Irish cause: he believed that the Irish required a strong leader, yet they would always secretly resent such a man, and betray him at the last.[26]

In the early stages of his attraction to socialism Joyce indulged in apocalyptic fantasies of an Irish revolution, to be ignited by his own incendiary rhetoric:

> To those multitudes not as yet in the wombs of humanity but surely engenderable there, he ["the Artist"] would give the word. Man and woman, out of you comes the nation that is to come, the lightning of your masses in

travail; the competitive order is employed against itself, the aristocracies are supplanted; and amid the general paralysis of an insane society, the confederate will issue in action.[27]

But in the ultimate elaboration of this sketch, the novel *Portrait of the Artist,* Stephen's hatred of tyranny leads to a course of action more in harmony with Joyce's essential temperament: reliance, not on the "confederate will," but on "silence, exile and cunning." In the "Circe" episode of *Ulysses,* Stephen's revolt has undergone a further introversion: "(He taps his brow.) But in here it is I must kill the priest and the king."[28] His struggle with the English soldiers is made analogous to Blake's (at Felpham in 1802), for by now Joyce clearly applied to his own position what he had said of Blake: "His spiritual rebellion against the powers of this world was not made of the kind of gunpowder, soluble in water, to which we are more or less accustomed."[29] Like his creation "Mr. Dooley", Joyce remained an anarchist, a pacifist, and a foe of English imperialism. He endowed Bloom with genial aspirations toward universal prosperity and brotherhood and scorned the reactionary, anti-Semitic tendencies of such literary peers as Pound and Wyndham Lewis. Still, it was entirely typical of Joyce that after the economic and personal setbacks of 1912 he never returned to Ireland, and that he sought refuge in Switzerland from both world wars.

Another great novelist in English, Charles Dickens, suffered a childhood trauma remarkably similar to Joyce's, in the sequel to his father's imprisonment for debt and loss of his government post. Dickens's radical sympathies, largely a product of these childhood misfortunes, found expression and fulfillment in the ongoing public work of social reform in Victorian England. But Joyce, trapped in a stagnant colonial backwater, saw no middle course between submission to the imperial power (and its local allies) or being crushed by it. His becoming a Continental exile liberated him, paradoxically, to become a profound explorer of the Irish consciousness; but the path of exile led inexorably, also, to the devastating bleakness of his response to Stanislaus, when he warned James (in 1936) of the imminent menace of fascism: "For God's sake don't talk politics. I'm not interested in politics. The only thing that interests me is style."[30]

Notes

1. Richard Ellman, ed., *Letters of James Joyce,* Vol. II (New York: Viking, 1966), p. 89.
2. Brewster Ghiselin, "The Unity of Joyce's *Dubliners,*" *Accent,* 1956, 16, pp. 75–88 and 196–211.
3. Ellman, *Letters,* p. 134.
4. R. Scholes and A.W. Litz, eds., *Dubliners: Text, Criticism, and Notes* (New York: Viking, 1964), pp. 277, 286.

5. Ellsworth Mason and Richard Ellman, eds., *The Critical Writings of James Joyce* (New York: Viking, 1964), p. 171.
6. Ellman, *Letters,* p. 68.
7. Ibid., p. 94.
8. Ibid., p. 148.
9. Ibid., p. 158.
10. Ibid., p. 167.
11. Ibid., p. 187. In this quotation, "proletariat" must denote the class of industrial workers; in the preceding one, Joyce apparently includes in the term exploited workers of any occupation, including agriculture.
12. Ibid., p. 215.
13. Ibid., p. 217.
14. Mason and Ellman, *The Critical Writings,* p. 174.
15. John Middleton Murry, *The Autobiography of John Middleton Murry: Between Two Worlds* (New York: Julian Messner, 1936), p. 65. For a fuller analysis of the mentality of this class see Christopher Caudwell's chapter on H. G. Wells, in *Studies in a Dying Culture* (New York and London: Monthly Review Press, 1971).
16. Mason and Ellman, *The Critical Writings,* p. 168.
17. Scholes and Litz, *Dubliners,* p. 81.
18. Shakespeare, *Timon of Athens,* IV,iii,42. Marx's brilliant commentary on this play is an ideal key to the materialistic and antiheroic universe of *Dubliners:* "The Power of Money in Bourgeois Society," in *Economic and Philosophical Manuscripts of 1844* (Moscow: Foreign Languages Publishing House, 1961), pp. 136–41. Hereafter cited as *Manuscripts.*
19. I would except Gabriel's "generous tears" at the end of "The Dead"; that story, I have already noted, stands apart from the others.
20. Marx, *Manuscripts,* pp. 72–75.
21. Robert Scholes, " 'Counterparts' and the Method of Dubliners," in Scholes and Litz, pp. 379–87.
22. Ellman, *Letters,* p. 192.
23. Ibid., p. 48.
24. Ibid., pp. 166, 202.
25. Mason and Ellman, *The Critical Writings,* p. 152.
26. Cf. Henchy's tribute to Parnell, in "Ivy Day": "He was the only man that could keep that bag of cats [the Irish M.P.'s] in order. Down ye dogs! Lie down, ye curs! That's the way he treated them." (Scholes and Litz, p. 133); and the savage conclusion of Joyce's article on "The Shade of Parnell": "In his final desperate appeal to his countrymen, he begged them not to throw him as a sop to the English wolves howling around them. It redounds to their honour that they did not fail this appeal. They did not throw him to the English wolves; they tore him to pieces themselves." (Mason and Ellman, p. 228).
27. This is the conclusion of Joyce's brief self-portrait, written in January 1904, but not published. Its title is: "A Portrait of the Artist" (p. 265–6).
28. James Joyce, *Ulysses* (New York: Vintage Books, 1961), p. 589.
29. Mason and Ellman, *The Critical Writings,* p. 215.
30. Richard Ellman, *James Joyce* (New York: Oxford University Press, 1959), p. 710.

Chapter Ten

Fenimore Cooper:
Natty Bumppo and the Godfather

Wilson Carey McWilliams

In America, we have always been troubled by barbarians. Periodically, one of our own disenchanted intellectuals echoes Emerson's complaint that America is a "barbarous" and unappreciative country.[1] With the perversity of the breed, other intellectuals from time to time follow Hawthorne in declaring that, for the purposes of art, we are not barbarian enough. From the beginning, there have been Europeans to tell us, exquisitely, that we are a barbarous country and a nation of innocents. Even a friendly observer like Chesterton could not resist the comment that American immigration officers were more barbaric in style than those "in the land ruled by a rude Arab chief."[2] From the start defending or defining America has required coming to terms with barbarism.

I. The Jeffersonian Persuasion

Responding to European questioners and critics, Thomas Jefferson could hardly deny that America had barbaric aspects. It was, after all, a rude society with many rough edges and few refinements. Nor was Jefferson inclined to deny our barbaric side: for him, it was a virtue.

In Jefferson's political theory, barbarism was a middle term between "nature" and "civilization," and if the crude societies of the barbarian retained some of the "inconveniences" of the State of Nature, they were also closer to the natural virtues. Nature made men free and equal; she also placed them in closer contact with those feelings and sentiments that, for Jefferson, were the source of all moral conduct. Nature, he wrote, "hath implanted in our breasts a love of others, a sense of duty to them, a moral instinct, in short, which prompts us irresistibly to feel and succor their distresses."[3]

233

To be sure, these sentiments were often parochial and shortsighted, too limited in space and time, and all too likely to become entangled with passions of a more earthy and self-centered nature. But though reason could help correct these defects, it could not claim sovereignty. Left to itself, reason taught only self-interest, hedonism, and calculations of advantage. His "Head," Jefferson wrote Mrs. Cosway, counselled him to avoid biting "at the bait of pleasure, till you know there is no hook beneath it. The art of life is the art of avoiding pain . . . Friendship is but another name for an alliance with the follies and misfortune of others." But fortunately, his "Heart" corrected that "miserable arithmetic." "Heart" told "Head" that "to you nature allotted the field of science. To me, that of morals. . . . Denying you the feelings of sympathy, of benevolence, of justice, of love, of friendship, she has excluded you from their control. . . . Morals were too essential to the happiness of man to be risked on the uncertain combinations of the head."[4]

In these terms, barbaric society — represented, in America, by the Indian — had something to be said for it. The Indian had courage and the fortitude to endure pain. He was economical in the use of violence, preferring finesse to force. He had strong affections for his children and love for his friends, to whom he was "faithful to the uttermost extremity." There were times, too, when even warriors wept. Politically, the network of friendships and interpersonal bonds, the warmth of affection and the power of example, the desire for honor among one's brethren — in a word, the "natural sentiments" — were enough to govern the Indian. He did not need formal laws, officials, or a state endowed with coercive power.[5]

True, Jefferson conceded, "great societies cannot exist without government," because our moral feelings, if stretched too far, weaken too much to govern our conduct. There was, however, a perennial moral lesson to be learned from the savages who rejected "great societies" in favor of small ones, limiting their polities to the compass of human feelings and to the scale of the human being himself.[6]

"Civilization," which violated that limitation, might be more commodious and affluent, but it was forced to govern its citizens without the support of their moral feelings. Compelled to appeal to reason and self-interest, it was also constrained to resort to force and coercion, to divide its citizens one against the other, to foster luxury and private vice as a distraction from public affairs, and to encourage in its subjects a cowardice born of felt weakness and individual isolation.

Given freedom, human beings corrupted by civilization behaved like the "canaille of the cities of Europe," lacking any sense of public responsibility, imbued with private licentiousness, and inspired — by years of degradation and oppression that had conspired to dehumanize them — with an urge to

destroy and, enviously, to revenge themselves on those few who had managed to avoid the general decay.[7]

So far the case seems clear, but barbaric society had fatal shortcomings of its own, rooted in its moral nature even more than in its comparative poverty. First, the barbarian misused women, submitting them to "unjust drudgery," the strong imposing on the weak. Second, barbarians were cruel, and addicted to the torture and maiming of enemies and captives. Barbarism was too dependent on the human feelings. It could not educate its citizens to "subdue the selfish passions," for human feelings left to themselves were self-centered. Reason was not enough to correct this, even were it available, for the ancient philosophers had not resolved the problem. Human beings needed sympathy, a moral sensibility which Christianity taught and which "civilization" allowed to emerge by broadening human perspectives. Sympathy alone led human beings to see themselves in those who were weaker and those who were strangers and, in principle at least, pulled them to embrace "with benevolence the whole family of mankind."[8]

America, Jefferson argued, was ideally situated to combine barbaric virtues with those of civilization, attaining a new synthesis, that "just equilibrium of the passions" which he equated with the perfection of moral character. Rude the situation of Americans might be, but they had inherited Christian teaching and the more inclusive view of civilized morality. At the same time, Americans lived near nature and in small societies, close, like the red "barbarians" across the frontier, to the strong passions and moral sentiments. Moreover, Jefferson contended (and how ironically to our eye!), Americans could be governed by a "natural aristocracy" as the Indian could not be; his rulers were warriors, but among us, gunpowder had made bodily strength only "an auxiliary ground of distinction." If our political system could be kept decentralized, avoiding the Hamiltonian seductions which lead toward the centralized, impersonal, coercive, and degrading model of civilized government; if immigrants could be kept to a number small enough to permit assimilation;. if foreign policy could be limited to the periphery of American life: then we would be set on the road to republican virtue. Above all, the people must be educated, trained to know and to defend their rights and to exercise their office as citizens.[9] In this civic education, it was vital to school the heart as well as the head. Partisan of science and education that he was, Jefferson denounced European educations as too dangerous to the barbaric side of the new synthesis. A student in Europe was likely to become fascinated with and fond of aristocracy and monarchy, to form "foreign friendships" listing "the seasons of life for forming, in his own country, those friendships which, of all others, are the most lasting and permanent," to "luxury and

dissipation" and, "by the strongest of all human passions, into a spirit of female intrigue . . . or a passion for whores, . . . and in both cases, learns to consider fidelity to the marriage bed an ungentlemanly practice. . . . Hankering after those places which were the scenes of his first pleasures and connections, he returns to his own country, a foreigner."[10]

Jefferson's hopes were all to be eroded by time, many within his lifetime. He had, however, articulated and bequeathed to America an enduring element in our political culture and in our definition of ourselves: the belief (1) that "barbaric" environments permit or encourage the strong, "natural" moral passions and personal attachments, (2) that "civilized" rearing makes it safe to allow these passions to "emerge," and (3) that "nature's nobleman" is that man raised in civilization who "goes out" to inhabit barbaric environments, his leathery countenance concealing a heart of warm, soft gold.

II. Cooper and the Mohicans

When James Fenimore Cooper recreated and elaborated Jefferson's theme in the Leatherstocking Tales, he certified that it had become truly national. Cooper was no Jeffersonian, but the son of a Federalist, born to that class Hamilton had described as "the rich, the good, and the wise." That Cooper became a democrat at all — because it seemed to him the conservative course — is a mark of his distaste for the new commercial civilization with its deceits, its unprincipled competition, its cowardly conformity, and its lack of loyalty.[11]

This new America had already lost the homespun, civilly barbaric quality which Jefferson celebrated. Increasing numbers of Americans were rootless, "nameless adventurers in quest of advancement . . . who live without the charities of a neighborhood, as they may be said almost to live without a home," a nameless multitude, hopelessly trapped in the present. Settled America seemed lost to the political and moral vices of Jefferson's "civilization," but without its refinements or its graces. The new world was given over to Bragg and Dodge, manipulative and external in their relations with their fellows, without emotional bonds, "Asiatic slaves" in relation to the new tyrant, the faceless majority, and "lions" only in relation to the few.[12]

Small wonder, then, that Natty Bumppo preferred the frontier, seeking the stronger affections of barbarism in preference to civil degeneracy. There, with his equally embattled Delawares, Natty found a world where courage and loyalty still counted; "Life," he remarked, "is an obligation which friends often owe to each other in the wilderness."[13] In the wilds, words had not been substituted for real feelings. As Natty told Chingach-

gook, "It is one of their customs" — among whites — "to write in books what they have done and seen instead of telling them in the villages, where the lie can be given to the face of the cowardly boaster and the brave soldier can call on his comrades to witness the truth of his words."[14] Even the villainous enemy, Magua the Huron, is allowed to be eloquent in denunciation: The Great Spirit, Magua orated, gave whites "the nature of the pigeon, wings that never tire, young more plentiful than the leaves on the trees, and appetites to devour the earth. He gave them tongues like the false call of the wildcat, hearts like rabbits, the cunning of the hog . . . and arms longer than the legs of the moose. With his tongue, he stops the ears of the Indian; his heart teaches him to pay warriors to fight his battles; his cunning tells him how to get together the goods of the earth; and his arms inclose the land. . . . His gluttony makes him sick. God gave him enough, and yet he wants all."[15]

But Cooper, like Jefferson, knew the frontier too well to forget that barbarity is cruel. Repeatedly, he remarks on the "barbarous ingenuity" of savage tortures and cruelty, calls attention to every scalping, and shudders — in great detail — at the massacre of the unarmed soldiers, women, and children who surrendered at Fort William Henry.[16]

It is a boastful, revengeful world, and hence it is essential that Natty has been safely reared in civilized codes and feelings, so that on hearing a familiar hymn, "he felt his iron nature subdued, while his recollection was carried back to boyhood . . . in the settlements of the colony. His roving eyes began to moisten and before the hymn was ended, scalding tears rolled out of fountains that had long seemed dry." But even Natty feels a conflict, the temptations of barbaric cruelty, and is frequently forced to remind himself that a "man without a cross of blood" may not do what is forgiveable in an Indian.[17]

The barbarian's treatment of women is the most visible of his defects, for he cannot comprehend the chivalrous code that requires a man to sacrifice all prudence to protect the life and honor of "the weaker sex." Again, even Natty feels a conflict; bargaining with Magua for the release of a captive maiden, Bumppo first declares that "it would be an unequal exchange to give a warrior, in the prime of his age and usefulness, for the best woman on the frontiers," and only in the last extremity does his civilized rearing win through; "I accept your offer; release the woman. I am your prisoner."[18]

Barbaric man, in Cooper's novels as in Jefferson's theory, lacked sympathy, the ability to generalize his feelings beyond himself and his own, the empathy needed for larger societies, and broader sentiments for humanity as a whole. Uncas, the last of the Mohicans, is unique in possessing it, and it is his sympathy that "elevated him far above the intelligence and advanced him centuries before the practices of his nation."[19]

But Fenimore Cooper, for all his "literary offenses," was too shrewd a moralist to leave it at that.[20] Empathy can lead us to identify with so broad a circle that all strength of feeling is lost, and with it all efficacy. Our empathic sentiments, too, can make us identify with so many others that we lose all personal identity. Sympathy, when overextended, acts only as a hypocritical guise expressed in sentimental words; identity is too diffuse to provide a direction above self-concern. Empathy beyond its limits is the root of civilized vice, of egotism and the tyranny of the multitude alike.

For Cooper, as for Jefferson, the good man fled civility for the borderlands, made proof by his civil rearing against the worst of barbarism, saved by his barbaric environment and connections from the worst of civilization. But in Cooper's work the "yeoman farmer" has become the frontiersman; the hope that America as a whole could achieve a new synthesis has disappeared. Natty Bumppo, the progenitor of a whole tradition of heroes, the mold in which John Wayne was cast, is driven to the edge of society. Natty and Chingachgook, as the years went by, moved ever further to the west, while Natty's new nicknames, "Deerslayer" and "Pathfinder," reveal his real social role. He tames the forest and clears the way for civilization, the nemesis always close behind, leading it even as he is driven by it. Natty Bumppo, the man "without a cross of blood," is compelled by his devotion to the virtues and morals in which he was reared to become the ally of the civilization he disdains.

Jefferson's hope became a slow lament, admirable in detail, fatal in denouement. The cattle baron yields to the sheep-herder, and the assembly line and the automobile follow in their own time. Cooper's John Effingham saw it beforehand: "the days of the Leatherstocking have passed away . . . I see few remains of his character in a region where speculation is more rife than moralizing, and emigrants are more plentiful than hunters."[21]

III. The Coming of the Godfather

The old vision — civilly reared man "going out" to meet the barbarians — was a long time dying. Turner, at the end of the nineteenth century, told us that the frontier had disappeared, yet the dream persisted in new forms. So many intellectuals in the thirties, for example, prowled the hills of the tenant and sharecropper South or explored the dark world of the coal miners. They went to Spain to fight in that barbarous war, "the last crusade." A decade ago, their spiritual descendants went on a better crusade into the semibarbaric South, or like the missionaries of old, found in the Peace Corps a way for civilly reared man to seek a home among the heathens. John F. Kennedy, after all, had promised us a New Frontier.

Suddenly, it was over. There had been intimations before: at home, the proletarians had deserted the cause of the left, and in Spain, Hemingway's

Natty Bumppo, Robert Jordan, moved in a stage in which shadowy puppeteers used his virtues for their own purposes. Ten years ago, however, finis came with a rush: the barbarians overseas and at home were, for the most part, hell-bent on modernization and treated our admiration with contempt, seeing it as a new form of oppression. In any case, they did not want us. These contemporary tribesmen had abandoned the rites of initiation. And in the final humiliation, Vietnam seemed to prove that we could not even force ourselves on them. Songs lingered; reality was disappointing. Small wonder if many crossed the frontier into a world of hallucinations where they met, not Uncas and barbarian brothers, but a prison of loneliness.

There has always, however, been an alternative theme in American thought and letters. If we cannot go to meet the barbarians, perhaps they will come to meet us. Melville's Queequeg came to save civilized man, a barbaric messiah like Danny in Steinbeck's *Tortilla Flat*.

But these were creatures of myth. Very early, Americans discovered that in real life, the political bosses and machines at least resembled tribes and chieftains. Cooper could not resist pointing out that Tamenund, the venerable Sachem of the Delawares, was the real Tammany, who had "transmitted his name, with some slight alteration, to the white usurpers of his ancient empire as the imaginary tutelary saint of a vast empire."[22] And when the Irish took control of the machines, the image became irresistible. H. C. Merwin wrote (in that pillar of nineteenth century respectability, the *Atlantic Monthly*) that to the Irishman, "Tammany is his party, his church, his club, his totem. To be loyal to something is almost a necessity of all incorrupt natures." Even among the great reformers, there were many like Brand Whitlock, who came to admire the loyalty and humanity of the politics, especially in contrast to the cold bureaucracies with which reform has replaced them.[23]

But the Irish, after all, were only semibarbarians. As they appear in the American legend, they are a whimsical, ironic folk. When Frank Skeffington lays the mighty low in *The Last Hurrah*, he does it with a joke — although taking advantage of an imbecile would have seemed, to Cooper, a cruel humor even barbarians should scorn.[24] The Irish were our amiable barbarians, insouciant in proclaiming the old virtues (as in the saying, "What's the Constitution between friends?"); charming, though inclined to drink; more prone to voting dead men than to killing live ones. It almost seemed, and seems, unkind to observe that so engaging a people could — on their home ground — be more sanguinary than any of Cooper's Indians. And to us, it may be pointless as well: Frank Skeffington was defeated by the New Politics; by money, bureaucracy, and a television image, and we catch only faint echoes of his "last hurrah."

Meanwhile, more and more of our attention has been captured by gangsters, spies, and men of violence generally, though until quite recently we were assured that the tale would have a moral ending. Sometimes we were allowed to sympathize, but we were not allowed to be openly admiring. Crime and force were still portrayed, for the most part, as gross, vulgar, self-seeking and — certainly — destined for a bad end, and we were repeatedly reminded that there "is no honor among thieves."

The Godfather is not merely a phenomenally successful novel. It documents our transition from the Natty Bumppos, who go to meet the barbarians, to new heroes, barbarians who can survive and succeed within civilization itself. Don Corleone is a great barbaric chief, a man who puts friendship, loyalty, and family high on the list of virtues, who has a code of honor and propriety that makes him scorn the drug traffic, value his word, and hold to a rather antique sexual morality. More important, although he is well aware of and able to use our political forms for his own ends, the Don stands for substantive justice against the procedural justice which is the norm in our law. Our elaborate mechanisms and concern for "due process of law," after all, show no concern for the results of law beyond a vague faith in the process itself — vague and abstract, because we all know how far the results of our trials can be from justice in concrete cases.

Amerigo Bonasera, frustrated in the courts, vows to go on his knees to Don Corleone. Surprisingly, the law-abiding undertaker finds the Godfather a sterner moralist than he is himself. He will not murder the youths who attacked Bonasera's daughter because she is alive; it would not be just, and he will go no further than the old rule of an eye for an eye. The exchange also allows Don Corleone to proclaim the superior virtue of barbaric politics: "You go to the law courts and wait for months. You spend money on lawyers who know full well you are to be made a fool of. You accept judgement from a judge who sells himself like the worst whore in the streets. Years gone by, when you needed money you went to the banks and paid ruinous interest. . . . But if you had come to me, my purse would have been yours. . . . If by some misfortune an honest man like yourself made enemies, they would become my enemies . . . and then, believe me, they would fear you."[25]

But barbarian that he is, Don Corleone is not Chingachgook. He has a veneer of civilization, needed for survival in his alien environment. Like so many of our recent heroes, he is a man of masks and hooded thoughts. His words have hidden meanings; in the Godfather's speech, "reason" is a euphemism for "threaten," and although he and his associates justify their murders as "business," impersonal necessities of a larger process and no more, this too is a disguise. As Michael Corleone observes, "Don't let anybody kid you. It's all personal, every bit of business. Every piece of shit

every man has to eat every day of his life is personal. . . . You know where I learned that from? The Don. My old man. The Godfather. If a bolt of lightning hit a friend of his, the old man would take it personal. . . . That's what makes him great."[26]

The disguises conceal, but the old barbaric passions remain. Michael can be a Marine Corps hero, but he is at heart a clansman, a warrior, and a chieftain, in contrast to Natty Bumppo, who was, at the core, a civilized man. If Michael marries, respectfully and almost rationally, a pale daughter of the Puritans, we know that his heart is still bound to the violent passion, the "thunderbolt," that struck him at the mere sight of Appollonia, his Sicilian first wife. Don Corleone and Don Michael are, in this sense, Chingachgook and Uncas in modern dress, but the costume has forced them to abandon as "dysfunctional" the honesty that characterized their predecessors.

It hardly needs to be said that these inner barbarians have not lost, however, their cruelty and violence. Their women, too, are reduced to objects of possession, drudges, or — in a slightly elevated status — to mothers.

The Corleones demonstrate, in fact, all of the barbaric vices Cooper and Jefferson feared, and unlike Natty Bumppo, they are not restrained by a deeply rooted civil morality, but by caution and fear alone. Their barbaric tradition aside, they are identical with Jefferson's civilized canaille — restrained by fear, driven by self-interest, angry and vengeful at the core.

This is only to emphasize that it is their tradition that Americans admire. If we are attracted to barbarians without the safeguards that made Natty Bumppo the ally of civilization, it is largely because so many of us have come not simply to dislike civilization, but to hate it for its impersonality, for the indignity, loneliness, and weakness we feel, for our sense of being without history, place and people. Civilization bribes us (rather erratically, to be sure) with relative abundance and with an endless array of products that pander to our weaknesses and illusions. We are offered a private liberty to engage in licentiousness at the price of public honor and personal intimacy alike. That we succumb to such temptations only increases our fury, for it makes us accomplices in our own degradation. The Corleones know the secret of our anger, the weakness beneath all the formal institutions, the powers and processes of civilization: "Every piece of shit a man has to eat every day of his life is personal."

Masses of us have, in fact, become the "canaille" of Jefferson's "civilization." Jefferson and Cooper never doubted that the gentle virtues and sympathy of civilization made it superior. Many Americans have gone further than doubt, and they are drawn to *The Godfather* because the tradition of the Corleones has, in contrast to so many of our lives, some

tinge of dignity, loyalty, and honor. Many of us are would-be barbarians, and not always in fantasy only. In its last spasm, the New Left — in fundamental ways, the most civilized of movements — tried desperately to barbarize itself, succeeding only in making itself at worst into a rabble, and at best into a farce.

That, however, should lead us to see that the Corleones are no answer. As Puzo realizes, the logic of greed and gain, the "business" that becomes an end as well as a style, decays the tradition that is the root of barbaric virtue. Virgil Sollozzo is killed, but in the end the Don must lend his prestige to the trade in drugs. Jerusalem passes into the hands of the infidel: Sollozzo, called "the Turk," posthumously vanquished Corleone, the "Lion-Hearted." Cooper was an artist in this at least: he made the tragedy of his barbarians plain, having Uncas die before his father. Puzo is less explicit, but it is that end of the line for the Corleones too. Civilization prevails, and Michael Corleone is, no less than Uncas, "The Last of the Mohicans."

Natty Bumppo is defeated by his morality, the civilized standards that help make him "safe." The Corleones are being overcome because the means of survival — money and power — become ends in themselves. Escape and disguise are both inadequate to protect barbarism from civilization's onslaught, and they are even less likely in real life to protect those audiences who identify with the characters, who become Bumppos and Godfathers in fantasy. But victory over the barbarians will not protect civilization, either, from the anger and rage within. The barbaric societies — across the frontier, or hidden within civilization — are passing away, and we have dreamed of them so long that the awakening is likely to be brutal. Cavafy's Byzantines spent all day preparing for the arrival of the barbarians, and then

> Why this sudden bewilderment, this confusion?
> (How serious everyone looks).
> Why are the streets and squares emptying rapidly,
> Everyone going home so lost in thought?
> Because it is night and the barbarians haven't come.
> And some people just in from the border say
> There are no barbarians any longer.
> What's to become of us without them?
> The barbarians were a kind of solution.[27]

Painful, yes, but we are only being freed from a kind of illusion. The external frontier tempted us to see barbarians "out there," as did the subtler lines of ethnicity which mark off the inner barbarians. But Jefferson was only incidentally referring to places, frontiers on the map, and then as a

happy accident. His real concern was the needs of human animal, the nature and happiness of humankind. Jefferson knew that without the barbaric virtues — the strong feelings, passions, and attachments which bind us to homes and friends and which inspire us to courage and great undertakings — civilization is fatally weak, tawdry, and miserable for human beings, a facade whose real foundation is force and fraud.

Jefferson thought that the rude wilderness would be a help to Americans in discovering and living in harmony with the barbarian within themselves. And although the two ideas were jumbled in his thought, the wilderness was only a help, not a necessity. Jefferson had faith that free institutions — based on stable localities where political participation could also be high — combined with education could create in Americans local, civic attachments to rival if not excel those barbarians, a courage born of involvement and a dignity discovered in political life. Our ardors, confrontations, and combats could emerge in the contests of politics, with sympathy as the safeguard of unity and the guide to policy. The barbarian and the civilized sides of the soul would be wedded in public life where both could find satifications, friends, and ends worthy of devotion. That is not only a challenging ideal; it may well be an impossible one. Yet, as Henry Adams remarked, it is the only experiment "worth taking."[28]

In our times, we have seen the politics of escape to the New Frontier fail, albeit with some grace and much eloquence. The politics of disguise that has succeded it has been a sordid catastrophe. Perhaps we can now turn our efforts to building a political universe in which Natty Bumppo can meet and embrace the Godfather. They need each other. As do we all.

Notes

1. Ralph Waldo Emerson, *Essays* (Boston: Ticknor and Fields, 1863, Second Series), p. 209.
2. G. K. Chesterton, *What I Saw in America* (New York: Da Capo, 1968), p. 5.
3. Adrienne Koch and William Peden, eds., *The Life and Selected Writings of Thomas Jefferson* (New York: Modern Library, 1944), p. 638; see also pp. 430–31.
4. Ibid., pp. 402–04.
5. Ibid., pp. 210–11.
6. Ibid., p. 221.
7. Ibid., p. 633.
8. Ibid., pp. 210–11, 568–69. In the Declaration of Independence, Jefferson referred to "cruelty and perfidy scarcely paralleled in the most barbarous ages."
9. Koch and Peden, *The Life and Selected Writings,* pp. 262–65, 440, 546, 555, 632, 660–61, 670, 696.
10. Ibid., pp. 386–87; see also pp. 382–83.
11. I owe much to Marvin Meyers' matchless essay on Cooper in *The Jacksonian Persuasion* (New York: Vintage, 1960), pp. 57–100.

12. James Fenimore Cooper, *Home as Found* (New York: Putnam, 1896), pp. 162–66; *Homeward Bound* (New York: Putnam, 1896), pp. 88–89.
13. James Fenimore Cooper, *The Last of the Mohicans* (New York: Lancer Books, 1968), p. 123.
14. Ibid., p. 14.
15. Ibid., pp. 517–18.
16. Ibid., pp. 183, 300–07.
17. Ibid., pp. 97, 235, 471.
18. Ibid., pp. 539–41; see also p. 154.
19. Ibid., pp. 192, 197.
20. Mark Twain, "Fenimore Cooper's Literary Offenses," *North American Review* 161 (1895), pp. 1–12.
21. Cooper, *Home as Found*, p. 197.
22. Cooper, *Last of the Mohicans*, p. 504.
23. H.C. Merwin, "Tammany Hall," *Atlantic Monthly* 63 (Feb. 1894), pp. 240–52; Brand Whitlock, *Forty Years of It* (New York: Appleton, 1925).
24. Skeffington bests Norman Cass, the aristocratic banker, by persuading Cass's dim-witted son to accept the post of fire commissioner, where his shortcomings would be on public display. Cass is forced to make the city a loan as Skeffington's price for withdrawing the nomination (Edwin O'Connor, *The Last Hurrah* [Boston: Little, Brown, 1956], pp. 140–52). On the Irish and politics, see Dennis Hale, "James Michael Curley: Leadership and the Uses of Legend," in Dennis Bathory, ed., *Leadership in America* (New York: Longman, 1978), pp. 131–46.
25. Mario Puzo, *The Godfather* (Greenwich, Conn.: Fawcett, 1969), pp. 32–33.
26. Ibid., p. 146.
27. C.P. Cavafy, *Selected Poems,* trans. Edmund Keeley and Philip Sherrard (Princeton: Princeton University Press, 1972), p. 7.
28. Henry Adams (as Frances Compton), *Democracy* (New York: Holt, 1880),

Chapter Eleven

Melville: Billy Budd and the Context of Political Rule

James R. Hurtgen

I.

> Outwardly regarded, our craft is a lie; for all that is outwardly seen of it is the clean swept deck, and oft-painted planks comprised above the waterline; whereas, the vast mass of our fabric, with all its storerooms and secrets, forever slides along far under the surface.
>
> *White-Jacket,* "The End"

Billy Budd, Sailor (An Inside Narrative) — to call it by its full title — was published in 1924, 33 years after Melville's death in 1891.[1] Because the manuscript was not left in fair copy form at the time of his death, and for additional reasons I will shortly detail, the author's intention in writing the work is not easily discerned. Indeed, the novel is obscure, and deliberately so.

In this essay I will investigate some of the obscurities in the novel, offer arguments to suggest why they are there, and finally apply these arguments to the details of *Billy Budd* in order to provide an interpretation which will stand up under scrutiny.

I will defend the argument that *Billy Budd* is most adequately understood as Melville's statement on the nature of politics and its location amidst the polarities of the demonic and the divine realms. I will contend that, at the deepest level of meaning, the work depicts the human, i.e., political, realm as bereft of natural or divine support and sanction. This means that Melville adopts the position of many modern political theorists, beginning with Machiavelli, who teach that civil society is artificial and merely conventional; that man is, in essence, asocial. The English political philosopher Thomas Hobbes argued in the introduction to his *Leviathan*: "For by Art is created that great Leviathan called a Commonwealth, or

State, (in Latine *Civitas*) which is but an artificial Man; though of greater stature and strength than the Natural, for whose protection and defence it was intended; and in which, the Sovereignty is an Artificial Soul."[2]

But our interest in Melville's politics is deepened by the awareness that even as he endorses the modern view stemming from Machiavelli, he refrains from doing so openly. He is compelled, I will argue, to keep a form of silence lest the awareness of its radically conventional basis undermine the continued existence of the political order.[3] I believe that it was Melville's position that the unambiguous treatment of the conventional basis of politics (as he understood it) seemed to him, to paraphrase Captain Vere, "insusceptible of embodiment in lasting institutions, but at war with the peace of the world and the true welfare of mankind."[4] Thus, Melville's obscurity, his use of a *Rhetoric of Concealment* (as I call it), stems from a need to keep silent.

The plot of *Billy Budd* may be quickly stated. A young sailor-innocent of singular male beauty is impressed off a merchantman, fittingly named the *Rights-of-Man,* into the service of the British man-of-war *Bellipotent.* Aboard the *Bellipotent* Budd goes about his duties scrupulously, but provokes by his innocence and natural rectitude — as well as his beauty — the hatred of the ship's master-at-arms, John Claggart. The master-at-arms during this period of the British navy (the year is 1797) served in the role of chief of police aboard ship. In this capacity he is the ship's principal disciplinarian. Claggart traps the unwitting sailor by luring him into a feigned mutiny plot. Budd's "complicity" arises out of his failure to report to an officer what he suspects is a plot of some sort. When Claggart later accuses Budd of mutinous intent before Captain Vere, the sailor strikes a killing blow to the forehead of the master-at-arms. It is clear from this scene and earlier discussions of Budd's nature that the sailor's act is one of desperate defense rather than malice. Soon after Budd's deed Vere resolves upon holding a drumhead court. The sailor is found guilty by his three judges and hanged early the next morning.

It should be noted here that the novel is set in a period a few months following what is known in British naval history as the Great Mutiny of 1797. This mutiny, involving several ships, imperiled Britain's defense against the revolutionary French Directory.[5] Fear of renewed mutiny persisted in the navy, the *Bellipotent* included. Hence, Budd's act occurred during a time when the concern for discipline and loyalty was already running high.

II.

It is the argument of this study that Melville's intention in *Billy Budd* is deliberately obscure. This is not the view that informed most of the early

criticism of the work. Initial studies focused on the element of tragedy in the novel by emphasizing the destruction of innocence in this man-of-war world. The necessity for Budd's demise was not generally at issue among the early critics. Rather, they were convinced that the novel expressed Melville's anguished acceptance of Vere's position, namely, that the law must be served, however harsh and pitiless it may seem. Accordingly, Melville's point of view was understood as corresponding with Vere's words before Budd's judges: "When war is declared," Vere says,

> Are we the commissioned fighters previously consulted? We fight at command. If our judgments approve the war, that is but coincidence. So in other particulars. So now. For suppose condemnation to follow these present proceedings. Would it be so much we ourselves that would condemn as it would be martial law operating through us? For that law and the rigor of it, we are not responsible.[6]

In a phrase well suited to this view, *Billy Budd* was understood as Melville's final "testament of acceptance."[7]

Beginning in the late 1940s, this interpretation came under attack by a number of critics who argued that Melville was *not* reconciled to the need for Budd's death, that the novel is in fact his final *testament of resistance* to an unjust world.[8] It was the view of these critics that *Billy Budd* is a bitterly ironic indictment of Vere and the kind of society he is made to serve. That society is seen as stupidly rigid, conservative, indifferent to its own cruel exactions. The hanging of Budd is interpreted as a tragedy from the ironist perspective precisely because it *was* avoidable and unnecessary, not the contrary, as the initial critical literature held.

How could such opposed interpretations arise? Let me offer a few observations which will suggest the difficulties in determining Melville's intention in the novel.

First, the narrator is silent or elliptical at key points in the story. For example, in the scene immediately following the confrontation between Budd and Claggart, the ship's surgeon is called in by Vere to verify the master-at-arms's death.[9] At this point the Captain is described by the narrator as agitated and excited. We see Vere "convulsively grabbing the surgeon's arm while exclaiming, 'It is the divine judgment on Ananias! Look!'"[10] Shortly, the narrator remarks that the surgeon was "profoundly discomposed" by Vere's "passionate interjections." Later we learn that Vere's decision to hold a secret drumhead court to decide Budd's fate is also greatly disturbing to the surgeon. It is his view that Budd should be confined until the ship can be reunited with the squadron (it is presently on a detached mission), at which juncture the Admiral could determine the outcome. So unusual does the surgeon consider Vere's decision and manner that he fears that the Captain may have been "temporarily

unhinged" by the occurrence in the stateroom.[11] In concluding the point, the narrator then tells us he will not judge between the Captain and the surgeon; we must judge for ourselves "by such light as the narrative may afford" whether or not Vere was temporarily unhinged by Budd's action. The problem is that the narrative provides light to draw either conclusion depending upon the reader's prior disposition to accept or reject the need for Budd's trial and subsequent hanging.

There is another occasion on which the narrator leaves the reader ambivalent about the events aboard the *Bellipotent*. In chapter 21, the trial scene, the incident aboard the *Bellipotent* is compared in part to a mutiny aboard the American vessel *Somers* in 1842 (the time of narration of *Billy Budd* is sometime after 1861), which resulted in the hanging of three crew members. The mutiny on the *Somers* and the executions following created a great stir in the American press shortly after the events. Moreover, the affair was revived in the press in the early 1880s, not long before Melville set to work on *Billy Budd*. But again, note the narrator's obliquity in his comment on the events. The executions were

> carried out though in time of peace and within not many days' sail of home. An act vindicated by a naval court of inquiry subsequently convened ashore. *History, and here cited without comment.* True, the circumstances on board the *Somers* were different from those on board the *Bellipotent.* But the urgency felt, *well-warranted or otherwise,* was much the same. (Italics added)[12]

The narrator's ambiguity on these and other occasions[13] is made more puzzling by his readiness to offer opinions on others. For example, he expresses himself unequivocally on the significance of the Great Mutiny in the British navy: "It was indeed a demonstration more menacing to England than the contemporary manifestoes and conquering and prosely-tizing armies of the French Directory."[14] And a bit later: "Reasonable discontent growing out of practical grievances in the fleet had been ignited into irrational combustion as by live cinders blown across the Channel from France in flames."[15]

A second source of difficulty in determining Melville's intention centers upon the ambiguities surrounding the characterization of Vere.

To begin, Vere's name itself is a source of ambiguity. "Vere" is related to the Latin *veritas,* meaning truth, or *vir,* meaning man. It is also related to *vereor,* a verb meaning to be afraid of. His acquired name of *Starry* can mean lofty, theoretic, comprehensive, high-principled; or it can mean abstract, remote, unfeeling, cold, undiscriminating. About his bearing as an officer, Melville says that "he had seen much service, been in various engagements, always acquitting himself as an officer mindful of the welfare

of his men, but never tolerating an infraction of discipline; thoroughly versed in the science of his profession, and intrepid to the verge of temerity, though never injudiciously so."[16] It is impossible to say precisely what Melville means by this description. Does he intend by the qualifiers to compromise Vere's attributes, or does he regard Vere as demonstrating a judicious balance of opposed responsibilities in a naval officer? Both views have been variously defended.

Vere is said at one point to lack brilliant qualities but very shortly after is described as "an exceptional character."[17] Moreover, he is a reader of books, though only one author is named, Montaigne.

> With nothing of that literary taste which less heeds the thing conveyed than the vehicle, his bias was toward those books to which every serious mind of superior order occupying any active post of authority in the world naturally inclines.[18]

And what kinds of books are these?

> Books, treating of actual men and events no matter of what era — history, biography and unconventional writers like Montaigne, who, free from cant and convention, honestly and in the spirit of common sense, philosophize upon realities.[19]

There is an ironic quality to this passage. Such works as novels and plays are omitted. As these do not usually treat actual men and events, they presumably do not form a part of Vere's reading. Moreover, the narrator remarks that Vere ignored technique, "which less heeds the thing conveyed than the vehicle," but a full understanding of the novel in which Vere is a foremost character requires precisely an understanding of how rhetorical structure bears upon the thematic concerns of the work. The ironic implication is that Vere would have no interest in the story in which he played a major role.

Lastly in this connection, in the scene describing the Captain's death in chapter 28, the narrator remarks that, despite the philosophical austerity of his spirit, "he may yet have indulged in the most secret of all passions, ambition, never attained to the fulness of fame."

These observations, touching upon the role of the narrator and the ambiguities surrounding the character of Vere, will serve to illustrate the difficulties in arriving at Melville's intention in the novel. Who speaks for Melville — the narrator? Vere? The surgeon? An unseen figure? Unless we are prepared to argue that these difficulties indicate Melville's failure to make up his own mind about his story, his death intervening to prevent a resolution, then we must assume that his ambiguities form a part of his

intention. Unlike Vere in his reading, we are not free to heed less the *vehicle* than the *thing conveyed* if we mean to understand *Billy Budd.*

III.

Melville frequently used what we may call a rhetoric of concealment in his writings.[20] His meanings are not immediately accessible to the reader, but rather are to be found beneath the surface narration and often hidden by it. This is the lesson in his review-essay of Nathaniel Hawthorne's collection of short stories, *Mosses from an Old Manse.* The review-essay was written anonymously and published in two parts in the *Literary World* in 1850.[21] The piece is important to us for the insight it offers on how Melville intended his readers to approach his writings.

Tucked away near the end of the review-essay is this important statement:

> No man can read a fine author . . . without subsequently fancying to himself some ideal image of the man and his mind. And if you rightly look for it, you will almost always find that the author himself has somewhere furnished you with his own picture.[22]

A close study of the piece reveals that Melville is indeed furnishing the reader with a picture of himself as well as Hawthorne. For example, the review-essay tells us little about the stories from Hawthorne's collection and a great deal about the nature of Hawthorne's writings in general; that is, what Melville chooses to tell us about the nature of his writings.

For our purposes the work may be divided into four parts. We will focus on the first two.[23] The ten paragraphs comprising the first part portray the introduction of the anonymous writer to the collection of stories, and his initial responses. This opening section is deliberately ironic in its treatment of Hawthorne. The image of this part is pastoral, radiant, hopeful, and nonthreatening. The second part alludes to what Melville considers the dark underside of Hawthorne's imagination and compares Hawthorne's methods to Shakespeare's techniques as a playwright. It is this side of Hawthorne's imagination that, according to Melville, is hidden from the "superficial skimmer of pages" whom Hawthorne directly calculated to deceive. It is precisely such a reader whom Melville anonymously portrays in the first part to the review-essay. In contrast to the first, the imagery of the second part is ponderous, dark, pessimistic and suffused with ill omen.

Early in the work, Melville remarks:

> It is curious, how a man may travel along a country road, and yet miss the grandest, or sweetest of prospects, by reason of an intervening hedge, so like all other hedges, as in no way to hint of the wider landscape beyond. So it has

been with me concerning the enchanting landscape in the soul of this Hawthorne, this most excellent man of Mosses.[24]

In quoting directly from the opening sketch of the *Mosses,* Melville remarks that Hawthorne sought to provide his readers "rest in a life of troubles."[25] But we must suppose that Melville did not take this assertion for Hawthorne's true intention, for Melville later states that the man of Mosses takes great delight in hoodwinking the world.[26]

The reference above to "the enchanting landscape in the soul of this Hawthorne" must be given careful attention. The theme of enchantment is frequent in Melville's works. In *Moby-Dick, White-Jacket,* "Benito Cereno," and *The Encantadas* (in English, *The Enchanted Isles*) the theme of enchantment, benign or malevolent in the beginning, is used to suggest an irresistible lure, the pursuit of which ends in terror, homelessness, or death. Consider the hold the white whale has upon the soul of Captain Ahab, or Budd upon Claggart. In this light the mention by Melville of an intervening hedge that hides the wider landscape of Hawthorne's thought is not an innocent remark. That Melville connects this hidden landscape with the idea of enchantment suggests that there is a dark and menacing side to Hawthorne's thought. Later in the review, Melville actually alludes to it:

> . . . Spite of all the Indian-summer sunlight on the higher side of Hawthorne's soul, the other side — like the dark half of the physical sphere — is shrouded in Blackness, ten times black.[27]

It is interesting to note that Melville does not disclose the basis of Hawthorne's dark underside.

Still later in the essay Hawthorne is compared to Shakespeare. According to Melville, the latter played his "grandest conceits" against an infinitely obscure background. What follows is this interesting comment:

> Through the mouths of the dark characters of Hamlet, Timon, Lear and Iago, he craftily says, or sometimes insinuates the things which we feel to be so terrifically true, that it were all but madness for any good man, *in his own proper character,* to utter, or even to hint of them. (Italics added)[28]

Shakespeare, he concludes, like other masters of "The Great Art of Telling the Truth," was compelled to disclose his meanings covertly and by snatches.

A number of interesting insights emerge from a study of Melville's review-essay. First, the opening section of the piece may itself be viewed as an intervening hedge, which, by its frivolous tone, partially conceals the meaning of the remainder of the essay. In this respect Melville's methods as a reviewer imitate the tactics he ascribes to Hawthorne as a writer. Second,

Melville endorses Hawthorne's unwillingness to openly disclose the basis of his gloomy prospect on life, by not disclosing it himself. Melville suggests that he agrees with Hawthorne's secret by refusing to tell it. This inference is strengthened by an examination of Melville's letters to Hawthorne during this period. One of the most instructive letters Melville wrote to Hawthorne praises the latter as "the man who, like Russia or the British Empire, declares himself a sovereign nature (in himself) amid the powers of heaven, hell and earth. He may perish; but so long as he exists he insists upon treating with all Powers upon an equal basis. If any of those other Powers choose to withhold certain secrets, let them; that does not impair [his] sovereignty.[29] Here is a theme which is crucial to Melville's intention in *Billy Budd:* the Powers of heaven, hell and earth — the Godhead — stand opposed to the sovereignty of man. In the same letter Melville suggests the possibility of atheism, but his more constant disposition was hatred of God, not disbelief. Melville was a *mis*theist rather than an atheist.

Third, by writing anonymously, Melville throws up a hedge to prevent easy identification of these observations with his own works.

What we may conclude from this brief discussion of the review-essay is that Melville replicates in his review the very methods he attributes to Hawthorne's writing. Like Hawthorne's his meanings are "hedged"; like Hawthorne's and Shakespeare's, they are revealed covertly and by snatches; like them, he does not speak "in his own proper person." If one's view of the writer's task — The Great Art of Telling the Truth, Melville calls it — requires concealment, as I think Melville's did, what better way to explain it, while yet maintaining the concealment, than by attributing the same view to someone else and then imitating the very tactics described?

Turning to *Billy Budd,* it must be noted that the novel is filled with many concealed meanings, which cannot all be examined in an essay of this length. Here let us consider a statement from chapter 3 in order to see how the above perspective on the review-essay applies to *Billy Budd.* In chapter 3 the narrator points out the significance of the Great Mutiny for the British navy. He states that concern for national pride and policy induced certain British historians, notably William James, to abridge their accounts of the Mutiny. Then follows this statement by the narrator:

> Such events [the Mutiny] cannot be ignored, but there is a *considerate way*
> of historically treating them. If a well-constituted individual refrains from
> blazoning aught amiss or calamitous in his family, a nation in the like
> circumstances may without reproach be equally discreet.[30]

When one stops to inquire, it is not at all clear why this comment is made. It offers no contribution to our understanding of the Mutiny or conditions

in the British navy in 1797. On its face it asserts the reticence of one British historian to discuss at length the circumstances of a weakened British navy. It makes no comment on a political event proper, but on the historical treatment of a political event. Herein lies its importance. It is relevant to the story, it seems to me, only as it suggests to the alert reader that Melville himself may be employing a *considerate way* of treating deeply disturbing events in political life. Plainly told, the story of Billy Budd *as seen from the inside* is profoundly disturbing to the foundations of free political orders. However, Melville's story is *not* plainly told. He gives us an inside narrative, as he promises in the title; that is, the meaning of the work is truly inside the narrative and concealed by it. *Billy Budd* contains the author's view of political life but does not disclose it. This we must do for ourselves.

We have now prepared the ground for our examination of the novel. The remainder of this essay will center on the meaning of *Billy Budd,* beginning with an examination of the three principal characters.

IV.

The singular feature of Billy Budd is his innocence. Too few critics have correctly understood the nature and significance of this trait. Two points need stressing. First, Budd's innocence distinguishes his inability to understand and defend himself against evil. We are told that his virtues are "pristine and unadulterate," deriving from a time "prior to Cain's city and citified man."[31] His virtues, if such they be, are natural in the sense that they are neither acquired from nor dependent upon the city or social life. In this sense they are prepolitical.

But it is insufficient to attribute Budd's being to presocial nature. Rather, I would insist that his particular being is attributable to Nature's God. At one point he is compared to Adam before the fall, an inferral of God's hand.[32] At another, Budd is asked details of his birthplace and paternity, but can give no answer: "God knows, Sir!" is his response.[33] Later, following Budd's killing blow to Claggart's forehead, Vere realizes the full import of the events played out before him: "Struck dead by an angel of God! Yet the Angel must hang!"[34]

Second: emblematic of the foretopman's innocence is a stutter which he suffers "under sudden provocation of strong heart-feeling." If we compare the three occasions on which Budd stutters, it is clear that on each he is confronted with an evil he cannot understand but knows he must somehow address. The situations he cannot deal with except by recourse to physical defense, or the threat of physical defense, are those which the law and political authority are established to mediate. From this, I think, we may fairly infer that his vocal defect is a consequence of his inability to make his way among men for whom political responsibilities have replaced natural

impulse. Budd is a prepolitical character lost among political men.

Three further points emerge from this discussion. First, Budd has no capacity for political behavior because he cannot grasp by reason or experience the conventional basis of order aboard the *Bellipotent*. The ship is run by rules, whereas Budd is moved according to his feelings. Budd's drubbing of Red Whiskers aboard the *Rights-of-Man* foretells that the innocent sailor's feelings and the actions which follow from them will run afoul of the ship's rules. Second, the sailor's lack of awareness makes him defenseless. His innocence becomes his snare. With no sense of evil in himself, Budd lacks the means for understanding it in others. Moreover, his innocence serves to provoke those in whom evil is more than usually concentrated; for example, Red Whiskers, Squeak (Claggart's "understrapper"), and the master-at-arms himself. A passage from chapter 12 is instructive on this point. The narrator observes that "envy and antipathy, passions irreconcilable in reason, nevertheless in fact may spring conjoined like Chang and Eng in one birth." And Claggart's envy "was no vulgar form of the passion." His envy runs deep, and with it his antipathy. The narrator remarks further that his insight into Budd's extraordinary innocence but intensifies Claggart's passion into an irresistible disdain and hatred. As for Billy, "innocence was his blinder."[35] Third, because innocence is oblivious to evil — as Budd is oblivious to the wellsprings of Claggart's behavior — it is unwittingly made to serve its ends, as we note in Budd's failure to report the supposed mutiny he is invited to join in chapter 14. In the strict application of the Mutiny Act, Budd's failure to report what he supposes to be a conspiracy is interpreted as complicity in it. If the conspiracy was a mutiny plot, as we are led to believe it was, then Budd's silence is punishable by death. Of course, the sailor knows nothing of this.

Several matters stand out in the assessment of Claggart's role and character. Charged with hatred for Budd, the master-at-arms nonetheless folds himself in the "mantle of respectability."[36] His malady, we are told, does not partake of the sordid or sensual. Here is every appearance of rectitude. He is never mercenary, never avaricious. He is without "vices or small sins."

> But the thing which in eminent instances signalizes so exceptional a nature is this: Though the man's even temper and discreet bearing would seem to intimate a mind peculiarly subject to the law of reason, not the less in heart he would seem to riot in complete exemption from that law, having apparently little to do with reason further than to employ it as an ambidexter implement for effecting the irrational. That is to say: Toward the accomplishment of an aim which in wantonness of atrocity would seem to partake of the insane, he will direct a cool judgment sagacious and sound. These men are madmen, and of the most dangerous sort, for their lunacy is not continuous, but occasional, evoked by some special object; it is protectively secretive, which is

as much as to say it is self-contained, so that when, moreover, most active it is to the average mind not distinguishable from sanity.[37]

As Budd's extraordinary innocence is entirely obvious, so is Claggart's extraordinary evil hidden, and for this reason it enjoys a kind of imperviousness to law.

The master-at-arms's antipathy for Budd is mysterious because "spontaneous and profound."[38] For the adequate comprehending of the man, the hints that are provided by ordinary experience of this world are not sufficient. In seeking to comprehend him, the narrator recalls a discussion held long ago with an "honest scholar." "I am not certain," said the honest scholar,

> whether to know the world and to know human nature be not two distinct branches of knowledge. . . . Nay, in an average man of the world, his constant rubbing with it blunts that finer *spiritual insight* indispensible to the understanding of the essential in certain exceptional characters, whether evil ones or good. . . . Coke and Blackstone hardly shed so much light into obscure spiritual places as the Hebrew prophets. And who were they? Mostly recluses. (Italics added)[39]

We are enjoined to look elsewhere than the works of Coke and Blackstone, that is, in general, the works of legal and political theorists, to acquire insight into exceptional characters such as Claggart or Budd. Biblical revelation must be our source of insight.

Is a parallel perhaps being suggested by Melville between the Bible and his story of the events aboard the *Bellipotent?* The Bible recounts the history of God's covenant with His chosen people. It is the account of God's direct intervention in secular history. Is there a form of divine intervention in *Billy Budd?* I have earlier suggested this in attributing Billy's innocence and beauty to the hand of God. There is also evidence that Claggart's part is given by God:

> With no power to annul the elemental evil in him, though readily enough he could hide it; apprehending the good, but powerless to be it; a nature like Claggart's, surcharged with energy as such natures almost invariably are, what recourse is left to it but to recoil upon itself and, *like the scorpion for which the Creator alone is responsible,* act out to the end the part allotted it. (Italics added)[40]

The confrontation between Budd and Claggart, between two exceptional and opposed natures, is a divine drama in which the characters are fated by God to respond to each other as they do. We will take up the significance of this later.

As I suggested earlier, the greatest difficulties have arisen over Melville's intention respecting Captain Vere. Many ambiguities surround his role and character. More than once the narrator intimates disturbing criticisms of the Captain. For example, he suggests that Vere may have been secretly ambitious. Can we with any confidence establish Melville's intention respecting Vere? I think we can, though it must be admitted that the following interpretation cannot resolve all the ambiguities facing us.

It will be helpful here to consider two aspects of Vere's role. First, it is by reliance upon the Mutiny Act, a legal convention, that Vere decides to execute Budd. It is by reliance upon another, literary, convention that we might better determine Melville's intention regarding Vere. The description of Vere in the novel falls between those of Budd and Claggart. Budd is treated in chapters 2 and 3, Claggart in 8 through 13, and Vere in 6 and 7. We know that Budd and Claggart are so opposed in their natures that the confrontation of the two will end in the destruction of both. They are safe only if separated; Melville has implied the same by interposing the description of Vere between the description of the other two. It is only when Vere physically steps aside during the accusation scene that they are made to confront one another. The Captain's failure, we might say, to stand between the foretopman and the master-at-arms provides the circumstances for their demise. Had Vere stood between them, literally, the blow from Budd almost surely would not have come. The Captain's physical presence, his interposition, becomes a correlate of his political role; his movement away from the two signals the removal of political authority from the confrontation. No human artifact is left to mediate the effects of the two opposed natures. The divine and the demonic face one another unrestrained by the political. I think this offers a glimpse into Melville's intention: political authority, represented in Vere, is given the role of *standing between* innocence and depravity — not to modify them, for this is beyond human possibility — but to interpose itself between the two in order to forestall the deadly consequences of their contact.

There is a second sense in which Melville attributes to political authority the role of standing between, which perhaps further illuminates his intention concerning Vere. The triad of Budd-Vere-Claggart is the most important in the story, but Vere is a member of a second triad. Graveling (the captain of the *Rights-of-Man*), Admiral Nelson (whom Melville compares to Vere in chapters 4 and 5), and Vere himself are each sea captains and each political officers. What kind of rule does each represent? It is apparent that they are distinctly different on this point. Graveling may be said to represent the rule of the *benevolent father*. There is little or no need for coercive rule aboard the *Rights*. As Graveling points out, Budd himself brings a kind of peace and benevolence to the crew. The disorders aboard his ship are trivial and untroubling; at most Graveling must

contend with an occasional brawl, promoted by an excess of exuberance rather than positive evil. Admiral Nelson, on the other hand, embodies the rule of the *hero*.

Nelson, the fallen hero of the Battle of Trafalgar, is called by the narrator a "poetic reproach" to the "martial utilitarians" who suggest that the "ornate publication of his person in battle was not only unnecessary, but not military, nay, savored of foolhardiness and vanity."[41] The narrator takes the opportunity to criticize the "Benthamites of war" for failing to observe that Nelson's bravado was in fact calculated to move his men to the accomplishment of the great deeds for which they and he have since been immortalized. While yet a rear admiral, Nelson was commanded to shift his pennant from the *Captain* to the *Theseus,* a ship which had participated in the Great Mutiny, and which, it was feared, might incite new disturbances.

> . . . Danger was apprehended from the temper of the men; and it was thought that an officer like Nelson was the one, not indeed to terrorize the crew into base subjection, but to win them, by force of his mere presence and heroic personality, back to an allegiance if not as enthusiastic as his own yet as true.[42]

In these few words Melville provides an account of the nature and function of heroism. The authority of the hero resides in his person rather than his position. Moreover, the allegiance he commands is likewise attached to him personally, rather than to the country he serves. These points distinguish both the strength and the weakness of the hero and the regime dependent upon his rule.

The narrator suggests earlier in the account of Nelson's death that a country needs heroes, who must of necessity be great men (hence rare), and who must, when the occasion calls, be sacrificed. Why? Because under conditions of dire threat to the country — for example, during war — heroism helps to forge a disinterested attachment of the citizen-soldier to his country's well-being above his own. Without a willingness among its citizens to risk paying "the last full measure of devotion," no country could long defend itself against others. According to this proposition, the utilitarians are not wrong; they merely cannot include in their calculations the incalculable benefit, indeed the indispensability, of heroism and self-sacrifice.

However, although heroism may be indispensable in situations of dire threat, by its nature it is limited to the extraordinary in political life. Heroism necessarily involves risk to one's life, and one must therefore set aside self-interest or self-preservation for the interest and preservation of the whole. This is precisely the burden the soldier must bear. Because the individual is not inclined by nature to sacrifice his self-preservation to the preservation of the whole, the hero must by his own example provide the

incentive for the soldier to overcome his passionate interest in life. One incentive, which Melville intimates by his own praise of Nelson and by his allusion to Tennyson's praise of him as "the greatest sailor since our world began," is the promise of immortality. One's life is offered on the condition that one's name be immortalized.

But where the sacrifice of self-interest is less pressing, that is, where the prospect of immortality is missing, the hero is out of place. He has no magic. To be immortal he must die, yet the incentive is lacking. This means that the hero cannot be a ruler in the ordinary sense of the word, because there is no place for heroism in the ordinary affairs of men. In such a situation, allegiance must reside in position — law and contractual authority — not person.

The third variety of rule is represented by Vere. It falls between the prepolitical rule of the *benevolent father* and the transpolitical rule of the *hero,* and is appropriately described as the *rule of law,* that is, the rule of human authority resting upon what Vere calls "measured forms."[43] Because the rule of law seeks, always imperfectly, to capture a wide range of possibilities in language general enough to hold them all, its "measured forms" inevitably encounter the uncovered instance, the event that cannot be fairly treated by the language or the spirit of the law. The rule of law, then, has the disadvantage of being at times insensitive and even pitiless. But it has the advantage of being permanent. Unlike heroism, laws are not dependent upon rare and exceptional men for their application. Treating Vere as the embodiment of the rule of law, we can see how this point is dramatized in chapter 28 of the novel. During the battle between the *Bellipotent* and the French ship *Athéé,* Vere is badly wounded and expects to die. He is replaced by the senior lieutenant under whom the *Bellipotent* eventually defeats the *Athéé.* It may be inferred from this that, however able a captain Vere is, command of the ship may be passed to a subordinate without grievous consequences. Unlike the hero, those who rule according to law may come and go without impairment to society as a whole.

In concluding these remarks on Vere, we may note that just as politics occupies a middle ground between depravity and innocence, Vere as a character in Melville's novel occupies a moral ground, an ambiguous moral ground, between benevolence and heroism. By occupying the center, Vere in his character and his role loses the consistency and clarity that exemplify the extremes.

V.

I have thus far maintained that *Billy Budd* is a novel that mixes the divine, the demonic, and the human. An adequate explication of this

mixture brings us to the trial scene in the novel. The trial of Budd poignantly indicates Melville's conception of the gulf between God's will and man's. However, this gulf is not stated openly; to paraphrase the review-essay on Hawthorne, it is not obtruded upon everyone alike. At his trial Budd is asked three questions: Why did Claggart bear such malice for him? Was he aware of any incipient trouble aboard ship? Why should Claggart lie if there was no malice between them? Why, in other words, would Claggart accuse a man if he knew him to be blameless? Let us focus on the first and third questions.

To the first, Budd answers that he does not know why Claggart should have borne such malice for him. Budd then interjects: "I had to say something, and I could only say it with a blow, God help me!"[44] *God help me;* why does Melville give these last words to Budd? A conventional plea by a man in trouble? Perhaps. But consider the very suggestive coincidence implied in Budd's plea, *God help me.* In chapter 2 the narrator describes the foretopman as lacking "any trace of the wisdom of the serpent, nor yet quite a dove. . . . " The point contains the well-known injunction of Christ to his apostles found in Matthew, chapter 10. He admonishes them to be innocent as doves but wary as serpents. But further:

> Do not put your trust in men; they will hand you over to courts of judgment, and scourge you in their synagogues; yes, and you will be brought before governors and Kings on my account, so that you can bear witness before them, and before the Gentiles. *Only, when they hand you over thus, do not consider anxiously what you are to say or how you are to say it; words will be given you when the time comes; it is not you who speak, it is the Spirit of your Father.* (Matt. 10:16–20, italics added.)

The parallels between Christ's injunction and the events aboard the *Bellipotent* are too close to dismiss. What then do they mean? That Budd is failed by his Maker who gives him *no* words when he is brought before a representative of the King? Or that the Spirit of the Father has indeed spoken through Budd with the killing blow to Claggart's forehead? I think the latter. Budd's invocation of God's help is more than rhetorical. He has in fact already been given the help he invokes — he kills his assailant — but not help that will save him. Moreover, if this argument is correct, we are given further indication that the drama of which Budd, Vere, and Claggart are a part is a mixture of the divine and the demonic with the earthly.

Turning to the third question: why should Claggart lie if there was no malice between them? The narrator follows the question with this remark:

> At that question, unintentionally touching on a *spiritual sphere* wholly obscure to Billy's thoughts, he was nonplussed. (Italics added)[45]

Vere then intervenes to narrow the inquiry to two points: did Budd strike a superior officer, and did the blow kill? Here the judges are disturbed by what they construe as a prejudgment on the captain's part. The captain of marines interjects a remark "in a tone of suggestive dubiety":

> Nobody is present — none of the ship's company, I mean — who might shed lateral light if any is to be had, upon what remains mysterious in this matter.[46]

Instead of replying to the suggestion for secondary witnesses, Vere underscores the mysteriousness of the event:

> "That is thoughtfully put," said Captain Vere, "I see your drift. Ay, there is a mystery; but, to use a scriptural phrase, it is a mystery of iniquity, a matter for psychologic theologians to discuss."[47]

For psychologic theologians indeed, but this is apparent only to the reader who has carefully pursued the interior as well as the exterior meanings of the work. Vere's characterization of the affair as a *mystery of iniquity* can have no clear meaning to the judges. What is mysterious to them is simply unknown, not unknowable. The illumination the judges seek has nothing to do with witnesses. Witnesses could not answer their questions. However, Vere's response is not meant for the judges; it is meant for the reader. What, then, is his, or Melville's, meaning?

I think the Biblical allusion contained in the remark is again the best clue. The phrase "mystery of iniquity" is taken from Paul's Second Epistle to the Thessalonians. At chapter 2 of the Epistle Paul warns his listeners that false prophets will from time to time appear among them:

> Let no man deceive you by any means: for that day shall not come, except there come a falling away first, and that man of sin be revealed, the son of perdition; . . . Remember ye not, that, when I was yet with you, I told you these things? And now ye know what withholdeth that he might be revealed in his time. For the mystery of iniquity doth already work. (*II Thessalonians* 2:3–7)

There are several similarities between this passage from Paul and Vere's words to the judges. Paul and Vere are each exhorting men for whose conduct they are responsible, though in different respects. Paul warns against the seductive appeals of false prophets who threaten faith; Vere counsels the judges "against scruples that may tend to enervate decision."[48] Paul's false prophets are not specified, but we can specify a false prophet in Melville's story: Billy Budd himself, the Angel of the Lord, the man whose very innocence provokes evil, the man who poses a threat to the well-being of the *Bellipotent* and the world it defends. Of course he intends no threat;

quite the opposite. Among all the sailors he is probably the greatest stickler for usage.[49] But he is a threat nonetheless. The appeal his nature sends out to the compassion of the judges is a compelling one; after all he is known as *Baby* Budd by many of the crew. But the appeal must be overruled, because at bottom Budd's nature, no less than Claggart's, is impervious to the law and to human reason. The foretopman emerges as not only a pre-political figure, but also as an antipolitical one who must ultimately contravene the law. Politics is possible only if action and meaning can be formalized into regularities of custom and law. To the extent that these regularities are missing or impossible, political life is endangered. In the end, innocence beyond the formalizations of custom and law is as disruptive to society as the profound depravity which "folds itself in the mantle of respectability."

A final comment based on the trial scene. Vere asks rhetorically in his comments to the judges, should not natural justice mitigate the crime? Budd intended no injury to Claggart; they are all convinced of this. And surely he is innocent of mutinous intent. These words follow:

> It is nature. But do these buttons that we wear attest that our allegiance is to Nature? No, to the King. Though the ocean, which is inviolate Nature primeval, *though this be the element where we move and have our being as sailors,* yet as the King's officers lies our duty in a sphere correspondly natural? So little is that true, that in receiving our commissions we in the most important regards ceased to be natural free agents. (Italics added)[50]

On the surface Vere repeats the arguments of certain natural rights theorists such as Hobbes. Civil society is purchased at the cost of natural free agency. The officers' commissions may be compared with the social contract whose terms abridge the rights of nature. However, there is a deeper, concealed meaning here. In Acts 17, the apostle Paul addresses the Athenians on Mars Hill. He says to them: "In Him [the Lord] we live, and move, and have our being." (Acts 17:27) Consider Vere's message: It is not the Divinity but the Secular Prince in whom man moves and has his being. If we combine this inference with the other hints in the novel, some of which I have earlier discussed, the suggestion is strong that the human order is not only separate from the divine and the demonic (there is nothing new about this view), but *opposed* to the divine *no less* than to the demonic. Each, in fact, emanates from the same source, God Himself. In this view, Budd and Claggart, though mortally opposed in themselves, together comprise the double face of God.

VI. Conclusion

Why, to conclude, does Melville conceal his full meaning inside the narrative? The answer to this question brings us to the heart of his

perspective on politics. Melville's narrative of events aboard the *Belli-potent* is controlled by an intention to speak protectively of the city and its concerns. Proof of this concern is evident, for example, in his civil war poetry, as well as the several criticisms in *Billy Budd* itself of the disintegrating effects of the French Revolution.[51] But the need to speak protectively out of concern for the well-being of the city does not require concealment unless open speech might itself threaten its well-being. And it is just because the city is founded upon opposition to the demonic and the divine that its well-being is always so tenuous. It might be argued that art alone will explain Melville's complex method; there is no need to import politics as an explanation. Such an argument overlooks a great deal of evidence, some of which I mentioned in connection with the review-essay of Hawthorne's *Mosses from an Old Manse*. The truth, Melville wrote in that piece, can only be told covertly and by snatches.

What then is the truth about politics that Melville tells covertly and by snatches? His teaching is this: Budd and Claggart, who are the double face of God, threaten the sovereignty of man over his own affairs. They threaten to dissolve the always precarious order men are able to achieve over their affairs by the rule of law, measured forms. This is so because neither profound evil nor profound innocence can be adequately explained or controlled. Claggart is not only able to use the law to further his own ends — recall that he was able through his "understrappers" to ensnarl Budd in a supposed mutiny plot — but he even advances to the position of chief of police aboard the *Bellipotent*. On the other hand, the foretopman of profound innocence proves himself on several occasions unable to ac-commodate his actions to the requirements of naval law and etiquette.[52]

But if God comprises both the dove and the serpent, it is vain to expect His solicitude. The lesson of *Billy Budd* would seem to be that God has no settled disposition toward mankind one way or the other. And here lies the necessity for concealment. The dependence upon God's solicitude is the very basis of political order. Without it, the city is unmoored, free to float in whatever direction force and cunning will carry it. Without this depen-dence upon God's solicitude, political moderation is gone. Nor can reason restore it, for Melville was thoroughly antirationalist.

> What though Reason forged your scheme?
> 'Twas Reason dreamed the Utopia's dream.
> 'Tis dream to think that Reason can
> Govern the reasoning creature, man.[53]

The indifference of God must not be revealed. Political order requires that it remain a secret. Ahab is Melville's Faustian God-hater. The *Pequod*

does not survive his command. The *Bellipotent,* a microcosm of this man-of-war world, survives because it keeps its secret hidden to all but a few. Outwardly regarded, the *Bellipotent* sails under the blessing of God; does it not defeat the *Atheé (Atheist),* known before the Revolution as the *Saint Louis?*

I close with the quote from *White-Jacket.*

> Outwardly regarded, our craft is a lie; for all that is outwardly seen of it is the clean swept deck, and oft-painted planks comprised above the waterline; whereas, the vast mass of our fabric, with all its storerooms and secrets, forever slides along far under the surface.[54]

In his last prose work Melville closed ranks around Machiavelli, the arch-blasphemer. However, unlike others among Machiavelli's disciples, he had the decency to keep the frightening secret to himself.

Notes

1. The text of *Billy Budd* referred to in this study is edited by Harrison Hayford and Merton M. Sealts, Jr. (Chicago: University of Chicago Press, 1962), cited herein as *BB.*
2. Hobbes, *Leviathan,* ed. C. B. Macpherson (Baltimore: Penguin, 1968), p. 81.
3. For an extended treatment of the distinction between modern and classical political theory, see Leo Strauss, *Natural Right and History* (Chicago: University of Chicago Press, 1953). In this work Strauss provides an elaborate analysis of the tension between nature and convention in the tradition of political philosophy.
4. *BB,* p. 63.
5. *BB,* pp. 54–56.
6. *BB.* pp. 110–11.
7. See James E. Miller, *Billy Budd:* The Catastrophe of Innocence," *Modern Language Notes* 73 (March, 1958), 168–76; Richard Harter Fogle, "*Billy Budd:* Acceptance or Irony," *Tulane Studies in English,* 8 (1958), 107–13; E. L. Grant Watson, "Melville's Testament of Acceptance," *New England Quarterly* 6 (June, 1933), pp. 319–27; Milton Stern, *The Fine Hammered Steel Of Herman Melville* (Urbana: University of Illinois Press, 1957).
8. See Lawrence Thompson, *Melville's Quarrel with God* (Princeton: Princeton University Press, 1952), pp. 355–414; Leonard Casper, "The Case Against Captain Vere," *Perspective* 5 (Summer, 1952), pp. 146–52; Arthur Sale, "Captain Vere's Reasons," *Cambridge Journal* 5 (October, 1951), pp. 3–18; Joseph Schiffman, "Melville's Final Stage: Irony. A Re-examination of *Billy Budd* Criticism," *American Literature* 22 (May, 1950), pp. 128–36; Phil Withim, "The Case Against Captain Vere," *Modern Language Quarterly* 20 (June, 1959), pp. 115–27.
9. *BB,* pp. 100–101.
10. *BB,* p. 100.
11. *BB,* p. 102.

12. *BB,* p. 112.
13. For example, is it the narrator's opinion that Vere was an ambitious man, see p. 129; or "a martinet as some deemed him," see p. 128.
14. *BB,* p. 54.
15. Ibid.
16. *BB,* p. 60.
17. *BB,* p. 62.
18. Ibid.
19. Ibid.
20. For a detailed study of Melville's use of concealment, see Lawrence Thompson, *Melville's Quarrel with God* (Princeton: Princeton University Press, 1952); also, Allan Haymond, "The Real and the Original: Herman Melville's Theory of Prose Fiction," *Modern Fiction Studies* 8 (1962), pp. 211–32; Merlin Bowen, "Tactics of Indirection in Melville's *The Confidence Man,*" *Studies in the Novel* 1 (Winter, 1969), pp. 401–20; and Wilson Carey McWilliams, "Herman Melville," *The Idea of Fraternity in America* (Berkeley: University of California Press, 1973), pp. 328–71.
21. Reprinted in *Moby-Dick,* ed. Harrison Hayford and Hershel Parker (New York: Norton, 1957), pp. 535–51, under the title "Hawthorne and His Mosses."
22. Ibid., p. 547.
23. The first part of the essay includes paragraphs one to eleven; the second, roughly paragraphs eleven to seventeen.
24. "Hawthorne and His Mosses," p. 536.
25. Ibid., p. 537.
26. Ibid., p. 548.
27. Ibid., p. 540.
28. Ibid., pp. 540–41.
29. Reprinted in *Moby-Dick,* p. 555.
30. *BB,* p. 55.
31. *BB,* p. 53.
32. *BB,* p. 52.
33. *BB,* p. 51.
34. *BB,* p. 101.
35. *BB,* p. 88.
36. *BB,* p. 75.
37. *BB,* p. 76.
38. *BB,* p. 74.
39. *BB,* p. 75.
40. *BB,* p. 78.
41. *BB,* p. 57.
42. *BB,* p. 59.
43. *BB,* p. 128.
44. *BB,* p. 106.
45. *BB,* p. 107.
46. *BB,* p. 108.
47. Ibid.
48. *BB,* p. 110.
49. *BB,* p. 68.
50. *BB,* p. 110.
51. *BB,* Ch. 3.

52. Consider, for example, Billy's fight with Red Whiskers and the breach of naval decorum described on pp. 48–49.

53. "A Reasonable Constitution," unpublished poem written in 1860, cited in *The Melville Log,* edited and compiled by Jay Leyda (New York: Gordian Press), vol. 2, p. 617. The poem is followed by this marginal note: "Observable in Sir Thomas More's 'Utopia' are: first, its almost entire reasonableness. Second, its almost entire impracticality. The remark applies more or less to the Utopia's prototype Plato's Republic."

54. Herman Melville, *White Jacket, or the World in a Man of War,* "The End" (London: Constable and Co., Standard Works, vol. VI, 1922), p. 503.

Chapter Twelve

Mark Twain: Technology, Social Change, and Political Power

Mary Lyndon Shanley and Peter G. Stillman

Mark Twain's *A Connecticut Yankee in King Arthur's Court,*[1] although frequently regarded as a fantasy for children, is a serious and devastating critique of feudal and modern industrial societies, and of utopian literature and political thought. It is perhaps not surprising that the darker aspects of *A Connecticut Yankee* are often overlooked. Indeed, Twain himself originally intended the work to be a burlesque of the Middle Ages. In his notebook he wrote:

> Dream of being a knight errant in armor in the Middle Ages. Have the notions and habits of the present day mixed with the necessities of that. No pockets in the armor. Can't scratch. Cold in the head — can't blow — can't get a handkerchief, can't use iron sleeve. Iron gets redhot in the sun — leaks in the rain, gets white with frost and freezes me solid in winter. Make disagreeable clatter when I enter church. Can't dress or undress myself. Always getting struck by lightning. Fall down & can't get up.[2]

This humorous tone prevails in the first chapters of the book, which Twain read to a group of cadets on Governor's Island in 1886 under the title "The Autobiography of Sir Robert Smith of Camelot."[3] The mocking tone of the original sketch, however, gave way to more serious concerns when Twain returned to the manuscript in 1887, 1888, and again in 1889.

In its final form, *A Connecticut Yankee* attacked aspects of both English and American society and values. The book ripped away the pretensions of those who asserted England's superiority over the United States. Twain had been particularly incensed by Matthew Arnold's caustically superior tone in his "Civilization in the United States," and the publisher's prospectus for *A Connecticut Yankee,* which Twain certainly edited if he

did not write the copy himself, reveals Twain's indignation at English postures of cultural or social preeminence:

> The book answers the Godly slurs that have been cast at us for generations by the titled gentry of England. It is a gird at Nobility and Royalty, and makes the most irreverent fun of these sacred things. . . . Without knowing it the Yankee is constantly answering modern English criticism of America, and pointing out the weakness and injustice of government by a privileged class.[4]

Sharper in tone is a notebook entry which declares,

> the man who believes there is a man in the world who is better than himself merely because he was born royal or noble, is a dog with the soul of a dog — and at bottom is a liar.[5]

Up to the last moment, Twain wanted to include an appendix to *A Connecticut Yankee* illustrating the boorishness and depravity of English civilization before the nineteenth century.[6]

Nor did Twain spare the United States in his humorous but sharply barbed critique of individual and institutional corruption and failings. *A Connecticut Yankee* is as critical of business and political corruption as is Twain's *Gilded Age* (1873), and as concerned with the desire for, and the impossibility of, escape from the repressive and dehumanizing features of nineteenth century American society as *Huckleberry Finn* (1884). Like both of these books, and like *A Tramp Abroad* (1880) and the late essay "What Is Man?" (1906), *A Connecticut Yankee* is a profound and at times despairing analysis of the degrading effects of industrial society and modern technology.

In *A Connecticut Yankee,* Twain clothes his critiques in the guise of a seemingly light-hearted tale about the journey of a nineteenth century American back to the sixth-century court of King Arthur. The plot of the story is fairly simple. The book's narrator is Hank Morgan, the Connecticut Yankee, who is a head superintendant at a Colt Firearms factory in Hartford. In a fight, a workman hits him on the head so hard that he is knocked unconscious. He wakes up in sixth-century Camelot. Once he realizes where he is, he resolves to "boss the whole country inside of three months" (II) and to develop it into a modern industrialized, Americanized democracy (X). After many varied episodes, he has much success: for instance, he imposes equality before the law, railroads and sewing machines, and schools, colleges, and newspapers (XL). But finally the church, the nobility, and — following them — the people turn against him. In the final battle on the Sand-belt, he, his chief assistant Clarence, and the 52 boys still loyal to him hold a defensive position in a cave, and, with

modern nineteenth century weapons, kill about 25,000 knights (XLIII). But Hank and his allies are trapped in the cave because they are surrounded by putrid corpses that make them sick. Merlin the magician sneaks into the cave, and puts a spell on Hank so that he does not awake until the nineteenth century; the others perish (XLIV).

The devices of travel in both space and time link Twain's work to a long tradition of utopian literature. From Thomas More's depiction of Hythloday's voyage to the uncharted island of Utopia and Jonathan Swift's tales of Gulliver's travels to the lands of the Lilliputians and Houyhnhnms, authors have used remoteness of place to free their imaginations to construct social and political orders widely removed from any known systems. Travel in time also allows criticism by contrast: William Morris sent William Guest through time to a medieval future in *News from Nowhere,* while Edward Bellamy rushed Julian West to the year 2000 in *Looking Backward.* Both authors intended to point out the shortcomings of late nineteenth century industrial society.[7]

While some utopian works (such as those of Fourier, Owen, Cabet, Bellamy, and most recently B. F. Skinner) are intended to inspire people to activity aimed at ushering in the good society each author describes, the major impetus in utopian theory has been critical, challenging the present order through the use of contrast (and often with the help of satiric wit).[8] *A Connecticut Yankee* joins Twain to this tradition, and he brilliantly exploits the genre by showing us that both the traveler's home country and the society he visits are in need of radical reform and reconstruction. Twain makes the reader into the only sound observer, the true voyager of the imagination.[9]

More serious than Twain's mockery of medieval England and nineteenth century America is his devastating attack on the attempt to realize utopia on earth. *A Connecticut Yankee* is unflinching in its condemnation of ideological or utopian zeal, of attempts to impose a vision of the good society on others. Twain is particularly appalled by the thought that modern technology might be coupled with political power to try to bring about drastic social change; the Yankee's effort to impose his utopia on others brings about destruction and death on a monstrous scale.

Despite Twain's multi-faceted critique of social and political reality, of utopian visions, and particularly of the attempt to realize utopia on earth by technologically advanced means, *A Connecticut Yankee* is neither a work of unmitigated pessimism nor a counsel for total despair. Twain decries large-scale and idealistic proposals for social transformation, but he does see some scope for the development and play of individual virtue in daily life, and even for legitimate and efficacious political activity. These insights are an important antidote to the bleak message of destruction

which places *A Connecticut Yankee* in the first rank of American antiutopian literature.

I.

As a critique of utopian visions, *A Connecticut Yankee* is most obviously a critique of Camelot, the golden age of chivalry, when knighthood was in flower. At first and superficial glance, chivalrous and pastoral Camelot is beautiful. The English countryside is dreamlike and peaceful:

> It was most lovely and pleasant in those sylvan solitudes in the early cool morning in the first freshness of autumn. From hilltops we saw fair green valleys lying spread out below, with streams winding through them, and island groves of trees here and there, and huge lonely oaks scattered about and casting black blots of shade; and beyond the valleys we saw ranges of hills, blue with haze, stretching away in billowing perspective to the horizon. . . . We crossed broad natural lawns sparkling with dew, and we moved like spirits, the cushioned turf giving out no sound of foot-fall; we dreamed along through glades in the mist of green light . . . and by our feet the clearest and coldest of runlets went frisking and gossiping (XII).

The knights that quest over this countryside are handsome, like Sir Sagramor:

> an imposing tower of iron, stately and rigid, his huge spear standing upright in its socket and grasped in his strong hand, his grand horse's face and breast cased in steel, his body clothed in rich trapping that almost dragged the ground — oh, a most noble picture (XXXIX).

All together the knights are, according to Hank, "a fine sight; I hadn't ever seen anything to beat it" (XLIII). The knights' tournament grounds so impress Hank that he notes, "well, I never saw anything to begin with it but a fight between an Upper Mississippi sunset and the aurora borealis" (XXXIX).

But this glitter is just a slim veneer on a society plagued by disease, dungeons, and death. The defects of Camelot are many and glaring. In the book's preface, Twain notes Camelot's "ungentle laws and customs," whose cruelties and costs are apparent in the bare facts Hank relates, even without the moral embellishments, judgments, and rhetoric the Yankee supplies. Social hierarchy renders the lives of most inhabitants of Camelot miserable. Most important, slavery exists. Further, the knights who top the aristocratic social system tell tedious stories (III), undertake futile quests (IX), and fight for childish reasons (III). The Bishops, who profit from the political power of an Established Church, exact tithes from all inhabitants.

The social and economic superiority of noble and bishop is reinforced by an inegalitarian legal system that is brutal and repressive. The Yankee catalogues mercilessly the disabilities of "freemen," whom the law severely restricts in economic and social matters. Freemen must, for instance, grind wheat only at their lord's mill; they are taxed almost to death in myriad ways; and they have fewer rights over their land and crops than do the deer and doves of their noble landlords (XIII). If a freeman breaks a law or insults a superior, he can expect to spend the rest of his life in a dark dungeon or be racked to death; his wife and family may be dispossessed (XVII). The subjection of the freeman is vividly portrayed in the episode where Arthur and Hank, disguised as peasants, come upon a family dying of small-pox, bereft of food because their sons were wrongly imprisoned, and under the Church's interdict for cursing the tithes (XXIX).

The social and legal systems operate within a political system of hereditary monarchy, which the Yankee abhors: "*any* kind of royalty, howsoever modified, . . . is rightly an insult" (VIII). The monarch has almost absolute power over his subjects, and is limited only by the limits of his force; Queen Morgan le Fay imprisons, tortures, or kills whomsoever she wishes (XVI–III), and the Yankee is saved from such fates only because his Lady, Sandy, convinces Morgan le Fay that Hank will dissolve her castle into thin air with his famous magical abilities if she arrests him (XVI).

Further, the inhabitants of Camelot are childlike. In many ways they are naive and simple. They love spectacles, whether as infernal smoke and thunder accompanying a magician's "miracle" (XXIII) or as elegant tournaments that maim and kill (IX). They fight for childish reasons; as Hank notes,

> Many a time I had seen a couple of boys, strangers, meet by chance, and say simultaneously, "I can lick you," and go at it on the spot; but I had always imagined until now that that sort of thing belonged to children only . . . ; but here were these big boobies sticking to it . . . into full age and beyond (III).

Like children too, they can be cruel to their human inferiors and subordinates, snubbing them as they pass (XXXI) or allowing their prisoners, just defeated in a joust, to bleed and suffer unattended (II). Nor do they give any thought to their cruel treatment of others (XVI), or to the cruelty wrought by institutions like slavery (XXI). Their childlike natures manifest not only the innocence but also the viciousness, "ignorance, and savagery" of children.[10]

Despite his early awe at the beauty of Camelot's "sylvan solitudes," Hank soon discovers that the landscape supports a world of suffering and

poverty, the results of ignorance and insensitivity, social inequality, an Established Church and an absolute monarchy.[11] Camelot is no sixth-century picturesque or pastoral utopia, but a society permeated by human misery and want.

II.

A Connecticut Yankee is also a critique of Hank Morgan's modern democratic, industrial, and business ideals. To indicate the defects of the Yankee's modern utopia, Twain conflates his narrator's utopian vision with the sixth-century horror of Camelot by using similarities of images, episodes, and characteristics.

For example, picking up an image standard in American utopian fiction of the nineteenth century,[12] Twain has Hank describe the first manifestations of modern society in Camelot, his factories, in these terms: "There it was, as sure a fact and as substantial a fact as any serene volcano, standing innocent with its smokeless summit in the blue sky and giving no sign of the rising hell in its bowels" (X). Hank's newspaper is a two-cent sheet called the Camelot *Weekly Hosannah and Literary Volcano!* (XXVI). The import of the volcano imagery comes clear in Hank's description of Morgan le Fay:

> The queen was the only power there. And she was a Vesuvius. As a favor, she might consent to warm a flock of sparrows for you, but then she might take that very opportunity to turn herself loose and bury a city (XVIII).

Like Morgan le Fay, Hank's "serene valcano," when unleashed, both runs railroads and electric lights and buries thousands on the Sand-belt.[13]

Dan Beard's drawings, about which Twain expressed "unqualified praise,"[14] link the centuries: a sixth-century slave driver has Jay Gould's features, Merlin looks suspiciously like Tennyson, and living European monarchs find their features on sixth century escutcheons. These pictorial links are reflected by many events in the text. When the Yankee succeeds in installing a nineteenth century world in Camelot, Launcelot, the greatest of the knights in chivalry and combat, is able to corner the stock market and fleece other knights as easily as he once unhorsed them (XL). Indeed, the Round Table essentially becomes the stock exchange (XL). Other knights, of lesser talents, move with equal ease into the modern world: as salesmen, they simply dispatch any commoner who does not buy their product.

The Established Roman Catholic Church does not make the same easy transition as the knights. But the Yankee, with his "man-factories" (XIII) and West Point (XXV), simply and unconsciously replaces a sixth century

Church with a nineteenth-century one. The Yankee's West Point closely resembles the medieval Church: it trains its students in skills not available to the rest of the population — reading, writing, and nineteenth-century science and war tactics (XXV). The Yankee then tries to make entry into the officer ranks in the army contingent on this knowledge, so that only West Pointers can become officers and men of influence in the army — just as only those trained by the Church can become priests and influentials. Like the Church also, all his educational factories take boys at their most impressionable ages and inculcate them with the Yankee's ideology and values; thus, at the end of the book (XLIII), only Clarence and "fifty-two young boys" (so young that they are still "as pretty as girls") are so propagandized by the Yankee's ideals that they stand by him, against the "massed chivalry of the whole earth" (XL).

Twain suggests many political parallels between the centuries. The Yankee, who claims to despise titles, blithely agrees to be called "The Boss" (VIII). Ironically, in the early nineteenth century "Boss" was the way slaves addressed their masters, and was the title of such Tammany luminaries as Boss Tweed. Further, Hank notes in despair how the poor frequently side with their aristocratic rulers who oppress them in the sixth century — as they do in the nineteenth century (XXX). But governments in both centuries do have moments of generosity, as Hank sees: he perceives that the River and Harbor Bills are essentially similar to the "king's-evil," where the king personally touches the sick and gives them money (XXVI). (What Hank overlooks, of course, is that on this point the sixth century is more humane than the nineteenth; for the "king's-evil" money goes to the sick and poor, not to the rich and powerful.)

Even in the ordinary details of daily life, the two centuries are similar. The idyllic countryside is disturbed in the sixth century by disease and violent death, in the nineteenth by industrial stench (XVI) and death (XLIII). Some of the same jokes exist, putting people to sleep as surely in the sixth as in the nineteenth (IV); some of the same songs exist, played as badly (XVII).

Perhaps the most striking similarity, and one that most strongly suggests Twain's criticism of the Yankee and his ideals, is that between Hank Morgan and Morgan le Fay. Both share the same name. Both have a superficial beauty and charm; both are magicians of one fashion or another; both rule through the fear they throw into the hearts of their subjects (XVI). Both hold their narrow political points of view rigidly: Hank cannot convince the Queen that "sudden passion is an extenuating circumstance in the killing of venison — or of a person" (XVIII), just as his years in Camelot cannot convince Hank that religious feeling exists and may have some good results, like "right-hearted" and helpful priests

(XVIII). Each is quick to engage his or her murderous whims. Morgan le Fay, for instance, wishes to kill the conductor of the incompetent chamber music ensemble; Hank Morgan allows her to do so (XVII). Morgan le Fay kills a page who slips (XVI); Hank Morgan kills Sir Dinaden for publishing his worst attempts at humor,

> a volume of gray-headed jokes which I had been familiar with during thirteen centuries. If he had left out that old rancid one about the lecturer I wouldn't have said anything; but I couldn't stand that one. I suppressed the book and hanged the author (XL).

Morgan le Fay takes an aesthetic interest in the killings; she assures that every drop of the page's blood is neatly mopped up (XVI). Hank Morgan has an equal eye for beauty: blowing up two knights with a dynamite bomb produces a sight as "pretty" as the explosion of a Mississippi River steamboat (XXVII). Ultimately, "what appalls the Yankee in the character of Morgan le Fay are the same insensitivities Twain objects to in the Yankee's character."[15]

It is Hank, not Twain, who praises the laissez-faire, democratic utopia he intends to establish in the English countryside. Twain has a different view. By his verbal imagery which conflates important features of the sixth and the nineteenth centuries, by his creation of numerous institutional parallels between the centuries, and by his approval of Dan Beard's illustrations, Twain shows that the nineteenth century the Yankee so admires is in essence very similar to Camelot.

III.

A Connecticut Yankee portrays supposed utopias — the idyllic Camelot and the modern industrialized vision of the Yankee — as undesirable, unpleasant, and indeed truly dystopian. Twain thereby sets himself at odds with those portions of the utopian tradition that either look back nostalgically to a lost "golden age" of simplicity and innocence, or look forward to a better future for mankind.

In his depiction of Camelot as a country of ignorance and oppression, Twain implicitly criticizes those who look to a simple and pastoral ideal world. This desire for rural ideals was common in the late nineteenth century in England and America. Evidence of this impulse exists not only in literature such as Butler's *Erehwon*, Morris' *News From Nowhere*, and Howells' *A Traveller from Altruria*, but also in the activities of the numerous communitarians who formed Brook Farm, New Harmony, Icaria, and Onedia.[16]

The Yankee's utopian vision, by contrast, is of an industrial, urban,

technically advanced, and scientific modern society. Its goal is to bring technical and material benefits to the masses, and to give them a say in government through democratic institutions. The Yankee's brave new world represents the utopian visions propounded in books like Cabet's *Voyage to Icaria,* Bellamy's *Looking Backward,* and H. G. Well's *A Modern Utopia.* Hank's attempt at constructing utopia is similar to the innumerable attempts to build utopia around modern industrial and technical achievements, attempts like Cabet's in the Missouri wilderness and those of the Nationalist Clubs for the spread of Bellamy's ideas.[17] Twain's critique of the Yankee is an implicit criticism of this strand of utopian thought and action.

But Twain's critique of utopian thought goes further than his satirical mocking of these supposedly ideal societies. Twain believes that the attempt to realize a utopia on earth can bring havoc in its wake. The devastation produced in *A Connecticut Yankee* is not intrinsic to sixth-century England or nineteenth-century America, but is brought about by the Yankee's attempt to realize his utopian vision. Unlike Plato, whose republic is a "pattern laid up in heaven" to be used to reform the individual's soul (*Republic,* 492b), the Yankee regards his republic as a blueprint, and he is determined to reconstruct English society according to it.

The Yankee's fanatical certainty about the desirability of his visionary utopia is made particularly dangerous by technological means he possesses and puts at the service of his enterprise. Twain clearly sees that, in his late nineteenth-century world (as in the twentieth century), there are apocalyptic dangers in the combination of certainty about utopia with the technologically advanced means that can be used to try to realize the utopia.

IV.

In *A Connecticut Yankee,* these apocalyptic dangers can be seen through an examination of the Yankee's utopian ideal. The central themes of the Yankee's stated ideals[18] can be described precisely. While Hank Morgan does not articulate in detail a full social order, with family structure, child-rearing, education and the like, he does believe that the perfect society will result (by an invisible hand) from the establishment of democratic government and a laissez-faire capitalist economy.

Hank describes himself as a democrat. For him, this seems to imply a number of specific aspects. Most obviously, he favors universal suffrage (XXX), or perhaps (XL) only universal male suffrage (XIII). He thinks that "where every man in a state has a vote, brutal laws are impossible"(XXV).

Hank also believes that political democracy requires a certain degree of

social equality. Citizens, to vote properly, cannot live in a society that degrades them; so the Yankee favors abolition of status by ascription and of an aristocracy of birth. "*Any* kind of aristocracy . . . is rightly an insult" to the people (VIII), especially since "a privileged class, an aristocracy, is but a band of slaveholders under another name"(XXV). All persons ought to view one another with respect, and as possessing humanity. "One needs but to hear an aristocrat speak of the classes that are below him to recognize . . . the very air and tone of the actual slaveholder; and behind these are the slaveholder's spirit, the slaveholder's blunted feeling . . . [,] the result of the . . . possessor's old and inbred custom of regarding himself as a superior being" (XXV). So, in Arthur's realm, the people "had been debased" by monarchy and aristocracy (XXV).

The Yankee also sees that democracy and the overcoming of the people's "debasement" require the elimination of severe economic exploitation and the degradation it produces. The Yankee's feelings against economic exploitation are expressed on a number of occasions. When he notes the economic restrictions on "freemen" and their poverty, he notes that "by a sarcasm of law and phrase they were freemen" (XIII). When he and the King are slaves and are warmed, one chill night, because their slavemaster will only give a mob the "witch" it is chasing if the mob will burn her near the slaves for heat, Hank bitterly comments: "our brute [the slavemaster], with a heart solely for business, lashed us into position about the stake and warmed us into life and commercial value by the same fire which took away the innocent life of that poor, harmless mother" (XXXV). But it is when he is training the King to go about the countryside disguised as a peasant that Hank most clearly connects democracy with the need to eliminate severe economic exploitation:

> Sire. . . . Your soldierly stride, your lordly port — these will not do. . . . The cares of a kingdom do not stoop the shoulders, . . . they do not put doubt and fear in the heart and hang out the signs of them in slouching body and unsure step. It is the sordid cares of the lowly born that do these things. You must learn the trick; you must imitate the trade-marks of poverty, misery, oppression, insult, and the other several and common inhumanities that sap the manliness out of a man and make him a loyal and proper and approved subject and a satisfaction his masters (XXVIII).

Poverty, misery, and the rest make a man a slave, not an independent and competent democratic citizen.

Finally, democracy seems to involve and require Hank's oft-repeated remark to the effect that

> A man *is* a man, at bottom. Whole ages of abuse and oppression cannot crush the manhood clear out of him. . . . Yes, there is plenty good enough material

for a republic in the most degraded people that ever existed — even the Russians (XXX).

In any society, there is hope. When individuals have been educated, the prospect is even better: "When a man is a man you can't knock it out of him" (XXXV). Democracy relies on the spark of manhood that resides in every person, and democrats can take heart in the resilience of undegraded, undebased citizens.

As well as being a democrat, Hank is a Yankee businessman and capitalist. He regards himself as both a "businessman and a statesman" (IX). He wants to bring people the material comforts and affluence of modern nineteenth century America. His first act in office is to establish a patent office, "for I knew that a country without a patent office and good patent laws was just a crab, and couldn't travel any way but sideways or backways" (IX). After he defeats Sir Sagramor and the other knights, and brings all his nineteenth century reforms into the open, he stresses how prosperous he has made the country, noting that "the telegraph, the telephone, the phonograph, the typewriter, the sewing-machine, and all the thousand willing and handy servants of steam and electricity were working their way into favor" (XL).

The businessman's jargon and entrepreneur's images fill his everyday speech. When, having "caused" the eclipse, Hank has King Arthur willing to grant him anything, even "the halving of my kingdom" (VI), Hank proposes to him instead a business arrangement:

> You shall remain king . . . but you shall appoint me your perpetual minister and executive, and give me for my services one per cent. of such actual increase of revenue over and above its present amount as I may succeed in creating for the state (VI).

Conceptualizing knight-errantry in a way that makes sense to himself, he sees it as "a corner in pork" (XIX). After the well in the Valley of Holiness has gone dry and both Merlin and he have come in to try to fix it, Hank, who arrives later, demurs from setting to work immediately because "Merlin has the contract" (XXII). When Hank gets the contract, he thinks of advertising his coming miraculous reopening of the well, because "many a small thing has been made large by the right kind of advertising" (XXII). In a preposterous manifestation of his entrepreneurial imagination, Hank uses a hermit (who bows continuously as a form of devotion) as the power generator for a sewing-machine. Hank makes a good deal of money retailing Hermit-made shirts, but sells out — *caveat emptor* — when he sees subtle signs of the hermit's impending lameness (XXII).

The Yankee talks a good deal of his democratic convictions, and does set out to abolish aristocracy and status by ascription. He combines his

democratic vision with a firm belief in laissez-faire capitalism. He appears
to believe that the free play of the market and unfettered competition will
raise the status and standard of living of all "men who are men, for all that."

V.

Ironically, it is in the name of his democratic and business ideals that
Hank kills English knighthood. The incongruity between the Yankee's
stated goals and the wholesale slaughter wrought in service to his dual
ideals is suggested by Twain at numerous points in *A Connecticut Yankee*.
Two aspects of Hank's ideals and behavior foretell, continuously through
the episodes, Hank's failure: (1) his entrepreneurship and bent for business
often work at odds with his goal of democracy; and (2) in his everday life he
does not see and act on the implications of his ideals.

Hank's entrepreneurship and business attitudes conflict in many ways
with his democratic goals. For instance, Hank sees advertising as truly
important, and he makes the knights into (slightly ludicrous looking)
walking billboards (XVI). His advertising, however, frequently appeals to
status, especially ascribed status. People should use Persimmons's Soap
because "*'All the Prime-Donne Use It!'*" (XVI). When a user of the soap
dies, Hank suggests adding the phrase, "*'Patronized by the Elect'*" (XVI).
When the Yankee turns the praying hermit into the power source for a
shirt-making factory, he plays on both religious and status motivations
among potential buyers: he names the shirts "Saint Stylite," and people
regard them "as a perfect protection against sin"; he asserts that they are
"'patronized by the Nobility'" in his advertisements, and produces fancy-
dress shirtings for the upper classes (XXII).

Hank also undermines his ideal of competent and independent citizens.
The needs of his industries make him regard people as (literally) cogs in a
machine. His schools and "man-factories" are to turn out technically
competent individuals (or automatons) to run his industries. Hank is as
concerned to manage demand as are the executives of a corporation in the
"new industrial state"; Hank has a knight out advertising stove-polish:

> I had chosen him to work up a stove-polish sentiment. There were no stoves
> yet, and so there could be nothing serious about stove-polish. All that the
> agent needed to do was to deftly and by degrees prepare the public for the
> great change, and have them established in predilections toward neatness
> against the time when the stove should appear upon the stage (XX).

Hank's democratic citizens are not to have any choice in what they wish to
buy, nor even in what predilections they bring to the market place.

Finally, Hank does not realize that laissez faire capitalism may keep

many in positions of economic degradation. Buying on the installment plan (XL) is the modern form of tithing, and creates economic indenture, not independence. To accompany the paragraph in which Hank tells the King that his shoulders do not stoop nor his heart know fear because it is only "the sordid cares of the lowly born that do these things" (XXVII, quoted above), Beard draws a freeman, carrying on his stooped shoulders a large bundle labelled "rent" and "tax," and dragging two balls-and-chains labelled "debt" — the burden of the nineteenth century worker as well as the sixth-century freeman.

In a moment of insight, Hank sees the monetary and psychological deprivations of modern work. He sees that "intellectual 'work' is mis-named; it is a pleasure, a dissipation, and is its own highest reward" (XXVIII), whereas physical labor is difficult drudgery: "there isn't money enough in the universe to hire me to swing a pickax thirty days." Yet the intellectual "worker" gets paid more.

> The law of work does seem utterly unfair — but there it is, and nothing can change it: the higher the pay in enjoyment the worker gets out of it, the higher shall be his pay in cash, also. And it's also the very law of those transparent swindles, transmissible nobility and kingship (XXVIII).

But, armed with this fleeting insight, Hank does not use his immense power as the Boss to change the wage scale, nor does he think about the significance of this insight for any of his other ideals (like democracy) or actions.

Unaware of the conflicts between his business and democratic goals, Hank is also unaware that he does not act on the implications of his goals. The instances of the Yankee's actual insensitivity to the requirements of his democratic ideals are legion. Perhaps the most notable are his frequent references to humans as animals or less. He refers to individuals and groups as "these animals" (V), "more or less tame animals" (VII), "rabbits" (VIII), "these innumerable clams" (XIV), "these catfish" (XXV), "this mollusk" (XXV), and, finally, "human muck" (XLIII). These appellations, incon-gruous enough in the mouth of someone committed to "liberty and equality" (XLIII), are even more ironic since Hank has lashed out at the aristocrats for just this attitude (XXV, quoted above).

His plans, responses, and actions reflect his derogatory words. Trying to figure out how to fix the well in the Valley of Holiness, he thinks that it may be best to have "a person of no especial value drop a dynamite bomb into it" (XXII). When Clarence tells Hank that Launcelot has rescued Guenevere from the stake in a bloody raid, Hank mourns some dead who were members of his baseball team — but he mourns them as baseball players!

"The very best man in my subordinate nine. What a handy right-fielder he was!" "My peerless short-stop! I've seen him catch a daisy-cutter in his teeth. Come, I can't stand this!" (XLII).

In his everyday relations with others, Hank Morgan constantly tries to humiliate them. Merlin is a frequent target (XXIII), perhaps with some reason since Merlin wished Hank burned (VI). But the Yankee also insists on humiliating Dowley, a self-made blacksmith in a little town, a man of only local repute, little real wealth, and much conceit. Hank is not content merely with "mashing" Dowley's pride over his worldly possessions (XXXII). When he cannot convince Dowley of a matter of political economy, Hank insists on catching Dowley and his friends in an admission of a minor crime worth the pillory and death; "You ought to have seen them go to pieces, the whole gang" (XXXIII).

Similarly, while he is against aristocracy and status by ascription, he is willing to be titled "The Boss" and he regards himself as "some kind of a superior being" (XXIII) because of his technical skills — in Hank's case, a gift of his (nineteenth-century) birth. Finally, Hank ignores instances in which he might do some immediate good. When he comes across a procession of slaves, Hank does not set them free (or buy them their freedom), because he himself wishes to end slavery only *en masse* and "by command of the nation" (XXI). When he is buying the goods for the dinner party at which he humiliates Dowley, Hank comes across the people fleeing from the burned Manor and the resulting riots, persons who are "shunned and tearful and houseless remnants of families whose homes had been taken from them and their parents butchered or hanged" (XXXI). Although Hank is spending money at a prodigious rate on a dinner party, he does nothing for these suffering children. Unlike Huck Finn, who has difficulty thinking abstractly but who can do concrete good acts, Hank Morgan thinks abstractly with ease but cannot carry out good actions in particular circumstances.

The contradictions between Hank's stated ideals and his specific actions are also numerous in economic affairs, where he mouths laissez faire and free enterprise ideals, but acts differently. Most notably, he engages in massive governmental (or personal) intervention in the economy; all the secret industry he builds up is, after all, the product of his actions as chief officer of the government.[19] In addition, as Merlin works to fix the well and Hank refuses to step in, Hank talks in terms that are hardly competitive: "Two of a trade must not underbid each other. We might as well cut rates and be done with it; it would arrive at that in the end" (XXII).[20] Hank wants competition only when it suits him. He advocates free enterprise in his abstract words, but in specific situations he frequently deviates widely from the norm of individual enterprise and free competition.

VI.

The devastation at the end of *A Connecticut Yankee* is in part attributable to the Yankee's failure to understand the incompatability between his democratic ideals and his attempts to modernize the material and economic aspects of life in Arthurian England,[21] and is in part the result of his inability to act on the implications of his own ideals. More than these two problems, however, brings on the concluding apocalypse. Twain imagines vividly the horror of the technological capabilities of the modern world put into the hands of a visionary assured of the righteousness of his goals.[22] No matter whether those goals are desirable or not, Twain finds the combination of technology with ideology (in the sense of a utopian vision that is a program for action) frightful and disturbing.

As Twain presents the case, technology combined with ideology creates a two-fold problem. First, when technological capability is used as a prime means by which to gain political power even for democratic ends, it nonetheless subverts democratic goals. It is Hank's superior knowledge and his technological expertise that make him "The Boss," for he gains his high position from Arthur after he has predicted the eclipse, and he gains full popular consent (or fear) after he blows up Merlin's tower. Hank uses his expertise to continue in power, by continuing to play on people's ignorance and superstition. For instance, in repairing the well in the Valley of Holiness, rather than simply patching the leaky walls of the well and showing the monks how to do in case the well might leak again, he keeps his (simple) technical knowledge of repairing wells from the monks and Merlin, leaving them in ignorance. Then with drama and fireworks, and apparent magic and incantation, he plays up his simple repair so that the people regard him with reverence (XXIII). Similarly, when a rival magician appears in the Valley, Hank uses his telephone, of which others know nothing, to surpass his rival in magical predictions. He shows himself a better magician but does not try to educate the public against magic (XXIV). Whereas Hank's vision of democracy requires citizens who are at least minimally competent, Hank plays on, rather than remedies, the ignorance and superstition of the inhabitants of Arthurian England. Only if they remain ignorant and superstitious can his technical expertise bring him political power. Thus, even when he is entrenched on the Sand-belt, Hank insists on blowing up his nineteenth-century civilization because "we could not afford to let the enemy turn our own weapons against us" (XLIII), for he cannot admit that all his "noble civilization-factories" might benefit England some even if he were not around or not politically powerful. To gain political power, Hank relies on his superior technical knowledge and expertise; to keep that power, Hank must retain his

superiority, and thus must keep citizens ignorant and superstitious.[23]

Second, technological expertise and capability at the service of an ideologue in power are terrifyingly destructive. This destructive potential is implied by Twain in the symbolism of the Yankee's first successful ploy: blotting out the sun. Having shown his (apparent) ability to use his skill to destroy nature, Hank blows up Merlin's tower, built by the Romans, and shows his (actual) ability to destroy handsome, old, and massive artifacts of human cultures (VII).[24]

Hank can also destroy human life with his modern technology in a way and at a rate hitherto unthinkable. Most killing in the sixth century is at least personal; the killer can see the person he is killing, and frequently knows his name. One occasional happy result of this closeness to flesh and blood is that two fighters can come to respect each other and can even be reconciled, as were Gawaine and Marhaus in one of Sandy's tales (XV). And in all cases there are severe physical limits to the scope of killing. Even when the medieval paragon of evil, Morgan le Fay, wishes to dispatch people, she can do so only one at a time, whether by dirk or rack. If, in a milder fury, she wishes to imprison them, she has room for only 48 prisoners (XVIII). Furthermore, even Morgan le Fay seems to dispatch only those who have done her some wrong. The wrong may be trivial, like slipping in her presence, or saying she has red hair, but she does not search out people to oppress.

By contrast, because of his technological skills, Hank's killing is subject to few natural or physical limits and is blithely impersonal. When Hank wishes to be rid of someone, he blows them up with dynamite bombs (two at a time [XXVII]); he shoots them with dragoon revolvers (ten in a moment [XXXIX]); and (as the number killed goes into thousands) mows them down with Gatling guns, electrocutes them, and drowns them by opening a dam (XLIII). With his modern weapons, he can kill almost any number as rapidly as he wishes.

Further, Hank's technological methods distance him from real, living human beings and their social relations. Although societies usually revere burial of the dead and friendship, Hank's technology does not: when he blows up someone, there is not even enough of a corpse left to provide a burial; when he electrocutes knights singly, it turns out that friends are killed by dead friends (XLIII). Moreover, Hank hardly acts as though he were killing humans: he relishes the technical competence of his defensive planning and execution, and after he has killed the 25,000 knights his first thought is not to mourn but to exalt (with unconscious irony) that "we fifty-four were masters of England!" (XLIII). Indeed, he never really sees individuals dying, he only sees a shadow stopped, a spark that indicates another electrocution, or the mass death of several thousand. Advanced

technology makes mass killing easy, and impersonal mass killing possible.

Finally, what makes Hank Morgan so much more terrifying than Morgan le Fay is that Hank does not kill only those who have offended him. In his eagerness to reform the sixth century and impose his utopian vision on it, Hank goes out looking for knights to kill. After defeating Sir Sagramor in single combat, he seeks to destroy knight-errantry by challenging all the knights together to fight him; when they call his "bluff" and accept his challenge, he shoots nine of them before they panic in defeat (XXXIX). After that victory, he renews his challenge (in terms that ironically fit the Battle of the Sand-belt); as Hank reports it, "I said, name the day, and I would take fifty assistants and stand up *against the massed chivalry of the whole earth and destroy it"* (XL), and "I was not bluffing this time" (XL). From the beginning, Hank is out to convert people to his way, whether or not they have done him any wrong, trivial or not (II); if he must kill them in order to save them or to convert them, he will do that.

Eager to realize his utopian program of democracy and material plenty in sixth century England, Hank Morgan instead uses his technological skills to kill on an unprecedented scale. Twain grimly shows the results of the combination of technology with the American goals, carried by the Yankee, to make the world safe for democracy and to impose material plenty on all.

VII.

A Connecticut Yankee is an antiutopian novel in the fullest sense. Twain punctures the ideal aspects of both pastoral and industrial utopias and portrays the terror of the combination of advanced technology with a utopian program. Though he may agree with specific parts of the Yankee's overall vision, it is clear that Mark Twain should not be identified with Hank Morgan, as has been done by too many interpreters.[25] Twain himself pointed out shortcomings of the Boss:

> . . . this Yankee of mine has neither the refinement nor the weakness of a college education; he is a perfect ignoramus; he is boss of a machine shop; he can build a locomotive or a Colt's revolver, he can put up and run a telegraph line, but he's an ignoramus, nevertheless.[26]

Equally miguided, however, is the contemporary reinterpretation that sees only pessimism in *A Connecticut Yankee,* that sees *A Connecticut Yankee* as merely an early version of Twain's later pessimism of, for instance, *The Mysterious Stranger* (1916).[27]

For political analysis the issue is not really Twain's optimism or pessimism. To put the matter differently, Twain's comprehension of

politics is not reducible to abstract concepts of optimism or pessimism. Rather, in *A Connecticut Yankee* Twain takes a clear position about political change and about the source and locus of virtue and goodness.

Twain sees virtue as resting not in the state or society, but in the individual, family, or small community, when separated from government and powerful social institutions. Many of the book's episodes and examples suggest that Twain appreciates the existence of good individuals and the possibility of virtuous individual acts. Hank is a loving husband with Sandy, and a loving and caring father of their daughter Hello-Central. When the cruel laws insist that a starving mother be hung for the theft of a linen cloth worth a farthing, Twain shows the reader the repentant and honest victim of the theft, the loving mother, and a virtuous priest (XXXV). When the slave driver tries to whip Arthur into submission, Twain convincingly displays the King as a man whose spirit is unbreakable. The family dying of smallpox, cursed by the Church and oppressed by their Lord, was a loving and close family. In the episode, Arthur shows his bravery by risking disease and death to help the family. As Hank writes: "Here was heroism at its last and loftiest possibility, its utmost summit. . . . He was great now; sublimely great" (XXIX). Removed from a political setting, or despite cruel laws and institutions, individual virtue does exist, just as Huck Finn, escaping from a civilized society he finds oppressive, takes the brave decision to stand by Jim.[28]

Indeed, Twain sees that not only virtue but also happiness reside in nonpolitical settings; generally, whenever the political order or powerful social institutions intervene in an individual's life, the result is unhappiness. The starving mother who is hung, the family in the smallpox hut, even Hank's leaving his family in France to return to an England under interdict — in all these cases, politics or powerful institutions impinge upon and destroy the love of individuals and the happiness of small groups. Here again, *A Connecticut Yankee* is similar to *Huckleberry Finn,* where Huck's and Jim's mutual friendship is continually threatened by cruel laws, institutions, and prejudices.

Because he finds individual virtue and happiness outside of or despite politics and powerful institutions, and because he sees the attempt to realize utopia as misguided and disasterous,Twain is chary of drastic or large-scale social and political change by political means. After all of Hank's struggles, the knights quickly returned to their old ways, and the mass of people fearfully responded to the Church's interdict, leaving Hank with only 53 allies in all England. In terms of political action, therefore, Twain advocates not a blueprint but a tendency or a stance: he favors a general lessening of the horrors of the law and of law-based prejudices, and a general freeing of individuals from restrictive institutions, especially

when such institutions are backed by the law. Thus, for instance, Twain (like Hank) opposes slavery, hereditary social stratifications, and an Established Church. Twain also (and unlike Hank) opposes arbitrary governmental power and the existence of numerous criminal laws that require death or confiscation of all property. Twain also (and again unlike Hank) wishes less political and social interference with the family and those other small communities (like Huck's and Jim's raft) within which people can be virtuous and happy. As Twain said,

> Let us say, then, in broad terms, that any system which has in it any one of these things — to wit, human slavery, despotic government, inequality, numerous and brutal punishments for crime, superstition almost universal, and dirt and poverty almost universal — is not a real civilization, and any system which has none of them is.[29]

In a rejected preface for *A Connecticut Yankee,* Twain praises "merciful-ness — a wide and general relaxing of the grip of the law."[30] Political and social reform should not try to impose a new order, a new ideal, a utopia. Rather, Twain wishes that rulers and reformers be merciful. Political actors should try to eliminate or alleviate injustice and prejudice wherever possible. They should try to relax the grip of large and powerful social institutions, including the government, and lessen the chances and the scope for the arbitrary exercise of power by those in the institutions. Finally, they should try to protect individuals and small communities, like the family, so that individual virtue and close inter-personal feelings may be nourished and may flourish.

The dilemmas that Twain accentuates in *A Connecticut Yankee* have prophetic relevance to the twentieth century.[31] The democratic ideals of individual autonomy and development conflict with business and indus-trial practices as much in twentieth-century America as in Hank Morgan's world. A century before John Kenneth Galbraith, Twain warns against the management of demand by industrial corporations. Presaging the current debate on business ethics, Twain portrays a world with undercurrents of fraud and chicanery in economic undertakings, both in the stock market and in Hank's own enterprises. Not only does Hank manipulate the market in favor of Persimmons's soap and stove polish, not only does he sell out of an enterprise on "insider's knowledge," but he maintains his own political power by skillful use of marketing techniques and "dirty tricks." To some extent at least, Twain sees the link between the decline of consumer sovereignty and threats to political self-determination.

Twain is also presciently skeptical of the effects of powerful large-scale institutions on individual self-determination and autonomy. Camelot's Established Church and Hank's army and political machine, for example,

lose touch with the clients and constituents they were founded to serve, fall prey to the ills of overprofessionalization, and use their power arbitrarily. Twain would probably not be surprised at the current complaints directed against the welfare bureaucracy, where officials frequently do not serve the interests of the clients, where professionalization and professional advancement are the desiderata, and where each bureaucrat can exercise wide latitude in making decisions — and thus can make them on whimsical grounds. For Twain, the managerial state has serious deficiencies.

Size and scale are most appalling to Twain, however, when they are linked to technology. Uneven distribution of technological benefits is as threatening to democratic equality as is extremely uneven distribution of economic resources. The monopoly of technological power in the hands of the state gives it enormous potential for destruction — as Hank too frequently demonstrates. The devastation of technology may be directed against other human beings, against the past that gives human beings their identity, and against the natural environment in which human beings live and on which they depend.

In short, Twain's message for the late nineteenth century is one that has not lost its relevance for the late twentieth century. Twain warns against utopian dreamings and abstract thought, especially when the dreamers have advanced technical means at their disposal. He warns about the drawbacks that derive from excessive activity by large-scale governments or other politically powerful institutions. In these warnings, he is concerned to defend the individual and those small communities in which the individual can find happiness and satisfaction. Twain does not have a blueprint for a future society, but he does take a critical stance towards the serious threats inherent in modern, industrial, technological society. Twain's stance speaks eloquently to many of the dilemmas that the United States faces as it approaches the end of this century.

Notes

1. Published 1889. Reprinted frequently. The text quoted is that of the editions published by Harper & Brothers (and their successors), New York; citations to *A Connecticut Yankee* are in parentheses in the text, and are to chapter. All Dan Beard's drawings are collected in a facsimile edition, Hamlin Hill, ed., *A Connecticut Yankee in King Arthur's Court*, by Samuel L. Clemens (San Francisco: Chandler Publishing Co., 1963). Twain's other works can be found in collected editions by Harper & Brothers.
2. Albert B. Paine, ed., *Mark Twain's Notebook* (New York: Harper & Brothers, 1935), p. 171.
3. Howard Baetzhold, "The Course of Composition of *A Connecticut Yankee:* A Reinterpretation," *American Literature,* 33 (1961), p. 197.
4. Prospectus for *A Connecticut Yankee,* New York, 1889, "Publishers' An-

nouncement," p. 77, quoted in Henry Nash Smith, *Mark Twain: The Development of a Writer* (Cambridge, Mass.: Belknap Press of Harvard University Press, 1962), p. 167.

5. Quoted in Hamlin Hill, "Introduction," *A Connecticut Yankee in King Arthur's Court*, by Samuel L. Clemens, p. xiii. On other notebook entries discussing Matthew Arnold in particular, see John B. Hoben, "Mark Twain's *A Connecticut Yankee:* A Genetic Study," *American Literature*, 18 (1946), pp. 205–12.

6. Hill, "Introduction," p. xiii.

7. There are so many utopias of remote place or different time that it is impossible to list them all here, but it is interesting to note that the best recent depiction of an alternate society, Ursula Le Guin's *The Dispossessed*, employs both space travel (to another solar system) and time travel (to the distant future) to perform her splendid imaginative feat.

8. See, for example, not only *Gulliver's Travels* but also Rabelais's works, Voltaire's *Candide*, and Samuel Butler's *Erewhon*. For a discussion, see Mary L. Shanley and Peter G. Stillman, "Utopia, Satire, and Skepticism in Rabelais, Montaigne, Montesquieu, and Voltaire," paper presented to the annual meeting of the American Political Science Association, 1975.

9. On utopian literature in general, see the excellent collection of essays edited by Frank Manuel, *Utopias and Utopian Thought* (Boston: Houghton Mifflin Company, 1966).

10. Samuel L. Clemens, *The Curious Republic of Gondor and Other Whimsical Sketches* (New York: Boni and Liveright, 1919), p. 36.

11. In showing that Camelot's superficial beauty covers pervasive cruelty, Twain is dealing with an agrarian society. But many twentieth-century antiutopian writers have developed, for their postindustrial societies, the same theme: a superficial beauty, order, and comfort, derived from technological and cybernetic advances, mask an underlying and pervasive repression, oppression, and dehumanization. Aldous Huxley's *Brave New World*, Yeugeny Zamyatin's *We*, and Kurt Vonnegut's *Player Piano* are well-known examples of this theme.

12. Kenneth M. Roemer, *The Obsolete Necessity: America in Utopian Writings, 1888-1900* (Kent, Ohio: Kent State University Press, 1976), pp. 22–24.

13. In a valuable essay, David Ketterer develops this theme, among others; see "Epoch-Eclipse and Apocalypse: Special 'Effects' in *A Connecticut Yankee*," in his *New Worlds for Old* (Garden City, N.Y.: Anchor, 1974).

14. Henry Nash Smith, *Mark Twain's Fable of Progress: Political and Economic Ideas in "A Connecticut Yankee"* (New Brunswick, N.J.: Rutgers University Press, 1964), p. 8; see also Louis J. Budd, *Mark Twain: Social Philosopher* (Port Washington, N.Y.: Kennikat Press, 1972 [reprint of 1962 Indiana University Press edition]), pp. 114, 123, and 129.

15. Edmund Reiss, "Afterword," *A Connecticut Yankee in King Arthur's Court*, by Mark Twain (New York: Signet, 1963), p. 325.

16. These pastoral ideals are discussed in almost every history of utopian thought and practice. For pastoral ideals contemporaneous with *A Connecticut Yankee*, see Roemer, *Obsolete Necessity*, especially Chap. 3. Twain is also criticizing here those who long to return to an aristocratic past, whether they be Anglophiles like Tennyson in "Idylls of the King," or Americans attracted to the Old South (for whom, see also Clemens, *The Curious Republic*, pp. 36–41.)

17. Modern industrial and technical utopias are also discussed in almost every

history of utopian thought and practice. For ideals contemporaneous with *A Connecticut Yankee*, see Roemer, *Obsolete Necessity*, especially Chaps. 2 and 8. Twain's disagreement with Bellamy is apparent from other texts; see Roger B. Salomon, *Twain and the Image of History* (New Haven, Conn.: Yale University Press, 1961), pp. 39–40.

18. The Yankee's stated ideals are at variance with much of his practice. This contradiction is considered in Section V.

19. Even if the Yankee were to change his stated goal of laissez faire to conform to his usual policy of governmental intervention, most of the contradictions discussed in this section would remain as contradictions between the ideal of governmental intervention for the public welfare and Hank's interventions, which are for selfish, personal, and self-aggrandizing reasons.

20. Conversely, Hank clings to a free-market attitude even in connection with markets that obviously do not have the classical economists' prerequisites for unregulated competition, e.g., the stock market, where the limited number of shares for sale makes possible Launcelot's masterfully engineered bear raid — done with finesse that would make his nineteenth-century successors jealous. (Unfortunately, Launcelot is so successful at fleecing the shorts that they expose his love for Guenevere to Arthur, thereby destroying Camelot [XLII].)

21. Twain is clearly aware that technology can be beneficial. Many of Hank's technological innovations — the telephone, the train, the newspaper — can help increase communication and understanding among people, and can help alleviate suffering and save lives (as in the case of Hello-Central's sickness). The Paige typesetter, in which Twain himself invested so heavily, had the same beneficial potential. Moreover, both communication and the alleviation of suffering are important in a democracy, or in any political system that purports to develop and respect individuals. (Equally clearly, Twain is aware that the beneficial effects of technology depend upon the individual using the technology. For instance, Hank, with all his technology, does not increase his own understanding of others, nor alleviate suffering wherever possible.)

22. In Malory's *Morte d'Arthur*, Camelot falls because of universal passions — the love of Launcelot and Guenevere, the envy of Mordred. In Twain's retelling, the ideal society is destroyed because of one of the Yankee's "modern improvements" (XLII), the stock market that Launcelot manipulated so well when he trounced Mordred and others. Stock market manipulation and speculative money-making — vices particular to the Yankee's type of industrial society — destroy Camelot. As Clarence says to Hank, "Well, if there hadn't been any Queen Guenevere, it [i.e., Camelot's downfall] wouldn't have come so early; but it would have come, anyway. It would have come on your own account by and by . . . "(XLII). Twain sees clearly that the Yankee's "modern improvements," imposed on Camelot, must lead to their own destruction. (Twain's changing such a central part of the Arthurian legend is also, it might be noted, a good indication that Twain is neither "ambivalent" about nor "unable to distance himself" from Hank Morgan and his "modern improvements," but rather perceives their destructive potential. It is not that Hank's world collapses despite Hank's technology and solely because of Launcelot's love; Hank's world collapses because of his "modern improvements," and Launcelot's love is secondary or irrelevant. Cf. Roemer, *Obsolete Necessity*, p. 31; Smith, *Mark Twain*, p. 170; and Salomon, *Mark Twain*, p. 126.)

23. For a contemporary restatement of this point, see Kurt Vonnegut, *Player Piano*.

24. The United States Air Force acted like Hank in Indochina; indeed, the Vietnam War provides too many recent examples of Twain's points in this and following paragraphs. For further treatment of Hank's contemporary relevance, see Chadwick Hansen, "The Once and Future Boss: Mark Twain's Yankee," *Nineteenth-Century Fiction*, 28 (1973), pp. 62–73.
25. For the interpretations of *A Connecticut Yankee* as optimistic, see Budd, *Mark Twain*, esp. pp. 112 and 138–44; the reviews and books cited in Smith, *Mark Twain*, pp. 146–50; and Stephen Leacock's "Appreciation"and Albert Bigelow Paine's "Introduction" to their edition of *A Connecticut Yankee* (New York: Harper & Brothers, 1929). For Leacock, "His own age [Twain] idealizes as the age of light and freedom. In other words he shared in that easy confidence in the age of machinery that was typical of the later nineteenth century." (Another school is represented by Smith himself, who sees Twain as ambivalent. Smith argues that Twain started out optimistically: "He planned a fable illustrating how the advance of technology fosters the moral improvement of mankind" [p. 170], but in the writing of the fable lost his faith. See also Salomon, *Mark Twain*, pp. 126–32.)
26. Quoted, by Gladys Bellamy in *Mark Twain as a Literary Artist* (Norman, Okla.: Oklahoma University Press, 1950), p. 314.
27. For the interpretations of *A Connecticut Yankee* as pessimistic, see Allen Guttmann, "Mark Twain's *Connecticut Yankee:* Affirmation of the Vernacular Tradition?" *New England Quarterly*, 33 (1960), pp. 232–37, and James M. Cox, *"A Connecticut Yankee in King Arthur's Court:* The Machinery of Self-Preservation," *Yale Review*, 50 (1960–61), pp. 89–102.
28. For an excellent treatment of *Huckleberry Finn*, see Leo Marx, *The Machine in the Garden* (New York: Oxford University Press, 1964), pp. 319–40.
29. Quoted in Budd, *Mark Twain*, p. 139, n.51.
30. Albert Bigelow Paine, *Mark Twain: A Biography* (New York: Gabriel Wells, 1923), Appendix S, pp. 1656–57. Some interpreters mistakenly see Twain as a "Manchester [laissez faire] liberal" favorable to business and robber barons, since Twain desires fewer oppressive laws (e.g., Budd, *Mark Twain*, p. 139). But, just as in the sixth century "merciful laws" would release "freemen" from disabling dependence on Established Church and nobility, so in the nineteenth-century "merciful laws" would lessen the burden of the modern workers' shackles of taxes and rents — not increase their burdens by adding the oppression of capital-owning barons. On this point and others, see also Catherine and Michael Zuckert, "'And in Its Wake We Followed': The Political Wisdom of Mark Twain," *interpretation*, 3 (1972), pp. 59–93.
31. One politically important theme that has not been stressed in this chapter is that *A Connecticut Yankee* may also be seen as an interpretation of the problems of modernization. The leader of the modernizers, Hank, mouths republican (or democratic) ideals but longs to be the "president" of the new republic — and perhaps even remain the "Boss." The traditional attitudes of the people, especially in religion, are extraordinarily difficult to eradicate; in the end, the inhabitants of Camelot meekly obey the Church's Interdict. The Church's power shows the staying power of traditional institutions. The traditional elite — the knights — retain immense political power and social prestige, as they gain all the important jobs under Hank. The fable of Hank's failure at modernization and Americanization foreshadows recent criticisms of United States foreign policy of the 1950s and 1960s.

Chapter Thirteen
Faulkner, Naipaul, and Zola: Violence and the Novel*

Peter C. Sederberg

Dissonance
(If you're interested)
leads to discovery
William Carlos Williams, Paterson IV

I. Art and Reality: The Metaphor of the Mirror

Art poses something of a problem for social scientists: Just what are we to make of it?[1] One obvious but unsatisfactory answer is to treat the production and consumption of art as we would any other social activity. The relationship between art consumers and producers has become a minor, though not inconsequential, area of sociological research.[2] This approach need not be restricted to the "high" arts; indeed, the analysis of kitsch, from mass consumption design to pulp fiction, may reveal more about a society than an examination of the art objects favored by the cultural elite. For example, some idea of both the level of technology and the nature of social norms can be gleaned from the surviving art of a historical epoch. The Marxist argument that the nineteenth-century novel reflects and confirms the dominant bourgeois values is one variant of this approach.

Yet works of art, especially those of literary artists, do not seem equivalent to most other everyday social actions. Whereas the latter unintentionally reveal the structure of the social world to the skilled observer, the reflections of social reality made by literary artists seem more deliberate. A similar self-consciousness characterizes the products of social-scientific research. Artists, therefore, not only act in the social world, but they intentionally say something about it as well.

A second way of coping with the problem of art, then, is to treat artists as pseudosocial scientists and to scan their works for testable hypotheses and analyses of data.[3] *Germinal,* one of the three works considered in this essay, can be viewed as a study of coal-mining conditions in nineteenth-century France, as well as a plausible exposition of how labor violence could be precipitated. The social artist might reflect upon society with the same acuity as the social scientist.

This second approach, however, is also unsatisfactory. Though it recognizes that both artists and scientists are relatively self-conscious in their activities, it obscures to the point of imperceptibility any cognitive difference between the two enterprises. It strips the art from the artist and leaves only the skeleton of what often turns out to be misleading if not false social analysis. The mirror the artist holds up to social fact is a dark glass that obscures and even distorts.

If art is an indifferent mirror of empirical reality, then perhaps it reflects some "deeper" truth. The beautiful lies of the artist might reveal the meaning of social reality beyond mere fact. Though false "as is," art becomes true "as if." Thus, one could argue that artists of every age strive "to uncover in a symbol the inner meaning of the real truth of human existence, by articulating its character as a fundamental concern for truth of being — in love of beauty, admiration of greatness, grief and gladness at the tragic, pathetic, and happy carefree unconcern regarding the trivial, or piercing despair over absolute nothingness."[4]

Of course, artists might accomplish all this, but so might philosophers. Certainly no special reason exists for expecting that the artist is uniquely qualified to mirror the "real truth." If, however, artists make no unique contribution to social understanding, why treat them and their work any differently from that of any other social actor? If, on the other hand, artists do make a unique contribution, then the nature of this contribution remains to be defined.

Perhaps investigation of this problem needs to be redirected. Most studies of the "meaning" of art focus on the work itself. But a work of art is nothing if there is no one to perceive it. Any meaning a work of art possesses must be brought to that work by the perceiver and, in this sense, is external to it. The artist may try to prompt a certain response in the perceiver by drawing upon certain signs assumed to call it forth, but if the perceiver is ignorant of the signs, the work will not communicate the artist's intention.

Assume, though, that the art perceiver is familiar with the signs used by the artist. Why does he spend his time contemplating art, when the meanings communicated could probably be acquired with greater facility through either science or philosophy? His interest is held, not exclusively

by *what* is being communicated, but by the *way* in which it is communicated; not the knowledge, per se, but the process of knowing it.

The notion that the manner in which a work of art presents its meaning has an impact on the orientation of the perceiver is hardly startling. The language of science, for example, is commonly characterized as essentially denotative, referring the perceiver's attention to the world "out there." The language of art, in contrast, is connotative, intended to evoke certain internal states in the art perceiver.[5] Both denotative and connotative language, of course, can contribute to the perceiver's understanding of the world, though in somewhat different ways.

The distinction between referential and evocative language, however, appears too stark and general to be of much use in considering the contribution of the literary artist to the understanding of the social world. We need to know what is being evoked, and how this affects the perceiver's understanding.

II. The Rage for Order and the Uses of Chaos

Most of us do not like to be surprised. We possess a need, indeed, a "rage," for order; that is, we want to be able to develop stable and accurate expectations of one another's behavior.[6] The world, much to our dismay, can be a very surprising place. The basic means through which we attempt to impose order upon the world is what might be called the strategy of categorization.[7] Predictions about the nature of "reality" and, consequently, our behavior are essentially based on these categories. Language is the basic system of categorization devised by humanity to impose order. Even the most referential words are still categories. "Cat," for instance, refers to no specific cat, rather a multitudinous array of cats. The only way we can refer to anything with a fair degree of precision is through the use of "overlapping categories" (e.g., the yellow cat on the wall next to the house third from the corner, etc., etc.).

One conclusion of this line of reasoning is that our efforts to impose order through language are inherently flawed. At no point is language tied to the world; rather, "it slips and slides and slithers on top of it."[8] Moreover, once a statement has been uttered, it must then suffer interpretation, introducing another instability (thus, the receiver of the cat message may misinterpret it and look to the wrong house). Finally, a third instability afflicts efforts to order through categorization — the world changes, "slipping and slithering" away from the category (by the time the receiver correctly interprets the message, the cat may have moved).[9] Language, then, is not strictly descriptive, but predictive: "An utterance amounts to a speaker's prediction that if the interpreter categorizes the

world as the utterer recommends, the interpreter will encounter such-and-such a world."[10] Thus, instability in the system of categorization, or polysemy, disrupts expectations and results in cognitive tension and frustration.

People manage polysemy in a variety of ways. One common tactic, familiar to all social scientists, is selective perception. Information contradicting the category is ignored. Although we all are guilty of a certain amount of screening, at some point excessive selection can threaten survival. Behavior predicated on highly inaccurate categories can result in disaster.

An alternative way of coping with polysemy is through adaptation of the categories in an effort to correct their inadequacies. Adaptation requires the acceptance of continual negative feedback — a fundamental characteristic of scientific method — and toleration of fairly high levels of cognitive tension. Problems cannot be solved until they are first admitted.

Although the adaptive individual must be able to tolerate a good deal of ambiguity, the objective still remains to impose order on the world. Science accepts negative feedback to improve its ability to predict and control. Nor should it be ignored that even those whose intellectual activity places a high value on negative feedback are often subject to selective perception and stubbornly cling to outmoded categories.

Where do the arts fit into all of this? Are they, too, a manifestation of the rage for order? Morse Peckham, in a series of provocative works, argues the reverse.[11] Art does not fulfill a need for a purer order, as some aestheticians assert; rather, "art offers not order but the opportunity to experience more disorder than does any other human artifact."[12] The basic evidence he finds for this proposition lies in the dynamism characterizing changes in artistic styles. This dynamism seems to serve no obvious purpose. Tools, for example, are modified over time to enhance performance, but as some maximum utility is approached dynamism in design tends to decline. Scientific theories change in order more adequately to categorize the world, but some scientific principles have remained unchanged for centuries. Art, in comparison, seems afflicted by a great deal of "unnecessary" dynamism, so much so that sometimes even the trained art perceiver is outraged, as demonstrated by the reception given to Stravinsky's *"The Rite of Spring"* or Marcel Duchamp's *Nude Descending a Staircase.*

In addition, Peckham argues that individual works of art establish patterns of expectancy and then frustrate them.[13] A poem might establish a pattern of rhythm or rhyme and then violate it. A symphony might establish a theme and then vary it. Stylisitic dynamism creates "external discontinuities," but the violation of expectations generated by a particular

work of art is caused by "internal discontinuities." In any given period, works of art at the higher cultural levels tend to display greater discontinuities than those at a lower level. Mass art, in effect, is intellectually accessible to the untrained perceiver. The discontinuities offered by the poetry of T. S. Eliot differ markedly from those of a Hallmark card. This conclusion, however, does not mean that art characterized by more significant discontinuities is "better" in some ultimate sense. Evaluation depends on the importation of a standard external to the work of art. If a high value is placed on the experience of discontinuity, then such works are better. If one values relief from the polysemy of the world, then pulp fiction and "realistic" art are better.

If art offers the experience of disorientation, it also supplies protection from it. The perceiver contemplates the work of art in a state of psychic insulation — whether provided by the frame of a painting, the walls of a concert hall, or the covers of a book.[14] Insulation functions to relieve the perceiver from the necessity of acting.[15] The experience of disorder, then, is made less threatening and more tolerable if not necessarily pleasant. In this insulated setting, the perceiver may be able to endure threats to his categories far better than in the real world.

In order to experience the disorientation offered by art, a person must be educated, just as a person who wishes to conduct scientific research must learn the role of a scientist.[16] He needs to be thoroughly knowledgeable of the traditions of categorization upon which the artist draws. The higher the cultural level for which a work of art is produced, the more demanding will be the art perceiver's task. James Joyce is reputed to have remarked that he spent a lifetime writing his books, and he expected his readers to spend a lifetime reading them. As Peckham indicates, the notion that a great work of art should be immediately comprehensible to everyone is fatuous. Indeed, there is no reason why we expect that the art perceiver's role should be any easier to learn than that of a scientist or a philosopher. A person might find a book by Joyce to be incomprehensible for essentially the same reasons as he might find an article on quantum mechanics incomprehensible — he has not mastered the relevant systems of categorization. The argument suggests that whatever the purpose of looking at art, it will only be accomplished to the extent that the observer is trained to appreciate such work. Assigning "political novels" to freshmen may have some entertainment value, but little else.

If disorientation is the consequence of the perception of art, the question still remains why we should bother. Peckham believes that the experience will aid adaptation, in that it provides the opportunity to "rehearse the power to perceive the failure" of our categories. "Art is the exposure to the tensions and problems of a false world so that man can endure exposing

himself to the tensions and problems of the real world." [17] This, then, is the fundamental contribution the arts make to our understanding of the social world.

Peckham's conclusion as to the function of art is nonspecific. Any form of artistic discontinuity could conceivably help the perceiver rehearse for any possible category failure in the real world. The tensions and problems of the false and real worlds, though, might be more closely linked. Sometimes the artist uses material either specifically drawn from the world of fact or parallel to it. The discontinuities in the work of art, then, might more closely approximate some of the actual ambiguities intrinsic to real-world problems. The literary artist, especially the fiction writer, can use his false world to illuminate some of the dilemmas of interpretation faced in the real world. Art does not so much hold up a mirror to reality as become a lamp that helps show the way to fuller understanding.

A final problem remains: Why does the art perceiver subject himself to such abuse? First, he must endure an arduous and continuous education in order to "appreciate" art at the higher cultural levels. But what is this appreciation? Not the relaxation of tension, but the creation of it; not the solution to problems, but the presentation of them; not the soothing sensation of order, but the disturbing flirtation with chaos. All this, it might be argued, is "good" for the perceiver, and the "pleasures" of art should be endured out of a sense of puritanical masochism.

Art, however, offers more than the experience of discontinuity. Something else is often there that attracts even as the tensions and ambiguities might repel, and holds the reader's attention throughout the ordeal of chaos. Superficially, this might be labeled the theme or content of a work of art; in the case of the fiction writer, the story the artist weaves. Norman Holland suggests that we need to penetrate more deeply — to the core fantasies of a story — if we are to understand why it fascinates. These fantasy meanings are essentially "unconscious, infantile, and fraught with emotion." [18] Holland classifies the primary fantasies in Freudian terms, but we need not embrace the Freudian lexicon to recognize how the artist draws more or less openly upon the basic lusts and fears of the human psyche. These underlying fantasies can horrify and attract at the same time, but the psychic insulation provided by the work enables the reader to enjoy the fantasy without the fear that it might break into the real world and require some form of action.

Holland argues that many of the factors that generate the experience of discontinuity in a work of art serve as "defense mechanisms" against too overt an expression of the fantasy core, because discontinuities tend to deflect attention from the fantasy to the intellectual level. In this sense, "form manages content." The reverse is also true: The fantasy content sustains the reader through the exigencies of form.

III. The Problem of Social Violence in Fiction — Three Novels

Social violence fascinates many scientists and literary artists alike. Works of literature dealing with themes of violence might be expected to offer an ideal instance where the ambiguities of the false world are more closely related to those of the real. The experience of violence is, after all, probably the ultimate discontinuity, and the epitome of the failure of our categories to predict accurately and serve as a dependable guide to action. One common reaction of participants in the everyday world to the threat of violence is to screen out its reality. Just as most people do not spend much time contemplating their own deaths, neither do they bother themselves greatly with the possibility of violence intruding upon their settled categorical schemes. This apparent indifference to violence and death probably reflects deep-seated fears rather than unconcern. After all, few of us have the stamina to gaze unflinchingly at the abyss of death, or to accept the possibility that the world that appears so orderly merely masks the unpredictable chaos of violence.

The psychic insulation of a fictional work dealing with violence relieves the perceiver from the threat of action, freeing him to participate vicariously in the artist's portrayal. Given such protection, themes of violence and annihilation can fascinate and even titillate. Pulp fiction writers are keenly aware that violence, as well as sex, sells books. Of course, attracting and holding a reader's attention is only the first step in providing an experience of discontinuity. Pulp fiction insulates the reader, but beyond the presentation of fictive violence of a more or less fantastic character, it tends to be predictable and easily understood.

Social-scientific studies of violence also insulate the reader from the real world even as they purport to describe and explain it. The entire thrust of contemporary social science is to move to higher explanatory levels, a goal that effectively sanitizes the experience of violence. Ironically, the more successful social science is as a science that seeks to prevent and control violence, the more impoverished will be the observer's understanding of the actual horror and beauty of the experience of violence in social life.

Take, for example, the following hyphothesis:

> The magnitude of political violence varies strongly and directly with the ratio of dissident coercive control to regime coercive control to the point of equality, and inversely beyond it.[19]

Where are the dead in this? Where are the bereaved? Where are the intentions of the perpetrators, from the idealistic to the petty? Where is the fear? The hatred? The envy? The contempt? Where is the agony? The psychic scars? The seething resentment and the lust for revenge? Nowhere,

nor should any of this be expected, for the purpose of science is to impose order, not to inject the chaos of emotion. As Thomas Pollock aptly notes, "The more accurately we report the results of experience, the less we communicate our experience itself."[20]

The literary artist, however, can inject something analogous to the experience of violence into his portrait of a fictive world. Literature tends to focus on the microcosmic rather than, as is usually the case in social science, the macrocosmic. The novelist is primarily concerned with a

> whole fabric of description, and with specific details while the political scientist is concerned with events, processes, and factors, with abstractions from wholes and with classes of general phenomena. The latter builds upon numerous instances, upon gross data, and upon repeated patterns of behavior. The former builds upon an amassing of individualized data fashioned into a unique chronicle.[21]

By presenting individuals rather than classes of data, the artist is able to intensify the illusion of participation on the part of the reader. Moreover, the artist, by concentrating on the specific, does not sacrifice a more general relevance. Despite their richness and specificity, well-developed characters can become "concrete universals," in that they are particular representations of shared elements of the human condition.[22]

The participants in the everyday world block out dissonant realities in an effort to maintain categorical stability, a tendency that can ultimately threaten survival. Social scientists are presumably open to contradictory data from negative feedback from their predictive efforts. Dissonance, however, is not accepted for its own sake; rather, the intention is to impose a more perfect categorization on a variable reality. The conclusions of science, therefore, produce a more satisfying sense of order. In the work of the artist, though, can be found an analogue to the tensions of categorical breakdown produced by the intrusion of violence. In short, by participating in the artistic illusion, the perceiver may come to a fuller understanding of the meaning of violence to those actually affected by it.

Such increased understanding, though probably desirable, does not emerge automatically. At least two factors intrude: the potential of the work of art to evoke the tension and ambiguities of categorical collapse, and the idiosyncratic response of the reader. Peckham believes that works of art directed at the higher cultural levels of any period are more likely to exhibit discontinuities than those reflecting mass taste. Moreover, extra-artistic forces in one society may tolerate less discontinuity in art than another. A good example is the highly accessible art resulting from the imposition of the doctrines of Socialist Realism that require art to be uplifting and to validate the values of the Soviet state. The "New Soviet

Man" is not to have his psyche disturbed by the machinations of "subversive" artists. Consequently, not every work of fiction is intended to evoke the tensions of discontinuity.

Second, whatever the nature of the work of art, the range of the perceiver's response is, in principle, infinite. In fact, of course, certain limits exist, insofar as the perceiver is sufficiently educated to make the "appropriate" (from the perspective of the artist) response to the signs offered by the work. The greater the perceiver's ignorance of the cultural milieu of a work, the more variable and unpredictable will be his response.

Using works of literature in an effort to enhance the reader's understanding of social violence, or any other social problem, becomes a rather hazardous enterprise. Disagreements easily emerge over the quality of the works selected and over their interpretation. In spite of the potential volatility, however, certain bases of agreement might be established. In any case, merely because an enterprise is arduous does not invalidate its utility.

First, certain works clearly exhibit more significant discontinuities than others. Although this does not make them "good," it serves as a criterion for selection. Second, some interpretations of a work are more supportable than others. Anyone can impose any meaning they choose on an art object, but, as Peckham notes, this is not interpretation but exemplification; that is, the perceiver is using the work to illustrate a preconceived "theory" or explanation.[23] Marxist and Freudian critics are sometimes guilty of confusing exemplification with interpretation. Interpretation, properly conceived, draws on the exemplary material contained in the work of art to generate appropriate explanatory statements. In order to verify interpretive statements, the critic needs to be familiar with the cultural environment of the artist, for the artist cannot draw on meanings that do not exist in his cultural setting. Thus, William Faulkner alludes to the Bible but not to the Yoruba pantheon.

Fortunately, these cautionary observations do not fully impact upon the argument of this essay. In order to illustrate how the artist can disrupt expectations, we will examine three novels dealing with problems of violence: Emile Zola's *Germinal*, V. S. Naipaul's *Guerrillas*, and William Faulkner's *Absalom, Absalom!*[24] These three novels were chosen because of their individual significance, the range of time and authorship involved, and their different perspectives on the problem of social violence. No effort is made, however, to provide a full interpretation of each work.

Germinal is Zola's "naturalist" masterpiece, which depicts the wretched conditions of French coal miners in the late nineteenth century and how they rise in an ultimately futile strike against their exploiters. Although the most accessible of the three, *Germinal* is not quite as straightforward as it appears. In terms of theme and content, this novel is most closely

concerned with a type of violence of interest to social scientists — that rooted in the class struggle between the bourgeoisie and the proletariat. Yet Zola incarnates this struggle in relatively few characters.

Naipaul's *Guerrillas* is a recent novel dealing with a very contemporary theme: Third World liberation struggles against the forces of neocolonialism. Set on a Caribbean island, it depicts the seething tensions of a people who awaken the "morning after" political independence and find they are not yet free. Somewhat more psychological than *Germinal, Guerilla,* is woven from threads of the interactions among three characters. General propositions concerning the sense of relative deprivation caused by the "revolution of rising expectations" are distilled into the often pathetic frustrations of these three people. Almost all the violence in the novel is "offstage," lurking ominously in the background, threatening to break into the lives of the central characters, in marked contrast to the vivid portrayals of massive violence in *Germinal.*

The most difficult and perhaps the most profoundly rewarding of the three works is *Absalom, Absalom!,* considered by some critics to be Faulkner's finest novel.[25] The violence of this novel is the most personal, basically involving the members of a single family, and the least political, although there are themes of racial and social stratification. Regardless of the apparent individuality of the characters and the Southern setting, the novel transcends mere regional status. The story of the rise and fall of Thomas Sutpen assumes a tragic dimension, for he truly is a great man brought down by a tragic flaw. The reverberations of his failure echo throughout the entire American value system, if not, indeed, that of the modern world. Possibly more important than these value implications is Faulkner's depiction of the agony involved in trying to understand the meaning of acts of violence. In a sense, the narrators of the novel approximate the position of participants in the everyday world who are trying to grasp and order events that have disrupted their categories. More so than either of the other two novels, *Absalom, Absalom!* is capable of generating the tensions caused by the violation of expectations.

All three novels end with failure. In *Germinal,* the miners' strike sputters out, and the central family of the story is practically destroyed. The three major protagonists of *Guerrillas* have their illusions and their lives spiritually, and in one case literally, killed. In *Absalom, Absalom!,* not only does Sutpen's dream of carving a familial empire out of the wilderness end in the howling of a half-caste idiot through the ruins of his plantation, but the novel's central narrator, Quentin Compson, discovers that he cannot escape the moral entanglements of the Sutpen family tragedy. These three novels, then, hardly qualify as pleasant entertainments.

Each work, however, also seems to illustrate Holland's suggestion that

the artist manipulates core fantasies in order to hold the reader's attention. In Freudian terms, the novels draw upon anal, oral, phallic, and oedipal fantasies. Somewhat more bluntly stated, *Germinal* depicts the often bestial state to which the miners have been reduced — their gluttonous pleasures, their casual, violent lusts, and, of course, the sweat, pain, fear, and filth of the mines. The themes of miscegenation, anal rape, and ritual butchery are indications of the fantasy core of *Guerrillas,* and implications of miscegenation and incest are woven throughout *Absalom, Absalom!* This is not to suggest that these fantasies are what the stories are "about," only that they help to sustain the reader through each work's difficulties.

IV. The Generation of Cognitive Tension in the Three Novels

The novelist can generate cognitive tension through the form in which the story is told, and through the creation of problems of interpretation. Peckham suggests that the artist develops both of these in the same way, "by postponing the presentation of data sufficient either to solve the problem of the plot or to facilitate the construction of an adequate interpretation."[26] This method produces something similar to the ambiguity and paucity of information that afflict participants in the everyday world when they try to order problems that have violated their categories of expectation.

The bifurcation into problems of "form" and "meaning," though, can be justly criticized as misleading, for the form in which a story is related can either reveal or conceal meaning. Yet, despite a certain degree of artificiality, the distinction suggests the different mental activities involved in first ascertaining the facts and then assessing their meaning. Consequently, it serves to organize the subsequent discussion of how novelists can violate the reader's expectations, thereby delaying or even preventing full resolution of the problems of plot and interpretation.

Discontinuities of Form

Every work of fiction tells a story in which a problem is presented but the solution to that problem is postponed. The very postponement of resolution creates cognitive tension. Participants in the everyday world, when confronted with a problem, generally try to move toward a solution as rapidly as possible. The psychic insulation provided by a novel allows the reader to luxuriate in the tension of postponed solution. Even under these controlled conditions, some people cannot stand the tension and turn to the last page to find how the problem is solved. In middlebrow fiction, the problem is usually neatly set out and neatly resolved. More complex novels heighten the simple tension of postponed resolution by injecting

discontinuities into the way in which the story is told. These discontinuities take four major forms: (1) interruption of expected resolution; (2) character development; (3) narrative ambiguities; and (4) tonal ambiguities.

Although the denouement of a story generally occurs near the end, the author often suggests earlier that a solution is about to be offered but after generating this expectation, pulls back and leaves the reader suspended. Peckham refers to these interrrupted solutions as "implicit discontinuities," for it is an implicit pattern in human behavior to try to resolve problems.[27] All three novels demonstrate discontinuities of this sort.

In many respects *Germinal* is the most straightforward of the three works, and the implicit discontinuities of interrupted solution are the most conventional. A good example concerns the relationship between Étienne Lantier and Catherine Maheu. From the beginning of the novel, Zola suggests that these two are the novel's "love pair." Yet he continually frustrates their relationship. On the first day they meet deep in the mine, Étienne resolves to kiss her, but he is interrupted by her presumptive lover, Chaval, who brutally and possessively kisses her (p. 49). Later, Étienne moves in with the Maheus as a boarder, and though sleeping in the same room, the mutually attracted pair again fail to consummate their desire: "He did not go to take her, and she did not turn around for fear of calling him. The more they lived side by side, the more a barrier was raised of shame, repugnancies, delicacies of friendship, which they could not explain even to themselves" (p. 163). Only at the end, huddled in the darkness of a collapsed mine shaft, with the rising subterranean waters lapping at their feet, do they finally make love (p. 468). And then she dies.

The primary relationship in *Guerrillas* is a triangular one among Roche, a white liberal South African hired by a neocolonialist firm to do public-relations work among the natives of a newly independent Caribbean island; Jane, his rather shallow mistress; and Jimmy Ahmed, a posturing, self-styled radical leader. Ultimately, the violence that has been brooding at the fringes of the novel breaks through as Jimmy and an erstwhile follower murder Jane. When Roche happens on the scene a short time later, he quickly deduces that "this place has become a slaughterground," and turns to leave (p. 244). The expectation for further violence, however, is not met. Roche not only escapes from Jimmy's "commune" unharmed, but he also leaves the island altogether, creating both a discontinuity of plot and changing the meaning of the murder.

The discontinuities of interrupted solution are most complex in *Absalom, Absalom!* Faulkner uses several narrators to relate the story of Thomas Sutpen. The basic outline of the plot is presented quite early, but as various parts are told and retold from different points of view the story changes and develops, as previously established explanations are revised or abandoned. Ultimately, the reader begins to realize that he has no sure way

of knowing just what happened and why. The problem of plot is never fully resolved nor even completely defined. A major instance of this repeatedly deferred resolution involves Quentin's nighttime journey to Sutpen's plantation forty years after Sutpen's murder. The fact that the journey took place and that it revealed something of importance is suggested early in the novel and repeated several times. Only near the close of the work, though, does Quentin recall how he discovered Sutpen's aging son, Henry, who had come home to the decaying mansion to die (p. 373). Moreover, Quentin could only have learned certain facts from this meeting with Henry, but his sketchy recollection of their conversation indicates none of these. As Cleanth Brooks notes, Faulkner seems "either teasingly reticent or, upon reflection, brilliantly skillful" in depicting the facts of the story.[28]

Character development is a second area in which discontinuity in the relation of a story arises.[29] Participants in the everyday world relate to each other on the bases of typifications (categorizations) of one another's behavior. The constructs of social scientists are also typifications, though presumably ones more amenable to verification and revision.[30] One major disorientation in the everyday world occurs when people fail to act according to type. Atypical behavior, then, creates a cognitive problem that must be either ignored or resolved. Fortunately for psychic well-being, people in a stable society basically behave according to type, at least in limited situations in which they relate.

The novelist also creates behavioral types in his fictional characters. In low- and middlebrow fiction, characters, once defined, seldom vary. James Bond always acts like James Bond. He is a "flat" or one-dimensional type. In fiction written for the higher cultural levels, at least the central characters develop, take on new dimensions, become "round" and hence unpredictable. Well-rounded characters "are deeply attractive, or repulsive, because they exhibit a range and discontinuity of behavior which, in our daring moments, but rarely in public, we would like for ourselves."[31]

One purpose of the story line of *Germinal* is to portray the development of its central character, Étienne Lantier. On the first page, he is simply referred to as "the man" (p. 9); soon, he is given a name (p. 10), and then, layer by layer, his character is defined and ramified. Like most well-rounded characters, Étienne is flawed — by jealousy, a hot temper, and posturing ambition — even though his presentation is basically sympathetic. As the story unwinds, he moves from being an outsider in the mining community to leadership of the strike, a fairly predictable line of development. Not so predictable are his fall from grace as he loses control of the forces he helped release, his murder of Chaval, and his near-entombment in a mine — experiences which purge him and change his character once again.

The three protagonists of *Guerrillas* are not drawn in as vivid detail as

Étienne, but they do take on fuller dimensionality as the story unfolds. Unlike Étienne, however, they do not exactly change, learn, and grow; rather, the author reveals more and more of what they already *are*. Who they are, and how they are going to affect each other, constitutes the primary problem of plot — a problem resolved through character revelation. The rape and murder with which the novel culminates, as well as Roche's failure to act, are surprising in their violence, but, upon reflection, complete the depiction of characters defined largely in terms of one another.

Faulkner develops the character of Thomas Sutpen in yet another way. At the time the novel "takes place," Sutpen has been dead for over forty years. Whoever he was, he is not going to change as Étienne does. Rather, what he was is gradually revealed through the efforts of a number of narrators to grapple with his memory. Initially, in the view of Rosa Coldfield, his embittered sister-in-law, he was "this demon" (p. 9). Gradually, through multiple retellings, the demon takes on flesh and becomes a powerful, willful, ambitious, and flawed man who wrenches a hundred-square-mile plantation from the wilderness as a basis for a familial dynasty, but then destroys it, perhaps because of his inability to treat people, even members of his own family, as anything more than objects to be manipulated for the achievement of his design. Faulkner noted a number of years later that none of the narrators has sufficient stature, wisdom, or sensitivity to see Sutpen "all at once." Their partial perspectives are like

> thirteen ways of looking at a blackbird. But the truth, I would like to think, comes out, that when the reader has read all these thirteen different ways of looking at the blackbird, the reader has his own fourteenth image of that blackbird which I would like to think is the truth.[32]

The character of Sutpen continues to reverberate after the conclusion of the story, and Faulkner leaves it to the reader to complete its development.

The story line and character development both serve to emphasize that fiction is a "time art," in contrast with the "space arts" of painting and sculpture.[33] More significantly, the stance adopted by the reader is essentially prospective in orientation, that is, looking forward to action to be completed in the future.[34] Even in *Absalom, Absalom!,* where the related events have all occurred in the past, the experience remains essentially prospective. In this sense, the orientation in reading fiction is analogous to that of the participant in ongoing social action, which, insofar as it is purposive, also looks forward to a goal.

Social-scientific analysis, in contrast, is by necessity retrospective, looking back upon already-completed acts. The retrospective perspective

of the social sciences (as well as that of those who, in the everyday world, step outside the flow of experience and reflect upon their already completed actions) is tied to conceptions of causality, predictability, and order. The prospective nature of the life experience accounts for feelings of volition in human activities and for the experience of discontinuity when reality fails to accommodate itself to the projection. This similar orientation to time is one of the reasons why the experience of plot and character discontinuities in fiction can be a rehearsal for the tensions and ambiguities of projection failure in everyday life.

In addition to the interruption of plot resolution and character development, the literary artist can also inject ambiguities into the narration of the story itself.[35] Questions of narrative technique cannot be neatly resolved into the simple distinction between first and third person narration; rather, they involve complex relations between the narrator and the author, the audience, and the other characters.[36]

The author can be more or less distanced from the narration of a story. At times, the narrator may express views clearly contrary to those of the author. At the other extreme, the author might directly inject himself into the narrative stream to comment on the action and characters. This type of direct authorial comment can be a clever device for creating discontinuity in the narrative flow. The author must also decide upon the degree of self-consciousness possessed by the narrator (does he "know" he is telling a story?), the mix of scene versus summary (how much of the story is to be shown to the readers as it unfolds, and how much is to be simply summarily related?), and the extent of narrator reliability. The author can use all these decisions to add still further discontinuities to the narration of a novel. Finally, the narrator can be more or less removed from the other characters and action. Perhaps the most significant decision here regards the degree of privilege given to the narrator:

> Observers and narrator-agents, whether self-conscious or not, reliable or not, commenting or silent, isolated or supported, can be either privileged to know what could not be learned by strictly natural means or limited to realistic vision and inference. Complete privilege is what we usually call omniscience.[37]

Shifting from one narrative technique to another and playing upon the ambiguities inherent in an unreliable narrator are common ways of using the narration of a story to disrupt the reader's expectations. *Germinal* draws upon neither of these, consistently using the omniscient narrator. This technique, though presenting little to disorient the reader, does provide privileged access to the subjective states of mind and emotion of the various characters. When skillfully done, as it generally is in *Germinal,*

privileged access communicates the facsimile of feelings denied to the social sciences, and for the most part to common-sense knowledge as well. In this way literature can, in a sense, transmit what is "nontransmissible" given the methodological strictures of social science.[38]

The other two novels make more extensive use of narrative discontinuities. The narration of *Guerrillas* shifts back and forth from a fairly conventional third-person omniscient narrator to the first-person narration of Jimmy Ahmed's journal and letters. To complicate the narration further, Jimmy writes in his journal a story in which he imagines a meeting between Clarissa (Jane) and himself as told from her point of view. The narrator of the journal and letters is clearly unreliable, yet he serves as a counterpoint to the dominant third-person narration and forcefully reveals Jimmy's posturings and his somewhat pathetic dreams. Another narrative discontinuity is injected when Roche is interviewed on a local radio show (or is he being interrrogated? — the situation is unclear) and is questioned about his motives and values. His efforts to cope with these questions are again not wholly reliable, but still revealing.

The narration of *Absalom, Absalom!* contains the most jarring discontinuities. There are a number of first person narrators — Rosa Colfield, Quentin Compson, his father Mr. Compson, and Shreve McCannon — all of whom are unreliable, as well as a third person *sotto voce* narrator who strings the story together. To add to the reader's disorientation, the first-person narrators are, for the most part, trying to reconstruct events that happened forty or more years in the past, rather than relating experiences that happened directly to them. The effect is to leave the reader awash in ambiguity, but a kind of ambiguity that closely resembles the sort that afflicts participants in the everyday world and social scientists as they try to grasp "the facts" of already completed acts.

The differences in narrative technique seem to relate to what might be called the internal facticity of the three works. The reader of *Germinal* has few doubts as to what is the case within the novel. Zola, moreover, in shaping the story, drew explicitly on a body of existing fact about nineteenth-century French coal miners and their condition. Thus, the facts of the novel were intended to mirror closely the facts of the real world. The shifting between reliable and unreliable narrators in *Guerrillas,* as well as deliberate ambiguity of place (some unnamed Caribbean island), dilutes somewhat the internal facticity of the work and adds a certain indefiniteness to the links between the work and the external world. In *Absalom, Absalom!,* as might be expected, even the internal facts are obscured. What is the case in the story of Thomas Sutpen is never fully clarified. If even the internal facts of the work are in doubt, it would be tenuous indeed to argue that the novel reflects the real world.

Factual ambiguity, however, can be a source of power in literature, in marked contrast to what pertains in the social sciences. Zola's efforts to strengthen the facticity of *Germinal* tie the novel to a specific time and place. As these become more remote, the novel, for all its power, must inevitably be sapped by a certain anachronism. Naipaul's island, however, becomes a prototype of all Third World countries, and the relationships among the three protagonists begin to echo the essence of "liberal" neocolonialism. Greater specificity of time and place would probably dilute the impact of the novel's "concrete universals." Finally, the efforts of several narrators in *Absalom, Absalom!* to reconstruct and understand the significance of events occurring a generation earlier push the reader toward recognition of how Sutpen's fall transcends the immediate time and place and takes on meaning for the entire American value system, with its peculiar combination of innocence and power.

The literary artist can disrupt expectations in a fourth manner through modulating the tone of the story.[39] Discontinuities of tone can jar the reader and hint that some interpretation may be intended, as well as provide clues as to what the author means. This type of discontinuity is present in all three novels, though again they appear more significant in *Absalom, Absalom!*

Zola is conventionally classed as a naturalist novelist, a categorization that suggests a realistic, expository kind of prose, but hardly prepares one for the opening paragraphs of the story:

> Over the open plain, beneath a starless sky as dark and thick as ink, a man walked alone along the highway from Marchiennes to Montsou, a straight, paved road ten kilometers in length, intersecting the beetroot fields. He could not even see the black soil before him, and only felt the immense flat horizon by the gusts of March wind, squalls as strong as on the sea, and frozen from sweeping leagues of marsh and naked earth. No tree could be seen against the sky, and the road unrolled as straight as a pier in the midst of the blinding spray of darkness (p. 9).

> Suddenly, at a bend in the road, the fires reappeared close to him, though he could not understand how they burnt so high in the dead sky, like smoky moons. But on the level soil another sight had struck him. It was a heavy mass, a low pile of buildings from which rose the silhouette of a factory chimney; occasional gleams appeared from dirty windows, five or six melancholy lanterns were hung outside to frames of blackened wood, which vaguely outlined the profiles of gigantic stages; and from this fantastic apparition, drowned in night and smoke, a single voice arose, the thick, long breathing of a steam escapement that could not be seen (pp. 9–10).

The power of this introduction rests not merely on the vividness of its language, but also in the way it evokes images of the mine as Inferno and

devouring beast — symbols that become reality in the course of the novel. Nor is the fusion of naturalistic and poetic modes the only way Zola creates tonal discontinuities. As Phillip Walker suggests, Zola, the presumed naturalist, fuses traditional styles by creating tragedy out of the materials of a low-life farce, draws on mythopoetic images, and engages in prophecy — none of which appear strictly compatible with "scientific" naturalism.[40]

The primary tonal discontinuities of *Guerrillas* and *Absalom, Absalom!* relate to the shifts in narrative point of view. The fairly flat, denotative style of most of *Guerrillas* is unpredictably interrrupted by the self-indulgent musings of Jimmy Ahmed. Another interesting tonal discontinuity involves Naipaul's description of place. Most readers probably come to the novel with the preformed idea that Caribbean islands are lush and green, whatever the economic status of the people. Yet the island is repeatedly described as blighted with drought: At some earlier time it was green, but now it is a wasteland. This is an example of a tonal discontinuity that cries out for interpretation. It possibly serves as a physical symbol of the bitter disillusionment of the dreams of independence.

Faulkner also varies the tone of his several narrators. Rosa Coldfield's verbal extravagence suggests a Jacobean drama, and Mr. Compson's tone is that of the weary sophistication of *fin de siècle* novels.[41] Shreve's somewhat ironic, detached tone serves to counter Quentin's emotionally charged retelling.[42]

In addition to constantly altering narrative points of view and tone, individual narrators shift from summary to dramatized scene, both of which are efforts to reconstruct the past. The cumulative effect of these discontinuities is to engulf the reader in a fictional equivalent of a fundamental problem of social life: "What is going on here?"

Discontinuities of Meaning

Art, according to Peckham, has no unique semantic function.[43] Although the artist may have nothing special to say, it does not follow that his meanings are always clear. On the contrary, the artist can inject discontinuities of meaning into his work, reinforcing the cognitive tension of the art perceiver. If discontinuities of the form in which the story is told raise questions like "what is going on here?," discontinuities of meaning generate a second problem analogous to one in the social world: "What is the meaning of all this?"

Problems of form and meaning are, as noted previously, intertwined; for if we cannot establish the "facts" of a situation, whether real or fictional, interpretation will hardly be possible. Knowledge of the facts, however, is no guarantee that the appropriate meaning will be assessed. Indeed, the literary artist often injects discontinuities apart from those of form, in

order to frustrate efforts at interpretation. The primary means of interrupting interpretative expectations are through (1) delayed meaning; (2) withheld meaning; and (3) value ambiguity and subversion.

Discontinuities of delayed meaning are common to almost all fiction and are most closely linked to various discontinuities of form. A story generally presents a problem and then proceeds to resolve it. As the plot evolves, information is progressively provided to solve the problem and to interpret its meaning. Mystery fiction neatly illustrates this progress: a murder takes place, and a number of suspects with a variety of motives are discovered (problems of fact and meaning); clues are gradually revealed, until the murderer is identified and his motive clarified (resolution of the problems of fact and meaning). The delayed presentation of fact necessarily delays the interpretation of meaning.

The problems presented in these three novels are rather more complicated than those devised by Dame Agatha, and as indicated previously, the presentation of sufficient facts to interpret the meanings proceeds in a discontinuous manner, especially in *Absalom, Absalom!*. In each case, the meaning pivots around an act of violence: the miner's strike in *Germinal,* Jimmy Ahmed's murder of Jane in *Guerrillas*, and Henry Sutpen's murder of his sister's suitor, Charles Bon, in *Absalom, Absalom!*. Unlike the violence in a conventional mystery, the violence does not occur at the beginning. The strike in *Germinal* constitutes the great center of the novel. Parts I – III lay the groundwork, and Part VII describes the bitter aftermath. In *Guerrillas,* the entire novel creates the setting for the acts of violence of the last few pages. The violence of *Absalom, Absalom!* takes place several decades before the novel begins, and the characters grope to reconstruct both the events and their meaning throughout the entire length of the work. Yet even when the novels are completed and the authors have presented all the facts they intend to, the meaning of each act of violence is still not entirely clear. This continued opaqueness results from other discontinuities of meaning.

Mysteries are usually nicely resolved at the end ("And that is why Lindsey killed Lord Heyward.") Writers of more complex fiction, however, often deliberately withhold their meaning, thereby forcing the reader into a kind of "imaginative cooperation" in order to complete the interpretation. Thomas Pollock argues that the experience evoked by a work "will be more vivid and more memorable if the writer permits it to develop of itself than if it is definitely completed by the writer's word."[44] What he fails to note is that being confronted with the necessity of completing the meaning is likely to provoke a degree of tension in the reader as well. Only if the reader accepts the challenge, rather than fleeing to more accessible works, will he undergo the more vivid experience.

Every story that fails to state an explicit moral probably withholds some meaning, but the ambiguity can be more or less murky. Zola comes the closest of the three artists to stating his meaning in the prophetic conclusion of *Germinal:*

> And beneath his feet, the deep blows, those obstinate blows of the pick, continued. The mates were all there; he heard them following him at every stride. . . . Now the April sun, in the open sky, was shining in his glory, and warming the pregnant earth. From its fertile flanks life was leaping out, buds were bursting into green leaves, and the fields were quivering with the growth of the grass. On every side seeds were swelling, stretching out, cracking the plain, filled by the need of heat and light. An overflow of sap was mixed with whispering voices, the sound of the germs expanding in a great kiss. Again and again, more and more distinctly, as though they were approaching the soil, the mates were hammering, In the heated rays of the sun on this youthful morning the country seemed full of that sound. Men were springing forth, a black avenging army, germinating slowly in the furrows, growing towards the harvests of the next century, and their germination would soon overturn the earth (p. 480).

In marked contrast to the explicit nature of the preceeding passage, Naipaul significantly concludes *Guerrillas* with a question. Roche has decided to leave the island without reporting Jane's murder. He tells Jimmy over the phone:

> "And you shouldn't think of coming here. It isn't safe for you to be out these days, Jimmy. You know that. There are police road blocks everywhere. There's one on the Ridge road. I think you will find that they will be particularly interested in you. Do you understand? I'm leaving you alone. That's the way it's going to be. We are leaving you alone. I am leaving. I am going away. Jane and I are leaving tomorrow. Jane is in her room packing. We are leaving you here. Are you hearing me? Jimmy?"
>
> "Massa" (p. 248).

Another suggestion at withheld meaning is contained in Jimmy's reply, "Massa." Throughout the novel he ironically addresses Roche in this fashion. This final use has been drained of sarcasm and suggests Jimmy's recognition of his condition of "bonded indebtedness" to Roche.

William Faulkner is a master of withheld meaning. Interestingly, *Absalom, Absalom!,* like *Guerrillas,* ends on a question. Shreve and Quentin have spent a cold evening grappling with the story of Sutpen. Finally Shreve asks:

> "Now I want you to tell me just one thing more. Why do you hate the South?"
> "I don't hate it," Quentin said, quickly, at once, immediately: "I don't hate it,"

he said. *I dont hate it,* he thought, panting in the cold air, the iron New England dark; *I dont. I dont! I dont hate it! I dont hate it!"* (p. 378).

The core of Faulkner's artistry of withheld meaning is centered in the technique of repetition, in which each return reveals more but never quite enough to solve the problem. John Irwin observes that this kind of continual reworking

> produces a story that almost makes sense but not quite, yet whose quality of *almost* being meaningful seems to indicate, seems to promise, that meaning has only been temporarily deferred and that some future repetition of the story, some further recollection and reworking, will capture that ultimate meaning.[45]

A final discontinuity of meaning can arise from the ambiguous values expressed by a novel, ambiguity that may ultimately serve to undermine the value assumptions brought by the reader to the work. One commonplace of sociological criticism is that the novel is a bourgeois art form and, therefore, reflects middle class values. In some general sense this may be true, but it appears a rather dubious enterprise to attempt to deduce any specific value orientations from this proposition. As some of the more perceptive sociologists of literature have observed, the artist often exists in a dialectical relationship with the dominant value system — neither slavishly mirroring it nor completely independent of it.[46] Additionally, the values held by the people who make up a "society" seldom, if ever, constitute a thoroughly homogeneous, consistent, normative system. Even where one can usefully speak of a dominant or prevailing set of values, this does not mean that the dominant set is completely consistent, or that values counter to it do not exist.[47]

Artists, including novelists, actually have a rather diverse array of values and norms on which to draw. They can present, if they choose, a completely unambiguous moral stance in an effort to uplift the reader. At the higher cultural levels, however, their value positions tend to be more complicated, either through dramatizing moral dilemmas or by directly countering the prevailing norms in society. Even in the Soviet Union, where an ideological elite attempts to dictate the values reflected in art, many dissident artists still import ambiguities or even "subversive" values into their work.

The most morally accessible of the three novels is not free from such deliberate ambiguities. Certainly Zola meant for the reader's sympathy to be with the miners, yet his portrayal of them is not a romantic, proletarian apologia. The novel contains many episodes of their brutishness and irrationality, alongside depictions of their perseverance, sacrifice, and primitive nobility. Étienne Lantier, the major protagonist, is not some

bronzed proletarian hero, but an attractive, though flawed, young man whose ambition and inexperience contribute to the strike's failure. Nor are the representatives of the middle and managerial classes shown as unfeeling demons; their characters, too, are drawn sympathetically.

Guerrillas masterfully undercuts the prevailing romanticism surrounding Third World liberation struggles. By reducing guerrilla war to the relations among three people, Naipaul reminds the reader of the personal, often petty, hopes, fears, and frailities that necessarily must inform all human enterprises. *Guerillas,* though, is not a shallow, cynical derogation of cardboard characters. Rather, as Paul Theroux notes, "This is a novel without a villain, and there is not a character for whom the reader does not at some point feel deep sympathy and keen understanding, no matter how villainous or futile he may seem."[48]

Finally, the tragic vision of *Absalom, Absalom!* prods the reader into the recognition of moral ambiguity. The novel does not incarnate a clash between absolute good and evil; rather, it becomes a tragedy because there are no clear moral decisions, no absolutes to dictate appropriate courses of action.

Facile morals have been read into the work, as well into as Faulkner's other fiction. Sutpen's fall is not a clear symbol of the sin of slavery ultimately dooming the masters. If anything, Sutpen deals with his slaves more as equals than do his fellow slaveholders, and after the war he refuses to join a Klan-like organization, earning the enmity of his neighbors. Nor does Sutpen's failure seem to stand for the decline of the Old South, for he is a precursor of the "New South" of material aggrandizement and exploitation of the land. Faulkner, though, is not simply espousing some idylic notion of the sanctity of the wilderness. Rather, as Cleanth Brooks notes:

> It is man's fate to struggle against nature; yet it is wisdom to learn that the fight cannot finally be won, and that the contest has to be conducted with love and humility and in accordance with a code of honor. Man realizes himself in the struggle; but the ultimate to be gained in the struggle is wisdom. Sutpen never really acquires wisdom, for he never loses his innocence.[49]

Even this interpretation of the novel's meaning cannot be unequivocally embraced, for the major internal evidence supporting it comes from an unreliable narrator, Mr. Compson.

V. Conclusion:

People generally use fiction to escape from the polysemy of the everyday world, to indulge their fantasies free from the responsibility of action.

Works such as these three, and especially *Absalom, Absalom!,* however, plunge the reader into cognitive tension arising from the deliberate frustration of expectations about "fact" and meaning. For this reason, many readers tend to respond to such novels with irritation ("Why can't the author say what he means?") and choose to avoid them in favor of more pleasurable and relaxing entertainments. This choice, however necessary for psychological recuperation, does little to enhance understanding of the social world.

If we desire clarity of fact about social life, then perhaps we should turn to social science; if we wish clarity of meaning, then the systematic musings of social philosophers may be helpful. The clarity of science and philosophy, though, is gained only by obscuring the chaos and categorical instability that haunt participants in the everyday world. A full understanding of any happening that undermines categorical stability would seem to require either that such an experience be directly apprehended or that some functional equivalent be found for direct apprehension.

Many daily activities reflect "stable, valued recurring patterns of behavior," supportive of the categories of both participant and observer.[50] The intrusion of social violence necessarily disrupts these categories, and both the observer and the participant usually rush to reimpose order upon their perceived worlds — to reestablish fact and reassign meaning. In this rush for order, the experience of discontinuity is minimized. In order to fully understand the impact of social violence, we need to experience the ambiguities of the unanticipated. Direct personal experience with social violence, however, is seldom possible and certainly not desirable.

The literary artist who chooses to deal with themes of violence can infuse his works with discontinuities of form and meaning, capable of generating feelings of cognitive tension equivalent to those felt by real-world participants who suffer categorical collapse. Through the writer's art, those who study the problem of violence can gain some idea of what it means to its victims. The experience of a work of art is not so much a mirror of reality but an analogue for it. Artistic vision is not a substitute for social science and philosophy, but a complement to them. Whereas science and philosophy impose the order of knowledge, the artist gives us the wisdom that comes with the recognition of chaos.

Notes

* I would like to thank Dr. Nancy B. Sederberg for her bibliographic, interpretative, and editorial assistance with this essay.
1. In conceptualizing the perspective in this essay, I was influenced by M. H. Abrams, *The Mirror and the Lamp: Romantic Theory and The Critical Tradition* (New York: Oxford University Press, 1953).

2. See, for example, Elizabeth and Tom Burns, eds. *Sociology of Literature and Drama* (Baltimore: Penguin, 1973); Diana Laurenson and Alan Stigwood, *The Sociology of Literature* (London: MacGibbon and Kee, 1971): Joan Rockwell, *Fact in Fiction: The Use of Literature in the Systematic Study of Society* (London: Routledge and Kegan Paul, 1974). For a comprehensive sociological interpretation of the arts see Pitirim Sorokin, *Social and Cultural Dynamics* (Boston: Porter Sargent, 1957), Part II.
3. See Alex Gottfried and Sue Davidson, "Utopia's Children: An Interpretation of Three Political Novels," *Western Political Quarterly,* 15 (March 1962), p. 19.
4. Albert Hofstadter, *Truth and Art* (New York: Columbia University Press, 1965), p. 211.
5. This common distinction is extensively discussed in Thomas Clark Pollock, *The Nature of Literature: Its Relation to Science, Language and Human Experience* (Princeton: Princeton University Press, 1942), Chapters V–IX.
6. This definition of order is adapted from Chalmers Johnson, *Revolutionary Change* (Boston: Little, Brown and Co. 1966), p. 8.
7. The following discussion of categorization is based on Morse Peckham, "Order and Disorder in Fiction," in *The Triumph of Romanticism: Collected Essays* (Columbia: University of South Carolina Press, 1970), pp. 290–317.
8. Ibid., p. 294.
9. Ibid., p. 295.
10. Ibid.
11. In addition to the previously cited essay, see also "Art and Disorder," in *The Triumph of Romanticism,* pp. 225–80 and, especially, Morse Peckham, *Man's Rage for Chaos: Biology, Behavior and the Arts* (New York: Schocken, 1967).
12. Peckham, *Man's Rage for Chaos,* p. 41.
13. Ibid., pp. 217–22.
14. Ibid., pp. 65, 81–82.
15. Norman N. Holland, *The Dynamics of Literary Response* (New York: Oxford University Press, 1968), pp. 72, 75.
16. Peckham, *Man's Rage for Chaos,* pp. 66–67.
17. Ibid., p. 314.
18. Holland, *The Dynamics,* p. 62.
19. Ted Robert Gurr, *Why Men Rebel* (Princeton: Princeton University Press, 1971), p. 234.
20. Pollock, *The Nature of Literature,* p. 94.
21. Richard C. Snyder, "Editor's Foreword" to Joseph L. Blotner, *The Political Novel* (Garden City: Doubleday, 1955), p. viii.
22. W. K. Wimsatt, Jr., *The Verbal Icon: Studies in the Meanings of Poetry* (New York: Noonday Press, 1958), pp. 69–83.
23. Morse Peckham, "Literary Interpretation as Conventionalized Verbal Behavior," in *The Triumph of Romanticism,* pp. 356–57.
24. The following editions were used: William Faulkner, *Absalom, Absalom!* (New York: Vintage, 1972); V.S. Naipaul, *Guerillas* (New York: Alfred A. Knopf, 1976); Emile Zola, *Germinal,* trans. Havelock Ellis (New York: Doubleday/Dolphin, 1961). All page references in the text refer to these editions.
25. Cleanth Brooks, *William Faulkner: The Yoknapatawpha Country* (New Haven: Yale University Press, 1966) p. 295.
26. Peckham, "Order and Disorder in Fiction," p. 311.
27. Ibid., pp. 306–7.

28. Brooks, *William Faulkner*, p. 316.
29. Peckham, "Order and Disorder in Fiction," pp. 311–12.
30. Peter C. Sederberg, "Subjectivity and Typification: A Note on Method in the Social Sciences," *Philosophy of the Social Sciences* (June, 1972), pp. 167–76.
31. Peckham, "Order and Disorder in Fiction," p. 314.
32. Frederick L. Gwynn and Joseph L. Blotner, eds., *Faulkner in the University* (New York: Vintage, 1965), p. 274.
33. Rene Wellek and Austin Warren, *Theory of Literature* (New York: Harcourt, Brace and World, 1956), p. 215.
34. For an extended discussion of retrospective and prospective stance see Gibson Winter, *Elements of a Social Ethic: Scientific and Ethical Perspective on Social Process* (New York: Macmillan, 1966), chapter 5.
35. Morse Peckham, "Discontinuity in Fiction: Persona, Narrator, Scribe," *The Triumph of Romanticism,* pp. 318–40.
36. See Peter C. Sederberg, "Transmitting the Nontransmissible: The Function of Literature in the Pursuit of Social Knowledge," in *Philosophy and Phenomenological Research,* (December, 1975), especially p. 182–186. See also Wayne C. Booth, *The Rhetoric of Fiction* (Chicago: University of Chicago Press, 1970).
37. Booth, *The Rhetoric of Fiction,* p. 160.
38. Sederberg, "Transmitting the Nontransmissible," passim.
39. Peckham, "Order and Disorder in Fiction," pp. 314–16.
40. Philip D. Walker, *Emile Zola* (New York: Humanities Press, 1968).
41. Michael Millgate, *The Achievement of William Faulkner* (New York: Vintage, 1971) pp. 153–54.
42. Faulkner later commented that "Shreve was the commentator that held the thing to something of reality. If Quentin had been let alone to tell it, it would have become completely unreal. It had to have a solvent to keep it real, keep it believable, creditable, otherwise it would have vanished into smoke and fury." *Faulkner in the University,* p. 75.
43. Peckham, *Man's Rage for Chaos,* p. 198.
44. Pollock, p. 119.
45. John T. Irwin, *Doubling & Incest/Repetition & Revenge* (Baltimore: Johns Hopkins University Press, 1975), p. 8.
46. Alan Swingewood, *The Novel and Revolution* (New York: Barnes & Noble, 1975), chapter 1.
47. See the discussion of "counterpoint values" in W.F. Wertheim, *Evolution and Revolution: The Rising Waves of Emancipation* (Baltimore: Penguin, 1974), pp. 105–10.
48. Paul Theroux, Review of *Guerillas, New York Times Book Review,* December 28, 1975, pp. 1–2.
49. Brooks, p. 308.
50. Cf. the definition of institution in Samuel P. Huntington, "Political Development and Political Decay," *World Politics,* 17 (Fall 1965), pp. 386–430.

Chapter Fourteen

Frank Capra: Politics and Film*

Morris Dickstein

So much of popular culture smacks of the assembly line that traditional critics felt they could simply dismiss it as mass-produced commodity rather than art. When they noticed it at all they tended to treat it only as cultural symptom — as evidence of mass opinion or of the decline of taste — never as a vehicle of personal expression, which was reserved for high art alone. Such critics were raised in a literary culture that venerated individual genius and on a modernist aesthetic that put a premium on difficulty, self-consciousness, and open-endedness. They could recognize few of these qualities in popular culture and mass art, which achieved ease of access through formula, sentiment, and simplification. They blinded themselves to the seriousness, sophistication, and even self-irony that can sometimes be found in popular art; for this they were punished by giving birth to a tribe of mutants who saw these qualities *everywhere* in the cultural supermarket.

This new generation of hip kids and grown-up media specialists was brought up in a pervasive electronic environment that bore little resemblance to the old cultural hierarchy dominated by literature. Yet many of the newcomers caught their elders' trick of using criticism as a way of giving intellectual validity to elemental pleasures and private intuitions. Thus was born the professional study of popular culture. Soon the New Criticism (with its techniques of minute analysis), left for dead in the field of literary studies, raised its head to search out irony and ambiguity in rock lyrics; and the new semiology (which couldn't distinguish between art and gesture, which was more comfortable with magazine ads than with *War and Peace*) found sermons in stones, subtle signals in movie images, and meaning everywhere. To one generation popular art was all commerce and hype; to the next generation it was a forest of signs, a thicket of prickly pleasures. The derisive snobbery of one group gave way to the heavy-breathing

317

solemnity of the next, but the slippery artifacts of popular culture still eluded the critics' grasp. The study of popular art became a growth industry and achieved academic respectability without ever determining what its subject really was.

If the glossy art of the 1960s and 1970s was difficult for conservative critics to accept, the art of the 1930s presented stiff barriers of a different kind. Politics is a nuisance to critics oriented towards aesthetics, and the 1930s were a period of social crisis and political urgency. The Communist party, which had considerable influence among artists and intellectuals, intermittently tried to get them to toe the official line. The 1930s were also a period of relative aesthetic innocence, which just preceded the first real impact of European modernism on American culture. Advanced writers like Faulkner and Henry Roth (in *Call It Sleep*) showed the influence of Joyce, but the gap between high culture and popular culture was far greater than it is today. Popular entertainment is still often escapist, but in the 1930s people felt they had more to get away from. The silken elegance of the Astaire-Rogers films and the fantastical high life of the screwball comedies belong firmly to a period in which poverty was a pressing and daily concern. Though some movie studios, especially Warner Brothers, specialized in low-budget social dramas, Hollywood, by and large, was never more a dream factory than it was in the 1930s.

But the literary culture of the period produced simplifications and fantasies of its own. There were few writers who didn't feel pressed to confront the social dislocations of the age, whether or not they had much to say about them. A patina of Marxism settled lightly on even the least political of temperaments, and this vaguely left-thinking aura, with its ideological platitudes and literary shortcuts, drew the ire of younger critics schooled in the complexities (as well as the implicit politics) of modernism.

My own view is that the naturalistic writers of the thirties, who subsequently fell from fashion, have taken a bum rap. The best writers offered genuine social dissections rather than simple ideological analyses; they portrayed the texture of life without trying to solve life's problems. I don't know whether time and taste can revive the so-called proletarian novelists, whose programmatic fictions were the first to seem thin and dated, but posterity certainly will give a new hearing to Farrell, Dos Passos, John O'Hara, even Steinbeck, as it has already resurrected Dreiser and Richard Wright. We still tend to prefer the writers who were neglected then, such as Henry Roth and Nathanael West, without noticing how much they, like Faulkner, were rooted more in naturalism than in the modern European novel.

My main subject here, however, is drawn from the popular culture of the 1930s; it is the social films of Frank Capra — great popular successes that

(as he tells us repeatedly in his 1971 autobiography, *The Name Above the Title*) were frequently ridiculed by critics and intellectuals for their "Capracorn" and sentimental simplicity. Only in recent years have they begun to receive close attention as rare examples of the American political cinema. But even now influential film critics like Andrew Sarris, Raymond Durgnat, and Gerald Mast still denigrate Capra's work. Capra is a good test case for the seriousness of popular culture, as well as the often unnoticed ambiguities of the political culture of the thirties. He was a deliberate *auteur*, who insisted on taking responsibility for every aspect of a film's creation ("one man, one film"). But he was also a Hollywood insider who prided himself on his instinct for the popular mind, who never questioned the iron judgment of the box office as the arbiter of success and failure. It would be hard to find a more typical figure in the Hollywood of the thirties. Unlike Fritz Lang and other closet expressionists, who found cinematic realism and studio control a straitjacket, Capra achieved his effects within the Hollywood conventions of lifelike storytelling he helped to perfect. As soon as he could afford to, he worked strictly with stars, or made stars of those he worked with, and he loved the dialogue of his collaborator, Robert Riskin because it made these improbable creatures sound so natural.

He was not a European sophisticate, like Ernst Lubitsch, who brought a touch of class to all his projects, or a temperamental aesthete like Sternberg, who loved plastic visual effects and loathed all verisimilitude, or an obsessed and self-destructive perfectionist like Stroheim, or a witty cynic like Preston Sturges, Billy Wilder, or Joseph Mankiewicz, who all came to directing from screenwriting and tended to overload clever dialogue onto meager characters and situations, in part because they were ambivalent towards their audience. On the surface Capra's work shows no such wavering in its zest for the people who buy the tickets; in his habitual eulogy of the common man, the ordinary American Joe, Capra shows himself to be a populist by temperament and conviction, not out of commercial calculation. Yet in his autobiography he crows over his box-office triumphs and Academy Awards in a style that has all the literary grace and zing of *Variety*.

The other directors I have mentioned are touched by "art" in a way Capra is not, though this does not make them better artists. Capra's sensibility, by contrast, is as popular as Chaplin's, and in touch with some of the same childlike feelings. Both grew up, like Dickens, with keen memories of poverty and social embarrassment. Both knew where they came from — the East End of London, an Italian immigrant family in Los Angeles — and, despite extraordinary wealth and acclaim, never ceased to look at society from the ground up, as outsiders. Both directors have been

derided (again like Dickens) for their pathos and sentimentality; both have the common touch.

Chaplin's genius is in his face, Capra's in his actors' faces. No director uses that great galaxy of 1930s character actors, with their chiseled features and piercing radio voices, to better effect than Capra. Graham Greene, one of Capra's first and most discriminating critics, saluted his "delight — equal to that of the great Russians — in the ordinary human face." Capra's care in casting was a byword. He delayed filming *Mr. Deeds Goes to Town* for months, at great cost, to get Gary Cooper for the lead. Character actors like Guy Kibbee, bald and weak-kneed, and Eugene Pallette, the "Human Bullfrog," achieved their apotheosis in his films, and the images of star performers like James Stewart, Jean Arthur, Gary Cooper, Clark Gable, Claudette Colbert, and Barbara Stanwyck were molded under his direction.

An unfriendly critic might say that this epitomizes the simpleminded view of character endemic to Hollywood and to popular culture, by which actors become personalities and develop recognizable images without learning to immerse themselves in difficult dramatic roles. He might add that Capra's politics were also two-dimensional, "simplistic and shallow," as Leonard Quart says, and always the victim of the Hollywood cult of the happy ending. "In Capra's world," Quart writes, "there would be no enduring conflicts — harmony, no matter how contrived and specious, would ultimately triumph in the last frame. . . . In true Hollywood fashion, no Capra film would ever suggest that social change was a complex, painful act. For Capra, there could be pain and loss, but no enduring sense of tragedy would be allowed to intrude on his fabulist world." In the same vein, the film historian Richard Griffith talked of the "fantasy of good will" in Capra's films, their supposed reliance on sentimental conversion to resolve all deep conflicts. The same criticism has frequently been levelled at popular culture in general. Even an intelligent defender like John Cawelti, in his book *Adventure, Mystery and Romance,* concedes that popular culture is rooted in escapism and wish-fulfillment, in "fantasies of a world more exciting, more fulfilling, or more benevolent than the one we inhabit."

The implication of these criticisms is that popular culture aspires to — and falls short of — the realistic subtleties of, say, the nineteenth-century novel. This would seem to be confirmed by the conservative plotting and characterization, as well as the general insistence on credibility and realism, of most American films before the 1960s. But in fact most Hollywood films are unstable mixtures of genre formulas, repeated from other films, and realistic elements designed to make them seem believable and even unique. (As Robert Warshow said of westerns, "we do not want to see the same

movie over and over again, only the same form.") Filmmakers like Capra and John Ford, who rework certain patterns repeatedly with only minor variations, are especially clear in their aspiration towards myth and fable rather than literal verisimilitude. ("The proper function of realism in the Western movie," according to Warshow, "can only be to deepen the lines of that pattern.") This is one reason why the myth-making apparatus of the star system, along with a stock company of secondary actors, is so congenial to them. It gives them performers who precisely do not submerge themselves in their parts, who instead come trailing clouds of association which are the residue of other parts, and whose "acting" has the bold simplicity of an icon rather than the literal detail of a photograph.

It's easy to see the mythical qualities of Chaplin's tramp or John Ford's West, for both have a timeless and emblematic quality that distances them from ordinary poverty or the historical frontier; both are allegorical ideas hatched in the minds of their creators. The same can be said of Capra's Hallmark version of small-town America, though it tries much harder to seem lifelike and real. Hollywood's fascination with the stellar and the exotic has always been qualified by its counterobsession with the quotidian and the ordinary — the average American family in the average American town. Frank Capra's common touch and his vivid imagery did a great deal to form this traditional picture, which by the 1950s could be described by Robert Warshow in the following terms:

> The film [a cold war movie by Leo McCarey] opens on a "typical" American town of the kind that certain Hollywood directors could probably construct with their eyes shut: a still, tree-lined street, undistinguished frame houses surrounded by modest areas of grass, a few automobiles. For certain purposes, it is assumed that all "real" Americans live in towns like this, and, so great is the power of myth, even the born city-dweller is likely to believe vaguely that he too lives on this shady pleasant street, or comes from it, or is going toward it.

By the time of the 1950s this provincial myth of a truly native America, free of foreign influence and ethnic or urban corruption, had assumed a clear ideological purpose; by then the myth was as threadbare as the studio sets on which it had been so frequently played out. But in the 1930s and 1940s, when Capra helped create it, this vision still had the warm glow of a remembered world that belonged to a timeless, idealized past, very much like that of the western. (When Ford began filming westerns during World War I, the veterans of the actual frontier were still around, and sometimes even worked on the movies themselves.) What Andrew Sarris calls "the cinema of memory," which, for all its authentic touches, is really a cinema of myth or idealized memory, casts its radiance not only on Ford's

Monument Valley but on the magical small towns of Welles' *Magnificent Ambersons* (1942), which is about how that old world died, and on Capra's great *It's a Wonderful Life* (1946), where the small-town myth achieved both its apotheosis and its critique.

Apart from this film, which is about a man who, more than anything else, wants to "shake the dust of this crummy town off my feet" but who never manages to get away, very little of Capra's work is actually set in small-town America. His best films, above all the social trilogy of *Mr. Deeds Goes to Town* (1936), *Mr. Smith Goes to Washington* (1939), and *Meet John Doe* (1941), take place, as their titles indicate, in the big city, the enticing Babylon where the important dramas of the modern world inevitably occur. The small town is already an anachronism in these films, an idea; it's where the hero comes from; its values are now embodied in his character, not in any fixed sense of place. This is how Capra brings together the two sides of Hollywood, the mythic and the quotidian, the stellar and the banal. He translated the small town — the idea of an unspoiled America — from a static tintype into flesh and blood, into Gary Cooper or Jimmy Stewart. No greatness attaches to these figures; they are not Odysseus, not Prince Hamlet, nor were they meant to be. Capra's heroes are not exceptional men, but only heightened versions of ordinary good men; they may stumble into heroism, but their myth is the 1930s myth of the common man.

These naive heroes come to a city where sophistication, cynicism, and corruption reign. *Sophistication* is what Capra feebly satirizes in the Algonquin-style wits and opera snobs who think they have found their mark in Mr. Deeds. Like Deeds himself, who writes greeting-card verse and plays the tuba with the hometown band, Capra always felt vulnerable to the ridicule of the café intellectuals and clever culturati. *Corruption* is embodied in various capitalist heavies impersonated with superb bloat and bluster by Edward Arnold: he plays a machine boss, Jim Taylor, in *Mr. Smith,* a Wall Street type in *You Can't Take It With You* (1938), and a media baron and would-be political strongman in *Meet John Doe*. *Cynicism,* in Capra's world, is the special style of fast-talking, wisecracking newspaper reporters, like Jean Arthur and Barbara Stanwyck, tough birds who first take the hero for a ride, only to find themselves undermined by his straightforwardness and simplicity, as he is educated by their worldliness. This twin ordeal, this mutual conversion from experience to innocence and innocence to experience, is the key to Capra's surprisingly ambivalent vision. In this chastening process, which involves much pain and humiliation for his characters, Capra manages to reconcile the cynical and Pollyannaish sides of his own sensibility. The director is able to synthesize country and city styles, emotional and intellectual values, in a way few

critics have recognized and that he himself never acknowledges.

There are really two Capra stories, the one he thought he had to tell — folksy, optimistic, uplifting — which most observers have taken at face value, and the one he actually told, which grew darker and more complicated in each new version. As he himself paraphrases his favorite theme it's a simple David-and-Goliath story, a fairy tale for grown-ups:

> A simple honest man, driven into a corner by predatory sophisticates, can, if he will, reach down into his God-given resources and come up with the necessary handfuls of courage, wit, and love to triumph over his environment.

This message is foreshadowed as early as the three films Capra made in 1926 and 1927 with comedian Harry Langdon, the lucky simpleton whose persona Capra helped create when they both worked for Mack Sennett. Langdon was one of the great silent comics, but scarcely the conscious artist Chaplin, Keaton and even Lloyd were. He played the holy fool, the wise baby — passive, rubbery, flaccid, and asexual where Chaplin and Keaton were always scrappy and resourceful. Whatever else Langdon could be, he could never be a hero, only a lucky survivor — the man who rolls down a hill and lands, magically upright, where his feet should have taken him in the first place. Langdon was Capra's first plebeian protagonist.

For nearly a decade after Langdon this figure of the indestructible innocent largely drops out of Capra's films. The hero and heroine of his great screwball comedy *It Happened One Night* (1934) are both in their way "predatory sophisticates," separated by class, who chasten each other in their battle of wits and wills. Not until the story of that "simple honest man" Longfellow Deeds, as played by Gary Cooper, did Capra find the perfect vehicle for his new gospel, from which he claims never to have strayed. As any fairy-tale character might, Deeds inherits twenty million dollars at the beginning of the film, a matter of remarkably little interest to him except that it forces him to go to the city and deal with his new responsibilities, which include a lot of "moochers" who want a piece of him.

Compared to the squishy Langdon, hardly your macho man, Gary Cooper is rather free with his fists — it's his standard way of cutting through problems; and for a supposed innocent he's surprisingly well equipped with what Hemingway and Mailer call a built-in shit detector. Only in matters of the heart is he vulnerable, a sucker, a "prize chump": where his money is concerned he fends people off so well he doesn't know what to do with it — until, two-thirds of the way through the film, he (and Capra) happen to notice the Depression, which had scarcely intruded into *It Happened One Night*. This sets Deeds off doing good deeds, pursuing a

New Dealish but paternalistic scheme to give away parcels of farm land. Deeds, like Capra, has at last found a purpose serious enough to justify his good fortune.

In Capra's autobiography we have some deceptive clues to how he came to dramatize such a process of conversion. It was something, he claims, he himself had recently experienced. Capra vividly describes the physical and emotional breakdown he suffered after the unexpected success of *It Happened One Night*. Feeling a sort of Catholic remorse and unworthiness about his worldly triumphs — the film won all five major Oscars — Capra falls into a slough of morose self-pity. Unable to work, wracked by psychosomatic ailments, he visits a mysterious figure, some kind of therapist or guru with all the solidity of an apparition, who accuses him of being a coward, "an offense to God," a man squandering his native gifts. After this accusatory confrontation, which became an obligatory scene in later Capra films, the director rouses his courage, shakes off all signs of physical illness, and becomes a man with a purpose, dedicated from that point on to *saying* something, to helping humanity.

All autobiographies require conversion scenes, but this one feels rather exposed without the dramatic context the films provide. Even its upbeat Rotarian message would be more convincing as a new start if we hadn't already witnessed a similar despondency and renewal in Walter Huston years earlier in *American Madness* (1932), and even in Clark Gable in *It Happened One Night*. Every man invents the oracle that would do him the most good, and Capra was more than ready to invent this one before he actually "appeared" in his life. Capra's nameless daemon comes to instill the Power of Positive Thinking, to which his films were already committed, but it would be wrong to put more stress on this message than on the desperate state of mind that calls it into being.

Capra's heroes are innocents, but when the great world they enter refuses to answer to their naive expectations they fall into bouts of serious depression that can be seen as a psychological parallel to the state of society in the 1930s. Walter Huston in *American Madness* has only a brief period of suicidal apathy as his bank is failing (and his wife, he thinks, is cheating on him), but Mr. Deeds sits autistically through an entire trial at which his fortune and his sanity are at stake. A Hollywood-style psychiatrist testifies in comical Viennese that he is a manic-depressive, and therefore incompetent, but Deeds's very evident state of deep withdrawal confirms a good deal of the man's glib diagnosis. Jean Arthur tells him to stand up and say his piece, as she would later tell a weeping Jimmy Stewart in *Mr. Smith* not to be a "quitter." We see Stewart in powerful close-up at the Lincoln Memorial, where he has fled from his humiliation on the floor of the Senate, his face covered with gloom and shadow, his patriotic ideals

shattered. By the time of *Meet John Doe* and *It's a Wonderful Life,* the heroes' impulse to withdrawal and flight has been exacerbated into a will to suicide. In the later film the huge blowups of Stewart's face have become emblems of nightmare, and only a deus ex machina in the person of Clarence, his guardian angel, saves him from doing himself in.

This crisis of depression and self-doubt is the other story Capra has to tell, the unofficial one, which gives his positive message its drama and credibility. Capra's films are fairy tales not in the superficial sense of having unlikely stories and happy endings, but because they develop fundamental narrative archetypes rooted deep in human consciousness. Capra's heroes must undergo a *rite de passage* of trial and frustration before they take their place in society. Innocent and unprotected — "fools with faith," as Jean Arthur calls them — they come from a rural America whose values have been forgotten; the ordeal they pass through, a catharsis of pain and despair, tempers them into a more mature determination, a resolute spirit, and the beginnings of a knowledge of the world.

Literature and legend are full of analogues to Capra's central myth, nowhere more clearly than in Hawthorne's great story "My Kinsman, Major Molineux." The young protagonist, Robin, who is even more anonymous than Capra's plain-man heroes, must leave his family, cross a river from the country to the city, and witness the public humiliation of his kinsman and protector, Major Molineux, whose tar-and-feather ordeal will leave Robin on his own, more ready to grow up. As Lionel Trilling comments in *The Experience of Literature,* "the difficulties which the young man confronts suggest those trials or tests that regularly form part of the initiation rites by which primitive peoples induct the youths of the community into the status of manhood." And because the Major is a British colonial appointee, unseated by a popular insurrection that foreshadows the American Revolution, his disgrace and Robin's new self-dependence suggest the whole country's coming of age.

In Capra's films something has gone wrong with this basic pattern of initiation, which presupposes a legitimate social order worthwhile enough to command our loyalty. Capra's populist politics make the opposite assumption: that American society is corrupt and decadent (though the people are good); that its machinery is meant not to integrate the newcomer and confirm his maturity but — as with Mr. Smith in the Senate — to render him harmless and superfluous, by prolonging his innocence, by debauching him with its own corrupt practices, or simply by crushing his rebelliousness, almost as a human sacrifice. All Capra's films have images of Christianity and Jesus: "I don't want any part of crucifying this boy," says Claude Rains, the Silver Knight of the Senate, once a crusading reformer along with Smith's late father, but now waist-deep in corruption,

his Roman profile a dignified front for the Taylor machine, which controls not only the politics but also the newspapers and radio stations in Smith's home state. "You leave public opinion to me," says Taylor, when Mr. Smith appeals in vain from the floor of the Senate to the people of his state. When newspaper headlines and telegrams come pouring in, all hostile — public opinion has been "Taylor-made," comments one cynical reporter — Jimmy Stewart falls into a pit of despair for the second time, smashed down by a display of monolithic power that makes a charade of the popular will. Only Claude Rains's last-minute change of heart — his attempt at suicide and his own confession and disgrace on the floor of the Senate — saves Stewart from certain defeat.

The ordeal of Capra's heroes becomes ever more extreme as the forces leagued against them become increasingly powerful. Gary Cooper in *Mr. Deeds* needs only to speak to rout his accusers; the spectators, the judges, are all eager for him to rally his spirits. But in *Meet John Doe* Cooper is hooted down by the very people who had idolized him, whose naive faith, once so precious to Capra, now appears gullible and vulnerable, easy to manipulate for the Taylors and Nortons who control the mass media. The sea of umbrellas in the rain and gloom makes the John Doe convention look funereal even before it subjects Cooper to his ritual humiliation. Capra has written in his book of the difficulty he and Riskin had in ending the film — they filmed five separate endings, none of them satisfactory: "Riskin and I had written ourselves into a corner," he says, for no triumph of the individual over the machine seemed possible. The ending we have merely manages to avoid Cooper's suicide, though the film still concludes on an exceptionally somber and qualified note. Cooper has been check-mated once again; his only remaining authentic gesture — his own death — has been taken away from him.

What Capra's autobiography describes as a technical problem — how to end a movie — was actually rooted in a serious shift in his own beliefs as European fascism and world war darkened the international horizon. In all his films Capra is a superb technician and entertainer. While making *American Madness* he learned to give comedy a pace and snap that, along with his gift for pathos and melodrama, long remained a key to his hold on the mass audience. By the time of *It Happened One Night* and *Mr. Deeds,* he had learned to undercut sentiment with bits of comic foolishness and to deepen comedy with touches of authentic emotion. Even when they sound corny his films rarely feel dated. But *American Madness,* with its virtuoso depiction of a run on the bank, was also the first film in which Capra set out to comment on the social and economic crisis of the age. He now had something to say, and before long critics like Alistair Cooke began complaining that he was "making movies about themes rather than about people" (just as he was entering his greatest period).

Because he repeatedly portrayed a conspiracy of money and power against the common people, Capra's films have sometimes been admired on the left (despite their remoteness from Marxism), and in recent years have been described as "populist." The Populist movement, which emerged almost simultaneously in Russia and America in the late nineteenth century, was essentially an agrarian revolt against modernization, against the shift of economic and political power from the country to the city and from agriculture to industry and big capital. In Russia it was the creation of urban intellectuals who idealized the Russian peasant and the life of the land. In America it was a grass-roots movement which sprang up in the South and Midwest and crested with the third-party presidential campaign of General Weaver in 1892 — he polled 8.5 percent of the popular vote — and the Democratic nomination of William Jennings Bryan in 1896, which co-opted populism as a force for national dissidence.

There is very little agrarianism in Capra — his idealized past is a small-town America, not an agricultural one — so in strict terms there's very little populism in him either. But as Richard Hofstadter stresses in *The Age of Reform*, it's more useful to think of populism as a whole cast of mind that existed long before the populist movement and continued to reappear long after its disintegration (most recently in Jimmy Carter's acceptance speech at the 1976 Democratic Convention). Populism goes back to this country's early Jeffersonian image of itself as a republic of self-sufficient yeomen free of the shackles of feudal hierarchy. The populist mood flared up again during the Jacksonian period, and in the cherished image of Lincoln as the railsplitter raised in a log cabin. (Mr. Smith's full name is Jefferson Smith, and he worships the memory of Abe Lincoln.)

Even the Progressive movement of the early decades of this century, though largely patrician in origin, was also populist in its reliance on journalistic muckraking and its attacks on corporate trusts, banking monopolies, and corrupt political machines. And during the Depression the spirit of populism is far more pervasive, especially among artists, than any doctrinaire Marxism. At the first Writers' Congress in 1935, dominated by the Communists, Kenneth Burke got into hot water by urging the substitution of the broader term "the people" for divisive phrases like "the masses," "workers," or "proletariat," because, he said, the term was "closer to our folkways" and "richer as a symbol of allegiance." One critic retorted that the substitution of "people" for "workers" was "historically associated with demagoguery of the most vicious sort"; in other words, a rightist notion reeking of *Blut und Boden* and peasant conservatism, eliding class conflicts. But within a few months the whole international Communist movement, supposedly seeking an alliance of all "progressive" forces against fascism, had shifted over to a Popular Front strategy and a populist rhetoric. The old terminology was out, Burke's terminology was in, and by

1936 the editors of *Partisan Review* were castigated for still pursuing an interest in something so sectarian and divisive as the proletarian novel, rather than more popular works with a liberal or progressive tinge.

We needn't suppose any undue sincerity on the part of the Communists; their remarkable tactical reversal was not the last of the bizarre shifts that eventually deprived the party of most of its American followers. But their evident opportunism highlights the immense prestige of the whole idea of "the people" throughout the culture of the 1930s. If a typical 1920s writer like Fitzgerald is riveted by an ambivalent fascination with the rich, a typical 1930s writer like Steinbeck comes into fiction from topical journalism without losing his burning sense of mission. Fitzgerald's 1930s novel *Tender Is the Night* is a tragedy of wasted gifts dissipated into triviality among the rich and bored. It ends with a resolute goodbye to all that: "You're all so dull," says Dick Diver, who is down but hasn't quite reached bottom. "But we're all there is!" cried Mary. "If you don't like nice people, try the ones who aren't nice, and see how you like that!"

The strongest impulse among artists and intellectuals of the 1930s was precisely to "try the ones who aren't nice." The characters in a book like *The Grapes of Wrath* have so much the burden of representing The People that they aren't sufficiently individualized, and big chunks of the plot are vaporized in epic generality.

Individuals in the novel each become "a little piece of a great big soul," as Tom Joad becomes a distant disciple of Emerson. When Tom flees from the law his mother, who pardonably thinks of him in personal terms, asks where he'll be, where she can find him. In the spirit of "Joe Hill" he answers: "I'll be everywhere — wherever you look. Wherever they's a fight so hungry people can eat, I'll be there. Wherever they's a cop beatin' up a guy, I'll be there." One of the ways John Ford's film version becomes more upbeat than the book is by transferring Ma Joad's stirring "we're the people — we're tough — they can't lick us" speech from the middle to the end, where it substitutes for scenes in which the people take a bad licking — the latter part of the book is all downhill. In its Romance of the People *The Grapes of Wrath* is the perfect imaginative specimen of the Popular Front, just as the fiction of Nathanael West, especially the comic-pathetic letters to Miss Lonelyhearts and the murderous mob scene at the end of *The Day of the Locust*, is its most brutal caricature.

Frank Capra was not one of the nouveau-radical artists left over from the 1920s who discovered "the people" because they were suddenly in fashion. He was no tortured intellectual out of Exeter and Harvard like James Agee, more a Russian populist than an American one, a true *Narodnik* in love with the salt of the earth. Capra's feeling for ordinary life is deep and intuitive, whatever his attempts to mythicize it. But only

gradually, under the influence of the Depression, did his fables develop towards a populist political analysis. Besides the nostalgic idea of a golden age and the belief in conspiracy, one key notion that sets the populist vision off from Marxism is, in Hofstadter's words,

> the idea of a natural harmony of interests among the productive classes. To the Populist mind there was no fundamental conflict between the farmer and the worker, between the toiling people and the small businessman. . . . Predatory behavior existed only because it was initiated and underwritten by a small parasitic minority in the highest places of power. . . . The problems that faced the Populists assumed a delusive simplicity: the victory over injustice, the solution for all social ills, was concentrated in the crusade against a single, relatively small but immensely strong interest, the money power.

If populism had not run an enormous risk of being offensive to established interests in its choice of targets, this kind of dualism would be exceptionally suitable for popular culture. Like Hollywood, populism has "an unusually strong tendency to account for relatively impersonal events in personal terms," says Hofstadter, especially in its fascination with individual villains, "marked with the unmistakable stigmata of the villains of melodrama." Yet until *Mr. Deeds* Capra was not ready to sort out heroes and villains along populist lines. In *Tramp, Tramp, Tramp* (1926) the big shoe manufacturer is putting Harry Langdon's father out of business, but *his* dreamy wish is to marry the man's daughter (Joan Crawford), whose picture he has seen on billboards. In *American Madness* (1932) the people's tribune is none other than the bank president, who lends out money on character and battles his own board of directors. In this, his first social film, Capra would have us believe that bank panics occur because telephone operators are given to idle gossip, and spread false rumors.

Claudette Colbert's millionaire father in *It Happened One Night* is much closer to the later Edward Arnold mold. His power reaches everywhere: escaping from him is like running from the Mafia, *until* he actually finds his errant daughter. Then he becomes a pussycat, the world's best daddy: he saves her from a ruinous marriage and sends her off to a waiting Clark Gable, who is no man of the people but one of the fast-talking sharpies, a cynic who has given up on women until this one reforms him. Only in *Deeds* did Capra finally personalize The People into his common-man hero, just as John Ford would solidify the vaporous Joad family in the unforgettable immediacy of Henry Fonda and Jane Darwell.

No sooner had Capra's populist mythology found its shape in *Mr. Deeds* than it began to disintegrate. *Mr. Deeds* is the first and last film in which Capra's hero scores any easy victories. From the beginning, the director's

social demonology is exceptionally vague, for all the cartoonish vividness of his bloated and oily villains. Capra's attack on machine bosses in *Mr. Smith* has nothing to do with the Depression; it's actually part of the reformist litany of the earlier Progressive period. The depredations of the Taylor machine serve merely as the occasion for Capra's civics lesson about the American system, and as a metaphor for his growing sense that stifling concentrations of power threaten to make this lesson irrelevant. Capra's melodramatic vagueness about actual public issues, as well as his ambivalence towards all centralized power, even make it impossible to tell from his films what he thought of the New Deal. When Jefferson Smith proposes the creation of a National Boys' Camp he stresses that he asks for no federal money, only the nickel-and-dime contributions of American boys: in effect a private, voluntarist, juvenile New Deal. But his scheme interferes with a piece of graft buried in an omnibus appropriations bill, so the machine sets out to crucify him, and nearly succeeds.

In his autobiography and in numerous interviews Capra presents himself as an incurable optimist, but the tone of his comments often veers off into the cranky and querulous. The Manichaean vision of populism, no matter how Pollyannaish, harbors great potential for pessimism, paranoia, and even apocalyptic anxiety. As the 1930s drag on and World War II approaches, Capra's faith in the wisdom of The People wanes with his sense that their adversaries' spidery power increases. By the time of *Meet John Doe* in 1941 Capra begins to parody some of the populist attitudes he himself had pushed in the 1930s. The John Doe Clubs and "the John Doe idea," which is Capra's own cherished ideal of good will and personal benevolence, are ludicrously inadequate to the problems they face, and to the villains who manipulate them from the very start.

Those who doubt the capacity of popular culture to send itself up, to be self-ironic and ambivalent, ought to look at *Meet John Doe* in the light of Capra's earlier films. As his name indicates, John Doe is very much the least of Capra's heroes, a cipher, anonymous, in Capra's own words "a bindle stiff, a drifting piece of human flotsam as devoid of ideals as he was of change in his pocket." In part he is a parody of Capra's plebeian hero; his identity, insofar as he has one, has been fabricated by a clever newspaper reporter trying to save her job. The letter he is supposed to have written, in which he vows to commit suicide on Christmas Eve to "protest against the state of civilization," is probably the vaguest social criticism ever enunciated. The Cooper character accepts the role of John Doe, man of the people, simply as an actor, because he is hungry, and he is accepted by them because he looks and sounds the part. The people, more gullible than ever, take to his performance, which, in a manner familiar to Capra, warms their hearts without making any undue demands. They all become good neighbors; an orgy of benevolence breaks out.

In case we don't clearly enough see the limitations of this reign of friendliness, Capra provides John Doe with a hobo sidekick, the Colonel (played by Walter Brennan), who greets every sign of the new era of good feeling with a withering skepticism. To him the masses are "heelots" — greedy, materialistic, and cautiously respectable — just like the big shots and newspaper vultures. Amid the warm banalities of the John Doe philosophy the Colonel insists, "Tear down one picket of your neighbor's fence and he'll sue you." At the John Doe convention the Colonel sits alone, apart from the volatile herd, Cooper's only real friend, watching in pain as the crowd turns on him. And Capra parodies himself outright in scenes of media hype in which a buxom broad comes on as Miss Average Girl and two midgets are brought in to represent "the little people"; the woman dwarf gets turned on by John Doe and refuses to let go of him ("half a heelot," the Colonel comments).

Meet John Doe is a remarkably complex and ambivalent film, which has never been accorded the critical attention it deserves. It raised problems for Capra he was simply unable to resolve. Without abandoning his belief in the common people, Capra not only satirizes them (and himself), but shows how fickle and vulnerable they can be, how easily an unprincipled plutocrat with dictatorial ambitions like D. B. Norton (Edward Arnold) can manipulate them. Though the John Doe Clubs are supposed to exclude politics for Good Neighborliness, Norton, a protofascist with his own band of storm troopers, hopes to use them as a springboard to the presidency. He believes, as many others did in the 1930s, that "what the American people need is an iron hand — discipline!" His instruments, besides the newspapers, radio stations, and politicians he controls, are the gullible Mr. Doe, who delivers his prepared public speeches without reading them beforehand, and the equally gullible populace, the many John Does, who are readily swayed by demagoguery and sentimental platitudes.

As in *Mr. Smith,* it takes a cynical newspaperman to get Doe wise to how he's being used, but in this film it's all to no avail; here no victory over Arnold is possible, and the common people shout Cooper down when he tries to speak to them (just as the members of the Senate — inconceivably — tried to silence Mr. Smith). In *Meet John Doe,* the individual knaves of *Mr. Deeds* and the corrupt state machine of *Mr. Smith* have ballooned into a national force whose control of the media threatens to turn democracy into a sham. Capra's politics have leapfrogged in one bound from the rural evangelism of William Jennings Bryan to the antitotalitarian pessimism of Herbert Marcuse! This time the fairy tale has no catharsis, no clean resolution. By 1941 Capra's faith in the people had given way to an anxiety for their future.

This is not the place to give Capra's last great film, *It's a Wonderful Life,* the detailed treatment it richly merits. *Meet John Doe* is Capra's *Citizen*

Kane: the two films came out within months of each other; both deal with overweening ambition masquerading as populism, and show how mass journalism and demagogic politics try to manipulate the popular will. Capra's film of postwar retrospection, *It's a Wonderful Life,* is instead a meditative film, Capra's *Magnificent Ambersons,* his *recherche du temps perdu.* Capra leaves politics behind to summarize his personal myth. He composes an elegiac footnote to the three populist films by reversing their plot. Here the young man from the provinces never leaves home, though this is his deepest wish — not even to go to war. (He is 4–F, a maimed creature like John Doe, a broken-down pitcher who wants to get his "wing" fixed.) *It's a Wonderful Life* has a large cult following which finds it a heartwarming work, the epitome of the Christmas spirit, while others criticize it sharply for sentimentality. In fact few films are more genuinely moving; I can't think of another that brings me so readily to tears, not from its uplifting ending but from the depths of the purgatorial ordeal which precedes it. Though they are rarely noticed by either critics or admirers, the film has many of the same dark elements as *Meet John Doe,* especially in scenes that are literally dark and somber in their lighting. This is Capra's most personal film, and the psychological ordeal of George Bailey summarizes the fears and anxieties which had surfaced repeatedly in twenty years of effervescent comic filmmaking — an undertone of stress and insecurity that had given his fairy tales their believable human solidity.

George Bailey's life epitomizes the ethic of altruism and benevolence that Capra had been preaching and questioning all through the trilogy. At every stage George sacrifices his own wishes to the needs of others, as his selfless father had done before him. He saves his brother's life, only to see his brother go on to lead the life he himself deserved and wanted. He doesn't leave town, doesn't go to college, can't go to war, and can't even go off for his own honeymoon trip. Finally, driven to the wall by a Scrooge-like local tycoon, he contemplates suicide, and is saved only by an angel who shows him what his world would have been like if he had never lived. The overall message of this part of the film is uplifting — yes, each man *does* make a difference — but the scenes themselves are nightmarish and terrifying. Bailey has been saved, but his ordeal has just begun. To be purged of his suicidal wishes, the character is temporarily robbed of all identity, so that even his nearest and dearest fail to know him. It's a powerful fantasy; not to be recognized by your own mother, to find that your wife has never married but become a spinster, to stumble on the grave of the brother whose life you thought you saved. Never to have lived: in this grim vision Capra's heroes face up to the gloomy underside of their own blank anonymity. The fairy tale becomes, like tragedy, a catharsis of pity and terror.

I have stressed Capra's darker side to show his complexity and the

unacknowledged complexity of a good deal of popular culture, but also because he has usually been portrayed — not least by himself — as a cockeyed optimist, a purveyor of marketable fantasies. But Capra's work was also simple in a way that was right for him to be simple. As Robert Warshow wrote about Chaplin, "the impact of his art . . . was helped rather than hindered by a certain simplicity in his conceptions of political and social problems." The same point could be made about Dickens. Capra's populist simplicity showed up in the way he tended to personalize social problems into boy scouts and bosses, heroes and villains. But the same approach enabled him to transform America into a vivid personal myth of archetypal simplicity, affecting humor, and elemental emotional power. Like Chaplin, like Dickens, Capra remained in touch with something raw and vulnerable in himself and his audience, a memory of humiliation, struggle, and inner resolution. The coming of the Depression gave it a more than personal meaning, helped turn it into a not always comforting social vision.

Note

* I wish to thank Charles Silver of the film division of the Museum of Modern Art for giving me the opportunity to refresh my recollection of nearly all of Capra's most important films.

Chapter Fifteen

Orwell: Ethics and Politics In the Pre-*Nineteen Eighty-Four* Writings

David Lowenthal

More than a quarter of a century has elapsed since the publication of George Orwell's greatest and best-known work, *Nineteen Eighty-Four.* In a brief essay called "Why I Write"(1947), he had described himself as primarily a political writer with a ". . . desire to alter other people's idea of the kind of society that they should strive after," adding:

> Every line of serious work that I have written since 1936 has been written, directly or indirectly, *against* totalitarianism and *for* democratic socialism, as I understand it. . . . *Animal Farm* was the first book in which I tried, with full consciousness of what I was doing, to fuse political purpose and artistic purpose into one whole. I have not written a novel for seven years, but I hope to write another fairly soon. It is bound to be a failure, every book is a failure, but I know with some clarity what kind of book I want to write.[1]

Very probably the germinating novel characterized as a political-artistic successor to *Animal Farm* was *Nineteen Eighty-Four,* finished two years later, just before Orwell's death.

True to his statement in "Why I Write," Orwell directed *Nineteen Eighty-Four* against the successful totalitarianism of the future, but the novel has little to say about democratic socialism. The post-atomic-war world it describes consists of three essentially similar Communist-style totalitarian dictatorships, so powerful and ruthless as to be impregnable to rebellion. The most tangible connection with socialism, oddly enough, occurs through Ingsoc (the "Newspeak" word for English socialism), which is the ideology of the regime established in Oceania through revolutionary upheavals in the wake of the war. Somehow, we learn at one point, the idea

335

of democratic socialism began to lose ground in the middle of the century just when the technology of abundance had made it feasible. For this reason, the good contrast to Communist tyranny in *Nineteen Eighty-Four* is suggested by references to "Oldspeak" and "the ancient-time" — i.e., to the prewar regimes in which liberty, equality and human decency had a settled place. In the appendix on "newspeak," Orwell explicitly hearkens back to the American Declaration of Independence and the English literature of Shakespeare, Milton, Swift, Byron and Dickens, and hence to societies, whether democratic or monarchical, that protected private property, privacy, liberty and art. By comparison, democratic socialism — the dream of a perfectly just society — seems insubstantial and almost fictitious.

What led Orwell to this startling and paradoxical pessimism about the ultimate fate of modern man? What had led him originally to democratic socialism, and why did he end up cherishing the liberal societies he knew rather than the socialist democracy he imagined? Why, with the future looking increasingly bleak, did it become all the more important to develop and live by the true conception of human good and evil? Using Orwell's essays primarily (because in them he speaks directly in his own name, and less ambiguously than in his novels), an attempt will be made to answer these and similar questions, thus furnishing the background necessary to a proper appreciation of *Nineteen Eighty-Four*.

I. Sketch of Orwell's Life and Writings

Orwell's thought and action were bound up with the rights and wrongs, promises and menaces, of secular machine civilization. Born in 1903 and educated at Eton, he was, according to his own account, both a snob and a revolutionary by the age of 17. Following graduation he became a British policeman in Burma (1922–27) and there developed an "immense sense of guilt" for having assisted in the oppression of the natives. On returning to Europe, and by way of expiation, he spent more than a year in self-inflicted hoboism, sharing the life of the downtrodden, and afterwards recording his experiences in *Down and Out in Paris and London* (1933). During the Depression he managed to eke out a living by one means or another and at the same time produced his first three novels: *Burmese Days* (1933), *The Clergyman's Daughter,* (1935), and *Keep the Aspidistra Flying* (1936). In 1936 he spent several months living with another group of the poor — this time British coal miners. By then he had become a confirmed though unorthodox socialist, for whom ideology was much less important than real concern for the people, and in *The Road to Wigan Pier* (1937) he made public both his firsthand observations showing the need for socialism and

his critique of the contemporary socialist movement. In 1937 he fought on the Republican side in Spain until wounded and learned directly of the Communist threat to freedom, recounting his experiences in *Homage to Catalonia* (1938). The next year, in *Coming Up For Air,* his last novel prior to *Nineteen Eighty-Four,* he portrayed lower-middle-class English life in the shadow of totalitarianism and a second world war. During the early years of the war, especially in *The Lion and the Unicorn* (1941), he wrote to encourage a socialist revolution in England as the only means by which Hitler could be repulsed and defeated. Here his hopes for an overall social change in England reached their peak, only to fade after the war's end as he became more pessimistic regarding revolutions and the future of mankind. He saw no fundamental changes forthcoming from the new Labour government, and feared that the atom bomb and the growth in power of the Soviet Union made another and greater war likely soon. Although he had been busy during the war with essays and articles that had already won him a following, Orwell's name did not receive wide prominence until the publication of *Animal Farm* in 1945. With its stark simplicity, this allegorical satire of Communist revolution became a popular classic overnight. Two years later Orwell retired to the island of Jura in the Hebrides and worked on *Nineteen Eight-Four,* barely completing it before the tuberculosis with which he had long been afflicted took his life in January, 1950.

II. Critique of Perfectionism

In reconstructing the central moral and political themes of Orwell's thought prior to *Nineteen Eighty-Four,* one must begin with his humanism. This general philosophical position he distinguished not only from the supernaturalism of religion but also from those nonreligious doctrines and ways of life that either espouse a similar perfectionism or are in other ways inconsiderate of the full complement of man's natural needs. Humanism's main interest is man's happiness, and the question of the possibility of making happiness a normal human condition constitutes the crux of serious political controversy.

In his essays on Tolstoy (1947) and Gandhi (1948) — each an outstanding modern figure in a different religious tradition — Orwell presents his objections to what might be generalized as the ideal of saintliness. In neither place does he attempt to prove the falsity of religious belief in its theological foundations. Instead, with the dogmatism of most modern intellectuals, he takes it for granted that religion is essentially wishful myth-making, and concentrates on the good or bad effects of religious belief. This procedure implies the existence of knowable norms of

good and evil independent of religion and its God. What are these, and how are they known?

According to Orwell, Shakespeare's later tragedies are exemplars of the humanist point of view. They " . . . start out with the humanist assumption that life, although full of sorrow, is worth living, and that Man is a noble animal. . . ." Tolstoy's saintly ideal, on the other hand, constitutes an abandonment of human life in favor of a life to come:

> If only, Tolstoy says in effect, we would stop breeding, fighting, struggling and enjoying, if we could get rid not only of our sins but of everything else that binds us to the surface of the earth — including love, then the whole painful process would be over and the Kingdom of Heaven would arrive. . . . Ultimately it is the Christian attitude which is self-interested and hedonistic, since the aim is always to get away from the painful struggle of earthly life and find eternal peace in some kind of Heaven or Nirvana.[2]

The saint is one who spiritualizes himself — i.e., cripples his natural faculties — in the hope of future reward, and his convictions may even encourage the use of worldly coercion in one form or another as a means of bringing others into the service of his ideal.

Gandhi is more admirable — " . . . an interesting and unusual man who enriched the world simply by being alive." But his teachings " . . . cannot be squared with the belief that Man is the measure of all things, and that our job is to make life worth living on this earth, which is the only earth we have." His saintly ideal enjoins the avoidance of animal foods, alcohol, tobacco, spices, sexual intercourse and even sexual desire, and finally all close friendships and exclusive loves. In criticism Orwell replies that:

> The essence of being human is that one does not seek perfection, that one is sometimes willing to commit sins for the sake of loyalty, that one does not push asceticism to the point where it makes friendly intercourse impossible, and that one is prepared in the end to be defeated and broken up by life, which is the inevitable price of fastening one's love upon other human individuals. No doubt alcohol, tobacco, and so forth, are things a saint must avoid, but sainthood is also a thing human beings must avoid.[3]

Hence, while Orwell admires Gandhi's personal courage, truthfulness and loftiness, he insists nevertheless that one must be for Man and his earthly existence rather than for God and otherworldliness.

In these passages Orwell opposes both the hedonism that calculates the worth of actions by the sum of pleasure conveyed to the actor and the perfectionism that seeks to reduce to a minimum man's natural attachment to earthly things. His humanism locates the good in the preservation of the whole of man's nature without retreating in the face of sufferings that will

have to be undergone. No part of man's nature is evil, and the right course of action is to keep doing the human things for their own sake, accepting the unhappiness that thus forms an essential ingredient of human life. The human is shed by the saint in favor of the divine, by the hedonist in favor of his ego, but psychologically the two have in common a desire to escape from the pain and hard work involved in a natural life.

In his essay on *Gulliver's Travels* (1946), Orwell objects to Swift's having claimed for Reason what Tolstoy and Gandhi later claimed for spirituality:

> Happiness is notoriously difficult to describe, and pictures of a just and well-ordered Society are seldom either attractive or convincing. Most creators of "favorable" Utopias, however, are concerned to show what life could be like if it were lived more fully. Swift advocates a simple refusal of life, justifying this by the claim that "Reason" consists in thwarting your instincts. The Houyhnhnms, creatures without a history, continue for generation after generation to live prudently, maintaining their population at exactly the same level, avoiding all passion, suffering from no diseases, meeting death indifferently, training up their young in the same principles — and all for what? In order that the same process may continue indefinitely. The notions that life here and now is worth living, or that it must be sacrificed for some future good, are all absent. The dreary world of the Houyhnhnms was about as good a Utopia as Swift could construct, granting that he neither believed in a "next world" nor could get any pleasure out of certain normal activities. But it is not really set up as something desirable in itself, but as the justification for another attack on humanity. The aim, as usual, is to humiliate Man by reminding him that he is weak and ridiculous, and above all that he stinks; and the ultimate motive, probably, is a kind of envy, the envy of the ghost for the living, of the man who knows he cannot be happy for the others who — so he fears — may be a little happier than himself.[4]

Again it is the thwarting of the natural instincts with their accompanying joys and sorrows, whether in the name of spiritual or rational perfection, that Orwell rejects. He also claims that Swift opposes science, whether practiced freely for its own sake or for advancing technology, individual liberty and democracy. Swift's ideal is "a static, incurious civilization," a totalitarian society "where there can be no freedom and no development." Because he fundamentally denies that man as we normally find him is a noble animal, and that life is worth living and can be made more so, he must turn against social progress in the modern sense.

Although Orwell sees clearly that Swift is an admirer of classical pagan reason and virtue rather than Christian spirituality, he fails to associate him and his utopia with the philosophies of Plato and Aristotle. Nevertheless, one can say that through Swift Orwell rejects the classical view of human perfection, and on such typically modern grounds as the claims of the instincts, individuality, inventiveness and social progress. But

he views neither the spiritual nor the rational perfectionists with sufficient sympathy. He shows little understanding of the intellectual, moral and psychological qualities of Biblical religion; he does not ponder the reasons that might have led Swift to separate the whole of human life into a Houyhnhnm and a Yahoo component. Nor has he reflected sufficiently on his own grounds for insisting that man is a *noble* animal — i.e., an animal that is also more than a brute, and that derives any special dignity it possesses from those traits, spiritual or rational, that lift it into a unique realm of freedom. Orwell rejects both hedonism and perfectionism because they are false to human nature and lead, in their application, to vast social harm. But how will humanism preserve the whole of human nature without discovering some way of resolving the conflicts posed by its parts, or without maintaining that some of its parts are worthier or higher than others?

III. Critique of Hedonism

In Orwell's usage, hedonism is of two sorts; the one selfish, the other altruistic. Either can tend toward the vulgar by stressing the primacy of bodily pleasures, but the altruistic sort derives from a moral dedication to the good of mankind; it aims at using scientific technology to liberate human life from scarcity and suffering, and to help men live together as free and equal brothers. The term "hedonistic" applies with special emphasis to those who consider this social ideal not only desirable but eminently practicable.

Though he strongly rejects selfish hedonism (again without systematic argument), Orwell's attitude toward what might be called the social-scientific variety is a mixed one — both with respect to its desirability and its practicability. His ambivalence on the count of desirability is most manifest in *The Road to Wigan Pier,* a critique of H. G. Wells and the Marxists. To both he attributes the view that a society based on the fullest development of science and technology is best equipped to suit man's needs and to make possible the solution of his most important problems. The twelfth chapter of *The Road* contains Orwell's summary of the "intelligent" and "sensitive" man's objections to unending progress in technology. By guaranteeing man against a host of difficulties, the machine lessens his need for physical, intellectual and moral exertion and prowess. The "comely attributes" necessary to being fully human will slowly disappear, leaving a race of little, fat, soft men to enjoy their artificial world of order and efficiency. In other words, the more admirable kind of hedonism reduces to the vulgar sort by virtue of its very success. But human life requires work and effort and the exercise of the various natural capacities: "For man is

not, as the vulgarer hedonists seem to suppose, a kind of walking stomach; he has also got a hand, an eye and a brain." The thought that H. G. Wells dares not face is

> that the machine itself may be the enemy. So in his more characteristic Utopias (*The Dream, Men Like Gods,* etc.) he returns to optimism and a vision of enlightened sunbathers whose sole topic of conversation is their own superiority to their ancestors. *Brave New World* belongs to a later time and to a generation which has seen through the swindle of "progress."[5]

Unfortunately, Orwell admits, the impulse to invent and improve, typical of recent western civilization, has itself become a machine, and suggestions that it be checked or controlled are regarded on all sides as blasphemous. On occasion (as we have just seen) he even expresses antagonism to machine or industrial civilization as such. But what is the alternative?

> When one pictures a desirable civilization, one pictures it merely as an objective; there is no need to pretend that it has ever existed in space or time. Press this point home, explain that you wish merely to make life simpler and harder instead of softer and more complex, and the Socialist will usually assume that you want to revert to a "state of nature" — meaning some stinking paleolithic cave: as though there were nothing between a flint scraper and the steel mills of Sheffield, or between a skin coracle and the Queen Mary.[6]

Something similar is said even more clearly in that part of his essay on Henry Miller (1940) dealing with English writers who repudiated modernity: "When Lawrence prefers the Etruscans (*his* Etruscans) to ourselves it is difficult not to agree with him, and yet, after all, it is a species of defeatism, because that is not the direction in which the world is moving." Because the machine is here to stay, only socialism is capable of employing it to further justice and liberty for the whole people. But this must be a humanized socialism, in which the machine is eyed suspiciously as something in the nature of a drug. To form a permanent humanizing opposition within the socialist movement is the proper task of intelligent and sensitive people today.

Orwell fears that modern social-scientific hedonism will lose sight of the "comely attributes" and the full man, but his sympathy for the poor man prevents him from accepting the scarcity, brute labor, inequality, and oppression characteristic (as he thought) of prescientific or premodern life, thus in some degree likening it to the "State of Nature" and in fact leaving man with two basic possibilities — the premodern and the modern. He frequently insists that the needs of the body are more urgent, though not higher, than the needs of the soul: "A human being is primarily a bag for

putting food into; the other functions and faculties may be more godlike, but in point of time they come afterwards." Or again, in a later essay on the Spanish Civil War (1943):

> All that the working man demands is what these others would consider the indispensable minimum without which human life could not be lived at all. . . . The major problem of our time is the decay of the belief in personal immortality, and it cannot be dealt with while the average human being is either drudging like an ox or shivering in fear of the secret police. How right the working classes are in their "materialism": How right they are to realize that the belly comes before the soul, not in the scale of values but in point of time! Understand that and the long horror that we are enduring becomes at least intelligible.[7]

Orwell's dilemma is now manifest: care for the bodily wants of all men comes first, care for their higher needs later. But the first requirement sets into motion an age of science and technology that tends to worship the body and discard the soul, ending in vulgar hedonism. He is confident that even without God and personal immortality, men can find their bearings and develop a conception of the most worthy life by which to guide, and give meaning to, their actions. But he realizes that setting bounds to the machine, and to hedonism, is extremely unpopular with capitalists and socialists alike. In fact, even his own writings waver on the amount of machine technology and the level of abundance that should characterize a socialist society. Nor could he bring himself to give serious consideration to the possibility that some kind of preindustrial society, permitting at least a sizeable minority to participate in a life of high quality, might be superior to the mass hedonism of the future: hence his merely fleeting references to the attractions of a society based on the hard and simple life.

This is not all. We should expect of anybody seriously concerned about the demise of the higher life that he systematically describe the higher life's nature and source. If hedonism threatens the perception of quality and the "comely attributes," the highest mission of "intelligent" and "sensitive" people would not merely be to oppose the misuse and overuse of technology, but to present clearly and fully the standards for judging its proper and improper use, and in particular the standard of the best human life. Orwell sensed the need for such a doctrine, and increasingly gave attention to it, but he was always too distant from the philosophic tradition of Socrates, Plato and Aristotle among the ancients, and Machiavelli, Bacon, Descartes, Hobbes, and Locke among the moderns, to appreciate the intellectual task before him. What we are given instead are incomplete references or dramatic illustrations, instructive and moving, but inadequate substitutes for comprehensive argument.

One of Orwell's newspaper columns from the year 1944 presents further

evidence of the seriousness with which he considered the problems of replacing the Christian ethic and scheme of meaning:

> Western civilization, unlike some Oriental civilizations, was founded partly on the belief in individual immortality. If one looks at the Christian religion from the outside, this belief appears far more important than the belief in God. The Western conception of good and evil is very difficult to separate from it. There is little doubt that the modern cult of power worship is bound up with modern man's feeling that life here and now is the only life there is. If death ends everything, it becomes much harder to believe that you can be in the right if you are defeated. Statesmen, nations, theories, causes are judged almost inevitably by the test of material success. Supposing that one can separate the two phenomena, I would say that the decay of the belief in personal immortality has been as important as the rise of machine civilization. Machine civilization has terrible possibilities, as you probably reflected the other night when the ack-ack guns started up: but the other thing has terrible possibilities too, and it cannot be said that the Socialist movement has given much thought to them.[8]

Here Orwell contrasts the traditional Christian ethic with its highly defective successors: power worship and vulgar hedonism. And he insists that a socialist civilization without a better system of good and evil will hardly be worthwhile. Nevertheless he seems hopeful that his socialist colleagues can be convinced of the need for adopting something superior to their hedonism, and this something is said to have its basis in Marxism itself. But if the Marxist ethic is so crucial, there must be some reason why, as he admits, it "has never been popularized." Orwell did not realize that original Marxism itself contains the origins of the ethical ambiguity he knew firsthand in the socialist movement, and that in some ways it even makes moral philosophy impossible (e.g., through its materialist and historical interpretation of ideas.) Had he done so, he might have been more hesitant to cast his lot at that time with those whose intellectual premises engendered the peculiar amalgam of humanity, wickedness and moral fatuity he himself later did so much to expose as leading inevitably to the cellars of the CPU.

In another newspaper article almost two years later (1946), Orwell focuses his attention on the "modern civilized man's idea of pleasure," and in so doing sums up what he means by the humanist ethic. Having read of an imaginary ultramodern "pleasure spot" providing, within a large scientifically-constructed and -controlled area, all the recreation and amusement that a "tired and life-hungry man" could want, he proceeds to compare its underlying ideas with those of Coleridge's *Kubla Khan:*

> When one looks at Coleridge's very different conception of a "pleasure dome," one sees that it revolves partly round gardens and partly round

caverns, rivers, forests and mountains with "deep romantic chasms" — in short, round what is called Nature. But the whole notion of admiring Nature, and feeling a sort of religious awe in the presence of glaciers, deserts or waterfalls, is bound up with the sense of man's littleness and weakness against the power of the universe. The moon is beautiful partly because we cannot reach it, the sea is impressive because one can never be sure of crossing it safely. Even the pleasure one takes in a flower — and this is true even of a botanist who knows all there is to be known about the flower — is dependent partly on the sense of mystery. But meanwhile man's power over Nature is steadily increasing. With the aid of the atomic bomb we could literally move mountains: we could even, it is said, alter the climate of the earth by melting the polar icecaps and irrigating the Sahara. Isn't there, therefore, something sentimental and obscurantist in preferring bird-song to swing music and in wanting to leave a few patches of wildness here and there instead of covering the whole surface of the earth with a network of Autobahnen flooded by artificial sunlight? The question only arises because in exploring the physical universe man has made no attempt to explore himself. Much of what goes by the name of pleasure is simply an effort to destroy consciousness. If one started by asking, What is man? What are his needs? How can he best express himself? one would discover that merely having the power to avoid work and live one's life from birth to death in electric light and to the tune of tinned music is not a reason for doing so. Man needs warmth, society, leisure, comfort and security: he also needs solitude, creative work and the sense of wonder. If he recognized this he could use the products of science and industrialism eclectically, applying always the same test: does this make me more human or less human? He would then learn that the highest happiness does *not* lie in relaxing, playing poker, drinking and making love simultaneously. And the instinctive horror which all sensitive people feel at the progressive mechanization of life would be seen not to be a mere sentimental archaism, but to be fully justified. For man only stays human by preserving large patches of simplicity in his life, while the tendency of many modern inventions — in particular the film, the radio and the aeroplane — is to weaken his consciousness, dull his curiosity, and in general drive him nearer to the animals.[9]

The one element in this analysis we have not encountered before concerns the relation between humanism and the scientific conquest of nature. Humanism wants to suit man's full nature, but it is unclear about the relation between man's nature and Nature at large. Linked with a manipulative science, it is tempted to assert that Nature at large is not intrinsically admirable or beautiful, and that it can all be altered to suit man's convenience. Natural man in an entirely artificial environment would be the result. To this conception Orwell objects on two grounds. Man cannot fully be himself if he is completely bereft of natural surroundings. In addition, the modern tendency is to narrow and distort the fullness of man's nature in the direction of the most vulgar hedonism. We must admit, however, that Orwell does not demonstrate his first objection satisfactorily. Assuming that man does indeed need "solitude,

creative work and the sense of wonder," why do these require contact with untouched Nature? Can he not wander in a garden rather than a forest, create nonrepresentative rather than imitative art, and wonder not at the moon but at his own technological ingenuity and its products?

The truth of the matter is that natural surroundings link man to the diversity of beings and provide him with models of aspiration. Indeed, the machine itself imitates the natural organism, every part of which fulfills some particular function, and no machine can rival even the slightest living cell in functional design. Machines, and works of fine art as well, impress us to the degree that they imitate or perfect nature. Moreover, at least one natural object in the humanist scheme must constantly be regarded as intrinsically beautiful and admirable, and that is man. This reflection suggests a danger to which Orwell does not directly refer in his articles, but which he later came to appreciate. When all natural objects are looked upon as mere material subject to human manipulation and transformation, can human nature itself continue to be regarded as intrinsically worthy, or will it too become a subject of manipulation? If all other parts of nature lack intrinsic dignity, can man possess it? Certainly if the more vulgar members of the species have their way, those more "comely" attributes of man which are linked to his consciousness may be completely discouraged, and the result of human progress will be to drive man "nearer to the animals."

Orwell speaks of "wanting to leave a few patches of wildness here and there" and of man's need to preserve "*large* patches of simplicity in his life" (my emphasis). The variation in adjectives here may indicate Orwell's lack of a clear standard for accepting or rejecting technology, as well as his desperation at the well-nigh irresistible vulgarization of life in advanced societies. Human nature requires that parts of Nature be kept as objects of intellectual and esthetic enjoyment — as things to be comtemplated, admired, inquired into, or used as models and images in the creative arts. In some of his other writings this attitude can be seen at work more concretely. The protagonist of *Coming Up For Air* (1939), George Bowling, experiences the peak of happiness while gazing, on a warm March day, at some primroses, the burning embers of a wood fire, and a pool covered with duckweed out in the country:

> Curiously enough, the thing that had suddenly convinced me that life was worth living, more than the primroses or the young buds on the hedge, was that bit of fire near the gate. . . . It's curious that a red ember looks more alive, gives you more of a feeling of life, than any living thing. . . . And I was alive that moment when I stood looking at the primroses and the red embers under the hedge. It's a feeling inside you, a kind of peaceful feeling, and yet it's like a flame.

> Farther down the hedge the pool was covered with duckweed, so like a carpet that if you didn't know what duckweed was you might think it was solid and step on it. I wondered why it is that we're all such bloody fools. Why don't people, instead of the idiocies they do spend their time on, just walk round *looking* at things? That pool, for instance — all the stuff that's in it. Newts, watersnails, water-beetles, caddis-flies, leeches and God knows how many other things that you can only see with a microscope. The mystery of their lives, down there under the water. You could spend a lifetime watching them, ten lifetimes, and still you wouldn't have got to the end even of that one pool. And all the while the sort of feeling of wonder, the peculiar flame inside you. It's the only thing worth having, and we don't want it.[10]

Bowling goes on to contrast the violence characteristic of war and fascism with such feelings of inner peacefulness. Here again we see a connection between the height of human happiness and these activities that are uniquely human and that derive from the mind itself taken in its natural relation to natural objects. And it is perhaps not accidental that Orwell stresses the satisfactions of observing and wondering rather than those of creativity or even of systematic inquiry into causes. Wonder's beginnings, rather than its completion through philosophy or science, seem more evidently natural and healthful to him. And again, it is perhaps no accident that the natural things immediately around us rather than the starry but distant heavens are what occupy his attention. A certain hesitancy with respect to a science of universal nature may have affected him — a fear that knowledge of nature destroys nature's beauty and admirableness, as he says, or that it may be applied in such a way as to harm natural objects and man himself. In addition, one senses that Orwell placed a higher value on living things — on their motility and variety — than he placed on any inanimate objects whatsoever, including stars and planets: even sunsets and dawns seem to lack the appeal of primroses, fires (which *act* alive), and newts.

In general, Orwell views nature primarily from the standpoint of its value for man — through its ability to engender highly worthwhile human satisfactions — rather than of its value in itself. Were this not the case, his basic position could not be called "humanism," and would instead approach the teleological philosophy of Plato and Aristotle. In two newspaper articles written just after the war, this standpoint still predominates, though accompanied by an unmistakable sense of the value possessed by natural things in their own right. One of these articles is devoted to encouraging men to do good for their contemporaries and future generations by planting trees. The other concerns the importance of appreciating the coming of spring, using the renewal processes of the toad as its foremost example. In it Orwell denies that interest in natural things is either politically or technologically reactionary, or an urbanite luxury:

> I think that by retaining one's childhood love of such things as trees, fishes, butterflies and — to return to my first instance — toads, one makes a peaceful and decent future a little more probable, and that by preaching the doctrine that nothing is to be admired except steel and concrete, one merely makes it a little surer that human beings will have no outlet for their surplus energy except in hatred and leader-worship.[11]

The reference to childhood suggests that certain of our natural interests are submerged by the stresses and strains of adult life, especially by the admiration for the manmade inculcated by a technological society. But maintaining our natural — i.e., our first and inherent — interest is the only way to ensure a full and satisfied life, while the frustration of these interests turns us toward such things as hatred and destructiveness. The idea that the natural is good, as Orwell employs it, presumes that it is a kind of harmonious working, a working that keeps harmony within each man and among men. But he fails to demonstrate such a thesis systematically, either with respect to Nature as a whole or the whole of any given nature, including man's.

IV. Free and Equal Brothers

If Orwell was unclear and even inconsistent about the society that could best bring about human fulfillment, his picture of the demands of perfect justice among men is less ambiguous. A good instance can be found in his analysis of Arthur Koestler's *The Gladiators,* which portrays the attempt of Spartacus' ancient slave rebellion to create a new society, the City of the Sun:

> In this city human beings are to be free and equal, and above all, they are to be happy: no slavery, no hunger, no injustice, no floggings, no executions. It is the dream of a just society which seems to haunt the human imagination ineradicably and in all ages, whether it is called the Kingdom of Heaven or the classless society, or whether it is thought of as a Golden Age which once existed in the past and from which we have degenerated.[12]

Such a society would in its perfected condition be worldwide, constituting a universal brotherhood of all men living without exploiting one another and without laws. This ideal Orwell sometimes regards as arising perennially in protest against social injustice (as above), or sometimes as the product of the Judeo-Christian tradition, and, more recently, of the French Revolution and Marxism. In one way or another, these have all contributed to the ideal of human brotherhood, but as Orwell uses it, the conception definitely has reference to a desirable state of affairs in *this* world, to an "Earthly Paradise." And so self-evidently well-founded does he deem it

that thorough argument in its favor is never attempted. The case for it probably begins with the assumption that the central political problem consists of the use of power by some men to exploit others — a practice taken to characterize all human history. Within each society there has been economic, social, and political inequality, and among societies inequality, dependence, and exploitation have again been the rule, so that everywhere majorities are underdogs to minorities. The underdog is an innocent victim who finds himself deprived of access to a decent life without just cause. Yet a decent life is good for all men, all desire a life free from insecurity, and only the selfish interests of individuals, classes and nations prevent these desires from being fulfilled. So long as there are rich and poor, so long as nation is separated off from nation, exploitation will go on — hence the need for equality and universality, for a world society. This provision would be ineffective, however, if the ultimate source of inequality lay in the selfish drives of each individual, if men by nature cared naught for their neighbor. But men are not only members of the same biological species. They have more in common than do lions with other lions, or rabbits with other rabbits: they are brothers.

Now in a sense this is manifestly untrue. Like other animals, men have particular parents, not a single great set of parents. And for one who rejects the Biblical tradition, it is impossible to maintain that God created all men in his own image, wishing them to be brotherly, to love each other. Perhaps, then, Orwell is trying to salvage one part of the Biblical tradition without having recourse to its theological principles. The only natural basis available for such an attempt would seem to be the multitude of particular human families, and no doubt the family plays a fundamental role in Orwell's thought. It is the original and natural social unit, the frame in which love, loyalty, and gratitude first appear as a strong and spontaneous growth. Here is where the joys and sorrows of others are really understood and shared. But the sibling relation — of brothers — is more nearly one of equality than the parent-child relation and is preferred as the general model for human society because it is closer to the democracy that can alone prevent the exploitation of man by man. And if men are not actually brothers they are in spirit potentially so. The fraternal sympathies they develop within their particular biological families can be extended, given the proper conditions. England, for example, is such an extended family:

> It has rich relations who have to be kow-towed to and poor relations who are horribly sat upon, and there is a deep conspiracy of silence about the source of the family income. It is a family in which the young are generally thwarted and most of the power is in the hands of irresponsible uncles and bedridden aunts. Still, it is a family. It has its private language and its common memories, and at the approach of an enemy it closes its ranks. A family with

the wrong members in control — that, perhaps, is as near as one can come to describing England in a phrase.[13]

But men are capable of extending their sympathies even further, of recognizing what they have in common with *all* men, and it is this recognition of a common humanity that would typify the perfect society. No doubt it will vary in its intensity and thoroughness from one individual to another. The majority of men, perhaps, will be capable at most of consideration for the rights of others, of mere sympathy rather than affection and devotion. A few, however, will really care about all mankind in the way a brother, or better still, a mother or father cares. Orwell, it seems, was himself one of these — a man who through direct or sympathetic experience kept putting himself in the place of the underdog masses, the world's victims, and acting in behalf of their just claims. With the help of such intelligent, sensitive and devoted caretakers, mankind might eventually develop the spirit and institutions to make possible a world society of free and equal brothers.

But Orwell also admits that human equality and world society were impossible prior to the advent of modern scientific technology. In his natural beginnings, man is impoverished and condemned to brute labor, with only the wealthy finding themselves able to cultivate the higher things. Without man's own technological creativity, the regime of plenty and the communications necessary to the Earthly Paradise could not have come into existence. Unfortunately, the capitalism that created the machine is not a fit manager. With its periodic depressions, its vast economic and social differences, and its emphasis on private profit rather than brotherliness, capitalism condemns the mass of men to inferiority and exploitation. Marxists, on the other hand, are all too frequently dedicated to envying and hating the bourgeoisie, and to extreme abstract programs rather than the welfare of the people. What is most needed, therefore, is a humanized, liberal socialism that will make justice, freedom, decency and the common good its real goals, and strive to become a world system.

This is the general picture that one can compose on the basis of the two works in which Orwell speaks most explicitly of his socialist aims: *The Road to Wigan Pier* (1937) and *The Lion and the Unicorn*. Only in this way, he claims (during the war), can fascism's tremendously aggressive menace to human equality be overcome. Because the old order is unjust to so many, because the technological conditions are immediately available by which the just socialist order can be instituted and rendered stable, and because the threat of fascism cannot otherwise be averted, there is a right and a duty to overthrow the fundamental institution of private property together with its domestic and foreign exploitations, replacing it with state ownership controlled by and run for the people.

In a few years Orwell himself came to the conclusion that violent revolution under modern conditions led necessarily to dictatorship and was therefore to be forborne. But even without this element, his version of democratic socialism has three defects (shared with Marxism) worth mentioning here. One is the tacit assumption that absolute democracy is a workable and good form of government, indeed the best and the only just form of government. This is based on his confidence that economic equality and abundance by themselves will produce good and just citizens of sufficient wisdom without any need for moral education or for superior political talent. He also fails to perceive that the people, however public-spirited they become and by whatever means, must like any other rulers be restricted in what they can rightly do — a restriction embodied in basic laws that cannot easily be changed.

Moreover, in a society in which everyone's economic life is at the disposal of the whole people, the ability of the people to control the various other aspects of individual life will be greater than ever before in human history, particularly with the help of modern science and technology. Certainly Orwell should have considered whether socialism and the civil liberties of noneconomic liberalism are ultimately compatible. Finally, one must not presume that political society can be universalized and given a global scope without important losses. There may be natural limits to human association that are exceeded only at the cost of diluting or lowering the quality of that association itself. Perhaps men can only attach themselves deeply to distinct and even small political entities, however universal their simple sympathies might be, and perhaps the striving for perfection requires such attachment. And this is wholly apart from the possibility — and in the long run the probability — that if any world government possessing a monopoly of atomic weapons ever grew corrupt, it might render resistance to unjust rule impossible anywhere, and bring about a lasting universal tyranny.

V. Critique of Power Politics

Although Orwell begins as a supporter of both the desirability and possibility of the Earthly Paradise, he usually denies that its coming is a matter of historical necessity, in this way departing from orthodox Marxism. He explicitly distinguishes his own position from the typical liberal attitude in two vital respects: he has a much higher estimate of the power of sheer passion and prejudice, and he claims that the admiration of force and fraud has come to characterize a sizable number of the intellectuals themselves.

The social-scientific hedonists — of whom H. G. Wells is the leading

example — regard motivations other than enlightened self-interest and social interest as doomed to extinction in the age of modern science. They neither appeal to, nor see, the tremendous strength of such emotions as patriotism, superstition, and traditionalism. They do not realize that

> the energy that actually shapes the world springs from emotions — racial pride, leader-worship, religious belief, love of war — which liberal intellectuals write off as anachronisms, and which they have usually destroyed so completely in themselves as to have lost all power of action.[14]

And again:

> He [H. G. Wells] was, and still is, quite incapable of understanding that nationalism, religious bigotry, and feudal loyalty are far more powerful forces than what he himself would describe as sanity.[15]

Orwell tries to base his own politics on the necessity and usefulness of some of these emotions. His call for a Socialist revolution in England in *The Lion and the Unicorn* is developed in conjunction with a first-rate analysis of English national character. For the most part he finds the beliefs and emotions underlying this character morally admirable — e.g., defensive patriotic loyalty, gentleness, trust in liberty and law, deep Christian decency. Whereas the tendency of English left-wing intellectuals is to "chip away" at patriotism and the martial virtues, Orwell claims that these are absolutely essential both to the survival of England in its war with Hitler and to its turning toward Socialism.

The essay called "Notes on Nationalism" (1945) begins by distinguishing nationalism from patriotism:

> By "patriotism" I mean devotion to a particular place and a particular way of life, which one believes to be the best in the world but has no wish to force upon other people. Patriotism is of its nature defensive, both militarily and culturally. Nationalism, on the other hand, is inseparable from the desire for power. The abiding purpose of every nationalist is to secure more power and more prestige, not for himself but for the nation or other unit in which he has chosen to sink his own individuality.
>
> . . . Nationalism, in the extended sense in which I am using the word, includes such movements and tendencies as Communism, political Catholicism, Zionism, anti-Semitism, Trotzkyism, and Pacifism.[16]

According to Orwell, the most worrisome trait of the twentieth century is the growing strength of nationalism and the relative weakening of moral, religious and patriotic restraints. The development of Nazi and Commu-

nist totalitarian tyrannies, ruthlessly using fraud and force for their own aggrandizement, has been accompanied by a growth among intellectuals everywhere of "realism" — the doctrine that might is right, the attitude of admiring power, cruelty, and wickedness for their own sake. Orwell continually contrasts the common people of the Western countries (and especially of England), who are "still living in the world of absolute good and evil," "the mental world of Dickens," with those intellectuals who have gone over to realism, power politics, power-worship and totalitarianism, whether of the left or right. These intellectuals have become the slaves of an aggressive orthodoxy, promoting its interest by every means and regarding all questions in the light of their bearing on these interests. So great is the degree to which falsification for one's own side is engaged in that Orwell fears "that the very concept of objective truth is fading out of the world." As applied to history, "what is peculiar to our own age is the abandonment of the idea that history *could* be truthfully written."[17] In England it is the mythos of Russian communism that has become the major nationalism of the intellectuals, and the one most in need of being combatted. Hence the paradox that the very people who require freedom most, and whose intelligence might qualify them to be the deliverers of mankind, comprise the totalitarian vanguard. The extreme wing of social-scientific hedonism institutes tyranny rather than democracy.

Orwell speculates about the causes of the growth of Communist sympathies among English intellectuals. Especially since about 1930, English society was able to offer them little status. The rationalistic debunking of "patriotism, religion, the Empire, the family" also prompted them to turn elsewhere for something to believe in. Many were led by a strong desire for power, or for association with power capable of getting its dictates obeyed. And there were, of course, those who were attracted by Communist slogans only because a comfortable and safe life in England and an ignorance of the special horrors of totalitarianism lulled them into doing so. As we have already seen, Orwell thought there was a causal connection between the decline of religious belief and the rise of modern power worship. It is the "emancipated" intellects who are attracted to a secular religion embodying and wielding ruthless power, and this fact added to Orwell's appreciation of the weighty merits of the "old regime" — of patriotism, the code of the gentleman, and even religion.[18] But what he actually calls for to combat the nationalism of the intellectuals is a moral effort on the part of every man to reduce his own biases and strive for greater objectivity and fairness — admittedly an effort few seem to be capable of putting forth. His final resort, in other words, is simply to moral exhortation.[19]

The essay on nationalism seems to make two related points: first, that the

confidence in objective standards of truth and morality is disappearing; second, that popular emotions and beliefs objectionable from the stand- point of rationality are crucial to practical life and hence to liberalism. But the argument hardly suffices. Orwell should show what the true standards are (and the reasons why they are in decline): he should indicate how they are linked to the emotions in question. He does maintain that the discovery of historical truth is possible, and he suggests that there is a vital moral distinction between defensive and aggressive loyalties or devotions to a cause. But why ought men to seek the truth, or have loyalties that are not aggressive? In the past, philosophers usually answered in terms of obligation or interest and defended these ultimately in terms of what is either right or good in itself. Orwell does not. He certainly does not speak of duties‚ or rights, virtues or vices, of character, or of the soul. He is no longer at home with the vocabulary either of practical moral discourse or of the long-established, but now moribund, philosophic discipline of ethics. The common people still believe in "absolute good and evil," in the moral world of Charles Dickens, but Orwell himself actually shares the doubts of the intellectuals, and is torn between the two.

Although Orwell perceives that "rationalism" is itself the source of the modern critique of absolutes, he fails to enlarge on the meaning of this term. Actually, the debunking of the old — of honor, patriotism, the martial virtues, religion — in the name of abstract universal principles of philosophy or science is characteristic of original liberalism and of its Marxist offshoot as well, and is therefore typical of modern politics as a whole. This modern rationalism originated with the philosophers of the sixteenth and seventeenth centuries, whose revolutionary writings gener- ated that great and vast surge of modern debunking in the eighteenth called the Enlightenment. It is, in fact, to the Enlightenment that we owe the birth of "intellectuals" in the precise sense — i.e., "intelligent" and "sensitive" men of popularized or second-hand knowledge who are eager to take part in social transformations, and who act on the assumption that the rationality of society and its well-being are mutually interdependent and can be indefinitely advanced together.

The paradox of the Enlightenment is that its very successes in the following centuries somehow worked toward undermining its own founda- tions. Modern philosophy and science ended by denying their own ability (which they generalized into the ability of reason as such) to determine truth and to establish the rational standards of morality, and it is this generalized and popularized skepticism, still advanced in the name of the ideals of the Enlightenment, that had already begun to pervade the atmosphere in which Orwell lived. Thus, Marxism criticized as historically limited and conditioned all attempts at truth-seeking but itself; it debunked

"bourgeois" morality, as if that morality did not contain elements of intrinsic worth for all societies and all times. Utilitarianism also assisted in the debunking of patriotism, honor and religion. But both philosophies tried to withhold and protect from the debunking process those rational principles on which they themselves depended — until the time when these were subjected to the same fate. The plight of the intellectuals then became one of not knowing which rationalism to hold and to what extent: inasmuch as rationalism had replaced older, traditional codes as the very fabric of their lives, they now clung to it with religious fervor. Someone witnessing their plight, or foreseeing it, would be compelled to raise the question whether unlimited enlightenment was any more consistent with the well-being of individuals (*especially* intellectuals) and society than unlimited scientific technology. This is the question Orwell should have asked at that time, and almost did, but he was still too much a creature of the Enlightenment. Prior to *Nineteen Eighty-Four* it was on his lips; in *Nineteen Eighty-Four* he began to express it.

Orwell always tended to speak of good and bad emotions rather than virtues and vices. An emotion seems to have an obviously real status, whereas virtues and vices do not — unless they are understood as states of character, and hence as conditions of good or bad order in the soul. A man will have a duty to seek the truth or not to hurt others if these are required by something that is not an emotion. In the same way a man will have a duty to harbor certain loyalties and refrain from others. Patriotism, or devotion to one's fatherland, is a duty similar to filial devotion, and should only be permitted to lapse in the name of higher goods. But the good of humanity, taken at large, does not by itself supersede patriotism and may, in fact, be best fulfilled through patriotism. Everything depends on the desirability, and possibility, of having a single, universal society and government. The case must be argued. Honor, religion, even "leader-worship" would have to be treated in the same way. Honor, or the "code of the gentleman", is, in its highest manifestations, a way of combining duty and self-esteem. It is part of the honor of a gentleman that he will not lie, shirk battle, or betray a confidence — and these are not "feudal" but human requirements. They are assumed by Marxists to inhere in "the true Marxist" or "true friend of the proletariat"; they are assumed by the utilitarian to inhere in the "true friend of humanity and progress." They derive, then, from a relation between a person of high standards and his fellows, and the practical issue dividing the various positions in question is not whether it is right to be a gentleman (at least with respect to the above qualities), but only in relation to whom one ought to be one.

Another of Orwell's difficulties is that he tends to regard aggressiveness and love of power as traits that arise in men only when their natural needs

and capacities are not suited to one another. He assumes, with Marxism and other forms of liberalism, that if men are given a material condition of abundance and then let alone to make their own choices, they will satisfy their own nature and be happy. Goodness, then, is a natural growth, requiring little by way of positive social or moral or intellectual training; and it provides both for common and necessary patterns of social behavior and for individuality at the same time. This view has its roots in part of Rousseau's teaching but, as stated, was rejected by no one more thoroughly than Rousseau himself. For it is unlikely that aggressiveness and the love of power have no foundation in human nature. Nor can we presume such inclinations are completely bad: on the contrary, one of civilization's main problems is to give them a suitable form and place, rather than to quell them utterly. Properly disciplined, they are the source of much that is good and even noble, such as lofty ambition, spirited resistance to subjugation, and the "competitive instinct," however constantly their evil temptations must be guarded against. Men, then, are not simply good by nature. Art or training, following the indications of nature, must combine with nature to make them good.

VI. Increasing Pessimism

Almost unwaveringly, Orwell holds to the desirability of the Earthly Paradise and to its need for controlling technological advance in a manner appropriate to the full complement of man's needs. But he does waver considerably on the likelihood of its coming. Most of the time he maintains that both liberal socialism and the totalitarian slave state can produce stable social systems, and that both are equal possibilities. Sometimes he expresses confidence in the ultimate victory of a reasonable scientifically-planned society and of the common man.[20] Sometimes he is so struck by the increasing might of totalitarianism as to admit that "almost certainly we are moving into an age of totalitarian dictatorships — an age in which freedom of thought will be at first a deadly sin and later on a meaningless expression."[21]

The state of Orwell's thought toward the end of World War II can best be seen in his essay on Arthur Koestler and in *Animal Farm*. On the whole he admires Koestler, agreeing with him as to the desirability of the Earthly Paradise and sympathizing with his view that revolutions necessarily lead to something like the Russian system, that "all efforts to regenerate society *by violent means* lead to the cellars of the Ogpu."[22] The world since 1930 has given every reason for pessimism rather than optimism: things are getting much worse instead of much better. But he cannot accept Koestler's renunciation of revolutionary activity, which he traces directly to the

latter's inability to accept misery as an inherent and sizeable portion of human life.

> The real problem is how to restore the religious attitude while accepting death as final. Men can only be happy when they do not assume that the object of life is happiness. It is most unlikely, however, that Koestler would accept this. There is a well-marked hedonistic strain in his writings, and his failure to find a political position after breaking with Stalinism is a result of this.[23]

Orwell then proceeds to restate the need for revolution on the basis of this less sanguine view of human possibilities:

> Perhaps, however, whether desirable or not, it (the Earthly Paradise) isn't possible. Perhaps some degree of suffering is ineradicable from human life, perhaps the choice before man is always a choice of evils, perhaps even the aim of Socialism is not to make the world perfect but to make it better. All revolutions are failures, but they are not all the same failure. It is his unwillingness to admit this that has led Koestler's mind temporarily into a blind alley. . . . [24]

The use of "perhaps" in this passage unintentionally, but strikingly, testifies to the boundless confidence in social transformation characteristic of both Marxism and a certain brand of liberalism in the nineteenth and twentieth centuries. By contrast, patience in the face of ineradicable suffering is called a "religious attitude" rather than simple common sense. But Orwell's relinquishing the optimism of social-scientific hedonism and his belated concessions to common sense cannot consistently lead to a new revolutionary position if Koestler's analysis of the consequences of violent revolution is true, and Orwell had as much as granted its truth. If violent revolution must result in tyranny, no revolution is justified. This is probably why *Animal Farm,* published the following year, seems to accept Koestler's analysis *in toto. Animal Farm* has been widely interpreted as a satire on Russian Communism, and no doubt much of its material is based on the events of the Bolshevik Revolution. Nevertheless, the circumstances of the animal revolution for the sake of an Earthly Paradise are depicted in a quite generalized manner, as if to say that any violent revolution would in all probability end in tyranny. The whole point of the book is that revolutions bring to the fore men of ruthlessness and cunning whose moral defects lead them to seize upon opportunities for domination, and ultimately to establish a regime much worse than the one revolted against.

In Orwell's view the opposite of revolutionary activity is the conscious, pessimistic abstention from politics, or "quietism." In spite of his numerous injunctions against this kind of withdrawal, there are two important places where he shows sympathy for it. The first occurs in the essay "Inside the

Whale" (1940), where a survey of the development of English literature in his own lifetime is used in analyzing Henry Miller's novels. As Orwell sees it, Miller's quietism represents the human voice speaking in an age of disintegration, of growing totalitarianism, and ". . . in the remaining years of free speech any novel worth reading will follow more or less along the lines that Miller has followed."[25] The second instance is the sympathetic portrait of Benjamin the Jackass in *Animal Farm*. Benjamin is a morose and silent animal, intelligent, desirous of living long, and devoted to his friends Clover, Snowball, and Boxer, but he is entirely without optimism concerning the alleviation of suffering through any kind of political action and simply goes about minding his own business.

In his own life Orwell was never capable of remaining quiet. The year after "Inside the Whale" his strongest call to Socialist revolution was published, and later, in 1947, he refers to himself as primarily a "political writer," attempting in *Animal Farm* and its sequel (*Nineteen Eighty-Four*) to combine political opposition to totalitarianism and support for democratic socialism with artistic purpose. These later writings, in other words, may be viewed as efforts to disprove his earlier contention that only literature like Miller's was still conceivable in a pretotalitarian age. The ideal to which Orwell remains true was the one he found in the person of Charles Dickens, about whom he wrote (shortly before he wrote on Miller) that one imagines his face as that

> . . . of a man who is always fighting against something, but who fights in the open and is not frightened, the face of a man who is *generously angry* — in other words, of a nineteenth-century liberal, a free intelligence, a type hated with equal hatred by all the smelly little orthodoxies which are now contending for our souls.[26]

Even as late as 1948 Orwell insists that the intellectual, the writer, cannot keep out of politics in an age so politically turbulent and so inundated by political influence as the contemporary one. The material forming his own experience is largely determined by politics. In addition, his own freedom as a writer is at stake in the political battles of the day. Furthermore,

> we have developed a sort of compunction which our grandparents did not have, an awareness of the enormous injustice and misery of the world, and a guilt-stricken feeling that one ought to be doing something about it.[27]

Orwell therefore supports not only the writer's participation in politics but also his use of political subject matter in literary writings, provided that he constantly attempts to reveal the truth as he sees it, undistorted by the requirements of any political dogma whatsoever.

Broadly speaking, Orwell's thought develops, not without backslidings,

from an early confidence that political action can bring about socialism to a later despair concerning the possibility of even preventing totalitarianism from dominating the world. Regardless of its impracticability, however, the struggle to ameliorate human suffering must be maintained. But Orwell's pessimism seems almost as excessive as his original optimism — at least he has not sufficiently shown why universal totalitarianism is inevitable. In addition, his view of political obligation seems too broad, and his view of the purpose of politics too narrow. Not everyone has an obligation to alleviate human suffering he himself does not directly cause, nor is such alleviation the sole aim of politics. There are great and noble achievements to which men ought to dedicate themselves even if it means political noninvolvement; similarly, there are great and noble deeds within the scope of politics that do not aim at the reduction of suffering. Political life has a higher intrinsic dignity than Orwell accords it, and greater limits as well. But to see this one must transcend the doctrinaire elements in liberalism and Marxism that raise the priority or urgency of politics at the cost of sacrificing its elevation.

VII. On His Predecessors

Orwell's remarks about those of his immediate predecessors who wrote utopian or antiutopian novels or made large-scale predictions about the future are of great importance in understanding *Nineteen Eighty-Four*. The authors he mentions are H. G. Wells, Jack London, Hilaire Belloc, Evgeny Zamyatin, Aldous Huxley, and James Burnham. As we have already seen, he sides with Huxley against H. G. Wells's social-scientific hedonism. Both, however, are regarded as making fundamentally deficient predictions about the future of mankind. Instead of Wells's technologically based hedonism of free men or Huxley's technologically based hedonism of slaves, a brutal tyranny in the fascist and Communist style is probable.

Orwell's book review of Zamyatin's *We* (1946) is largely devoted to comparing it with Huxley's *Brave New World*.

> Both books deal with the rebellion of the primitive human spirit against a rationalized, mechanized painless world, and both stories are supposed to take place about six hundred years hence.[28]

Both picture a world in which happiness is achieved at the price of freedom, but Zamyatin's is "on the whole more relevant to our own situation," first, because such "primitive" or "ancient" human instincts as maternal feeling, sexual love, and the desire for liberty have not been removed from the population by scientific manipulation; second, because the motivation

attributed to the rulers is sounder. Whereas Huxley does not make this motivation clear (neither economic exploitation nor power-hunger seems to be their objective), Zamyatin does grasp "the irrational side of totalitarianism — human sacrifice, cruelty as an end in itself, the worship of a leader who is credited with divine attributes. . . ." Orwell concludes by noting that "what Zamyatin seems to be aiming at is not any particular country but the implied aims of industrial civilization," and that " . . . he had a strong leaning toward primitivism." In effect, *We* is " . . . a study of the Machine, the genie that man has thoughtlessly let out of its bottle and cannot put back again."

Whereas Huxley and Zamyatin write about a rather distant future, James Burnham describes the revolutions now occurring in Western civilization and is concerned with shorter-term trends. In an essay appearing a few months later than the above review, Orwell states his reactions to Burnham's outlook.[29] As he sees it, Burnham proposes a general Machiavellian view of the history of human societies, an interpretation of the present that accords with that view, and corresponding directives for action. All history is and must remain the history of class domination. All political rule must be oligarchical and must involve force and fraud. Promises of democracy and human brotherhood are meant only to lead the unpolitical masses into action for a cause not really their own. Today capitalism is doomed, and not free socialism but oligarchical, state-controlled "managerialism" of the Nazi and Communist kind is replacing it. A few such superstates will divide the world among themselves and then endure, and the only practical action is to cooperate with and guide this process.

Orwell agrees with Burnham that capitalism is disappearing and doomed, and that managerialism is on the rise "if one considers the world-movement as a whole." But he rejects the oligarchical law of history and the acceptance of the need for political immorality as distinguished from private morality. Modern technology makes possible the existence of a moral political order, a Socialist democracy, whereas in earlier times "class divisions were not only unavoidable, but desirable" for the progress of civilization. At the same time he denies that a Nazi or Communist oligarchy built on continuing force and fraud can last, arguing that "certain rules of conduct have to be observed if human society is to hold together at all," and that "slavery is no longer a stable basis for human society." He criticizes the "realism" of Burnham and the "managers," using the latter term to refer (at least in the English case) to "scientists, technicians, teachers, journalists, broadcasters, bureaucrats, professional politicians." These are the middling people who admire totalitarian success, power and cruelty and would like to share in it themselves. Burnham's moral defects ruin his forecasting

power by biasing him against democracy and in favor of totalitarianism. His fundamental error is an inability to realize that totalitarianism is wicked and should be fought to the death. Accordingly, his arguments against the possibility of democratic Socialism and his prediction of an inevitable, enduring tripartite oligarchical division of the world are badly in error.

It is somewhat disconcerting to see Orwell criticize Burnham for the thought that totalitarianism can endure, inasmuch as he did not find the same thought defective in Zamyatin, and had, in fact, frequently expressed it himself. As his treatment of Koestler has already revealed, he was at times given to impulsive reaction when some of his own basic premises were directly threatened. Koestler had jeopardized the desirability of revolution, Burnham both the desirability and possibility of the Earthly Paradise. But just as further reflection must have convinced Orwell to adopt Koestler's thesis in *Animal Farm,* so it must also have convinced him — and only shortly afterward — to adopt Burnham's analysis of history and forecast of the future in *Nineteen Eighty-Four.* Yet he refuses to accept the latter's Machiavellianism, and in fact writes to oppose, and help others oppose, the probable or inevitable spread of totalitarianism.

This concludes the survey of Orwell's main moral and political views prior to *Nineteen Eighty-Four.* We have noted certain philosophic shortcomings, some of the shifts in his thinking, and occasional inconsistencies. But there is a remarkable depth, steadiness and unity in the problems that perplexed him, and his most complex, most mature and final writing must be understood as an attempt to draw his questions and answers together into an intelligible synthesis.

Notes

1. George Orwell, *Such, Such Were the Joys* (New York: Harcourt Brace and Co., 1953), pp. 9–10.
2. George Orwell, "Lear, Tolstoy and the Fool," in *Shooting An Elephant* (New York: Harcourt Brace and Co., 1950), pp. 47–48.
3. Ibid., "Reflections on Gandhi," p. 98.
4. Ibid., "Politics vs. Literature: An Examination of *Gulliver's Travels,*" pp. 70, 71.
5. George Orwell, *The Road to Wigan Pier* (London: Victor Gollancz, 1937), p. 235.
6. Ibid., p. 241.
7. Orwell, *Such, Such Were the Joys,* p. 150-51. Previous quotation from *The Road to Wigan Pier,* p. 91.
8. *Tribune* (March 3, 1944), p. 10.
9. *Tribune* (January 11, 1946), pp. 10–11.
10. George Orwell, *Coming Up for Air* (London: Victor Gollancz, 1939), pp. 192–94.

11. Orwell, "A Good Word for the Vicar of Brag," pp. 166–70 and "Some Thoughts on the Common Toad," p. 165, in *Shooting An Elephant*.
12. George Orwell, *Dickens, Dali and Others* (New York: Reynal and Hitchcock, 1946), p. 190.
13. George Orwell, *The Lion and the Unicorn* (London: Secker and Wasburg, 1941), p. 35.
14. Orwell, *Dickens, Dali and Others*, p. 118.
15. Ibid., p. 123.
16. Orwell, *Such, Such Were the Joys*, p. 74.
17. Ibid., pp. 140, 141.
18. Orwell, *The Lion and the Unicorn*, pp. 44–50; *Such, Such Were the Joys*, pp. 74–75, 82, 86, 182–184.
19. Orwell, *Such, Such Were the Joys*, pp. 96–97; *Dickens, Dali and Others*, p. 221.
20. Orwell, *The Road to Wigan Pier*, p. 247–48; *Such, Such Were the Joys*, pp. 67, 142–43, 152, 197; and *Dickens, Dali and Others*, p. 120.
21. Orwell, *Such, Such Were the Joys*, p. 197.
22. Orwell, *Dickens, Dali and Others*, p. 195.
23. Ibid., p. 200.
24. Ibid., p. 201.
25. Orwell, *Such, Such Were the Joys*, p. 197.
26. Orwell, *Dickens, Dali and Others*, p. 75.
27. Orwell, *Such, Such Were the Joys*, p. 65.
28. *Tribune* (January 4, 1946), pp. 15–16.
29. Orwell, "Second Thoughts on James Burnham," in *Shooting An Elephant*, pp. 122–50.

Chapter Sixteen

Kesey and Vonnegut: The Critique of Liberal Democracy in Contemporary Literature

Michael J. Gargas McGrath

The ideal of individual autonomy has been a central value of American liberalism, especially in its conception of public revolt. Thomas Jefferson, whose ideas have become legendary in popular culture as well as political theory, remains the most significant proponent of legitimate revolt in the American tradition. Jefferson was convinced that no amount of government power could prevent legitimate insurrections. In an oft-cited letter written to James Madison in 1787, Jefferson proclaimed that rebellion in public affairs is a "medicine necessary to a good government" and that " a little rebellion now and then is a good thing and as necessary in the political world as storms in the physical."[1] In another letter that same year to William Smith, Jefferson wrote that in a free society rulers must be warned occasionally that common citizens will preserve liberty even if this requires violent public protest. Said Jefferson, "The tree of liberty must be refreshed from time to time with the blood of patriots and tyrants. It is its natural manure."[2]

Jefferson did not hold, however, that revolt was the only conduit for citizens to assert their wills in public action. He firmly believed that the heart of a free polity is an educated citizenry knowledgeable about public affairs, committed to the control of public officials at all levels of government, capable of conducting most public business in small, local government bodies, and dedicated to economic self-sufficiency. In Jefferson's political writings the basic values of liberal democracy appear again and again: popular sovereignty, natural rights, majority rule, and participation in public affairs are the natural principles of a free society. And, for Jefferson, education is the most practical way to guarantee the survival of

363

these principles. But whenever government fails in its responsibilities to free citizens, they have no other alternative but to overthrow it and erect another in its place. The purpose of public power is to enforce and protect each citizen's rights, and anything short of this charge is intolerable.

Since the turn of the century, but particularly in the last two or three decades, it has become commonplace for political scientists to emphasize the extent to which public life in America has changed radically since the age of Jefferson: an ever-expanding military-industrial complex, a powerful, centralized state, a prominent role in world affairs, and other well-known transformations of the American polity have rendered anachronistic those Jeffersonian ideals of liberal democracy in which the individual plays such a prominent role, especially the right of rebellion. This is not to suggest that Jefferson's ideals have been wholly absent from twentieth-century America — the activists of the 1930s and 1960s, for example, bore the stamp of Jefferson's commitment to participatory democracy, and Jefferson's hope for education has continued to underscore the rhetoric of modern liberals. In large measure, this trend is due to John Dewey, the most notable American liberal of this century, who shared Jefferson's high regard for an educated citizenry and participatory democracy. But like most liberals after him, Dewey rarely gave even lip service to Jefferson's claims for revolution; instead, he repeatedly emphasized the prudent adaptation of public institutions to the changing needs and values of citizens.

Not even John Kenneth Galbraith, the most prominent contemporary liberal, who so thoroughly examines those forces in American society that have undermined the virtues of liberal democracy, has much to say about legitimate revolt. Though he is concerned about the decline of citizen participation and control of public affairs in America, he seems to understand only too well how wrong Jefferson was when he insisted that legitimate insurrections would triumph over the most powerful of governments. In place of revolution, Galbraith himself proposes more education and more political muscle to the educational and scientific communities as the only hope for the renovation of responsible citizenship in American politics. And he does this after arguing that educational and scientific groups have become the handmaidens of corporate industry — the organizational force in American society which, according to Galbraith, is chiefly responsible for the death of liberal values in modern times.

This essay examines two literary portraits of public life in contemporary America that highlight the personal tragedies resulting from the loss of Jeffersonian ideals. The first work, Ken Kesey's *One Flew Over the Cuckoo's Nest*,[3] is a portrait of life in a mental institution that allegorically emphasizes the outmoded nature of Jefferson's values of individualism in contemporary society. The second book, Kurt Vonnegut's *Player Piano*,[4] is

a powerful indictment of modern liberals such as Dewey and Galbraith, who would try to renovate Jeffersonian ideals in America by supporting the "enlightened policies" of educators and scientists. Kesey's book, which captures the bureaucratic annihilation of liberal individualism in modern society, was first published in 1962, at a time when the Jeffersonian idealism of the mid-1960s was just beginning to surface in the civil rights movement, well before it was violently crushed in Chicago six years later. Vonnegut's volume, which vividly describes the triumph of corporate values in modern society, was first published in 1952 at the height of McCarthyism in America, when corporate industry was gripping its tentacles deep into the public values of most American citizens. Careful analysis of the main characters and themes of these works reveals a tragic view of contemporary political action, in particular the potential for revolutionary struggle to alter the power relationships of contemporary politics in America. But the understanding of public action that *Cuckoo's Nest* and *Player Piano* depict is more insightful than what modern liberalism has bequeathed to this century.

I.

Perhaps no other popular American novel in recent years has received so much exposure as Ken Kesey's *One Flew Over the Cuckoo's Nest*. The book's successful adaptation to stage and screen insured that its main themes and characters would become known even to those who do not typically read popular literature. The political messages of the novel are tied to the experiences of Kesey's hero, Randle Patrick McMurphy. McMurphy is a contemporary version of the American frontiersman, a rugged type of fellow whose boisterous assertiveness borders on arrogance. He enjoys wild parties, fast women, gambling, and an occasional brawl. McMurphy received a dishonorable discharge from the service for insubordination after having received the Distinguished Service Cross in Korea for leading an escape from a Communist prison camp. His civilian record lists a series of arrests for drunkenness, assault, battery, disturbing the peace, repeated gambling, and even one rape (a charge McMurphy insists didn't stick in court).

After one of his many arrests, McMurphy is sent to a mental hospital for rehabilitation. Soon after his arrival on the ward, McMurphy senses an authoritarian structure of power personified in the head nurse, Ratched. Kesey's narrative unfolds with a power conflict between McMurphy and Ratched: McMurphy constantly stirs his fellow patients to resist the nurse's unreasonable rules and practices, and the nurse fights McMurphy to insure that her control over ward politics remains viable. In the end McMurphy loses: he is lobotomized for attacking nurse Ratched after she goads a

patient (an insecure, stammering young man) to commit suicide because he slept with one of McMurphy's woman friends at an illegal ward party.

The story of McMurphy's plight unfolds through the eyes of Chief Bromden, who is described by one of the inmates as a "giant janitor, a vanishing American, a six-foot-eight sweeping machine scared of its own shadow." Kesey has the Chief feign a deaf-and-dumb state during most of the story because, as Bromden explains, no one can take him seriously as a contender for public power and values, and so he is left alone. The Chief chose this strategy after witnessing as a youth the destruction of his father's home and life-style by real estate agents and local public officials. They successfully forced his father and other Indians who fished for a living on an Oregon river to leave the land so that a power dam could be constructed to provide the energy needs of the region. The real estate people simply ignored his father's claims for just treatment, and ever since the Chief has lived with a loss of self-esteem and feelings of ineffectiveness, symbolized by his deaf-and-dumb state. He identifies the government as the "combine" and believes that its power is so pervasive that one simply cannot resist its demands, even if one's claims in public action are justified. Like most American Indians, the Chief has learned from experience that the combine is concerned not with justice, but with the expansion and maintenance of its power base. Ironically, the Chief's deaf-and-dumb charade, his own personal brand of public revolt, is the main reason for his incarceration.

Soon after the Chief's narration begins, the political motif of *Cuckoo's Nest* crystallizes around Kesey's critique of contemporary liberalism in our society. As with other social institutions in America, the ideology of the ward is rooted in liberal democratic values. Doctor Spively, the Chief Psychiatrist who starts to "squirm unless he's talking about his theory," assures all new patients that ward practices are derived from the "Theory of the Therapeutic Community." The goal of this community, the doctor explains, is a "democratic ward run completely by the patients and their votes." The intention of the staff is to make the ward "as much like your own democratic, free neighborhoods as possible — a little world inside that is a made-to-scale prototype of the big world outside." Steeped in liberal rhetoric,the psychiatrist talks at length about individual initiative and self-reliance as the two goals to which all patients should strive.

Chief Bromden leaves no doubt, however, that although the ward is indeed a microcosm of other institutions in American society, it hardly has anything to do with liberal individualism. After Doctor Spively concludes his ideological cant, the Chief muses that the ward is a "factory for the combine. It's for fixing up mistakes made in the neighborhoods and in the schools and in the churches." Individual rights and freedoms are always subordinated to the bureaucratic need for social order and control as

determined by Nurse Ratched. No wonder, then, that the Chief finds little difference between life on the outside and life in the ward. His powerless role as a janitor in the daily routines of the ward parallels the fate of American Indians throughout history. Understandably, the arguments of liberals such as Robert Dahl, who defends a pluralist model of public power in America, would not convince Chief Bromden. More likely, Dahl's claim that the normal political process in America insures "a high probability that an active and legitimate group in the population can make itself heard effectively at some crucial stage in the process of decision,"[5] would fall on the deafness of the Chief. Instead, Kesey is urging the reader to understand that minorities in American society are treated by bureaucratic officials with the same callous disregard for their rights that patients experience in our mental hospitals.[6]

Chief Bromden is not the only patient in Kesey's Cuckoo's Nest who reflects on the problematic nature of American liberalism. Another inmate named Pete symbolizes the plight of propertyless working-class people in American society. His opportunities outside of the ward were circumscribed by lower-class status, and the only reward he received for years of hard work was fatigue. Pete is judged to be insane because he refuses to continue with such a self-defeating existence; he prefers the security of the ward over the grand opportunities of the "free market." The ravings of Colonel Matterson, one of the psychotic inmates, focus on a side of American public life that would embarrass Jefferson. "The but-ter . . . is the Re-pub-lican party. "(Fat, expensive and slippery.) "The flag is . . . Ah-mer-ica."(Empty patriotism rather than a commitment to ideals) "America . . . is tell-ah-vision."(A major means of contemporary social control, and symbol of materialism and a life of consumptive pleasure.) And lastly, the cynical, oppressed intellectual among the inmates, Harding, describes the individual in American culture in language that would please any Social Darwinist:

> The world belongs to the strong my friend. The ritual of our existence is based on the strong getting stronger by devouring the weak. We must face up to this. No more than right that it should be this way. We must learn to accept it as a law of the natural world. The rabbits accept their role in the ritual and recognize the wolf as the strong. All of us here are rabbits — we'd be rabbits wherever we were — we're all in here because we can't adjust to our rabbithood. (p. 62)

Decision-making on the ward has little to do with the head psychiatrist's quixotic vocabulary of paticipatory democracy; rather, it reflects what Carole Pateman terms "pseudoparticipation," participation for the purpose of gaining acceptance of and thus legitimizing a decision previously

made by someone with power.[7] In keeping with the experiences of most American citizens, the decisions made by the patients on the ward are merely symbolic and have little bearing on crucial aspects of their lives. The principle of majority rule defended in Jefferson's writings and in Doctor Spively's talk about democratic neighborhoods is ignored whenever it even remotely threatens the policies established by ward authorities.

These antidemocratic features of ward politics are highlighted when McMurphy urges a change in the normal pattern of television viewing so that the patients can watch the World Series. During one of the group sessions a vote is taken on the issue, but the other patients are afraid to follow McMurphy's example and the motion is defeated. At another session McMurphy insists that a second vote be taken; but when this brings about the support of most of the inmates, Nurse Ratched rejects the vote, on the grounds that a majority decision is required by the democratic ward constitution and the chronics, who never participate in group sessions, haven't voted. But even after Chief Bromden's affirmative vote secures the needed majority, it is clear that the nurse will not tolerate anyone "who's free enough to foul things up right and left and constitute a threat to the whole smoothness of the outfit." She insists that the meeting is over, and the inmates are not allowed to watch the World Series after all.

Throughout the narrative McMurphy plays the activist role that so many American citizens took seriously in the sixties. He pushes the other inmates to accept responsibility for their own public destinies, to use the electoral process guaranteed by the ward constitution, and to insist that Nurse Ratched and other ward authorities respect the legitimacy of their demands. When he urges them to vote on a salient issue in ward politics, one inmate responds with a question shared by the others — What should they vote on? And McMurphy says, "Hell, I don't care. Vote on anything. Don't you see you can't let her take over completely. . . . You say the Chief is scared of his own shadow, but I never saw a scareder-looking bunch in my life than you guys."

But voter apathy signifies something more fundamental than a failure to use the voting privileges guaranteed by law. In the words of one political scientist, apathy "is a sign of alienation and frustration; it stands as evidence of an underdeveloped civic personality."[8] This is a fitting description of the deep feelings of resentment and cynicism that underlie Harding's query. "Vote on what my friend? Vote that the nurse may not ask any more questions in Group Meeting? Vote that she shall not look at us in a certain way?" Harding well understands that the voting rights of the inmates amount to so much rhetoric in light of the nurse's power in group meetings.

The meetings do nothing to foster the development of civic virtues and the sense of political efficacy that Jefferson cherished. Summarizing the

literature on political efficacy, Carole Pateman notes that "people who have a sense of political efficacy are more likely to participate in politics than those in whom this feeling is lacking and it has also been found that underlying the sense of political efficacy is a sense of general personal effectiveness, which involves self-confidence in one's dealings with the world."[9] But instead of self-confidence and the feeling that one's participation can indeed have an impact upon the political process, the therapeutic meetings foster hostility and low self-esteem. The patients are required to write down observations about one another's behavior, and they are encouraged to interrogate one another about embarrassing incidents and slips of the tongue. Worse yet, the patients believe that these meetings actually do have therapeutic value and are conducted for their own good.

Alan Wolfe defines ideological repression as "the attempt to manipulate people's consciousness so that they accept the ruling ideology, and distrust and refuse to be moved by competing ideologies."[10] The extent of ideological repression on the ward is evident when McMurphy openly criticizes the Big Nurse's tactics at the meetings by claiming that she is not helping the patients but harming them. Even though he eventually sides with McMurphy against the nurse, Harding, an inmate who is subjected to considerable abuse in one of the meetings, defends the nurse and all of her rules: "You completely disregard, completely overlook and disregard the fact that what the fellows were doing today was for my benefit. That any question or discussion raised by Miss Ratched or the rest of the staff is done solely for therapeutic reasons."

Even those patients who initially are inclined to agree with McMurphy's charges find themselves confronted with a kind of "Catch-22" dilemma. When McMurphy urges them not to answer the nurse's questions about their private lives at meetings, Scanlin points out, "If you don't answer her questions, Mack, you admit it just by keeping quiet. Its the way those bastards in the government get you. You can't beat it." Much like the poor in American society who are blamed for their own impoverishment, the inmates on Nurse Ratched's ward are told that their problems in coping with life are self-inflicted. In the words of Erving Goffman, this is part of the unsettling experience of "the moral career of the mental patient."

> Once lodged in a given ward, the patient is firmly instructed that the restrictions and deprivations he encounters are not due to such blind forces as tradition or economy — hence dissociable from self — but are intentional parts of his treatment, part of his need at the time, and therefore an expression of the state that his self has fallen to.[11]

Ratched's patients are stripped of their basic freedoms, including the two staples of modern life postulated by liberal ideology — personal dignity and material possessions. They are deprived of any privacy, their

environment is cut off from "normal" social relations, and their schedule is highly regimented. Such features of the combine are supposed to be for the patients' own good, but as one inmate aptly notes, " . . . the hospital is a vast efficient mechanism that would function quite well if the patients were not imposed on it." Ratched's Cuckoo's Nest has much in common with the slums of urban America, her patients with the poor in American society, her bureaucracy with bureaucracies everywhere.

II.

The two protagonists who vie for control of public values in this narrative, Nurse Ratched and Randle P. McMurphy, represent distinct, almost antithetical, perspectives on public action in modern life. Nurse Ratched is a model of bureaucratic efficiency, who prides herself in the smooth-running operation of the ward and who intends to maintain her order and power at all costs. She has a monopoly on public power to punish infractions of the rules and, "of course, she always wins. . . . She's impregnable herself." Chief Bromden offers a character portrait of the nurse that captures what typically escapes the models of bureaucratic efficiency in most social-science theories. She is nothing but a calculating machine, the Chief reflects, a robot who carries a bag that is "full of a thousand parts she aims to use in her duties today — wheels and gears, cogs polished to a hard glitter." When she's angry "she blows up bigger and bigger, big as a tractor, so big [you] can smell the machinery inside the way you smell a motor pulling too big a load." Her uniform is an extension of her personality; it has an impenetrable quality to it and even after half a day of work it "is still starched so stiff it don't exactly bend anyplace: it cracks sharp at the joints with a sound like a canvas being frozen."

Nurse Ratched surrounds herself with the best bureaucratic assistance. Her three black orderlies, for example, are recruited for their ability "to hate enough to be capable" of the enforcement of ward politics. And hate they do, carrying out the Nurse's orders with relish and excess. Yet not even they escape the discipline and order the Nurse demands in the ward; she acts with the firm conviction that everyone, including her immediate subordinates, "must follow the rules."

"Ya know, Ma'am, that's the ez-act thing somebody always tells me about the rules just when they figure I'm about to do the dead opposite" is McMurphy's reply to the nurse's first amendment. McMurphy is Kesey's heroic rebel in the narrative — a role designated by his shorts "covered with big white whales. . . . From a coed at Oregon State. . . . She gave them to me because she said I was a symbol." Yet McMurphy is no less enigmatic than

Melville's whale. His actions often betray a selfish bent to his character: he obtains a room so that the patients may enjoy more leisure activities but he uses the room for gambling with the inmates and takes their promissory notes with ease; he even takes the inmates on a boat trip in order to make some money. After Mack plays out a winning streak in a card game, Harding says, not inappropriately, "Let's be honest and give this man his due . . . I feel compelled to defend my friend's honor as a good old red, white and blue, hundred-percent American conman."

At times McMurphy's actions suggest little more than sheer "ego-tripping." During his first week on the ward, for example, McMurphy bets all the IOUs he won playing poker that he can lift a steel control panel that is bolted securely to a cement floor. "Everyone knows that he can't lift the panel, so they bet, but he's beat them so many times at poker and blackjack they can't wait to get back at him; and this is a sure thing." After losing the bet, McMurphy proclaims proudly, "I tried though. . . . Goddammit, I sure as hell did that much now, didn't I?

Yet, however much McMurphy's actions are self-centered, there is no denying that most of his arguing and fighting with Nurse Ratched is for the good of the patients. He urges them to take more responsibility for their lives; he stands up for them when they are bullied by the nurse or her orderlies, even when this results in physical punishment such as electric shock; and he provides them with a model of civic virtue that has a significant impact on their conduct in group meetings. After a few short weeks of McMurphy's presence, the inmates start to gripe publicly about things that "had already changed . . . the guys started letting fly at everything that had ever happened on the ward they didn't like." And in the end, when McMurphy attacks Big Nurse after Billy's suicide, Chief Bromden understands that it

> wasn't the nurse that was forcing him, it was our need. . . . It was us that had been making him go on for weeks, keeping him standing long after his feet and legs had given out, weeks of making him wink and grin and laugh and go on with his act long after his humor had been parched dry between electrodes (p. 302).

Kesey says of Randle Patrick McMurphy, "Yes McMurphy was fictional, inspired by the tragic longings of the real men I worked with on the ward, the sketches of whom, both visual and verbal, came more easily to my hand than anything before or since, and these sketches gradually enclosed for me the outline of the hero they wanted." Confronted daily with oppressive bureaucratic power, people understandably will long for a rebel leader who can realize the demands of Jefferson's model of public revolt.

III.

Kesey's critique of liberalism is harsh and his views on the potential for public revolt in America are less than sanguine, but he is not a thoroughgoing pessimist. Employing the absurdist technique, Kesey exaggerates the deficiencies of liberal democracy, often making the reader feel that the authoritarian denial of individual rights and freedom simply is not as extensive in contemporary America as on Nurse Ratched's ward. For example, when Kesey develops the theme of pseudoparticipation in American politics, he pictures the inmates as not even having control over their work responsibilities or their dining hours. Even toothpaste and cigarettes are distributed according to Nurse Ratched's instruction, and all patients, including those who do not eat breakfast, must remain in the breakfast room in the morning until a designated time. The "moral careers" of American citizens may be less than ideal, but they have not yet degenerated to the "moral careers" of mental patients. Nonetheless, even though life on the outside could be much worse, Kesey rejects Dahl's complacent pluralism, believing that the denial of liberal values in the Cuckoo's Nest has too many parallels with what Dahl terms the "normal political process in America."

At first glance it might appear that McMurphy's demise at the hands of Nurse Ratched reveals an unmitigated pessimism in Kesey's thoughts about public revolt. But the author's theme on rebellion is qualified with a defense of the *individual* merits of McMurphy's actions. On the one hand, he is emphasizing how hopeless it is to expect revolt to bring about fundamental changes in the structural distribution of power in modern society. According to Kesey, those with public power are so firmly entrenched that even the most well-organized resistance or the most tenacious individual commitment is bound to fail. On the other hand, though, Kesey is arguing that legitimate revolt, directed at alleviating the suffering of others, is intrinsically valuable because it provides the rebel with a moral purpose in public action that is rarely attained these days. Furthermore, Kesey believes that even though public revolt like McMurphy's may have little bearing on structural relations of power, it is not likely to leave things completely the same.

Nurse Ratched's power base is not destroyed because of her conflicts with McMurphy, but her terrified look when Mack physically attacks her reveals that she knows she has met her match, for here is a citizen who will not even succumb to the threat of public death. After spending a week away from the ward to recuperate from her injuries, the nurse returns looking pale and nervous, and she is unable to manipulate the inmates as before. Each patient is more at ease with himself, and none respects her. Eventually

they all either transfer to another ward or leave the hospital altogether. And though those who leave will not enter a public situation that has changed in any fundamental way because of McMurphy's commitments, they will carry a better sense of personal identity and they will be better able to cope with perverse public power.

Once again, the Chief communicates Kesey's theme. Shortly before McMurphy attacks the nurse, the Chief reflects, "The thing he was fighting, you couldn't whip it for good. All you could do was keep on whipping it till you couldn't come out any more and somebody else had to take your place." The Chief indeed takes McMurphy's place in dealing with Nurse Ratched. She returns to the ward keyed for one final triumph over McMurphy. Several weeks later, "the black boys wheeled in this gurney with a chart at the bottom that said in heavy black letters, McMurphy, Randle P., Post-Operative. And below this was written in ink, lobotomy." The inmates refuse to believe that the public vegetable claiming McMurphy's name is him. "Aah, what's the old bitch tryin to put over on us anyway," exclaims one of the patients, "for craps sakes. That ain't him." But the Chief's main concern is how, precisely, McMurphy would handle the nurse's move. McMurphy, thinks the Chief, "wouldn't have let something like that sit there in the dayroom with his name attached to it for twenty or thirty years so the Big Nurse could use it as an example of what can happen if you buck the system." That night Chief Bromden smothered McMurphy with a pillow until his body was still "a while and had shuddered once and was still again." Later, the Chief tore from its bolts the steel control panel in the ward and threw it through a window opening out to his escape. And as the Chief runs to freedom one can't help remembering what McMurphy cried out when he failed to lift that same control panel during his very first week on the ward, "I tried, but I tried though. Goddammit, I sure as hell did that much, didn't I?"

IV.

One of the dominant themes in the analysis of contemporary political economy is how much machines have replaced crude manpower in modern industry and how increasingly they are replacing the higher forms of human intelligence. In Illium, New York, a microcosm of the technocratic world that Kurt Vonnegut portrays in *Player Piano,* this trend has fully matured during the onslaught of the Third Industrial Revolution. Large mechanized factory centers are responsible for the production of all material goods: The machines produce better goods for more people than their human predecessors and do it 24 hours a day. Agriculture and most crafts are also controlled by the machines. Even the professional ranks of

lawyers, doctors and teachers have been decimated by computers.

Because the economy of Vonnegut's Illium no longer needs manual laborers or much brain power, there are few functional jobs remaining for humans to fill, and the only important positions are those tied to the machines. Managers, supervisors, engineers and other technical specialists constitute the membership of Illium's elite. There is no mistaking the organizational resemblances of this group to the technostructures that dominate our economy, those "associations of men of diverse technical knowledge, experience or other talent which modern industrial technology and planning require . . ." and which extend "from the leadership of the modern industrial enterprise down to just short of the labor force."[12] According to John Kenneth Galbraith, all important decision-making in modern industry emanates from the technostructure, and its consolidation of power has shifted control of the corporation away from the capitalists and stockholders. The expertise and knowledge requisite for large-scale corporate decisions, says Galbraith, effectively shields technocratic elites from interference by the firms' owners or by the state.[13] In *Player Piano,* Vonnegut animates this feature of corporate power as it matures in post-industrial America. Illium's technostructure is not simply protected from outside interference; it has become an autonomous public elite planning for and controlling the lives of all citizens. Not surprisingly, the Jeffersonian ideals of responsible citizenship and participatory democracy do not fare well in this environment. In Vonnegut's Illium, New York, human autonomy is a relic of the past.

Because machines have made manual labor anachronistic, the only blue-collar work forces in Illium, the Army and the Reconstruction and Reclamation Corps (the "Reeks and Wrecks"), do next to nothing. The technostructure's monopoly of mechanized public violence has rendered the Army impotent. As one citizen of Illium reflects: "These kids in the army now, that's just a place to keep 'em off the streets and out of trouble because there isn't anything else to do with them." And those in the ranks of the Reeks and Wrecks perform trivial maintenance tasks that leave them too much time to stand around and bemoan their plights.

When the commoners of Illium are not exhausting idle hours in these pursuits, they spend leisure time in mechanized recreation, especially watching television. Television, though, is the major vehicle for selling Illium's populace the following message: the average citizen is happy and fulfilled, but the rigorous demands of organizational know-how and computer planning make life for the technocrats difficult and trying.

Unfortunately, life for Illium's average citizen is not without its shortcomings. Even though the economy is automated, and the material desires of all citizens are satiated, their beliefs are still geared to the

traditional work ethic, a point about which more is said below. The commoners, moreover, are required to deposit 80 percent of their yearly income back into the system for more "products for better living," and consumer sovereignty is limited to purchases of some food, beverages, cigarettes, and a few other commodities that are either necessary for survival or addictive in nature. Additionally, the average citizen must tolerate the condescending paternalism and smug mannerisms of the technocrats, who believe that the commoners have reaped significant harvests from the postindustrial revolution and look at them with "the same sort of sentiment felt by most for the creatures of the woods and fields."

Yet, however drab is the commoner's life in Vonnegut's world, elite status is no guarantee of immunity from the hardships and insecurities of the Third Industrial Revolution. Bud Calhoun, for example, one of the top managers in Illium, loses his job to a machine he designed and can't find another position anywhere in the technostructure. A computer informs another technocrat, who is fired from a top managerial position, that he has lost all social and economic privileges. Not even E. J. Halyard, Manager of the U.S. Dept of State, is free from a computer's harsh judgment. He is stripped of all influence and rank because a machine audit finds that he failed to meet a physical education requirement for a B.A. degree at Cornell, thereby making him ineligible for his advanced degrees and his post at the State Dept.

On the whole, though, the elites of Illium benefit from the most important cultural norm of postindustrial America — the maximization of economic efficiency in the production and distribution of goods. After all, the technocrats are responsible for the "dizzy heights" of American culture measured, for example, by production of "93% of the world's electrostatic dust precipitators." Much like their counterparts in contemporary America, Illium's elites are driven by a sense of spiritual importance in what they are doing, and "moved emotionally, almost like a lover, by the great omnipresent and omniscient spook," the corporation. And they share with corporate management in contemporary America the belief that

> the ordinary individual encounters, in the ordinary course of business, a thousand times a year. Things are better because production is up. There is exceptional improvement because it is up more than ever before. That social progress is identical with a rising standard of living has the aspect of a faith. No society has ever before provided such a high standard of living as ours, hence none is as good.[14]

It is common in the literature on postindustrial society to ignore government institutions, on the assumption that the administration of

things will soon replace the governing of man. But few scholars agree on just who will direct the administration of things. For Vonnegut, however, there is no question that the postindustrial technostructure will control public administration, and Jean Maynaud's observation that "the overall effect of technocracy is to compromise business and politics"[15] will be something of an understatement. Vonnegut's scenario for this development occurs after a great war during the embryonic stages of the Third Industrial Revolution, when the technocratic elites who dominated American society simply overwhelmed the military and consolidated public power. In *Player Piano* public decision-making is the exclusive domain of the National Industrial, Commercial, Communications, Foodstuffs and Resources Board, a rather august body in the technostructure's hierarchy that was first chaired by a prominent hero of the Second Industrial Revolution. But the real brains of the conglomerate is Epicac xiv, a computer that the technocrats hold in awe as the "greatest individual in history. . . . The wisest man that ever lived was to Epicac xiv as a worm was to the wisest man." The elites believe that this computer advances the cause of justice for all, because it considers simultaneously hundreds or even thousands of sides of a question "utterly and rationally . . . wholly free of reason-muddying emotions."

Vonnegut believes that in a society so dominated by technocratic values government will become a mere appendage of the public relations profession, specializing in the "cultivation, by applied psychology in mass communication media, of favorable public opinion with regard to controversial issues . . . without being offensive to anyone of importance, and with the continued stability of the economy and society as its primary goal." Political parties, interest groups and responsible congressional leaders — all staples of contemporary liberal politics — do not even receive lip service in postindustrial Illium. As Vonnegut explains, "Just as religion and government had been split into disparate entities centuries before, now, thanks to machines, politics and government live side by side but touch almost nowhere." So far removed is Illium from the traditional side of American liberalism that an engineer imagines with horror what the public situation must "have been like when . . . any damn fool little American boy might grow up to be President, when the President actually had to run the country."

V.

Like everything else in postindustrial America, education serves the machines. Universities are organized entirely around an engineering curriculum that provides the technostructure with personnel and allows no

room for intellectual autonomy. As a consequence, education is devoid of scholarly and humanistic content, and a college degree has become a meaningless symbol of social status. Every college graduate receives an "achievement and aptitude profile" along with a quite useless and unimportant "sheepskin." The profile is an integrated graph of the student's grades and other performances that is translated into perforations on each technocrat's personal card. Anyone who aspires to a white collar job, including, for example, real estate salesmen, must earn a Ph.D. in order to qualify for the position. Even the head football coach at a typical American university is a "Doctor."

Long before contemporary scholars published books arguing that American education reproduces inequality by justifying privileges,[16] Vonnegut showed why education would likely do little, if anything, to facilitate social mobility in technocratic societies. Although access to the technostructure in Illium is indeed not predicated on wealth but on I.Q., the mechanisms for testing intellectual ability feed directly into a static system of social stratification. The general Classification Tests taken shortly after graduation from high school are, when computed with one's I.Q., the criterion for entrance into college, but this criterion itself has become an insidious form of discrimination because no one can change these early testing results after they are put on computer tapes. And testing results correlate highly with socioeconomic status. "I'm no good to anyone in this world," says Edgar Hagstrohm, a typical worker in the R & R Corps, "Nothing but a Reek and Wreck, that's all my kids'll be."

For those not fortunate enough to be admitted to college there are no remaining options but service in the Army or the Reconstruction and Reclamation Corps, both involving a life of drudgery and despair that often leads to suicide. In player piano society, passing the precollegiate exams has replaced lucrative salaries in the dreams fathers have for their children. But as the outspoken chaplain of the Reeks and Wrecks notes: "The smarter you are, the better you are. Used to be that the richer you were, the better you were. Either one is, you'll admit, pretty tough for the have-nots to take."

The arts share the fate of education in postindustrial Illium: they are not spared the mechanistic corruption of the Third Industrial Revolution. But when one of Illium's most prominent technocrats is told that the arts have atrophied, he indignantly replies: "Not with all his gold and armies could Charlemagne have gotten one single electric lamp or vacuum tube. . . . Don't tell me art is dying!" Cultural pursuits are cheap in every respect as picture clubs reproduce the work of famous artists on a mass scale and prints cost less than home insulating materials. "It's the golden age of art," says a State Department official, "with millions of dollars a year poured

into reproductions of Rembrandts, Whistlers, Goyas." Books are pub-
lished with an eye toward mediocrity and are promoted by mass appeal
tests, readability norms and wholesome, noncontroversial themes. A
national best seller examines the history of clipper ships on the Erie Canal.

As one might expect, culture in Illium has little relevance to artistic
creativity, a theme of *Player Piano* that is highlighted in a heated exchange
between a State Department official and a writer's wife. She is pleading
with the official for her husband's right to publish even though the
computers have decided that he is not qualified. Unfortunately, her
husband's book fails to comport with the guidelines established by the
National Council of Arts and Letters, a clearing house for all publications
in America. His book is 27 pages over the maximum length and its
readability quotient is six points above the norm, so not one of the twelve
national book clubs will consider it. The manuscript, moreover, has an
"anti-machine theme, something that would classify any writer dangerous-
ly close to sabotage." "What's his classification number?," the official asks
of the writer's wife. "That's just it. He hasn't one." "Then how can you call
him a writer?," asks the official. "Because he writes," is her response. "My
dear girl," responds the official paternally, "on that basis we're all writers."

VI.

If Vonnegut's claims about the state of education and the arts in
postindustrial society are on target, then the modern liberal's faith in the
academic and scientific estates is hopelessly misplaced. *Player Piano*
disputes liberals such as Dewey and Galbraith who believe that education
promotes the liberal virtues of skepticism, autonomy, and pluralism, that it
encourages growth of the entire personality, and that it defends values that
"serve not the production of goods and associated planning, but the
intellectual and artistic development of man."[18] Vonnegut's narrative
underscores the corporate dominance of education and the arts. Ironically,
one would expect Galbraith himself to agree with the Shah of Bratpher, a
visitor to Illium from a preindustrial society who asserts that Americans
are enslaved by machines and that Epicac xiv is a false god because it
cannot answer the most profound human question, What are people for? In
a book published only a decade ago, Galbraith warned: "We are becoming
the servants in thought and action of the machine we have created to serve
us. This in many ways is a comfortable servitude," but it results in economic
goals having "an undue monopoly on our lives and at the expense of other
and more valuable concerns."[18] Galbraith's sobering comments are far
removed from Dewey's proclamation earlier in this century that liberal
society "will make possible effective liberty and opportunity for personal

growth in mind and spirit in all individuals. Its present need is recognition that established material security is a prerequisite of the ends which it cherishes, so that, the basis of life being secure, individuals may actively share in the wealth of cultural resources that now exist and may contribute . . . to their further enrichment."[19]

However much Galbraith's observation is a fitting description of Vonnegut's technocratic society, the humanistic side of modern liberalism is not wholly absent from Illium. There emerges among Illium's population widespread alienation and unrest that eventually crystallizes in the Ghost Shirt Society, a revolutionary organization dedicated to overthrowing the technostructure and destroying all machines. The Society's membership believes that the machines have taken all the jobs "where a man could be true to himself and false to nobody else" and left all the silly ones for the common citizens, and that people have no choice "but to become second-rate machines themselves, or wards of other machines."

The main goal of the Society is to realize the "promise of regaining the feeling of participation, the feeling of being needed on earth — hell, dignity." Von Neuman, a coconspirator in the Society, expresses hope that revolt will lead to the rediscovery of the "two greatest wonders of the world, the human mind and hand," and that this will bring about widespread reemployment of the human element in economic production. Even Paul Proteus, son of one of the most respected leaders of the Second Industrial Revolution, converts to the Society's ideology, recognizing that "in order to get what we've got . . . we have, in effect, traded these people out of what was the most important thing on earth to them — the feeling of being needed and useful." Paul's summary of the Society's values reads like a litany of Jeffersonian principles in a technocratic age.

> The sovereignty of the United States resides in the people, not in the machines, and it's the people's to take back, if they wish. The machines . . . have exceeded the personal sovereignty willingly surrendered to them by the American people for good government. Machines and organization and pursuit of efficiency have robbed the American people of liberty and the pursuit of happiness. (p. 298)

When Paul is eventually arrested and put on trial for treason, the Society's revolt is unleashed behind a thundering Luddite determination to destroy every machine in Illium. But as Vonnegut's narrative draws to a close, it is evident that the revolution is doomed to failure. After the elites have been driven from the city, the machines destroyed, and barriers erected to seclude Illium from the outside world, the remaining citizens find themselves helplessly at the mercy of a technocratic albatross they had set out to destroy. Their first "postrevolutionary" public act is to labor

shamelessly to rebuild the machines. But Calhoun, who lost his job to a machine he had designed, works feverishly behind the urging of his comrades to fix the dispenser of an orange drink that only the National Director of the technostructure can stomach. After the machine is fixed, the people applaud and line up for their Orange-O. "The first man up emptied his cup, and went immediately to the end of the line for seconds" — a rather undignified burial for the humanistic side of liberalism in postindustrial society.

Cognizant that the revolt has failed, Paul Proteus asks of Lasher, a leader of the revolution, "If we didn't have a chance, then what on earth was the sense of it . . . ?" To which Lasher replies, "It doesn't matter if we win or lose, Doctor. The important thing is that we tried. For the record we tried."

VII.

For the last decade and a half scholars from various disciplines have been interested in the topic of postindustrial society, and they have speculated about the conception of man that will, or should, be central to political ideology in postindustrial life. There is now a substantial body of literature dealing with this subject, and, although there is little agreement on a host of issues surrounding it, many scholars contend that the postindustrial world will embody a "postbourgeois" belief system. Samuel Huntington,[20] e.g., one of the few political scientists to address this topic, holds that postindustrial man will be committed to a postbourgeois value structure "concerned with the quality of life and humanistic values" in contrast to the inner-directed work ethic of contemporary society. But noticeably absent from Huntington's analysis is an account of what this "postbourgeois value system" implies for public action. Rather, one's attention is drawn to a number of incipient trends in postindustrial life inferred from the American experience since World War II: the shift from a predominantly industrial to a predominantly service economy, an increased number of white collar jobs and workers, rising levels of formal education, and so on *ad nauseam*. Such lists of sociological developments have become tediously familiar in this literature, but they do not provide a solid foundation for the conception of postbourgeois values that scholars such as Huntington promise.

It does not help to argue, as Huntington does, that politics will be the "darker side" of postindustrial life, ridden with tension and strife, emotional frustration and irrational impulse, or to suggest that post-industrial values will be the product, not of ideology, but of the social processes that lead to a postindustrial world. For one must immediately ask: Who will direct and control the transition to postindustrial society?

What will be the values and goals of the postindustrial elites who manipulate public resources?

To these questions, Kurt Vonnegut responds in *Player Piano* with a pessimistic view of modern man and science that challenges the sanguine prophecies embedded in the liberal tradition. In explaining his cynicism about claims that scientific discoveries guarantee human happiness, Vonnegut has said: "[S]cientific truth was going to make us *so* happy and comfortable. What actually happened when I was 21 was that we dropped scientific truth on Hiroshima. . . . Maybe pessimism is the thing."[21] Vonnegut puts no stock in the contemporary liberal's hope that man can humanize the machines, because he finds that the machines have so thoroughly mechanized man. More importantly, Vonnegut argues that the prospects for any fundamental change in cultural values that would reverse this trend is simply not likely to occur through liberal democratic politics or revolutionary action. Vonnegut's views on these matters reflect a keen appreciation of industrial man's love/hate feelings toward machines and mechanized life. Throughout his narrative, individuals from all socio-economic strata are alienated by, but ensnarled in, the mechanized labyrinth they helped to create. Even workers for the Reeks and Wrecks long to use their mechanical skills in productive work. Vonnegut understands that the mechanical ingenuity of industrial man is responsible for the ever increasing role of machines in our daily lives, machines that render human worth and importance so many nostalgic memories in postindustrial society. Furthermore, as Bud Calhoun's experience illustrates, not even revolutionary struggle in postindustrial society will likely conquer the mechanization of human existence. Calhoun, it will be recalled, lost his job to a machine that he designed, but after the revolutionary struggle in Illium came to a halt, he worked to the applause of his comrades to fix the Orange-O dispenser that the Luddite violence in Illium had smashed.

According to Vonnegut, therefore, the postindustrial individual will not likely reach out to embrace the humanistic postbourgeois side of modern liberalism; he will be too preoccupied with a self-defeating struggle against the mechanical world of his industrial predecessor. This is, indeed, the tragic theme that permeates *Player Piano*. Even more tragic, however, is the possibility that we may be closer to this fate than we realize.

IX.

At first glance, it might appear that neither *Cuckoo's Nest* or *Player Piano* concludes with any concrete recommendations to remedy the quite bleak portrait of contemporary public life in America that they present. The heroes in both narratives fail when they attempt to transform through

public revolt the dehumanizing power relationships that Kesey and Vonnegut identify as the plight of modern man. The authors seem to agree that it is important to rebel against social injustice and alienation, but that revolutionary struggle is no match for the "powers that be." As the preceding analysis of these books has highlighted, however, Kesey is not quite as pessimistic as Vonnegut about the possibilities of effective revolt against autocratic public power.

True, Kesey's hero, R. P. McMurphy, is reduced by his protagonist to a lobotomized vegetable, a shadow of his former self who was dedicated to advancing the needs and well-being of his fellow inmates against Ratched's oppressive and indecent exercise of power. But one must not forget that, unlike Vonnegut's rebellious citizens of postindustrial Illium, who have internalized the mechanized life against which their rebellion is directed, McMurphy's heroic resistance to Ratched has a salutary influence on most of his mates on the ward. McMurphy bequeaths to them a sense of self-respect and public awareness that Ratched is unable to destroy, even after she has McMurphy silenced. His friends do not regress to their former dependence on, or acceptance of, Ratched's authoritarian style. In the end, McMurphy loses his life, but Ratched loses one of the most important struggles of modern times — the battle to influence the values of ordinary people through praiseworthy action. This may only approximate Jefferson's model of liberation through revolt, but perhaps it is the best that we can do.

One must hope, therefore, that in the real world of power politics Kesey's artistic vision is a more reliable guide to action than that of Vonnegut's. In large measure, this will depend on whether or not we, the readers of these books, have the capacity to embrace the decency and courage of Randle P. McMurphy while avoiding the seductive appeal of Bud Calhoun's addiction to machines. No doubt we are confronting this dilemma in our daily lives, but it is a dilemma that we must confront through action, not artistic vision.

Notes

1. Edward Dumbard, ed., *The Political Writings of Thomas Jefferson* (Indianapolis: Bobbs-Merrill, 1955), p. 67.
2. Ibid., p. 69.
3. Ken Kesey, *One Flew Over the Cuckoo's Nest* (New York: Signet, 1962).
4. Kurt Vonnegut, *Player Piano* (New York: Avon Books, 1952).
5. Robert Dahl, *A Preface to Democratic Theory* (Chicago: University of Chicago Press, 1956), p. 145. Dahl amplifies his claim with a point that makes little sense in light of the treatment of American Indians in our society. "When I say that a group is 'heard' effectively I mean more than simply that it makes a

noise: I mean that one or more officials are not only ready to listen to the noise, but expect to suffer in some significant way if they do not placate the group, its leaders, or its more vociferous members."

6. The treatment of patients in mental hospitals is discussed in Erving Goffman, "The Moral Career of a Mental Patient," in *Asylums: Essays on the Social Situation of Mental Patients and Other Inmates* (Garden City, N.Y.: Anchor Books, 1961), pp. 125–71, and Lara Jefferson, *These Are My Sisters: a Journal from the Inside of Insanity* (Garden City, N.Y.: Anchor Books, 1975).

7. Carole Pateman, *Participation and Democratic Theory* (London: Cambridge University Press, 1975), pp. 68–73.

8. David Ricci, *Community Power and Democratic Theory* (New York: Random House, 1971), p. 198.

9. Pateman, *Participation,* p. 46.

10. Alan Wolfe, *The Seamy Side of Democracy: Repression in America* (New York: David McKay, 1974), p. 171.

11. Goffman, *The Moral Center,* p. 135.

12. John Kenneth Galbraith, *The New Industrial State* (New York: New American Library, 1971), p. 72.

13. Ibid., chap. 6.

14. Ibid., p. 167.

15. Jean Maynaud, *Technocracy,* trans. Paul Barnes (New York: Free Press, 1969), p. 185.

16. See, for example, Samuel Bowles and Herbert Gintis, *Schooling in Capitalist America* (New York: Basic Books, 1976).

17. Galbraith, *New Industrial State,* chap. 15.

18. Ibid., p. 53.

19. John Dewey, *Liberalism and Social Action* (New York: Capricorn Books, 1963), pp. 56–57.

20. Samuel Huntington, "Postindustrial Politics: How Benign Will It Be?," *Comparative Politics* (January, 1974), pp. 163–91.

21. Jerome Klinkowitz, ed., *The Vonnegut Statement* (New York: Delacorte, 1973), chap. 2.

Contributors

BENJAMIN R. BARBER is professor of political science at Rutgers University, editor of *Political Theory: An International Quarterly,* and a John Simon Guggenheim Memorial Foundation Fellow for 1980-81. His books include *Strong Democracy* (forthcoming), *Liberating Feminism* (1975), *The Death of Communal Liberty* (1974) and *Superman and Common Men* (1971). His plays have been seen off Broadway in New York, at the Hopkins Center (Dartmouth) and at the Berkshire Theater Festival. He wrote lyrics for the Martin Best album *Knight on the Road,* and he contributes articles and reviews to *The New Republic, Harper's* and other journals. His first novel, *Marriage Voices,* has just been published.

MARSHALL BERMAN teaches at City College and the Graduate Center of CUNY. He has written extensively on social thought, cultural history, and urbanism. He is author of *The Politics of Authenticity* and the forthcoming *All That Is Solid Melts into Air,* a study of modernist culture and modernization, from which his essay was adapted.

RICHARD H. COX is professor of political science, State University of New York at Buffalo. He is the author of *Locke and War and Peace* and the editor of two volumes: *The State in International Relations* and *Ideology, Politics and Political Theory.* Professor Cox's scholarly essays have appeared in edited volumes such as *A History of Political Philosophy* (eds. Leo Strauss and Joseph Cropsey) and *Nomis VI* (eds. C. J. Frederich and J. Chapman) and in journals such as *Social Research.*

PAUL DELANY is professor of English at Simon Fraser University. A former Canada Council Fellow and Guggenheim Fellow, he is the author of *British Autobiography in the Seventeenth Century* and *D.H. Lawrence's Nightmare: The Writer and His Circle in the Years of the Great War.*

MORRIS DICKSTEIN is professor of english at Queens College and at the Graduate Center of the City University of New York. He is the author of *Keats and His Poetry* and *Gates of Eden: American Culture in the Sixties,* which was nominated for a National Book Critics Circle Award in criticism in 1978. With Leo Braudy he edited *Great Film*

Directors, and he writes regular film criticism for the *Bennington Review* and *American Film.* He has been a contributing editor of *Partisan Review* since 1972 and has been awarded fellowships from the Guggenheim Foundation, the American Council of Learned Societies, and the Rockefeller Foundation. He has taught at Columbia and served as visiting professor of American studies at the University of Paris (Vincennes).

SAMUEL H. HINES, JR. is associate professor of political science, College of Charleston, and editor of *South Atlantic Urban Studies.* His scholarly essays have appeared as chapters in *Legislatures in Plural Societies* (ed. Albert Eldridge) and *Aspects of Development* (ed. S. K. Sharma) and in scholarly journals such as *Comparative Political Studies.*

JAMES R. HURTGEN is associate professor of political science at the State University of New York at Fredonia. Professor Hurtgen has received the Chancellor's Award for Excellence in Teaching and a National Endowment for the Humanities grant. He was the founder and first director of SUNY's Albany Semester Program in 1978-80.

DAVID LOWENTHAL is professor of political science at Boston College. His scholarly essays have appeared in such journals as the *American Political Science Review, History and Theory, The Political Science Reviewer,* and *Interpretation;* and as chapters in books such as *Ancients and Moderns.* Professor Lowenthal is the translator of Montesquieu's *Greatness and Decline of the Romans.*

MICHAEL J. GARGAS McGRATH is senior program analyst and project director in energy public policy and technology assessment at Systems Consultants, Inc., Washington, D. C. Dr. McGrath has taught political science and international relations at the University of Minnesota, Purdue University, Northwestern University and Brown University. His recent publications include *Liberalism and the Modern Polity* (1978) and a report prepared for the U.S. Department of Energy, *Productivity and Government Regulation in the U.S. Coal Industry* (1979). He is currently principal investigator for a series of R&D assessments of the U.S. oil shale industry for the U.S. Department of Energy.

WILSON CAREY McWILLIAMS is professor of political science, Livingston College, Rutgers University. He is the author of *The Idea of*

Fraternity in America, which received the National Historical Society Prize in 1974. His essay in this volume was originally presented as a President's Lecture, Rutgers University.

LYMAN TOWER SARGENT is professor of political science, University of Missouri, St. Louis; and editor of *Newsletter,* Conference for the Study of Political Thought. He is the author of four books: *Contemporary Political Ideologies, New Left Thought, Techniques of Political Analysis,* and *British and American Utopian Literature,* and editor of *Consent: Concept, Capacity, Conditions, and Constraints.* Professor Sargent's scholarly essays have appeared in *Extrapolation, Science-Fiction Studies, The Personalist, Political Theory* and *Comparative Literature Studies.*

MARC N. SCHEINMAN is assistant professor of political science at Rutgers University. He is the recipient of a National Endowment for the Humanities Summer Seminar Fellowship and a Colloquium Grant from the Rutgers University Research Council to direct and organize the Conference on Politics and Literature held at Rutgers in 1977.

PETER C. SEDERBERG is a professor in the department of government and international studies, University of South Carolina. Professor Sederberg is the author of *Interpreting Politics: An Introductory Analysis* and co-editor (with H. John Rosenbaum) and contributor to *Vigilante Politics.* His scholarly essays have appeared in *Comparative Politics, Philosophy of Social Science, Journal of the Developing Areas, Philosophy and Phenomenological Research,* and *Society.*

MARY LYNDON SHANLEY is assistant professor of political science at Vassar College. She has published scholarly essays in *Social Science Quarterly, Polity, Western Political Quarterly, Political Theory,* and *Signs: A Journal of Women in Culture and Society.* In addition to her work with Professor Stillman on utopian political thought, Professor Shanley's current research deals with women and the family in liberal political theory and law.

PETER G. STILLMAN is associate professor of political science at Vassar College and sometime visiting associate professor of politics at Princeton University. He teaches primarily the history of political thought. He has published numerous articles and book chapters, including his current research interests: Hegel's political philosophy, ecological political theory, utopian political thought (with Professor Shanley), and politics and literature.

TRACY B. STRONG is associate professor of political science at the University of California, San Diego. He has previously taught at Amherst College, Smith College, Yale University, the University of Pittsburgh and Harvard University. Professor Strong is the author of *Friedrich Nietzsche and the Politics of Transfiguration* as well as many scholarly essays in journals such as *History and Theory, Polity, Humanitas,* and chapters in books such as *Power and Community: Dissenting Essays in American Political Science* (eds. Philip Green and Sanford Levinson), *Nietzsche* (ed. Robert Solomon), *Structure, Consciousness and History* (eds. R. Brown and S. Lyman) and *Foreign Policy and Human Rights* (ed. P. Newburgh). He has been the recipient of a fellowship from the National Endowment for the Humanities as well as other research grants.

MICHAEL A. WEINSTEIN is professor of political science at Purdue University. He has published thirteen books in the fields of philosophy, political science, and sociology, including *Instrumentalism and Finalism: The Polarity of Mexican Thought, The Tragic Sense of Political Life, Meaning and Appreciation,* and *The Structure of Life.* Professor Weinstein also has published more than forty articles in the fields of political philosophy, law, sociology, philosophy, and criticism. He won the prize for the best paper presented at the meeting of the Midwest Political Science Association in 1969 and has received a Guggenheim Fellowship and a Rockefeller Foundation Humanities Fellowship for his work on existentialism and vitalism. He was Milward Simpson distinguished professor of political science at the University of Wyoming in 1979.

Index

Index prepared by Jacqueline Bittner